THE ROUTLEDGE COMPANION TO APPLIED PERFORMANCE

The Routledge Companion to Applied Performance provides an in-depth, far-reaching and provocative consideration of how scholars and artists negotiate the theoretical, historical and practical politics of applied performance, both in the academy and beyond.

These volumes offer insights from within and beyond the sphere of English-speaking scholarship, curated by regional experts in applied performance. The reader will gain an understanding of some of the dominant preoccupations of performance in specified regions, enhanced by contextual framing. From the dis(h)arming of the human body through dance in Colombia to clowning with dementia in Australia, via challenges to violent nationalism in the Balkans, transgender performance in Pakistan and resistance rap in Kashmir, the essays, interviews and scripts are eloquent testimony to the courage and hope of people who believe in the power of art to renew the human spirit.

Students, academics, practitioners, policy-makers, cultural anthropologists and activists will benefit from the opportunities to forge new networks and develop in-depth comparative research offered by this bold, global project.

Tim Prentki is Emeritus Professor of Theatre for Development at the University of Winchester. He is the co-editor of *The Applied Theatre Reader* (2008), author of *Applied Theatre: Development* (2015) and *The Fool in European Theatre: Stages of Folly* (2011), and co-editor with Ananda Breed of *Performance and Civic Engagement* (2018).

Ananda Breed is Professor of Theatre at the University of Lincoln. She is the author of *Performing the Nation: Genocide, Justice, Reconciliation* (2014), co-editor with Tim Prentki of *Performance and Civic Engagement* (2018) and Principal Investigator of the Arts and Humanities Research Council (AHRC) Global Challenges Research Fund (GCRF) project *Mobile Arts for Peace (MAP): Informing the National Curriculum and Youth Policy for Peacebuilding in Kyrgyzstan, Rwanda, Indonesia and Nepal* (2020–2024).

ROUTLEDGE THEATRE AND PERFORMANCE COMPANIONS

The Routledge Companion to Michael Chekhov
Edited by Marie-Christine Autant-Mathieu and Yana Meerzon

The Routledge Companion to Jacques Lecoq
Edited by Mark Evans and Rick Kemp

The Routledge Companion to Scenography
Edited by Arnold Aronson

The Routledge Companion to Adaptation
Edited by Dennis Cutchins, Katja Krebs and Eckart Voigts

The Routledge Companion to Butoh Performance
Edited by Bruce Baird and Rosemary Candelario

The Routledge Companion to Theatre, Performance and Cognitive Science
Edited by Rick Kemp and Bruce McConachie

The Routledge Companion to African American Theatre and Performance
Edited by Kathy A. Perkins, Sandra L. Richards, Renée Alexander Craft, and Thomas F. DeFrantz

The Routledge Companion to Theatre of the Oppressed
Edited by Kelly Howe, Julian Boal, and José Soeiro

The Routledge Companion to Theatre and Politics
Edited by Peter Eckersall and Helena Grehan

The Routledge Companion to Dance Studies
Edited by Helen Thomas and Stacey Prickett

The Routledge Companion to Performance Practitioners
Edited by Franc Chamberlain and Bernadette Sweeney

The Routledge Companion to Performance Philosophy
Edited by Laura Cull Ó Maoilearca and Alice Lagaay

The Routledge Companion to Theatre and Performance Historiography
Edited by Tracy C. Davis and Peter W. Marx

The Routledge Companion to Applied Performance
Edited by Tim Prentki and Ananda Breed

For more information about this series, please visit: https://www.routledge.com/handbooks/products/SCAR30

THE ROUTLEDGE COMPANION TO APPLIED PERFORMANCE

Volume One – Mainland Europe,
North and Latin America, Southern Africa,
and Australia and New Zealand

Edited by
Tim Prentki and Ananda Breed

Routledge
Taylor & Francis Group
LONDON AND NEW YORK

First published 2021
by Routledge
2 Park Square, Milton Park, Abingdon, Oxon OX14 4RN

and by Routledge
52 Vanderbilt Avenue, New York, NY 10017

Routledge is an imprint of the Taylor & Francis Group, an informa business

© 2021 selection and editorial matter, Tim Prentki and Ananda Breed; individual chapters, the contributors

The right of Tim Prentki and Ananda Breed to be identified as the authors of the editorial material, and of the authors for their individual chapters, has been asserted in accordance with sections 77 and 78 of the Copyright, Designs and Patents Act 1988.

All rights reserved. No part of this book may be reprinted or reproduced or utilised in any form or by any electronic, mechanical, or other means, now known or hereafter invented, including photocopying and recording, or in any information storage or retrieval system, without permission in writing from the publishers.

Trademark notice: Product or corporate names may be trademarks or registered trademarks, and are used only for identification and explanation without intent to infringe.

British Library Cataloguing-in-Publication Data
A catalogue record for this book is available from the British Library

Library of Congress Cataloging-in-Publication Data
Names: Prentki, Tim, editor. | Breed, Ananda, editor.
Title: The Routledge companion to applied performance/
edited by Tim Prentki and Ananda Breed.
Other titles: Companion to applied performance
Description: Abingdon, Oxon; New York: Routledge 2021. | Series:
Routledge companions | Includes bibliographical references and index.
Contents: v. 1. Mainland Europe, North and Latin America, southern
Africa, and Australia and New Zealand – v. 2. Brazil, West Africa,
South and South East Asia, United Kingdom, and the Arab World
Identifiers: LCCN 2020022722 (print) | LCCN 2020022723 (ebook)
ISBN 9780367542634 (v. 1; paperback) | ISBN 9780815359654 (v. 1; hardback)
ISBN 9780367134433 (v.2; hbk) | ISBN 9781003088042 (v.2; ebk) |
ISBN 9781351120142 (v. 1; ebook)
Subjects: LCSH: Theater and society. | Performing arts.
Classification: LCC PN2049 .R627 2021 (print) | LCC PN2049 (ebook) |
DDC 792.01–dc23
LC record available at https://lccn.loc.gov/2020022722
LC ebook record available at https://lccn.loc.gov/2020022723

ISBN: 978-0-8153-5965-4 (hbk)
ISBN: 978-1-351-12014-2 (ebk)

Typeset in Bembo
by Deanta Global Publishing Services, Chennai, India

CONTENTS

List of figures x
Contributors xi
Acknowledgements xxiv

Introduction to volume one: Considering the ethics of representation in applied theatre 1
Tim Prentki and Ananda Breed

PART I
Australia and New Zealand 7

Introduction to Part I: Considering the ethics of representation in applied theatre 9
Helen Cahill and Peter O'Connor

1 Identifying and understanding the notion of quality within an applied theatre project designed to playfully engage people living with dementia 19
Julie Dunn and Michael Balfour

2 Repairing the evil: Staging *Puppet Antigone* (2017) at Auckland Prison 32
Rand Hazou

3 Taurima Vibes: Economies of *manaakitanga* and care in Aotearoa New Zealand 43
Molly Mullen and Bōni Te Rongopai Tukiwaho

4 Small acts at the margins: Making theatre work at cross-cultural intersections 56
Linden Wilkinson

5 The art of listening in prison: Creating audio drama with
 incarcerated women 65
 Sarah Woodland

PART II
The Balkans 77

Introduction to Part II and III: Memory, identity and the (ab)use of
representation 79
Kirsten Sadeghi-Yekta and Darko Lukić

6 Performing the otherness: Representation of the invisible communities
 in post-conflict and post-communist societies: Croatian example 82
 Darko Lukić

7 The bridge to hope: Applied theatre in post-war Bosnia and Herzegovina 93
 Sead Đulić

8 Theatre against violence, action in classrooms 101
 Ines Škuflić-Horvat, Maja Sviben, and Nina Horvat

9 Interview with Vladimir Krušić: Theatre and drama in education 108
 Darko Lukić

10 In search of polyphonic concepts of participatory theatre and art for
 social change: Almost half a century of engagement 116
 Ljubica Beljanski-Ristić

11 Giving voice to the voiceless: Raising awareness and spurring debate on
 the Homeland War (1991–1995) in Croatian theatre 130
 Nikolina Židek

PART III
North America 139

12 Examining the ethics of research-based theatre through *Contact!Unload* 141
 *George Belliveau, Susan Cox, Jennica Nichols, Graham W. Lea
 and Christopher Cook*

13 We are here: Glyphing a re-creation story through waterways, bloodlines
 and constellations 149
 Jill Carter

14 Applied performance practices of therapeutic clowns: A curated
 conversation with Helen Donnelly 158
 Julia Gray, Jenny Setchell, and Helen Donnelly

15 Playback Theatre conductor as ritual guide: The artful and sensitive job
 of extracting personal stories 166
 Hannah Fox

16 Theatre to address social justice issues with gatekeepers in Canada 173
 Lauren Jerke and Warwick Dobson

17 Tensions of engagement: Oscillating between distance and implication 180
 Yasmine Kandil

18 Questioning social justice: A dialogue on performance, activism, and
 being in-between 186
 Asif Majid and Elena Velasco

19 Timely homecomings 194
 Carrie MacLeod

20 The arrivals legacy process: Reviving Ancestral stories of recovery
 and return 201
 Diane Roberts

21 Applying *Hamilton* 210
 Hana Worthen

PART IV
Latin America **215**

Introduction to Part IV: Applied performance in Latin America 217
Paloma Carpio and Rodrigo Benza

22 The body, women, and performance art in Latin America 226
 Josefina Alcázar

23 Dance as a tool for the construction of peace and identity 235
 Ana Carolina Ávila

24 We play as we mean to resist: Theatre games as political participation 245
 Matthew Elliott

25 Communal living culture: From the many to the few, from the few to the many 254
Iván Nogales and Paloma Carpio

26 Latent conflict or latency in conflict: The liminal space between art actions and the Chilean civic-military dictatorship 261
Andrés Grumann Sölter and Francisco González Castro

27 The community and its gaze: Argentine community theater 271
Edith Scher

28 Three community experiences and a resignation 278
Rafael Murillo Selva

PART V
Southern Africa 287

Introduction to Part V: Applied performance in Southern Africa 289
Alexandra Sutherland

29 *Romio ndi Julieti* (*Romeo and Juliet*): Chichewa language production of a serious drama 294
Amy Bonsall

30 *Rituals* (2010) as a counter narrative of healing and reconciliation in Zimbabwe 305
Kelvin Chikonzo and Ruth Makumbirofa

31 Dear Mr Government 315
Jessica Lejowa, Bongile Gorata Lecoge-Zulu and Cheraé Halley

32 Applied performance as a space to address issues affecting girls and young women in Zimbabwe: A case study of *Rachel 19* 331
Cletus Moyo and Nkululeko Sibanda

33 Applied arts in business contexts: Selling out to the oppressor or doing transformational work? 341
Petro Janse van Vuuren

PART VI
Western Europe 357

Introduction to Part VI: Care for the Open: intercultural challenges and
transcultural potential of applied performances in Western Europe 359
Julius Heinicke

34 Realistic art and the creation of artistic truth 364
Rolf Bossart

35 Artistic creation and participation in Portugal and Brazil:
The urgencies of today 371
Hugo Cruz
Translation: Adriana Miranda da Cunha and Matthew Wilhelm-Solomon

36 Core of Nordic applied theatre: Challenges in a subarctic area 383
Rikke Gürgens Gjærum

37 Youth transformation in search of freedom 393
Maria Kwiatek

38 *Legami in spazi aperti* (Bonds in Open Spaces) 403
Giulia Innocenti Malini

39 Exploring dramaturgy in participatory refugee theatre as a dialogical art
practice: Dialogical tensions in a temporary relational playground 415
Sofie de Smet, Lucia De Haene, Cécile Rousseau, and Christel Stalpaert

40 The right artistic solution is just the beginning 430
Lene Thiesen

Index 443

FIGURES

1.1	The O'Rourke et al. 2015 model of factors that affect quality of life according to people living with dementia	21
13.1	Creator's First Thoughts (Philip Cote). (Photo: Jill Carter, July 2017.)	153
13.2	You Are Here. (Photo: Jill Carter, July 2017.)	154
13.3	Indigenous star mapping. (Photo: Jill Carter, July 2017.)	154
13.4	Grandmother Moon teaches First Man. (Photo: Jill Carter.)	155
13.5	Routes and Roots workshop participant. (Photo: Jill Carter.)	155
20.1	Jude Wong, Danielle Smith (head down) & Liliona Quarmyne. Archive of The Arrivals Co(Lab), Vancouver 2009. (Photo: Diane Roberts.)	203
20.2	Rosemary Georgeson. Archive of The Arrivals Cross Canada Workshop Series, Vancouver 2009. (Photo: Diane Roberts.)	205
20.3	Augustine Efe Olaijo, Ny Langdon, Liliona Quarmyne. Archives Arrivals Atlantic Project residency, Cardiff, Wales, 2011. (Photo: Diane Roberts.)	207
20.4	Protocols table. Archive of The Arrivals Legacy Project workshop, Toronto 2016. (Photo: Diane Roberts.)	208
22.1	Nao Bustamante in *America the Beauty* (1995). (Photo: Monica Naranjo.)	230
24.1	Outside of CIP San Joaquin, 17 November 2016. (Photo: Matthew Elliott.)	246
24.2	Floor plan of CIP San Joaquin, 15 December 2016. (Photo: Matthew Elliott.)	247
27.1	*Herido Barrio* written and directed by Edith Scher. (Photo: Julio Locatelli.)	276
35.1	The Map show presented at Casa da Música in Porto, Portugal. (Photo: Patrícia Poção.)	376
35.2	Duck March #Porto by Caterina Moroni and pregnant women at Mexe 2019 edition, Portugal. (Photo: Patrícia Poção.)	378
35.3	António Bukhar and Faizal Ddamba performance with participants of the workshop at Mexe 2019 edition, Portugal. (Photo: Patrícia Poção.)	380
39.1	A temporary common playground. (Photo: Steff Nellis.)	418
40.1	Performance by Thalias Tjenere, Hanstholm School. (Photo: Søren Kløft.)	435
40.2	Workshop, Hanstholm School. (Photo: Søren Kløft.)	436
40.3	Workshop, Hanstholm School. (Photo: Søren Kløft.)	437
40.4	*Body Parts*, Uppercut Dance Theatre, Brovst School. (Photo: Lene Thiesen.)	438

CONTRIBUTORS

Part I

Michael Balfour is head of School of the Arts and Media, and professor of theatre and performance at the University of New South Wales, Sydney, Australia. Michael's research explores applied theatre and performance work in a range of social contexts. He has received numerous competitive national grants for projects, including theatre and performance-based work in prisons, creative approaches to supporting the mental health of returning servicemen from Iraq and Afghanistan, and arts-based work with newly arrived refugee communities. Michael's work with creative approaches to working with people with mid- to late-stage dementia won a Creative Partnerships Award, and he was also the recipient of the Arts and Health National Leadership Award.

Helen Cahill is professor of student well-being and director of the Youth Research Centre in the Graduate School of Education at The University of Melbourne, Australia. She specialises in the use of drama-informed participatory methods in youth research, and in the development of social wellbeing and gender education programmes for use in school and community settings. She is co-editor of the Springer Series: *Perspectives on Children and Youth*.

Julie Dunn is a professor of drama education and applied theatre within the School of Education and Professional Studies at Griffith University, Brisbane, Australia. Julie's research is focused on improvised and playful forms of drama within settings including early childhood classrooms, secondary schools and aged-care homes. She has been a chief investigator on two Australian Research Council Linkage projects (*Playful Engagement* and *Refugee Resettlement*), as well as two large-scale Queensland Government funded studies (*Y Connect* and *Age Appropriate Pedagogies*). Julie is passionate about the impact that drama, play and playfulness can have on engagement, understanding and empathy.

Rand Hazou is a theatre academic and facilitator with experience working across a variety of creative and community contexts. In 2004, he was commissioned by the UNDP to travel to the occupied territories in Palestine to work as a theatre consultant running workshops for Palestinian youths. He is currently a senior lecturer in theatre in the School of English and

Media Studies at Massey University. His research explores theatre that engages with issues of social justice. His research on asylum seeker and refugee theatre has been published in a series of international journal articles. In Aotearoa he has recently led teaching and creative projects engaging with both prison and aged-care communities.

Molly Mullen is a senior lecturer in applied theatre in the Faculty of Education and Social Work at the University of Auckland. To this role she brings over 15 years of experience producing theatre education, youth theatre, community arts and children's theatre projects in the United Kingdom and New Zealand. Molly's research examines the economies of artists and organisations involved in creating socially committed theatre, drama and performance. Her book, *Applied Theatre: Economies* focuses on applied theatre's relationship to the economy and the ways in which socially-committed theatre makers fund, finance or otherwise resource their work.

Peter O'Connor is professor of education and director of the Creative Thinking Project at the University of Auckland, New Zealand. His most recent work involves working alongside artists on Skid Row in Los Angeles as part of a residency at the Museum of Contemporary Art. He is the co-editor, with Mary McAvoy, of the *Routledge Companion to Drama Education* to be published in 2020.

Bōni Te Rongopai Tukiwaho (Tūhoe, Te Arawa, Tuwharetoa) is an Auckland-based artist and educator who has worked in the arts for 30 years. He has leadership roles and expertise in the performing arts and mental health sectors. In all *mahi* undertaken, he helps others to find a common ground to enable togetherness. He works to combat stigma and negative social perceptions of othered communities and health. Bōni is leader of his own arts company Taurima Vibes. His *mahi* sits in four main areas: Producer, artistic director, educator, mentor and artist; community arts and well-being brokerage; well-being/*hauora* facilitator and cultural safety advisor; and internal process and strategic consultant.

Linden Wilkinson completed an economics degree at Sydney University, and went on to attain a Diploma in Acting at the National Institute of Dramatic Art, and performed extensively across Australia and New Zealand. She added television series writing and playwriting to her repertoire and later returned to Sydney University for higher study. Using performance ethnography as a method of delivering research, she explored long-term trauma, individual and intergenerational, through the lens of verbatim theatre for both her master's and doctoral degrees. She has further developed a hybrid verbatim mode using testimony and improvisation for performance in the arts health rehabilitation space.

Sarah Woodland is a researcher, practitioner and educator in socially-engaged and participatory arts. She has over 20 years' experience in the arts and cultural sectors in Australia and the United Kingdom, with a particular focus on engaging communities and groups from diverse social and cultural backgrounds, and those with experience of the criminal justice system. Sarah's recent roles include research fellow for the Australian Research Council Linkage project 'Creative Barkly: Sustaining the Arts and Cultural Sector in Remote Australia' (2016–2019); and chief investigator for 'Listening to Country: Exploring the Value of Acoustic Ecology with Aboriginal and Torres Strait Islander Women in Prison' (2017–2018, funded by the Lowitja Institute). Sarah teaches theatre in the School of Humanities, Languages and Social Sciences at Griffith University and has published extensively in the fields of applied theatre and participatory arts.

Contributors

Part II

Ljubica Beljanski-Ristić graduated in Yugoslav literature and the Serbo-Croatian language from the Faculty of Philology in Belgrade. Since 1977, she has worked in the Cultural Centre Stari Grad, where she has initiated the Drama Studio Škozorište, Studio of Creative Education, Školigrica and other innovative, creative and interactive projects for children and youth, providing support to young professionals and artists to engage in practice and practical research projects. In 1999, she founded the Centre for Drama in Education and Arts (CEDEUM), which became the National Centre of the International Association for Drama/Theatre and Education (IDEA). In 2000, she designed the concept of Bitef Polyphony, the associated programme of the Belgrade International Theatre Festival of new theatre tendencies Bitef. She is currently an external consultant within the 'Cultural Participation and Cultural Heritage' project realised by the Institute for the Study in Cultural Development of Serbia.

Sead Đulić is a director in the Centre for Drama Education of Bosnia and Herzegovina, which is a member of the International Association of Drama/Theatre in Education, and he is the chairman of the BH Centre of ASSITEJ (International Association of Theatres for Young Audiences). He was born in 1950 in Stolac, Bosnia and Herzegovina. He studied drama in Sarajevo, and moved to Mostar where he founded the Mostar Youth Theatre (MTM). Since its foundation in 1974, the theatre has focused on drama education and Sead has worked as the theatre director. He led various workshops in the country and abroad (Croatia, Serbia, Monte Negro, Slovenia, Bulgaria, Italy, Singapore, USA, Great Britain, Greece, Hong Kong, Germany, Jordan, Spain). He was a regular collaborator at the Department for Acting and Drama Pedagogy at the Faculty of Humanities at Džemal Bijedić University in Mostar.

Nina Horvat is the artistic director of Tirena Theatre where she works as a drama pedagogue and leads workshops. She was born in 1989 in Zagreb, Croatia. She received her bachelor's and master's degrees in dramaturgy at the Academy of Dramatic Arts in Zagreb. As a dramaturg she worked on ten theatre productions. Her plays for children and adults have been staged in several theatres in Croatia and Serbia. She won three awards for her plays.

Vladimir Krušić is a theatre director and drama pedagogue. From 1988–2008 he was the head of the Educational Department of the Zagreb Youth Theatre, and since 2008 he heads the Youth Theatre Studio of the Croatian National Theatre in Varaždin. In 1996, he founded the Croatian Centre for Drama Education (HCDO) and is its president. From 2004–2010 he was the chair of the General Council of the International Drama/Theatre and Education Association (IDEA). From 2000–2010 he taught drama pedagogy at various faculties of the University of Zagreb. Since 2012, he has been teaching at the Zagreb Faculty of Teacher Education.

Darko Lukić is a theatre scholar, playwright, novelist, researcher, teacher and practitioner, living in Germany and working around Europe. He was born in 1962 in Croatia. As an academic he was tenured professor at the University of Zagreb, guest professor at the Faculty of Philosophy, University of Zagreb (where he completed his doctoral studies of theatre, film, literature and culture), and a guest professor at Karl-Franzens-Universität, Austria - Institut für Slawistik. As a teacher he also worked (lecturing, teaching and leading workshops) in Brazil, Bulgaria, Costa Rica, Croatia, France, Germany, Italy, Romania, Slovenia, Spain, USA, United Kingdom and Venezuela. He is also a mentor and trainer at the Audience Development and Capacity Building programmes in Rijeka 2020 European Capital of Culture.

Contributors

Ines Škuflić-Horvat is currently teaching the postgraduate specialist study of drama pedagogy at the Faculty of Education, Zagreb. She was born in Pula, Croatia. She received her bachelor's and master's degrees at the Faculty of Humanities and Social Sciences in Zagreb where she is currently working on her doctorate dissertation. She works in Tirena Theatre as a drama pedagogue and project coordinator. She directed numerous theatre productions with children and young adults who have participated in a variety of international festivals. She was a workshop leader on several different festivals and performances in Europe and the artistic director of 12 theatre camps and European Drama Encounters (EDERED) in Croatia.

Maja Sviben is a drama teacher for Theatre Tirena and leads theatre workshops for children and young people as well as for their educators in Croatia and abroad. She was born in 1981 in Zagreb, where she studied dramaturgy at the Academy of Dramatic Arts. She worked as a dramaturg and/or playwright on more than 30 performances for various theatres, companies and institutions throughout Croatia. She is a member of the editorial board of drame.hr, a website publishing contemporary Croatian playwrights, and the co-founder of the artists' collective SKROZ. Among much published research in drama and theatre she is the author of the books *The War Trauma Drama* and *Introduction on Applied Theatre*.

Nikolina Židek, PhD is adjunct professor at IE University Madrid, School of Global and Public Affairs, and researcher in the field of memory politics. She is also a guest lecturer at the advanced study course in human rights and genocides, Universidad del Museo Social Argentino (UMSA) in cooperation with Luisa Haraibedian Foundation, Buenos Aires, Argentina. Her most recent articles were published in the *Memory Studies Journal* and a volume on political rituals and cultural memory in Croatia, published by Routledge. She is also a theatre translator and promoter of Croatian theatre in Spanish-speaking countries. So far she has translated more than 30 plays, published in five volumes and staged in Croatia, Argentina, Chile, Venezuela, Uruguay, Paraguay and Mexico.

Part III

George Belliveau is professor of theatre/drama education at the University of British Columbia, Canada. He co-produced, directed and performed in *Contact!Unload*. His research has been published in various arts and theatre education research journals and books. He has written five books, including a co-edited one with Graham Lea, *Research-Based Theatre as Methodology: An Artistic Approach to Research*.

Jill Carter (Anishinaabe/Ashkenazi) is a theatre practitioner and researcher, currently cross appointed to the centre for drama, theatre and performance studies; the transitional year programme; and indigenous studies at the University of Toronto. She works with many members of Tkaronto's indigenous theatre community to support the development of new works and to disseminate artistic objectives, process and outcomes through community-driven research projects. Her scholarly research, creative projects and activism are built upon ongoing relationships with indigenous elders, artists and activists, positioning her as witness to, participant in and disseminator of oral histories that speak to the application of indigenous aesthetic principles and traditional knowledge systems to contemporary performance.

Christopher Cook is a therapist, playwright and theatre creator. He is passionate about using theatre as a therapeutic, learning and research tool. His plays include *Quick Bright Things* (Persephone Theatre, 2017) and *Voices UP!* (UBC Learning Exchange, 2017), a collaborative creation with community members in Vancouver's Downtown Eastside. Chris is currently com-

pleting his PhD at the University of British Columbia, focusing on the intersections between mental health and research-based theatre.

Susan Cox is associate professor and director of the PhD and MSc programmes in the School of Population and Public Health at the University of British Columbia. Susan is an interdisciplinary health researcher with a background in medical sociology and ethics. Her current research focuses on the relationship between the arts and health, especially the use of arts-based methods in health research, and the experiences of human subjects participating in health research. Her current projects include 'Don't Rock the Boat', a research-based theatre performance addressing issues of graduate supervisory relationships and well-being.

Warwick Dobson, PhD is currently university scholar in applied theatre at the University of Victoria, Canada. He has worked as a classroom teacher, a teacher educator, a theatre director and a university professor.

Helen Donnelly has been a professional circus and theatrical clown for 25 years and a professional therapeutic clown since 2004, as well as an award-winning clown teacher. An alumna of Cirque du Soleil and Circus Orange, she has clowned around the world in circus, festivals and in theatre. For over a decade, Helen has served as a therapeutic clown in pediatrics (both trauma and rehabilitation) and geriatrics (specifically with elders with dementia). In 2018, she created and taught North America's first Therapeutic Clowning Certificate Programme through George Brown College, Continuing Education. Her graduates have now joined her new not-for-profit therapeutic clowning service Red Nose Remedy where they serve vulnerable populations in Ontario, Canada.

Hannah Fox is a professor of applied theatre, co-director of the New York School of Playback Theatre, and founder of Big Apple Playback Theatre, a professional multicultural playback theatre company based in New York City. Hannah is an internationally recognised playback theatre trainer and has a special interest in using playback and other applied theatre forms to address social justice issues. She has published several articles on playback theatre as well as a book of theatre games, entitled *Zoomy Zoomy: Improv Games and Exercises for Groups* (2010). Hannah is the daughter of the founders of playback theatre.

Julia Gray is a playwright, theatre director, physical theatre creator and artist-researcher; she is currently visiting scholar at Sensorium, a research centre based in The School of the Arts, Media, Performance & Design at York University. Her award-winning scholarship and research focuses on applied performance, health humanities, performance-as-research and socio-cultural and aesthetic approaches to embodied differences, including disability and aging. Julia's work spans the fine arts, humanities, social sciences and health sciences, and she has published and presented across disciplines. She recently completed a postdoctoral fellowship at Bloorview Research Institute, Holland Bloorview Kids Rehabilitation Hospital, which was supported by an award from the Social Science and Humanities Research Council of Canada.

Lauren Jerke is an applied theatre practitioner and PhD candidate at the University of Victoria, Candada. As a practitioner she has worked with diverse groups, such as psychiatric patients, university students in Canada and China, and high school students throughout rural Malawi. Rather than structuring drama work to find solutions, Lauren's drama work aims to foster deeper understanding about the nature of the conflict itself. Her doctoral research focuses on revolutionary applied theatre and examines three case studies she facilitated with future and current gatekeepers through this lens.

Contributors

Yasmine Kandil is assistant professor of applied theatre at the University of Victoria. Her research interests are in celebratory theatre with immigrant and refugee communities, understanding applied theatre initiatives post political revolutions (Cairo-based), and most recently in how applied theatre is utilised in policing and mental health response.

Graham W. Lea is an assistant professor of theatre/drama education at the University of Manitoba. His research interests include research-based theatre methodology, narrative in mathematics education, theatre/drama in health and teacher education research. Graham speaks and publishes widely on theatre education and research methodology. He has been involved in theatre for 25 years, working variously as a playwright, stage manager, director, actor, musician and technician. He is co-editor, with George Belliveau, of the book *Research-Based Theatre: An Artistic Methodology*.

Carrie MacLeod works worldwide with NGOs, humanitarian agencies, educational institutions, non-profit organisations and for-profit enterprises. Carrie specialises in arts-based approaches in conflict transformation, peacebuilding, refugee and immigrant resettlement, curriculum design and experiential pedagogy. She is a faculty member of the European Graduate School in Switzerland and the Vancouver School of Healing Arts. Carrie offers workshops, intensive practitioner trainings, project consultation and keynote speaking through her atelier, Intermodal Arts. She also designs and delivers courses for graduate and undergraduate level programmes as adjunct or visiting faculty.

Asif Majid is a scholar–artist–educator who researches, teaches, performs and makes work at the intersection of performance and politics. He is pursuing a practice-based PhD in anthropology, media, and performance at The University of Manchester, earned an MA in Conflict Resolution from Georgetown University, and graduated with a self-designed BA in Interdisciplinary Studies from the University of Maryland, Baltimore County. Performance credits include work with The Stoop (US), the John F. Kennedy Center for the Performing Arts (US), Convergence Theatre (US), Royal Exchange Theatre (UK), Unity Theatre (UK) and Action Transport Theatre (UK).

Jennica Nichols holds a Master in Public Health (epidemiology and global health) from the University of Toronto and the credentialed evaluator designation from the Canadian Evaluation Society. She has previously worked doing programme planning, evaluation and quality improvement while co-owning a research-informed theatre company called Starfish Productions. Since 2016, Jennica has been pursuing her doctorate at the University of British Columbia. Her research combines research-based theatre with implementation science. The goal is to refine a method that fosters reciprocal research and facilitates the co-design of health interventions. Her other research interests include arts-based research, data science, ethics, implementation science and teaching evaluative thinking.

Diane Roberts is an accomplished director, dramaturge, writer and cultural animator, who has collaborated with innovative theatre visionaries and interdisciplinary artists for the past 30 years. Her directorial and dramaturgical work has been seen on stages across Canada and her reputation as a mentor, teacher and community collaborator is nationally and internationally recognised. Diane is a 2019 Pierre Elliott Trudeau Scholar and current PhD candidate in the fine arts interdisciplinary HUMA programme. Diane's celebrated Arrivals Personal Legacy Project has birthed new interdisciplinary works across Canada, throughout the Americas, in the United Kingdom, Europe, Africa and the Caribbean. This work has allowed her to articulate, cultivate and realise a vision for theatre that encourages indigenous ways of knowing as a stepping stone to creative expression.

Contributors

Kirsten Sadeghi-Yekta (PhD, University of Manchester) is an assistant professor at the University of Victoria, BC, Canada. Currently, she is working on her Social Sciences and Humanities Research Council Partnership Development Grant and Insight Development Grant on Coast Salish language revitalization through theatre. Her theatre facilitation includes working with children in the Downtown Eastside in Vancouver, young people in Brazilian favelas, women in rural areas of Cambodia, adolescents in Nicaragua, and students with special needs in The Netherlands.

Jenny Setchell is senior research fellow at the School of Health and Rehabilitation Sciences at The University of Queensland in Brisbane, Australia. She holds an adjunct scientist position at the Bloorview Research Institute in Toronto, Canada. Her research interests include critical perspectives on health care and she uses social theory and philosophy to examine health care practices. She has a PhD in health psychology, and 20 years of diverse clinical physiotherapy experience. Jenny is a founding member of the international Critical Physiotherapy Network. She has also been an acrobat and a human rights worker.

Elena Velasco is a theatre artist whose work encompasses many aspects of performance, production, activism and education. She is the artistic director of Convergence Theatre, a multi-disciplinary performance collective focused on social justice. Additionally, she is a tenure-track assistant professor of theatre at Bowie State University. For over 25 years her work has been featured in Washington, DC theatres, including the Kennedy Center, GALA Hispanic, Synetic Theater and Imagination Stage, where she is an affiliated artist with Óyeme, a programme for unaccompanied minors. She holds an MFA in Directing and BA in Drama from the Catholic University of America.

Hana Worthen is associate professor of theatre and performance studies at Barnard College, Columbia University, USA. She serves as an associate director of Barnard's Center for Translation Studies as well. Her current scholarship takes up the intersection between theatre/performance humanism and critical posthumanism, human/animal rights and interspecies ethics, and transmedia and multiplatform performance. She has two forthcoming monographs, *Humanism, Drama, Performance: Unwriting Theatre* (2020) and *Shakespeare Among Military Veterans* (2020).

Part IV

Josefina Alcázar is a doctor in sociology from the Universidad Nacional Autónoma de México. She is a researcher at the Rodolfo Usigli Theater Research Center focused on the study of performance, art action and gender. Her publications include her books: *Arte-Acción y Performance en Los Muchos Méxicos*, 2016; *Performance, un Arte Del Yo. Autobiografía, Cuerpo e Identidad*, 2014; *La Cuarta Dimensión Del Teatro, Tiempo Espacio y Video en La Escena Moderna*, 2011. She is co-editor of *Performance y Arte Acción en América Latina*, 2005; of the *Serie Documental de Performance Mujeres en Acción*, 2010, and of the Performance Series in Mexico, 2014. She has published articles and book chapters in Mexico, Ecuador, Chile, Spain and the United States.

Ana Carolina Ávila holds a Master in Performing Arts with Emphasis on Contemporary Dance of the Superior Academy of Arts (ASAB). She has experience in teaching since 2004, with projects focused on dance and cultural management in rural and urban settings in the country, and in the last eight years, particularly in the reconstruction of the social fabric based on the impact of the armed conflict, and the development of methodologies based on different dance and cultural legacies. She has collaborated in the organisation and development of the National Dance Research Congress for several years. She is a candidate for the Master in Aesthetics and Art History of the Humanities Department at Jorge Tadeo Lozano University.

Contributors

Francisco González Castro is an artist, curator and researcher. He has a Bachelor of Arts, a Master of Arts and a Doctor of Arts (Visual Arts) from the Pontificia Universidad Católica de Chile (UC). As an artist he has developed his work since 2005 to date with exhibitions and presentations, both individual and collective, in Chile and abroad. He has presented his research at various conferences and in magazines in Chile and abroad. Recently, he published the book *Performance Art en Chile: Historias, Procesos y Actualidad*. He is a member of the Charco Collective, with which he has developed artistic, academic and educational activities, and he is also director of the Global Center for Advanced Studies – South America Collective.

Matthew Elliott is a facilitator and director based in Liverpool. After training at the Liverpool Institute for Performing Arts, Matthew has worked collaboratively on a national and international basis with a range of companies including Collective Encounters (UK), Colectivo Sustento (Chile) and Lagnet (Kenya). Specialising in theatre for social change practice, he has worked extensively with young people and adults in a range of settings including the criminal justice system and educational institutions. Matthew is a Winston Churchill Fellow and recipient of the Koestler award for work undertaken at HMP Altcourse prison. He completed a practice as research PhD at the University of Leeds in 2019; *Embodying Critical Engagement: Experiments with politics, theatre and young people in the UK and Chile*. Matthew currently teaches at the Liverpool Institute for Performing Arts and his research interests include theatre for development practice, critical pedagogy and the depoliticisation of community theatre practice.

Rodrigo Benza Guerra is a director and researcher on performing arts, and professor of the Department of Performing Arts of the Pontificia Universidad Católica del Perú (PUCP). He has a Master in Theater from the Universidade do Estado de Santa Catarina (UDESC) and a Bachelor of Performing Arts from the PUCP where he serves as director of cultural activities. Among his most outstanding scenic projects are the creation of the work *La Gran Fiesta de la Democracia Real (2017)*, *Ausentes – Proyecto Escénico (2016)* and *Proyecto Empleadas (2009)*, winner of the Iberescena prize. He has published articles in academic journals and books in Peru, Brazil, Cuba, Argentina, England and South Africa mainly on intercultural theatre, community theatre and documentary theatre.

Iván Nogales (La Paz, Bolivia; November 13, 1963 – La Paz, Bolivia; March 21, 2019) was a leading actor, theatre director and Bolivian cultural manager. Iván began his theatrical activity in 1982 by integrating the *Agujón* group. He developed his work in the city of El Alto, where he founded *Teatro Trono* with a group of street children. Subsequently, *Teatro Trono* was converted into the Compa Foundation (Community of Art Producers) to support popular, self-managed community theatre. Together with *Teatro Trono* he created a dozen theatre plays, as well as several adaptations of well-known authors. *Teatro Trono* toured Bolivia, Argentina, the United States, the Netherlands, Denmark, Germany, France, Spain and other countries. He developed an artistic methodology called "decolonisation of the body", which he developed in the book of the same name. It was published in 2013 and proposes a manifesto on the pedagogy of free bodies and the liberation of society. In 2013 he led the organisation of the First Latin American Congress of Community Living Culture which has become a benchmark around cultural projects that propose decolonisation, depatriarisation and good living.

Edith Scher trained in theatre with Raúl Serrano and in clown at the school of Marcelo Katz. She studied piano, flute, accordion, clarinet and audioperception. She studied literature at the University of Buenos Aires, and dramaturgy with Mauricio Kartun and Pablo Iglesias. Since 2002, she has directed the community theatre group Matemurga of Villa Crespo with which

she created the plays *La Caravana, Zumba La Risa, Herido Barrio* and co-directed, with Emilia Goity, *Falta de Aire*. She has conducted directing workshops at the International Community Arts Festival, Rotterdam, Netherlands (2011); in the Community Theater Meeting, Madrid, Spain (2012); at the Imaginarius Festival, Santa Maria Da Feira, Portugal (2013); in the Our People Cultural Corporation, within the framework of the International Art Meeting, Medellín, Colombia (2015); on the 25th anniversary of the Andante de Todos Theater Group, Bayamo, Cuba (2016); in the 4th International Clown Workshop, Las Tunas, Cuba (2018); and at the Mexe Festival, Faro, Portugal (2018). In 2010, she published *Teatro de Vecinos, de La Comunidad Para La Comunidad*. She has been invited to write articles about community theatre in the books of ICAF 2011 (Rotterdam) and Arte e Comunidade (Portugal), and in the magazine *Paso de Gato* (Mexico).

Rafael Murillo Selva is a Honduran playwright and theatre director, and holds a Doctor of Law and Political Science and Economic History. He was part of the theatre group La Candelaria (Colombia) and is the founder of the experimental theatre La Merced (TEUM). He has been cultural attaché of Honduras in Colombia and deputy director for Latin America and the Caribbean in the area of Culture of the United Nations Educational and Cultural Organization (UNESCO). He has written several publications, both about theatre and analysis in various international media, and has conducted many processes of scenic creation, mainly in community settings. One of his most representative works is *Loubavagu* or *The Other Side of the Bridge*, which was presented for 18 years.

Andrés Grumann Sölter has a Doctorate in Theatre and Dance Studies from the Freie Universität Berlin. He also has a Degree in Philosophy from the Pontificia Universidad Católica de Chile (UC). He teaches and researches at the Faculty of Arts of the UC (School of Theatre and Postgraduate in Arts). He also teaches the Masters in Art Theory and History at the Universidad de Chile and the Arcos theatre school. He has published several articles in Chile, Argentina, Brazil, the United States, Mexico and Germany and is the author of the book *Anfiteatro Estadio Nacional* and co-author of the books *Danza Independiente en Chile, Reconstrucción de una escena 1990–2000* (2009), *XVI Muestra Nacional de Dramaturgia (2014), and Prácticas creativas, discusiones y registros* (2015). He is also president of the Voltajes Aleatorios Foundation and is deployed as a sound artist under the alias of Anders Klümppe.

Paloma Carpio Valdeavellano holds a Master in Human Development – Approaches and Policies, a Bachelor of Performing Arts and a Bachelor of Science and Communication Arts from the Pontificia Universidad Católica del Perú (PUCP). She has more than ten years of experience in design and facilitation of collective creation processes, both in the artistic field and in projects associated with culture, development and public advocacy. She is a founder and member, since 2005, of Tránsito: Vías de Comunicación Escénica, a group of artists that promotes projects that link art and citizenship. She has complemented her training and professional development in important cultural institutions, such as La Tarumba and Yuyachkani. As a stage creator, she has directed more than ten collective creations, like *Partido Perú Partido, P.A.T.R.I.A, El día en que cargué a mi madre, RECONSTRUCCIÓN_Nombre Femenino, MUROS*, among others. Since 2007, she has been actively involved in articulation and advocacy processes around community culture, being part of initiatives such as the Latin American Art Network for Social Transformation and the Puente Platform for Community Living Culture. She has been coordinator of the Public Living Culture Community programmes (Metropolitan Municipality of Lima, 2011) and Points of Culture (Ministry of Culture, 2012–2015). She is part of the Department of Performing Arts of the PUCP and teaches at Universidad Científica del Sur.

Part V

Amy Bonsall is a theatre director and academic. She is the co-artistic director of Bilimankhwe, an intercultural theatre company based in the United Kingdom. She has worked as a freelance director for over 15 years. Amy gained her PhD from the University of Leeds, UK and her thesis was formally recognised for its research excellence. She has published journal articles and book chapters and is co-editor of *Talking Bodies Vol. II* and she is working towards her first monograph. She is currently a researcher at the University of Manchester. Amy is the founder and a director of the global Women in Academia Support Network #WIASN, an online network with over 10,000 members worldwide.

Kelvin Chikonzo is a senior lecturer in the Department of Theatre Arts at the University of Zimbabwe. His current research interests are in the field of democracy in performance, particularly how performances can be viewed as sites of public spheres as well as how style impacts on the democratic intentions of performance. At present, he teaches acting and criticism at the University of Zimbabwe.

Bongile Gorata Lecoge-Zulu works across the disciplines of education, music performance and composition, writing, performing and directing for theatre, and applied theatre. She has a Bachelor of Music and a Masters in Music from the University of the Witwatersrand, and holds a DipABRSM and LRSM in flute performance from the Royal School of Music. Bongile has performed in live orchestral, band and theatre pieces across South Africa and Botswana over two decades. She has been involved in collaborative, interdisciplinary endeavours in which she investigates possibilities of merging music with other art forms. She is the playwright of *Divas of Kofifi*, a tribute to South African female music legends, and co-researcher/co-facilitator in the creation of *Dear Mr Government*. Through these works and her membership of the Drama for Life Playback Theatre Company, she addresses social justice issues in varying platforms for varying audience demographics. Her work has been shared at South Africa's National Arts Festival, Assitej Cradle of Creativity, and at seasons five and seven at the Centre for the Less Good Idea and New York's Performing The World. She teaches flute at Brescia House School and St Stithians Girls' College in Johannesburg, South Africa.

Cheraé Halley completed both an Honours and Masters in Dramatic Arts at the University of the Witwatersrand. Cheraé creates theatre with both deaf and hearing people with particular interest in human rights and using drama as process to educate and dialogue on the matter. Cheraé coordinated a five-year HIV/AIDS deaf awareness project at GALA which travelled across deaf schools in Gauteng using educational theatre in addressing sexuality, and where she created a manual using participatory methods for working with the deaf community, a pre and post HCT DVD and deaf lesbian video tutorials. Cheraé's performing credits come from *The Merry Wives of Zuma*, *What the Water Gave Me*, *Scorched* and *Dear Mr Government: Please May I Have A Meeting With You Even Though I Am Six Years Old?* Cheraé is the director of Drama for Life Playback Theatre, the only accredited school of playback theatre in Africa, and is currently using playback theatre to document the narratives of migrant experiences of health care in Johannesburg. She coordinates and lectures the Master of Arts in Applied Drama courses: Drama in Education and Theatre as Activism and Education and Therapy at Wits University under the Division of Drama for Life.

Jessica Lejowa holds a BA (Hons) and a Master of Arts in Dramatic Art from the University of the Witwatersrand, where she lectured in the Division of Dramatic Art. She has directed a number of productions with students and professional theatre makers, covering experimental theatre,

ritual as performance and ethnographic devised work. She has participated in various theatre and arts festivals, among them the National Arts Festival, Assitej and Cradle of Creativity Festival for young audiences in South Africa, Rwanda's KINA Festival and Zimbabwe's MITF. Jessica is an early years theatre practitioner. As a facilitator, director and performer, her work has included growing and supporting theatre initiatives and output in the Southern African region, with a particular focus on the lived experiences of women in Africa. Additionally, Jessica is interested in renegotiating and transgressing accepted theatre practices to create theatre that is more inclusive and reflective of changing political and social currents. She is the author of *Auto-Ethnography as Performance Practice in an African Context: Negotiating Gender and Culture Through Performance Practice*. Jessica is currently the head of School of Live Performance at AFDA Botswana.

Ruth Makumbirofa is a lecturer in the Theatre Arts Department at the University of Zimbabwe, where she teaches applied drama and performance studies. She is currently a doctoral fellow, researching on African funerary ritual as performance and its functionality. Her research interests and publications include drama and life-skills development, African performance studies, drama and bereavement therapy as well as drama in peace building.

Cletus Moyo is a drama lecturer at Lupane State University in Zimbabwe. He has also worked at Amakhosi Cultural Centre in Bulawayo as the course coordinator for the Amakhosi Performing Arts Academy (APAA). He has also previously worked under the Department of Theatre Arts of the University of Zimbabwe as a graduate teaching assistant. In 2007, Cletus was a trainee writer at Studio 263. He is also a Canon Collins Scholar currently studying for a PhD (Drama and Performance Studies) at the University of KwaZulu-Natal, South Africa. His research interests are in applied theatre. Cletus has been involved in many applied theatre projects in Zimbabwe and South Africa. He holds a Master of Arts (Drama) degree from the University of the Witwatersrand where he studied under a Drama for Life scholarship, and an Honours in Theatre Arts degree from the University of Zimbabwe. In 2014, he completed a Train-the-Trainer Course in Arts and Cultural Management at the African Arts Institute (AFAI) in Cape Town, South Africa.

Nkululeko Sibanda is a drama lecturer at the University of Pretoria. He holds a PhD (Drama and Performance Studies) and a Master of Arts (Drama and Performance Studies) from the University of KwaZulu-Natal (Howard College) as well as a BA (Hons) Theatre Arts from the University of Zimbabwe. Nkululeko is a practising scenographer in South Africa and Zimbabwe, having worked with esteemed companies such as Theory X Media (Harare), Intuba Arts Development (Durban), Harare International Festival of Arts (HIFA) and Intwasa Arts Festival KoBulawayo. The need to develop a formidable, relevant and effective scenographic theory and practice model within African performance practice (from an African paradigm) sits at the base of his research endeavours. His other research interests include applied theatre practice in Africa, African theatre, alternative scenography, alternative performance and identity and performance and memory.

Petro Janse van Vuuren is head of department and PhD programme co-ordinator at Drama for Life, University of the Witwatersrand School of Arts. Petro has worked in community, leadership and organisation development for the past 16 years. She has a PhD in Drama and Performance studies and is a certified master coach with the Institute for Management Consulting South Africa. Her research interests include the effectiveness of strategic narrative embodiment for designing social change interventions in organisational settings; the value of and adaptation needed for doing embodiment processes online; and the characteristics and challenges of creative research practices, specifically engaging in applied theatre and drama as modes of enquiry.

Contributors

Part VI

Rolf Bossart studied theology and history and received his doctorate with a thesis on "The theological readability of literature. Studies on a suppressed hermeneutics". He is a lecturer in religious studies and psychology and publishes in various journals. Rolf is the editor of various books on Milo Rau. Most recently: *Milo Rau, Rolf Bossart: Repetition and Ecstasy.*

Hugo Cruz works in the fields of artistic creation and civic and political participation in various contexts. Co-founder of PELE, Theater of the Oppressed Group of Porto and Nómada. Doctoral candidate at CIIE-UP and CHAIA-EU. Artistic director of Mexe_Encontro Internacional de Arte e Comunidade. He has published on *artistic creation and public space, community artistic practices* and *art and politics*. He teaches frequently at various national and overseas institutions, particularly in Brazil and Spain. He edited the books *Art and Community* (2015), *Art and Hope (2019)*, published by the Calouste Gulbenkian Foundation. Consultant in PARTIS (Artistic Practices and Social Inclusion) at the same Foundation. (hugoalvescruz@gmail.com)

Rikke Gürgens Gjærum is the leader of the Artic Centre of Welfare and Disability Research at the University of Tromso and a professor at OsloMet. Her research areas are applied theatre, disability art, art and dementia, and art-based research.

Lucia De Haene obtained her PhD in Educational Sciences at the University of Leuven (KU Leuven), Belgium in 2009 with a dissertation on attachment security in refugee families, including an analysis of the role and meaning of a narrative methodology in research with vulnerable, traumatised populations. In 2010, she received a Fulbright Research Scholar Award, which enabled her stay as postdoctoral fellow at New York University School of Medicine and the Bellevue/NYU Programme for Survivors of Torture. Starting from 2012, Lucia is assistant professor affiliated to the research unit education, culture and society where she teaches in the domain of intercultural education. Lucia's current research focuses on the psychosocial impact of organised violence, forced migration and exile on refugee and migrant family relationships, the role of disclosure and narration in individual and collective processes of reconstruction in the aftermath of traumatisation, and process analyses of family therapeutic and community-based interventions in host societies and post-conflict settings.

Julius Heinicke is professor for cultural studies at the University of Applied Sciences and Arts in Coburg and head of the research project Schnittstellen Zwischen Hochkultur und Kultureller Bildung (Interfaces Between Cultural Education and High Culture). He studied Culture and Performance at Humboldt University in Berlin and in 2012 defended his PhD thesis on Theatre and Politics in Zimbabwe at the Department of African Studies. Between 2012 and 2016 he held a post-doc position at the Department of Theatre Studies at Freie Universität in Berlin, where he focused on theatre, performance and transculturalism, culture policy and international cultural work (ERC-Project The Aesthetics of Applied Theatre). In the last years, Julius spent time researching and teaching as well as working in cultural projects and in arts in education, mainly in Africa and Europe.

Maria Kwiatek is a drama facilitator and theatre leader with a psychological background (University of Warsaw; Polish Psychological Association) and within a community arts context (Media and Theatre for Development, University of Winchester; Cardboard Citizens, London; School For Drama Trainers, Warsaw; PO ASSiTEJ, Warsaw). She has over 10 years' experience in the field of performing arts, using improv and applied drama. She's been developing Augusto Boal's Theatre of the Oppressed methodology in Poland, co-editing his book *Games For Actors and Non-Actors* (2015), leading workshops and training on Forum

Theatre. For the last two years she has been cooperating with Teatr Polski in Warsaw, facilitating workshops and co-directing performances dedicated to youth at risk. At the moment she is a freelancer working in Poland and abroad, active in voluntary work, theatre training and drama facilitation. Contact: maria.kwiatek@gmail.com

Giulia Innocenti Malini is a researcher in the Department of Communication and Performing Arts at the University Cattolica del Sacro Cuore, Italy, where she teaches theatre and performance in the Faculty of Political and Social Science and Anthropology of Performance in the Faculty of Arts, Media and Entertainment. She is coordinator of the higher education course for facilitators of social and community theatre. She has over 30 years of experience as social theatre facilitator and trainer in various contexts such as schools, psychiatric institutions, prisons and local communities. Her most recent publications Innocenti Malini G. and Carpani R. (eds.) The Performing Arts in the Time of Migrations: Thinking, Creating and Acting Inclusion. *Comunicazioni Sociali. Journal of Media, Performing Arts and Cultural Studies*, 1, 2019; Innocenti Malini G. From the school to the educating community: Practices of social theatre in Italy as a new form of activism. *ArtsPraxis*, 2019 5(2), 63-79.

Cécile Rousseau is a professor at McGill University Division of Social and Cultural Psychiatry. She has worked extensively on migrant and refugee mental health, and developed art based school prevention programs for children and youth. Her present research adresses social polarization and violent radicalization.

Sofie de Smet holds a Degree in Psychology from the Catholic University of Leuven in Belgium and a Degree in Performance Studies and Film from Ghent University in Belgium. In her master thesis she explored the concept of trauma reconstruction in relation to the potential of postdramatic aesthetics in visual and performing arts. In October 2014, she started her doctoral research on the role of non-narrative modes of trauma coping in the performing arts in the framework of an FWO-NRF research project.

Christel Stalpaert studied German philology and theatre studies at Ghent University, Belgium. She got promoted in 2002 with a doctoral dissertation defending a post-semiotic method of analysis, based on Gilles Deleuze's aesthetics of intensities (aesthesis) and Luce Irigaray's philosophy of embodied cognition and corporeality. Since 2003, Christel is a lecturer in theatre studies (performing and media arts) at Ghent University, and has published numerous articles on theatre and performance. She co-edited, among others, *No beauty for me there where human life is rare: on Jan Lauwers' Theatre Work with Needcompany* and *Bastard or Playmate? Adapting Theatre, Mutating Media and the Contemporary Performing Arts*. Together with Prof. Katharina Pewny, she is directing the research group S:PAM (Studies in Performing Arts & Media), and is founder and convener of the associated research group for postdramatic aesthetics since 2007.

Lene Thiesen is the former director of the Copenhagen International Theatre (Københavns Internationale Teater). In 1992, Lene was named Woman of the Year by the Danish magazine *Alt for damerne*. Lene earned a PhD in French at the University of Copenhagen, with a thesis on the Armenian, Russian-born Theatre of the Absurd playwright Artur Adamov, who wrote in French after moving to Paris. She worked as an EU translator in Brussels for a time, but left to return to Denmark. Lene worked with the Copenhagen International Theatre for a number of years before becoming its director.

ACKNOWLEDGEMENTS

The editors wish to offer their deepest thanks to the regional sub-editors for their extraordinary dedication to the curating of their sections: Helen Cahill, Peter O'Connor, Darko Lukić, Kirsten Sadeghi-Yekta, Rodrigo Benza, Paloma Carpio, Alexandra Sutherland and Julius Heinicke. This book would not exist without them. They have given their expertise and time for no other reward than the promotion of international understanding and the advancement of scholarship. We also wish to express our gratitude to all those communities and groups whose work forms the substance of these chapters and who create performances that stretch the limits of human imagining, often under the most challenging and dangerous circumstances. Lastly, the belief and support of Ben Piggott at Taylor & Francis has been a core element in our process. Ben has been quick to share our vision and marshal the resources necessary for its expansion into two volumes, with translation where necessary.

INTRODUCTION TO VOLUME ONE

Considering the ethics of representation in applied theatre

Tim Prentki and Ananda Breed

'We acknowledge and pay respect to the Elders past, present and emerging, for they hold the memories, the traditions, the culture and hopes of peoples across the world.' This adaptation of an 'acknowledgement of country' from the Maori community in Aotearoa/New Zealand serves to open our volume with the awareness that many of the chapters that are presented in this volume rely on the memories, experiences and narratives of indigenous peoples. The authors engage with applied performance practices that materialise dormant or hidden power dynamics; often with the stated or unstated aim to correct imbalances of power or injustices from the past to create a different kind of future. The focus on a decolonizing structure and positioning of theoretical, practical and epistemological frameworks is key to the ambition of this project; although we, alongside the authors, consistently stumble, falter and fail to reach this aim. However, the spirit of the volume stretches across cultures, continents, projects and different points of perspective in order to potentially come to some kind of understanding concerning the desires of applied performance on an international scale. We apologize in advance for any misunderstandings or omissions in our knowledge or ability to provide accurate representation for a project of this size and scale.

There are key arts-based research methods (Leavy, 2015) that have been used across each volume, often taking the form of performance ethnography, auto-ethnography, performance art, community arts and verbatim theatre, or clowning through music, dance, visual arts and drama. The focus is often on process with an emphasis on care and the consideration of approach, relation and configuration of people, place, space and time. There is more often than not, a consideration of past to future; remedying past wrongs or materialising a vision for a better world. Arts-based research can be defined as 'a set of methodological tools used by researchers across the disciplines across all phases of social research, including data generation, analysis, interpretation, and representation' (Leavy, 2015: ix). Contributors are often explicitly or implicitly mindful of the wider social, cultural and economic forces that shape these phases of research and the introductions of each region serve as an epistemological anchor for the reader to position themselves prior to embarking on a journey through the considerations of current and emerging applied performance practices in each particular region. The performative state of 'coming into

being' through the negotiation of identities past and present illustrates a longing for belonging and companionship that can be witnessed across the project.

Current debates are critical to the reframing of applied performance in relation to the 'doing' of drama and performance. However, how can we consider these practices across geographic, political and social realms? How might this applied performance companion help us to think globally and internationally as we consider current issues related to climate change, conflict and social intolerance? There are numerous essays that help us to consider methodological and practical approaches to applied performance across disciplinary boundaries. The desire is to expand the repertoire of the current applied performance canon to offer a more fluid consideration of values, ideologies and practices to help us rethink our approaches to address global challenges. In this way, we have integrated a range of thinkers and makers to consider varied and diverse perspectives and approaches to working with people, communities and places. What questions emerge out of this convergence of ideas? How might the contributions provide a protocol that could be considered globally and internationally? What new tools might evolve? What is our approach as practitioners, researchers and participants? How and why do these roles overlap (common to applied performance) and what skills and tools do we need to employ in order to maintain the flexibility to rotate between these roles?

Australia and New Zealand

Listening versus 'giving voice' emerges as a key practice and potentially establishes another kind of resonance within applied performance as a method of encounter or engagement. Woodland uses radio to represent and reinterpret the sounds of convict ships, early prisons and missions across the United Kingdom and Australia stating:

> In his work *the Art of Listening*, Back (2007: 23) encourages an orientation towards 'artful' listening in sociology, which involves openness to others: 'The task is to link individual biographies with larger social and historical forces and the public questions that are raised in their social, economic and political organisation'. It was precisely this kind of listening that *Daughters* invited for audiences outside the prison, to make connections between the historical and contemporary stories being represented in the audio work, and Australia's ongoing carceral legacy.

Other contributions from Australia and New Zealand focus on the negotiation of cultural practices to create methods of engagement for individuals and communities to work alongside each other while acknowledging injustices, atrocities and ongoing imbalances of power. Julie Dunn and Michael Balfour focus on the importance of the 'moment' when clowning with dementia patients through connectedness, relationship, agency, wellness, sense of place and happiness or sadness. The relational clowns achieved these varied states with the patients through affective relationality, reciprocal playfulness and co-constructed imagination. There is inherently a negotiation between 'outside' and 'inside' throughout the section; using participant observation, thick description and interviews as research methods.

While the Australia and New Zealand section edited by Helen Cahill and Peter O'Connor focuses on reparation of wrongs and prioritises indigenous knowledges, the Western Europe section edited by Julius Heinicke presents some of the ethical dilemmas core to the practice of applied performance; in particular the construct of applied performance manufactured by organizations and practitioners who have been trained and informed by Western theoretical and practical notions of performance that dominate any other forms.

Introduction to volume one

Western Europe

Current social and political conditions, including the rise of nationalism and fascism in Europe, inherently position performance practices within a 'we' and 'other' dichotomy of sovereign citizens and/versus migrants without suitably acknowledging current and ongoing neo-colonial practices that drive migration. In this way, the case studies and commentaries often highlight the limitation of applied performance practices to manifest alternative realities or political contexts outside of the workshop or project.

However, there are instances in which devised theatrical productions based on painful pasts are explored as a group process to understand the difficult negotiation of representation, agency and aesthetics between the director and participants who have the shared understanding of war, displacement and migration. In a chapter focused on the production *Temporary* written by Sofie de Smet, Lucia De Haene, Cécile Rousseau and Christel Stalpaert, the director, Mokhallad Rasem, used a series of *tableaux vivants* to depict 25 words negotiating between the old and new through non-verbal means of expression. Rasem remarks on the use of aesthetics as a form of protection for both the participants and the audience, but also to enable the critical thinking process:

> In *Temporary*, we have a kind of representation of what has happened, without texts, but with the use of the body and the use of images. When you see the *tableaux vivants* of the performance, they seem portraits of people who experienced terrible events. But how do you present that to an audience while still creating space for the audience to interpret? That is a very important question for me. As an audience member watching the performance, you are looking at a beautiful painting. However, if you explored the beauty of the painting more deeply, you would perhaps discover a painful colour. You would discover certain horrifying thoughts in that same painting. The performance is like a very beautiful flower. But as an audience member, you might wonder, what are the roots of this flower? As a director I started working with the roots, but I will not present the roots. I present something that can communicate with the audience. I will present a flower. But I find it very important that the audience can go back and forth from the flower to the roots, as a continuous back and forth analysis. Perhaps, it is an analysis that the audience member cannot make at the very moment of watching. But if one wants to explore, one will discover.

In this case, there is a careful negotiation between the 'flower' and the 'roots' and the consideration of how to address representation in terms of agency. One of the six Syrian participants 'explained that he disliked the stretched series of *tableaux vivants*. He indicated the importance of speaking a language that continues to address his people, the men and women in the street, as revolution in the past and the future will always arise from the street'. In this case, there was a direct contrast between the artistic and aesthetic frameworks and the need for a language to address his people. Similarly, there are questions concerning the assumed actors and audiences that run throughout the section and consideration regarding how and why some of the varied premises of the projects engage with migration. The remainder of the contributions from Western Europe could be considered as 'artivism' as introduced by Hugo Cruz to encompass practices that intersect with territories of social protest and the political dimension of art with the purpose of highlighting politically significant social situations (Raposo, 2015). This is particularly relevant to the contribution by Rolf Bassart regarding the work of Milo Rau who reflects on the use of agonism to portray key historical events like the 1994 Rwandan Genocide

Against the Tutsi through the production *Hate Radio* (2011) that employed documentary theatre techniques to re-enact Radio Télévision Libre des Mille Collines (RTLM) using interviews with original broadcasters to restage the studio setting. Both Lene Thiesen and Rikke Gürgens Gjærum situate applied performance practices in relation to state policies and inclusion practices in Denmark and Nordic countries.

Both Kirsten Sadeghi-Yekta and Darko Lukić provide an eloquent introduction to their sections as a dialogue between North America and the Balkans. We will not try to emulate this excellent example of exchange that harnesses the nuances of geographic region and approach between applied performance; but rather to highlight some of the entries in relation to the overall volume and project.

North America

North American entries edited by Kirsten Sadeghi-Yekta echo similar principles and practices from Australia and New Zealand with a focus on decolonizing epistemologies through social justice. There is an emphasis on active listening and witnessing through Playback Theatre by Hannah Fox and the Arrivals Legacy Project by Diane Roberts who both offer methods to negotiate the shifting roles between witness, observer, participant and performer, emphasising the need for ritual to shape critical encounters between communities with varied histories of oppression and colonization. Other entries by Carrie MacLeod consider the physical and social aesthetics of public space as street-connected encounters between settler and non-settler groups, alongside Jill Carter who negotiates the layering or mapping of place – past, present and future – through bus tours. Similarly, Hannah Worthen applies current renditions of colonial legacies through the restaging of the founding fathers of the United States using *Hamilton* and musical theatre as a framing device for inner city youth to write their own stories and songs; positioning oneself in the past to perform the future. Gray, Setchell and Donnelly inhabit micro and macro ethics throughout the planning and execution of applied performance projects through a self-reflexive mode of enquiry: a) to provide a space or atmosphere that connects people and humanizes the space; b) to consider your own stories and or triggers, to have done the work in advance; c) to listen to the needs and sensitivities of others, including non-verbal subtle signs; d) to evaluate the macro and micro ethical considerations of day-to-day and stage-by-stage project and or production processes; e) to prepare; f) to work in partnership and support intentions or focus of practitioners and the group as a whole whether that be based on the audience and or workshop participants; and g) to be present. The section considers methods of encounter, with consideration of the varied models that might be required to formulate spaces through acknowledgement of past wrongs through playful reinterpretations of history and the remapping of public spaces to be inclusive and reflexive. By and large, the contributions consider how and why 'what we are doing in here' relates to 'what is happening out there' with a focus from the micro to the macro politics at play.

The Balkans

The *Balkans* section, edited by Darko Lukić, hones applied performance in relation to cultural and political production, noting the potential difference in positioning to the other entries stating: 'Applied theatre in those societies can always be found somewhere in-between cultural production and social activism since the inclusion of those who are excluded and providing visibility to those who are marginalized in applied theatre projects is closely linked to fields such as local reshaping of various preconditions, networking and layering of those local activities, which

results in raising awareness and thus changing the existing relations of inequality on long-term bases'. Here, there is a focus on the engagement of individuals who have been affected by conflict and the ongoing process of reform caught within global power struggles. Ljubica Beljanski Ristic provides an example of how applied performance was used to engage young people on a local to national scale through the Drama Improves Lisbon Key Competencies in Education (DICE) project; embedding the arts as a tool for conflict transformation within the national education curriculum. While Ristic focuses on the reiterative process of drama to destabilise dominant narratives through the co-production of curricula materials, Nikolina Židek interrogates representations of war in Croatian theatre to explore how playwrights have dealt with the past to potentially open up spaces for debate. Focusing on youth theatre, Sead Đulić comments on the damage of so-called experts and the limitation of applied performance in the region due to lack of trust and ethnic division. He illustrates a kind of methodology to explore violence and war moving from reality to theatre, back to reality. The focus is on examining the causes of violent behaviour as a preventative measure, versus dealing with the consequences of violence. This section thinks through structures of violence, reform and education using applied performance as a mechanism to address varied narratives of violence and peacebuilding with an awareness of internal and external power relations that often influence political dynamics that applied performance sits within, and therefore cannot be considered as neutral.

Latin America

The section on Latin America edited by Paloma Carpio and Rodrigo Benza explores the use of performance art to negotiate the social body, alongside the use of performance as a vehicle to reclaim platforms for the public; engaging with policy through a movement entitled Communal Living Culture (CVC) to prioritise cultural processes versus products, and achieve public policies from the bottom up. In varied ways, the chapter serves as a call to action or manifesto for the potential of developing communal approaches to knowledge production and bridging between borders and bureaucratic divides.

The focus on art as body and the body as art, as signifier and signified, becomes apparent in the chapter by Josefina Alcázar who provides a glossary-like overview of female Latin American performance artists who use their bodies to 'make visible' the often social and gendered dimensions of labour, violence and discrimination. These performances take the form of ordering everyday objects based on categories to demonstrate the often repetitive and durational nature of domestic tasks (María Teresa Hinacapié, Colombia); cutting often-recited and inscribed defamations that have been written on the bodies of murdered women into one's skin (Regina José Galindo, Guatemala); and knitting and unknitting a long scarf with the national colours to symbolically knit and unravel the country (Antonieta Sosa, Venezuala). In this way, applied performance is considered as a medium to alter perceptions that relate to physical, kinesthetic and embodied forms of representation; serving as performance and protest commenting on the body as a social construction.

Andrés Grumann Sölter and Francisco Gonzáles Castro position practices that can be associated with applied performance in Chile as 'art actions' that had a concrete political objective in the form of an *Illamiento* or 'call to action' under the Chilean civic-military dictatorship. *Collective of Art Actions* (CADA) can be constituted through examples of agonistic art; Janet Toro covered her nude body with blood and wrapped herself in a white cloth next to the Estadio Nacional in order to make visible the mutilated bodies that populated the Mapocoho River. The campaign *No me olvides* (Don't forget me) staged silhouettes of missing persons and victims of state terrorism on iconic buildings and placards. In this way, using bodies (both real and repre-

sented) to recover public spaces. Similarly, the writing style and representation of performance-based actions for social transformation in Latin America have a 'call to action' quality within the other contributing chapters. Ana Carolina Ávila calls for the potential of dance to transform and rewrite bodies that have been used as instruments of war in Colombia. Edith Scher categorises community theatre in Argentina as a kind of epic theatre that tells collective stories to broaden expectations for life and to vanquish hegemonic value systems in order to constitute art as a human right for all. Scher states: 'When a community develops its creativity, with the full breadth implied by this concept, it begins to leave behind its role as a spectator of its destiny, instead becoming an active part of social life. Art is one of the key aspects in this transformation'. Additionally, Matthew Elliott expands on the role of play within the juvenile justice system as a political act that enables an emotive and sensory mechanism to aid children's rights.

Southern Africa

This section grounds applied performance as a practice that has emerged due to the failure of mainstream theatre to capture the political, economic and cultural realities of the majority. The focus is on the shared, understood and appreciated aesthetics that are created by, with and for the local populace. Cletus Moyo and Nkeluleko Sibanda illustrate how the *Laundry Café*, a methodology devised by Victory Siyanqoba Arts, provides a space for girls and young women in Zimbabwe to literally and figuratively wash their clothes while sharing their 'dirty laundry' or problems from which performances are later devised for reflection and critique. Simultaneous dramaturgy is employed to stage revised versions of the performances informed by participant interventions. Jessica Lejowa, Bongile Gorata Lecoge-Zulu and Cheraé Halley describe the making of *Dear Mr Government, the children have something to say* as a cross-border project that focused on how children experienced and processed displacement and violence. Petro Janse van Vuuren explores the values gap between the ethics of applied performance and business contexts. While working with corporations that sought to use Applied Performance techniques towards the commodification of products, the following values were incorporated into the work to broker between organisations and communities: 1) deep collaboration; 2) sustainability of human relationships; 3) intersectional symbiosis; 4) intrinsic value and contribution; 5) rigorous self-reflexivity; 6) systemic awareness; and 7) responsible sharing of intellectual contributions. Finally, Amy Bonsall explores the use of Chichewa popular drama to stage *Romio ndi Julieti (Romeo and Juliet)* to ground the production within the Malawian cultural landscape. Overall, the section evidences projects that challenge, question and expose variances between national and grassroots day-to-day critiques related to past, current and future tensions and debates as evidenced by Kelvin Chikonozo and Ruth Makumbirofa, related to the production *Rituals* (2010) and counter narratives to healing and reconciliation in Zimbabwe.

References

Back, L. (2007) *The Art of Listening*. Oxford: Berg.
Leavy, P. (2015) *Method Meets Art: Arts-based Research Practice*. New York: Guilford.
Raposo, P. (2015) "Artivismo": Articulando dissidências, criando insurgências. *Cadernos de Arte e Antropologia*, v. 4, n. 2, p. 3–12.

PART I

Australia and New Zealand

INTRODUCTION TO PART I

Considering the ethics of representation in applied theatre

Helen Cahill and Peter O'Connor

Introduction

Applied theatre makers are called on to engage intensively and extensively with the ethics of representation. They tussle with the ethics of the devising process, and consider the ways in which their creations will impact on those whose stories they tell, and those who are audiences to the work. They are concerned with the impact of their choices. They ask themselves: *Is there a good fit between process and purpose? Does the artistry enhance the agency of actors and audiences? Does the work activate and enable?* These are inherently ethical questions.

Ethical decisions are always made *in situ*. Practitioners are called on to read the interpersonal, social and political contexts in which they work, and the complex ways that power dynamics influence the freedom to think and to act. Sometimes these decisions are difficult, and involve sifting through competing priorities and possibilities. It can be useful to have a number of reference points against which to think through decisions, particularly those that present along the way, rather than during the conceptualization phases of a project.

It is in the offering of reference points that many rich offerings can be found, made by those who use arts-based methods in research and education, and by social scientists who discuss the politics and ethics of participatory and emancipatory research.

In this chapter, we offer insights from a range of practitioners who have considered these matters closely. We draw from the fine contributions of the Australian and New Zealand authors within this compendium, as they each deal explicitly with ethics of representation. We also draw from our own experiences in witnessing applied theatre, and share stories from our own experiences leading applied theatre projects, aiming to show how we responded to the multiple questions that can present for ethical attention in this field. We offer some insights that can be gleaned from these works. We also provide some thinking frames which can be used when considering the choices that we make around ethics of representation in applied theatre projects. We do not set out to provide a comprehensive work which attempts to capture the full range of ethical quandaries that can present and pointers that can be offered. This would be an impossible task, as ethical decisions are contextual, complex and emergent. Equally, each decision has a ripple effect, and calls for subsequent decisions. Thus ethical decisions cannot simply be pre-cooked and packaged for later consumption.

Story ownership: considering the conflicting rights of the individual and the collective

Story-makers can easily lose sight of those who are not central to their story, but nonetheless are implicated, as marginal characters, or as those who also hold this story as reflecting on their own story. Those called to represent others face this dilemma. Is their story their own to shape and share? Or will it also implicate others? Biographies are social. They involve surrounding others, and forebears. They harness the past, and influence what can become possible in the future. Megan Alrutz shares some of the ethical dilemmas she encountered around story ownership when working as a teaching artist with a group of Native American youth (2006). Her experience showed that the individual is never the sole "owner" of their story and indeed, there are nearly always competing claims about how a story should be told, and about what should be included or excluded in the telling. An ethical challenge emerged in her project when it became clear that elders of the community found that the young people had portrayed themselves in ways the elders believed to be inappropriate and harmful to the community image. They felt their young people had showed themselves in an unduly negative light, and further that they had used traditional songs in ways that were not sufficiently attuned to the song sharing traditions of their culture. This situation foregrounded the complexity that can arise when the rights to voice of an individual or particular group sit at odds with the rights to voice and representation of others within the larger social, familial or cultural context. In response to this dilemma around ownership and voice, Megan Alrutz urges artists to consider carefully who and what is valued (or not) in the representations made. In this, she points to the ethics that underpin the art-making endeavour itself, and the importance of considering whether the product fashioned through the process of collective devising remains true to its orienting moral purpose and heritage of values. This story also points to the importance of recognizing that performances will be differently understood and received by different audiences, as they bring their own listening, knowledges and expectations to bear. In thinking through an ethics of representation, it becomes important to consider not only whose story, but which version, will be told to which audiences and with what effect.

Positioning and power relations: considering the ethics of inclusion and ownership

A focus on power relations is particularly pertinent in consideration of the ethics of representation. As is demonstrated in the collection within this compendium, many applied theatre artists are at work within emancipatory projects, advancing a social justice agenda, or at least a critical re-thinking of accepted practices and their consequences.

Power relations are always at play: at the micro level of interpersonal relations, at institutional levels, at which commissioning agents might wield particular influence, and within the macro context of the culture, economies, law and belief systems. Thus, consideration of the dynamics of power will always press forward for consideration in relation to the ethics of representation.

Particular sensitivity to power relations has been recommended by artists whose work includes representing the needs of highly vulnerable populations such as refugees (Blomfield and Lenette, 2018). Blomfield and Lenette (2018) argue the importance of using a fully inclusive process such that full and informed permission is given not only for taking and sharing the stories, but also for the wider political frame or overall communicative intent within which the stories will be shared. They note that a danger can arise when dominant groups presume that they can *speak for* others in marginalized groups. This can lead to practices of othering,

and disempowerment. We argue that speaking for others can work to perpetuate forms of voicelessness.

The importance of speaking *alongside* and *with* rather than speaking *for* is given attention by **Linden Wilkinson** who is amongst the authors in the Australia and New Zealand section of this book. She tells of a cross-cultural project within which Aboriginal and non-Aboriginal theatre-makers developed a play exploring the horror and lasting impact of dispossession, murder, rape and oppression of indigenous people in Australia. Through their artistic collaboration, they set out to accomplish a practice of exchange and befriending both between players and within the script. This process brought together characters who had variously experienced privilege and those who had experienced exclusion. Their artistic impetus pivots around an inherently ethical question, exploring how it can become possible to *create a unified dramatic story when cultural and experiential diversity is a given?*

Throughout their five-year period of growing the script, the artists considered the impact of story content, casting, players and mood or affect – thinking through when to use humour, and when to use pathos, when to horrify and when to uplift. They were particularly concerned to find an ending through which the strong would be remembered. They sought to model the possibility of becoming hopeful and moving towards reconciliation through a clear recognition of wrongs enacted in the past and living on in the present. Their performance work thus takes up both a politicizing and an educative orientation, seeking to challenge a silenced history of oppression via a public and embodied truth-telling. Their work becomes a theatre towards reconciliation. Their ethics of representation encompasses a practice of boundary crossing, bridging between cultural systems, and between past and present injustices, and in this creating hope towards new possibilities in relationship, justice and dignity of recognition.

Accuracy or artistry: representing the affective nature of experience

As part of their choice-making about representation, applied theatre artists decide whether to present "accurate" stories or embellished stories. Gallagher discussed an approach to this challenge of representation as experienced in documentary theatre-making with youth (Gallagher, Jacobson and Mealey, 2018). She and her co-authors note that a simple reproduction of narrative "truths" can be inadequate to communicate the affective nature of the experiences and world views that the participants want to share with their audiences. Their young artists sought to harness the aesthetic power of re-crafted stories so as to better speak about what *might* be or what *should* be, as well as about what has happened. In this, they followed their impulse towards the type of performance that would most effectively create the educative and politicizing impact that they sought for their work. Thus, their ethics of representation leant somewhere between honouring the accuracy of the stories they had sourced from each other, and shaping the impact they wanted these stories to have upon their audiences. In this, their ethics of representation focused on the ways in which the audiences might receive their works as well as on ways to honour those whose stories they told. This balancing act, in which they sought to harness the power of the aesthetic medium to activate their broader ethical agenda of having their work make a difference, speaks to the interests of many applied theatre workers.

The politics of editing: which parts of the story (not) to tell?

No story is ever told in full. It is always edited and shaped in the telling. People are culturally attuned to traditions in storytelling, and tend to offer what is presumed to be a "tellable tale" or one that might be acceptable and of interest to a given audience (Elliott, 2005). The ethics of

representation include decisions about what to include as well as what to exclude. Blomfield and Lenette point to the political nature of editing (Blomfield and Lenette, 2018). The way a story is sliced has a major impact on how the story is received and who the "characters" are understood to be. They argue that it is important to guard against over-sensationalizing by including the mundane within narratives, in this sharing the view of Michelle Fine (1994) who has argued the importance in research methodology of avoiding what she calls voyeuristic research, and the hunt for tellable tales, particularly in relation to oppressed or disadvantaged communities. She also notes the importance of including the mundane, so as to avoid a tendency to pathologize or to glamorize life experiences. She points to the importance of including multiplicity in order to conjure the richness and complexity of people's lives. Thus, the politics of the storying act and the impact of the story should be considered. She argues the need to interrogate how we "have settled on the stories we tell; how else these stories could be told; how we can organise disruptively for what could be" (Fine, 1994, p. 26). Blomfield and Lenette recommend that artists be clear about the ways in which their own political motives inform their art-making and influence their sense of what is ethical. They recommend that critical reflexivity be an essential practice for applied theatre artists (Blomfield and Lenette, 2018).

Colonisation, collaboration and captivities: exploring ethics of engagement within prison theatre

Particular challenges present for applied theatre projects that take place in prison settings in which containment erases not only freedom of movement, but also deprives people of opportunities for expression, interaction and the dignity of making social contribution. Here, the ethics of engagement and representation are a key focus.

Sarah Woodland shares insights from her work in a women's prison in Australia, a country in which the prison population disproportionately includes indigenous people, a symptom of the impact of colonization, oppression, marginalization and poverty. She describes a project in which a collectively devised theatre piece was developed using Australian prison history as its context. The team worked to interweave fact and fiction in their historically informed work, with fictional narratives adding an affective and personalizing layer. Here, a turn towards historical truth-telling is an ethical practice which represents the present and the personal as connected to and emergent from the historical, political and cultural practices of confinement, disadvantage and oppression. Politico-ethical attention is given to the evocation of listening and to creating opportunities for the silenced and marginalized voices of imprisoned women to be heard in mainstream Australia.

In order to reach audiences beyond the prison, the audiences that most needed to hear the work, the performance was crafted into a radio drama, a necessity born of a refusal on the part of the prison for actors to leave the prison to perform or for outsiders to enter the prison for performances. Sarah notes that one of the affordances of radio is that it calls for active listening, and argues, "At its best, I would suggest applied performance is certainly an art of listening".

As is common throughout much applied theatre, the contribution of the work is both for those immediately involved, as they engage in the meaningful, intimate and empowering encounter of making together, and in the impact of the work as it lands in the listening of those who receive it. Ethical attention must thus be directed to the makers and receivers of the work.

Ethical insights into working within the prison context are also provided in the chapter authored by **Rand Hazou** in which he draws on his work with male detainees within Auckland Prison, New Zealand. His applied theatre project responds to requests from the inmates to work with an established performance text, rather than to continue with the forum theatre work

they had been engaged with. In taking the role as actors working towards performance of a re-worked version of the Greek text *Antigone* they were repositioned from inmates to artists, with a disciplinary challenge of crafting a quality performance. Rand Hazou selected *Antigone* as the text because it held cultural resonances with Māori worldviews around the importance of honouring the dead. The stylistic structure of the play also held resonance with the tradition of oracy in Māori culture and rituals. With a vision of the applied theatre project as one which also engaged respectfully and inclusively with Māori, Hazou collaborated with a senior Māori man within the prison. He provided the cultural guidance needed to engage with Māori traditions and worldviews around honoring the dead and to accomplish a culturally informed re-working of the text and the stylistic interpretation. Culturally informed stylistic performance choices included the use of non- naturalistic movements to heighten respect for spiritual and cultural rituals and the intensity of emotion felt following the death of a family member. Indigenous cultural references informed the characters, movement and song works used throughout. Ethical attention was paid in this process to foster a cultural occupation of the text, such that the players worked themselves into and upon its narrative, embodiment and themes.

Part of their ethics of engagement included use of life-sized puppets to stage the female characters. In the contained all-male and gender normative environment of the prison, this stylistic choice avoided a possible parodying of women that could occur in an embodiment of male playing as if female. The use of puppets also called for a stylized embodied artistry on the part of the players, in part assisting the prisoned bodies to become something other than who they were confined to be. As some of the prison inmates were sex offenders, the artistic dexterity and care needed to orchestrate the puppets also became a medium through which to foster care and respect in handling of the female body.

In an overarching way, the work to create and perform the play is done with and for the prison inmates, and thus its ethics of contribution is that of bringing creativity, respect, challenge, discipline and dignity to the performers. However, this project does not only contribute by interrupting the boredom, meaninglessness and depersonalization of prison time. It also takes up an interpretive and communicative mission to enrich cultural knowledge and representation via articulation of rich and respectful performance embracing indigenous knowledges. In this, the ethics of engagement is elevated beyond occupational therapy, to become a form of educative, restorative and political identity work.

The overarching engagement with the ethics of representation at work here is closely informed by the constraints and indignities of the setting, and social, political, cultural and historical contexts within which the work takes place. The ethics of reparative engagement, cognisant of the harsh and continuing impact of colonization, provides an orienting sensibility within the project, such that the historical and cultural are held as a lens through which to approach the present, and the creative work of storying and enactment.

Trauma and transformative experience: considering ethics of representation in recovery theatre

Applied theatre work can offer an experience of expression, healing and hope following collectively-experienced trauma. Peter O'Connor has created theatre in post and ongoing disaster settings for over 30 years. Most recently, this has included working in Mexico City following a major earthquake that killed 400 people, and in Christchurch following the terror attack on March 15 2019 when 51 people were murdered whilst at prayer in mosques. He argues that applied theatre post disaster is always fraught with ethical choices that centre around the role and purposes of the work, and the political and cultural constraints it operates inside.

Performative events are deployed in the immediate aftermath for multiple reasons. First and foremost, they create formal and informal spaces for communal grief. As bodies are pulled from rubble, or into make-shift morgues outside mosques, communities gather to sing and pray and connect themselves again to those who have died. Theatre acts as a bridge between the present and the past, the living and the dead. Often supported by religious ceremony, these performances include improvizational outpourings where the boundaries between religious and civic leaders and citizens become blurred in mass performances where the pain of death and the guilt of survival are displayed. They can become focal points for the creation and sustenance of national narratives that speak to the hurt and fragility of a nation post trauma.

Theatrical forms can be harnessed towards great harm. The Christchurch attacks had themselves been fashioned as a performance event, with a camera attached to the terrorist live streaming the murders across social media and into the dark neo-Nazi recesses of the internet for thousands to watch in real time and then later for millions to share. O'Connor wrote the following in the national newspaper just days after the attack as a call to the arts post disaster to be used as a tool to combat the harm.

> The night after the terror attack I stood in the Auckland Town Hall with 1,000 others. After the traditional voices rang out to farewell the dead we stood and we sang *Whakaaria Mai*. New Zealand's unofficial national hymn. We started tentatively, listening carefully to each other. We found ways to weave our own voice, our own story into the wider song. The waiata (song) connected us together in the room and then it felt, somehow to the people of Christchurch. In the soaring chorus as we grew louder and more confident our singing became a bridge to possibility. Our song was a cry of faith and hope. In its communally created beauty it was an act of defiance against the ugliness of terror. This is the possibility inherent in arts making. It gives us, as individuals and communities, the strength to imagine afresh, to see the world again as a place where hope might dwell. It gives us the possibility of connecting to others across time and space and beyond life itself. Through the arts as a nation we will remember, mourn, come together, rebuild who we are. *The arts will be the way we resist and claim back the spirit of who and what we might be as a nation.* In the same way we did last night, through different art forms we will find ways to deeply listen to each other and to find new ways to breathe in harmony. Terrorist attacks deliberately make the world unbearably ugly. The arts are the finest and best tools we have for resistance to terror. They do this as indestructible acts of solidarity, potent healing balms that remind us of our common humanity. The world has always needed the arts, but perhaps never as much as we do today.

Across the country, in the days following the attack, people gathered to lament the loss of life and the end of a sense of political innocence that had persuaded New Zealanders they were inoculated by distance from the possibilities of mass murder and the obscenity of white supremacy terror. Within a week in Christchurch, following the terror attack, tens of thousands gathered in the city gardens, performed or watched ritual haka (indigenous dance), and sang hymns and songs of reconciliation. The Prime Minister wore a hijab as a symbol of solidarity and thousands of non-Muslim women followed her example. Haka was performed across the country, children painted and drew images of kindness, poetry was shared, and tears of grief and anger found form for communal and individual expression.

The terror on the Friday afternoon had forced the city's schools into lockdown. Children had lain on the floor in silence for hours. Two days later, they then returned to their classrooms.

Following advice from educational psychologists on the Ministry website who stressed the need for a return to normalcy, to routine, teachers were left to deal with the trauma without any advice or support other than to ignore the fact that their city had changed forever.

O'Connor had worked extensively in Christchurch schools following the 2011 earthquake that killed 181 people and then in the ongoing trauma of thousands of aftershocks and quakes. A Christchurch drama teacher, Alys Hill, contacted O'Connor for advice and support as she was working in an after-school drama programme with groups of refugees and recent migrants at the high school that had been the makeshift police centre for the response to the attack.

O'Connor travelled to Christchurch and met with Hill ten days after the attack. Primary concern for both of them was to structure work that provided ways for the young people to safely explore their fears and their deep feelings of loss and confusion. The ethic of care incumbent on them was to work with aesthetic forms so as to not merely retell the horror of the recent events but reshape possibility for present and future. Hill used physical theatre forms to create ways into stories. The group of teenage Muslim women she was working with wanted to create a dance about the paradox of the weight of the hijab. They said it was light and yet heavy to wear, and it made you a target. How this story might be told was eventually at the heart of the work she did with this group. O'Connor was welcomed into the room as the group began making small dance pieces. Hill worked slowly, deliberately and layered her work with opportunities for the group to relax and laugh together. The work inched forward over a period of weeks as Hill built her relationship with the group. Her commitment to the group was that she would be there week after week for the long term. This wasn't a helicoptered applied theatre project to paste band aids across a hurt community. It grew within a promise to make and build work together.

As part of this commitment, O'Connor worked with a small group of young Muslim and migrant children ranging in age from 7–11. In the first workshop that night immediately after the attack, the children chose to act as if they were superheroes. They flew around the room, whooping and laughing, and then decided to be invisible. They were asked to test out their superpower by standing in front of their parents in the room and being rude to them. There was the delicious tension of them knowing they weren't really invisible, their parents acting as if they were, and working out how far they could push the conceit. Giggles erupted everywhere. Looking at Hill, the group decided they wanted to create a drama about Alice in Wonderland. When questioned why they wanted to, this group of young migrants and refugees said that they wanted to know more about wonderland, because it sounds like it is a great place to go to, but it's hard to understand how it works, when people aren't quite what they seem. One little girl commented, "And there is a queen who wants to take her head off".

Over the following weeks, O'Connor and Hill worked in wonderland, finding ways to confront the queen about her meanness, attempting to find ways of making sense of the rules of this strange world. As a metaphor for the lives they were leading, the enquiry within Wonderland was remarkably close. The process of exploration reinforced the recognition that a sustained engagement via applied theatre can provide the opportunity to use metaphor and create fictional worlds through which to better understand real worlds.

Impact, effect and affect: considering the possibility of unintended negative consequences

It can be an easy assumption that to have positive intent will lead to positive impact, and that aesthetically pleasing work will also be ethically strong. But this is not necessarily so. Helen Cahill has explored the notion of unintended negative impact in her analysis of applied theatre projects

conducted with young people in the key affected populations for HIV (Cahill, 2011, 2014). She points to the importance of critically considering the meta-narrative that is transmitted via the performance and the possibility that certain storylines and characterizations can inadvertently reinforce negative stereotypes. In her work with young people living with HIV, she found that they did not want to perform their diagnosis identities or their risk biographies in public forums, but preferred to speak from their advocacy standpoint (Cahill, 2014). They wanted to critique the ways in which structural disadvantages such as poverty, discrimination, stigma and low access to education and health care played a role in creating and maintaining their vulnerabilities. They found an empowering sense of dignity when they shifted from a focus on telling their personal story to providing advice to governments about the kinds of policies, laws and programmes that would best provide prevention and re-integrative care for young people.

She notes that there may need to be a critical awareness of the tendency to invite those affected by disadvantage to chiefly speak from their "victim" identities. This can have a negative effect, working to demonize or pathologize people. These kinds of tales might be relished by voyeuristic audiences and experienced as evoking a strong emotional engagement, but they can have an inadvertent negative outcome by distracting attention from the economic, institutional and cultural conditions that influence people's lives and further perpetuating limiting stereotypes, and associated stigma and victim blaming. An individualized troubling tale can distract attention from the possibility of corrective action, and thus contribute to a form of depoliticization or collective irresponsibility (Cahill, 2017).

These examples highlight that representation is always also a political act. People may want to choose which versions of their stories are told, if they are to be told at all. Some may prefer to be recognized for their stand, their deeds, their contribution or their vision for action, in this seeking a form of recognition that reaches beyond their personal biography. Others may find that restrictive religious, cultural and social norms work to limit what they feel free to safely voice or perform in front of others, particularly when dealing with sensitive material (Cahill, 2016).

Economies of care: creating enabling spaces for cultural safety and system change

An interest in the ethics of representation in applied theatre extends not only to the works created, but to the mission of the applied theatre organization itself. The organization, its objectives, practices and selection of works itself communicates to the world a story about who and what is held to be important. This is illustrated well in the chapter in this text provided by **Molly Mullen** and **Bōni Te Rongopai Tukiwaho**. They explore the financial and human resourcing and economics of human labour exerted within the Māori-led applied performance company Taurima Vibes, led by Bōni.

Within his broader project of using the arts to empower, Bōni describes the ways in which his company uses traditional Māori rituals in gathering and speaking, and thus keep participants socially and culturally safe – in this embracing a culturally-informed pedagogy for interaction. Here, an ethics of representation extends to the very practices through which people represent themselves with and to each other when working together.

Bōni talks about the ways in which his theatre group places importance on holding and creating relational space, and using that space for empowering conversations within and beyond the Māori community in genuine partnerships for social change. He speaks to the contribution of the vision Taurima Vibes in "holding space" and "walking alongside" others as part of an effort to collectively combat stigma and influence systemic change. His company uses performance work to create connectedness and thus to strengthen community.

This space for interaction and generation of applied theatre works is chiefly sustained through pro bono labour, and when funds can be found, efforts are made to share monies between players. Thus an economy of commitment and love sustains the organization and maintains its presence throughout lean times as well as when funding sources are found for particular commissions or projects.

This is an ethics which attends to a process of empowerment through relationality, accompaniment, and opening of space for traditions to be cherished and change brought to pass.

Therapeutic theatre: relational encounters with strangers in care

When applied theatre activity extends into health institutions, it is often deployed for therapeutic purposes, or to improve quality of life of those confined due to their fragility, age, disabilities or illness. Work in these confined and medicalized settings can call for heightened awareness of the ethics and practicalities of engagement, and applied theatre workers are often part of an interdisciplinary team within which health professionals share their expertise, evidence-based and practice frameworks with the artists. One such endeavour is explored in a chapter offered by **Julie Dunn** and **Michael Balfour** in which they discuss the contribution that their artists/clowns make in eliciting forms of *playful engagement* with elderly people with dementia who live in residential care. The aim of the project is to use these playful interactions to improve "quality moments in life" for the old people who have significantly reduced access to their own memories. The clowns use their low status roles to position the elderly persons as those who know more, and are capable of bringing their knowledge to correct and direct interactions.

Within their interdisciplinary orientation, they are guided by a research-informed framework developed by therapists for those in dementia care. This framework points to the importance of key concepts through which to appraise quality of life experience: including connectedness, relationships, agency, wellness and emotion. Using this framework, they read the clowning exchanges for signs that they evoke affective engagement, and sense of interaction and for evidence that the elderly person is exerting a level of agency or choice about the direction or the form that the interaction takes.

Their accounts reveal that the effort to connect will not always be successful, as the clowning overtures do not always accomplish a reciprocal encounter. However, there are instances when through skillful observation and choice of appropriate stimuli, an interaction is triggered and sustained, sometimes evoking signs of joy, and sometimes bringing signs of sadness. However the affective response, whether tinged with delight or grief, is noted to be a form of aliveness and presence in the world, and in this the artworkers somewhat challenge the health framework that places positive and negative affect in a binary signifier of success. Nonetheless, their ethics for engagement has them focus on the quality of the experience that is engendered for the participants, rather than chiefly on the quality of the artist's performance. A combination of insight, responsiveness, creativity and relational responsiveness is required to work with the emerging encounter so as it contributes to the participant, rather than fulfils a skill set or the performative intent or pre-scripted intent of the theatre artist.

The ethics of representation here is partly accomplished through positioning of the clowning artist as of lower status than the respondent. The clowns seek to engage a type of commissioning interest and a playing-with the elderly person. In their research, they find that the dramatic play here proceeds just as much through positioning of artist to be creatively responsive to emergent engagement and expressions of identity and affect on the part of the respondent. This is somewhat akin to a form of responsive improvisation which is alert to its constraints. The artists work

to draw out the performance of the participant via eliciting and sustaining their engagement in life, rather than working to create a performance that is gifted to another.

This is an ethics of responsive reciprocity, taking a moment by moment reading of embodied affect and response as the orientation for the timing, direction and duration of the work. It is an ethics of attention to micro moments in the relational exchange and to how representations are registered with the responding other.

Drawing from this work, the interest in producing affective engagement and politicizing or mobilizing towards action that is often the hallmark of the accomplishment of applied theatre interactions, can also be understood as the production of aliveness and a contribution to the capacity to be present to and engage with life.

Drawing some conclusions

The applied theatre work showcased in this collection of case studies from Australia and New Zealand highlights the manner in which ethics of representation are navigated and decided on *in situ*. All of the applied theatre makers in these studies engaged with ethical questions as they work through devising processes, and considered how the theatre they made would impact on those whose stories they tell, and those who are audiences to the work. We see how the work they make is driven by concerns which sit in the nexus of the aesthetic, the political and the ethical.

We have suggested a number of reference points for applied theatre makers to consider as they read the complexities of their situation and evolve their projects. We suggest they may provide an opportunity to learn through the stories of others, and offer points of resonance when thinking into the ethics of representation within applied theatre practice.

References

Alrutz, M. 2006. A stream of conscience: Reflecting on ethics and representation in drama with youth. *Teaching Artist Journal*, 4(4), 252–256.

Blomfield, I. and Lenette, C. 2018. Artistic representations of refugees: What is the role of the artist? *Journal of Intercultural Studies*, 39(3), 322–338. doi:10.1080/07256868.2018.1459517.

Cahill, H. 2011. Transdisciplinary practice: Using systems thinking tools to generate new stories about HIV. *Drama Australia (NJ)*, 35, 15–33.

Cahill, H. 2014. Withholding the personal story: Using theory to orient practice in applied theatre about HIV and human rights. *Research in Drama Education: The Journal of Applied Theatre and Performance*, 19(1), 23–38. doi:10.1080/13569783.2013.872427.

Cahill, H. 2016. Playing at being another we: Using drama as a pedagogical tool within a gender rights and sexuality education program. *In:* M. Finneran and K. Freebody, eds. *Drama and social justice: Theory, research and practice in international contexts.* New York: Routledge, 155–167.

Cahill, H. 2017. Performing the solution: Cautions and possibilities when using theatre conventions within HIV prevention programmes. *In:* V. Baxter and K. Low, eds. *Performing health and wellbeing*, 162–167. http://www.bloomsbury.com/uk/applied-theatre-performing-health-and-wellbeing-9781472584595 /#sthashn.EojIWU2M.dpuf.

Elliott, J. 2005. *Using narrative in social research: Qualitative and quantitative approaches.* London: SAGE.

Fine, M. 1994. Dis-stance and other stances: Negotiations of power inside feminist research. *In:* A.D. Gitlin, ed. *Power and method.* New York: Routledge.

Gallagher, K., Jacobson, K. and Mealey, S. 2018. Accuracy and ethics, feelings and failures: Youth experimenting with documentary practices of performing reality. *Theatre Research in Canada*, 39(1), 58–76.

1
IDENTIFYING AND UNDERSTANDING THE NOTION OF QUALITY WITHIN AN APPLIED THEATRE PROJECT DESIGNED TO PLAYFULLY ENGAGE PEOPLE LIVING WITH DEMENTIA

Julie Dunn and Michael Balfour

In this chapter, we examine notions of quality and quality of life (QoL) as they relate to applied theatre work conducted in dementia care contexts. To do this, we draw upon a framework created by researchers from the health sector (O'Rourke et al., 2015) to analyse and thus better understand data collected within a research project entitled *Playful Engagement*. Focused specifically on individuals with mid to advanced dementia, this mixed methods, multidisciplinary project was funded through an Australian Research Council Linkage Project grant that saw Wesley Mission Brisbane (WMB), one of Queensland's largest aged care service providers, partner with a team of Griffith University researchers, including those with expertise in nursing, applied theatre and ethnography.[1] Conducted across six WMB sites and involving 60 participants, the project generated 340 visits, totalling 85 hours of practice.

The O'Rourke et al. framework describes QoL from the perspective of individuals living with dementia, and we apply it here to help us understand a series of visits between an elderly woman we have called Heather and two *Playful Engagement* applied theatre artists named Clark Crystal and Anna Yen. At the time of the visits, Heather, originally from Scotland, was living in a WMB care home on the Southside of the city. Clark and Anna were a pair of relational clowns who called themselves the "Lamingtons". Specifically trained in working with people living with dementia, within their work Clark and Anna's approach is spontaneous and responsive, designed to affirm and celebrate each individual's personal identity and life experience. Each wears a red nose and they dress in clothing from the 1950s. Their story is that they are identical twins who live together out of town, with the very tall Clark becoming "Tiny" Lamington and Anna his sister becoming "Dumpling" Lamington. As out-of-town visitors, they carry suitcases which are home to their props. Like most clowns, they adopt low status roles and as such are

constantly lost, tangled, confused, hopeless and late. However, unlike "traditional" clowns that seek laughter in response to this status lowering, within their work Tiny and Dumpling use their low status roles to empower individuals who are not normally provided with opportunities to be the experts or the ones "who know".

For the WMB residents, involvement in the research component of the project required formal consent from their families, whilst assent from the individuals themselves was confirmed on a continuous basis via a simple question, "Can we visit with you today?" To support these processes, families were provided with information packages and also invited to attend workshops where they had the opportunity to meet the team and have their specific questions addressed. Consent options included participation with video documentation or observation only.

In previous publications, we have drawn on data from across the project to explore and understand the vocabularies of practice used by the *Playful Engagement* artists (Balfour et al., 2017) and more recently to question the value of employing quantitative QoL measures to understand the effectiveness of applied theatre projects in dementia contexts (Dunn, Balfour and Moyle, 2019). In each of these works, we have focused on the importance of the "moment", and in the latter work have suggested that when attempting to understand the impact of applied theatre in dementia settings, it might be more appropriate for researchers to focus on "quality moments of life" rather than the broader notion of QoL. This idea emerged as a way of reconciling the contrasting findings between the qualitative and quantitative data sets within this mixed-methods study. These findings revealed that while the majority of participants demonstrated positive responses within the visits, including displays of pleasure, engagement and an improved level of alertness, the quantitative measures employed were unable to identify any significant shifts in QoL.

In developing the notion of "quality moments of life", we took the lead from nursing professionals like Pringle (2003) who has argued that when working with people living with dementia, emphasis should be placed on "improving the quality of the moment". Of course, as Pringle also notes (2003, 9), this emphasis leads to the inevitable question: What constitutes a quality moment? This is clearly a challenging question. Applied theatre work with people moving towards the end of their life is unlike similar work in any other setting. Participants are living with declining linguistic and cognitive capabilities, they have fragmented perceptions of past and present, and feel disconnected from themselves and others. Their short-term memories are particularly fragile and, as such, they usually do not remember interactions that have occurred just a minute or two previously. As a result, some of the common intentions of applied theatre and the approaches used to gauge their effectiveness are problematic, leading McCormick (2017, 8) to argue that the efficacy of relational applied theatre with older adults is best understood in terms of the kinds of affects that are both individually and communally experienced in moments of interaction. In offering this view, McCormick contributes to the ongoing debate within applied theatre around the relationship between affect and effect (Thompson, 2009), specifically in relation to participants living with dementia. But what are these affects and how do we understand them in the context of creating high-quality moments?

Informing literature

In order to support our attempts to address this question, we turn to the work of O'Rourke et al. (2015) who completed a meta-synthesis of qualitative studies that directly sought the perspectives of people living with dementia. Their argument is that any understanding of QoL for people living with dementia must be based on the views of those experiencing it. Here the work of Jing, Willis and Feng (2016) is important, for they have articulated the view that there are con-

Identifying and understanding quality

siderable differences between QoL factors identified by those living with dementia and factors identified by carers, family members, medical practitioners and researchers. Further, O'Rourke et al. (2015) note that while some individuals living with dementia are quite capable of discussing their QoL with researchers, their perspectives are rarely considered. They suggest (2015, 24) that individuals without dementia "find it difficult to imagine a good QoL" for people with dementia, and for this reason they "overemphasize disability by focusing on direct consequences of dementia such as cognitive impairment, dependence, and communication problems".

The synthesis of research put forward by O'Rourke and colleagues is useful to us in our attempts to identify quality moments in applied theatre work as they have outlined a framework made up of six critical concepts (O'Rourke et al., 2015, 28). The first of these concepts is connectedness, which is a state represented in each of four concepts: relationships (Concept 2), agency in life today (Concept 3), wellness perspective (Concept 4) and sense of place (Concept 5). Concept 6, according to these researchers, is happiness and sadness, described as the outcome of either good or poor QoL. Figure 1.1 provides a visual summary of these concepts and their relationships (O'Rourke et al., 2015, 29).

In reflecting on the interactions created within the *Playful Engagement* project, each of these concepts appears to have relevance, with five being of particular relevance – connectedness, relationships, agency, wellness and emotion. The sixth concept, relating to a "sense of place", is also highly relevant, but possibly not in the form described by these researchers. Drawing on the studies in their meta-synthesis, they suggest that "sense of place" as a QoL concept should be

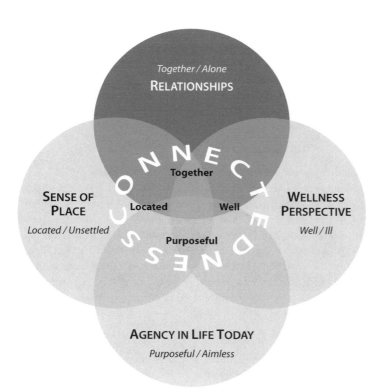

Figure 1.1 The O'Rourke et al. 2015 model of factors that affect quality of life according to people living with dementia.

used to describe an individual's satisfaction with the physical environment of their care situation. However, within our study, it appears to have broader influence, with many of the interactions we witnessed being characterised by exploration of place as an aspect of memory, with the immediate physical environment appearing to be less significant.

The remaining five concepts within their framework are more closely aligned. For example, to clarify the concept of connectedness, O'Rourke and colleagues describe it (28) as the "perception of a positive or harmonious linkage between one's sense of self and one's experiences of relationships, agency, wellness, and place". Meanwhile, the concept of relationships describes interactions with a broad range of individuals including family, friends, care staff and other residents. Their meta-synthesis (2015, 28) revealed that contact with others is important, and that a lack of opportunity to interact with others detracts from QoL. They found that in all of the studies they analysed, "relationships characterized by kindness, love, or respect enhanced QoL" (28), with these relationships leading to "feeling accepted, listened to, and understood". Meanwhile, "agency" is described within the framework as the "ability to express one's sense of self and to experience autonomy and independence in day-to-day living … being able to determine the structure of daily activities, have a direction in life, or achieve one's goals" (29). Finally, in relation to wellness, the authors argue that for people living with dementia, wellness relates not simply to their particular experience of living with dementia, but also to their overall experience of health and aging.

Later in this chapter we will draw upon these six concepts to support our examination of a series of vignettes developed in response to data collected across three visits between Heather and the applied theatre artists. These vignettes provide insights into the way songs from childhood, fragmented memories of home, dance, props, narratives of Bonnie Prince Charlie crossing the sea to Skye, and deeply personal reflections on family and loved ones were spontaneously shared and experienced during interactions between Heather, Tiny and Dumpling. Our goal in linking these vignettes and the six QoL concepts is to identify which visits, if any, might be described as "quality moments of life". First, however, some further background material relating to the practice and research approaches within *Playful Engagement* is offered.

Practice approach

Clown work in health care settings began almost three decades ago (Barkmann et al., 2013; Oppenheim et al., 1997). A common characteristic of all clowning in health contexts is the need for the clown activities to be closely attuned to the clinical and personal needs of the elderly or ill participants (Kontos et al., 2015). Work of this kind is part of a growing field of arts-based practices applied to address the challenges associated with rising rates of dementia. Music has traditionally been a strong area of practice (Cooke et al., 2010; Raglio et al., 2010; Svansdottir and Snaedal, 2006), as well as dance and movement (Guzman-Garcia et al., 2013; Ravelin et al., 2013), storytelling (Basting, 2006) and reminiscence theatre (Schweitzer, 2007). The growth of these approaches derives from recognition that, in the absence of a cure for dementia, there is a need to develop approaches that address its key impacts of social isolation, depressed mood and QoL (Moyle et al., 2011).

In the *Playful Engagement* work, a relational clowning approach was used. Drawing on a legacy of European clowning that has at its heart a philosophy of spontaneity, connection and respectful playfulness, relational clowns, often also referred to within aged care contexts as elder clowns, focus on communication, engagement and relationship building. Kontos et al. (2015) have suggested that successful and meaningful practices involving elder clowns and individuals living with dementia is predicated on a practice and state they have described as "relational pres-

ence". They argue that relational presence is achieved and experienced through a combination of three strategies that involve both the clowns and the resident they are visiting. These include: 1) affective relationality, 2) reciprocal playfulness and 3) co-constructed imagination. Whilst all three of these are relevant to the *Playful Engagement* work, their term "affective relationality" is particularly apt as it describes (2015, np) the way the artists demonstrate "sensitivity to, compassion for, and in some cases their susceptibility to becoming affected by, the joyful and sad emotions of residents".

Within the various interactions that made up the *Playful Engagement* sessions, a range of play vocabularies were employed including: singing, music and dancing, status giving, storytelling, humour, the playful use of language and paralanguage, mirroring, validation, and the use of objects and props (see Balfour et al., 2017). These varied practices were necessary in order to ensure that the individual personalities and interests of each participant were catered for. Vocabulary selections were also dependent on the context of the visits (common spaces versus private ones), the wellness of a participant on any given day, and their personal experience of dementia. A further important feature of the *Playful Engagement* approach was the fictional relationship between Tiny and Dumpling, with their sibling rivalries allowing for the introduction of playful tensions such as spats over domestic duties and family finances. These tensions were regularly used to drive the action forward, whilst also supporting the creation of humour and subsequently connection (Dunn et al., 2013; Kontos et al., 2015).

As noted above, to further support the visits, the relational clowns brought with them suitcases containing a range of props and stimuli. Where possible, these props included objects specific to the interests of individuals and their particular social biographies (for example, a violin for a woman who once conducted an orchestra) or others of more general interest (including old magazines, unfinished knitting, percussion instruments, wigs, etc.). The social biographies were informed by formal documentation shared with the artists by the care home, or in its absence, contextual clues located within each individual's room such as family photos, art works or trophies. Moos and Bjorn (2006, 431) argue that "knowledge about the residents' pasts must be systematically collected and assimilated to enable the staff to deliver individualised and personalised care".

Research approach

As noted above, the *Playful Engagement* project adopted a mixed-methods, multidisciplinary approach that made use of a range of quantitative and qualitative data collection methods. Across the study, the quantitative data collection and analysis processes were managed by the health researchers and their specially trained research assistants, whilst the corresponding qualitative processes were the responsibility of the applied theatre researchers and a further research assistant who also worked as the project manager. Due to the goals of this article and the constraints of space, we draw here only on the qualitative data, but nevertheless offer a summary of the quantitative processes.

One of the key quantitative data sources was an assessment of each participant's cognitive status. At the design stage of the study, the Mini-Mental State Exam (MMSE) (Folstein et al., 1975) was selected for this purpose. However, as many of the participants were experiencing advanced stages of dementia, the Test of Severe Impairment was used instead. QoL was assessed through the Quality of Life in Alzheimers Diseases (Edelman et al., 2005) for residential care. This brief instrument obtains a rating of the individual's QoL by interview from both the resident (where possible) and the caregiver. A four-option multiple-choice format is consistent across all questions. An associated measure applied was the Geriatric Depression Scale (GDS) (Yesavage and

Sheikh, 1986), designed to assess each individual's level of depression. It assesses psychological wellbeing by asking participants how they have felt over the past week using a yes/no response to 15 questions. Medication records were also audited, with baseline and end of study data recorded for individual participants and compared following the applied theatre work. The survey completion process was facilitated by a trained research assistant who did not engage with any of the field work but gathered responses both before and after the applied theatre work. It should be noted, however, that due to the fact that many of our participants were experiencing advanced stage dementia, it was not always possible to use these measures with all participants, thus reducing the size of the data set.

Qualitative data sources were also diverse and these inform the vignettes presented here. Sources included: observations of the interactions, completed by members of the research team; video recordings of the sessions; interviews with staff and artists; and post-session reflective conversations between the artists and those members of the research team who were present on the day. Qualitative data directly relevant to Heather was collected across seven visits, with these visits having a total contact time of just under 2 hours (109 minutes). Within these visits, but at various degrees of distance, two members of the research team (with at least one of these always being one of the chapter authors) engaged in activities designed to capture the interactions on camera and to create written observation notes. The written notes were highly useful within the post-session discussions to prompt recall of key moments, whilst the video recordings served as a supplement to the recordings made via a GoPro camera strapped to Tiny's chest. Whilst these would seem to be standard data collection processes in most contexts, they often proved to be challenging within this study, especially when the visits between the Lamingtons and the residents were conducted in the intimate space of a bedroom. In these cases, the observers tended to remain outside the room for fear of overwhelming the work. Observations in community spaces were far easier and fortunately, the bulk of the visits occurred here.

The setting

Across the various WMB sites, physical environments were diverse in terms of the opportunities they provided for playful engagement and meaningful interaction. Heather lived in a 61-bed care home, with a small living and dining room, and a secure outdoor garden and sitting area. The living area, where all her visits occurred, was homely, but reasonably cluttered with heavy-duty seats arranged in groupings. While more appropriate for personal visits than arrangements encountered at some of the other sites (where rows of seats were lined up to face the television screen), the space nevertheless presented challenges. The communal space overlooked the gardens and felt light and airy. Adjacent to this living area was a small library accessed via a sliding door. Residents could also access a courtyard garden, which was well kept and had shaded areas for sitting. The location was secured and locked, with access via a coded entry door.

All of the residents of this home were female, with a key criterion for their placement being their mobility. While this level of mobility differed from individual to individual, most residents were able to move about without support. This was certainly the case for Heather.

The vignettes

Within this chapter, three vignettes are used to describe our first three visits with Heather. These visits were chosen as they provide the most interesting examples of how the interactions between Heather and the Lamingtons progressed over time. The vignettes have been created based upon co-analysis of the video recordings, reflective conversations between artists

and researchers immediately after each session and observation notes. Following each vignette, key points about the visit are outlined, together with analysis of them using the six concepts included within the O'Rourke et al. (2015) QoL framework.

The *Playful Engagement* team first met Heather during a pre-study orientation visit. We had just entered the communal living room and observed that Heather was shouting abuse in the direction of staff. This was followed almost immediately by a similar outburst aimed at Clark, who was not in role as Tiny for this orientation session. Heather objected to Clark's loud voice. Staff indicated to us that she was prone to angry outbursts of this kind, loudly challenging the actions of care staff, family members and other residents. Based on this information and our initial interaction, we were somewhat anxious about how to approach engagement with Heather and were therefore particularly keen to access biographical material about her. This material revealed that Heather had lived most of her life in Scotland, arriving in Australia in the early sixties. It also helped us to understand that while she had children and grandchildren living locally, her attitude and behaviour meant that visitors were quite rare and their visits brief.

Vignette one

Heather is asleep at a table. Tiny sits on a chair beside her, introduces himself and asks if he can visit. She nods faintly. He immediately uses his personal experience of living and working in Scotland as a way to create a connection, beginning tentatively and somewhat playfully by listing the places she probably doesn't come from … not from Inverness or Isle of Skye or Aberdeen … but gets almost no response. He talks about places he has visited … but Heather continues to ignore him.

Three minutes into his visit and Heather remains expressionless. She briefly sparks up at the mention of Kelvingrove, a suburb of Glasgow, but her body language is defensive with her arms clasped in front of her. Tiny, who is seated beside her, continues to share random stories of his memories of Scotland – delivering them in a gentle tone of voice. She appears to listen, but is not fully present. There is quite a lot of silence between them. Seven minutes into the visit, Tiny shares with Heather a photograph of his sister Dumpling. For some reason, this catches her attention and she asks about her strange name and appearance. Her interest in the response is limited, however.

Eventually, Tiny suggests that he will leave her to enjoy her cuppa and makes a soft exit. Heather does not even appear to be aware that he has left.

This vignette outlines events occurring during the first visit between Tiny and Heather. It was an uncharacteristic visit owing to the fact that Tiny visited without his sister Dumpling. As noted above, the Lamingtons would normally work in partnership, drawing on each other's energy and letting the individual living with dementia "off the hook" in terms of participation. Here, however, Clark is forced, due to Dumpling's unavoidable absence, to create a connection with Heather on his own. He does this by talking about Scotland and playfully using names of places that might be familiar to her. However, apart from some sparks of interest, her engagement is not ignited.

When considering this vignette in relation to the six QoL concepts outlined earlier in this chapter, it is clear that this visit could not be described as a moment of quality. There is almost no sense of connectedness (Concept 1) and, as such, no level of relationship (Concept 2) is established. Whilst there are interactions between the artist and Heather, they could not be described as meaningful. Interestingly, a possible cause for these outcomes appears to have links

to another of the six concepts – wellness (Concept 4). When Tiny arrives to visit with Heather, she is asleep at a table and throughout the visit remains quite expressionless. Even as Tiny leaves, she does not seem to notice. This passivity and lack of expression are in stark contrast with the demeanour we had witnessed just one week earlier, during the orientation visit, and suggest that on this particular day and for whatever reason, Heather is not experiencing a level of wellness that might allow her and Tiny to co-create a quality moment of life.

Vignette two

Visit two also begins with Heather sitting at a table. Once again, Tiny seeks permission to visit, this time dropping down onto his knees in front of her. Heather responds immediately with a bright hello, putting her arms around him. As a very tall man, Clark's face is at her eye level and, as such, she is able to look straight into his eyes. Tiny says that it is beautiful to see her and then as a means of breaking this close and quite intimate embrace, invites Heather to dance.

She doesn't respond, however, so Tiny introduces his sister Dumpling. Aware of what occurred during the last visit, Anna (as Dumpling) tries a different approach by seeking Heather's advice on how best to keep her money safe. Heather brightens immediately and surprisingly suggests it is good to keep it down your bra. Tiny asks that since he doesn't wear a bra, what should he do? Heather laughs, and as Tiny is still kneeling beside her on floor, she affectionately rubs his bald head. There is much laughter.

Dumpling asks Heather if she wants to have a dance with her brother…and this time Heather responds by saying, "Why not?" Tiny helps her up and they begin to dance and sing the song "I Belong to Glasgow". Dumpling plays the finger cymbals to accompany. There is great joy on Heather's face.

As the dancing slows, Tiny shifts the song to a more lyrical one – the Skye Boat Song. In response, Heather's movements become more rhythmic and she seems to drift into a different zone, noting, "Scotland is very far away. I'd rather be there". Nevertheless, she soon lets go of Tiny's hands to clap along. Dumpling compliments her and says she is musical and a good dancer. She seems very surprised by this affirmation and says, "We are not going on about that … whoa". She seems more interested in the experience than the affirmation.

As the camera spans the room, it is clear that Heather is the only resident who is active or engaged at this moment. She has two people touching her, engaging with her … letting her lead. Dumpling again offers an affirming comment, suggesting that Heather has looks and brains. This time Heather responds quite differently, responding to Dumpling by saying that she has promised herself that she will do something more with her mind … that she has plans.

A lull follows and eventually Dumpling breaks the silence by announcing, "He's a good brother, my brother", referring to Tiny. Immediately Heather responds, commenting that she has three brothers. Dumpling asks if they are as nice as her brother. Heather immediately turns in a flirtatious way and announces, "Never".

They begin to discuss one brother and Tiny asks, "Was he a big man? Was he a rugby player?" Heather's response is loud and immediate. "IS", she calls loudly, correcting Tiny very aggressively. "Don't talk about my brother like he isn't here". Tiny

responds in a reassuring tone, apologising for his error. There is an extended silence where Heather appears to be deep in thought.

Before too long, Heather turns her attention to Dumpling, engaging her in a heartfelt conversation about life lessons, life tales and life choices. Heather is very intense and almost whispering. Although much of what she is saying is quite incoherent, Dumpling listens carefully.

Another lull occurs and eventually Dumpling asks again: "Do you want to dance?" "Yes", says Heather. "I haven't done that for a long time!" She starts dancing a small jig. Tiny and Dumpling mirror her actions and she laughs.

Soon, Tiny announces that it is time for them to leave. In response, Heather reaches up and hugs him. It appears to be a spontaneous impulse, followed by another where she initiates the singing of the Skye Boat song. The dancing begins again. It appears to be difficult for the Lamingtons to finish the visit. Is she singing as a way of keeping him connected to her and engaging with her?

Eventually, the visit ends and Heather is guided back to her seat by Tiny. She smiles contentedly.

This vignette is in strong contrast with the previous one. Here, connection between Heather and Tiny is immediate. Nonetheless, it is a complex visit, with many moods, twists and turns. In the time they spend together, she reveals aspects of her fiery nature, but on the whole the visit is a happy, and at times tender, one. There are moments of regret too, including when Heather reveals that she would prefer to be back in Scotland and also when she suggests that she has unrealised dreams.

In attempting to understand the differences between the two visits, there are a multitude of possible causes, including Heather's level of wellness and the presence of the two artists this time, whose combined offers seem to have a freeing effect on Heather. In addition, whilst Heather is occasionally incoherent in her offerings, there is a complete lack of judgement or evaluation from Tiny and Dumpling with regard to what she offers.

In terms of the six concepts of QoL, this vignette is in direct contrast to the previous one, with Heather's greater sense of wellness (Concept 4) making possible a range of responses that did not appear to be available in the previous visit, including dancing and singing. Importantly too, Heather is able to take the lead, with Tiny and Dumpling accepting and building on both her physical and verbal offers. This agency is further evident in relation to the two extended pauses, with both artists being comfortable with the silence – avoiding the trap of rushing Heather into action or interaction. These responses, when considered together, appear to demonstrate that relationships are being built (Concept 2) and connections are being made (Concept 1). Agency (Concept 3) is also evident, with Tiny and Dumpling's gentle and responsive approach ensuring that Heather is the one making key choices, including in relation to the type of action they engage in and the narratives explored. Interestingly, and as discussed briefly above, Concept 5, which relates to a sense of place, was also significant, with the songs of Scotland reminding Heather of how much she misses her homeland.

While Heather's responses across the visit appear to suggest that at times she was feeling sad, indicated within the framework as being an aspect of Concept 6, these moments also related strongly to her sense of self, which is included within the connectedness concept (Concept 1). For example, earlier in the visit when Heather wistfully, and somewhat surprisingly, suggested that she needs to do more with her mind and that she has plans, she appeared to be using this opportunity to reflect on an aspect of her sense of self.

Based on this analysis, we would suggest that this visit could appropriately be described as a quality moment in Heather's life. Whilst she certainly moves through various moods, with her emotions shifting markedly, she has also experienced physical closeness and had opportunities for reflection. She has been listened to and respected.

Vignette three

When Tiny and Dumpling arrive for the third visit with Heather, they discover that she has been put into the small room adjoining the common living room. She is alone with the door shut. This move has been deemed necessary based on her aggressive interactions with other residents. The staff suggest that today might not be a good day for a visit. Nevertheless, Tiny pops his head through the door, and asks if it is ok to visit. Heather looks tired but nods agreement. Dumpling immediately sits down beside Heather and takes her hand. In response, Heather pats Dumpling on the back. Tiny attempts to engage Heather by singing a couple of songs and inviting her to join in, but she resists and remains quite disengaged.

Tiny changes tack and starts to sing Skye Boat Song. Heather responds by tapping her leg, whilst still holding hands with Dumpling. However, as the song progresses, Heather becomes more and more involved until she is raising her hands into the air and emphasising key words as she sings. Once the song finishes, she looks at Tiny with a warm expression and notes, "We all love it".

Next, Tiny joins Heather and Dumpling on the small couch and begins to bounce playfully. Dumpling joins in and Heather laughs loudly, enjoying the fun. Tiny, noting increasing engagement from Heather, opens his case, pulls out a kilt and begins to try it on. Dumpling uses the strategy of sibling rivalry to suggest that Tiny is too big for it saying in a Scottish accent, "It's not going to fit you laddie!" Tiny gives up trying to make it fit and suggests that they come out of the room and go for a walk. Heather says, "Let's all come out".

Heather gets to her feet but instead of going outside, starts to put the kilt on. Tiny and Dumpling help her and she smiles as they do this. Dumpling has retrieved a larger kilt from the bag now and puts this on Tiny. It fits! Dumpling takes a photo of Heather and Tiny together in their kilts and then shows it to Heather who smiles. She seems very touched by this moment and says, "That's a nice picture".

Now out of the small room, Tiny and Dumpling begin walking with Heather around the communal space. They all start to sing again and soon Tiny leads them in a Highland dance. Louise, another resident, joins in. The dance continues for a full four minutes and during this time, Heather's enthusiasm doesn't flag at all. She sings along to the words and conducts too.

One of the staff members who was so negative about Heather's mood when we arrived observes the dance and Heather's transformation. Close to tears she says, "It's so beautiful. It's just beautiful."

Before long, Tiny starts a rendition of "I'll take the high road, and you'll take the low road". The singing is infectious and soon enough everyone in the room is either singing or clapping their hands. However, this song seems to create a sudden shift in Heather's mood. She moves in closer to Dumpling and suggests that they sing something a bit quieter. Tiny responds by once again singing Skye Boat Song, and the three of them begin to slow dance and sway together.

Heather asks for a wee cup of tea and so Dumpling helps her to sit down.

Once seated, she begins to share information with Dumpling about her family and her ten children. Heather has suddenly become very warm towards the other residents and once she has finished her tea, she gets up and puts her arms around one and kisses her on the top of the head. At this point Dumpling and Tiny say farewell and exit to begin a visit with another resident.

This vignette offers further opportunities to understand quality in the moment, since analysis of this visit in relation to the six concepts identified earlier, clearly marks it as providing Heather with a quality moment of life. Indeed, such was the joy and laughter generated by all in the room, it could appropriately be described as a quality moment of life for almost everyone present, including the artists, research team, staff and fellow residents.

Whilst many of the vocabularies of practice were similar to those used in other visits, including singing and dancing, the introduction of the kilts and the couch bouncing were new and significant. The couch bouncing was a spontaneous and shared attempt by the Lamingtons to build upon the improvement in Heather's mood, which they had achieved by singing one of her favourite songs. In using this song, which she had responded to in the past, they were attempting to activate aspects of her sense of self relating to place (Concept 5), whilst also re-establishing relationships initiated during the previous visit (Concept 2). Heather's response to the highly playful bouncing was to laugh loudly – reflecting her enjoyment of this unexpected experience.

The two kilts were then employed to further progress Heather's engagement. Twigg and Buse (2013) suggest that material objects, including clothes, can be powerful affective triggers, with the feel, smell and touch of these items evoking memories of the past and associated affective responses. In this case, the kilts appeared to energise her, resulting in her engaging in an extended period of dancing which becomes infectious and soon sees involvement across the room. These scenes are in stark contrast with those that Tiny and Dumpling faced upon arrival, with Heather banished to a private space due to her inability to sustain appropriate relationships with fellow residents. Clearly associated once again with her sense of wellness (Concept 4), in this case potentially her depressed mood, the transformation in these relationships (Concept 2) across this short visit is remarkable. Of particular significance, in terms of relationships, are the responses of the staff member whose observations of this visit provided her with new insights into Heather – as a woman capable of fun and laughter and someone able to create joy for others (Concept 6). Surprised by both the action she observed and the shift in Heather, she expresses the view, both at the time and later within an interview, that this was a beautiful moment for Heather.

Conclusion

Across the duration of the *Playful Engagement* project, the authors of this chapter were lucky enough to witness the work of Clark Crystal and Anna Yen as they carefully and creatively interacted with more than 60 individuals living with dementia. After each session, we came together with these artists to discuss the interactions we had just witnessed. Inevitably, as part of these discussions, we discussed the "quality" of each visit. Our judgements were keenly informed by what we had seen and felt, but were nevertheless intuitive, made without reference to any formal framework or set of criteria. As experienced applied theatre practitioners and researchers, we were all capable of identifying those moments when the artistry of Clark and Anna was at its best and, at the time and since, have been able to pull apart their vocabularies of practice in order to better understand the construction of these moments. However, until recently, we have not

given sufficient attention to understanding how *our* notions of quality might *differ* from those of individuals living with dementia.

By examining the interactions between Heather, Tiny and Dumpling, and considering them in relation to the six concepts of QoL outlined in the O'Rourke et al. framework, we believe we now have a more nuanced understanding of what constitutes quality in relation to engagements between applied theatre artists and individuals living with dementia. Obviously, more work is needed, such as by deepening our appreciation of these six concepts and through the broader application of this framework. For now, however, we hope that the spotlight we have thrown on understanding QoL from the perspective of people living with dementia has helped to inform and enrich the way applied theatre artists and researchers develop, interpret and report upon their work.

Note

1 ARC Project ID LP120100194 Playful engagement and dementia: understanding the efficacy of applied theatre practices for people with dementia in residential aged care facilities. Chief investigators: Professor Michael Balfour, Professor Julie Dunn, Professor Wendy Moyle, Professor Marie Cooke and Dr. Kirsty Martin (Research Assistant).

References

Balfour, M., Dunn, J., Moyle, W. and Cooke, M.. 2017. Complicite, Le Jeu and the Clown: Playful engagement and dementia. *In:* S. McCormick, eds. *Creative ageing*. London: Bloomsbury, 125–146.

Barkmann, C., Siem, A.K., Wessolowski, N. and Schylte-Markwort, M. 2013. Clowning as a supportive measure in paediatrics – a survey of clowns, parents and nursing staff. *BMC Pediatrics*, 13(1), 166.

Basting, A.D. 2006. Arts in dementia care: 'This is not the end ... it's the end of this chapter.' *Generations*, 30(1), 6–20.

Cooke, M., Moyle, W., Shum, D., Harrison, S. and Murfield, J. 2010. A randomised control trial exploring the effect of music on quality of life and depression in older people with dementia. *Journal of Health Psychology*, 15(5), 765–776.

Dunn, J., Balfour, M. and Moyle, W. 2019. Quality of life or 'quality moments of life': Considering the impact of relational clowning for people living with dementia. *Research in Drama Education: The Journal of Applied Theatre and Performance*, 24(1), (pages not yet available).

Dunn, J., Balfour, M., Moyle, W., Cooke, M., Martin, K., Crystal, C. and Yen, A. 2013. Playfully engaging people living with dementia: Searching for Yum Cha moments. *International Journal of Play*, 2(3), 174–186.

Edelman, P., Fulton, B., Kuhn, D. and Chang, C. 2005. A comparison of three methods of measuring dementia-specific quality of life: Perspectives of residents, staff and observers. *Gerontologist*, 45(1) Spec No 1, 27–36.

Folstein, M., Folstein, S. and McHugh, P. 1975. Mini-mental state. *Journal of Psychiatric Research*, 12, 189–198.

Guzmán-García, A., Hughes, J.C., James, L.A. and Rochester, L. 2013. Dancing as a psychosocial intervention in care homes: A systematic review of the literature. *International Journal of Geriatric Psychiatry*, 28(9), 914–924.

Jing, W., Willis, R. and Feng, Z. 2016. Factors influencing the quality of life of elderly people with dementia and care implications: A systematic review. *Archives of Gerontology and Geriatrics*, 66, 23–41.

Kontos P., Miller, K.L., Mitchell, G., and Stirling-Twist, J. 2015. Presence redefined: The reciprocal nature of engagement between Elder-Clowns and persons with dementia. *Dementia*, 16(1), 46–66.

McCormick, S. 2017. The care home as creative space. *In:* S. McCormick, ed. *Creative Ageing*. London: Bloomsbury, 125–146.

Moos, I. and Bjorn, A. 2006. Use of the life story in the institutional care of people living with dementia: A review of intervention studies. *Ageing and Society*, 26(3), 431–454.

Moyle, W., Kellett, U., Ballantyne, A. and Gracia, N. 2011. Dementia and loneliness: An Australian perspective. *Journal of Clinical Nursing*, 20, 1445–1453.

Oppenheim, D., Simonds, C. and Hartmann, O. 1997. Clowning on children's wards. *The Lancet*, 350(9094), 1838–1840.

O'Rourke, H., Duggleby, W., Fraser, K. and Jerke, L. 2015. Factors that affect quality of life from the perspective of people with dementia: A metasynthesis. *Journal of the American Geriatrics Society*, 63(1), 24–38.

Pringle, D. 2003. Making moments matter. *Canadian Journal of Nursing Research*, 35(4), 7–13.

Raglio, A., Bellelli, G., Traficante, D., Gianotti, M., Ubezio, M.C., Gentile, S., Villani, D., and Trabucchi, M., 2010. Efficacy of music therapy treatment based on cycles of sessions: A randomised controlled trial. *Aging Mental Health*, 14(8), 900–904.

Ravelin, T., Isola, A. and Kylmä, J. 2013. Dance performance as a method of intervention as experienced by older persons with dementia. *International Journal of Older People Nursing*, 8(1), 10–18.

Schweitzer, P. 2007. *Reminiscence theatre: Making theatre from memories*. London: Jessica Kingsley Publishers.

Svansdottir, H.B. and Snaedal, J. 2006. Music therapy in moderate and severe dementia of Alzheimer's type: A case-control study. *International Psychogeriatrics*, 18(4), 613–621.

Thompson, J. 2009. *Performance affects: Applied theatre and the end of effect*. London: Springer.

Twigg, J. and Buse, C. 2013. Dress, dementia and the embodiment of identity. *Dementia*, 12(3), 326–336.

Yesavage, J.A. and Sheikh, J.I. 1986. 9/Geriatric depression scale (GDS) recent evidence and development of a shorter version. *Clinical Gerontologist*, 5(1–2), 165–173.

2

REPAIRING THE EVIL

Staging *Puppet Antigone* (2017) at Auckland Prison[1]

Rand Hazou

Introduction: the colonial legacy, the prison community and puppets

On 8 December 2017, a small group of prisoners of Unit 9 at Auckland Prison staged a production of *Puppet Antigone* using puppets for an audience of invited guests and other prisoners from the unit. Auckland Prison, also known as Paremoremo, is located on Auckland's North Shore and contains New Zealand's only specialist maximum-security prison unit. Working over a rehearsal period of eight weeks, the project involved rehearsing an abridged version of the Greek tragedy *Antigone*. Written by Sophocles in around 441 BC, the play tells the story of Antigone who is the oldest daughter of Oedipus. In the play, Antigone insists on giving her dead brother Polyneices a form of ritual burial in keeping with divine laws. But her brother has been named a traitor by her uncle, King Creon, who has decreed that anyone caught giving Polyneices burial rites will be executed. Should Antigone follow her heart and insist that family responsibilities and religious rites are more important than man-made laws? Or should she bow to her uncle and king and follow the responsibilities expected of a citizen of the state? The modern interpretation of this ancient play raises important questions about ethics, standing up for what is right, and not bowing to authority. The play also raises questions about pride, intransigence, and the importance of humility and flexibility, all of which seem particularly relevant considerations to the prison community.

New Zealand's prison population is one of the highest in the Organisation for Economic Co-operation and Development (OECD), at around 220 per 100,000, and rising, compared to an OECD average of 147 per 100,000 (Gluckman, 2018, 5). Moreover, the total cost of prisons has doubled since 2005, and tripled since 1996. Since 1972, criminal-justice costs have grown twice as fast as any other category of Government spending (Gluckman, 2018, 12). According to the Department of Corrections, in March 2018, New Zealand's prison population reached an all-time high of 10,700. This number is projected to rise to 12,000 prisoners in the next four years (Owen, 2018). Moreover, over 50% of the current prison population are Māori, compared to 31.3% European, and 11.6% Pacific (Department of Corrections NZ, 2018). Māori constitute more than half the prison population, despite making up only 15% of the overall population (Stats NZ, 2015).

Most research findings suggest that the high rates of Māori imprisonment are caused by greater levels of socio-economic deprivation. Moana Jackson links this deprivation to the dis-

possession caused by colonisation (Jackson, 2017). Similarly, Khylee Quince cites empirical evidence that suggests that Māori offending can be linked to both economic disadvantage as well as the ongoing effects of the colonial process (Quince, 2007, 12). Tracey McIntosh and Kim Workman suggest imprisonment must be read in the broader context of colonisation, dispossession of land, urbanisation, the imposition of the Western system of common law, cultural assimilation, and the undermining of *tikanga* (cultural protocols) and traditional forms of social control (McIntosh and Workman, 2017, 727).

The *Puppet Antigone* project was co-directed by storyteller Derek Gordon and I, in collaboration with Auckland Prison. Entering into Auckland Prison, the cultural makeup of the prison community we were working with, as well as the disparate levels of literacy, were considerations at the forefront of our minds when designing and delivering a creative project. Within the small theatre group that had been established at the prison, half of the participants identified as Māori, with two having obvious affiliations with the Black Power gang. We were fortunate to recruit an incarcerated senior Māori man who occupied a position of *kaumātua* (senior person of status) for the group. Prickles (not his real name) composed the music for the production and was also the leader of the prison Kapa Haka group (Māori performing arts group). It was through his concern and attention to *tikanga* Māori (cultural protocols) that the cast were able to navigate the world of the play and imbue it with particular cultural significance.

We suggested that the production utilise puppets, based on the half-life-sized Japanese Bunraku puppets, because we wanted to create a piece of physical theatre in order to develop the physical skills of the performers. The use of puppets was also proposed as an innovative approach to staging the female characters within the all-male prison environment. Within the hyper-masculine context of the prison, the use of puppets for the female characters offered a potentially useful approach to circumvent anxieties and the ridicule that cross-casting gender roles might entail within the strict time limitations that the production schedule afforded. The use of puppets also provided an opportunity for the prisoners to incorporate stylised and dynamic movement into their presentation, rather than relying on naturalistic acting techniques. In this way, the puppets might serve as a potentially liberating distancing device that could encourage freedom of movement rather than self-consciousness among the untrained participants.

The *Puppet Antigone* project represented the culmination of a series of engagements with Auckland Prison involving myself and Derek Gordon. As a senior lecturer in theatre at Massey University, I had experience in leading and teaching applied theatre projects within refugee and aged-care communities. Derek had been employed as a senior tutor at Massey University, and had a background as a professional storyteller and experience in numerous community theatre projects. In November 2016, Derek and I were invited to Unit 8 at Paremoremo, a specialist therapy unit for those convicted of sex offences at Auckland Prison, where we gave a short presentation on Shakespeare, introducing the men to different approaches to directing and performing the soliloquy 'to be or not to be'. Building on the enthusiastic response, we offered a series of short theatre workshops to the incarcerated community which included physical theatre skills and some writing workshops. In May 2017, we designed and delivered the Theatre Behind Bars programme, partially funded by Creative New Zealand's Creative Communities Scheme, which offered six introductory theatre workshops to participants at Unit 9, including storytelling, physical theatre skills, and mask work. In June 2017, Massey University partnered with Auckland Prison to provide a two-day theatre workshop facilitated by David Diamond, Artistic and Managing Director of the Vancouver-based company Theatre for Living. The workshops culminated in a 'forum theatre' production exploring the struggles the men experienced within the prison institution which were presented to a small audience of invited guests. Upon the conclusion of the Theatre for

Living project, the men of the theatre group suggested they would like to work with an existing text. We had made a commitment to the men that as long as they were interested in engaging with theatre, we would continue to support them. After some consideration, we suggested that we explore a Greek tragedy for our next project.

In suggesting *Antigone* as a suitable text for a prison production, my collaborator Derek and I saw certain cultural resonances in the text that we hoped the prison community we were working with could connect with. As non-Māori practitioners, Derek and I were attentive to the potential dangers of cultural appropriation involved in trying to facilitate engagement with Māori concepts and understandings. Our approach was guided by an acknowledgement of Māori protocols which 'privileges Māori knowledge and ways of being' (Smith, 2008, 120). Given my own position within an educational institution that is committed to being 'treaty-led', my approach was also informed by my sense of responsibility to acknowledge the principles of the Treaty of Waitangi which include a commitment to protect and promote Māori knowledge by working in partnership with Māori.[2] In encouraging the prisoners to engage with *Antigone*, a text that is part of a Western and European literary and theatrical canon, it was important that we did not reinforce a colonial cultural hegemony that might risk further alienating a community that had already experienced forms of educational exclusion in the past. Rather, our approach was to facilitate their engagement with the text by exploring what we saw as certain cultural resonances that we perceived in the text between the Ancient Greek and Māori worldviews.

In this chapter, I begin by discussing some of the perceived cultural resonances in the text and how they were explored in production. These include the importance of *tangihanga* (protocols around death), the figure of Tiresias as a *tohunga* (traditional Māori healer or priest), and the importance of *whaikōrero* (the art of oratory). The chapter then explains the choice of incorporating puppets into the staging and how this was informed by the Māori concept of *manaaki* to help foster an ethics of care. The chapter suggests that by facilitating an engagement with these cultural aspects, the production might be understood as incorporating a syncretic approach to the staging. The chapter will conclude with some brief comments about the ways in which the *Puppet Antigone* project might be situated as part of a decolonial approach to staging theatre in prison in Aotearoa (the Māori term for New Zealand).[3]

Tangihanga: respect for the dead

The play *Antigone* explores the primal and universal desire to respect the dead with appropriate rites and the sacred obligation to provide them with a dignified transition from the land of the living to the world of the ancestors. In this way, we thought, the play resonated culturally with Aotearoa, particularly given the importance of Māori *tikanga* and protocols around death. As Nikora et al. affirm, 'death, observed through the process of *tangihanga* (time set aside to grieve and mourn, rites for the dead) or *tangi* (to grieve and mourn), is the ultimate form of Māori cultural expression' (Nikora, et al., 2010, 400). In his chapter 'A View of Death', Harry Dansey suggests that one attitude to death that distinguishes Māori is how the 'dead are to be cared for, cherished, mourned, spoken to, honoured in a way which others might consider to be over-emotional and over-demonstrative' (Dansey, 1992, 108). This seems to resonate with Antigone's desire to perform the rites of the dead for her brother and the obligation she feels to usher her brother's soul into the afterlife. There is also something resilient in the Māori observance of *tangihanga* that has in some ways resisted colonial suppression. Dansey argues that the strength of *tangihanga* as a ceremonial occasion is such that 'in spite of Pākehā opposition, criticism and derision for more than a century, it has survived and continues, with many adaptations and changes in form, but with the same

purpose and spirit as in the past' (1992, 110). By proposing *Antigone* as a suitable play to stage in the prison, we hoped that the importance of death rites would offer connections for the participants to which to anchor meaning. In the early stages of the project, we suggested this possible connection to the incarcerated actors and it became a useful entryway for the men to engage with the text in our initial play reading.

Tiresias: a blind *tohunga*

We also proposed that the figure of Tiresias might capture the imagination of the men as a *tohunga* who is connected to the spirit world. The word 'tohunga' means expert or adept (Voyce 1989, 99). Mead suggests that implied in the term is the double notion of highly skilled and priestly knowledge (Mead, 2003, 63). Traditionally, *tohunga* were expert practitioners of any craft. They included expert carpenters, carvers, tattoo artists, and also *tohunga ahurewa* and *tohunga mākutu* who functioned as priests and shamans (Woodard, 2014, 43). As Woodard explains, The Tohunga Suppression Act of 1907 outlawed *tohunga* and traditional healing methods, and can be seen as part of a concerted effort to assimilate Māori into British/European culture and society (ibid. 43). The opportunity of staging *Antigone* in the prison and situating the figure of Tiresias as a blind *tohunga* was an opportunity to situate the play within the Māori world as well as providing a reading about the impact of colonialism in this country.

Whaikōrero and the art of oratory

In *Puppet Antigone*, the role of Tiresias was played by a *Pākehā* (European) actor called Ping (not his real name). This casting decision was determined primarily by the need to distribute the speaking parts equally among the small cast. Nevertheless, the *Pākehā* actor managed to imbue the role with certain Māori cultural resonances – especially in regard to the performance of *whaikōrero* or the art of oratory or speech-making. The fostering of this and its acceptance by the rest of the cast may have been due to Ping's own engagement with Māori *tikanga* in the unit, as he was one of the few *Pākehā* prisoners who participated in haka (traditional dance or challenge) that were performed for guests. In the production, the actor playing Tiresias entered the stage with a prison-issued green blanket wrapped around his shoulders like a cloak. He entered the playing area carrying a *tokotoko* (ceremonial walking stick). As Hirini Mead notes, traditionally *tohunga* may have used carved *tokotoko* as part of particular ceremonies (Mead, 2003, 66). In his performance, the actor playing Tiresus crossed the playing area and used his stick in his speech condemning the actions of King Creon:

> Sickness has come upon us, and the cause
> Is you: our altars and our sacred hearths
> Are all polluted by the dogs and birds
> That have been gorging on the fallen body
> Of Polyneices. Therefore, heaven will not
> Accept from us our prayers, no fire will burn
> Our offerings, nor will birds give out clear sounds,
> For they are glutted with the blood of men
> *(Lines 1014–1022)*[4]

The use of the *tokotoko* in performance signalled the importance of *whaikōrero* or Māori oratory. In Māori custom, *whaikōrero* is most often associated with the ritual encounters between hosts

and guests as part of *pōwhiri* (welcoming ceremony). Dame Anne Salmond (1975) provides a short description of a traditional *whaikōrero* in such a context, describing how a senior leader of a tribe greeted guests:

> He strides towards the opposite party, chanting or calling out his greetings and gesticulating with a walking-stick, then abruptly spins upon his heel and walks back in thoughtful silence. He returns with the next few sentences, stressing each point with a stylized gesture, occasionally getting really carried away and making terrific faces. Tongue out and eyes rolling; but turning back as quietly as before.
>
> <div align="right">(Salmond, 1975, 56)</div>

Hemi Kelly argues that the impact of Christianity, the influence of European culture, and the movement of *pōwhiri* from outdoors to indoors have created a more subdued speaker, free of weaponry and limited body movement. Hemi also notes that in recent years there has been a renaissance among particular groups to revive past ways of performance which involved the use of weaponry and stylised movement.[5] Kelly documents how the use of weaponry and stylised movement were part of traditional oratory practices and have been revived recently to 'enhance the delivery' of speech (Kelly, 2017, 193). Central to this approach is the importance of the Māori understanding '*whakakōrero i te rākau*' ('make the stick speak'). As Kelly explains, for the orator the use of a weapon changes it from an intimidating thing to a means of letting words and ideas flow (2017, 192).

The importance of stylised movement was a significant element of the production and particularly important in the physical characterisation of Tiresias – a prophetic figure who occupies a liminal space between the world of men and the spirit world. The stylised use of the walking stick helped the actor playing Tiresias to develop his character – giving him permission to incorporate large stylised movement and gestures which reinforced to the audience an anti-naturalistic approach to the staging. In the performance, Tiresias walked slowly, his arm and stick outstretched and pointing at King Creon. When describing how the sacrifices and prayers had been polluted, he allowed the stick to clatter to the ground before retrieving it a moment later to emphasise subsequent points in his speech with sweeping arm gestures.

It is important to note that Tiresias's performance was not an attempt to mimic or culturally appropriate *whaikōrero* in the production. Rather, the stylised movement and use of the *tokotoko* imbued the performance with cultural symbolism and significance that would have been recognisable to the wider prison community and audience. Moreover, the performance was created by the prison actors under the watchful gaze of Prickles, the senior prisoner and *kaumātua* of the cast who was also the leader of the prison's Kapa Haka group, who would have raised concerns if the presentation or characterisation were inappropriate. This provided a framework of safety and cultural propriety for the representation of the character.

In the play, the blind prophet Tiresias warns King Creon of the dangers of hubris and says: 'all men make mistakes, but a good man yields when he knows his course is wrong, and repairs the evil. The only crime is pride' (Lines 804-806).[6] In this way, the play raises questions about pride and the importance of humility, all of which seemed particularly relevant considerations to the prison community. Having Tiresias situated as a *tohunga* provided a further layer of meaning to these lines, engendering a reading in which the prophetic healer was diagnosing a condition for the prison community as a whole and offering a reading that commented on the legacy of colonialism and the adverse effect it continues to have on Indigenous communities.

Bunraku puppets, *manaaki*, and an ethics of care

A modern interpretation of the play also highlights the conflict between men and women in a patriarchal society, and demonstrates the harsh and tragic consequences for one woman who decides to stand up to this patriarchal power. In this way, the play commented on gendered power-relations and violence, and this seemed particularly important given the unit we were working in included sexual offenders. According to the New Zealand Family Violence Clearinghouse, in 2016 there were 118,910 family violence investigations by New Zealand Police, 5,072 applications for protection orders by women, and 6,377 assaults on women by men (New Zealand Family Violence Clearinghouse, 2017).

The idea of using puppets emerged as an opportunity to encourage the participants to develop their sensitivity of touch, empathy, and an ethics of care when portraying the female characters in the play. When we pitched the idea of the play to the prison authorities and explained that we wanted to do a puppet version of Sophocles' *Antigone* using half-life-sized Bunraku-style puppets, the prison management were not overly concerned about the choice of a Greek play and the potential difficulties the text might pose for the prisoners in terms of literacy and engagement. Rather, they were worried about the idea of half-life-sized puppets being used for female characters. Some of the prisoners we were working with were sexual offenders, and the prison authorities were particularly concerned that some of these men might be quite literally 'handling' and manipulating the female form. We had argued that the physical requirements of handling the puppets, particularly given that they might require more than one operator, and the effort involved in coordinating movements would promote a sense of care and respect from the participants. Once we explained our rationale and our intended way of working, the authorities approved the project.

Through a small grant from Creative New Zealand's Creative Communities Scheme, we were able to commission puppet-maker Sarah-Jane Blake to create two Bunraku-style female puppets. We also invited theatre-maker and puppeteer Kate Parker into the prison to give the men an introductory puppetry workshop. The workshop developed the cast's physical performance skills as well as getting them thinking about how to animate objects, and how to invest them with character traits and intentions.

A feature of Bunraku is a constant reliance on stylised elements in order to produce the desired realistic effect of the animated puppet (Adachi, 1985). Keene describes the entrance of the Bunraku puppets to the stage, noting that they appear 'often with spectacularly vigorous strides, arms and legs thrust forward as if in excess of energy' (Keene, 1990, 126). There is a constant oscillation of attention that is produced in Bunraku, which is a necessary ingredient that is actively sought after and deliberately heightened by the constant friction between realistic and stylised elements. According to the Japanese dramatist Chikamatsu Monzaemon (1653–1725), who specialised in Jōruri which would later come to be known as Bunraku, 'art is something that lies in the slender margin between the real and the unreal' (Cited in Keene, 1990, 398). For Chikamatsu, the pathos of the puppets depends on this ability to oscillate between real and unreal simultaneously (Bolton, 2002, 739).

The use of the puppets encouraged the prisoners to incorporate stylised and dynamic movement into their presentation, rather than simply reinforcing naturalistic movement that would have been at odds with the ritualistic and mythic elements of the drama. Moreover, unlike traditional Bunraku where the puppeteers are dressed in black and have their faces hidden, in the final *Puppet Antigone* production, the puppets were animated by a sole puppeteer who was visible to the audience. The puppets also interacted with the live actors on the stage in various scenes. In the production, Antigone is caught in the act of giving burial rights to her brother, and she

is brought before King Creon who demands to know why she has disobeyed the law. Led into the space by an actor clasping the puppet by the wrist, Antigone explains:

> It was not Zeus who published this decree,
> Nor have the powers who rule among the dead
> Imposed such laws as this upon mankind;
> Nor could I think that a decree of yours—
> A man—could override the laws of Heaven
> Unwritten and unchanging. Not of today
> Or yesterday is their authority;
> They are eternal; no man saw their birth.
> Was I to stand before the gods' tribunal
> For disobeying *them*, because I feared
> A man? …
> (Lines 449–459)[7]

During this scene, the actor playing the guard releases the puppet's arms, allowing the puppeteer to incorporate dynamic movements while also voicing Antigone's speech. The puppeteer moves in a quick sweeping motion across the stage trailing an arm of the puppet to point to the dead in the 'underworld', and then lifts the puppet above shoulder height while shouting at the heavens. In the final moments of the speech, the puppet tosses the derisive line about fearing a 'man' and then turns her back to the actor playing Creon.

In this way, the staging incorporated what Steve Tillis describes as 'figurative occlusion' – where 'the operator works the puppet in full view of the audience, with the words clearly coming from his mouth in a more or less natural voice, and yet the puppet is the site of the signification' (1996, 113). This mode of operating results from directing the audience's attention away from the visible operator and toward the puppet. Yet, in *Puppet Antigone*, the figurative occlusion was only partial. The puppeteer's focus on the puppet compels the audience to focus on the puppet as well, but the quality of care informing the relationship was also central to the performance and, as such, the puppeteer was never fully occluded. In the final staging, the relationship between the puppeteer and the puppet was informed by the reciprocal principle of *manaaki*.

The prison participants were asked to engage with the puppets utilising the concept of *manaaki*. The Māori concept of *manaaki* is often translated as hospitality, but it can also denote caregiving and compassion. Jacqueline Shea Murphy and Jack Gray explain that *manaaki* means 'to care for', *tanga* means 'the doing of'; the compound word means 'the act of looking after others, the reciprocal nurturing of relationships with kindness and respect' (2013, 275, Note 2). In framing the approach to the puppeteering, the project drew on Krushil Watene's definition of *manaaki* as 'literally, to enhance *mana*' of each other's lives, where *mana* refers to dignity and rights (2016, 143). In this way, the project asked the participants to engage with *manaaki* as a guiding principle and as an ethics of care, and to ensure that the performances enhanced the dignity of the puppets and the female characters they represented. Elsewhere I have traced *manaaki* as a principle of care that guides approaches to creative practice between theatre-makers, as an obligation to the stories and experiences performers are engaging with, and as a dramaturgical principle that might potentially impact on how audiences engage with material on stage (Hazou, 2018). In *Puppet Antigone*, we get a sense of *manaaki* as a particular approach to staging and stage-craft and one that can guide the quality of puppet presentation.[8]

Repairing the evil

As this chapter draws to an end, I return again to Tiresias's warning that 'all men make mistakes, but a good man yields when he knows his course is wrong, and repairs the evil' (Lines 804-806). Within the context of facilitating applied theatre within a correctional facility that continues to be impacted by the legacy of colonialism, the idea of 'repairing the evil' takes on a different meaning.

By highlighting the importance of *tangihanga* and death protocols, by situating Tiresias as a *tohunga* or traditional Māori priest, by emphasising the importance of *whaikōrero* or the art of oratory, and by establishing *manaaki* as a key cultural protocol that would frame an ethics of care and an approach to stage-craft, *Puppet Antigone* attempted to facilitate cultural connections that would help situate the ancient Greek text within a Māori world. In this way, the production might be understood as a form of syncretic theatre which generally involves 'the incorporation of Indigenous material into a Western dramaturgical framework, which is itself modified by the fusion process' (Gilbert and Lo 2002, 36). As Christopher Balme suggests, the strategy of syncretisation is one of the most effective means of 'decolonising' the stage since it is creative and liberating in the way it combines elements from Western and Indigenous cultures as a response to 'what is perceived as a peculiarly Western tendency to homogenise, to exclude, to strive for a state of "purity", whether it be racial or stylistic' (1999, 8).

Rather than using a text from the Western and European canon to reinforce colonial cultural hegemony, I contend that by enlisting syncretic approaches in the staging, the production provided an opportunity for the cast to reinscribe the text with cultural readings and a subaltern politics that might be understood by the cast and resonate with the wider prison community. Yet, while the facilitation of cultural connections attempted to situate the play within the Māori world, performed within the confines of a correctional facility, this world is one that is tangibly impacted by the legacies of colonialism. Any creative engagement inside the correctional system in Aotearoa has to ultimately contend with the structural forms of power and the legacy of colonialism that adversely impacts minorities. Theatre in prison, and other creative engagements, have to find ways to challenge these forms of power as part of an effort to help decolonise the system. This can involve exploring cultural traditions that have been excluded or subsumed by colonialism and finding ways that theatre can help to revive or at least highlight them. A decolonial strategy might also involve opportunities to practise and facilitate forms of 'epistemic disobedience' (Mignolo, 2013). This might involve theatre projects that resist established knowledge and which use artistic engagement to co-construct knowledges and ways of being that are not defined, and limited, by the prison institution. This approaches the importance that Linda Tuhiwai Smith attributes to creative work, suggesting that it is about 'transcending the basic survival mode', as it enables people to 'rise above their circumstances, to dream new visions and to hold on to old ones' (Smith 2012, 263). Certainly, the cast reported a real sense of accomplishment and pride in being involved in the project, and one prisoner expressed a desire to pursue further education and training opportunities – something he had never considered before.

In the context of prison where technologies of surveillance and control are mobilised to produce 'obedient' bodies, practitioners need to be wary that theatre is not also used as a way to control prisoners or at least make prisoners more compliant. In the aftermath of the *Puppet Antigone* project, we received positive feedback from corrections staff noting benefits of the project on the whole unit. I think that this was the result of the pride and sense of accomplishment that the project imbued in the men. It might also be attributed to the project's focus on *manaaki* and the enhancement of dignity that resulted. I would also argue that *Puppet Antigone* provided the incarcerated actors with a different way of seeing and being – engaging a different epistemo-

logical focus than the one that confinement enforces. This kind of 'epistemic disobedience' can be subtle, soft and kind. It need not be understood as non-compliance with correction officer demands. It can be traced in the men expressing gratitude at being able to engage in creative activity that breaks up the boredom and monotony that infiltrates their prison lives. Ultimately, theatre in prison in Aotearoa needs to find ways to resist and repair the legacy of colonialism, such as the racism, and the adverse health and literacy conditions that seem to be exemplified in the correctional system in New Zealand.

Acknowledgements

Special thanks to storyteller and artistic collaborator Derek Gordon whose passion for the arts was so infectious and disarming. I would like to acknowledge the men at Unit 9 for their willingness to be challenged, and their emotional and intellectual dedication. To Prickles for his musical direction and *tikanga* guidance – *ngā mihi nui*. The *Puppet Antigone* project was made possible through the support of Simon Chaplin, the Assistant Prison Director at Auckland Prison; Kellie Paul, the Principal Adviser: Rehabilitation and Learning; and Janice Naden, the Intervention Coordinator. Thanks also to Trevor Tohill, the Residential Manager for Unit 9; Terry Marsh, the Principle Corrections Officer; and the corrections staff who supported the project. Special thanks also to Jacqui Moyes from Arts Access Aotearoa for her guidance and wisdom. The *Puppet Antigone* project was partially funded by Creative New Zealand's Creative Communities Scheme. I would also like to acknowledge my colleague Associate Professor Krushil Watene (Ngāti Manu and Ngāti Whātua Ōrākei) for the numerous consultations and discussions which have guided my understanding and research for this chapter.

Notes

1 This chapter is dedicated to Derek Gordon who co-directed *Puppet Antigone* and collaborated with me on several theatre projects. Derek passed away 2018 but his passion for the arts and kindness endure. He is missed but not forgotten.
2 Signed in 1840, the Treaty of Waitangi is a founding document of New Zealand representing an agreement between the British Crown and about 540 Māori chiefs. The Treaty provided the basis for British governance while guaranteeing Māori rights and sovereignty. The principles of the Treaty are an attempt to address the historical abrogation of the Crown's responsibility to Māori and allow the application of the Treaty in a contemporary context through enacting principles of partnership, reciprocity, autonomy, and active protection. See the Waitangi Tribunal website: www.waitangitribunal.govt.nz
3 It should be noted that Sophocles' *Antigone* has inspired other productions that problematise the colonial experience such as Fugard, Kani, & Ntshona's *The Island* (Fugard 1993), and Femi Osofisan's *Tegonni: An African Antigone* (2007). These examples adapt the canonical European drama by incorporating African experience and cultural elements as part of a decolonial strategy.
4 Sophocles. (1998) *Antigone; Oedipus the King; Electra* (H. D. F. Kitto, Trans.). Oxford: Oxford University Press.
5 This renaissance and use of weaponry in oratory is controversial. Kelly is careful in speculating about why the revival of this way of performing whaikōrero is condemned by certain quarters. The style of theatricalisation is seen by some as 'an imposition of European stage practice that distracts from the purity of the form' (Kelly 2017, 194).
6 Sophocles. (1995) *Antigone* (D. Fitts & R. Fitzgerald, Trans.): Caedmon. Note: While the production used a heavily abridged version of the Kitto translation, these were the only lines that were included from the Fitts and Fitzgerald translation of the text.
7 Sophocles. (1998) *Antigone; Oedipus the King; Electra* (H. D. F. Kitto, Trans.). Oxford: Oxford University Press.
8 Charles Royal has documented that a Māori puppetry tradition known as Karetao did exist in traditional Māori society which can be traced back to the Whare Tapere, or traditional 'houses of entertain-

ment', which were pre-European sites for storytelling, dance, music and games (2007, 194). While the traditions of Whare Tapere and Karetao have been largely lost as a consequence of colonialism, they are recently being revived as part of research activity on pre-contact performing arts. Recent revivals of the Māori puppetry form include the performance *Te Ao (The World)* by Horomona Horo, Hinemoa Jones, and James Webster, which was presented as part of the Tauranga Moana Matariki Festival in 2016 (See www.maramaarts.co.nz). The artform has also been revived by Jeffrey Addison and Whaitaima Te Whare, founders of Toro Pikopiko Puppets (See www.akee.co).

References

Adachi, Barbara. 1985. *Backstage At Bunraku*. New York: Weatherhill.
Balme, Christopher. 1999. *Decolonizing the Stage: Theatrical Syncretism and Post-colonial*. New York: Oxford University Press.
Bolton, Christopher A. 2002. "From wooden cyborgs to celluloid souls: Mechanical bodies in anime and Japanese puppet theater." *Positions: East Asia Cultures Critique* 10 (3):729–71.
Dansey, Harry. 1992. "A view of death." In *Te Ao hurihuri: Aspects of Māoritanga*, edited by Michael King, 105–16. Auckland: Reed Books.
Department of Corrections NZ. 2018. "Prison facts and statistics - March 2018."
Fugard, A. 1993. *The Township Plays: No-Good Friday; Nongogo; The Coat; Sizwe Bansi is Dead; The Island*. Oxford: Oxford Paperbacks.
Gilbert, Helen, and Jacqueline Lo. 2002. "Toward a Topography of Cross-Cultural Theatre Praxis." *TDR* 46 (3):31–53.
Gluckman, Peter. 2018. "Using evidence to build a better justice system: The challenge of rising prison costs." Office of the Prime Minister's Chief Science Advisor.
Hazou, Rand. 2018. "Performing manaaki and New Zealand refugee theatre." *Research in Drama Education: The Journal of Applied Theatre and Performance* 23 (2):228–41. doi: 10.1080/13569783.2018.1440203.
Jackson, Moana. 2017. "Prison should never be the only answer." *E-Tangata*.
Keene, Donald. 1990. *Noh and Bunraku: Two Forms of Japanese Theatre*. New York: Columbia University Press.
Kelly, James. 2017. "The performance of Whaikōrero." *MAI: A New Zealand Journal of Indigenous Scholarship* 6 (2):189–96. doi: 10.20507/MAIJournal.2017.6.2.11.
McIntosh, Tracey, and Kim Workman. 2017. "Māori and prison." In *Australian and New Zealand Handbook of Criminology, Crime and Justice*, edited by Antje Deckert and Rick Sarre, 725–35. Melbourne: Palgrave Macmillan.
Mead, Hirini. 2003. *Tikanga Māori: Living by Māori values*. Wellington: Huia Publishers.
Mignolo, Walter. 2013. "Geopolitics of sensing and knowing: On (de)coloniality, border thinking, and epistemic disobedience." *Confero* 1 (1):129–50.
New Zealand Family Violence Clearinghouse. 2017. "Data summaries snapshot." (June).
Nikora, L.W., N. Te Awekotuku, M. Rua, P. Temara, T. Maxwell, E. Murphy, K. McRae, and T. Moeke-Maxwell. 2010. "Tangihanga: The ultimate form of Māori cultural expression - overview of a research programme." In *Proceedings of the 4th International Traditional Knowledge Conference 2010: Kei Muri i te Kāpara he Tangata Kē Recognising, Engaging, Understanding Difference*, edited by J.S. Te Rito and S.M. Healy, 400–5. Auckland, New Zealand: Ngā Pae o te Māramatanga.
Osofisan, F. 2007. *Tegonni: An African Antigone*. Lagos: Concept Publication Limited, 2007.
Owen, L 2018. "Prison inmate numbers hit all-time high in New Zealand." *Newshub*.
Quince, Khylee. 2007. "Māori and the criminal justice system in New Zealand." In *Criminal Justice in New Zealand*, edited by Warren Brookbanks and Julia Tolmie. Wellington: LexisNexis NZ.
Royal, Te Ahukaramū Charles. 2007. "Ōrotokare: Towards a new model for indigenous theatre and performing arts." In *Performing Aotearoa: New Zealand Theatre and Drama in an Age of Transition*, edited by Marc Maufort and David O'Donnell, 193–208. Brussles: P.I.E Peter Lang.
Salmond, Anne. 1975. *Hui: A Study of Maori Ceremonial Gatherings*. Wellington: Reed Publishing. .
Shea Murphy, Jacqueline, and Jack Gray. 2013. "Manaakitanga in motion: Indigenous choreographies of possibility." *Biography* 36 (1):242–78.
Smith, Linda Tuhiwai. 2012. *Decolonizing Methodologies: Research and Indigenous Peoples*. 2nd ed. London: Zed Books.
———. 2008. "On tricky ground: Researching the native in the age of uncertainty." In *The Landscape of Qualitative Research*, edited by Norman K. Denzin and Yvonna S. Lincoln, 133–43. Los Angeles: SAGE.

Sophocles. 1995. *Antigone*. Translated by Dudley Fitts and Robert Fitzgerald. London: Caedmon.
———. 1998. *Antigone; Oedipus the King; Electra*. Translated by Humphrey Davy Findley Kitto. Oxford: Oxford University Press.
Stats NZ. 2015. "How is our Māori population changing?"
Tillis, Steve. 1996. "The actor occluded: Puppet theatre and acting theory." *Theatre Topics* 6 (2):109–19.
Voyce, Malcolm. 1989. "Maori healers in New Zealand: The Tohunga suppression act 1907." *Oceania* 60 (2):99–123.
Watene, Krushil. 2016. "Indigenous peoples and justice." In *Theorizing Justice: Critical Insights and Future Directions*, edited by Krushil Watene and Jay Drydyk, 133–51. London: Rowman and Littlefield International.
Woodard, Wiremu. 2014. "Politics, psychotherapy, and the 1907 tohunga suppression act." *Psychotherapy and Politics International* 12 (1):39–48.

3
TAURIMA VIBES
Economies of *manaakitanga* and care in Aotearoa New Zealand

Molly Mullen and Bōni Te Rongopai Tukiwaho

The economies of applied performance include the multiple ways in which projects and organisations are resourced and managed. They involve complex interactions between financial and more-than-financial resources, along with activities and notions of value within specific economic, social and cultural conditions. In Aotearoa New Zealand, applied performance has struggled in a policy context infused with neoliberalism, neoconservatism and managerialism. These discourses place demands on socially committed arts organisations to produce and represent themselves and their work in particular ways. However, responses to these demands have not been straightforward acts of compliance. Applied performance groups and organisations continue to explore and adopt a range of economies and value systems for their practice.

As a Māori-led applied performance company, Taurima Vibes Ltd. offers two modes of engagement: Facilitation and community brokership. Its work draws on the ideals of *manaakitanga*[1] and safety, and its director's grounding in *tikanga* Māori[2]. This chapter examines Taurima Vibes' *kaupapa*[3] and process. Taurima Vibes *walks alongside* the people it engages with, creating safe, interactive environments for collective creativity. We look at what this means in Taurima Vibes' creative practice and its approach to resourcing and organising its work, with a focus on the Puāwai Festival, an event aiming to reduce stigma through performance, education, laughter and song.

Two perspectives

Ki te taha o tōku Pāpā
Ko Maunga Pohatu te Maunga
Ko Ohinemataroa te Awa
Ko Mātaatua te Waka
Ko Tūhoe te Iwi
Ko Ngāti Raka te Hapu
Ko Taitaiahape te Marare
Ko Bōni Te Rongopai Tukiwaho tōku ingoa

We begin with our *pepeha*[4], which speaks to who we are, who we affiliate with and what our relationship is to the land. In this one introduction, speakers can understand all of these things from each other and know how they connect.

Bōni connects back to Tūhoe country, his ancestral lands being Waimana, Ruātoki and Ōpōtiki. He affiliates with, and was raised in, Te Arawa, Rotorua. Bōni has been part of the performance industry from an early age, and he lived and worked overseas for over 20 years. Since arriving back, he has worn many hats: Director, producer, educator, performer and an arts wellbeing broker. As a broker, he helps others to find a common ground, a *kaupapa* and space to enable togetherness regardless of differing backgrounds. He works to combat stigma and negative social perceptions of "othered" communities and mental health, helping companies to create a solid wellbeing infrastructure and creating accessible, tangible resources for all.

> Ko South Downs te maunga
> Ko English Channel te moana
> Ko De La Warr Pavilion te whare toi
> No Bexhill on Sea ahau
> Ko Tāmaki Makaurau tōku kainga
> Ko Molly Mullen tōku ingoa

Molly is from Bexhill on the south coast of England, where she developed her passion for theatre and the arts. She worked for ten years as an education manager and facilitator for theatres in London before moving to Aotearoa. She now works at the University of Auckland, teaching applied theatre and researching the economies of community-based theatre and arts organisations.

We each arrived/arrived back in Aotearoa in 2009 and have since been finding/re-finding places to stand in the cultural context and within the arts community. After meeting in 2017 at an arts evaluation meeting, we found a mutual interest in what arts organisations are expected to be and do in Aotearoa. We are interested in the elements that need to change in order to better support artists and organisations, and destabilise the colonial foundations of the policy and funding contexts.

We bring different bodies of knowledge to this chapter, *tikanga* Māori and performance craft (Bōni) and applied theatre, feminist and post-capitalist theory (Molly). In our writing, we have tried to place our different perspectives alongside each other. This is why a significant part of the chapter is presented as a scripted conversation. We began writing this chapter with the transcript of a conversation about Taurima Vibes, which was edited to draw out the most relevant issues and examples and add detail or clarity. This approach to writing started with a collaboration between Sasha Matthewman, Molly Mullen and Tamati Patuwai (2015). It is informed by feminist and decolonising methodologies. Feminist scholars argue that academic writing is never a neutral representation, but involves political and ethical choices (Richardson and Adams St. Pierre, 2008). There are particular tensions for academic work in a nation where research is deeply embedded in the colonial project (Tuhiwai Smith, 2012). There is no easy way to collaborate on knowledge projects in such a context. In Aotearoa, Alison Jones and Kuni Jenkins argue for "the hyphen" as a metaphor for a "research and writing relationship based on the tension of difference, not its erasure" (2014, 478). We have attempted to write in this space of tension, exploring our different perspectives on issues of mutual interest and concern.

One tension we have wrestled with is how best to integrate *Te Reo Māori*, Māori language, into a chapter written for an international readership, without reducing the richness and status of the language. As Bōni explains: "The lands of Aotearoa have been inhabited by Māori since long before British colonisers settled here. Māori connection to the land and heritage is strong. Māori language, values, systems and stories are handed down from generation to generation. To

this day, we unapologetically live our lives with Māori culture as our 'main stream' and norm. *Te Reo Māori* is an official language of Aotearoa. With this in mind, the chapter you are about to engage with uses a multitude of words and concepts which you may not recognise and understand. To help guide you in what I feel is the most culturally appropriate fashion, a glossary is provided. Whilst searching for the translation, I encourage you to relish the richness that is *te ao Māori*, our worldview, and perhaps research further. I hope you enjoy our *koha*[5]."

Tikanga Māori and wellbeing as a *kaupapa* for performance practice (Bōni)

Tikanga can often, mistakenly, be thought of as *only* ritual, or perhaps even a form of education. Both ritual and education play a part, but *tikanga* is much more. *Tikanga* represents our Māori customs, systems and protocols learnt over generations and handed down through *whanau*[6], underpinned by a Māori worldview. As a Māori practitioner who is rediscovering their own identity and place within *te ao Māori*[7], I am guided by my understanding of *tikanga* protocols, informed by how I was raised and what I learnt from my *whānau*. For instance, how to behave in certain situations (like *marae*[8] protocols and due process of *hui*[9]) and the concept of respect and looking after our elders (my great-grandmother spent her final years of dementia with my family from when I was seven years old until I was in my 20s). I learnt how *manaakitanga* and *whānau* are vital to us, not only as "concepts" but how they, as combined elements, create a strong basis and tightly woven map of intrinsic values. I grew to understand that, in *te ao Māori*, *hauora*[10] isn't separated. It is but one thread woven in to the *whāriki*[11] of *tikanga*. So when the need to address wellbeing matters arises, the basic tools to do so are a part of our makeup.

Te ao Māori helps me to facilitate performance practice by giving structure in a way that is pliable whilst having clear guidelines and safety mechanisms in place. I believe this is a strength and has worked well for my own practice and for many other companies in Aotearoa. If we take specifics from our *tikanga* ideals and implement them to aid our performance process, we can use that due process *as* ritual. There is a very important difference between conscious and unconscious ritual in the arts. The ritual is often under-utilised, yet it is a very important tool to enable any leader to keep a group safe. Too often this happens accidentally or simply out of habit, so it can be unconsidered and never fully realised. Not so when we are lucky enough to be able to draw on our *tikanga* for support.

Rethinking the economies of applied performance (Molly)

My interest in the economies of applied theatre and performance stems from my own practice. I finished my theatre degree in 2001 and starting working for a fringe venue in London, setting up and running education and outreach programmes. I found myself spending at least as much time on fundraising as I did developing and running participatory theatre projects. New to this work, I was caught up in the pragmatic challenge of ticking the boxes to get the funds we needed. Over time, I realised the deeper implications of decisions I was making, particularly where I took ideas from funders, or the wider policy space, into the development of projects. These were ideas about who we should be working with, why we should be working with them and how we should work, as well as about what could count as being "of value." When I stepped back to examine the *politics* underlying the policy and funding context, I became concerned about the ways policy and funding agendas might conflict with or undermine the interests of participants or the social and artistic values of the work. These concerns evolved into a research obsession with trying to understand and rethink tensions arising from the ways applied theatre and performance gets resourced and managed (see Mullen, 2019).

The aim to *rethink* the economies of applied theatre is important in my research. It involves finding new ways to theorise long-standing issues as well as identifying emergent challenges. It also involves looking beyond the "economics" of funding and finance, to the less tangible economies at play. Rethinking the economies of applied theatre and performance is about understanding the complex ways in which economic decisions are also often aesthetic, pedagogic, ethical and political decisions. Inspired by the post-capitalist work of J. K. Gibson-Graham (2006) and other feminist economic theorists, I am also committed to identifying examples and possibilities within applied theatre and performance practice for doing economy differently and for generating diverse economic identities and imaginaries (Gibson-Graham, 2006).

The context

We write this chapter at what feels like a moment of possibility and uncertainty for participatory, socially engaged art and performance in Aotearoa New Zealand. Aotearoa is renowned for its extensive neoliberal reforms of the 1980s and 1990s. This process "undermined the policy goals of full employment and state responsibility for social well-being with the consequence being a new emphasis on market provisioning and self-responsibility" (Larner, 2006, 131). Community-based arts practice has not particularly benefited from the subsequent alignment of social and cultural policy with the goals of post-industrial economic development and creating a national identity/brand (Skilling, 2005). There remains a dearth of appropriate, sustainable options for resourcing practice. "Community Arts" appear to have been a marginal focus for the national arts council until recently, and outside the scope of many other donors (Maunder, 2013). Most organisations depend on a fragile patchwork of grants, government service contracts, private donations and earned income. Considerable time, energy, creativity and emotional resources are expended on negotiating funding requirements and managing short-term, insecure sources of income. These conditions have made political and aesthetic risk taking difficult, but not impossible.

More recently, the Prime Minister and Minister for Arts, Culture and Heritage, Rt Hon. Jacinda Ardern, has questioned commercial models for subsidising the arts; recognised the need for greater sustainability in the sector; and proposed that the value of the arts, to society or individuals, is not something that needs to be proved (Ardern, 2018). Government funds have been directed to youth arts and arts in schools initiatives. It is yet to be seen, however, whether further changes will be made to sustainably resource a rich ecology of applied performance and arts practice. Our conversation below reveals how some of these challenges and opportunities impact on Taurima Vibes and on the wider sector. In examining the tensions experienced and negotiated by Taurima Vibes, we are proposing a new understanding of the contemporary economies of applied theatre in Aotearoa.

Taurima Vibes: *Kaupapa, whānau, mahi*

Molly: Let's start with how Taurima Vibes came into being. How and why did you start it?
Bōni: Formally, Taurima Vibes was unveiled a year ago, but I have always worked with the same *kaupapa* base in any work I have undertaken (especially with my *whānau* at Te Pou Theatre).

I arrived home from overseas in 2009 after 22 years away. I had worked as an entertainer and singer. When I returned, I decided to take a different path and completed a Bachelor of Performance and Screen Arts. I had previously worked in fashion and hair. As a stylist you become a pseudo-therapist and, with no training, can only offer band-

aid solutions. It didn't seem fulfilling or safe. I wanted to contribute to something with more depth. I made a decision to look at how I could assist with community groups and was given the opportunity to work on an initiative for the homeless through the Hobson Street Theatre Company. That was my kick-start. I began to understand what my *koha*[12] was: A drive for social justice and wellbeing, an inherent cultural foundation and an ability to help people feel heard.

Molly: I wonder if we could unpack the idea of a desire to assist as a motivation for making performance with different communities. I'm thinking about some of the critiques of the intentions applied theatre makers have when they start working with communities.

Bōni: "Assist" is a loaded word. It can conjure images of one entity having more power than another and using it to control the other. I completely understand how apprehensions and mistrust can be formed when people choose to work with communities that are considered "marginalised" or "other." In my experience, the communities I have worked alongside, sometimes socially or economically challenged, have proved to be streetwise, intelligent and know "bullshit" when it's presented to them. They sense authenticity and integrity. To assist is not about who has *more* power; it's about discovering what it really means to *em*power. When I began this *mahi*[13], I could have been seen as the person with the power to help others less fortunate than myself. In actual fact, it was completely different. In the mutual building of a trusting, authentic relationship, power dynamics and ego needed to be thrown out the window immediately. I started to understand that assisting a community was about understanding the humans in the room, in this case a group of predominantly Māori or Pasifika people who understood *tikanga* protocols, *manaakitanga* and *whānau*. For me, it was about comprehending what a privilege it is to be trusted and invited in.

Molly: I'm really taken by the idea that assistance doesn't have to involve a power imbalance or pity. Instead, it can mean "to stand to or by; to be present"[14], meaning that the humans in the room acknowledge and respect who they are, understand your position, and carefully build relationships accordingly. But, talking in retrospect can make things seem straightforward. What did it feel like at the time?

Bōni: At the time, I was plagued with doubt and a good dose of imposter syndrome. In conversation, there were constantly people who would visibly shut off when they realised I wasn't formally trained – somehow 20 years of performance experience didn't seem enough. Bronwyn Bent and Sally Barnett, who initiated the project with the Auckland City Mission, laid the perfect foundation which meant everything we were doing always *felt* right. I didn't have a degree to begin with, but I had tenacity, heart and could connect on a cultural level utilising *tikanga* protocols, *manaakitanga* and reference to *te ao Māori*. We developed a process that worked and because of the collaborative nature of the *mahi*, needs and wants became easier to determine and address.

Molly: Can you explain *manaakitanga*?

Bōni: In *Te Reo Māori*, it's important to understand each component of a word to understand its essence and how it is derived. The online Māori Dictionary (n.d.) translates *manaaki*, a verb, as "to support, take care of, give hospitality to, protect, look out for – show respect, generosity and care for others."[15] *Manaakitanga* is a noun meaning "the process of showing respect, generosity and care for others."[16] As someone on a journey of rediscovery with *Te Reo* and *tikanga*, understanding these fundamentals is vital to share *mahi* clearly. There are many ways to translate the meaning of *Te Reo Māori* words. Translations into English are often "as close as possible." Unfortunately, most people simply understand *manaakitanga* as "hospitality." This robs it of its full, profound meaning.

My brother Tainui Tukiwaho is a force in the Māori theatre community of Aotearoa. Alongside him, the Te Pou Theatre and the Te Rehia Theatre Company *whānau* (led by himself and Amber Curreen), I have solidified a way to implement *tikanga* in an approachable and engaging fashion as part of the daily workings of Taurima Vibes. Our understanding of *manaakitanga* is not different to the dictionary translation. We are not saying anyone else is wrong, but we communicate this fundamental component of our protocols by breaking down *manaaki* as follows:

Mana = personal power
Aki = to encourage or uplift

Our function, in all our *mahi*, is to uplift people's personal power. In this, we have a strength within our *pou*[17], a consistency of purpose that belies *Pākehā*[18] models. It is instinctive, intrinsic. It is a part of who we are as Māori.

Molly: It sounds like the work demanded a deep concern for the quality of the conditions around and within your practice, to make sure that the right values were in place and could be articulated in appropriate ways. James Thompson (2015) talks about an "aesthetics of care" as involving this kind of "attentiveness" to the relationships within and beyond an applied performance project (437). I'm interested in how this flows into the funding and financial aspects … but we'll get to that. Following through on the principles you have described, it must have been an incredibly involved process. Was it more complex than running a weekly theatre workshop?

Bōni: The moment I know I want to be involved in more than just a weekly occurrence is always in the first week of engagement. I have learnt to trust my instincts. My explanation of *tikanga* and *manaakitanga* gives a strong indication of how my cultural approach and connection informs my understanding of "involvement." Understanding *whānau* could be useful here. In everyday circles, *whānau* is direct family, but, depending on the context, *whānau* can also include extended family and people you have close relationships with who are not blood related. It can also be used when speaking about a unit of people who are in the same work or life situation. It indicates a strong sense of interconnectedness and interdependency between people that goes beyond a professional limit. Along with this, *awhi*[19] is entrenched in our culture, meaning the barriers and pomps normally associated with engaging with different groups can be broken down very quickly. *Awhi* involves communication that surpasses language alone. We use *waiata*[20] and other forms of performance to connect. Joy and celebration become an expectation in all *mahi* and relationships.

Molly: Do you think your *kaupapa* also gets drawn into organisational and financial practices or decision making? Maybe talk about that in relation to how you formed a company around this work.

Bōni: I was already collaborating with friends on all levels of the creative processes, from physical to administrative, including performance. It was going well, but it built very quickly and became too much for one person. In 2017, the Puāwai Festival expanded and I needed solid, ongoing support. Four friends offered to help and, once the festival finished, I invited them to stay on board as other projects were growing. When they agreed, I had to make decisions about legitimising the economics of the *mahi* and having a centralised identity, an organisation that existed for a reason.

Molly: What reason is that?

Bōni: It's as simple as: We are necessary and we fulfil a purpose. We are about combatting stigmas and negative social perceptions of different people by creating and holding spaces for authentic connections, open conversations and using the arts to empower. We also aim to influence systemic change where possible, but we choose to do it by walking alongside others to show what is possible. This requires knowledge on how to bring balance to an atmosphere and allow *manaaki* to be resonant through action, not implemented.

Molly: In terms of the politics of Taurima Vibes, then it's not a politics of telling or intervening, but of creating relational spaces, of walking alongside? And the experience of those spaces, those relationships, as a participant or someone viewing the work, *is* a political experience (Thompson, 2015). But, again, how does that flow into the organisation? Maybe explain a bit more about the other people who are involved in Taurima Vibes and the ways you work together.

Bōni: There is constant support from various people but, as we stand today, there is myself and five friends who hold the Taurima Vibes *kaupapa*: Gemishka Chetty, South African Indian born/heritage; Marc Seymour, British born/heritage; Gary Hofman, European Jewish heritage; Zach Robinson, NZ Pākehā; and Daniel Goodwin, Scottish heritage.

Taurima Vibes is a Māori-led company with a vibrant team who brings a mix of worldviews stemming from our cultural and personal backgrounds, including LGBTQI+ and *wahine toa* (strong women). The team is made up of volunteers. They have backgrounds in media and/or performing arts, allowing us a wealth of resources. Regardless of what the project is, each person injects a strong sense of camaraderie, authenticity and unity.

Molly: What would a typical work week look like for everyone?

Bōni: There is no typical week. Our *mahi* has been wide reaching and varied. We have worked in Wellington and Auckland, creating three festivals and producing five shows between June and December 2018. Everyone has other commitments and we rely on small funding grants that generally just cover the project costs. Work is distributed by availability, interest and expertise. We function with base guidelines and expectations that need to be reasonable. The team donate their time so we need to appreciate when they can say yes because there are no funds for wages.

Economies of care and *manaaki*

Molly: I didn't realise that everyone is a volunteer. Is that sustainable?

Bōni: Our in-house currency is based on what we have available at any time. In terms of financial resources, if a show we produce is profitable, profit is divided amongst the team involved. We try to support each other in tangible ways that have benefits past the *whānau* unit. There is a lot of learning on the job, which is not always the best way, but we make sure there is a clear balance of learning and feeling valued. Our main commitment for 2019 is to give Taurima Vibes support (financial and otherwise) for each of its core *whānau* in any project they create.

Molly: It is hard to dispute the idea that relationships within an applied performance process need care and attention. What does it mean to bring that same care and attention to the resourcing and management of the work? So, right now, it seems that everyone agrees that working for Taurima Vibes is about something more important than generating financial income, but in Auckland this is difficult to sustain for individual artists and organisations. And, in the arts, some unpaid work, even self-exploitation, seems to be

necessitated by, and helps sustain, inadequate and unevenly distributed funds. Working for free can be a genuine act of care and commitment and Taurima Vibes is experimenting with a form of economy ripe with potential. But, at each stage it seems like you need to check in about whether working in this way is enabling or limiting the ability of the organisation and people in it to "survive well" (Gibson-Graham, Cameron, and Healy, 2013, xiii). Does that resonate with you at all, or am I off on a tangent?

Bōni: Yes, it does. We rely on short term arts- or wellbeing-specific grants to get projects done. Most are small, covering basic project needs. Much of our *mahi* has a wellbeing focus. There has been a divide between the arts and wellbeing sectors and it's been difficult to get funders on either side to see they are related. Another challenge is to get funded without our integrity and *kaupapa* being compromised.

Molly: These seem to be challenges for everyone making applied performance practice here: Finding donors who recognise the nature and value of bespoke practices, finding sustainable ways to finance the work and to engage in experimentation.

Bōni: It is slowly changing, but sometimes you just need to tick boxes. There are questions we address before making an application to ensure the fund aligns with our *kaupapa*: What is most important to us: The money or the *kaupapa*? Who is this work important for and why are we doing it? At the moment, we create regardless of whether we are funded or not.

Molly: Do the organisations you partner with ever pay you directly?

Bōni: If the organisations have funding, they cover most of their project costs. I have a policy that we will accept whatever is left. It would be awful to become an organisation where the people you set out to help can't afford it. But, working for no income is not sustainable either.

Molly: So you make the exchange relationship with each organisation a contingent one? How do you keep up with attending to the flows of resources, financial and otherwise, and how that is experienced by people on the ground?

Bōni: This is a learning process for all of us. In those first six months we opened so many doors and ran so vigorously with the opportunities we found, I forgot to stop and make sure that we were okay. We worked on many projects, engaged with intense subject matter (at times) and had other major commitments. We started to forget what it meant to hold a space and to walk alongside others. To do this effectively, we needed to recognise our limits. We didn't. We got caught in the tide of progress and became a production house instead of the support system we aimed to be. It didn't fit with our *kaupapa* and it started to burn people out.

Molly: Burnout seems to be a hidden cost of this work. Perhaps a cost of sustaining an aesthetic and ethic of care for applied performance? It seems like your role, looking after the *kaupapa* of the company, must encompass looking after the people involved too?

Bōni: We have also been working with arts organisations, performance institutions and emerging artists, helping them understand their wellbeing needs and how to focus on care and support in their infrastructure so they feel they can authentically engage with others. It is new territory and is not about finding a specific solution.

Molly: This work sounds almost like a consultancy process. How do you view it?

Bōni: To some extent, in *Pākehā* terms, I view it as a service. I do hope it equates to financial benefit eventually. Everything we do, from theatre and performance, festivals and productions, to these subtler processes, are held together coherently by the term *taurima*. Part of the word's essence is "to treat with care" which is a core component of our foundation.

The Puāwai Festival

Molly: That's a great transition! We're going to talk about the Puāwai Festival, to get a sense of how your *kaupapa*, and the economy of care I am interested in, are enacted within a specific project. Can you provide some background?

Bōni: In 2015, I was approached by Body Positive, an HIV-awareness organisation, after they heard about the community work I was involved in. After our first conversation we connected with Positive Women. These two organisations look after those diagnosed with HIV. Later, we connected with the New Zealand Aids Foundation, which focuses on prevention. The Body Positive CEO at the time wanted to do more work around awareness, breaking stigmas and changing negative social perceptions. I walked away from our initial meeting overwhelmed. It seemed many people retreated or became "closeted" when they were diagnosed and felt separated from the wider community. Together, we landed on the concept of the festival, aimed at strengthening awareness and support during the week of World AIDS Day.

Molly: How did you act on that aim?

Bōni: In the first year, the focus was how best to support people within the community to creatively express what they wanted to say, to allow their voices to be heard. *Puāwai* means to "open up and blossom"; we saw this as an analogy for storytelling. Body Positive and Positive Women found five people who wanted to share stories; only one was a performer. They decided to self-direct their process. Our role was to keep the space safe, have the right people available and guide them through the creative process. It was about them being able to deliver their narratives with as much creative autonomy as possible.

The festival was curated around what emerged from their *mahi*. Their rehearsals blossomed into a two-evening stage performance of dance, song, spoken word and drama. Other performances and events were included: A Whakapapa[21] panel evening (a public discussion with panellists who had strong histories in either HIV support or lived experience), spoken word, comedy and cabaret.

Molly: How were the stories performed?

Bōni: The participants wove multiple art forms together to create vignettes. The performer in the group was a dancer, so there were beautiful movement elements. One participant did a piece based on their personal routine. They built a fake fire and showed us the ritual they have when finishing a round of medication. It was powerful and compelling. No dialogue. They spent two to three minutes going through the steps of dismantling the labels and bottles down to many pieces. So many that they become unrecognisable and are dispersed into various bins and fireplaces. All so they felt safe in not being discovered. It was performed with such authenticity. Once the festival was completed, this participant, who arrived with the most visible barriers, finished closing night with greater openness and the joy of accomplishment.

Molly: Can you explain more about your process?

Bōni: We have our core values and processes we adhere to every time we engage with a new group (connected to *tikanga* and *manaakitanga*). But it also takes collaboration and negotiation with the communities, organisations or individuals. We adapt and negotiate this depending on who we are walking alongside (we may make peer support available and are aware of gender specific needs, for example). That means making sure we arrive with an open mind and flexibility. I tend to think of it as decolonising the process. We need structure and boundaries, but it's not about taking control or owner-

ship. Our practice always has a similar base-structure, or ritual to create a foundation for trust and communication using our connection to *tikanga* and *te ao Māori*. The following is an outline of how it can look:

1. **Opening:** We come together in a circle, introductions are made and then we individually use the central *pou* in the *wharenui*[22] as a metaphorical representation of what each individual feels they would like to concentrate on in the journey together. Our *pou* can be flexible but it is the one thing that we can envisage if we feel we are waning during the process.
2. **Protocols and ground rules:** We work together to create the ground rules for working together. Not always necessary but always encouraged.
3. **Connectivity activities:** Games and activities that relate to the *mahi* to be done.
4. **Mahi:** Getting the work done.
5. **Closing:** We revisit our *pou* and touch base to see how everyone's individual journey went and how they feel at the end of the process so that we can resolve and leave work behind when we leave.
6. ***Waiata* and/or *karakia*:** Using either to complete the day.

Coming back to the notion of creating and holding a space, we create spaces where all of those involved can meet, negotiate and exist together, from which something new might emerge.

Molly: Are there also examples of your *kaupapa* in action in the way the project is managed or resourced? Has it helped navigate any changes or challenges over the years?

Bōni: Definitely. One change is the expansion of the partnerships and project. In 2017, the New Zealand Aids Foundation joined us. And, we have grown from a series of performances at one venue, Te Pou Theatre, to multiple events in ten venues Auckland-wide.

Molly: How did this change things?

Bōni: One change was a shift away from personal narrative as the core. The first year had a great celebratory climax for those involved, but was an exhausting process for the participants. With the larger scale festival, the focus has shifted to celebration and awareness-raising. People with lived experience are still involved throughout. Recently, we worked with the Positive Speakers Bureau, a group of HIV positive people who are happy to share their experiences at our events.

Molly: Are there any challenges around the economies of the project?

Bōni: Economically, although the partner organisations contribute substantial amounts, it just covers basic costs. The organisations would like to secure stronger remuneration options and are as generous as possible when events are reconciled. But, we still need to find solid funding, particularly to pay our professional artists.

Molly: That seems to relate back to what we talked about earlier. The need to keep attending to the way resources (including money), support and care flow through a project or organisation. To attend to what people need to "survive well" – the participants, but also the people working on the project. What else needs care and attention in the management of the festival?

Bōni: The whole thing is about building an initiative the community feels is authentically for them. We curate the week carefully so that someone attending has the opportunity to learn, view the *whakapapa* of the HIV community of Aotearoa, and experience new perspectives. We want to humanise all interactions within the festival and intentionally infuse joy and celebration into events and publicity. It is about the community

celebrating what has been achieved, and allowing wider connections and conversations to be had without fear or prejudice. The fight to combat stigma and negative social perceptions continues. We are contributing positively to the overall conversation change in society alongside all the other powerful work being done year-round by the partner organisations.

Final comments

Molly: I am interested in examining the economies of applied theatre that are critical, but also create a sense or space of possibility. For me, that means thinking about Taurima Vibes as an example of applied performance within the specific cultural, political and economic contexts of Aotearoa. It has been a challenge for Taurima Vibes to fairly and sustainably resource its work without departing from its core principles and processes. This exemplifies challenges faced by the wider field. I see possibilities, however, in the way Taurima Vibes has brought a sense of care to its creative and organisational practices, creating spaces for collective creativity that are equitable, safe and joyful for those involved – as far as possible. Drawing on feminist scholars and James Thompson's aesthetics of care, I find in Taurima Vibes' practice an economy of applied performance based in a careful attentiveness to the enactment of a particular *kaupapa* in all areas of the work.

Bōni: I would like there to be two takeaways from reading this conversation. First and foremost, understanding the benefits grounding oneself in cultural processes can bring. In my case, *tikanga* and *te ao Māori*, which used at the core of any initiative can serve many, whilst honouring its cultural specificity. Secondly, to see the merits of approaching work with flexibility and an open mind. From experience, using your creative practice together with empathetic cultural approaches can create sustainable authentic relationships that can move past initial interaction and disengagement. It is vital that we engage with true intention, even if it incites conflict. Being able to question and query is critical for us to discover the common ground we seek. As in life, I have chosen to respond with as human a voice as possible to try and illustrate that our aesthetic, political and economic views stem from our humanity.

Taurima Vibes has developed a distinct approach to resourcing and manging its work, which we suggest can be understood as a relational economy of *manaakitanga* and care. Taurima Vibes enacts ethically and culturally informed ways of being as an organisation, which flows from and through relationships with the people and groups it assists and walks alongside. Within the relatively short time since the company formed, the economies of Taurima Vibes' work have shifted and adapted. Many of these changes have taken place in response to new relationships and new understandings of the *mahi*. They are also changes necessitated by a context where recent policy and budget shifts seem yet to have any far-reaching effects on the day-to-day struggles of small, socially engaged arts organisations. We do not present Taurima Vibes as a model or exemplar. Instead, we hope our discussion highlights issues and ideas that resonate with new, small applied theatre organisations elsewhere. These include the pressures to take up all opportunities for work, which can mean deviating from the *kaupapa* of the organisation. Also, how the scarcity of financial resources, together with an understanding of the work as transcending any professional frame, can create the pressure to work beyond what is paid for. Taurima has responded to this pressure by putting non-financial resources in place, attending with care to the wellbeing of its

members. The wider issues of under resourcing and the reliance of this area of practice on free labour, even on funded projects, are yet to be fully addressed.

Writing this chapter challenged us to confront tensions around collaborative knowledge projects in colonial settings. We drew on Jones and Jenkins' (2014) argument for the hyphen as a way that manifests rather than erases this "tension of difference." We have proceeded through conversation as a method for knowledge production and representation, based on a willingness to listen to each other and respect each other's funds of knowledge. This doesn't mean all problems have gone away; we continue on with unresolved questions about this work. But this approach has, we propose, led to a rich understanding of a particular economy of applied performance and of the relationship between economic, ethical and cultural values and practices.

Acknowledgements

It has been a pleasure to use this platform to discuss the merits that *te ao Māori* has for all. I would like to thank everyone who allowed me to mention them directly, and would like to especially thank my cousin, Marama Turei, who always leads with generosity and helped me negotiate what is instinctual and put it in to writing. Lastly, to my mother Rahira Tukiwaho (without whom I wouldn't have this specific voice) and brother Tainui Tukiwaho, both of whom are constantly challenging me, editing my work and being my champions! **Bōni Te Rongopai Tukiwaho.**

Notes

1 *Manaakitanga*. A noun encompassing: Hospitality, kindness, generosity, support – the process of showing respect, generosity and care for others.
2 *Tikanga*. A noun encompassing: Correct procedure, custom, habit, lore, method, manner, rule, way, code, meaning, plan, practice, convention, protocol – the customary system of values and practices that have developed over time and are deeply embedded in the social context.
3 *Kaupapa*. A noun encompassing: Topic, policy, matter for discussion, plan, purpose, scheme, proposal, agenda, subject, programme, theme, issue, initiative.
4 *Pepeha*. A noun encompassing: Tribal saying, tribal motto, proverb (especially about a tribe), set form of words, formulaic expression, saying of the ancestors, figure of speech, motto, slogan – set sayings known for their economy of words and metaphor and encapsulating many Māori values and human characteristics.
5 *Koha*. A noun encompassing: Gift, present, donation, contribution – especially one maintaining social relationships and has connotations of reciprocity.
6 *Whanau*. A noun encompassing: Extended family, family group, a familiar term of address to a number of people … sometimes used to include friends who may not have kinship ties to other members.'
7 *Te ao Māori*. A noun used in this chapter to mean Māori worldview.
8 *Marae*. A noun used in this chapter to mean 'courtyard' – the open area in front of the *wharenui* where formal greetings and discussions take place. Often used to include the complex of buildings around the marae.
9 *Hui*. A noun encompassing: Gathering, meeting, assembly, seminar, conference.
10 *Hauora*. A noun encompassing: Health and vigour.
11 *Whāriki*. A noun in this chapter to indicate a woven mat.
12 *Koha*. See above.
13 *Mahi*. A noun, encompassing: Work, job, employment, trade (work), practice, occupation, activity, exercise, operation, function.
14 "assist, v.". OED Online. December 2018. Oxford University Press. http://www.oed.com.ezproxy.auckland.ac.nz/view/Entry/11951?rskey=9C6twQ&result=2 (accessed February 24, 2019).
15 "*manaaki*". Māori Dictionary. N.d. https://maoridictionary.co.nz/search?idiom=&phrase=&proverb=&loan=&histLoanWords=&keywords=Manaaki (accessed February 25, 2019).

16 *"manaakitanga"*. Māori Dictionary. N.d. https://maoridictionary.co.nz/search?idiom=&phrase=&proverb=&loan=&histLoanWords=&keywords=Manaakitanga (accessed February 25, 2019).
17 **Pou**. A noun encompassing: Post, upright, support, pole, pillar, goalpost, sustenance.
18 **Pākehā**. A noun used in this chapter to refer to a 'New Zealander of European descent.'
19 **Awhi**. A noun encompassing: To embrace, hug, cuddle, cherish.
20 **Waiata**. As a verb it means 'to sing'; as a noun it means 'song, chant, psalm.'
21 **Whakapapa**. A noun encompassing: Genealogy, genealogical table, lineage, descent.
22 **Wharenui**. A noun used in this chapter to refer to 'Meeting house, large house' – main building of a *marae* where guests are accommodated.

(Unless otherwise stated, the above definitions are quoted directly from www.maoridictionary.co.nz. This website is based on the book: *Te Aka Māori-English, English Māori Dictionary and Index* by John C. Moorfield)

References

Ardern, Rt Hon Jacinda. "Recognising the Importance of Our Arts, Culture and Heritage." 17 May 2018. Accessed 25 February, 2019 https://www.budget.govt.nz/budget/2018/releases/r44-la-ardern-recognising-the-importance-of-our-ar.htm.

Gibson-Graham, J. K. *A Postcapitalist Politics*. Minneapolis, MN: University of Minnesota Press, 2006.

Gibson-Graham, J. K., Jenny Cameron, and Stephen Healy. *Take Back the Economy: An Ethical Guide for Transforming our Communities*. Minneapolis, MN: University of Minnesota Press, 2013.

Jones, Alison, and Kuni Jenkins. "Rethinking Collaboration: Working the Indigene-Colonizer Hyphen." In *Handbook of Critical and Indigenous Methodologies*, edited by Norman K. Denzin, Yvonna S. Lincoln, and Linda Tuhiwai Smith, 471–486. Thousand Oaks, CA: SAGE, 2014.

Larner, Wendy. "Brokering Citizenship Claims: Neo-liberalism, Biculturalism and Multiculturalism in Aotearoa New Zealand." In *Women, Migration and Citizenship: Making Local, National and Transnational Connections*, edited by Evangelia Tastsoglou and Alexandra Dobrowolsky, 131–148. Aldershot, England: Ashgate Publishing, 2006.

Matthewman, Sasha, Molly Mullen, and Tamati Patuwai. "The River Talks: An Ecocritical 'Kōrero' About Ecological Performance, Community Activism and 'Slow Violence'." *Research in Drama Education: The Journal of Applied Theatre and Performance* 20, no. 4 (2015): 442–463.

Maunder, Paul. *Rebellious Mirrors: Community-based Theatre in Aotearoa/New Zealand*. Christchurch, New Zealand: Canterbury University Press, 2013.

Mullen, Molly. *Applied Theatre: Economies*. London, England: Bloomsbury Methuen Drama, 2019.

Richardson, Laurel, and Elizabeth Adams St. Pierre. "Writing: A Method of Inquiry." In *Collecting and Interpreting Qualitative Materials*. 3rd ed., edited by Norman K. Denzin and Yvonna S. Lincoln, 473–499. London, England: SAGE, 2008.

Skilling, Peter. "Trajectories of Art and Culture Policy in New Zealand." *Australian Journal of Public Administration* 64, no. 4 (2005): 20–31.

Thompson, James. "Towards an Aesthetics of Care." *Research in Drama Education: The Journal of Applied Theatre and Performance* 20, no. 4 (2015): 430–441.

Tuhiwai Smith, Linda. *Decolonizing Methodologies: Research and Indigenous Peoples*. 2nd ed. London, England: Zed Books, 2012.

4
SMALL ACTS AT THE MARGINS
Making theatre work at cross-cultural intersections

Linden Wilkinson

Introduction

This chapter examines the development, over a five-year period, of a particular performance work, *This Fella, My Memory*, in the Australian cross-cultural space we Aboriginal and non-Aboriginal theatre-makers discovered we inhabited. The developmental processes articulated below recognise that the journey from an idea to a production enabled a collective maturation of craft skills and a subsequent growth in confidence. This shift in skills and confidence allowed stories to flourish theatrically, while we simultaneously addressed the inherent challenges in performance projects motivated by a decolonising intention.

The principal challenge we faced can be addressed in a question: *how do we, as artists, collaboratively create a unified dramatic story when cultural and experiential diversity is a given?*

This question is important because when we enter the cross-cultural space, we all begin from somewhere else. No matter how familiar or foreign it may seem, none of us is ever neutral.

Day one

In the beginning, a play was never intended. Our play, *This Fella, My Memory*, didn't emerge from an idea, an issue or a desire to develop a performance work together. After all, most of us were strangers. Our play began with an improvisation and then remained an intriguing, untold story, hovering in the ether.

We were a group of eight Aboriginal actors and myself, a non-Aboriginal actor and writer. We met in a hired community hall in Sydney's Redfern, the geographical, cultural and emotional centre of the Aboriginal diaspora, for a one-day workshop on a film script to fulfil one task only. As workshop actor and facilitator, Lily Shearer said at the beginning of the day, we had assembled "to make the blackfellas in this script sound like real blackfellas and not like blackfellas written by a whitefella." Which of course they had been; it was my script.

Over the course of our workshop, we discovered that improvisation was the story and character development technique of choice. Unlike anecdotes and expressed opinions, improvisation overcame the challenge of difference, of boundaries and caution in our emerging cross-cultural space. Improvisation accentuated the possibilities of play. And, as the improvisation process involves intense and immediate immersion in an unknown environment, in which no doubt

some kind of imposed crisis is a distinct feature, the characters who appear quickly to deal with this crisis are readily physicalised, embodied, free. So, consequently, the results are often quite simply hilarious.

But there are deeper forces at work. As a play-making technique for creating a shared but imagined reality, improvisation, in my experience as an actor and a teacher, demands trust, focus, courage and reflexivity. One senses such qualities are present when action continues to develop through silence as well as through dialogue, when surprising offers are readily incorporated into a scene's development, and when emerging characters reveal a long-held desire or secret and the veracity of this reveal is supported by others' responses. So, on the floor we had laughter as well as tears, hurt as well as incredulity. The workshop offered abundant story possibilities, as the amount of dialogue decreased, and the characters grew. And late in the day, the play found us.

Three characters came together for an improvisation and discovered on the floor that their differences were not the story; instead their need for each other was the story.

The spark

My curiosity about how different cultures might merge with each other, rather than compete, was sparked in a drama classroom in New Zealand in 2007. I had been teaching an intensive on improvisation to second year drama students at Toi Whakaari New Zealand Drama School. We had been together for a week. The students were of different ethnicities, Pākehā, Māori, Pasifika, even an Anglo-Australian, and most were in their early 20s. Typically, for source material when locating characters for given improvised scenarios, students return to cultures of origin for inspiration. It's in those places of childhood and adolescence that the most significant personas dwell; personas that are easy to access and are comfortable to inhabit. It had been the same here. All week I had watched Māori and Pasifika students move between cultures – their own and European. Their improvised characters, undoubtedly based on powerful past influences, particularly in terms of body language, were different to how these same students presented in the classroom. In their improvisations the men adopted more aggressive postures, the women more passive, and in both cases the characters they captured expressed sentiments that reflected their physical change.

When our week was done, I was told that the students wanted to thank me. I was to be presented with a ceremonial gesture of gratitude: the students were preparing to perform the school haka. I was invited to stand on a chair and was advised that I had been given the best seat in the house. When I asked how I should respond, I was told with a shrug that most people generally cry. Feeling so very honoured and already surrendering to quiet tears of anticipation, I watched the students clear the space; then suddenly: stillness. Men in the front, women behind the men; the students had found their places. Suddenly with a deep roar, the school haka began.

It was a breathtaking experience to be so close to a dance of such ceremonial focus and potency. But once I had dealt with the shock of the event itself, I realised I was witnessing something even more amazing. I was watching all the students from all their different cultures of origin step out of a Pākehā way of being and way of sounding, and collectively step into inhabiting, for those three or four minutes, another culture. And this culture, Māori culture, to me exuded a confidence and authority that these same Pākehā students had not previously demonstrated. They were expressing themselves with a physicality I hadn't seen, making sounds I hadn't heard.

Standing on the chair, I realised all week I had watched Māori and Pasifika students step in and out of their own and Pākehā cultures and had not thought anything of it. And now for the first time, I was watching Pākehā students do the same. And suddenly I understood the uninterrogated assumptions that came with a dominant culture mindset, like mine. If, as Denzin and

Lincoln (2008) maintain, "the performative is where the soul of a culture resides" (2008, p.14), what I was witnessing was the potential for a particular non-dominant culture to emotionally and physically embrace diversity through ritual and, through this embrace, manifest inclusion, history, respect, celebration and acknowledgement. Furthermore, the embrace hinted at the possibility of an emergent national identity as a fusion of influences, when both the colonised and the colonisers could free themselves of a shared British heritage. And what might this look like? How would those stories be told? Which traditions would survive and grow and which would disappear?

And so the school haka offered a challenge: could I be part of creating a similar cross-cultural experience in my own county? I'm not a dancer or a singer; I'm an actor and a writer. So, if it could happen, what would an Australian cross-cultural experience be like?

After returning home from New Zealand in November, 2007, I wrote the short film script mentioned earlier in this chapter. I called the film *Stop, Revive, Survive*, appropriating a popular road safety slogan at the time. The film was about a group of Aboriginal and non-Aboriginal people, mostly strangers to each other, whose lives intersect at a roadhouse one night in a storm. In April, 2008, I took the script to Moogahlin, a fledgling performing arts company based in Redfern.

Meeting Moogahlin

Moogahlin is a Bundjalung word meaning to play or fool around. The Moogahlin company was officially formed in November, 2007, by a group of Aboriginal and Torres Strait Islander performance artists, educators and community workers who had spent years building a profile in the Redfern community. The company's mission is to nurture and promote the creation of Aboriginal and Torres Strait Islander stories through performance, and thereby honouring Aboriginal actor, the late Kevin Smith's request for a theatre to continue to exist in Redfern after the Black Theatre of the 1970s, a theatre that told local stories, so that people would know they existed.

Key Moogahlin artists, Lily Shearer and director/actor Frederick Copperwaite, agreed to read the draft, if we could fund it. We applied for and received a small grant from the City of Sydney and the workshop was set for a date in September, a Saturday. Lily called us into a circle where we introduced ourselves. Lily gave us our task and we began to read. I didn't know it at the time, but my work was clichéd, not because it was necessarily bad, but because it completely ignored the most important character in the room – History. Slowly I discovered over the course of the day that it wasn't only the dialogue that needed to be rewritten; it was the relationships themselves.

Although 2008 had, by September, become a remarkable year in Australian race relations, with Prime Minister Kevin Rudd's apology to the Stolen Generations seven months before, the bitter trauma of the Aboriginal past had been brought into a restless, leaderless non-Aboriginal consciousness. Interrogation of that past created division, as the comforting mythology of a benign process of colonisation began to disintegrate under the pressure of generations of Aboriginal testimony. It wasn't just in our little workshop that big questions were being asked about the systemic improbability of recognition and relationship.

Finding the play

Fred, the director, chose the end of the day to investigate this issue of relationship. In the script the three old women, "Toots", "Dolly" and "Col", happened to be on a road trip. They called

into the *Stop, Revive, Survive* roadhouse because a creek was up and they were unwilling to keep driving. Fred didn't care why they went to the roadhouse, he wanted to know why they were together, these two Aboriginal women, "Toots" and "Dolly" and this argumentative non-Aboriginal woman, "Col". Their friendship struck Fred as odd, inauthentic, too dramatically convenient and not based, for him, on friendships in the real world. I explained that they were marginalised women, impoverished; they had banded together because of shared occupancy in low socio-economic group housing. This explanation wasn't enough for Fred. He laughed, "What's really going on?"

What remained unspoken between Fred and I was our different experiences of history: history as it is lived every day and history as it is taught in primary school. And both histories are legacies of colonisation; one is a history of dispossession, the other a history of entitlement. One is a history of exclusion, the other a history of privilege.

We set up the improvisation involving three characters referred to earlier, where the two Aboriginal women, "Toots" and "Dolly", were in a craft group in an aged care facility. We gave "Dolly" a backstory: she had been taken from her country as a child and now, at the end of her life, she wanted to go back. She asked "Toots" to help her but "Toots" refused. She didn't have the money to take "Dolly". "Dolly" didn't think it needed money; they just needed "Col", the non-Aboriginal woman everyone disliked. They needed "Col" because "Col" had a van. The object of the improvisation was to persuade "Col" to take them all on a trip to "Dolly's" country.

"Toots" and "Dolly" succeeded in doing this through humour, affection, inclusion and silence. We ended the day but none of us forgot the longing and the loneliness haltingly expressed by all the women. Fred, Lily and I got together. We decided to pursue the idea of a play. We had characters, we had a beginning, now we needed a story. And we needed to work together to find it. Again, we sought funding and a year later we were able to spend a week together telling stories and developing them through increasingly structured improvisations.

Early in the workshop process, we invited the first of our two cultural advisors to join us. Aunty Christine Blakeney had lived in the community for decades and knew many members of the Stolen Generations who had been determined to die on their ancestral land even if they had no actual memories of being there. We listened to these stories, talked about the people, the pull to go back, and tried finding ways to capture the longing to go home. But we found trying to perform that longing slowed down the emergent play; we needed it to be implicit, but we needed to keep all the women active, not just letting "Toots" and "Col" be there to support "Dolly". Everyone needed their own story, their own goals, their own regrets.

So, we gave "Toots" a fading career as a Country and Western singer with a fake tour to Southeast Asia happening no time soon; and "Col" a long-ago deceased Aboriginal lover with an estranged daughter, "Tamsin", who thought she was Spanish because "Col" wanted to deny any Aboriginal connection. And we gave "Dolly" a murdered sister, "Bindi". "Toots'" tour was the only one of the three stories we invented; the other two stories were events that had happened within either our ensemble or within the wider Aboriginal community known to ensemble members.

History, country and context

Although we effortlessly created a story, we could not yet confidently say we had, through story alone, created an accessible understanding of context. We needed to demonstrate what kind of a world, culturally, these three women were negotiating, so it was not an impediment to an audience's empathetic immersion in the women's emotional and psychological journey ahead. We couldn't have the biggest question of the night echoing Fred's crucial question on day one:

but why are these women together? We had to ensure that the audience would accept quickly that they were. We needed to find a way of dealing with the two most significant characters on stage: History and Country.

In a cross-cultural scenario, these two influences and major characters, History and Country, we felt, needed to be articulated, as audience members are likely to have distinctive, perhaps bitter, perhaps uninterrogated understandings of both. In a monocultural play, a dominant culture play, for example, these challenges don't exist in the same way; the audience may not know the world of the play, but they do know there will be enough familiar signposts that they will come to understand it. But we also recognised that History and Country cannot be the story, otherwise the play would run the risk of being descriptive, didactic and stagnant.

We addressed the problem of context through speed, a function of our growing confidence, and through juxtaposition, a reflection of our growing skillset. Visually we opened the play with an image of a full moon on still water. Behind the image there was a soundtrack of waves, creating a sense of wonder. A recorded prologue in Yuin language, recorded by a cast member, shares a devised poem about sky and earth, love and order:

> Now Father Sky takes care from above
> And Mother Earth nurtures below
> And Grandfather Sun, as fire, keeps us warm,
> With water he makes things grow.
> But old Granny Moon, her power is strong;
> She draws us all together;
> Takes water up, turns the tides,
> Offers us love, if we let her.

During the recorded prologue, "Dolly" entered and drew in the sand. The lighting changed to day, the image changed to bushscape, the soundtrack changed to birds and again, Country was idealised, as two half-lit spirits, young "Dolly" and her sister, "Bindi", play a fast game of hide and seek. Slowly, adult "Dolly" stopped drawing, she turned to see the spirits, she screamed. Suddenly, "Dolly" was in the cacophony of the city. Drunk, "Dolly" gets to her feet, the blare of car horns, the sweep of headlights across her face. "Dolly" focused on the audience and growled:

Dolly: What are you staring at, fuck yer?! Got a dollar? Want to get something to eat. Hey there, sister! Yeah! I'm looking at you! Here! Got a coupla bob?

A squeal of brakes, "Dolly" is hit by a car.

And so, the play begins; we established an ancient world, where Country is a serene place of love, order and harmony. And we established a contemporary world that conveyed the trauma of colonisation, the dispossession, disadvantage, discrimination and despair.

On country with Uncle Max

Crucial to our being able to devise this introduction to the play was our research weekend spent in Yuin country, down the South Coast of New South Wales. This is Aunty Rhonda Dixon Grovenor's country and where, as "Dolly", she was taking us in the play. There we met our second cultural advisor, Uncle Max Dulumunmun Harrison, a Yuin elder, writer and international spokesperson for Australian Aboriginal People. Amongst his many contributions towards raising awareness of the true nature of ongoing colonisation, he runs cultural familiarisation weekends

in Yuin country. With ceremonies and stories beside the sea as well as on Gulaga, a particular mountain beyond, he introduces mainly non-Aboriginal people to Aboriginal beliefs around connectedness to country, to spirit and to the importance of ceremony. I had written the prologue above based on text from Uncle Max's book, *My People's Dreaming*. The prologue, though philosophically correct, never worked until Uncle Max translated it into Yuin, and one of our ensemble recorded it almost at a whisper. Like the haka in the New Zealand drama classroom, in language, once banned, the words unleashed an incomparable surge of identification defying ethnicity, but instead based on the universal level of ritual, of soul.

It was participating in one of the weekend workshops that gave the four of us, Fred, Lily, Aunty Rhonda and myself, the all-important shared experiences that we needed to have in order to continue finessing the play. We were close now to scripting "Dolly's" death and we needed permissions from Uncle Max to be able to include the ceremony. Because we were there, Gulaga, an ancient mountain of deep cultural and spiritual significance, became "Dolly's" final destination, as well as the site of past trauma. A place of extraordinary rock formations, it features in foundation stories and was a place for men's business for thousands of years. As part of the rituals around raising cultural awareness, we walked up Gulaga in silent contemplation. Once at the summit we ate, talked, explored and then Uncle Max invited us all to sit, be still and to feel Gulaga's power in the present. Then, Uncle Max conducted a ceremony encouraging us to see with our minds as well as our eyes. It wasn't hard to feel the ghosts there, as the twilight came and went. We scurried down the track in heart-thumping silence, like kids out too late and in big trouble.

We called our play "*The Aunties' Epic*" until we knew we were to have a mainstage production. Delighted to now have a performance to work towards, there was a general feeling that "*The Aunties' Epic*" no longer told the play's story. The road trip had morphed into a story about redemption, as each of the three women, "Dolly", "Toots" and "Col", was forced to face her past and acknowledge the damage she had caused. It was felt we needed a title to reflect heartache but without any sense of self-pity.

Uncle Max was with us in Redfern when he told a story about his triple bypass, which had happened about three weeks before. He told us he was so afraid because the heart is where memory lives and now that his heart was to be handled by others, would his memories be destroyed? He asked the anaesthetist if his memories would be safe. He was assured they would be. Then Uncle Max put his hand on his heart and smiled. This fella, he said, pointing towards his chest, still holds all the stories. And so, *This Fella, My Memory* is about the memories the damaged heart holds.

Our ensemble workshop days always began with stories; I thought of our stories as potentially content. Only slowly did I begin to realise I was being given a lens through which to view a world I would never experience. I didn't understand what I had absorbed and what I had been given permission to know until we were about to perform, until the pressure of rehearsals and drafting the final script.

Rehearsal

Fred wanted "Dolly", to have a long speech, a monologue, which explained her relationship with her deceased sister and her reason for wanting to return to country, but which also explained her decline into alcoholism. The relationship had to be filled with trauma. Fred called it a Sam Shepard moment. The speech I wrote quickly one morning was based on the many stories I had absorbed over the time we had been working together; stories about police harassment, sexual abuse and fear. It was accepted, trimmed and used in the play. In performance, the rage was

repressed, as it had been in the stories. The events were simply facts. Because of this repression, the violence became normalised. It was the speech of a woman crushed by a lifetime of disempowerment and abuse. The speech begins (the word "gunjies" is slang for police):

Dolly: This bracelet belonged to my sister. My sister Bindi. This is her bracelet. We was close. Two years apart but twin souls. Real close. Played in the bush; running, hiding, singing out, this way, that. Playing terrible tricks (laughs). Hiding up that tree, "Where are you, Sis? Come and find me! Come on!"

One night, there was this party. We dress up – tight pants, high heels, looking like The Supremes. Just before we race out the door, Bindi goes back. Me bracelet! Forgot my lucky charm. And she slips it on. And off we go. We're almost at the party, when the trouble starts. There's a car. Cruising up behind us. Passes me and picks up Bindi in the headlights. Pulls to a stop. Blue lights flashing. Gunjies?

Now at that time there was some bad buggers there. Bad. We all knew they was raping girls. Stories, you know. Walk it or fork it. And 'cos they was gunjies, well, they weren't going to get caught, were they.

The speech then reveals "Dolly's" escape and "Bindi's" murder. It concludes:

Dolly: Then early in the morning while it's still dark they go back down the mountain. Two red taillights like the blood-red eyes of a wild dog, turning back as he slinks away. And when the sky gets light and the stars fade, I go looking for her. But this (holding bracelet) is all that's left. I don't know what to do. I can't go home. What would they say? I was fifteen. I didn't know what to do … so I ran.

Two girls on the South Coast disappear … two black girls … who cares? Our family did. But I couldn't go back. Knowing I'd let Bindi get killed. I couldn't go back … and sometimes … lots of times… she comes to me… but I always know… I could have saved her … I could have saved her.

In the play no comment is made about the speech; it's just like the stories, they are told and left to hang in space. The play continues. Some minutes later there's a silence and it's non-Aboriginal "Col", who bursts out with:

Col: Those police … how could they do that? Bastards!
 Toots laughs.
Toots: So many men, so few bullets, eh, Col.

And the play moves on.

What I believe we captured in that brief exchange and silence was a lifetime of disempowerment and, for "Col", the intense discomfort of her ignorance exposed. Like the non-Aboriginal anger at confronting the past after Prime Minister Kevin Rudd's apology to the Stolen Generations, knowing one truth disrupts believing one knows all truths. But disillusionment and rage for me, as "Col", weren't the only responses to new insights into the workings of dominant culture; there was shame as well.

As mentioned earlier, "Col" had an estranged daughter, "Tamsin". I wanted, as "Col", to make amends for lying to her about her heritage; the actor playing "Tamsin" did not. I found it difficult to write a scene that suited us both. Then during a workshop, we did a story-telling exercise, this time as characters. We had to tell a story of what our characters were doing six

months after the play ended. I told a story about how I, as "Col", was optimistic about finally having a meeting with my daughter. The actor playing "Tamsin" had a very different story. She was playing a character who had been brought up to believe she was part-Spanish. That's what she had been told by her mother, "Col". Discovering her father was Aboriginal in the play and that she had been lied to by her mother was so disorienting for her, so she chose to embrace materialism, which, for her, was the one value of permanence. And, like the students at Toi Whakaari, she chose, as a character in crisis, to return to her culture of origin, her mother's culture.

Her extemporised speech was about the acquisition of a new diamond ring. She never mentions her mother. As an actor, I was challenged by this choice. I was embarrassed when faced with another's perspectives on the cultural values I represented. But, like standing on the chair in the drama classroom, it gave me a new perspective. It made me think about what kinds of knowledge we exchange with our stories. They tell us how we might understand the Other, but also how we are understood by the Other.

The play ends with "Dolly's" death. Finally, back on country and forgiven, her death, unlike her life, is happy. "Toots" and "Col", who have spent the whole play hating each other, decide to stay together, because they realise they need each other. They both have unfinished business with the people they have wounded in the past. The final scene was supposed to end ultimately with laughter, laughter through tears. Most surprisingly to me, once the play went into rehearsal, Fred wanted a different ending, something upbeat. I was incredulous. I pointed out that "Dolly" had just died; the ending has to be sad, even if the death was happy. The crying remained, giving way to laughter right at the very end. And, yes, I was aware in rehearsal something was wrong and no amount of expressing grief as "Col" alleviated this disconcerting awareness.

Then, in the dress rehearsal, the actor playing "Toots" (we had had a cast change) began laughing much earlier than scripted; she too, she said, was sick of crying. Outnumbered, I reluctantly let "Col" lighten up – the scene finally worked; we shifted the energy, the catharsis was complete, and this final scene became a scene to finish a play. Wrenched out of self-pity, the scene was about a better future and two feisty characters an audience might want to be with, should there be another play. It wasn't about being united through grief; it was about choosing to be together, warts and all. It was now about the apparent foolhardiness and resilience of hope as a life force, rather than being about the stasis of despair.

Fred was happy; he thought we had finally captured the spirit of reconciliation. I thought he was talking about friendship. Now I think he was talking about the possibility of a shared future, one where there is an acknowledgement that the past is not past and that Country, whether it owns you or you own it, dictates opportunity, privilege and perceptions of justice and what is fair.

Inside the third space (Bhabha, 1990)

The site where cultures intersect is contentious. As we trek towards the unknown, the third space, the frontier, the place where cultures overlap, we begin to experience the limitations of what we know and so we are given a choice: either we confront our own ways of knowing and being and prepare to change or we demand that others do the changing for us.

As questions of relationship and identity are integral to cultural cohesion, Chilisa (2012) urges us as researchers – and artists – to have a solid understanding of ourselves, our own culture, beliefs and epistemologies before we attempt to understand another's. It is my experience, as a non-Aboriginal Anglo-Australian, that when investigations within this third space involve

challenging the ongoing legacies of colonisation, interrogating one's own culture becomes profoundly problematic.

There have been no truth and reconciliation commissions here, there are no treaties in place that implicitly recognise the true nature of British invasion and the long guerrilla war that ensued, there is no constitutional recognition of prior Indigenous occupation and country ownership. However, the recent Uluru Statement from the Heart (May, 2017), which called for a First Nations Voice to be enshrined in the Constitution, might have been dismissed by the then Turnbull Government, which itself was dismissed in August, 2018, but the Uluru Statement has not disappeared from surveys, from polls, from the Australian psyche. Its support is diverse; opinion leaders across the political spectrum outside parliament continue to lead the charge for change and subsequent calls for action consistently indicate that the broader public finally and fearlessly wants to own the truth of its past, which in the words of anthropologist W.E.H. Stanner (1968) "sticks out like a foot from a shallow grave." All that's lacking is non-Aboriginal leadership.

Without a political will prepared to acknowledge both the brutality of dispossession in the colonial past and its perpetuation through a dominant culture of privilege and denial in the present, we cannot expect justice or moral leadership. We cannot heal, because we cannot share. And our work at the decolonising margins does not yet carry the weight to create a tipping point. However, *This Fella, My Memory* was never about a tipping point.

Conclusion

In the broadest sense, the making of *This Fella, My Memory* reflects a shared experience and a collective curiosity. Through collaboration, consultation and humour, the play evolved because three characters, in trying to find a future, instead had to face their pasts, and a group of people wanted to find out what happened. The play asks questions about marginalisation: marginalisation of people and marginalisation of the truth. And, hopefully, it suggests that resilience is the gift of hard-won integrity.

This play is a small contribution to our understanding of the complexity of the bigger picture. It's an emotional experience of possibility, it's a story for right now. The play ends by saying the way forward is a new story, waiting in the wings. We have to recognise and dismantle the institutional barriers to equality, but the play demonstrates we can find the energy to do this one relationship at a time.

References

Bhabha, H. 1990. The third space. *In:* J. Rutherford, ed. *Identity – community, culture, difference*. London: Lawrence & Wishart Ltd, 207–221.
Chilisa, B. 2012. *Indigenous research methodologies*. Thousand Oaks: SAGE Publications Inc.
Denzin, N. and Lincoln, Y. 2008. Introduction: Critical methodologies and Indigenous inquiry. *In:* N. Denzin, Y. Lincoln and L.T. Smith, eds. *Handbook of critical and indigenous methodologies*. Thousand Oaks: SAGE Publications, 1–21.
Melbourne Law School, ND. *Uluru Statement from the Heart: Information booklet*. Available from https://law.unimelb.edu.au/__data/assets/pdf_file/0005/2791940/Uluru-Statement-from-the-Heart-Information-Booklet.pdf [Accessed 30 November 2018].
Stanner, W.E.H. 1968. The Boyer lectures: After the dreaming. *In:* R. Manne, ed. *W.E.H. Stanner – The dreaming and other essays*. Melbourne: Black Inc. Agenda, 172–225.
Wilkinson, l. and Moogahlin Performing Arts Inc. 2013. *This fella, my memory*. Unpublished play script.

5
THE ART OF LISTENING IN PRISON
Creating audio drama with incarcerated women

Sarah Woodland

Prelude

World events over the past few years have left me regularly swinging between outrage and just plain rage. In Australia, we see the continued erosion of Indigenous sovereignty, human rights, civil liberties, and environmental protections in favour of "border security" and relentless economic growth. Despite being more connected with others through technology and social media, we are more depressed, anxious, and lonely than ever (Jorm et al., 2017; Lim, 2018). Notwithstanding the strong emphasis on hope in applied theatre research, I often feel quite hopeless. In March 2018, I was in Vancouver, Canada, attending the Carceral Cultures Conference. Presented by the Canadian Association of Cultural Studies, this event brought together scholars, artists, and activists to consider all the different ways human beings are becoming, now more than ever, subject to tyrannies and technologies of displacement, separation, surveillance, and control. One of the keynote speakers was African American political philosopher and feminist Joy James (2018). She spoke about how it might be possible to regain a sense of agency in these chaotic, neoliberal times of post-truth, me-too, and failed democracy. How we all, regardless of gender, must engage our maternal capacities for care and love, to "steal ourselves back" from capitalism, violence, and misogyny. She said, "The axis of power is in our intimate relationships. Everything else is a commercial for something you're never going to get." Her words resonated strongly for me in a moment of feeling hopeless. They cut through the white noise of dense theoretical debate and got to the heart of the issue. Love. Care. Intimacy. In that moment, I was reminded of the power that can come from small, intimate, creative encounters; how cross-cultural drama practice can enable us to explore together the complexities, conflicts, and entanglements of being human. For me, this can be viewed as an aesthetic process, in the broadest pragmatist sense – the art of living – the embodied, relational act of making of selves, worlds, and cultures in art, and in life: Introduced as a Western aesthetic theory by John Dewey in the 1930s (Dewey, 1934; Shusterman, 2000), yet valued and pursued by Eastern philosophers and Indigenous peoples for millennia. I have been facilitating drama programmes in Brisbane Women's Correctional Centre (BWCC) since 2010, developing the practice, and my thinking around the practice, in response to each new group of women. Lately, I have wondered how these tiny programmes can possibly act in counterpoint to the misogynistic, divisive, "carceral cultures" the world is now experiencing. Perhaps they cannot. But in pursuit of this question,

Joy James' words have provoked me to dig down underneath abstract concepts of citizenship, democracy, agency, and social justice in applied theatre, and into an aesthetic space of intimate cross-cultural encounter.

Background

Over the past nine years, I have run five drama programmes in BWCC, with a sixth commencing at the time of writing in early 2019. BWCC is a maximum-security prison on the outskirts of the city that holds a population of up to 300, offering inmates vocational education and training, criminogenic rehabilitation, and recreational programmes that encompass sport, and occasionally art and music. Over the years, my drama programmes have been offered with support from all of these areas, overseen by the manager of offender development. Up until 2017, I was supported by BWCC in principle, but funded with a combination of federal and state government arts funding, research grants, and in-kind university access to resources. In 2017, BWCC contributed a significant amount of funding, which seemed to demonstrate that the work was being recognised and valued by management at that institution.

I delivered my first programme as part of my doctoral study in 2010 (see Woodland, 2013, 2016). I had recently returned to Australia after being a company member of Geese Theatre UK for three-and-a-half years. I had honed my applied theatre skills through Geese's very specific approach and explicitly rehabilitation-focused work (see Baim, Brookes and Mountford, 2002). This first programme at BWCC represented my move to explore new ways of working in an Australian prison context, focusing more on artistry than rehabilitation. The practice was therefore experimental, moving through different structures and approaches, such as image theatre, drama therapy, text-based work, improvisation games, drama skills development, and process drama; concluding with a final performance centred on inspiring women from history. The participant group for this programme fluctuated between five and ten women, two of whom mentioned in passing that they had Indigenous heritage, yet did not strongly identify in the group *as* Aboriginal or Torres Strait Islander. These women rarely mentioned their cultural background in the context of the drama, and the cultural references they brought to the process were largely drawn from Western history, literature, and popular culture. The reasons for this could be many and varied – too many to explore in this chapter – but it may have resulted from the dominance of Western culture in Australia's mainstream, the then limited access to Indigenous-focused cultural programmes and experiences in the corrections system, and the very strong possibility of racial intolerance within the wider prison cohort at BWCC. I must also accept some responsibility for this, working through a Western lens, and not yet recognising the magnitude of Indigenous incarceration in this country, or the depth of cross-cultural exploration that might be possible through the drama.

Following this first programme, where the women had demonstrated an interest in historical narratives, I decided to experiment with Australia's penal history as a dramatic frame through which we might explore contemporary experiences of imprisonment. In this, I was partly inspired by the work of Playing for Time Theatre Company in HMP Winchester UK (McKean, 2006), where they had created a piece about the history of the prison. Piloting this approach at BWCC in 2012, I worked with a group of six women, all of whom were Anglo-Australian, with the exception of one who had Māori heritage. I led the programme with support from applied theatre students from Griffith University, devising a performance with the women that was based on the history of Old Boggo Road Gaol, a somewhat infamous historical prison in Brisbane that was built to house women in the late 1800s. In this pilot, I observed that many of the women were interested in developing historical characters through the lens of their own lived experience, and that this process allowed the women to express their own emotions and

experiences of imprisonment at a safe distance. I also became interested in the voice recordings that we were generating to document the creative process, and how these stood alone as highly engaging performance pieces. This led me to experiment more with audio performance, developing a participatory approach to radio (or audio) drama that became *Daughters of the Floating Brothel*, a practice-led project delivered in two iterations at BWCC over 2014 and 2015.

Aside from my emerging interest in audio performance, and its inherent aesthetic possibilities, the idea also came out of a sense of necessity, given the unique constraints of running drama programmes in BWCC. At that time, the majority of women were serving short-term sentences, and their attendance in the drama group could be interrupted at any moment by medication calls, disciplinary actions, legal visits, court dates, and work commitments; or cut short by sudden release or transfer to other facilities. There was no possibility of inviting outside audience members into BWCC unless they already had security clearance, and we were unable to clear the performers for release into the community or to other prisons to tour a performance. I therefore saw audio work as a way to reach a wider audience outside the prison walls, to capture performances on the fly, and to create a more satisfying outcome for participants in the face of the continuous interruptions and prisoner movement issues. For *Daughters*, I collaborated with socially engaged performance practitioner Daniele Constance, playwright and director Shaun Charles, and another small group of students. We worked over 2014 and 2015 with two different groups of women in two iterations of 16 two-hour sessions. This project forms the basis of my discussion in this chapter, where I will describe how my work in BWCC has now shifted towards cross-cultural practice, and how the *Daughters* project reflects an aesthetics and politics of listening that interrogates, and attempts to resist, the continued legacy of settler-colonialism in Australia.

The "Floating Brothel" and Australia's colonial legacy of female incarceration

Australia has a long and troubling history of female incarceration, going back to its establishment as a penal colony in 1788. In 1790, the first all-female convict ship, the *Lady Juliana*, arrived in the unceded land of the Gadigal people of the Eora Nation (Port Jackson). The ship was given the nickname, the "Floating Brothel", due to the sex trade that many of the women on board had practised in London prior to being transported, and reputedly continued to practise in exchange for fresh food, as they visited ports on the 11-month journey to Australia.[1] By some accounts, these 226 young women, mostly aged between 11 and 40, were sent to Australia from the overcrowded jails of England in an effort to "tame" the ragged horde of hungry, desperate, sexually frustrated men who had arrived two years earlier on the First Fleet (see Hughes, 1987). I felt that this story might provide an engaging pre-text for the women to explore Australia's carceral history, and named the project to recognise its role as a kind of origin story for female incarceration in Australia, the contemporary women in BWCC being the figurative daughters of those first convict women.

We were initially surprised to find that 10 out of the 15 women who volunteered for the *Daughters* project in 2014 identified as Indigenous, a much larger proportion than I had worked with previously. There were several possible reasons for this increase in Indigenous participation. First, in 2014, the general manager of the prison requested that we target our programme to what she described as the most "intractable prisoners", who were known to have continued drug dependency and behavioural problems inside, and who had not enrolled themselves in other programmes on offer in the centre. For reasons that are made clear below, the majority of women fitting this profile also happened to be Aboriginal or Torres Strait Islander. Also, the posters that we used to advertise the project in 2014 showed images of the "Floating Brothel" and Old Boggo Road Gaol, and invited women to come and explore this history through drama. We later found out that many of the Aboriginal and Torres Strait Islander women in

BWCC had family connections with men and women who had been incarcerated at Boggo Road through its notorious period of riots and disorder in the 1980s, before its closure in 1992. The strong presence of Indigenous women in the group led us to expand our understanding of historical incarceration beyond prison ships and prison buildings, and to recognise Aboriginal missions as equally significant carceral spaces in Australia's penal history (see Baldry et al., 2015; Casella and Fredericksen, 2004). We therefore chose to include Barambah Aboriginal Mission as one of the sites for exploration in the drama. Located 260 kilometres north-west of Brisbane and established on Wakka Wakka country in 1904, people from over 50 tribes from all over the state of Queensland were forcibly removed to Barambah as part of the Stolen Generations.[2] Children were separated from their families to live in dormitories, strict curfews were imposed, and the residents were referred to as "inmates" (Williams and Belsey, n.d.). I consulted on this aspect of the story with Gunggari elder and memoirist Ruth Hegarty (1999), who had grown up in Barambah from the 1930s to the 1950s and written extensively about her experiences.

Drawing on data from the Australian Bureau of Statistics, recent reports in the media have focused on the increase in female incarceration in the past decade (see Willingham, 2015). There is wide acknowledgement that large numbers of incarcerated women are likely to have experienced violence, sexual assault, and mental illness, and that they receive inadequate support, both inside prison and in their transition to the community (see Bartels and Gaffney, 2011). In Australia, as in other settler-colonial nations such as Aotearoa New Zealand and Canada, Indigenous peoples are imprisoned at an alarming rate. Citing data from the 2016 census, the Australian Law Reform Commission (2017: 93) reported that Aboriginal and Torres Strait Islander people constituted 2% of the Australian adult population, but comprised 27% of the national adult prison population. Aboriginal and Torres Strait Islander *women* are the fastest growing prison populations in Australia, currently being 21.2 times more likely to be imprisoned than non-Indigenous women (Australian Law Reform Commission, 2017). Criminologists and correctional authorities often invoke a litany of pathologies in explaining these shameful statistics: High rates of poverty and homelessness, low educational attainment, drug and alcohol abuse, violence, sexual abuse, disability, trauma, and mental illness (see The Law Society of Western Australia, 2017). But this is part of a colonial legacy of genocide; displacement and removal from tribal homelands; incarceration in reserves, orphanages and missions; and indentured servitude and enslavement in forced labour. Versions of these continue today through the structurally racist systems of criminal justice, human services, health, social welfare, and education. Indigenous leaders refer to this as the "torment of powerlessness" (Referendum Council, 2017: i). They are united in their belief that there must be an Aboriginal and Torres Strait Islander voice to parliament; and a process of truth-telling that precedes any efforts towards healing and reconciliation in Australia.

Most of the Indigenous women in our two groups had been part of the intergenerational legacy of incarceration going back to the early days of forced removal. Their great grandparents, uncles, and aunties had been removed to Barambah and other missions around Australia; they had parents, uncles, and aunties in Old Boggo Road Gaol before its closure in 1992; and many had grown up together inside the system of state care and juvenile detention. One participant recalled seeing a photograph of a male ancestor who had been transported from Vanuatu to Australia as a slave; another spoke of her uncle who had been a victim of black death in custody.[3] Judy Atkinson (2002), an Aboriginal scholar with Yiman/Bunjalung heritage, believes that the traumas of colonisation are shared by both Indigenous and non-Indigenous Australians, and that we must therefore all share in healing them; and this idea became a cornerstone to my cross-cultural practice in BWCC.

Over the two iterations of the project, we worked with groups to make a 30-minute audio docudrama. With the 2014 group, we produced a rough creative development version of the work, which the 2015 group then developed further into a more polished outcome. Each time,

we worked with the women to create fictionalised texts based on archival documents, historical records, and images, and interspersed these with the women's contemporary opinions and lived experiences of incarceration. Both versions of the drama incorporated contextual narration, dramatic scenes, soundscapes, personal stories, diary entries, and poetic monologues created with the women, which the artistic team then edited and produced off site. The final 2015 version of *Daughters of the Floating Brothel* mixed fact and fiction in an episodic structure that moved through three historical sites of incarceration:

1. The *Lady Juliana* and its 1789 voyage to Australia, including fictional diary entries from women convicts, written by women at BWCC, and then voiced and recorded by English women at HMP Styal in Manchester, UK.[4] This episode also included the sighting of the ship and its passengers by the traditional Aboriginal landowners, the Gadigal people, as it arrived in what is now Port Jackson.
2. The Barambah Aboriginal Mission in the early 1900s, established under the Queensland state government's moves to "protect" and segregate Aboriginal peoples. In this episode, Dorothy, a young Bidjara woman, becomes pregnant out of wedlock and decides to run away from the mission.
3. Brisbane's historic Old Boggo Road Gaol in the early 1900s, where a young woman, Mary, is arrested for vagrancy, locked in the gaol and sent to the punishment cell, colloquially known as the "black hole", for allegedly inciting violence among the other women.[5]

Each of these episodes was framed by factual historical narration and spliced with moments of contemporary storytelling set in the modern prison, BWCC. We presented the final version of *Daughters* as an audio performance in each of the three women's correctional centres in South East Queensland (BWCC, Numinbah Correctional Centre, and Helana Jones Centre), and a public event at Griffith University – all locations where the women performers were unable to physically travel.

Participatory audio drama, intimacy, and acoustic agency

The decision to make an audio drama was, in part, inspired by a cultural turn towards listening, with the rise of immersive audio-based performance works and internet podcasts. I had recently experienced Pan Pan Theatre's immersive audio performance of the Samuel Beckett radio play *All That Fall* (2014), and was excited about the contemporary possibilities of this form of storytelling. There is widespread acknowledgement that these forms facilitate a special kind of performative intimacy, arising not only from the act of close listening through headphones or high-quality surround sound speakers, but also through the imaginative power of storytelling through soundscape and voice, in the absence of other sensory information (see Bottomley, 2015; Joseph, Avieson, and Giles, 2017; Swiatek, 2018; Wilson, 2018). The final listening events in the prisons were set up fairly minimally, in classrooms or larger shared spaces, with chairs arranged in audience formation, facing a PA and speakers. In the university, we were able to be more creative with the space, placing chairs and rostra randomly around the room, and using low, atmospheric theatre lighting. Audiences were extremely quiet and focused throughout the 30-minute piece, even at Numinbah, where officers commented on the complete focus and lack of disruptive behaviour among the 60-strong crowd of women inmates. During discussions after the performance, audience members in the prisons reflected that the act of listening allowed them to connect more strongly to the emotional lives of the women in the drama, and to generate their own powerful imagery for the story, reinforcing the notion of audio drama as a "theatre of the mind" (Verma, 2012).

> When all you've got is a voice, then we as the audience have to clothe it in everything else, so it's a very different experience for us an audience not seeing actors in costume, so we have to fill in the rest for ourselves. I think it was really powerful.
>
> *(Audience member, Brisbane Women's Correctional Centre)*

The turn towards listening in performance has been accompanied by a concurrent turn in sociology and cultural studies, reorienting ideas of empowerment and agency away from an emphasis on voice (see Back, 2007; Bassel, 2017; Dreher, 2009). Drawing on the work of ethnomusicologist Tom Rice (2016), producing audio work inside a prison potentially facilitates acoustic agency, where those who are incarcerated might resist oppressive prison soundscapes – electronic buzzers, radio chatter, industrial white noise – with their own sonic practices. Rice describes shouting between cells, eavesdropping on conversations, and escaping into music as examples of how people might achieve this kind of agency. Making audio drama allowed us to use soundscape intentionally with the group, working with the women to represent and reinterpret the sounds of convict ships, early prisons, and missions; using found objects and props brought in from outside, and juxtaposing these with the contemporary recorded soundscapes of BWCC. In these moments, the women rushed around a seemingly empty institutional classroom finding things that they could use to create Foley effects. They scrunched up pieces of paper and plastic bags to recreate the sounds of wind in the gumtrees and crackling fires in the Gadigal camp. They filled a waste paper bin with water to approximate waves lapping on the beach. They turned tables over and walked on the wood to signify the officers marching on the *Lady Juliana*'s upper deck. They used the screech of a rotating metal magazine rack to represent an old rusty windmill in the mission. This required an active, creative, playful kind of listening as they repurposed and reframed the institutional space in order to build the imaginary world of the play. Participants later reported that this had been one of the most engaging aspects of the creative process. In another potential example of acoustic agency, two of the Aboriginal women in the group performed a scene in white-voice, depicting police officers arresting the character "Mary" for vagrancy and sending her to Old Boggo Road Gaol. Having been on the receiving end of this treatment themselves, these two women played the scene for humour, and seemed to relish the opportunity to be playful with the roles of police officers and to co-opt the voices of white male authority.

Listening across time, distance, and difference

In his work *The Art of Listening*, Back (2007: 237) suggests "our culture is one that speaks rather than listens. From reality TV to political rallies, there is a clamour to be heard, to narrate and gain attention." He encourages an orientation towards "artful" listening in sociology, which involves openness to others: "The task is to link individual biographies with larger social and historical forces and the public questions that are raised in their social, economic and political organisation" (23). It was precisely this kind of listening that *Daughters* invited for audiences outside the prison, to make connections between the historical and contemporary stories being represented in the audio work, and Australia's ongoing carceral legacy. According to our post-performance surveys, several audience members at both prison and public listening events felt strongly affected by the authenticity of the contemporary women's voices representing historical stories of incarceration. In addition, the historical story in *Daughters* was juxtaposed with accounts of the contemporary women's experiences. Perhaps the most compelling example of this was in relation to the "black hole", an underground punishment cell in Old Boggo Road Gaol that was accessed via a trapdoor, and secured by two further doors that ensured total darkness. According to the Boggo Road Gaol Historical Society (n.d.), a superintendent in the 1980s declared, "Even with both

doors open, the darkness inside the cell was incredible. The air was foul and the floor was usually covered with water from underground seepage." To evoke this atmosphere, we recorded the superintendent's voice and footsteps with high levels of reverberation, barking orders to "Mary" to descend the stone steps into the cell where we used stock audio of dripping water, squeaking rats eerily underscoring Mary's spoken monologue. While we were creating this scene, one of the participants recorded a diary entry based on one of her own experiences of being sent to the "care bears" or protection unit, in her eyes, the contemporary equivalent of the black hole.

> I had some bad news and the counsellors wanted to talk to me. I refused to talk to either one of them, so they decided to send me to S4, which we call the "care bears" unit – a place where girls go that don't cope. Well, when I got there, I was soon stripped of all my dignity, as they took all my clothes off me and put me in a heavy white and blue striped gown and paper knickers. I remember just breaking down and crying. In the cells of the care bears unit, there was only a thin grey mattress and a blue and white heavy blanket. It was cold, and the light in our cell never turned off. I was so lonely at some times.

The transition from the black hole to the "care bears" monologue was achieved with one of the BWCC doors slamming loudly, leading into a stock ambient soundscape of a contemporary women's prison,[6] which included radio chatter, murmuring voices, and squeaking footfalls on the polished synthetic floors. The dark gothic horror of the black hole found a contemporary parallel in the stark, empty, brightly-lit space of the protection unit. In the creative process, and the finished piece, participants and audiences were invited to engage in a kind of auditory continuity between the past and the present.

Being focused on audio performance enabled the work to reach across distance to and from prisons in other countries, firstly through our collaboration with the women in HMP Styal in the UK whose performances of convict women on the *Lady Juliana* opened the drama. When we first played these recordings to the women in Brisbane, they spoke about how exciting it was to collaborate with women on the other side of the world, and how "realistic" it was to have English accents voicing the roles of female convicts. I also shared the performance work with incarcerated men from William Head on Stage, a long-running prison theatre company on Vancouver Island, Canada. Presenting the work to them prompted us to have a frank and thoughtful discussion about the politics and small practicalities of incarceration in both countries. Some men were interested in the Australian prison's security mechanisms and daily routine. A couple of the First Nations men in the group were interested in the parallels between over-incarceration in Canada and Australia. But more than this, the men showed a deep compassion and empathy for these unknown, unnamed women on the other side of the world. They felt that the women were disadvantaged because they did not have their own ongoing theatre company. They recently went on to record their own contemporary diary entries to send back to the women in Australia, which we will hopefully be sharing at BWCC in the future.

Back (2007:4) suggests "the art of listening is an invitation to engage with the world differently without recourse to arrogance but with openness and humility." From an Indigenous methodological perspective, this idea can also be found in the concept of *dadirri*, a traditional practice of "inner, deep listening and quiet, still awareness" brought to prominence by Aboriginal educator, artist and activist Miriam-Rose Ungunmerr (2017). The word *dadirri* comes from the Ngan'gikurunggurr and Ngen'giwumirri languages of the Aboriginal peoples of the Daly River region (Northern Territory, Australia). Ungunmerr describes how important listening is in this practice: "We learnt to listen from our earliest days. We could not live good and useful lives unless we listened. This was the normal way for us to learn – not by asking questions. We learnt by watching and listening, waiting and then acting" (14).

Ungunmerr's description of *dadirri* foregrounds the importance of listening as an ethical practice, enabling us to live a "good and useful" life. The turn towards a politics of listening in cultural studies is described by Bassel (2017) as being connected to, but distinct from the *art* of listening. Speaking about the rise of participatory media such as digital storytelling, Dreher (2012: 142) urges "a greater commitment to political listening in media research, practice and policy, lest the promise of 'voice' remain only partially fulfilled." Swan (2017: 554) suggests, "Political listening has a clear aim of producing social change through a kind of consciousness-raising rather than being an interpersonal relation of consensus, empathy, therapy or friendship." *Dadirri* can be viewed in a similar way, and indeed, scholars such as West et al. (2012) have brought this cultural practice into conversation with ideas from, in their case, Freire and Habermas, to develop a critical Indigenist research methodology. Although Atkinson (2017) embraces *dadirri* as a therapeutic model for healing the traumas of colonisation, she articulates this as very much a collective process, intimately tied to the settler-colonial politics of our nation. She also warns, "With listening comes a responsibility. It forces us to listen to ourselves." This attentiveness to reflexivity reflects the process of destabilisation and decentring that is brought about for white researchers, practitioners and activists who are engaged in the process of "listening across difference" (Dreher, 2009). As Swan (553) therefore suggests, "Listening is not a feel-good panacaea," and drawing on Sara Ahmed (2004), she urges those of us who represent the dominant culture to resist the need to "make a difference" or do good in an effort to "transcend the conditions of white power" (547).

Listening in these ways became key to the cross-cultural creative process in *Daughters* where, as with all applied performance processes, ethics and politics were integral to the aesthetics of listening for participants and audiences alike. At this point it seems appropriate to return to the idea of truth-telling as a key component of healing and reconciliation in Australia. Successive Australian governments have managed to sidestep the important process of officially sanctioned truth-telling in which other countries, such as Canada and South Africa, have engaged through their truth and reconciliation commissions. And yet our cultural landscape is replete with examples of how Indigenous and non-Indigenous Australian theatre makers, filmmakers, novelists, visual artists and storytellers collectively attempt to deal with the traumas of our nation's founding. Making theatre based on difficult historical "truths" moves us beyond the truth-teller/witness binary of the truth and reconciliation commission, into an aesthetic space that reflects the complexity and intimacy between the past and the present, Indigenous and non-Indigenous, coloniser and colonised (see Robinson and Martin, 2016).

In the 2015 version of *Daughters*, the convict women's diary entries were written by both Indigenous and non-Indigenous group members, poetically exploring the hopes, fears, regrets, and dreams of these fictionalised women as they were leaving Portsmouth, England. The drama then shifts perspective onto the shoreline of southern Australia, where a group of Gadigal people observe its passage along the coast towards their homeland. Some of the content from these moments came from an early devising session, where we had invited the women to create tableaux of the ship approaching Australia with the convict women watching the shore, and a group of traditional owners on the shore watching the ship. Without any prompting from the facilitators, the group divided along racial lines, and the Aboriginal women in the room created an image of the Gadigal people looking on as the ship arrived. Some of the women playfully imitated the early colonial depictions, holding spears and standing on one leg. In order to move past this stereotypical colonial imagery, we invited the women to consider the emotions that they would be feeling as they watched the ship approaching, and their bodies and faces instantly changed, reflecting surprise, concern, and curiosity, and telling a much more meaningful and emotionally resonant story. When it came to creating a tableau from the ship, many of the Aboriginal women participants were happy to step up and take on the roles of English women convicts, depicting a similar range of emotions as they watched the shoreline. In a seemingly

inadvertent nod towards the aesthetic, Back (2007) argues, "Thinking with all our senses can change our appreciation of ethics in a multicultural society" (p. 8). This small example reflects much of the devising process in *Daughters,* which invited us to listen to the contemporary reverberations of history, and to each other, interpreting and representing these stories in ways that we hoped would be aesthetically engaging for ourselves and our listening audiences. In this way, it could be seen as embodying the aesthetics of listening in every sense. Speaking about the project later, both Indigenous and non-Indigenous women reflected that they valued the opportunity to educate themselves and their audiences about the experiences of these historical women, and specifically, the post-contact experiences of Aboriginal and Torres Strait Islander peoples.[7]

Ethical tensions: Compromising acoustic agency

As my engagement with Aboriginal and Torres Strait Islander women has deepened over the course of these projects, I have been forced to confront my own biases and complicity in the colonial project, and try to challenge them. Acclaimed Australian author Peter Carey recently spoke of why he has finally come to confront Australia's colonial past as a white author, declaring: "You wake up in the morning and you are the beneficiary of a genocide" (Convery, 2017). The *Daughters* project therefore became pivotal for my own learning and understanding about this fact, where I began to recognise a rare opportunity to explore the potentials and limits of applied theatre to reveal the structures of settler colonialism; and to interrogate with the women the colonial histories and legacies of female and Indigenous over-incarceration in Australia from within this contemporary carceral context. But of course, as Linda Tuhiwai Smith (1999: 4) observes, for the participants in these projects, "Questions of imperialism and the effects of colonisation may seem to be merely academic; sheer physical survival is far more pressing." There were varying degrees of formal education and political literacy among the women in our groups, and my own political literacy in these matters is ongoing. With the time available to us, it was impossible to explore with the group all the complexity and nuances of the political and historical terrain we were covering, and I remain unsure of how many women engaged deeply with the politics of incarceration that underpinned the project.

There were other ethical tensions that also speak to the politics and aesthetics of listening. With the exception of one of our applied theatre students, the production team was entirely non-Indigenous. Having selected the original story of the "Floating Brothel", and the subsequent historical records, materials, and images that we used as stimuli for devising, we (myself in the lead) provided the frame for the drama, acting as mediators of this post-contact story. Although there were high levels of participation and collaboration built into the process, for reasons of logistics, prisoner mobility, and access discussed at the start of this chapter, the production team edited the work offsite, eliminating some of the mistakes that had been made in the recorded vocal performances, and adding certain music and sound elements that heavily influenced the overall aesthetic of the piece. The women were extremely positive about the outcome, and surprised by how "professional" it sounded, but this way of producing work certainly compromised some of the potential for a more sophisticated form of collaboration and acoustic agency.

The biggest blow to acoustic agency occurred when we were restricted from broadcasting the piece publicly. One of the key goals of the project was for the women's work and voices to reach a wider audience through our partnerships with community and prison radio organisations both in Australia and the UK, and by making the work available online as a podcast. Management at BWCC initially approved these broadcast elements of the project, and continued to allow the project to unfold as planned throughout the course of the workshop programme for 2015. But in the end, Queensland Corrective Services refused permission at the

executive level to broadcast the piece on community radio and internet podcast. It seems that there had been some kind of error or miscommunication within their bureaucratic processes that led to this occurring. After I sent a letter of appeal, they upheld the decision, stating that the content of the piece did not "meet community expectations" for Queensland Corrective Services, and could potentially be "confrontational for listeners." They did not elucidate how and why this might have been the case, but unfortunately the decision resulted in the continued marginalisation of the group by denying them a wider public voice.

Conclusion

At the start of this chapter, I reflected on Joy James' statement about the agency that might come from intimacy, and I have gone on to explore how this intimacy might be achieved in participatory audio drama – or any applied performance work – as an aesthetic process of "listening across difference" (Dreher, 2009). The story of the "Floating Brothel" served as a symbolic marker for our cross-cultural meeting in the prison. It provided a creative space where Indigenous and non-Indigenous women (myself included) could be playful, learn from each other, and critically engage with the systems of incarceration that had brought us together in that time and place. My experience of this project has informed how I have since approached my practice in the prison, moving now towards Aboriginal and Torres Strait Islander co-design and leadership.[8] The art of listening and the call for *dadirri* invite me to stop talking, to take pause from the constant stream of information I receive, to reconnect myself with my environment and with others, and to interrogate the concept of "giving voice." There is no real way of knowing whether the work I have described here did, or will, move us from smaller moments of micro-empowerment into the level of agency that might bring about wider systemic change. Following Swan's (2017) comment above, maybe it is time for me to stop thinking about the process in these terms. Instead, I deliberately embrace Back's phrase, "the art of listening", in the same way as I do the "the art of living" that is present within pragmatist aesthetics (Shusterman, 2000). Much as Indigenist knowledge systems refuse to separate the inseparable, conceiving art in this way acknowledges ethics, politics and aesthetics as being inseparable aspects of relationality, cultural production, and everyday life. At its best, I would suggest applied performance is certainly an art of listening. Practitioners and participants come together in a heightened space of intimate encounter, making work together from the heart. This work is built on the notion of sharing stories, reading emotional resonances, and finding ways to ethically represent shared "truths" within the wider flows of culture and politics. And to do this in ways that will encourage us all – facilitators, participants, and audiences – to *listen*.

Author's note

The research discussed in this chapter was completed with support from Queensland Corrective Services. The views expressed herein are solely those of the author and in no way reflect the views or policies of Queensland Corrective Services.

Notes

1 Our understanding of the Floating Brothel story came predominantly from the BBC Timewatch series The Floating Brothel (2006), a historical novel by Sian Rees (2001), a personal account by one of the crewmen John Nicol (Nicol and Flannery 1997), and the brief description in Robert Hughes' *The Fatal Shore* (1987).
2 This came out of the landmark report *Bringing them home: Report of the National Inquiry into the Separation of Aboriginal and Torres Strait Islander Children from their Families* (Wilson 1997), which detailed the extent and impacts of government policies of forced removal that were carried throughout the early nineteenth century up until the 1970s. For many in Australia, the term 'Stolen Generations' has become a kind of

short-hand for the cruel acts of separation, institutionalization, physical and sexual abuse and neglect that have resulted in widespread intergenerational trauma among aboriginal peoples.
3 This shameful, well-documented phenomenon has continued to exist in the Australian criminal justice system since the Commission of Inquiry into Aboriginal Deaths in Custody 25 years ago (Johnston 1991). Despite a number of recommendations tabled in the report eighteen years ago, there have been at least 136 reported deaths in custody since 2008 alone (The Guardian 2018).
4 For this, we established a partnership with the Prison Radio Association (PRA) in London, who work with women in HMP Styal to produce radio. We had planned for PRA to broadcast our work through their network, but this was made impossible by the broadcast embargo. For more information on PRA, see https://prison.radio/.
5 Our understanding of the history of Boggo Road Gaol came largely from print and online resources published by the Boggo Road Gaol Historical Society (n.d.). These outlined the daily life and routine at the gaol, and included historical news clippings and photographs of the site, and the women who were imprisoned there.
6 For security reasons, we were only able to record sound at BWCC inside the classroom where we were working, not elsewhere within the Centre.
7 This is detailed further in the chapter entitled "Daughters of the Floating Brothel: Engaging Indigenous Australian women in prison through participatory radio drama" (Woodland, 2020).
8 This shift in approach is outlined in a forthcoming chapter entitled "'This Place is Full of Drama Queens': Reflecting on the Value of Drama in a Women's Prison" (Woodland).

References

Ahmed, Sara. *The Cultural Politics of Emotion*. Edinburgh: Edinburgh University Press, 2004.
All That Fall. By Samuel Beckett. Dir. Gavin Quinn. Perf. Pan Pan Theatre Company Brisbane Powerhouse. 11–16 February 2014. Performance.
Atkinson, Judy. *Trauma Trails, Recreating Song Lines: The Transgenerational Effects of Trauma in Indigenous Australia*, Vol. 1. North Melbourne: Spinifex Press, 2002.
Atkinson, Judy. "The Value of Deep Listening - The Aboriginal Gift to the Nation." Published August 1 2017, TEDxSydney Video. Accessed 3 December 2018 https://www.youtube.com/watch?v=L6wiBKClHqY.
Australian Law Reform Commission. *Pathways to Justice – Inquiry into the Incarceration Rate of Aboriginal and Torres Strait Islander Peoples*, Final Report No 133. Sydney: ALRC, 2017. Accessed 3 December 2018. https://www.alrc.gov.au/publications/indigenous-incarceration-report133.
Back, Les. *The Art of Listening*. Oxford: Berg, 2007.
Baim, Clark, Sally Brookes, and Alun Mountford. *Geese Theatre Handbook: Drama with Offenders and People at Risk*. Winchester: Waterside Press, 2002.
Baldry, Eileen, Bree Carlton, and Chris Cunneen. "Abolitionism and the Paradox of Penal Reform in Australia: Indigenous Women, Colonial Patriarchy, and Co-Option." *Social Justice* 41, no. 3 (2015): 168. https://www.jstor.org/stable/24361638.
Bartels, Lorana, and Antonette Gaffney. *Good Practice in Women's Prisons: A Literature Review*. Technical and Background Paper No 41. Canberra: Australian Institute of Criminology, 2011. Accessed 3 December 2018. https://papers.ssrn.com/sol3/papers.cfm?abstract_id=2188681.
Bassel, Leah. *The Politics of Listening: Possibilities and Challenges for Democratic Life*. London: Palgrave Macmillan, 2017.
Boggo Road Gaol Historical Society. "Inside Boggo Road: The Black Holes." n.d. Accessed 10 February 2019. https://www.boggoroadgaol.com.au/2015/10/the-holes.html.
Bottomley, Andrew. J. "Podcasting, Welcome to Night Vale, and the Revival of Radio Drama." *Journal of Radio & Audio Media* 22, no. 2 (2015): 179–89. doi:10.1080/19376529.2015.1083370.
Casella, Eleanor Conlin, and Clayton Fredericksen. "Legacy of the 'Fatal Shore': The Heritage and Archaeology of Confinement in Post-Colonial Australia." *Journal of Social Archaeology* 4, no. 1 (2004): 99–125. doi:10.1177/1469605304039852.
Convery, Stephanie. "Peter Carey: 'You Wake up in the Morning and You Are the Beneficiary of a Genocide'." *The Guardian*, 18 November 2017. Accessed 3 December 2018. https://www.theguardian.com/books/2017/nov/18/peter-carey-you-wake-up-in-the-morning-and-you-are-the-beneficiary-of-a-genocide.
Dewey, John. *Art as Experience*. New York: Capricorn, 1934.
Dreher, Tanja. "Listening Across Difference: Media and Multiculturalism Beyond the Politics of Voice." *Continuum: Journal of Media & Cultural Studies* 23, no. 4 (2009): 445–58. doi:10.1080/10304310903015712.

Dreher, Tanja. "A Partial Promise of Voice: Digital Storytelling and the Limits of Listening." *Media International Australia* 142, no. 1 (2012): 157–66. doi:10.1177/1329878X1214200117.

Hegarty, Ruth. *Is That you, Ruthie?* Brisbane: University of Queensland Press, 1999.

Hughes, Robert. *The Fatal Shore.* London: Collins, 1987.

James, Joy. "The Captive Maternal and Abolitionism." *Keynote Lecture Presented at the Carceral Cultures Conference,* March 3. Vancouver: Canadian Association of Cultural Studies, Simon Fraser University, 2018.

Jorm, Anthony F., Scott B. Patten, Traolach S. Brugha, and Ramin Mojtabai. "Has Increased Provision of Treatment Reduced the Prevalence of Common Mental Disorders? Review of the Evidence from Four Countries." *World Psychiatry* 16, no. 1 (2017): 90–9. doi:10.1002/wps.20388.

Joseph, Sue, Bunty Avieson, and Fiona Giles. "Memoir for Your Ears: The Podcast Life." In *Mediating Memory*, edited by Bunty Avieson, Fiona Giles, and Sue Joseph, 114–32. Oxford/New York: Routledge, 2017.

Law Society of Western Australia. "Issues That Contribute to the Incarceration of Aboriginal and Torres Strait Islander Women in Western Australia." Briefing paper, October 2017. Accessed 26 January 2019. http://www.lawsocietywa.asn.au/wp-content/uploads/2015/10/2017OCT06_LawSociety_BriefingPapers_IssuesContributeIncarceration_ATIPWA.pdf.

Lim, Michelle H. *Australian Loneliness Report: A Survey Exploring the Loneliness Levels of Australians and the Impact on Their Health and Wellbeing.* Melbourne: Australian Psychological Association and Swinburne University, 2018. Accessed 26 January 2019. https://psychweek.org.au/wp/wp-content/uploads/2018/11/Psychology-Week-2018-Australian-Loneliness-Report-1.pdf.

McKean, Annie. "Playing for Time in 'The Dolls' House': Issues of Community and Collaboration in the Devising of Theatre in a Women's Prison." *Research in Drama Education: The Journal of Applied Theatre & Performance* 11, no. 3 (2006): 313–27. doi:10.1080/13569780600900685.

Referendum Council. *Final Report of the Referendum Council.* Canberra: Department of Prime Minister and Cabinet, 2017. Accessed 3 December 2018. https://www.referendumcouncil.org.au/sites/default/files/report_attachments/Referendum_Council_Final_Report.pdf.

Rice, Tom. "Sounds Inside: Prison, Prisoners and Acoustical Agency." *Sound Studies* 2, no. 1 (2016): 6–20. doi:10.1080/20551940.2016.1214455.

Robinson, Dylan, and Keavy Martin. (Eds.). *Arts of Engagement: Taking Aesthetic Action in and beyond the Truth and Reconciliation Commission of Canada.* Waterloo: Wilfrid, Laurier University Press, 2016.

Shusterman, Richard. *Pragmatist Aesthetics: Living Beauty, Rethinking Art.* 2nd ed. Lanham: Rowman & Littlefield Publishing Group, 2000.

Smith, Linda T. *Decolonizing Methodologies: Indigenous Peoples and Research.* London: Zed Books, 1999.

Swan, Elaine. "What Are White People to Do? Listening, Challenging Ignorance, Generous Encounters and the 'Not Yet' as Diversity Research Praxis." *Gender, Work & Organization* 24, no. 5 (2017): 547–63. doi:10.1111/gwao.12165.

Swiatek, Lukasz. "The Podcast as an Intimate Bridging Medium." In *Podcasting: New Aural Cultures and Digital Media*, edited by Dario Llinares, Neil Fox, and Richard Berry, 173–87. London: Palgrave Macmillan, 2018.

Ungunmerr, Miriam-Rose. "To Be Listened to in Her Teaching: Dadirri: Inner Deep Listening and Quiet Still Awareness." *EarthSong Journal: Perspectives in Ecology, Spirituality & Education* 3, no. 4 (2017): 14–5.

Verma, Neil. *Theater of the Mind: Imagination, Aesthetics, and American Radio Drama.* Chicago: University of Chicago Press, 2012.

West, Roianne, Lee Stewart, Kim Foster, and Kim Usher. "Through a Critical Lens: Indigenist Research and the Dadirri Method." *Qualitative Health Research* 22, no. 11 (2012): 1582–90. doi:10.1177/1049732312457596.

Williams, Lesley, and Jo Besley. "The Cherbourg Memory." Cherbourg: The Ration Shed Museum, n.d. Accessed 2 February 2012 http://cherbourgmemory.org/.

Willingham, Richard. "Victoria's Female Prison Population Hits Record Levels." *The Age*, December 6 2015. Accessed 22 March 2017. http://www.theage.com.au/victoria/victorias-female-prison-population-hits-record-levels-20151204-glfgrp.html.

Wilson, Robbie Z. "Welcome to the World of Wandercast: Podcast as Participatory Performance and Environmental Exploration." In *Podcasting: New Aural Cultures and Digital Media*, edited by Dario Llinares, Neil Fox, and Richard Berry, 273–98. London: Palgrave Macmillan, 2018.

Woodland, Sarah. "Magic Mothers and Wicked Criminals: Exploring Narrative and Role in a Drama Programme with Women Prisoners." *Applied Theatre Research* 1, no. 1 (2013): 77–89. doi:10.1386/atr.1.1.77_1.

Woodland, Sarah. "The Art of Living in Prison: A Pragmatist Aesthetic Approach to Participatory Drama with Women Prisoners." *Applied Theatre Research* 4, no. 3 (2016): 223–36. doi:10.1386/atr.4.3.223_1.

Woodland, Sarah. "Daughters of the Floating Brothel: Engaging Indigenous Austrlaian Women prisoners through Participatory Radio Drama." In *Applied Theatre: Women and the Criminal Justice System*, edited by Caoimhe McAvinchey, 79-104. London: Bloomsbury Methuen Drama.

PART II

The Balkans

INTRODUCTION TO PART II AND III

Memory, identity and the (ab)use of representation

Kirsten Sadeghi-Yekta and Darko Lukić

Author Carlos Ruiz Zafón writes in the *Shadow of the Wind* that "one feels freer speaking to a stranger than to people one knows ... because a stranger sees us the way we are, not as he wishes to think we are" (Zafron, 2004: 177). The work on this book has brought two complete strangers, Kirsten and Darko, together to reflect on their edited chapters in this compendium. An experimental comparison between Eastern Europe and North America; in Zagreb, Croatia and Vancouver, Canada, between two scholars and theatre practitioners. Zafón had a point. It is exciting that in a process of such free and unlimited dialogue foreigners are stopped from being strangers. What Kirsten and Darko have learned from each other and what they found similar in their chapters – even though the authors and topics are an ocean away from each other – was very useful for both of them.

Memory, remembrance and remembering the past: one of the most obvious themes that comes to mind while reading over the North America and South-Eastern European chapters. The psychological, social and artistic consequences of artists and people in general living in wars and facing its atrocities are in multiple ways described in these chapters. Perhaps in a more urgent manner in South-East Europe as the last war in the Balkan region is still so fresh and ever present. Nonetheless, in North America, people (still) suffer from similar issues due to their lives or work in wars overseas, as described in the chapter by George Belliveau, Susan Cox, Jennica Nichols, Graham W. Lea and Christopher Cook on veterans and research-based theatre. The veterans in this arts project have taken responsibility after realizing that their past would haunt them without taking any action. For them, working with theatre has assisted them through many intricate issues. The political influence (and direct and indirect pressures on theatre) based on the post-colonial approach to the loss of history and memory in the North American chapters, could be easily compared with the situation in ex-Yugoslavia analyses in the South-East European chapters. The new identity creation, with the loss of previous identities, as well as the activism in representation of different memories could be found in most of the essays in these chapters. The process of the construction of new identities and new collective narratives which will contribute to consolidation of new ideologies and new national mythologies, precisely followed the pattern marked by Mark A. Wolfgram (2014) for all the authoritarian systems and ideologies. Very unstable individual temporary memories produced long-term memory storages which tended to become permanent and stabile. Such processes were executed with strong

outer pressure and its creation of meaning was highly dependent on chosen cultural matrixes. (see Wolfgram, 2014: 15–17).

Another North American chapter working through remembrance, identity, and memory is Carrie MacLeod's chapter on the ongoing refugee struggle. She asks, "Who speaks for whom? Whose voices are inflected in the normative white noise? As most migration theories are constructed around who is moving across the horizon, it is also worth asking who is assuming aesthetic responsibility for our shared human condition" (2019). North American contributors Diane Roberts and Jill Carter write about some of these questions as well and emphasize the significance of the ancestral memory of indigenous peoples and diaspora artists in Canada. Both chapters also address the challenges of cultural representation, as well as topics such as identity, justice, representation, and legalislative activism, which we can clearly recognize as the common in all chapters.

Jasna Ćurković Nimac asks, during the 51st Annual Conference of the Societas Ethica in 2014, "Is memory the root cause of violence or a path to violence avoidance?" By researching the ethics of memory, Nimac interrogates its relation to values and obligations. These values and obligations of memory, and how to ethically work through these concepts, are at the root of most of all the chapters.

In the South-Eastern European section, concepts include: representation, resistance, reconciliation, social activism, social changes via the medium of theatre, minorities, marginalized groups, and, again, memory. The experiences of Vladimir Krušić, the witnessing of Ljubica Beljanski-Ristić and Sead Đulić, the research of Nikolina Židek or the examples of Teatar Tirena are very similar examples of applied theatre responses to the social environment in different Balkan countries (recently at war with each other).

In the North American section, the authors also explored a range of concepts including: Hana Worthen's social activism in musicals; Julia Gray, Jenny Setchell and Helen Donnelly's practice around clowning and health; Hannah Fox's conductor's experience in Playback Theatre; Yasmine Kandil's pedagogical approach to community-based theatre; Asif Majid and Elena Valesco's virtual dialogue on social justice issues; and Warwick Dobson and Lauren Jerke's research on theatre with gatekeepers.

Each society, as Paul Connerton (1989) reminds us, persistently repeats different commemorative social ceremonies. Such social rites contain highly selected social memory, from commemoration the changes of the seasons through religious calendars with its holidays and festivities to the commemorative ceremonies of reproducing national mythologies. In the process of negotiating and harmonization between individual, collective, national and transnational memories there is an inevitable discrepancy between two different levels of memory – personal and social. National mythologies were built on carefully selected particles of memory which became the material for building of the collective memories, preserved and reproduced through the national educational and cultural institutions. In such process of selection, the main procedure was what Paul Ricoeur (2004) called "the censure of memory". On the contrary, applied theatre gives the voices and right for the truthfulness for all the different memories and witnessing, especially the ones which are opposing the "official versions" of memory and history. Such performances overcame and challenged oversimplified collective templates and patterns based on the dualism of "we and they", "aggressors and victims", "good guys and bad guys". As Alex Danchev (2016) explains, each serious understanding of culture should be rooted out of the binary discourse of black and white, because the real culture and real-life are always happening in the "grey zone" between the two-dimensional space of the "black and white" extremes. Applied theatre challenges such black and white images by its disturbing and exciting plays of the myriad shades of grey shadows, bringing onto the stages of collective histories frightening

phantoms, corpses from the national closets, the ghosts of the innocent victims, faces of the atrocities, and Erinyes of the bad consciences. And in all these different contexts, applied theatre thrives. It illuminates, as it challenges, questions and reflects on the dominant narratives. Where many agree to the "main narrative" and/or give up on alternatives, applied theatre in many of these dark spaces becomes the "counter-memory", the story that dares to adjust and modify according to the real and genuine facts of the current context.

In the conflict between personal witnessing and collective memories, applied theatre opens the space in which a variety of different memories and different narratives could be presented and represented. On the other side of the official history, many different and even opposite personal histories fund the stage to be performed. And such theatre could more and more admonish, point to the bleached bloody stains on the blank pages in the books of national memories, speak in the name of that which has been silenced, erased, removed, and could also constantly challenge still fragile new mythologies and new monuments. Such theatre could, as Mark Wolfgram (2014) puts it, confront "counter-memory" to the "main narrative".

The new identity creation and the loss of previous identities is a reoccurring theme in many of our chapters, as well as on one of the main foci of applied theatre: its audience, its participants, its collaborators. If identity creation is so significant for the artists in both geographic sections of the volume, what impact does that have on its audiences? To whom does theatre belong then? The performers, the audience, the community, all equally? Perhaps "a manoeuvring space for political activism … found somewhere in-between cultural production and social activism?" (Lukić, 2016: 281) as the queries on identity in applied theatre indeed quickly focus on political activism. In such situations, the theatre is the perfect place for asylum, the perfect shelter for creative processes. As a place for representation of the forgotten, neglected or even forbidden memories, applied theatre appears as a space opened for invisible images, untold stories, erased histories and neglected persons. Applied theatre becomes the stage for confrontation and for representation of all the memories, which had no place in the official version of the collective memory. Everything that was carefully excluded and erased from cleansed and selected versions of new dominant narratives and governing mythologies suddenly recognized its possibility and its chance in such applied theatre actions.

References

Connerton, Paul. (1989) *How societies remember*. Cambridge: Cambridge University Press.
Danchev, Alex. (2016) *On Good and Evil and the Grey Zone*. Edinburgh: Edinburgh University Press.
Lukić, Darko. (2016) *Uvod u primijenjeno kazalište - Čije je kazalište? / An Introduction to Applied Theatre - Whose is the Theatre?*. Zagreb: Leykam International.
Ricoeur, Paul. (2004) *Memory, History, Forgetting*. Chicago & London: The University of Chicago Press.
Wolfgram, Mark A. (2014) *Getting History Right: East and West German Collective Memories of the Holocaust and War*. Lewisburg: Bucknell University Press.
Zafron, Carlos Ruiz. (2004) *The Shadow of the Wind*. London: Orion.

6
PERFORMING THE OTHERNESS
Representation of the invisible communities in post-conflict and post-communist societies: Croatian example

Darko Lukić

In my theoretical research and practical work dedicated to various issues, I try to find answers (and those are then reflected in the titles of some of my books) to a number of questions, such as the "whos," "whats", "whys," and "hows." In this specific case, the following questions need addressing: "What is theatre, who needs it, and why?" These questions, comprising mostly of "hows," have always revolved around the one very important point and the most important question that has never been raised, i.e. "with whom" or "for whom." These questions have opened an entirely new space for my further research, focusing on continual testing and questioning based on the question "to whom does theatre actually belong?" Does it belong to its owners or founders, as we know from our experience in production or theatre management? Does it belong to the audience, as we know from our knowledge of cultural anthropology and sociology of theatre? Does it belong to performers, as we know from performance studies? Does it belong to the community inside of which it operates, as we research in the studies of social context and cultural policies? Or does it belong to all of those categories simultaneously? To which extent and in what proportions?

Questions like these arise naturally and they can be plausibly answered within the context of applied theatre. However, after tackling various theatrical topics in post-totalitarian societies, and, unfortunately, in post-conflict societies as well, from both theoretical and practical perspectives and after confrontation with numerous problems inherent to such environments, with which the distribution of cultural production simply has to deal, I was forced to repeatedly ask the same questions but also to ponder the same answers. Issues such as the accessibility and availability of theatre in societies with fragile civil society standards and deficient democratic tradition, which at first sight focus on diverse theories of theatre, subsequently evolve into first-class political issues. Moreover, they become a manoeuvring space for political activism. Because of that, applied theatre in those societies can always be found somewhere in-between cultural production and social activism since the inclusion of those who are excluded and providing visibility to those who are marginalized in applied theatre projects is closely linked to fields such as local reshaping of various preconditions, networking, and layering of those local activi-

ties, which results in raising awareness and thus changing the existing relations of inequality on long-term bases.

Public theatres are financed by public funds or taxpayers' money. In line with that, they should be accessible and available to everyone. Is that really the case? At first glance and on the surface, this seems to be the case. Any kind of in-depth research into their accessibility and availability, as well as research into representation and participation, proves the opposite. As well as all other cultural and public institutions, especially those subsidized with public funds, theatre has always been utilized to express and reflect the ruling majority, its beliefs, needs, aspirations, and (world) views. At the same time, the question of who receives cultural products according to their own aspirations, needs, expectations, and taste on the one hand, and who remains left behind and denied the access and right to representation on the other has always served as a reliable and indisputable indicator of all those symptoms defining a social community, as well as the level of its democratic development.

By redirecting the focus of my research to those individuals, groups, and communities to which I collectively refer as "invisible audiences" and "invisible performers," my intention was to identify the state of society and the cultural public in Croatia over the past 10 or 15 years. (Thanks to my frequent and intensive professional encounters with the neighbouring countries, I managed to obtain a fairly clear insight into the situation with applied theatre in Serbia, Bosnia and Herzegovina, and Slovenia, and subsequently, a better insight into various experiences in Poland, the Czech Republic and the Slovak Republic, which proved to be very useful for comparative references.) I use the syntagm "invisible audiences," primarily to describe the concept of "ineligible audience(s)" broadly covering the inappropriate, divergent, undeserving, unimportant, unwanted, unavailable, unacceptable, unreachable, and unrecognized audience.

My research over the past few years has been entirely focused on the "invisible" phenomena in contemporary Croatian theatre. By "invisible," I am not only implying the invisible audience and the invisible performers but also the invisible topics, problems, poetics and aesthetics, as well as those invisible illogical phenomena and invisible injustices made, as well as invisible abuses and various models of submission or privilege. At first glance, such phenomena remain invisible because they have been camouflaged so meticulously or because they are deeply rooted in the monocultural perception of theatre, so deeply that it is very difficult to determine them as the established hegemonic practices. In my research, I also paid special attention to unique and unrepeatable individual approaches as well as the fact that the specific nature of applied theatre and its specific context is "at once its strength and its limitation." That expression is based on "personal rather than master narratives; a plurality of voices rather than a spokesperson on behalf of the group" (Prentki, 2009a: 364).

As a result of that segment of my research, I published a book titled *Introduction to Applied Theatre*. The book was published in Zagreb in 2016. It is a multidisciplinary work that has opened a number of new sub-disciplines in my theatre analysis at the time. However, with the publishing of that book that uses various examples of applied theatre to describe different procedures relevant for the construction of social norms in theatre and with theatre, i.e. the norms supported by the predominant positions in society in line of which they are constructed and which construct them, my research did not come to an end. On the contrary, the book was only the beginning, a trigger for a number of other new activities. The experience to date showed that there is a vast and yet unexplored, curious, and very interesting space for topics such as representation, presentation, and visibility of marginalized audiences, performers, themes, and procedures in contemporary Croatian theatre, as well as for different representation practices operating in the context of cultural policies and, even more so, through various political aspects of culture. In the field of applied theatre, one can observe, and also deconstruct, analyse, and pro-

voke, diverse socially rooted patterns of dominance and discrimination, privilege or submission as well as procedures utilized to "normalize" the viewpoints of the majority, which usually use theatre to systematically impose intolerance inherent in such worldviews or at least to the apparent predominance in comparison with other worldviews. Bearing in mind that no hegemony is ever an absolute category, it is in its nature to try to become absolute.

As a result of many severe problems linked to transitional policies, instability of insufficiently developed democratic institutions, and neoliberal intentions characteristic of neglected, post-conflict and post-authoritarian societies in combination with the lack of or suppression of the independent media, Croatian applied theatre (together with other forms of cultural and art production) managed to find possibilities to become an important and serious arena for challenging, questioning, and disputing hegemonic practices and unprogressive intentions. In the context of an expressed divergence from what used to be called "political theatre" (in my view, an entirely imprecise and largely incorrect concept), applied theatre implies a set of engagement strategies applied through different theatre policies. In order to present those strategies, analyse theoretical approaches and examples of good practice in Croatia, a single book written by myself or somebody else within the Croatian community theatre could by no means provide an answer. Rather, it turned into just another new question raised. Following the publication of *Introduction to Applied Theatre*, I started to intensively investigate the central questions of Croatian theatre: To whom does it belong, to whom does it not belong, who claims to have the right to it and who is denied that right, who has access to performative practices and who is excluded from them, whom does it represent and on whose behalf does it speak, and who has been excluded from such representation therefore being deprived of the right to speak on their own behalf? At the same time, I have always followed the idea that opposition to the mainstream is symptomatic for applied theatre as a rule so that "in circumstances where fear is dominant, it can be a theatre of celebration. In circumstances where celebratory escapism is dominant, it can be theatre of serious enquiry" (Thompson, 2012: xvi). It is clear that in post-authoritarian and post-conflict societies and cultures currently undergoing the process of constructing new collective memories founded in the mythology about the construction of a state, the second type of applied theatre dominates and that is the theatre of "serious enquiry."

In my research, I paid special attention to large groups of excluded citizens to whom access to public theatres still remains denied, and who remain excluded from cultural production, consumption, and distribution despite the fact that they are taxpayers and citizens nominally enjoying equal rights. Generally, I call them "invisible audiences" or "invisible performers" because the intolerant mainstream, with a tendency to exclude, made them socially invisible. When I discuss "invisible audiences," I am mostly talking about a very large number of individuals or entire groups that are being excluded, not only from their practical participation but also from theoretical consideration of concepts such as theatre or theatre audience. Normally, mainstream theatre never takes into consideration those who are unable to access theatre buildings or theatre halls because of their disability (although, pursuant to legislative regulatory requirements, it is becoming obligatory to install wheelchair ramps). Very rarely, and only as an excess, do authorities consider the audience faced with problems such as watching a particular theatre performance if a person has hearing problems or visual impairments, problems with understanding, communication or knowledge of the language and/or culture that a particular theatre represents. Those individuals or groups are not being taken into account on the level of sensibility for special niches within the regular repertoire (by selecting themes that would tackle the problems that those individuals or groups face or the problems that directly concern them) neither on the level of providing an access to regular theatre performances – from making it impossible or very

difficult for them to physically attend a theatre performance to the absence of various means, tools, and devices that are necessary for observing and understanding a play.

Even without any direct, open, or conscious intention to discriminate, by using different methods of exclusion, mainstream theatre makes choices and thus significantly contributes to the pattern of exclusion in the publicly privileged representation of its value system. Elliot W Eisner describes this phenomenon by stating: "Those who control images, those who influence decisions about which images will be shown, those who manage the media control a disproportionate amount of power in the society" (Eisner, 2002: 28).

Taking into account that there are 510,274 registered disabled persons in Croatia, making up about 12% of the total population, and the fact that most of them (268,803 people or 52.7%) fall within the working population category of people aged 19–64 years (Benjak, 2014: 5), it is clear that there is a significant number of Croatian citizens who need special attention in the field of applied theatre of this type. Also, it is apparent that such needs are still largely ignored or neglected and different avenues to resolve the problem are not yet explored or put into use. Disabled persons, of course, represent only one group of all those who are uncared for, marginalized, or invisible (performers and participants, in particular) that need to be taken into account and included in various forms of applied theatre.

Nevertheless, the problem relating to integration and inclusion in theatre in Croatia has been lately taking centre stage only sporadically, both at the level of thematic problematization and the level of performative practices. In that context, it is important to point to several very successful productions, such as *Ana and Mija* (*Ana i Mija*) by Anica Tomić and Jelena Kovačić, produced by the Mala scena Theatre (2010); *Njarabum* by Ana Prolić and Anja Maksić Japundžić, produced by the Eurokaz Theatre Festival (2010) which thematizes eating disorders (anorexia and bulimia); *My Son Just Walks a Bit Slower* (*Moj sin samo malo sporije hoda*) by Ivor Martinić, staged at the Zagreb Youth Theatre (2011); *Difficulties of Sexpressing Oneself* (*Teškoće s izražavanjem*) by Raul Damonte Botana, produced by &TD Theatre (2015); or *Vincent* by Olja Lozica, produced by the Croatian National Ivan pl. Zajca in Rijeka (2015). Those plays address different forms of diversity and social exclusion, ranging from physical disability and gender diversity to neurological and emotional differences. Mala scena Theatre and SKROZ collective jointly produced an educational play for children and youth titled *No, Not You! or on Being Different* (*Ne ti ne! ili o drukčijatost*) directed by Nora Krstulović (2015) following the text written by Kristina Gavran. The play deals with the social invisibility of persons suffering from epilepsy and various problems resulting from gender stereotypes. Apart from tackling the problem of otherness and diversity, it is possible to observe some apparent improvement in terms of inclusive practices in theatre where disabled persons or members of marginalized groups are being involved as performers. On several occasions, Eurokaz, Contemporary Dance Week, and International Theatre Festival hosted different forms of that kind of play in Zagreb. Lately, we have seen the emergence of the domestic art practice in the field, especially so in numerous dance projects by choreographer and dance pedagogue Iva Nerina, or the play titled *A Funny Monster* (*Smiješno čudovište*), produced by Mala scena Theatre in Zagreb (2014). A raised level of awareness about the problem and the necessary care is also apparent in a different approach to various target audiences. There were purposefully adapted performances of two plays, i.e. *Tribes* (*Plemena*) (2014), produced by EXIT Theatre and Planet Art Theatre, and *The Right Thing* (*Prava stvar*), produced by Mala scena Theatre (2014). Unfortunately, in both cases there was no public funding available for this form of care for invisible audiences. The Festival of Equal Opportunities has been in existence since 2002, and Gavella City Drama Theatre has been organising performances suited for the blind and visually impaired persons since 2015, while the Zagreb Youth Theatre has been systematically implementing the action called "inclusive theatre" with subtitles and translations into sign

language since 2016. However, when it comes to a rather deficient Croatian theory, a valuable exception to the rule was portrayed in a special issue of the magazine *Kretanja* (issue no. 22, 2014) published by the International Theatre Institute. The entire issue was dedicated to inclusive performative practices.

A very active dance association named the Integrated Movement Research Collective started operating in Zagreb in 2012. Together with the Zagreb Dance Centre and under the competent professional leadership of choreographer and pedagogue Iva Nerina Sibila and producer Amela Pašalić, the dance association includes disabled persons in numerous and diverse dance projects. Their results are presented at the mini-festival named Inclusive Stages. Their activities have inspired individual art projects by certain disabled artists who initially started collaborating with the Integrated Movement Research Collective only to develop their own inclusive practices after that. Performer, dramaturge, and producer of inclusive projects Vesna Mačković has been active in Zagreb through a number of different performance projects. Her work shows the different performances that disabled performers can provide, and her production from 2015 titled *Intensities* (*Intenziteti*), created in collaboration with theatre director Vedran Hleb, was very successful in the broader Croatian context.

The performance titled *Art Diagnosis* (*Dijagnoza umjetnost*) by Žak Valenta from 2012 deals with issues relating to psychological disorders and defining insanity in the process of art creation. Vrapčići is an association located in Slavonski Brod which was developed for the improvement of psychological wellbeing and quality of life of patients with psychotic disorders and members of their families. It was founded in 2009 with the objective to raise awareness about human and citizen rights of patients with psychotic disorders (schizophrenia, bipolar affective disorder, psychotic depression, severe cases of various personality disorders, etc.), and utilizes applied theatre as one of the forms for their public activities. The association named Srce, located in Split and headed by Slavko Sobin, works with persons with cerebral palsy and autism. The association had a very successful production titled *Heart on Stage* (*Srce na sceni*) in 2014 in the form of a musical performed by young people with different disabilities. The association named DLAN from Zagreb organizes theatre performances that include persons with hearing problems. A project sponsored by the US Embassy in Zagreb in 2014, a play titled *I am... (Ja sam...)*, was the result of collaboration between the Arena Stage theatre from Washington DC and young disabled performers from Croatia, collective named "The Group" (Skupina). The association named Zamisli, founded in 2005 in Zagreb, has been systematically dealing with the quality of education for young disabled persons, including applied theatre practices. The art association named Teatar Erato in collaboration with foreign partners, organizes education in the field of applied theatre in Zagreb since 2014. Also, in Zagreb, the institution called Mali dom, founded in 2001, works with children with various disabilities by developing programmes comprising stage plays, dance therapy, and puppets in combination with other forms of art expression, such as visual arts and music. Also, in Zagreb, there are activities organized by the so-called Theatre for Inclusion. In collaboration with Compagnie Arti-Zanat', Croatian Centre for Drama Education, Faculty of Education and Rehabilitation Sciences, Centre for Education Zagreb, Centre for Education Dubrava, and Youth Centre Ribnjak, they staged an inclusive play named *Enkidu/Gilgamesh* (2016).

Regarding professional performances organized at health care institutions, the puppet studio of the Zagreb Youth Theatre School performed at a children's hospital while the private theatre Smješko from Zagreb took part in the project named "Painless Hospital" by performing for the children in a hospital. Since 2015, there is an ongoing activity named "Red Noses – Clown Medical Doctors" and its founder Zoran Vukić applies contemporary performative techniques to make the stay at the hospital easier for the youngest patients with various diseases. Actor

Dražen Šivak has been continuously organising performances at children's hospitals and has thus developed a wealth of practice in the domain of performances for children.

In respect of performative activities in the domain of delinquent or violent behaviour, such examples in Croatia are still very scarce and occur only sporadically. The correctional facility in Turopolje has a drama section that has been continuously organising activities since 2007 together with the Ardura Association from Šibenik, and in 2008 the actor Stojan Matavulj staged a drama with the convicts at the penitentiary in Lepoglava. The production was very successful, had a guest performance in Zagreb at the Gavella City Drama Theatre, and had good media coverage. Later on, film director Ivona Juka made a documentary about the whole project. In addition to the activities organized by the counselling institution Luka Ritz, the most prominent organisation is the amateur theatre company, initially named Sineki (Sons), which has subsequently expanded its activities to cover other age groups and changed its name to Sineki, tateki, dedeki... (Sons, Fathers, Grandfathers...). The group has been systematically developing its activities, initially comprising (re)socialisation of underage delinquents and then broadening them to cover a wide area of psycho-drama, socio-drama, puppet theatre, therapeutic theatre, and theatre for children, adults and elderly fundamentally focusing on prevention or correction of socially unacceptable types of behaviour.

Through all of the above-described projects, professional theatres, amateur groups, and independent projects merged with community theatre with their individual productions or actions, which was previously a rare or unseen phenomenon in Croatian society. In such a relatively new situation, it is still impossible to establish definite and precise relations between applied theatre and the social environment according to a very useful classification Prentki and Preston offer (2009). They propose a categorisation or a differentiation between the notions of "theatre 'for' a community," where theatre organizes performances or workshops for particular social groups, "theatre 'with' a community," where participants take part in various investigating processes, which can but do not need to result in a performance, and "theatre 'by' a community," where a community produces theatre by performing for a special (its own) audience (Prentki and Preston, 2009: 10). Theatre actor Vilim Matula, in collaboration with theatrologist Nataša Govedić, initiated pioneer work in the domain of community theatre in the framework of the "Workshop on Cultural Confrontation" in which they implemented the theory and practice of Boal's "Forum Theatre" mostly in Zagreb but subsequently also in other parts of Croatia as well. The Curators' Collective BLOK has largely contributed to community theatre with a broad spectrum of artistic endeavours in Zagreb, especially with Urbanfestival that took place in the period 2001–2015. In addition to that, Tirena Theatre has been uninterruptedly implementing projects and educational programmes related to ecology, bullying, process drama, forum theatre, and psycho-drama since 1997. By combining the abundant professional experience of pedagogue Ines Škuflić-Horvat with the youthful enthusiasm of Nina Horvat, this theatre has been nurturing a wide spectrum of various forms of applied theatre while at the same time focusing on community theatre activities. Since 2010, artists Lana Bitenc and Otokar Levaj, together with their company Don Hihot Theatre, have been cultivating different forms of community theatre activities, ranging from educational theatre and working with disabled persons and children with developmental difficulties, to theatre education and theatre for education. Actor Dražen Šivak has been using theatre methods for the education of children both in cooperation with actor Zijah A Sokolović and individually in the framework of the "Theatro Project Croatia." They have also been involved in a preventive project called "Life Without Violence," implemented by the Ministry of Interior Affairs and the United Nations Development Programme. Zijah A Sokolović's performance titled *Violence – There Is No Excuse for It!* (*Nasilje – Za nasilje nema opravdanja!*), produced in 2014 and dedicated to crime prevention and domestic violence,

succeeded internationally as well. Luka Ritz Counselling Centre is active in the field of violence prevention against young people by using forum theatre methods (in 2014, the institution published a brochure with instructions on how to spread the method to all schools and youth centres). Anica Tomić and Jelena Kovačić staged a play, *This Could Be My Street* (*Ovo bi mogla biti moja ulica*) in 2010, inspired by a real incident of fatal juvenile violence that took place in Zagreb. The production was staged at the Zagreb Youth Theatre and according to all its characteristics, it was a direct reaction to the current problem, which is very typical for a community theatre project. The repertoire of the Istrian National Theatre in Pula has been continuously organising summer workshops on forum theatre since 2003 in the framework of the international summer education programme. The theatre programme organized at the Community Centre in Sisak, Teatar mali started producing plays in 2013 under the leadership of Jasmin Novljaković. Ivan Kristijan Majić, theatre director at the Children's Theatre and initiator of the Atelier Drama Studio in Osijek, developed a project for raising awareness about bullying and juvenile violence in 2015.

By initiating the "A Graduated Spectator" programme, having a very active involvement in a number of challenging social topics, and by using the façade as a billboard to communicate with the local community (and broader, by means of the media), the Croatian National Theatre Ivan pl. Zajc in Rijeka has been including many elements of expression typical for community theatre in its programme and communication strategies since 2014. Somewhat more discretely, the Croatian National Theatre in Zagreb has been doing the same since 2014, with its programme named "Open Square Day" (Dan otvorenog trga) and by organising guest performances in rather atypical urban and suburban environments with the project named "The CNT in your District." There are also other similar activities, such as the action "Cultural Incidents" organized by the Croatian National Theatre in Split in 2015. This action implied guerrilla intrusion of artists at the premises of the University of Split. This situation is somewhat atypical in Croatia in comparison to common European experiences where the methods of community theatre are used much more frequently by smaller theatres or theatre companies, regional institutions, or specialized theatres and very rarely by the central national theatre institutions.

For the purpose of observing the methods and effects of community theatre, and a more detailed analysis of their intervention in the social situation in Croatia, I applied the guidelines that Prentki and Preston (2009) use to describe theatre of intervention as the state of "the arrival of some outside force to alter the dynamics of a static situation." Pursuant to this, applied theatre "is the agency of intervention forcing its way into closed worlds (schools, prisons, African villages, old people's homes, aboriginal communities) in order to provoke changes," acting gradually but always efficiently and producing visible impact, "such as dropping a boulder into a stagnant pond" (Prentki, 2009b: 181). Croatian examples of good practice (as well as the other ones, of course) reaffirm that in any kind of social intervention by means of theatre it is necessary to preserve a high level of sensibility to special characteristics of each individual community and to know its cultural features in order to avoid any unintentional, undesired, or directly contrary effects.

In a society such as Croatia, which is post-authoritarian, post-conflict, and undergoing a transition, democratic institutions are fragile, culture of respecting others and different ones is only beginning while the cultural life and the environment remains exposed to new authoritarian, non-liberal, and conservative tendencies. Therefore, unfortunately, there are many diverse incidents of breaches of human rights and European social justice is put into question. Those incidents range from attempts to reduce the effects of the economic crisis by striking those who are most vulnerable and least protected and, as such, politically least dangerous social categories, to economically irrelevant but ideologically significant reduction of the visibility of minorities in the domain of public and social life. From seriously jeopardizing the National Foundation

for Civil Society Development, radical and systematic cuts of funds available to civil society associations and different minority projects to the benefit of a monocultural dominance of the predominant majority, to financing cultural programmes of NGOs and civil associations almost exclusively according to ideological criteria of the majority monopoly, there are tendencies and aspirations to install a monopolistic and monocultural society together with all hegemonic practices inherent in it.

In such an environment, all tendencies to respect different voices, or to fight for the visibility of those who are invisible, actually represent a certain effort and a call for a dialogue between all those who are previously denied an opportunity to participate in that dialogue by the traditional environment. As Jan Cohen-Cruz puts it: "Theatre reproduces the same hierarchies that plague the world at large, the same assumptions of who can speak, who must listen, and who is not even invited into the conversation" (Cohen-Cruz, 2010: 5). For those very reasons, applied theatre in Croatia has been expanding the scope of its activities to those fields that usually do not belong to applied performances in more stable and developed democracies, and it refers to different forms of theatre for those who are different. In those cases, applied theatre uses the term "otherness" in order to denominate the cultural representation of various minority groups. At the same time, that is a very wide and fluid space covering all those who are treated by the norms of the predominant culture as the "others" or "different." For that reason, it is crucial for these forms of applied theatre to primarily focus on various issues, themes, and performers, to target different audiences but not necessarily to formally utilize different forms of performance. This is why Cohen-Cruz also warns that an engaged theatre does not need to be "different" in the way it appears but, above all, it needs to include certain voices and narratives that are "different" because they are socially marginalized. In respect of this observation, the basic principle and the first rule of the theatre of otherness is to allow those oppressed people – who cannot do anything but listen without even being given an opportunity to take part in a discussion to speak on their own behalf – an opportunity to nominate their problems, and to talk about them loudly by addressing a wide audience to overcome their position of oppression. This opportunity to nominate, speak about, be present, and represented by way of various forms of applied theatre allows us to express those identities that the majority community does not recognize as the subject of direct narratives or, in the "best" case, only occasionally discusses on their behalf or instead of them. Such feigned "representation" is a special form of sophisticated discrimination because the oppressed are denied the right to speak on multiple levels, and by speaking on their behalf, there is an illusion being created that they are socially represented and presented through a selective presentation of only those truths that are filtered by the majority in line with the majority's criteria. In order to avoid such forms of hidden oppression, by treating ethical aspects of the applied theatre, Sheila Preston (2009) emphasizes the importance of the notion of representation as a "powerful system of communication whereby meaning is culturally constructed and received." In such a communication system, "any representation created to speak 'for' a community is vulnerable to misrepresentation or simplification" (Preston, 2009: 65-67). Preston believes that it is very problematic to speak on behalf of "others" and to represent the "others" in a patronizing way, which occurs when the majority speaks "on their behalf" instead of allowing them to directly speak about themselves on their own behalf. A common monocultural practice to speak "on someone's behalf" or "about" someone or something is thus confronted with an entirely new and opposite practice of opening space for everyone to speak for themselves and on their own behalf. To describe that approach to theatre representation, Petra Kuppers (2014) uses the term "the ethic of accommodation," which defines a new, sensitive, and equal approach where the "majority does not rule. Instead, accommodation means including everyone wanting to participate, often necessitating that the majority make difficult changes in practices and envi-

ronment." At the same time, the ethics behind it implies the "politics of listening as well as the politics of speaking," "making room for difference possible" while it "inspires creative aesthetic choices"(Kuppers, 2014: 8).

Many important performance artists focused their attention to this problem in Croatia, e.g. Damir Bartol Indoš and Siniša Labrović in the festival named Extravagant Bodies: Extravagant Years (2013) organized by Kontejner – Contemporary Art Practice Bureau. The problems of the silver generation, or the discrimination against people based on their age, were successfully tackled by theatre director Borut Šeparović and his collective named "Montažstroj" in the production 55+ (2012), and later on in a documentary Consumed (Potrošeni) in 2015. Olja Lozica's play The First Time I Saw Your Face (Prvi put kad sam ti vidjela lice, 2015) thematizes the problems with dementia in elderly people and their struggle for personal dignity. The eighth edition of the Zagrebi Festival in 2015 combined a number of projects at the Centre for Culture and Information, Zagreb Dance Centre, and various locations in the city of Zagreb, including the Well of Life (sculpture) close to the Croatian National Theatre focusing on the topic of ageism, or discrimination against individuals on the basis of their age. The production challenged this form of discrimination according to three basic components: prejudice against senior citizens, silver generation and ageing process, and various practices of discrimination and institutional practices and norms contributing to perpetuation of stereotypes against persons of age. Outside of Zagreb, a theatre group called Theatar mali has been organising activities at the residential care facility in Sisak since 2013, in collaboration with professional theatre director and pedagogue Novljaković.

The Queer Festival Zagreb and Association Domino, under the leadership of Zvonimir Dobrović, has been systematically working on various projects to promote queer culture and raise awareness about the status of the LGBTQ community in Zagreb and Croatia since 2003. Over more than a decade of continuous activities, they have considerably contributed to changing public awareness, visibility, and presence of queer culture. After that, a number of diverse performative activities took place in other parts of Croatia. For example, the student drama group from Pula called Korak, under the art direction of Patrik Lazić, staged the play A Step Forward (Iskorak) in 2013 as a breakthrough in the Croatian educational system by utilising applied theatre methods directed at education about the problems LGBTQ persons face and discussing with high school students about discrimination and violence in the society to which queer persons are exposed only because they are different. However, in 1998, long before the above-described activities, there was another revolutionary step forward in the Croatian school system when the theatre section organized at the 10th Gymnasium in Zagreb, under the art direction of professor Neli Mindoljević, produced the play Hush! Be Quiet! (Psssst! Šuti!) about accepting gay students in society and understanding differences. With that project, the 10th Gymnasium took part in a number of festivals and received many awards and acknowledgements. The student who came with the idea for the activist play was Marina Petković, nowadays an affirmed theatre director and pedagogue, and the author of numerous socially engaged projects. Žak Valenta's play Soul Hermaphrodites (Hermafroditi duše, 2013) tackles the problem of homophobia in contemporary society and aggression (oftentimes resulting in homicides) as a radical and direct consequence of the generally accepted homophobia.

The musical and theatrical production The Little Man Wishes to Cross the Line (Mali čovjek želi preko crte, 2014) by Montažstroj collective and theatre director Borut Šeparović was an amalgam of experiences of a marginalized position of several vulnerable groups in Croatian society. At the same time, this production presents and represents very different individuals and communities categorized as "little," i.e. individuals belonging to the third age, Africans, children, homosexuals, members of ethnic minorities, the precariat, etc. One of the productions of the Zagreb Youth

Theatre that was already mentioned here, *This Could Be My Street* by Jelena Kovačić and Anica Tomić (2010), was the first play in a public theatre in Croatia to thematize the problem of violence in society, and serves as an example of hybridization of applied theatre forms, ranging from community theatre, theatre for education, and activist theatre to socio-therapeutic theatre and theatre organized in prisons. Along similar lines, the Italian Drama of the Croatian National Theatre Ivan pl. Zajca in Rijeka produced a play for children and youth titled *Spillo, Ciccio, Falco* (2015), directed by Renata Carola Gatica, merging the elements of theatre for education and applied theatre with the topic of physical difference, body stigmatization and community theatre, while the project produced by KUFER Theatre "Go Someplace Else" (Idi negdje drugdje, 2016), directed by Helena Petković according to several texts written by Vedrana Klepica, summarizes the topics and problems of marginalized communities, the oppression of women, immigrants, victims of violence, and other citizens in general.

All the above applied theatre projects fiercely resisted superficial, unscientific, and pointless estimation of the "majority" that is often utilized in hegemonic practices, which are, unfortunately, a norm in the Croatian public arena. The political, media, educational, and cultural mainstream in Croatia is dominated by prevailingly non-inclusive approaches that legitimize the "majority" social position and justifies their ideological monopoly on public funds. For that reason, all intentions of applied theatre are more than welcome as well as performative practices, social activism, and engagement for the development of democratic capacities of a community.

While working on this research, I noticed several obstacles imposed on a broader application of such performative practices and their involvement in the mainstream but, in most cases, they can be reduced to what Doug Borwick (2012) defines as problems relating to constructing an entirely new paradigm in the approach to cultural production and distribution. Borwick notes several basic obstacles before introducing this new approach and they can be eliminated if standpoints change. As paradoxical as this might sound, theatre artists represent an obstacle because they are used to old and deeply-rooted paradigms together with those who support art (institutions, individuals, and the public or private sector) and art organizations characterized by survival instinct, obsolete programmes, and limited and traditional marketing as well as traditionalistic and limited thinking about the creation of "*for*" instead of "*with*" various communities, individuals, and audiences combined with a general perception about limited and exhausted resources.

By following Borwick's list of obstacles in the analysis of the situation in Croatia, my intention was to also provide some concrete proposals for possible solutions and improvements, more so in the educational system, then in the media and, last but not least, in the ways of financing subsidized projects. Including "invisible" persons and groups in the institutionalized system of theatre education very often encounters many obstacles and problems justified by technical, professional, or practical reasons (Lukić, 2015: 292). Technical problems mostly comprise the lack of adequate premises and technical capacities to include, for example, disabled persons in the regular system of theatre education. Professional problems are apparent in the fact that there is a significant lack (or complete absence) of lecturers, trainers, teachers, and professors who are sufficiently skilled to educate disabled persons, socially different individuals, and other minorities but also in the justification that professional theatres do not have any need for those profiles, which makes their education unjustified and unnecessary from the point of view of potential employment. Practical reasons are oftentimes even more brutal – they state that including those groups of students in the regular educational system would slow down, complicate, or probably create an "obstacle" in the teaching process (as a consequence of internalized discrimination) or presuppose lower results and modest learning outcomes to be achieved with students with "objective" limitations for regular theatre education (as a consequence of ignorance and

prejudice). At first sight, all three categories are convincing and most of the explanations behind them are correct. However, educational systems (as the very foundation and a starting point for understanding the need for a changed paradigm) are not always given and are unchangeable. Simply, they would have to be more flexible and follow the change in the environment. By using that approach, classrooms and other spaces can be easily readjusted, necessary technical equipment existing abroad can be procured, educators can be additionally educated and trained, educational process can be innovated and adapted, and the labour market can be made more inclusive. However, that requires a serious change of paradigm and a complex action on the level of multiple sectors. On the other hand, a changed paradigm does not only imply formal steps taken to provide adequate education and training, but a genuine inclusion of minority groups in planning, creating, and implementing the process of theatre education. In addition to education, it is necessary to raise awareness in the media. The media has to learn that those less "attractive" theatre productions, although they are far from red carpets, spotlights, and glamorous opening nights with celebrities and tabloids, still deserve media attention and reporting because of the role they play in society and the social value they hold. Finally, it is extremely important to emphasize the importance and need for an organized and systematic support to applied theatre projects in the institutions that subsidize theatres. Without all those elements, the process of formal inclusion and temporary projects initiated by enthusiasts in the context of predominating educational, media, and institutional monoculturalism will only maintain and reproduce various positions of oppression or privilege.

References

Benjak, T 2014. *Izvješće o osobama s invaliditetom u Republici Hrvatskoj*. Croatian Institute of Public Health. Available from: http://www.hzjz.hr/wp-content/uploads/2013/11/Bilten_invalidi_2013.pdf [Accessed 6 September 2015].

Borwick, Doug 2012. *Building communities, Not audiences: The future of the arts in the United States*, [Kindle, DX Version] Available from: Amazon.co http://www.amazon.com [Accessed 26 November 2018].

Cohen-Cruz, J 2010. *Engaging performance, Theatre as call and response*, [Kindle, DX Version] Available from: Amazon.co http://www.amazon.com [Accessed 7 November 2018].

Eisner, EW 2002. *The arts and the creation of mind*, [Kindle, DX Version] Available from: Amazon.co http://www.amazon.com [Accessed 5 December 2018].

Kuppers, P 2014. *Studying disability arts and culture*. Basingstoke: Palgrave Macmillan.

Lukić, D 2015. Theatre education and students with disability. *Teaching Education*, 4(3), 291–297.

Lukić, D 2016. *Uvod u primijenjeno kazalište - Čije je kazalište? / An Introduction to Applied Theatre - Whose is the Theatre?* Zagreb: Leykam International

Prentki, T 2009a. Applied theatre in a global village. *In:* T. Prentki and S. Preston, eds. *The applied theatre reader*. London and New York: Routledge, 363–368.

Prentki, Tim 2009b. Introduction to intervention, *In:* Tim Prentki and Sheila Preston, eds. *The applied theatre reader*. London and New York: Routledge, 181–184.

Prentki, T and Preston, S, eds., 2009. *The applied theatre reader*. London and New York: Routledge.

Preston, S 2009. Introduction to ethics of representation. *In:* T. Prentki and S. Preston, eds. *The applied theatre reader*. London and New York: Routledge, 65–69.

Thompson, J 2012. *Applied theatre - Bewilderment and beyond*. Oxford: Peter Lang.

7
THE BRIDGE TO HOPE
Applied theatre in post-war Bosnia and Herzegovina

Sead Đulić

The very first activities which today I would name as applied theatre, actually started with the forming of The Mostar Youth Theatre in 1974. Back then, we didn't know how to define these activities; we didn't even know what we wanted. In the meantime, we learned from others, we gained experience and our own knowledge, and we kept on working. Some were defining our work as experimental theatre or similar to that, while others proclaimed our work as something utterly stupid and dilettante. And then came 1992.

It was springtime. Mostar was engulfed by the scent of early spring bloom and gunpowder. We, from the Mostar Youth Theatre, were still buoyed up and flying on the wings of success of our last performances *Galeb/Seagull* (Chekhov, 1959) (after Chekhov) and *Hamlet*, and we ignored the real happenings around us. We lived in a sort of self-isolation where we were busy exploring the possibility to work on Aristophanes' *Lysistrata* (Aristophanes, 1963). We had our first big rehearsal. The audience was at the rehearsal too. Then an enormous explosion shook the whole town. The devastation started, the first victims fell, and the fear set in …the war. In the chaos that started, someone stole our equipment. We were banished from the facilities. They took it all. We were left with nothing. Everything we created in the span of 18 years was just simply swept away. We were left with nothing and not even enough to do a single performance. The only possible decision was to keep on working in spite of everything and rebel against all who wanted to stop life in the town. We continued gathering and rehearsing. We tried to carry on, but it was impossible. The explosions were interrupting the music. Death was too near. But we started. It wasn't easy at all. Truthfulness proved to be the crucial problem. For the very first time, my actors had some secrets they were not willing to express outwardly, and I was convinced that in those secrets were the only and true answers we were searching for. I was stubborn and led the process towards their complete opening. We were entering the field of psycho-drama of which I knew a lot but hadn't practised before. At that time, I was watching in front of me and listening to the painful stories of young people. It wasn't a theatre any more. My actors performed, or better said, relived parts of their lives. We were rehearsing every day, each time longer and longer. It was our exile, our therapy. It was our island of hope. We went further and deeper, more open, more painful; we were opening the most hidden secrets. We shared fears, pain, tears.

The people who were watching that which we presented thought it was a performance. True, it had the form of a performance, and as days went by it grew more and more, but we knew that it wasn't a performance at all. It was our life, but theirs too, and that is why they kept on coming back time and time again. They were watching it as if they were watching some old videos, recorded some time ago at the seaside, at a picnic, an excursion, or a birthday party. I realized that they also needed to watch and listen, just as we needed the 'playing'. I realized that it mattered a lot to us all, facing up to the personal past and coming to our senses, soberly, because numerous dealings didn't explain all the causes why our worlds were destroyed. When it all happened, and it did happen, the pain at that stage disappeared. It stopped being life. The theatre came forward. Then we started playing a performance. And we play it even today. It is a circle of death, a circle of pain, it is *Pax Bosniensis*. It is a performance that came out of our own experiences, but at the same time it is a play that touches the hearts of each spectator, regardless of age, nationality, or the country the person comes from. It is a play which managed to speak out in a universal tongue that everyone can understand and accept as their own.

Then we, especially because of the memories we had, created a performance about the great constructor of the Mostar Old Bridge from the distant past of 1566. We didn't create a historical story, but, based on that story, we used imagination and dramatic scenes to present the efforts and obstacles that stood in front of the constructor back in that time. We wanted to send a message that the bridge we are building is a value that belongs to everyone, a value that has its place in the history of civilization, and that it has been created in spite of numerous difficulties and problems by the unseen stubbornness, persistence, courage, and endurance of its constructor.

We were calling our audience to build the bridges inspired by Hayrudin's example. Each of these 23 pictures that our performance was made of, has offered a clearly stated problem which opens up and suggests how to solve it. One of the dilemmas which we often had to solve with the young people in Mostar, and widely in Bosnia and Herzegovina, was: does history better remember the constructors or the destroyers? By taking the young people into a fictional context, in the time of the bridge construction, we gave them a safe distance from the time in which we live. By pulling them inside the problems the original constructor had, and by giving them the chance to use their imagination to solve those problems, we taught them how to cross over the abyss they had in the central street in the middle of their own town. I invited the young people to ask their colleagues whatever they wanted about the bridge. And they asked all sorts of questions, openly, cleverly, directly, fully aware of the present time in which they live. They asked bravely, and without hesitation they pronounced the words their parents have forgotten. I remember a dialogue:

- Who are you?
- People from the other side.
- Why are you standing at the very edge of the bridge?
- I want to come over to the other side.
- Why don't you go then?
- I'm waiting for him to make the first step.
- Who is he?
- The people from the other side.
- Why is it important that he makes the first step?
- So that they won't think that I am the weak one.
- And are you?
- Yes I am, as long as I don't dare make the first step.
- Why?

- 'Cos I am weak.
- What do you think, why doesn't he make the first step?
- 'Cos he is weak, too.
- And so until when are you going to be like that?
- Not long.

I come from Bosnia and Herzegovina, a land of death and destruction, a land which the inner and outer forces of darkness have destroyed so much that it is a miracle that the land still breathes, that it still gives signs of life. I am from a land whose peoples have been scattered around, from a land where hatred has been planted in order to tear it apart. Love has been systematically destroyed, along with every possibility to imagine the mutual life of ethnic communities. And after years and years spent here and work done in this kind of environment, I think that I have the right to sound a bit pathetic, because what I have done and explored for years affects me directly and concerns me. It's not about the methodology anymore, but about life. It's not about a metaphor, but about a cruel reality. It's not about a fiction, but about my painful emotions. It is about the reality from which we have started from, and by 'we' I mean us from the Mostar Youth Theatre. We began our work as theatre or, rather, we have continued our work dealing constantly with the dilemma: does it make any sense? Our work in the youth theatre with children and adolescents, in spite of horrible war actions around us, still has been and continues to be the creative and inspirational source which opens up and forms huge space, a space to play. Today we constantly wonder: how will the rest of the world comprehend and perceive the almost unperceivable reality of our long-time-taking living and dying?

Young people from our theatre, like so many young people in my town and in my country, are a part of a typical generation of youth like anywhere in the world. What is their humane and theatrical perspective on this time and this social situation we live in currently? There are two options. Firstly, to leave the country and try to live and survive somewhere abroad, in the wide world, with uncertainty and all the hardships of life in a new environment. The second option is to stay with uncertainty and all the hardships of being drawn into this grey gloominess of everyday life here, being drawn into all the schemes and problems of the social and theatrical context, which more often than not is discouraging. So, what to choose? We from the MTM, as it is locally known, have chosen the third option. To stay together, and work together. To create communication even with those from the other side of this country, but also with the world abroad. To show to the world our own creativity, knowledge, possibility, truth about us in the world and the world that is within us. That is why we believed, that we as witnesses, have the right to call for and offer bridge-building. And we offered. And we are still offering, because we are firmly convinced that drama and theatre are the right of every person, and not just the privilege of those who are talented. It is an ongoing process. Our bridges have remained here throughout Bosnia and Herzegovina in the form of nicer looks, handshakes, embraces, a kiss, pure thoughts, forgiveness. Our bridges are enduring because the only material they are made of is love, a constructor's free will to create them. The constructors were those who decided the size and the quality and for how long they will stand there.

I remind you here: the bridges have always been the objects from where the other construction spread. That is how many towns started to exist and grow in history. We believe, and that is happening, that around our bridges the construction will go on and that the new towns will spread and grow. Slowly, with difficulties, it is going to take a lot of time, painfully, but they will grow. That is why we are here still, in spite of many problems.

The authorities on many levels looked at us doubtfully and shook their heads. Many of them would be happy just to prohibit such work. The professional theatres also looked at us with a

lot of doubt, because for them these are some suspicious novelties, and the school is far too traditional and conservative to open the door widely for such work. Mostly it is work with the individuals who are keen or interested. Financing? In the country – zero. First of all, there is no money for it, and secondly, even if someone offers you help, there is immediately an obligation to return the favour. So how to survive? We frequently respond to those questions: out of spite or out of love. In reality it is our friends who live abroad, who help us through donations, and numerous organisations in the world. But as one war-zone ceases to be actual and in focus, they turn to help the newly opened war-zone. Such is their work by nature, and we remain in the painful reality. A hope and a scream that can hardly be heard, but to our ears it is deafening. And so these are the perfect pre-conditions to stop working at all. For despair. For escape. Or maybe for the new beginning. Our decision is to stand in spite of everything, and not allow that sign of pain to be visible on our faces. Our decision is to work and share the destiny of those with whom we cooperate, and our key motto is: truth, love, and theatrical aesthetics. And when we use drama and theatre solely as a tool, as a means, then our personal intake is trust, confidence, openness, and love. We never got a negative response to it.

Since the very beginning of dealing with the various kinds of applied theatre, the main difficulties were with the lack of trust and confidence. It came from various reasons. One was due to the ethnic division which was the direct outcome of the war and post-war politics. Another came as a result of our activities being mainly financed by international organisations. The local authorities were very suspicious of them, and we were treated as foreign spies or even worse. The third reason for their distrust was that they didn't have an understanding of the methodology we used. Furthermore, a great number of both local and international so-called 'experts' were travelling across the country and offering their services. The damage they did took years to repair. Some consequences are still here. Apart from these problems, a big difficulty was the lack of professionals. We had a small team of people, and the need for the work in the territory of a whole state was huge. At the same time, while we were working directly, we also had to train numerous teachers, professors, actors, and other activists in practising different kinds of applied theatre. The training was accompanied by difficulties because the schools and various ministries in different areas weren't willing to give their consent, so the teachers were coming to work with us usually on their own initiative, sometimes even in secret. The situation isn't much better, even today.

Several years ago, I read the devastating results of the research that The National Democratic Institute from Washington gave, after they finished research among all the categories of the young people of Bosnia and Herzegovina. Then I saw in black and white what I already anticipated. More than 62% of young people would like to leave the country immediately. They only wait for the opportunity. Some 20% of young people have still some hesitation but want to go. They all want to leave this country because they don't see any future. Nowadays, the situation is even worse. I myself have stayed through thick and thin in the war in Mostar, so I felt that I had to at least try to answer this and similar questions. That was the only motive I offered and I still offer to young people with whom I want to explore the dilemma: to leave or to stay? It was a dilemma I myself had once, but before everything else it was their life's decision. I had to and we had to speak out about it. We went on, starting off with this dilemma, and we started to deal with the intertwined paths of our souls. We started exploring our personal lives in facing the past, the present, but also the future. We sought the answers, the causes, and the possible solutions. We tried to reinforce ourselves and prepare ourselves for what was awaiting us. In that searching, which still goes on, it seems to us that we are dealing with the same questions that were tormenting us at the time of making our first performance during the war, *Pax Bosniensis* 1992, and it seems as if we're here making the second part/sequel of that performance only some 10 or 20 years later. In Mostar, even after the war, people were being killed by explosions

or shootings. The whole town actually looks like an ideal setting for some Greek tragedy which is going on today and here in everyday life. In such an environment a handful of 'lunatics' have found asylum in theatre, as they did once a long time ago during the actual war.

We are aware that many things in the future depend on us. We are in the position to explain to those who decide here that theatre doesn't exist, that we pull and draw the curtain every evening (as Brecht said). We are trying to throw the glove right into their faces. That is why now we do all our activities towards that goal, to liberate people from fear and to lead them towards their own facing up to their personal past in which they must recognize the cause. They have to face it. They have to reach catharsis and, so purified, move on into their own small or big 'war'. The main inspiration for our work was the possibility to win over the fear and the possibility of giving back hope to the ordinary 'little' man. All that also made us much healthier. Today, when I think of it, it seems that, had we not taken that decision in the spring of 1992 to continue our work, today we would be very ill. I am convinced of that because, on a daily basis, I notice people around me, and I run away with my colleagues into the world of drama and fiction in order to gain strength and prepare for new challenges that life here in this town and this country gives us.

The drama-line of the *Pax Bosniensis* wasn't prepared in advance, nor has it come out as a result of much thinking or care about the audience and its reactions. It was a line of our lives, a line of people's sufferings; people I lived with and shared evil that was forced upon us. It was life as we lived it in those four years of hell. And the life was the struggle of unarmed people to survive that fierce hunt of them. It was a war against people, unarmed people. It was a time in which death was the best friend, because what we lived there wasn't life at all. That is why the images in *Pax Bosniensis* are more like a gallery of our lives, as a frozen time of pain. To many spectators, they even seem unreal, and yet they are exact representations of life as it was. Had it not been for that, this performance wouldn't have lasted for 26 years and always able to find its audience.

When in 1996 the performance went abroad, I had in mind only the need to speak as a witness. I wanted to witness as the one who survived, as the one who took part in the happenings that were just news to the world. There was no anger, nor bitterness, nor the need for pity or to inform anyone. I wanted to use this performance as a tool to say that we knew what had happened and no one anywhere has the right to judge us and what we have been through. That right belongs to us and we wanted to say it directly right there from the stages where we performed abroad. There were no other motives. And we testified, but we were very difficult witnesses, the witnesses who hide nothing and speak right from the heart of the happenings. I know that at times it was quite shocking for the audience, but I didn't choose the audience, they chose our testimony.

We performed also in the countries whose armies took part on the opposite side during the war. Going there wasn't easy. We had to win ourselves over, face our own past, and look at oneself in the mirror and make it clean and clear.

Right after the war, we were a part of the Pax project and did workshops based on material from the myth of Pandora and Prometheus, and developed a very interesting programme of theatre in education which deals with the topic of violence. We kept on working on that idea and explored it further and developed it through the work of the Mostar Youth Theatre where we worked with people of all generations in Bosnia and Herzegovina and many countries abroad.

I remember that the 30 participants of that workshop were mainly young people from all parts of Bosnia and Herzegovina. By learning the techniques of theatre-in-education and mastering them, and at the same time exploring the material of myth, in the end they offered a very exciting theatrical challenge for further exploration and investigation of all sorts of violence.

Developing that exciting material, a part of that group of young people who took part in its creation at the workshop, have later on worked under the framework of the Mostar Youth Theatre and developed the theatre-in-education programme called The Masks, which follows the original idea generated at the workshop.

In the beginning, our focus was on the topic of rape as a war strategy. Then we dealt with violence as a mythological event in the Balkans, a life behind the masks, about the hypocrisy, about violence in the family and, in the end, about violence among young people and violence on young people. Why did we place the violence of young people at the end?

Back then, the ten-year long existence of the Centre for Drama Education in Bosnia and Herzegovina and the continuous realization of a whole line of projects in Bosnia and Herzegovina and wider, provided us with valuable information (information gathered through independent evaluations of the project) about the needs of children and youngsters in our country.

Naturally, to get the complete picture we used all the parameters of the official institutions that were available to us, and given by the non-government organizations, both local and international.

Since Mostar is in a specific situation with two separate school systems and programmes, and since there is a lack of school buildings, and since there are examples that in one school building co-exist both primary and secondary schools, all these reasons have contributed to education in schools decreasing, and schools have been reduced to solely teaching subjects and nothing else. If to all of this we add the catastrophic financial situation in town, and the fact that this is still a divided town, all of this together means that the people are in a state of apathy and that the children are left on their own. In such a situation, the children become more violent and often out of control. Evaluating this situation, we have approached the schools, with one aim, to enter the classrooms from the first grade to the eighth/ninth, and to show them a theatrical scene, a micro-drama, sometimes a complete show that deals with the issues that open up a problem we want to explore with the audience, that came out as a result of the Pax Project workshop which was inspired by the myth of Pandora and Prometheus. It was the last version of 'The Masks' programme. We worked with all classes directly in the classrooms and were limited by the duration of the school hour.

The structure of our work was:

- Short introduction (presentation of the Theatre-in-Education methodology with the accent on participation).
- Playing theatre 'bait' (four scenes already prepared, and played by the young actors who would in the second phase turn into the role of drama-pedagogues).
 - Short analysis of the bait in order to gain perspective into their understanding of the situation, characters and basic problem in the scene.
 - After the notification that the main problem in the scene is the violence, we continue to briefly discuss violence in general and kinds of violence, etc.
 - Using a suitable technique we divide pupils all into several groups of five participants.
 - We ask all participants to remember one example/situation they experienced themselves when they have either been violent towards someone or someone was violent to them, or if they witnessed a violent situation but didn't do anything.
 - After that we ask them to work in their small groups and tell their stories to each other.
 - Then the drama-pedagogues enter the groups; those are the actors who performed the scene earlier, to help the group, and to initiate the discussion. We don't rush the participants to hurry with it.

- After they have recounted their experiences, we ask each group to select one situation out of five given examples according to their choice; what they found most violent, or most interesting, or most aggressive.
- When they have selected the situation, we give them the task to analyze, one more time, what happened and to define all who took part in it. After that we ask them to take the roles and try to make a frozen image (a sculpture) of the key moment in that violent situation. We give them time to rehearse.
- We then call all groups to present their frozen images. We invite the others to recognize the situation and define all who took part in it. Depending on time, we use these techniques: hot seat and interrogation while in the role. It is possible that the perpetrator and the victim change roles and then repeat the interrogation-in-role.
- In the end, we draw the conclusion from the thoughts that the participants have spoken. We remind them of it.

The purpose of this project, which is still ongoing, is to raise awareness about violent behaviour, to point out the causes and explore them, but also to state the consequences. We don't intend to do that only with the pupils. In the project we have also included the parents, the teachers, and all the children in the school, without pinpointing those who are demonstrating extremely violent behaviour. The purpose is to point out the causes of violent behaviour and, in that way, try to prevent it, and avoid the consequences.

The project is aiming to highlight the causes of violent behaviour in each individual and to face him/her with it so that he/she realizes it, and to try to initiate the change of such behaviour today.

Parallel to these activities, we organized a series of workshops with the teachers whose aim was to enable them to use and practise the methodology of drama, theatre-in-education, and forum-theatre in their everyday pedagogical work.

Well aware of the fact that the problem is very serious and that there are no easy, quick, or short-term solutions to it, we expect to achieve these results:

- More active participation of all interested sides in dealing with the problem.
- Dealing with the causes which leads to prevention and avoiding consequences.
- Enabling a huge number of teachers to apply this new methodology to their everyday work (but still not enough practised in the teaching process here).

We believe that the positive effects of this project in the schools of Mostar has promoted this kind of work and influenced its further spreading, and that the teachers will apply this methodology in their everyday work.

So far, we have been to 520 classrooms and my primary concern with the work in the classrooms was how to motivate and stimulate pupils to speak openly and express their opinions (and not just answer with a short 'yes' or 'no').

For example, in one local school in a village near Mostar, we worked with pupils in the eighth grade. They were very interested in watching the play-bait, which is actually a small piece of theatre, but as soon as the situation changed and it was their turn to speak and express their own opinions and dilemmas, it all turned drastically. The girls turned their heads, hid their mouths, and clearly showed that for them the programme had finished. They were not there to speak, but to sit and listen and be quiet. Such is the tradition even today. And not just there. There is another very striking example from one school in Mostar where we worked in the

classrooms with 30 pupils. The teachers were not present. In each class, at least one of the five small groups of pupils repeated almost exactly the same scene. Even in some other grades, the same scene was repeated. It was alarming to us. By using the method of interrogation-in-role, we found out that there was a teacher in that school who regularly maltreats the pupils and sometimes even hits them. The method of hot-seating helped us to identify the teacher. After this one-day visit to school, and a conversation with the school's principal and the school pedagogue, this long-time secret finally saw the light of the day. The teacher was sanctioned and everything changed. The power of the game in fictional contexts and the sense of security they acquired gave these young people the strength to speak out, and when they spoke out, the solution to the problem was found.

The second example is a very interesting experience we had in a school in one village near Mostar. We went there with our usual stereotypes of schools in villages and we thought we knew what awaited us. But we were so surprised when we arrived. Although the school building was small and poorly equipped, everything was so impeccably clean, neat, and well organized. We were also most cordially received. It felt great to be there. The children were so open and ready to cooperate, and were very curious. We offered to play the game 'The Masks'. We felt special joy working with one class in the sixth grade, where the children are 12 years old. After only five minutes, the actor put the white masks on. I noticed one small boy who got nervous and started asking his teacher something. She was trying to silence him and pointed at us. He barely managed to keep quiet for 15 minutes. As soon as he got the chance, he instantly asked, 'why is there no opening for the mouth on the masks for children, while there are openings on the masks for the parents?' It was the first time that someone asked us that. This process that we have done in many countries across Europe and even in the US, with human rights activist, with students…, but after at least a hundred of such sessions we were never asked this key question. The child gave the answer. He clearly recognized the hopelessness of the society he lives in, which won't let him speak freely.

After all this, I am convinced that the young people with whom we have met would speak and truly change their micro cosmos. Those changes are our greatest success. That is why we are hurrying to reach more and better micro worlds in our town and our country.

The situation is much better today. During its 26 existence, the Centre for Drama Education has gathered hundreds of individuals and groups as members who through their everyday life, practise and promote these activities. Throughout the year we continuously have dozens of workshops where we practise different kinds of applied theatre and organize the festival of applied theatre. Then programmes and performances which are a kind of applied theatre, after thorough selection, become included in the regular repertoire of the festivals. Significant numbers of artists are becoming more and more interested in this kind of theatre. The truth is that we still don't have a true appreciation for this kind of work in this environment, but the very fact that applied theatre is no longer at the margin, and that people write and talk more and more of it, all that gives us hope that in time to come, there will be more space for this kind of work.

References

Aristophanes. (1963) *Lysistrata*. Ann Arbor, MN: University of Michigan Press.
Chekhov, A. (1959) *Plays*. Harmondsworth: Penguin.

8
THEATRE AGAINST VIOLENCE, ACTION IN CLASSROOMS

Ines Škuflić-Horvat, Maja Sviben, and Nina Horvat

Tirena Theatre was founded in 1997. In 20 years, we produced three Theatre in Education (TIE) projects and two classic plays with the subjects of violence prevention and addiction.

Entitled to a Mistake

The first TIE project, *Entitled to a Mistake*, was produced in 1998. The aim of the project was violence prevention and integration of juvenile offenders into society. It was the first TIE programme made in Croatia with full audience participation. The theme was acceptance of someone who is different, whether a person is entitled to a mistake and what are the possibilities of returning into 'regular' society after the line of social norms was crossed.

The project had two versions. The first was intended as a tool for sensitivity training among high school students, working on juvenile offenders' reintegration. It was performed in schools. The second version was performed in correctional institutions and centres for children and young people with inadequate parental care. The aim of this version was the integration of juvenile offenders among their peers, to find out the questions that were raised during such a process, to explore the situations that could happen and prepare for them.

The programme itself was performed over two days. On the first day, an invisible theatre scene was played out in a classroom. Introduced by their real-life teacher, a new student was coming to class (an actress who was a member of our drama studio and who was the same age as the rest of the class). During the same period, the class was also visited by a teaching student (also an actor) who would start teaching for about ten minutes. After that, an actress playing the new girl's mother would barge into the classroom, demanding to speak to the girl. They fought. The mother, who looked unkempt and frazzled, not inspiring confidence, wanted the girl to come home as she had been missing for days. The girl tries to fend her off and runs out of the classroom, the mother follows her and after monitoring the immediate reactions, the teaching student explains that what they had just seen was theatre. His task was to address the feelings of students in that moment and to discuss the situation that had developed. He would also inform them that the rest of the performance was to follow on the second day. The reactions of the students were varied, sometimes very loud in defence of the girl. The interest in the performance was huge.

The following day would bring a story of a girl that had been involved with prostitution and was then trying to come back to a 'normal' life. It was envisaged as an incentive for teenagers

to think about acceptance of different people; people who have found themselves outside of boundaries of social norms. With the use of drama techniques and forum theatre, the participants were led through a process where they explored their personal responses to the situation. The performance was limited to 30–40 participants.

The reactions to the performance were extremely positive. They were further discussed in conversations with their teachers. During the preparation, the ensemble worked with a psychologist to learn how to pose open-ended questions and develop a discussion. The project was performed in Croatia and Bosnia and Herzegovina.

There is a definite need for projects that deal with prevention of violence and addiction in the teenage population, who sometimes deal with the problems of growing up and being accepted through consuming opiates. That is why, with the support of the Ministries of Health and Social Services, we decided to put on two plays dealing with addiction prevention.

Bottom(s up)

Bottom(s up) is a theatre production about under-age drinking. Since its opening night in March of 2016, *Bottom(s up)* has been performed over 50 times throughout Croatia. It was also performed at two theatre symposiums and was part of a series of events organised by the Croatian Institute of Public Health during the Month of Fight Against Addiction.

Alcohol is usually the first opiate teenagers come into contact with, without considering the possible consequences of alcohol abuse, such as alcohol poisoning, hangovers, risky behaviour and, potentially, addiction. According to the European School Survey Project on Alcohol and Other Drugs (ESPAD) research, in Croatia 17.1% of boys and 13.9% of girls had consumed alcohol during the 30 days prior to the survey. 51% of boys and 42% of girls had 5 or more drinks during the 30 days prior to the survey. When we started working on the production in 2015, Croatia held third place in Europe in binge drinking but has since dropped to fifth place which it shares with Malta.

Under-age drinking is a serious issue and we wanted to do a production that would show teenagers the dangers of alcohol abuse, without talking down to them. Schools and all other institutions have a stance that children under 18 should not drink since it is illegal. But the fact remains they can get alcohol easily, in stores and in bars, so just telling them 'NO' and giving them pamphlets (which consist mostly of information about cirrhosis of the liver) is not the way to get through to them. We decided to take a different approach. There is really no way to stop them from drinking alcohol altogether, but you can explain some things to them, urge them to reconsider and make them understand the potential consequences of their choices.

Nowadays, teenagers are under a lot of pressure, ranging from their parents and the school system which expect them to be the very best, to their peers who have very specific criteria about what is or is not 'cool'. Sometimes the pressure can be too much, so they try to ease it by partying and drinking. Binge drinking has become a form of initiation into a group. If you are not drinking, you are, by definition, not cool.

Bottom(s up) follows three teenagers from their first encounters with alcohol, to bad decisions and serious consequences – with one of their friends ending up in a coma. In the form of a TV show and through sketches and songs, it shows different types of drunken behaviour, stages of intoxication, examples of alcohol impaired judgement and strategies grown-ups use while trying to communicate with teenagers. It is a devised theatre production that was based on conversations with the target audience – teenagers. It was very well received, and started a dialogue between teenagers and their parents and teachers.

Lie

Lie is a theatre production which deals with drug addiction. It was made in 2007 and was performed over 200 times. This production talks about everyday situations teenagers find themselves in: fighting with your parents, peer pressure, parents who try to control everything, parents who neglect and parties that offer 'something new.' Everything starts off innocently: skipping school here and there, smoking, experimenting with soft drugs. Everybody does it, what's the big deal? But everything has consequences that teenagers are unaware of most of the time. Sometimes only one mistake is all it takes.

Through three different stories we see how three teenagers start spiraling out of control and how they lose touch with reality. Nowadays parents often don't have the time for their children because they work a lot and schools are not equipped to deal with serious issues, such as drug abuse. Meanwhile, children are being exposed to opiates at very early stages in their lives. Opiates offer short-term oblivion and relief, but they do not solve problems. They cause new, more serious and drastic problems. This is the message we try to convey to our audience.

After each show, the performers talked to the audience about what they saw. When we asked them if they recognise something from the show as something that happened to them, we would get a firm 'no' response. But then we would point out they must have been late here and there, got a bad grade or fought with their parents at some point in their lives. We tried to emphasise that drugs are not something that happens only in a bad neighbourhood or a dysfunctional family. Then we would discuss why the characters in the show start using drugs. Most of the time we would get two answers: 'so they would forget about their problems' and 'because they thought it would make them seem cool.' After we got the answers, we would go on to discuss whether the characters solve anything by using drugs and if there is another way to be cool. At the end of the conversation we would ask what they would do if something like this happened to them or to someone close to them. We tell them that there is always someone they can talk to. Most of the time there is a grown-up around who can help them and give them advice. If it's not a parent, it can be a teacher, a relative or an authority figure. If there is no one they trust around them, they can call different hotlines and services or get counselling. We finish the programme by emphasising there is always a way out, always something that can be done if they communicate in time.

Here are some of the audience impressions:

> I liked the discussion and questions after the performance. We concluded that problems can be solved in much better ways than by escaping into drugs and alcohol. I loved the show and it made me think about what is happening around me.
>
> *(Leontina, 7th grade)*

> The most important message in this show is: if you have a serious problem, you don't need drugs to escape it. You can always talk to your friends, family, teachers and ask for help.
>
> *(Lucija, 7th grade)*

> I liked the performance. I think it can encourage young people to say NO to drugs.
>
> *(Andrija, 7th grade)*

> It was very interesting to follow the stories of three different families which all have a dark side. This performance shows us we need to think long and hard before we do

something bad. Everything has a cause and a consequence. In this case, the causes are parents who are always fighting, an overprotective mother, a drunken father. The consequences are a desire to escape, anger, addiction.

(Mirko, 7th grade)

I liked the show because it was very realistic and detailed. I would recommend it to everyone so they can see the dark side of addiction.

(Ines, 7th grade)

Turn On Your Computer, Turn On Your Brain

Turn On Your Computer, Turn On Your Brain was devised as the first wave of social networking hysteria swept through Croatia. Coinciding with mobile communications operators significantly lowering prices of data packages, it was not a surprise that the generation of digital natives quickly jumped on the social networking train. By that time (2013), Facebook and Twitter were already old news, and as the teenagers described it, 'used only by old people', but Snapchat, Instagram and somewhat older Tumblr, as well as WhatsApp (a messenger app that was, and still is, confused by many for a social network) were experiencing their high point and not looking likely to move from the spotlight. That led to many dubious practices being silently and conveniently overlooked and a lot of bullies suddenly found a new channel for expression, using a medium that was not only accessible but had a wider reach than ever.

That was the climate in which we started developing *Turn On Your Computer, Turn On Your Brain*. It was not a peer violence TIE programme *per se*, because the storyline followed characters quite a bit older than the age group it was aimed at, although we maintain that cyber bullying is a problem that spans ages, social groups, etc. Nevertheless, it was devised in order to deal with problems developing from teenagers using technology that most of their parents weren't versed in, thus making it difficult to recognise and discuss the serious issues arising from such use.

The storyline follows three young women who share a very close friendship – or so it seems. Two of them are actually old friends, and one of them meets the third girl in a dance class. They start hanging out together; the two childhood friends both fascinated by the third girl who, judging by appearances at least, is the picture of perfection. Her own self-image issues, however, almost immediately start manifesting themselves as inability to see others in a positive way, making her judgmental and petty. Thinly-veiled insults to both her new friends quickly escalate to brutal gossip in social media inboxes, and are eventually leaked to the general public.

As the TIE programme was aimed at 15–17-year-olds, we decided to make it participatory in a way where we didn't assign the audience a role, but asked them to comment and share experiences as themselves. Focusing specifically on girls, who according to available surveys at that time, were leaders in cyberbullying, we also toyed with the idea of making the performance not only participatory but at the same time inviting the audience to communicate online after (or even during) seeing it. Before the performance, they were specifically told that not only were they allowed to use their phones during the performance, but they were encouraged to do so. Not a lot of them did though – gripped by the performance, they chose to 'experience it directly', to quote a 16-year-old audience member when asked if she forgot about her phone. To this day, we see it as a point in the theatre versus real life competition, real life being the one online.

The idea of online collaboration with the audience during and around the programme was also the reason why an elaborate Internet presence was created for the characters – they all had

different social media accounts and the actresses were asked to maintain that presence during the run of the programme. Part of the performance was happening in real time on social media, while other parts were realistically faked as if in real time.

The audiences' responses were varied. As this was one of the first TIE programmes where we intentionally went open-ended, and tried to steer away from leading the audience in a certain direction, we wanted to finish the performance with an honest discussion, leading us out of the story and into the real world. Some of the tasks for the audience during the programme were, however, designed to keep the plot evolving and the audience was asked for answers that were meant to progress the storyline. But the actresses/facilitators were instructed to follow the direction the audience took, and to try not to manipulate it in any way.

Although most of the time we were successful in creating space for a serious discussion, where we found out that a lot of them didn't consider cyberbullying as dangerous as bullying in real life, because it lacked the component of physical violence, we were also, as often, frustrated by the lack of means to continue the conversation after the event itself. Even though this programme offered the possibility for the audience to keep communicating afterwards, not a lot of them took that opportunity, and we were once again left with the knowledge that our reach is very limited to the happening itself. The impact of TIE programmes can fulfil their full potential only if the educational system follows up by continuing the conversation on difficult issues. We are often reminded that for some of the participants, just raising awareness might have been a very important experience, and feel lucky that we were able to help out with that, but we always keep wondering what more could have been done if only…

2042 AD

The project was envisaged as a continuation of Theatre Tirena's successful experience in offering TIE programmes as an answer to formal educational institutions' rising needs for extra-curricular activities that helped their teaching staff and students in dealing with issues such as bullying, peer pressure, peer violence, etc. Having previous experience with the age groups from 15 upwards (*Entitled to a Mistake*) and 6–10 (*The Apple Land*), *2042 AD* was an attempt to gain insight into an age group we hadn't devised TIE programmes for before.

Subtitled *Understanding Before Violence*, the programme was aimed at 12–14-year-olds and specifically dealt with growing violence that was as much a product of changed circumstances in the post-war period (e.g. xenophobia, conservatism, poverty on the rise) as the system's inability to cope with them quickly and efficiently. A continuing debate on whether schools are places where children and young people only acquire knowledge and work skills or places that also give them mechanisms for dealing with life in general was the starting point for a TIE programme that envisions a future where all education as well as parenting is left to government-run facilities called educational centres. The somewhat bleak, dystopian world was created in order to lure the audience into the story and remove them from feeling it too personally at the same time. It was important to us that they could both identify with the characters and feel secure in knowing this was a story happening somewhere out there, in another time, not being directly linked to anything or anyone they knew, but still resonating with them.

The story itself begins with a helpless educator in such a facility who is asking for help with a runaway teenager. The audience, under the Mantle of the Expert (Dorothy Heathcote's renowned technique) is asked to consult on the options for dealing with the problem. However, as the educator is whisked away to deal with an emergency, the runaway girl, who's been hiding in the space where the audience, in their role as Special Counsel, is waiting, appears before them and asks them to keep silent about her whereabouts. She is clearly distraught and at that point

we were trying to establish whether the audience would lean towards empathising with her or following the rules. Almost all of the performances have shown that the audience was more than ready to break the rules when faced with a person obviously in fear and in need of protection. It has also shown us that there was a lot of peer solidarity – they were quick to identify with the problematic teenager (the actress was close to their age) but not so much with the educator, who was played by a slightly older actress.

As the story unravels, the audience finds out that the girl has been running away from the facility because she is being bullied by two of her peers. She's asked for help before, but the educator is unable to deal with the bullies. That is when the girl started running away from the centre and, at this moment, the Special Counsel is there to determine what kind of punishment she should receive for her behaviour (it was her third runaway attempt). The programme was actually trying to get the audience to stand up against systemic injustice and to help find a solution that would offer protection and awareness instead of continuing the cycle of violence.

The audience reacted somewhat predictably in the first part of the programme – they were ready to help, they had words of advice, and they were very knowledgeable about where the girl could turn for help, from school authorities to police and special institutions. Nobody questioned the fact that we successfully removed parents from the equation. In the beginning of the performance, they were told that in 2042, children and young people were being raised in educational centres and that was a fact they happily accepted.

As much as the futuristic setup, as well as the power given to the audience by the Mantle of the Expert, might have seemed more like fun than responsibility in the beginning, it turned out that the problem they were there to solve ran much deeper and could not be resolved with simple platitudes. Even though for some of them the bullying shown in the beginning was more amusing than disturbing, and they were having fun working in role, gradually the fictional world (built to give the audience some semblance of protection – working within a metaphor was used to speak up about things that some of them might have gone through in real life and would have been reluctant to work on if not for the fictionalised frame) began merging with the real one.

After a particularly gruelling scene that left the girl beaten up by the bullies and lying broken on the floor beneath their feet, it was clear to the audience that violent tendencies were not something to have fun with. They were shocked into a serious discussion about how such a situation could be handled in real life and immediately started demanding severe punishment for the abusive peers. We listened to their propositions, and tried incorporating them into the storyline. In the end there was no doubt that it was the kind of behaviour that was not to be tolerated. But then again, we asked the audience to consider – would a harsh punishment bring peaceful resolution?

The final part of the performance was reserved for a simplified forum theatre scene, where the audience, now leaving their role of Special Counsel and speaking for themselves, offered advice to the actress playing the bullied girl. The actress tried out different versions of the story, different ways of standing up for herself, but the bullies stood ground. (The actors playing the bullies were instructed to stop with the violence but not change their attitude.) The audience kept insisting on modifying their behaviour, so we decided to break off from a traditional forum scene and allow the audience to modify the behaviour of the oppressors (in this case, the teenage bullies). The interesting thing that happened is that the solutions the audience provided stemmed from very realistic grounds: there were no magical transformations, the characters didn't suddenly become good people – but it was important that they acknowledge their behaviour, admit that it was wrong and apologise to the victim, thus beginning the process of communication. The audience was adamant that it was not an easy process or a quick one, but they were happy to offer a second chance and wondered if it

would have made a difference had that chance been offered earlier in the story or in similar instances in real life.

From the questionnaires they filled out during the performance in their role as Special Counsel, we found out that they often thought of violence as some sort of misguided excess of energy that should be channeled differently – the solutions they offered in this part often included organised sports or leisure activities. Some of them were more inclined to propose stricter oversight and surveillance, more aggressive enforcement of the rules and punishment for those who don't obey them.

However, their responses changed throughout the performance and towards the end of it they became more introspective and personal – they veered away from the storyline and shared experiences from their lives. A lot of them had advice coming from real-life situations or envisaged how they would react should it happen to them or their friends. Also, a lot of them admitted to previously silently condoning bullying and feeling shame for not helping the bullied – the reasons varied from fear for their safety to fear of being ridiculed and/or being thought of as weak. Even though the TIE programme always brought the audience back into the fictional realm, the questionnaires that we asked them to fill in after the programme showed a significant change in awareness of what constitutes violence in the real world and how they were better prepared to deal with it after seeing the performance.

It would be preposterous to claim that a single TIE programme can make a huge dent in societal tendencies. But it is also clear that for around 500 students who had the chance to see the programme during its run, the subject of peer violence became more than a concept they were lectured on. And fortunately, for most of them, something they could experience in laboratory conditions where the outcome was not predetermined but carefully guided to where it wouldn't leave scars and bruises but an awareness and understanding of failings and bad decisions, also of others, of differences.

9
INTERVIEW WITH VLADIMIR KRUŠIĆ
Theatre and drama in education

Darko Lukić

Darko: How did you start your engagement in applied theatre/drama, and what was your motivation and goal?

Vladimir: Considering the concept of applied theatre/drama as an umbrella term covering very different practices and commitments is of a rather recent origin[1], so it is a bit difficult to respond without hesitation to this question. It will be easier for me to speak about it in terms and categories that were dominant in the drama in education/theatre in education (DiE/TiE) discourse, before applied theatre/drama became the general covering notion for the whole field. In deciding the principal domain of my professional interests, both aspects of the notion, theatre and drama, are important and relevant. Although all my professional life I have been, and am still, working in the field of youth theatre, I have never been concerned with producing theatre pieces in the first place, which I did very successfully on several occasions. Instead, ever since my professional theatre education in the 1970s, I was more interested in outcomes – intellectual, emotional, social, developmental, etc. – that involvement with the medium of theatre might have on those who are dealing with it, i.e. in the effects that we might call didactic, pedagogic, educational or, generally speaking, experiential. In my formative years as a theatre/drama practitioner, my motivations were stirred and nourished mostly by my reading of Brecht's ideas on didactic theatre and by his concept of 'learning plays' (*Lehrstücke*). So, along with my studies and activities in professional theatre, I began working with young people in the context of amateur theatre. In the 1980s, however, this non-professional engagement with young theatre amateurs turned into my first permanent employment as a theatre associate at the Croatian Council of Culture and Education, where I was mainly engaged in the organization and coordination of amateur theatre. At that time, amateur theatre was very active and very 'alternative', representing a kind of subversion in regard to the professional theatre mainstream. At that post, along with all organizational work, I was constantly preoccupied with my permanent subject – the effects and impacts of theatre experience on the real life of its participants, whether they be actors or audience, professionals or non-professionals.

Such an interest turned into a more specific professional commitment when I started to work, in 1989, as the head of the educational department of the Zagreb

Youth Theatre (*Zagrebačko kazalište mladih*), at that time the centre of creative drama in Croatia. I held this post for the next twenty years. My previous general concern for the experiential and real-life outcomes of theatre as an art form was now refocused on the creative engagement of children and youth with the theatre medium and more specifically, with improvisational drama, which was very much practiced there before my arrival.[2] From a more specific pedagogic perspective, which was quite influential in educational theories after the Second World War, these practices, regarded as education in and through (dramatic) art, were considered and advocated as strongly contributing to the integral development of the child's personality and his or her creative potential. So, when I started to work in the Zagreb Youth Theatre in the first years of the 1990s, in the domain of creative theatre/drama work with youngsters in Croatia, there already existed a positive context for reception of the concepts based on improvisational drama, as developed in the educational drama/theatre practices in the UK and Western Europe (like DiE, TiE, the theatre of the oppressed and more particularly forum theatre, the mantle-of-the-expert, etc.).

Darko: In that time, how was the environment for such activities? Did you have any institutional support?

Vladimir: It is a sad fact that many of these new and stirring experiences were introduced into Croatia at the most painful moments of its modern history – during and immediately after the wars raging in the region, which generally devastated social and family life, and disrupted the childhood and education of practically all children in Croatia. With the influx of various forms of humanitarian aid, and through the activities of the international humanitarian organizations and institutions, there were many projects aimed at giving psychosocial assistance and therapy support to various war-affected groups in the warfare zones, refugee settlements, and communities suffering the consequences of war. That was the way the first techniques of the theatre of the oppressed and of DiE were introduced into Croatia, where a huge number of educationalists, therapists, and artists, as well as local organizations and institutions, both GOs and NGOs, launched their own programmes of help and social assistance, often supported and funded by international organizations. Through these activities, whose more obvious positive effects were recognized and evidenced, a general awareness has been created of the psychosocial, educational, and therapeutic values of drama and theatre work with vulnerable groups, especially with children and young people. From that period also dates, at the wider social level, the recognition of drama education as a socially and educationally valuable set of creative practices. In a narrower sense, the notion, literally taken over from its English context, was understood as covering very different forms of drama and theatre work out of the professional theatre context.

If we talk about the institutional opportunities for these strivings, I must admit that in my professional life, I was able to work only through the institutions. I was always more interested in conceptual aspects of practices I was dealing with, i.e. what principles govern them, is there any practical 'philosophy' behind them, how do they function as a kind of 'system', and how can the 'system' be improved or changed? And in order to influence, change, and eventually develop such 'systems', the need for institutional support looks obvious. In the 1990s, the first and most supportive institutional stronghold for the activities I was concerned with was, of course, the Educational Department of the Zagreb Youth Theatre with its venues and huge number of young participants (at that time about 500 children and young people were involved in drama/theatre creative activities), which provided the necessary conditions

for continual practical checkout of different concepts and approaches we were facing, as well as for the development of methodology appropriate for our contexts and needs.

Another important form of institutional support in the 1990s was provided by the Croatian school system, with which I and my enthusiastic colleagues closely collaborated in structuring and monitoring the reviews and festivals of the school theatre groups inherited from the pre-war tradition. Thanks to this collaboration, in the following years we successfully instructed many motivated school teachers and other educators all over Croatia. Conceived as intensive practical workshops and supported by the Ministry of Education, these educational programmes were mainly intended to help teachers master the basic methods of creative drama/theatre work with children and youth (e.g. games, exercises, improvisational techniques).

But the most important event in building the institutional basis for our work was the foundation of the Croatian Centre for Drama Education in February 1996 by a group of 13 people, most of them working in the Educational Department of the Zagreb Youth Theatre, with the financial support of the Soros's Open Society Institute Croatia. The establishment of the Centre was based, on the one hand, on the outcome of the fervent engagement of many people within and out of schools interested in the new educational, social, and cultural practices (based most often on the methodology of creative drama), which were entering into the Croatian educational and cultural context. On the other hand, it was the result of our intention to connect the development of these practices in Croatia with the most current experiences and attainments of the world drama/theatre education, which was at that time probably reaching one of its peaks. In this sense, the foundation of the Croatian Centre for Drama Education was somehow the direct consequence of my attendance at the 2nd Congress of the International Association of Drama/Theatre and Education held in Brisbane, Australia, in July 1995, which made a strong impact on my commitments and understandings of drama/theatre practices in educational contexts.

In the first activities of the newly established Centre, the main emphasis was on the tasks of mapping the area and affirming the practices of contemporary drama education, as well as on transferring the main methods of drama/theatre educational work into Croatian contexts. For this purpose, in its first years, the Croatian Centre for Drama Education organized several notable workshops led by foreign drama/theatre teachers and trainers. The very first one was led by Tintti Karppinen, a prominent Finnish drama/theatre trainer. Another stimulating and, for Croatian and regional contexts, very innovative workshop was the eight-day Theatre-in-Education seminar held in August 1997 on the Adriatic coast, led by the British drama educators Tag McEntegart and Roger Chamberlain. The workshop was particularly important because it laid the foundations for the first TiE productions in Croatia and Bosnia and Herzegovina over the next decade.

In striving to promote and advocate the potentials of drama/theatre education as a 'tool' of valuable social and cultural practices, the Croatian Centre for Drama Education, in cooperation with the Zagreb Youth Theatre, organized two conferences, the Potentials of Drama Educational Work in the Prevention of Psychosocial Consequences of War for Children and Young People held in 1996 with over 80 participants, and the Potentials of Drama Educational Work with Children and Young People with Special Needs held in 1998 with more than 120 participants. 'The conferences had strong public advocacy effects, because they testified to what extent and with what enthusiasm the different professions in the field of education and psycho-

logical and social support (teachers, school psychologists, rehabilitators, social workers and other educators) embraced drama work and related educational approaches as an effective methodology of psycho-social assistance and social integration, of personal growth and as an experiential and participatory way of teaching and learning.'[3]

The culmination of this initial period, and in a certain sense its conclusion, was marked by the publication, in 2002, of the book by Iva Gruić *The Passage into the Imaginary World – Process Drama or Drama in the Making: Manual for Educators, Teachers and All Those Involved in Drama Work with Children and Young People*. In the book, the author,[4] one of the co-founders of the Croatian Centre for Drama Education, exposes in detail one of the main genres of British drama pedagogy – process drama. The minute methodological elaboration of its structural features is supported by description of several examples of process drama realized through her teaching practice at the Faculty of Teacher Education, University of Zagreb.

Darko: What were the main obstacles and problems you were facing in developing your concept of drama education?

Vladimir: In that first and formative period of contemporary drama education[5] in Croatia, which covers more or less a decade (from 1992 to 2002), there were in fact no obstacles worth mentioning to our growth and development, either at the level of institutions on which we based our activities or at the wider level of social, cultural, and educational policies. However, in 2002 the close cooperation of the Croatian Centre for Drama Education with the Ministry of Education, realized mostly through our professional assistance in organizing the school theatre festivals, was broken, creating an institutional 'obstacle' to our activities. After that, as the majority of our members work inside the school system, we had to find other means and levels of accessing it and implementing our programmes within it. So we participated in the projects of other organizations cooperating with the Ministry and the school system. We also began to launch our own projects targeting some other segments of the educational system and we started a closer cooperation with civil society organizations.

Our reduced involvement with the creative drama practices within the school system had, in a way, some positive effects, inasmuch as we now started to pay more attention to the challenges – some of them considered as problems and some of them as tasks – that emerged as results of 'importing' into the Croatian educational context, ideas, concepts, and methodologies already highly developed, structured, and widely practised in their culture of origin, i.e. in British DiE/TiE practice and theory. The checkout of the 'imported' concepts and practices, as well as their elaboration for their use in the new context, took place on two levels. Firstly at the level of their application by teachers and practitioners in their everyday work, either in formal or informal education, and secondly, on a more academic level, in structuring the study programmes and syllabi of the institutions educating future teachers and other educators.

At the level of applying the acquired methodology in everyday work, we recognized the need to provide educational drama/theatre practitioners, especially those less experienced, with the auxiliary literature to assist them in the structuring and effective implementation of their work, both in the field of creative drama as well as for purposes of teaching. With this goal, in 2005, the Croatian Centre for Drama Education started its publishing programme aimed at providing the drama/theatre education field with the basic professional literature needed for practical work. It is no accident that the first book published was the Croatian translation of *100+ Ideas for Drama*, by Anna Scher and Charles Verrall, an excellent creative drama handbook intended for drama/

theatre practitioners working inside and outside formal education. The choice was intentional since this kind of work, with its goals and concepts inherited from our educational tradition, prevailed and is still prevailing in the practices of drama/theatre education in Croatia.

However, the books that followed were related to drama education understood in a more specific sense; they were more focused on the DiE methodology to be used in different educational contexts. In 2007 and 2008, we produced two handbooks written by our members, each containing a collection of over 50 comprehensively described basic methods (e.g. games, exercises and techniques) of educational drama.[6] In both books, the lists of methods were supplemented with the examples of their application in everyday school practice.

We paid special attention to the practices of the theatre of the oppressed, more particularly to forum theatre, which induced a great interest among both drama and theatre practitioners in Croatia.[7] In 2007, as a result of the project realized in cooperation with the organisation Formaat Workplace for Participatory Drama from Rotterdam, NL, we published a handbook of forum theatre entitled *Don't Talk, Act!*, which was completely written by our members and associates. Alongside a very informative methodological and theoretical introduction into the experiences of forum theatre as a significant theatre/drama practice, the book presented 12 very different examples of forum theatre programmes carried out and described by the participants in the project. As forum theatre became an attractive issue for a wider audience, in 2009 we published the Croatian translation of Augusto Boal's *Games for Actors and Non-Actors*, providing theatre/drama practitioners and activists in the region with his seminal book. In 2016, our list of handbooks had been supplemented by another title: *Education for Citizenship, Education for Life – Handbook of Active Methods for Citizenship Education with Examples of Good Practice*. The book, published as an e-edition, was one of the outcomes of a two-year project which, as its principal aim, had the implementation of DiE techniques as suitable participatory methodology for teaching citizenship as a school subject.

At an academic level, the challenge was to create and structure the new study programmes of drama/theatre pedagogy needed for the systematic education of future teachers and other educators. In the beginning of the 2000s, several institutions of higher education expressed a demand for such programmes.[8] However, the institutional centre of this development has been the Faculty of Teacher Education in Zagreb (the former Academy of Pedagogy) and its Department of Croatian Language and Literature, Performing and Media Culture, where Iva Gruić is actually heading the study programmes of performing culture. Until recently, in the study programmes of the Croatian teacher, higher schools, and academies, there was traditionally a subject called 'puppetry and performing culture', or similar, designated mainly for the students of preschool education. The course was primarily intended for acquisition of knowledge and skills in puppetry and stage performing understood as theatre art forms, as well as the media of creative work for children and with children. With the arrival of Iva Gruić in 1993 at the Zagreb Academy of Pedagogy and her subsequent engagement with experiences of contemporary drama/theatre education, the content of the inherited study programmes was gradually expanded and then divided into three subjects: 'puppetry', taught to the students of preschool education, and 'performing culture' and 'drama education', taught to school classroom teachers. In this way, by 2010 drama education in Croatia had been established as an academic subject. Moreover, in the years to come, the efforts to build and structure drama education as a specific

field of educational practice characterized by a specific teaching/learning methodology have been crowned by the creation of the first Croatian Postgraduate Specialist Study in Drama Pedagogy programme, which was successfully launched in 2016 at the Zagreb Faculty of Teacher Education under the guidance of Iva Gruić.

Implied in all these endeavours of both the Croatian Centre for Drama Education and the Faculty of Teacher Education, was the intention, permanently present in our activities and objectives since the foundation of the Croatian Centre for Drama Education, of implementing contemporary drama education into the Croatian educational system in a more solid and stable way. Along with continuous education through workshops and courses for teachers and educators in basic drama education methods and principles, the important achievement in approaching that objective was the adoption, in 2010, of the *National Framework Curriculum for Preschool, General Compulsory and Secondary Education*, to which I contributed as the author of the section titled 'dramatic culture and art', in which drama for the first time gained a separate place beside other artistic fields in the chapter 'art area'.[9] Although the title of the section as well as its placement in the art area suggests that drama will be treated in the first place as an art form, the extensive elaboration and description of the expected learning achievements of the students at all educational levels specifies not only artistic or aesthetic attainments of the students but, much more often, the outcomes resulting from using the medium of drama in the processes of individual and social growth and maturation, in developing social skills and communication, in cultivating critical thinking, and fostering social and humanistic values, i.e. the effects resulting from methods and goals specific for contemporary drama education. The inclusion of 'dramatic culture and art' as a separate educational area in the main National Curriculum Framework generated the formal conditions for conceiving more concrete curricula at lesser levels of the school system, e.g. at the level of an individual school, or a teaching subject, or some particular educational field. Besides, the broad scope of outcomes stated in the National Curriculum Framework allows the creation of very different curricular programmes, ranging from those in which the art form of drama/theatre will be learned and experienced, to those in which the methods of educational drama will be used for some specific educational purposes.

Darko: What are the perspectives for further development of drama education and pedagogy in Croatia?

Vladimir: With the three achievements – first, positioning the field of drama/theatre in the national curriculum; second, establishing drama education as a teaching subject in the study programmes of future teachers; and third, setting up the postgraduate study in drama pedagogy as a specific field of educational practice and methodology – the premises have been set for a wider social, cultural, and academic recognition of drama education as a specific, although interdisciplinary, domain of art education, as well as of drama pedagogy as a specific educational methodology of experiential teaching/learning based on the medium of drama. All attainments and premises taken together and sustained by further persistent work at all levels, from everyday classroom practice to the academic research and institutional procedures, should lead to the eventual legitimation and legal acknowledgement of drama education as a specific professional field, and of drama pedagogy as a specific and legitimate profession. Reaching this objective, which implies more solid institutionalization of drama/theatre practices inside the educational system, should not mean the ending of developing and promoting drama/theatre education and pedagogy beyond the borders of school programmes and

curricula, the feature and the ambition that contemporary educational drama/theatre always cherished. The old and the new institutional fulcrums and forms of work, either within or outside the school system, could be productive hotbeds for deepening, researching, and expanding the experiences of educational drama/theatre both in theory and in practice.

Notes

1. In the last decade in Croatia, the term has been sometimes used in everyday professional discourse, but as a concept it was first elaborated by Darko Lukić in his book *An Introduction to Applied Theatre – Who Owns the Theatre?*
2. The credit for the Zagreb Youth Theatre as the hotbed of *creative drama* in Croatia goes to two extraordinary women, Đurđa Dević-Šegina (1916–2002) and Zvjezdana Ladika (1924–2005), both drama/theatre pedagogues, who were heading the Zagreb Youth Theatre Drama Studio, Dević-Šegina in the 1950s and Ladika from the 1960s–1989. Officially retired, Ladika continued to work in the Drama Studio until her decease in 2004. In her mandate, Ladika made connections with at that time the most prominent traditions in the field of *creative drama*, that of Winifred Ward in the USA and even more so with the practice and concepts of Peter Slade's *child drama*, which she applied in her own work and further developed in her books *Child and Theatre Art : A Manual for Drama Education of Children and Youth* (1967) and *Drama Games* (1970), which she wrote together with Đ. Dević-Šegina and S. Čečuk. Their *creative drama* work was not restricted only to the institutions where they were employed; throughout the years they gave numerous workshops and have spread the methods and techniques of improvised drama into the practice of the school theatre and drama groups.
3. Krušić, V. (2015). *Drama Education in Croatia Today - An Experience Based Story*. In: The European Journal of Social and Behavioural Sciences, Vol. XIV/3; p. 1950 – 1959. http://dx.doi.org/10.15405/ejsbs.176
4. In 2005, Iva Gruić defended her doctoral thesis at the University of Central England in Birmingham and became the first Croatian PhD in the field of drama/theatre education.
5. I prefer talking about 'contemporary' drama education, referring to practices, methodologies and theoretical approaches predominantly developed and conceptualized in British post Second World War educational and cultural contexts, as opposed to the mostly unknown and unexplored practices and concepts of drama/theatre work for educational and didactic purposes present in the educational traditions in different European cultural contexts ever since the Age of the Enlightenment. These practices, although the term had not been in use at that time, I usually call 'modern' drama education referring to the idea of 'modernity' as being connected with the emergence of the bourgeois classes and with their cultural self-affirmation.
6. The books are: Radetić-Ivetić, J., ed. (2007). *I Play and I Learn! - Drama Methods in Classroom Teaching*. Croatian Centre for Drama Education – Pili Poslovi. Zagreb. and Lugomer, V., ed. (2008). *Imagine, Experience, Express! - Drama Methods in Teaching Croatian Language*. Croatian Centre for Drama Education – Pili Poslovi. Zagreb.
7. The Croatian Centre for Drama Education has organized forum theatre workshops since the mid-1990s, but it gained larger public interest with the Workshops of Cultural Confrontation, the project realized from 2001 to 2003 by theatre professionals in the Exit Theatre in Zagreb and later in some other cities and specific environments such as prisons and correctional institutions for young offenders.

In December 2002, in the Zagreb Youth Theatre, I organized the four days forum workshop, with participants from Croatia, Bosnia and Herzegovina, and Serbia. As its outcome, in November 2003 the Forum Theatre Marathon was held with 12 forum theatre performances/programmes performed first in the Zagreb Youth Theatre and then in schools and NGOs. The largest action of the Croatian Centre for Drama Education in the promotion of forum theatre was realized in 2005, in cooperation with Croatian UNICEF and the Ministry of Education. The project entitled 'Forum Theatre for the School without Violence' consisted in organizing 14 workshops throughout the country with the aim to teach the participants – over 200 teachers, school pedagogues, and psychologists, as well as a number of students – the basics of forum theatre. Since then, along with workshops we used forum theatre techniques in most of the Croatian Centre for Drama Education projects in the following years.

In Croatia today, the principal hotbed of forum theatre and of the theatre of the oppressed practices in general, is the Pula Forum-The Theatre of the Oppressed Festival, established by our members in 2008 in the city of Pula. The Festival developed intensive international activity bringing each year to

Pula professional forum theatre groups and prominent practitioners (Augusto Boal personally opened the first session of the Festival) and organizing workshops for experienced and non-experienced participants.

8 From 2001 to 2010, I was teaching the basics of drama pedagogy at several academic institutions. In 2001, I gave an initial course in drama pedagogy at the Social Work Study Centre of the Faculty of Law in Zagreb, after which the Study Centre established it as a permanent course led by their own staff. From 2001 to 2007, I was teaching the same subject to future classroom teachers at the Petrinja High School of Pedagogy. From 2003 to 2010, at the Department of Croatian Studies at the Faculty of Philosophy in Zagreb, the students in the course were future teachers of Croatian language and literature. Since 2012, I have been teaching at the Faculty of Teacher Education at the University of Zagreb, Department in Čakovec.

9 It would be useful here to explain the title of the section, which does not actually mention drama education at all. It was chosen in accordance with the possibilities offered by the given methodological matrix, reflected in the terminology and categories used, according to which the curriculum and its parts were to be formed. At that time, in the operating vocabulary of the 'official' makers of the new curriculum (Ministry of Education, etc.) the notions of 'drama' and 'dramatic' could be related either to the standard school subject of Croatian language and literature, where they had always made parts of its content, or, in a wider and for our purpose much more appropriate sense, to the field of (dramatic) art. Using the *Art Area* as an entrance to the curriculum, in the section *Dramatic Culture and Art* I developed drama in all its aspects, from art form to dramatic play, and stated the numerous outcomes of its broad application in educational processes and for educational purposes.

10
IN SEARCH OF POLYPHONIC CONCEPTS OF PARTICIPATORY THEATRE AND ART FOR SOCIAL CHANGE

Almost half a century of engagement

Ljubica Beljanski-Ristić

The purpose of this chapter is to present the times that opened certain key spaces, and the roads that led me to new collaborators who were of central importance, to my explorations and social engagements in what I started to call "drama and theatre of participation". I will describe here a process of transformation of a small drama studio where, from the very start in 1970, together with the first generations of children who were its true founders, I wished to create a new kind of theatre – their theatre, a theatre of children's reality, creativity, and play.

Later, at the end of the 1980s and the beginning of the 1990s, at the start of the breakup of Yugoslavia and civil war in the country – sanctions, the fall of the socialist regime, the political and economic crisis, unresolved issues, and the prolonged state of transition in Serbia pulled our small community into a whirl of events that deeply affected our work, changing the very sense and meaning of our existence as a drama group. The way we saw ourselves, the others, and the world in which we lived was rapidly changing, directing us to search for new approaches, new topics, content, elements, and ways of existence. We wondered what the new environment would be – what new communities there would be, and the ever growing circles of theatrical groups, their leaders, participants, and audiences would be – with which we would be able to forge new events in the theatre of the play for life "where art and will to resist conquer every evil, even death".

Numerous activities and projects on which I worked, together with children, youth and many colleagues, artists, and educators, were developed both as my own creative and artistic work and as a way of socially engaging in the areas of importance for our lives and work. In this text, I describe especially those projects that were the most meaningful and most effective in helping me realize my desires. These were those activities and projects that brought changes and affected multiple existential planes: personal and professional, cultural, educational, social, and societal.

The first was the Children's Drama Studio named *Škozorište* at the Cultural Centre, "Old Town" in Belgrade. Then came four projects that were created in Belgrade and wider in Serbia with the Centre for Drama in Education and Art.

One must not exclude four individuals and organizations when talking about the first activities, the current moment, and the look into the future for the still informal Applied Theatre Platform in Serbia.

At the end, there is also an important manifestation, a programme named Bitef Polyphony, as part of the Belgrade International Theatre Festival of the New Theatrical Tendencies (BITEF), where all these activities are tied together and made visible internationally.

Theatre of participation: a polyphonic concept

It turned out that drama and theatre of participation, which was my primary focus at the start of my work with children, became the main drive of my artistic, educational, and social engagement, lasting now almost 50 years. My search for polyphonic concepts of drama and theatre was enriched through focusing on multiple voices, interaction, and dialogue in diverse forms of work with various groups of participants and audiences. It is important to stress that I searched for the concepts of polyphony, both in regard to particular actions and projects, and in regard to whole processes of shaping performances and other types of events like, for instance, festivals and professional conferences. I took basic values that underlie the interaction between multiple independent voices and used them as a source that, in practice, enables the very possibility of having freedom of choice, respect for differences, and nonviolent communication. All of these are, in turn, indispensable for enabling us to enter into new relationships and jointly build new worlds and new realities through full participation and openness for co-authorship in all work processes, social changes, and new challenges in our everyday life.

It started as just a hazy inkling in my work with children in our drama studio, developing through many diverse forms of psycho-social support of the marginalized social groups and projects within the arts for social change. The concept of polyphony grew clearer and stronger through my continuous work on sustaining and further developing programmes for the drama and theatre of participation within the frame of the renowned Belgrade International Theatre Festival. I believe that this search for polyphonic concepts contains values and meanings that are the basis of a wide spectrum of activities and practices that we, whether we agree with them or not, are getting used to and currently increasingly calling "applied theatre".

Škozorište

Regardless of the point in time when the notion of "applied theatre" was put into use, and subjected to ongoing theoretical attempts to define it, I was first introduced to the field back in the 1970s when I worked first as an external associate and then as an organizational and artistic leader and a director of the Cultural Centre "Old Town" in Belgrade. By some stroke of luck, I got a position in the Centre and was given the opportunity to design a drama studio for children, where they would spend their free time after school. My initial aim was to first let all interested children hear each other out, share their experiences, and freely express how they imagined the theatre that would be *theirs*. It turned out that the Cultural Centre "Old Town" was the right place for this kind of a new programme activity – *Škozorište*.

Škozorište Plays

The child as creator, children's creativity as a process, and play as a creative principle were the foundations of the entire work of Škozorište. The first public outdoor performances took place in summer in 1978. And without any major problems (today it would take a dozen permits).

Škozorište was given a wonderful amphitheatre in Belgrade's most renowned park and a cultural and historical complex Kalemegdan, with a wonderful view of the confluence of the rivers Sava and Danube. Every Friday at 5pm, *Summer Škozorište Plays* were regularly held, including countless improvisations called *Say Škozorište*.

Summer Škozorište Plays used to bring together children and their parents. Anyone who wanted to join only had to say "*Škozorište*"! That was the audition and the ticket – the beginning of interaction and participation in the play. Their involvement in the play would start on their way to the venue, where they would be greeted with "ŠK!" After that, they were invited to draw their self-portraits or to complete drawings, which would introduce them to the topics of the play: *Škozorište School*. The classes and breaks, and the entire "school" was quite different from regular schools. It was just as children would imagine and want it to be. For example: "*Why in mathematics there is no sign to solve life's problems?*" or "*The time of biology is best when walking in nature*". One of the children who was a show-host of Studio ŠK led the event, involving everyone in hilarious conundrums of škez-classes and škez-breaks, featuring humorous spoofs of the contemporary TV commercials, with inverted messages addressed to adults and parents – "how to produce a perfect child". At the end, the children always sang the Škozorište anthem, "It is not school, it is not theatre, Škozorište, Škozorište!" and continued chatting and playing together.

Over the years, Škozorište's participatory theatre plays grew ever more powerful in their choices of topics focussing on current events and problems children had. The participating children recognized that they had freedom to tackle the questions that really concerned them. Through their involvement and improvisation they could speak up and speak from their hearts, address their peers, parents, teachers, and other adults, and involve them in interactions.

Škozorište offered a wide spectrum of different topics emerging from the children's free time activities and socializing, from interests, games, secrets, sympathies, and first love, to problems in relationships with adults, conflicts with peers, obsession with television, loneliness, etc. Titles of Škozorište plays that followed in the second half of the 1980s focused very directly on the issues of the conflicts and pressures of actual life events and relationships.

The Children's Hamlet Workshop for Adults

It was the first time at the end of the 1980s that the children expressed a wish to work with an actual dramatic text by a real author in their own improvisational games. They wanted to use their dramatic exercises, plays, and improvisations based on such a text, to create a public performance in which they would, as always, include the audience. In addition, they wanted to have not only children as an audience, but also adults. Since the oldest ones in the group were high school students, according to them, the main, the greatest, and the most serious author was Shakespeare. And the text that received the most votes was *Hamlet*, a play that the older children were reading about in high school. The younger participants of Škozorište were awed by the justifications of the proposals by their older friends and they expressed their full interest to be included. The title of the project was coined immediately "The Children's Hamlet Workshop for Adults". And so, Shakespeare entered Škozorište with his *Hamlet*, in 1989.

The workshops entailed three different layers: the layer of play, the layer of dreams, and the layer of the texts (famous lines and phrases) from *Hamlet*, all intertwined with the personal stories of the participants inspired by *Hamlet*. The main topics were derived from the situations in which adults' decisions lead to tensions, pressures, and conflicts affecting the children's and adults' relationships leading to negative, even tragic, consequences.

It is important to point out that the interactive performance was the result of a two-year practical research project on the topic of authoritarian adults and so-called unruly children.

Three generations of Škozorište students – elementary, middle, and high school – took part in this project. Workshop facilitators were former members of Škozorište.

The first public performances of *The Children's Hamlet Workshop for Adults* in 1991 marked 15 years since the beginning of Škozorište. The project introduced an important change in the very concept of Škozorište. For the first time, it had addressed adults. The involvement of Ana Marjanović Shane, a psychologist, and Aleksandar Gubaš, a videographer, introduced Škozorište to an artistic practice-based research process. For me, as a coordinator and the artistic leader of the project, this was a great challenge, especially because of the opportunity to deepen our work on the project through research into "drama in education – the real and fictive planes in directed socio-dramatic play". At the same time, this project created an opportunity for me to test the theory of dynamic competences directly in practice. The theory of dynamic competences is based on the idea that the arts have a role of correcting life's imbalances. This experience of a research interactive process, including multimedia, was of crucial importance for the realization of the future interdisciplinary and intercultural research projects that followed.

Twenty years later, on the occasion of the promotion of the first book about Škozorište, Dr. Milena Dragićević Šešić, a scholar of culture, confirmed this pivotal change saying:

> We have here a very important cultural and theatrical process of work, that resulted in a specific model of the role of theatre in society, where equal importance is given both to an action research and to the performance. This model can be characterized, in the words of Mađarev, as a children's theatre, but not as a theatre for children, rather, as a theatre that is created by children, where the children actually self-educate themselves. We use a term peer education, although this term was not in use at the time when Škozorište was working. According to this model it is a theatre in the best sense of the word, and at the same time, it is an experimental scholarly platform.

At any rate, the performance of *The Children's Hamlet Workshop for Adults* opened up a path to research and to social engagement dealing with themes that were increasingly becoming a sad reality for all of us.

"Living Together"

In the early 1990s, major social and political changes in Yugoslavia significantly influenced both our everyday life and the deeper consideration of our creative, artistic, and social activities. The complex political and economic situation in the country, increasing conflicts, sanctions, and war made us face the responsibility of responding to urgent problems. The need was especially urgent to open programmes for children and youth who were refugees, especially from Croatia and Bosnia and Herzegovina.

The innovative practices we were actively developing within our cultural programmes were now implemented in the new programmes of psycho-social support. We had embarked on a large project launched by the newly founded Open Society Foundation. The project was named "Living Together". It was organized throughout the summer of 1992 near Subotica, a beautiful setting near Lake Palić, including a park and the local zoo. This natural environment was not only a space, but also an incentive for various artistic workshops and performances. The refugee children and children from the local community created together a world with the purpose to live life without pressures and conflicts. Experience in this camp was one of the most important in our life. It showed all the power and all the benefits of both the world of art and the creative community of children and artists

Here is a statement from a girl from Sarajevo who stayed in the camp during all three shifts:

> We have been shown in the camp that it is possible to live in friendship and in harmony, in spite of all the differences. While the grown-ups quarrel, the children know how to live and they can live in friendship, and during the whole stay in the camp, only togetherness and friendship spread among us.
>
> *(Maja Vasiljević, 11 years old)*

In the meantime, under the pressure of new circumstances, in 1992 there was a change in the law regarding municipal cultural institutions. The Centre entered the hardest period of its existence because of the introduction of new legislation relating to the status and financing of cultural institutions that were under the jurisdiction of municipalities.

We were left without funding and without the status of a municipal institution. The Centre was left to be shut down with the authorities' hidden aim to take it over, in order to transform the beautiful space of 1,000 square metres the Centre occupied into something else, something much more commercial than the programmes for children, young people, and artists. But we decided not to surrender so easily. Schools did not work regularly and there was plenty of free time to be filled with some constructive activities where children would be protected and safe.

It was not easy. The efforts to sustain everything had their own consequences. Sometimes it seemed impossible to achieve the desired outcomes. But all of those children, young people, associates, parents, and friends were the ones who created the vital force of action. To endure those turbulent years of the war, with more and more displaced people, was not a burden; it was a challenge and a strong incentive. The real challenge was to not succumb to prejudices, but to remain open-minded, without trying to make decisions about the needs we thought that others should adopt as their own. We tried to create the themes in the ways in which the processes of play, drama, and theatre would be interwoven in an interchange of ideas and views among people coming from different regions and different backgrounds. We became inspired by each other. We were discovering each other as if discovering new, unknown worlds. We realized how little we knew about ourselves and how important it was to feel, recognize, and support each other in the choices of working and living together. Sometimes we were cautious, and sometimes we were very open. Sometimes the topics were heavy and troublesome, sometimes they were funny. Drama structures, especially "frozen images" always create wonders. This joy of creation had established the communication and relationship of trust and closeness and the feeling of festivity, happiness, and excitement with the experience of applause.

"Art for Social Change: Play Against Violence"

Our engagement and full commitment to our projects gave us the strength to be persistent in our endeavours and to persevere. We were not alone. We felt the support of colleagues from around the world, regardless of the situation of exclusion that existed in the country due to the state of war.

At the end of the 1990s, we had been invited to participate in the new project "Art for Social Change – Play Against Violence" launched by the European Cultural Foundation in Amsterdam with the support of the Network of Open Society Foundations in South East Europe. Pilot projects in Yugoslavia share the joint title: Play against Violence – Play for Life. Each consisted of an annual process and a final presentation. In parallel with the work with young people, we create the framework for new partners and new productions within a network and exchange at regional level, in places like Novi Sad, Niš, Valjevo, Podgorica where Open Clubs and informal

theatre groups engage with young people. The project introduces involvement with the arts as a way in which young people at risk can explore their lives and environment and build their self-esteem. The role of the artist within "Art for Social Change" was crucial. Their responsibility was not to focus solely on their own creative aspirations, but to work through their art to create a safe and collaborative space for the young people in the programme.

Evaluation through the workshop process became the best way to exchange the methods of work and shape activities. Here are some selected statements by the theatre artists/workshop leaders:

> I believe ... there is a secret sound – in every person. So I try to help young people to find the secret sound in themselves ... But also ... to make a bridge between that secret sound and the outside world. Through creativity. To say something to the others. And for that, I use theatrical techniques, not to learn them for their own sake but to enable them to ... say what they want in the best, most beautiful way they can. Because if you want to say something and you don't have the instrument – if you want to play something and you don't know how ... So that part of the work is very important work for me.
>
> *(Gordana Lebović, theatre director)*

> We are living in a society that is so highly structured, by knowledge. You have to do radical things, in my opinion, to break through that. What is really problematic is the issue of being spontaneous ... I don't want to instruct others I want to search together with the group ... to produce a situation in which everyone can be comfortable with not knowing ... The end should be freedom and creativity. And creativity is about flexibility and the ability to react to what is coming at that particular moment as it comes. If you are able to do that, then you are really very resilient. Very able to cope with life. It essentially empowers you ... It is the only way you can deal with very difficult circumstances.
>
> *(Igor Dobričić, dramaturge)*

> I think that in one point of the work it is very important to include form – theatrical form, because they can learn to work together in a group. They can aim for an objective that is greater than their individual possibilities, so they can work to achieve something together. And if they create a good artistic piece, it has an emotional effect, a cognitive effect, and a theatrical effect. And then we can see practically how art can affect people in society.
>
> *(Slobodan Beštić, actor)*

Our long-time friends and colleagues from Croatia and Bosnia and Herzegovina also took part in "Art for Social Change - Play Against Violence" in their countries. We met with them at a workshop in Bulgaria as a neutral territory for meetings in a delicate time (due to the state of war). Art spaces had reconnected us and had opened up possibilities for joint cooperation.

We were also able to establish our civic association Centre for Drama in Education and Art – Centre for Drama in Education and Arts, which soon became the national centre of the International Drama/Theatre and Education Association. Centre for Drama in Education and Art gathered together a large number of interested artists, pedagogues, teachers, and other experts. The focus has been on drama and theatre in educational projects, and also on other forms of participatory performance practices with children and young people. Centre for

Drama in Education and Art networks of associated members from Belgrade and other cities in the country have been created.

Enthusiasm about and faith in the future returned again. Our cultural centre entered into the process of resolving its legal status. We felt good, valuable, and important. Everything looked like a new beginning. By engaging in reforms in the field of education, we were able to participate in working groups for the arts and had succeeded in introducing drama and creative movement, in addition to music and visual arts, to the school curriculum.

At that time, the Centre for Drama in Education and Art was involved in organizing various performances and other activities designed for vulnerable and marginalized groups. We worked in different parts of the country, especially in areas with ethnically diverse populations. The Centre for Drama in Education and Art was the only organization with such experience. As a result of these projects, both the participants and the audiences highlighted topics from their everyday life, communication with the audience, and the ability to express what they mean and to be heard. Since we often had open workshops, presentations, and performances in the venues belonging to various cultural institutions, some of the young people had an experience of entering a theatre for the first time. Many were pleasantly surprised when, at the end of the event, everyone was offered refreshments and snacks while continuing informal socializing.

Unfortunately, the change of government in 2004 again led to a crisis and halted the educational work that had begun. We were again entering a transition into a new social and political order. Working under the conditions of violent social transitions demanded from us clear and strong determination to keep our educational and artistic values, and not fall into various traps of commercialization of our offers or other economic, political, and ideological abuses.

"DICE – Drama Improves Lisbon Key Competences in Education"

Over time, we began to evaluate, formulate and highlight the positive effects of different aspects of the practices we organized. At the beginning of 2009, we had the opportunity to participate in an important research project, popularly called "DICE – Drama Improves Lisbon Key Competences in Education, in which we became one of the affiliated partner organizations. The DICE project was an international EU-supported project to research and support teaching of drama and theatre in educational contexts. In addition to other educational aims, this two-year project was a cross-cultural research study investigating the effects of educational theatre and drama on five of the eight Lisbon Key Competences. The project was conducted by 12 partners investigating more than 100 different educational theatre and drama programmes with the participation of about 5,000 students. The project was led by Adam Cziboly from Hungary, a psychologist, cultural manager, drama teacher, and an outstanding expert in the field of applied theatre.

The main part of the Serbian project took place in Belgrade Pharmacy-Physiotherapy High School, with ninth grade students and a Serbian language and literature teacher, Jelena Stojiljković. It took place in her class within the scope of the regular curriculum, and it followed the predefined teaching units. A particular goal of the project was the implementation of a lesson-long workshop that can be done within 45 minutes, which was a difficult but still a possible and achievable goal, as we may conclude from the experiment's positive outcomes and results. The workshops explored topics required by the regular curriculum of Serbian language and literature in combination with innovative, creative, and interactive approaches deriving from play, drama, and theatre. Ten teaching units based on the literature programme were carried out. Basic starting points for these workshops were derived from the goals and tasks set by the regular curriculum, with an additional goal and task to carry out each lesson in the form of a creative

and interactive workshop using drama structures. In addition, each literature unit was put into the context of exploring the school's pharmaceutical and professional contents, for which the students of this school were being educated. For example, in *Romeo and Juliet* the issue of conflicted groups, conflicts, violence among young people, conflict resolution, and peace-making (in the period and today), were coupled with questions of responsibility of the professional pharmacists and professional ethics of pharmacology.

The Serbian language and literature programme for ninth graders in our system is mostly not interesting or motivating for the students, and the literature is not attractive to read. For the most part, it consists of traditional epic poetry, and ancient and medieval literature. The workshops we created presented very interesting material inspiring the students to read the school mandated literature in the light of their future profession.

Ivana Pantić was a young teacher of Serbian language and literature in the High School for Pharmacy and Physiotherapy in Belgrade. This was her first job, and her second year of teaching. She was present at all workshops, and here are some comments she made:

> After the cycle of workshops, I have much better and closer collaboration with experimental classes now. The relationship between these two groups and me is warmer. I got to know them all better, and they got to know me better. They developed better relations between themselves and in particular those who didn't communicate before that. Some students opened up for communication with their peers, where they were closed before. Students are now all motivated to read…They show high motivation for work, if they expect the workshop. They are all involved in a workshop, which is not a case when I teach in a form of a classic lesson. In both classes the average grade is above 4.00, which is not usual.

The DICE research was a longitudinal cross-cultural study, which basically means that we have been measuring the effect of educational theatre and drama in different cultures over a period of time. The project demonstrated that educational theatre and drama is a powerful tool to improve the key competences. The research was conducted with almost 5,000 young people aged 13–16 years. Also, the project compared theatre and drama activities in education in different countries and helped various organizations, artists, teachers, and young people to exchange experiences and expertise. The key outcome of the project was the Education Resource and the Policy Paper, and hopefully it will also lead to a series of publications of the detailed research results in future years, beyond the scope of the project.

New Creative Choices – Building an Open System of Educational Theatre and Drama for Enhancing Roma Inclusion

In January 2010, a project initiated by the Art and Culture Programme of the Open Society Foundation, Budapest was created to explore the potentials and effects of educational drama and theatre as tools to enhance Roma inclusion. The implementation of the joint project was carried out from September 2011 to August 2012 by eight organizations, national project leaders in their countries: Bosnia and Herzegovina, Bulgaria, Croatia, Hungary, Macedonia, Poland, Romania, and Serbia. Based on research of the existing situation and practices, the project team formulated a three year scheme, conceptualizing the core and optional activities. The mission of the project was fighting discrimination, and strengthening of mutual understanding between young Roma and non-Roma using theatre and drama techniques in creating communities of learning. The joint title of the project was "Educational Theatre and Drama as Tools to Enhance

Roma Inclusion". Our project title was: "New Creative Choices – Building an Open System of Educational Theatre and Drama for Enhancing Roma Inclusion". The focus group of our project was a group of young people, Roma and non-Roma, gathered around an activism project of the Association "Generator" from Vranje.

Working with contemporary and traditional approaches, the Roma tradition of storytellers and contemporary storytelling techniques, educational drama, and techniques such as image theatre, forum theatre, and other theatrical forms based on the workshop approach, led our project to interactive performances.

Our work was focused on promoting Roma culture and the specific form of active participation involving the Roma population in creating cultural life in their environment and encouraging social action in their community. The goal was to initiate interest, to increase visibility, and to turn the attention of the public to the values of Roma culture, but most of all, to the current social issues, vital for each intercultural community. Roma cultural tradition has a rich and diverse repertoire of orally transmitted myths, encapsulating all the categories, from folklore tales and various legends, to humorous narrative materials. Usage of these materials may be based on original versions, through an author's interpretation, or as explorative work through various theatrical forms, and also currently relevant themes, facing the issues that have always triggered reflection and provoked discussions.

Here are some selected statements by the participants and the associates:

I am glad that I was a part of this project and gave my contribution. It was very good. I have to point to several situations. Considering that others nowadays create performances on Roma and visit Roma settlements, teaching Roma how to brush their teeth or use a condom, and I don't like it one bit. I am very pleased, and I like this idea about a storyteller and grandma telling tales. This is one of the Roma traditions and we should show it. When I was a small boy, we used to gather as large families, neighbours, we would all sit in one room in the evening, and the elderly would tell stories. We learned a lot from those stories. I support this kind of work and I am glad to participate.

(Haki Ibrahimi, collaborator on the project – leader of workshops, performer – teller/amateur actor, member of the Roma NGO New horizons, Novi Sad/Belgrade)

I would like to follow that with where we are now, what can we do now, after everything. I would like to make my profile – Jugi, living in a Roma settlement, striving to contribute to his family and his community. I would like to tell about Roma people who succeeded. The beginning is in the Roma roots, but after that we have to demonstrate that it is important not only to be Roma, but also human, and that everything is possible if you try hard.

(Jugoslav Hamza, unemployed/amateur actor – in the first team of peer educators and trainers in the group NeKi from Vranje, the initiator and leader of his own informal group from Leskovac)

For me it was a valuable and positive experience when I found out recently, during the programme in the Ethnographic Museum, how many enthusiastic and creative people exist, that through drama, storytelling and play, make vivid and alive certain

values from tradition. In this case I talk about the tradition of Roma storytellers. I realized that sometimes real creative power comes out of organizations and events from which I would not be expecting at first sight impulses for such projects. My mistake and – apology! :) The Center for Non Material Cultural Heritage in the Ethnographic Museum will continue the collaboration with you, because one of the main lines of the UNESCO Convention for the preservation of Non Material cultural heritage is just that moment where, on bases of tradition and cultural heritage, a fertile ground is created for contemporary artistic creation and artistic education.

(Saša Srećković, high curator, leader of The Centre for Non-material Cultural Heritage in the Ethnographic Museum, Belgrade)

The final project presentations and performances in the Ethnographic Museum in Belgrade were the first public promotion of such an initiative. The presenters from different fields of education and culture set the foundations for the future of the project, using the existing experiences and potentials of the Roma storytellers' tradition, exploring the form promoted within this project to further develop as an open system and methodology which will contribute to the improvement of artistic and intercultural education.

Young people from the group from Vranje welcomed the visitors of the presentation in the hall of the Ethnography Museum, where they performed the Roma tale "Gan and Chen" in the form of image theatre. Further down the aisle, the members of Belgrade Mimart Theatre performed "Gan and Chen" in their non-verbal theatre performance. The presentation of the project took place in the art cinema hall within the Ethnographic Museum, opened with scenes and public reading of the drama text "Storyteller" and the "Gan and Chen" tale. The round table was an invitation for the exchange of experiences and further joint work on preserving the Roma storyteller tradition and educational drama in creative interaction.

Applied theatre platform

The DICE project gave new strength to our engagement, and made way for new projects that were taking place at that time, in particular on the further work and activities of the Centre for Drama in Education and Art. There are many who make up the applied theatre platform today and act in different ways in the field of innovative, creative, participative, inclusive, and educational activities and other drama and theatre forms which can be classified under the great umbrella of applied theatre. In this sense, the Centre for Drama in Education and Art is one of the important associations in the field, an open network of regular members and a wide group of associate members, participants, collaborators, and project partners both from Belgrade and from all over the country.

In addition to the Centre for Drama in Education and Art, an important association for all those who are engaged in applied theatre is the Independent Cultural Scene of Serbia, which constitutes a platform of nearly 80 organizations, initiatives, and individuals in the field of culture and arts from 20 cities in Serbia.

In the meantime, since 2016, "applied theatre" has become a regular programme of study at master's level in the Department of Dramatic Arts of the Academy of Arts Novi Sad. Fully aware that young artists have to be prepared for the challenges of the new millennium through contemporary methods, the Academy, along with its educational and scientific activities, is actively developing international cooperation with numerous cultural, artistic, and education institutions and organizations.

Here I wish to mention and highlight some of the authors and professionals who were undoubtedly harbingers in this area or at least active in promoting it and carrying it into the future:

Zorica Jevremović is a theatre and video director, dramaturge, writer, choreographer, multimedia theoretician, and literary historian. She also works as a dramaturg (playwright) in alternative theatre and film groups. She founded various alternative theatres which operated as "neighborhood theatres" in ghettoized communities. Pocket Theatre M (1993–1995) at the Dr Laza Lazarević Pychiatric Clinic where the core of the group was made up of convalescents, children of the hospital's therapists and from the hospital vicinity, psychologists, professional actors, and other public figures. The Children's Street Theatre (1985) with Romany and "White" children from the area, in Skadarlija, an artistic and bohemian area in downtown Belgrade. WAY 5a (1997–1998), a feminist theatre group based in an apartment of the Autonomous Women's Centre against Sexual Violence. The core of this troupe was made up of women who came to the Centre for help, Centre activists, ballet dancers, painters, students, neighborhood women, and women refugees. At the beginning of the 1990s, Zorica initiated the production of many sociocultural projects through two anti-war activist groups: The Civil Resistance Movement and The Belgrade Circle. She is founder and director of the Center for Media Ranko Munitić in Belgrade. She is the editor of the first regional journal for media and culture, *Mediantrop* (2012).

Marina Mađarev, a theatre scholar (theatrologist) is especially focussed on applied theatre. She writes about applied theatre in diverse journals and participates in projects, organizes round tables, and plans to write a book about it. Among other things, she started a project "Applied Theatre in Vojvodina from 2000 to Today". Her purpose is to inform a wider community about the creative authorial work of diverse pedagogues and artists who practice applied theatre. She wants to highlight the opportunities for the whole life learning enabled by applied theatre. She especially stresses, "when we think about applied theatre we focus on all kinds of theatrical studies, first and foremost those that aid community and persona; development. The artistic outcome is secondary. In evaluating the work in the domain of applied theatre, we place a strong stress on following the creative process as well as the performance of the final forms of this process, as well as a good interaction with the audience. In the third place, we think that applied theatre cannot achieve its goals with high quality, if the artists and pedagogues who work in this area do not have a good insight into the context of their work".

Hi Neighbour is a local non-governmental organisation founded in 1991 when a group of psychologists and volunteers initiated a programme of psycho-social support to mothers and children in the refugee collective centres. Their main activities are focused on the local community, children, and vulnerable groups of people in collective centres – refugees, internally displaced persons, and the local population. Special attention is given to war-affected children, single parents, the disabled, and the elderly. The Hi Neighbour teams have been implementing programmes of cultural integration, psycho-social support, international exchange, summer schools, alternative education, local community development, and many others. Several hundreds of thousands of people have been participants in Hi Neighbour's impressive, life-supporting ventures. Vesna Ognjenović, a psychologist and founder of Hi Neighbour, in her introductory speech on the evaluation of the project, talked about how they started this work and how they shaped their own variation in creating performances.

> We started by using all means of expression … Speaking in terms of ontogenesis, we started from those first steps, movements, and went towards those more complex, the movement from voices to words, the movement from colours and lines to forms and images. What was happening, what it was like in practice, is this: the participants dealt

with tasks that displaced them from everyday reality; but not in a way of escaping from it, but of living in it in a richer and more human way.

ApsArt Centre for Theatre Research, founded in 2004 in Belgrade, has been aiming to develop a practice of applied theatre and promote the idea of theatre as a means of personal and societal action. The mission of the ApsArt Centre is a promotion and practice of all different forms of participatory arts that immerse citizens in creative processes. ApsArt is a place for exploration of self, others, and society through theatre and all viable drama and dramatic tools. Here I want to especially mention a few performances: "The Wizards of OZ" ("OZ" stands for the Serbian term for municipal Jail), a nonverbal performance of physical theatre with jail inmates; and "Whose are you, Peter?" a forum performance that problematized the existence of an informal network formed among the convicts, as well as the impotence of the formal institutions, in the life of a young man who is fighting for a good outcome for himself. The founder and president of ApsArt Centre for Theatre, Aleksandra Jelić, stresses,

> We desire a theatre free from the business industry, marketing, someone's planned repertories, techniques, buildings … and people free from fear, free from hopelessness and all types of oppression. Our mission is not people going to theatre, but the theatre going to people. Art is not a privilege of some chosen people, but a right of everyone – the work of ourselves, for a more humane society! The theatre, like a person, starts its life through play, and falls into depression in the moment when it forgets to play, to explore, to learn and change … This is why we play! We play in jails, in schools, on the streets, in the parks, in hospitals, in day-care centres … wherever life exists. We don't play FOR the audience, but WITH the audience. For all these years we've been working with all sorts of social groups, amongst them prisoners, psychiatric patients, young delinquents, kids/youth with learning disabilities, kids, elderly, young people, Roma people, immigrants, etc. We made dozens of theatre performances that have been performed in the ApsArt Community Theatre or in other Belgrade and Serbian theatres. We believe in the power of play and theatre. In self-healing processes, in play-oriented education and lifelong learning! We bring play and theatre everywhere where people are! Never stop playing!

Bitef Polyphony

The Bitef Polyphony programme accompanies the renowned Belgrade International Festival of New Theatre Tendencies (BITEF). The first Bitef Polyphony was held in 2000 as a programme dedicated to theatre artists and their work with young people during the time of crisis, conflicts and war. Through its editorial policy Bitef Polyphony introduced a significant change in designing a recognizable "polyphonic concept" into the process of festival programming. The changes concerned the selection of the performances and other activities, the ways that the organizational team worked, and ways of including audiences into the festival events. It is comprised of various performances by youth and other non-traditional theatrical groups, presentations of the processes, and methods of dramatic creations, as well as artistic and educational workshops, round tables, symposia, and inclusion of the audience into these processes. It is especially significant that the Bitef Polyphony works with its participants over large periods of time, thereby supporting their creative and educational development.

Named after a musical form, and challenged by it, Bitef Polyphony continues to develop its layout as a music composition, through a specific structure of cyclical organization of "feed-

back". Polyphony as a metaphor has become a conceptual symbol for the multitude of voices, variations, and counterpoints that take place during the festival. In its programming it always looks for the voices of the beginners, the marginalized, and the invisibles.

Every year, Bitef Polyphony develops a conceptualization, a theme and a slogan as a dialogic response to the main Belgrade International Theatre Festival programme. For instance, the 50th Belgrade International Theatre Festival programmatic examinations were focused on the fact that hybridization of diverse artistic forms, genres, and styles is more and more present in contemporary art. The message of the Belgrade International Theatre Festival selectors was that all these artistic forms and performances are, in fact, a kind of theatre. This concept was exactly the same as Bitef Polyphony has been promoting for the almost 20 years of its existence. It is the very openness of the Bitef Polyphony space that enables recognition of the new tendencies, new visions, and otherwise invisible authors.

That year, the Belgrade International Theatre Festival problematized Europe's relation with the Other (migrants, wars, etc.). The slogan "On the back of the raging bull" (based on the Greek myth about the goddess Europe riding Zeus as a bull) expressed the focus of Belgrade International Theatre Festival on artistic problematizing of the current events in Europe. This theme coincided with the focus of the Bitef Polyphony organizers on the current situation of refugees and migrants, especially in the project "Selice" (migratory birds).

In response to the Belgrade International Theatre Festival slogan, "On the back of the raging bull", Bitef Polyphony organizers chose "Resisting the rage" for their slogan. In the introduction to the Belgrade International Theatre Festival catalogue, we asked the question:

> To what extent do we ourselves, determine the truth, our commitment, togetherness and the extent of resistance to rage in our world, here and now? How much do our actions and decisions represent inevitability and fate or is it all the upshot of our inaction and acceptance of that fate? How did we come to believe that we can dispense with togetherness and that disunity, grabbing from or obliterating others, are attractive and constitute the supreme confirmation of our social existence? Truth is always conditioned by the multitude, Bakhtin reminds us, it cannot be created or uttered from one or a simple set or sum of voices. It is the whole which expands the possibilities and constitutes the meaning, no matter how heterogeneous and unique were its parts. This is how polyphony comes about: in a counterpoint of voices and interlacing of different experiences and practices - polemic, educational, developmental, artistic or participative. Yet always shared, turned towards that long-neglected, permeable and synesthetic zone of the theatre in which we search for action through public social practices, theatre in education, in dialogue with otherness. This is, perhaps, how we step out of the zone of our cushioned rage, desiring a new form of collectivity, of equal and expanded opportunities.

Bitef Polyphony is specifically dedicated to young people, their growth, social integration, burning issues, and delicate questions and topics. But above all, it is dedicated to permanent attempts to create grounds for mutual engagement and agency, important and valuable for life discovering and supporting those who are marginalised and invisible, both as participants and as audiences.

Instead of a conclusion

Applied theatre is an open theatre space. A space of creative processes and collaboration. A theatre of everyday life and everyday people. Community theatre. A theatre that does not exclude,

but always includes. Interactive, playful, inclusive. Educational. Socially engaged and promoting social activism. It can be children's theatre or youth theatre, seniors' theatre, the theatre of the marginalized, sensitive, and vulnerable. A theatre for the invisibles. A theatre that focuses on topics of ontological interest to its players. A theatre where the players can express their own aesthetics, their beliefs, needs, desires, and views. A theatre where the boundaries are erased between the stage and the auditorium, between the actors and the audience. A theatre which is provocative and subversive. A theatre which is critical, ready for dialogue and never-ending changes. A theatre that is live, that is a reflection of the challenges of the times and a response to these challenges. A new kind of theatre for life that theatre artists, researchers, and others may experience as a challenge.

The above described circumstances and conditions in which various forms of this kind of theatre appeared in our country, and how they had a profound effect on the current state of applied theatre and its outlook. We are the product of the times that we lived through, with all these diverse dramatic and theatrical forms. They may have been valuable achievements or insignificant passing events. They were remembered or forgotten. They stayed in our mind as difficult or happy memories. They were experiences that we carry into the future.

If we look at applied theatre as a theatre that enters various spheres of culture, education, social work, and social activism, the need to act together with others, to cross these spheres, connect them and coordinate them, becomes essential. Here we think of all forms of collaboration, from the local and regional to the international. We wonder what purposes we could discover for all forms of applied theatre, in a future society that strives to recreate itself under the unknown circumstances, with the unknown diverse others. We face ethical questions, questions of community development, questions about the development of society towards unknown but desired futures, ethical questions about the tensions between clashing visons of diverse Others. We see the greatest tensions between visions of applied theatre as an instrument of social management and planning, on the one hand, and on the other, applied theatre as a free zone where social and cultural issues can be deconstructed, problematized, and creatively recast by each and every member of society regardless of her/his otherness: a child, a refugee, a migrant, a politician, a doctor, or an artist. Although various laws and political strategies exist that regulate spheres of culture, education, social work, and others, the question is how open and flexible these institutions can be to support the free development of applied theatre and its subversive cultural, educational, and social activism.

11
GIVING VOICE TO THE VOICELESS
Raising awareness and spurring debate on the Homeland War (1991–1995) in Croatian theatre

Nikolina Židek

Introduction[1]

Croatian independence from Yugoslavia was accompanied by the Croatian War of Independence, locally called "the Homeland War" (1991–1995), denoting its significance in Croatian nation building and framing the identity of a nation forged in war. According to the Croatian Parliament Declaration on the Homeland War from 2000, it was a "just and legitimate, defensive and liberating, and not an aggressive and conquering war"[2], while its final Operation Storm, carried out by Croatian troops in 1995 that liberated the Serb-occupied territories of Knin and surroundings, was enshrined in a special declaration as a "legitimate, victorious, antiterrorist, final and unforgettable battle", ordering the scientific and educational community to transform the battle into a "part of Croatia's useful past for future generations".[3] The discourse framed in the two parliamentary declarations is further perpetuated in official statements, commemorations, and history textbooks, thus creating a mainstream narrative that Croatia was only defending itself. It consequently creates an atmosphere of denial of any human rights violations by the Croatian side, and society does not deal with the dark episodes of its recent past.

This chapter focuses on Croatian theatre as a space of fostering debate on the country's recent past during the Homeland War by dealing with issues of responsibility and concrete actions of Croatian soldiers towards innocent victims, as well as efforts at demythologizing Croatian warriors as sinless and righteous fighters. After an overview of war trauma playwriting in Croatia from 1991–2004 analyzed by Lukić (2009), this study analyzes Croatian theatre in the last 13 years and how it dealt with the past. While identifying a shift towards more open efforts at demythologization, it contextualizes the plots of the analyzed plays by explaining the issues and events they treat, and examines the reactions and discussions the staged plays provoked, as well as how their effects were multiplying beyond the theatre audience, further opening space for debate.

The war in Croatian theatre and playwriting (1990–2004)

The Homeland War has been a recurrent topic in Croatian playwriting from the early stages of the conflict. Lukić defines war trauma playwriting as "not political theatre because the plays

don't advocate for any political view, but they are focused on demythologizing and questioning ruling social myths" (Lukić, 2009: 15). In the period covered in Lukić's book, I have identified three main topics: the lost generation of former combatants, wartime rape, and forced evictions of Croatian citizens of Serb ethnicity at the beginning of the war.

The first main topic was the difficulty of former combatants to reintegrate into peacetime life. Such is the case of Renato Ryan Orlić's *Between the Two Skies*[4], which took place in a mental hospital after the war where the characters talk about life outside, but prefer staying within the safe walls of the hospital. Filip Šovagović also discussed the difficulties of resocialization in peacetime society in his so-called "homecoming play" *Brick*, while in another play, *The Birds*, he questioned the purity of the Homeland War (Lukić, 2009: 262–263). In Ivan Vidić's *Big White Rabbit*, soldiers coming back from the warfront were also unable to find their place in society. Finally, in Nina Mitrović's *When We Dead Slay Each Other*, dead soldiers kept fighting in their graves, sending a message that the war does not finish when the soldiers surrender their arms, and that the peace is a learning process of tolerance and acceptance of diversities.

Another recurrent topic was wartime rape. While Slobodan Šnajder's *Snake Skin* treated the subject of children of wartime rape, *Marija's Pictures* by Lydija Scheuermann Hodak offered testimonies of women who were victims of sexual violence.

A third, frequent subject was the massive forced evictions of Croatian Serbs at the beginning of the war. Miro Gavran was the first author to raise the issue of forced occupying of flats "under state blessing" (Lukić, 2009: 326), a massive phenomenon of war plunders, in his comedy *Eviction*. It was an act of bravery, a protest of a generally mainstream author since it was written and staged before the end of the war. Nina Mitrović's *Neighborhood Upside Sown* looked through the lens of a Croatian veteran about to be evicted from an illegally occupied flat whose owner is a Serb, but both sides are portrayed as victims: one who was deprived of his ownership, and another who fought for the country and has nowhere to go. *Umbrella Organization* written by Ante Tomić and Ivica Ivanišević, was the first to show an "aggressive attitude towards social mythology" (Lukić, 2009: 270). The play defied the myth that Croats were the only victims of forced displacement during the war and touched upon several sensitive issues: voluntary sign-up for war, massive exodus of Croatian Serbs, and the rapid switch of mythologies from the veneration of Yugoslav socialism to radical Croatian patriotism. It was harshly criticized by the general public, politicians, and war veterans, but also by part of the profession. The reactions should be contextualized. The play was staged in 2001, when a center-left coalition took power after a decade-long rule of the right-wing Croatian Democratic Union (*Hrvatska demokratska zajednica*). At that time, Croatia turned towards European integration that implied cooperation with the International Criminal Tribunal for the former Yugoslavia in the form of extradition of Croatian top military officials. The first crisis occurred when the International Criminal Tribunal for the former Yugoslavia issued the indictment against Croatian Army general Mirko Norac in January 2001, who then went into hiding. In February, massive protests in Split were organized, gathering around 200 000 people accusing the government of treason.[5] The play was staged precisely in Split only a few months later, and not in any theatre, but at the Croatian National Theatre. This was particularly provocative since National Theatres are "the very altar of the temple where national mythologization is supposed to be created and preserved" (Lukić, 2009: 270).

In the period covered in his study, Lukić rarely finds plays with an intention of "a stronger destabilization of social mythologies". But, as the author concludes, in 2004 it was too early to draw the line and conclude the list and make a possible evaluation (Lukić, 2009: 342).

Nikolina Židek

A step forward in Croatian war playwriting: dealing with the uncomfortable past (2005–2018)

This research continues where Darko Lukić's study stopped, and analyzes the development of Croatian playwriting in the last 13 years, with a focus on those plays that would be considered by Lukić as "subversive" or "aggressive" in their efforts at demythologization towards the Homeland War. In this period the issues of Croatian responsibility and concrete actions of Croatian soldiers towards innocent victims, as well as efforts at demythologizing Croatian warriors as sinless and righteous fighters began to emerge as topics.

Mate Matišić's posthumous trilogy

One of the first examples of this shift in focus was Mate Matišić's posthumous trilogy staged in 2005 and 2006. In *Sons Die First,* a family is unable to make peace with the death of a son whose body was never recovered. But it also treats the issue of a world of mafia trading with human remains of the victims of the war across former Yugoslavia, and the issue of war veterans who are here, no longer a lost generation, but idle retirees without perspective whose lives go by between the post office where they collect their retirement and the local bar. *No One's Son* is about an encounter between the former political prisoner, Professor Barić (a Croat) and his Serbian guard Simo Aleksić who saved his life. Barić helps Aleksić financially, but eventually it turns out that Barić was the main prison snitch, and Aleksić was his wife's lover. In fact, Barić's son Ivan is Aleksić's son, a Serb – the other, the enemy. Finally, *The Woman Without a Body* brings back the issue of wartime rape, but this time committed by Croatian soldiers against a Serb woman.

The defenders of the mainstream narrative reacted promptly at this attempt at demythologization, stressing that the plays:

> were not talking about all the victims and the aggressors but pretentiously concentrated on non-Croat victims … thus imposing guilt on the Croatian nation as a whole because there is not a single positive character of Croatian ethnicity, and created a stereotype of a crazy war veteran torn by PTSD, playing with his gun in a bar, thus representing a menace to himself and society. The earlier boring plays did not manage to explain what really happened because they were creating a general image of violence, and then these plays about Croatian guilt explained to everyone who is the real culprit.
> *(Nikčević, 2015)*

Generation 91-95

Another noteworthy project, *Generation 91-95,* staged in 2009, was based on the novel by Boris Dežulović titled *Jebo Sad Hiljadu Dinara* (*Who Gives a Fuck About a Thousand Dinars Now*), about the conflict between Croat and Bosniak (Muslim) armed forces in Bosnia and Herzegovina during the war years (1992–1995). Although the novel is a fiction, it was based on a true historical context – the interethnic conflict in Bosnia and Herzegovina. The central plot is a face-off of two groups of soldiers on a secret mission, dressed in the enemy army's uniform in the summer of 1993 somewhere in the middle of Bosnian nowhere.

Under the subtitle *A Lesson in Croatian History*, the play was divided into theory and practice. What is particularly interesting about this project is its creation process that lasted for a year. The actors were 12 young men aged between 14 and 18, born between 1991 and 1995, the time

when the war took place. Apart from going through a military drill (the audition itself was called "recruitment"), typical for *Montažstroj* company's physical theatre[6], the actors went through a learning process about the war in Bosnia and Herzegovina, watched war movies, and talked about the war. To begin with, the actors were told to bring their history textbooks to the first rehearsal and they realized that there was nothing about the war in Bosnia and Herzegovina. No wonder, since the participation of Croatian troops in the neighbouring country has been one of the most controversial topics, one of the motives why the Declaration on the Homeland War defined it as "not an aggressive and conquering war".

The play points to the fact that the sides in the Bosnian war were people with similar names and faces, who speak similar, if not the same, languages. What constitutes an enemy's identity is only the uniform he wears. And the identity of one group in opposition to the other is artificially constructed through military drill, school, and the media. Furthermore, the best target group for this drill is precisely children and young people, extremely malleable raw material for identity construction and hate incitement. The director plays with that fact by working with actors in an age group somewhere between boy and man, but who are at the same time old enough to keep playing war and to go to a real one. But rather than converting them into cannon fodder, he makes them go through "a kind of emancipatory process, maturing in both performance and art, and in their social awareness".[7]

In the second part, the actors told their personal stories and give their interpretations of recent Croatian history. Most of them argued that the war was not inevitable, thus questioning the official narrative that Croatia was only defending itself from external aggression. They also got to the conclusion that there are no big differences between different ethnic or religious groups (e.g. Catholic Croats, Orthodox Christian Serbs, Muslim Bosniaks), pointing to one of the main messages of the play: artificially constructed identities as tools for warmongering.

Trilogy on Croatian Fascism

Trilogy on Croatian Fascism, directed by Oliver Frljić, presents itself as the first effort of direct demythologization of the official narrative by spurring debate on the events that have been systematically denied by Croatian state institutions, the media, and consequently, society. The *Trilogy* in general covers the issue of the lack of responsibility and covering up crimes, and their later wrapping into an idea of nationalism and mythologization of history.

The first part of the *Trilogy* is an adaptation of Euripides' *Bacchae*, referring to the original plot when gods drive humans to insanity and arouse their lowest passions that incite them to slaughter, in order to portray the crimes committed in the Homeland War. It was staged in 2008 at the Split Summer Festival and spoke up about hiding and denying war crimes during the war in Croatia. It started with a scene of four actors hanging in closed bags with tags of victims who were (some even still today, ten years after the premiere) waiting for justice to be served by the Croatian judiciary: Milan Levar, former Croatian Army officer and witness at the trial against Croatian Army officers for crimes committed against Serb civilians, who was killed by a bomb placed under his car in 2000; Josip Reihl-Kir, peace-seeking Osijek Police Chief killed in 1991 by the Croatian side while trying to prevent the conflict between Croats and Serbs in the Osijek area; Aleksandra Zec,[8] 12-year-old Serb girl murdered by members of the Croatian Police reserve unit on the outskirts of Zagreb after witnessing the execution of her father; and an unknown Croatian soldier, the only one who survived, but ended up in a wheelchair and carried the three bodies along as a burden. The play then raised the issue of the torture of prisoners of war and civilians at the Lora Port Military Prison in Split. It was at first banned and later allowed – showing that in 2008, it was a very controversial issue in society.

The second part, *Aleksandra Zec*, staged in 2014, raises the issue of the murder of a child. The play used photos from the crime scene and transcripts of testimonies of the perpetrators of the crime, who were acquitted for procedural errors. Unlike in the earlier period of the war trauma playwriting, which, as observed by Lukić, has depersonalized characters, the characters in the *Trilogy* carried real names, and in the case of *Aleksandra Zec*, they were taken from the victims and the perpetrators of the crime. Unlike *Bacchae*, that used performance technique, *Aleksandra Zec* reached for different techniques and tools. The spoken lines were excerpts from the testimonies, mixed with the imaginary lines of a family who was about to be killed, because their words were not written down and could not be reproduced. In a particularly strong scene, Aleksandra was buried in front of the audience under a pile of earth and then unearthed by three 12-year-old girls. Similarly to *Generation 91-95*, the actress who plays Aleksandra asked the girls about their lives and what they thought about her life and death, thus involving young generations in the debate.

What is particularly important about *Aleksandra Zec* are the media repercussions and public discussion provoked beyond the theatre audience. At the premiere of *Aleksandra Zec*, veterans' associations organized protests in front of the theatre, carrying banners with messages such as: "402 Croatian children killed by *Chetniks*",[9] "86 children killed in Vukovar", "When are you going to stage a play about Croatian victims?" or "402 children killed by savage *Chetnik* bombings against civilian targets. Isn't that enough for you, Frljić?"[10] The force of the mainstream narrative is detected in the messages of the protesters: instead of interpreting the play as a protest against the killing of an innocent child on grounds of her ethnicity, it was perceived as *serbophilia*, as an attempt at vilifying Croats and underestimating Croatian victims. The play itself started with the same question directed by one actress to the audience: "Why haven't you staged a play about Croatian children killed in the war?"

Finally, the last part, *Croatian Theatre*, also premiered in 2014, dealt with the responsibility of the theatre itself, which instead of being the ultimate platform of freedom of expression, during the "dark years" stayed silent, relativized or even fostered war crimes. The third part provoked particularly harsh criticism by theatre professionals, especially those who were denounced for their role in the 1990s in the play, when actors called out their names and wore their photos on their underwear. Again, the final scene of the play is particularly strong: the appearance of the only character present in all the three parts of the *Trilogy*, Aleksandra Zec, pointing a machine-gun at the actors who are dancing and having fun, calling upon their conscience.

In 2015, the three plays were staged together as a *Trilogy* at the Croatian National Theatre in Rijeka, and included the speeches of current leading political figures, and pointed to the continuous and systematic denial of the dark side of the Croatian war.

The Fall and later plays

Apart from the effects in the media that multiplied beyond the audience, the *Trilogy on Croatian Fascism* had an impact on the theatre itself, and other plays that followed treated other sensitive issues from the Homeland War and further opened space for debate.

Such is the case of *The Fall*, directed by Miran Kurspahić, which premiered in 2016 at the Zagreb Youth Theatre. The play also used original transcripts of the telephone conversations between the Croatian political and military leadership (Croatian President Franjo Tuđman, Army Chief of Staff, Minister of Defense, etc.) and lieutenant colonel Mile Dedaković Jastreb ("Hawk"), commander of the defense of Vukovar, the town in Eastern Slavonia that fell at the beginning of the war in 1991, almost completely destroyed by Serbian forces, forcing all its non-Serb inhabitants to abandon their homes and killing those who stayed. Vukovar symbolizes the

sacrifice of Croatia laid on the altar of the homeland for its freedom and independence. The yearly commemoration of the fall of the town on 18 November, Remembrance Day of the Sacrifice of Vukovar, is one of the most important Homeland commemorations, built into the very foundations of the creation of the Croatian nation-state, with a strong victimization mark that sends a message that Croatia was a target of aggression by a superior enemy.

The play revolved around the issue of treason and questions the responsibility of state leadership for the fall of the town because of not sending the indispensable help for the town's defense. The performance should be seen twice, because the first act was played in two different rooms at the same time: the first room shows the events from the perspective of the state leadership, and the second room from the perspective of the command of the Vukovar defense, thus implying that there are different versions of the truth on the fall of the town. *The Fall* also talked about the decline in human and moral values that followed the defeat.

Its second part is "a complete historical fabrication dealing with an alternative history of 1993 and an entirely different outcome of the war, in which the City of Zagreb, President Tuđman and his headquarters are surrounded by enemy forces, awaiting the final fall".[11] In his last hours, the President was faced with his conscience regarding the fall of Vukovar, thus alluding to his personal responsibility, which is practically taboo in Croatian society. The play started and finished with emblematic documentary material: original recordings of Radio Vukovar's journalist Siniša Glavašević, one of the symbols of the Vukovar tragedy, who was reporting until the day of the fall of the town and was later executed by Serbian forces.

As in *Aleksandra Zec*, the characters were also carrying the names of real people, Croatian political and military leadership in 1991. Also, in the first part they spoke the words taken from the original transcripts of telephone calls, thus recreating the situation, creating an atmosphere of extreme anxiety. This is because the spectators could observe that on the stage, the Vukovar defense was hopeful of salvation until the last moment, but they knew that, in fact, it never came.

Another work is the omnibus *Que Sera, Sera,* which premiered in June 2015 at the Satiric Theatre Kerempuh in Zagreb consisting of four parts. In the last part, carrying the title *The General*, a Croatian Army general explains to the President of the country that:

> This is not the country that I fought for … If we could abolish it and start from scratch … So that it could become as we had imagined it while it did not yet exist.
> *(Matišić, 2015: 104)*

We have had examples of disillusionment, but it was generally coming from war veterans, men who were enlisted or voluntarily defended the country. But in this case, it was the first time that an (imaginary) army general showed his nonconformity with the country he fought for.

Also, in some other plays that do not specifically treat the topic of war crimes, there are frequent references to some dark episodes of the Homeland War. Such is the case of *#workingtitleantigone*, staged at the Zagreb Youth Theatre in 2015, a 21st-century version of Sophocles' play, where Antigone is a young and rebellious Internet activist who enters into conflict with Creon, a large media magnate, determined to defend the country at all costs. At one point he orders his men to torture Antigone:

> You already have the instructions, duct tapes, car batteries, buckets with water, wires, everything. Remember that you are doing a great favor to your country. As soon as you commit these abhorrent sins, you are sacrificing the purity of your souls for a common good.
> *(Sequeira, J., Delprato, L., 2015)*

Duct tapes and car batteries are a clear reference to the torture and killings committed against Serb civilians in Osijek in 1991.[12] There is an ongoing trial against the town's wartime Defense Commander Branimir Glavaš, who is still a free man, after 12 years of being prosecuted and five separate court verdicts. Not only that, he is also an elected Member of Parliament, which is a clear message of how strong the mainstream narrative remains.

Finally, in Tena Štivičić's *Three winters*, when a character who lives in Great Britain is asked about the British opinion on Croatia joining the EU, she says:

> We don't feature on their radar much … when it's not to do with beaches … or war criminals.
>
> (Štivičić, 2014: 17)

This final observation is a sort of shift in focus, implying that while Croatia has its dominant narrative of innocence and victimization, the view from the outside is quite different.

Conclusion

The chapter shows how theatre in Croatia in the last 13 years opened a crack in society and provoked controversy in and beyond the audience by bringing up the issues and events that have been systematically denied, contesting the hegemonic narrative of a victorious and victim nation.

For the purpose of trauma representation and event recreation, the theatre becomes a witness, uses diverse tools and techniques, introduces documentary evidence, and turns actors into *hyper-historians* who function as witnesses of the events that are treated in the play and "serve as a connecting link between the historical past and the 'fictional' performed *here* and *now* of the theatrical event" (Rokem, 2000: 13).

By using documentary evidence, the theatre faces the audience with facts, crosses the limits of artistic creativity and imagination, and steps into reality by exposing and denouncing violations of human rights, and giving voice to the victims who have been silenced.

During the performance itself, the theatre, unlike other forms of art, creates *in situ* a connection and interaction between the audience and the actors, and gives way to reimagining and empathy, one of the main elements of education. It also recreates an unspeakable experience in Walter Benjamin's terms, creating empathy in the audience and beyond, making them act and react, and ultimately fostering inclusion of those who were marginalized through silence. In this sense, the work of the directors with young people in the plays, who are studied in this chapter, is extremely important. Apart from empathy, the theatre should also bring the *emancipated spectator* (Rancière, 2009) to act.

With its multiplying effects during the performance and afterwards, by fostering debate and causing reactions, the theatre can participate in the construction of a more democratic community that will acknowledge the wrongdoings of its own side and thus contribute to the deterrent effect.

Hopefully, the emancipated spectators in Croatia will keep seeking this information and act upon it, thus contributing to a more equal society in the long term. And hopefully, the theatre will be there to keep responding to the challenge.

Notes

1 The author would like to thank the director Oliver Frljić, Croatian ITI Center and Zagreb Youth Theatre for providing video material of the plays that are subject of this research.
2 Official Gazette of the Republic of Croatia No.102/2000,13 October 2000, Available at: http://narodne-novine.nn.hr/clanci/sluzbeni/2000_10_102_1987.html (in Croatian) (Accessed: 4 July 2018).

3 Official Gazette of the Republic of Croatia No.76/2006, 10 July 2006, http://narodne-novine.nn.hr/clanci/sluzbeni/127530.html (in Croatian) (Accessed: 4 July 2018).
4 All the plays and their respective stagings are listed in the bibliography in the order that they appear in the paper.
5 'Miting u Splitu: Od potpore Norcu do zahtjeva za raspisivanjem izbora' (Rally in Split: from support to Norac to demanding early elections), *Monitor*, 12 Feb 2001 http://www.monitor.hr/clanci/miting-u-splitu-od-potpore-norcu-do-zahtjeva-za-raspisivanjem-izbora/11537/
6 Montažstroj is an internationally renowned Croatian theatre company founded in 1989 that works on socially engaged projects. It is particularly known for physical theatre.
7 *Generation 91-95*, Montažstroj website: http://www.montazstroj.hr/en/projekt/index.php?id=42 Accessed on: 1 July 2018).
8 The author/s of Milan Levar's killing were never found; the material author of the killing of Josip Reihl- Kir; Antun Gudelj, was found guilty after 17 years and three retrials, but the moral author who ordered the murder was never found; the criminal trial for the murder of Aleksandra Zec was dismissed on grounds of procedural errors, but the surviving Zec children, siblings Dušan and Gordana, sued the Republic of Croatia and near the end of the court case in 2004 the Croatian Government agreed to a settlement and compensation of 1,500,000 Croatian kuna (around €200,000).
9 The term 'Chetnik,' which historically mainly refers to Serb royalist and nationalist guerrillas during the Second World War, was in the 1990s widely used as an epithet by Croats and Croatian media to refer to all Serbs.
10 Denis Derk 'Kraj predstave *Aleksandra Zec* publika dočekala u dubokoj šutnji' (The audience welcomed the end of the play *Aleksandra Zec* in a profound silence) *Večernji list*, 15 April 2014. Available at: http://www.vecernji.hr/kazaliste/kraj-predstave-aleksandra-zec-publika-docekala-u-dubokoj-sutnji-933182 (Accessed on: 6 July 2018).
11 *Pad* (*The Fall*), Zagreb Youth Theater website: http://www.zekaem.hr/en/the-fall (Accessed on: 1 July 2018).
12 In the 'Duct tape' case, Glavaš's unit arrested six civilians in 1991 and after torturing them, they were brought to the Drava riverbank, where they were executed, with their hands tied behind their backs with duct tape. In the case code-named 'Garage' the civilians were forced to drink the acid from car batteries (Milekić, 2018).

References

Dežulović B. 2005. *Jebo sad hiljadu dinara (Who gives a fuck about a thousand dinars now)*. Zagreb: Europapress holding.
Lukić, D. 2009. *Drama ratne traume (War Trauma Playwriting)*. Zagreb: Meandar.
Matišić, M. 2006. *Posmrtna trilogija*. Zagreb: Croatian ITI Center.
Matišić, M. 2015. *General* - part of the omnibus *K'o živ, k'o mrtav* (*Que sera, sera*). Zagreb: Archive of the Satiric Theatre Kerempuh.
Milekić, S. 2018. Branimir Glavaš, Croatia's luckiest war crimes defendant. *Balkan Investigative Research Network*, 26 September. Available from: http://www.balkaninsight.com/en/article/branimir-glavas-croatia-s-luckiest-war-crimes-defendant-09-26-2018 (Accessed 7 November 2018)
Nikčević, S. 2015. Odjeci Domovinskog rata u hrvatskom kazalištu i drami (Echoes of the Homeland War in Croatian Theatre and Playwriting). *Hrvatska revija*, 3. Available from: http://www.matica.hr/hr/461/odjeci-domovinskog-rata-u-hrvatskom-kazalistu-i-drami-24971/ (Accessed 5 September 2018)
Rancière, J. 2009. *The emancipated spectator*, London and New York: Verso.
Rokem, F. 2000. *Performing history: Theatrical representations of the past in contemporary theatre*. Iowa City, IA: University of Iowa Press.
Sequeira, J. and Delprato, L. 2015. *#radninaslovantigona*. Zagreb: ZKM (unpublished).
Štivičić, T. 2014. *3 Winters*, London: Nick Hern Books.

Plays (in the order that they appear in the chapter)

Između dva neba (Between the two skies), director Jasmin Novljaković, Teatar ITD, premiere: 2002.
Filip Šovagović: *Cigla (Brick)*, director Paolo Magelli, Croatian National Theatre Split, premiere: 1998.

Ivan Vidić: *Veliki bijeli zec (Big white rabbit)*, director: Ivica Kunčević, Zagreb Youth Theatre, premiere: 3 February 2004.
Nina Mitrović: *Kad se mi mrtvi pokoljemo (When We Dead Slay Each Other)*, director: Saša Anočić, Zagreb Satirical Theatre Kerempuh, premiere: 2004.
Slobodan Šnajder: *Zmijin svlak - Die Schlagenhaut (Snake skin)*, director: Roberto Ciulli, Theatre an der Ruhr, Tübingen, premiere: 1996.
Miro Gavran: *Deložacija (Eviction)*, director Robert Raponja, Teatar &TD, Zagreb, premiere: 1995.
Nina Mitrović: *Komšiluk naglavačke (Neighbohood upside down)*, director: Saša Anočić, Croatian National Theatre Rijeka, premiere: 2003.
Ante Tomić and Ivica Ivanišević: *Krovna udruga (Umbrella organization)*, director: Mario Kovač, Croatian National Theatre Split, premiere: 2001.
Mate Matišić: *Sinovi umiru prvi (Sons Die First)*, director: Božidar Violić, Zagreb Drama Theatre Gavella, premiere: 2005.
Mate Matišić: *Ničiji sin (No One's Son)*, director: Vinko Brešan, Croatian National Theatre in Rijeka, premiere: 2006.
Mate Matišić: *Žena bez tijela (The Woman Without a Body)*, director: Dražen Ferenčina, Agit-Kult d.o.o. Varaždin, premiere: 2006.
Boris Dežulović, Goran Ferčec and Borut Šeparović: *Generation 91–95*, Zagreb Youth Theatre; director: Borut Šeparović; premiere: 24 November 2009.
Trilogija o hrvatskom fašizmu (Trilogy on Croatian Fascism), director: Oliver Frljić, dramaturgy: Marin Blažević, Croatian National Theatre in Rijeka, premiere: 2008/2014.
Pad (The Fall), directed and written by: Miran Kurspahić, Zagreb Youth Theatre, premiere: 7 May 2016.
Mate Matišić, Svetislav Basara and Hristo Bojčev: *K'o živ, k'o mrtav (Que sera, sera)*, director: Dino Mustafić, premiere: 5 June 2015.
Jazmín Sequeira and Luciano Delprato: *#radninaslovantigona (#workingtitleantigone)*, director: Renata Carola Gatica, Zagreb Youth Theatre, premiere: 13 April 2015.
Tena Štivičić: *Tri zime (3 Winters)*, director Ivica Buljan, Croatian premiere: Croatian National Theatre, Zagreb, 2016. (*3 Winters* was first staged at National Theatre London in 2014, directed by Howard Davies).

PART III

North America

12
EXAMINING THE ETHICS OF RESEARCH-BASED THEATRE THROUGH *CONTACT!UNLOAD*

*George Belliveau, Susan Cox, Jennica Nichols,
Graham W. Lea and Christopher Cook*

Introduction

There is a growing interest from researchers across disciplines to employ creative means of data generation, analysis, and dissemination with stakeholders, community members, and other researchers. One such approach is research-based theatre (RBT), an innovative means of knowledge translation that uses embodied approaches to address a broad range of critical social issues such as youth incarceration, the conditions of foreign domestic workers, and mental health, to name a few (Belliveau and Lea, 2016). However, the growing use of RBT raises ethical challenges for researchers, performers, and audiences (Boydell et al., 2012). For example, playwrights may wish to draw on dramatic license to reimagine specific aspects of research findings in order to craft an aesthetically powerful piece. This tension between fidelity to research findings and the aesthetics of performance may bring competing sets of values into play in the design, development, and sharing of RBT projects. This raises salient questions for how institutional research ethics boards should assess research protocols that employ RBT as a methodology.

From a research perspective, there are currently few guidelines addressing ethical challenges in RBT, and many research ethics boards lack expertise when it comes to assessing research protocols that employ theatre or other innovative arts-based approaches. From an artistic perspective, theatre practitioners may find that the norms of ethical practice in theatre do not map easily onto institutional ethics. It is therefore helpful to make a distinction between procedural ethics and practical ethics. Procedural ethics (macroethics) describes the formal process of obtaining approval from an institutional research ethics board to undertake research involving human participants. It typically includes plans to mitigate the potential risks to research participants, balancing research benefits and risks, and developing strategies to safeguard confidentiality of data, including consent forms and plain language statements in the material provided to participants to ensure that their consent is both meaningful and voluntary.

Not all issues that have ethical significance in research are, however, subject to procedural ethics. Practical ethics (microethics) refers to the day-to-day ethical issues that arise when doing research that does not always fall under the scope of institutional ethics; the complex, subtle, or unpredictable situations that RBT practitioners may face such as when an interviewee unexpectedly discloses something sensitive about another research participant, or a person in a

position of power blocks researcher access to potential research participants. These issues are not often addressed in research ethics applications, nor can they be easily anticipated when applying for approval. Guillemin and Gillam (2004) note that procedural ethics cannot alone provide all that is required for addressing ethically important moments in qualitative research. For their part, White and Belliveau (2010) suggest how microethics of RBT should be anticipated as much as possible and discussed in advance as well as throughout the entire research process. Consequently, RBT practitioners need to develop a critical awareness of emergent ethical issues and explicitly and continually address these issues as an integral part of the RBT process.

This chapter identifies some of the ethical challenges arising during the typical, often interweaving and overlapping, phases of RBT that include: researching, creating, producing, performing, witnessing, and evaluating. Each activity or process is illustrated below with selected examples of ethical issues drawn from *Contact!Unload* (Lea, Belliveau and The Company, 2020), a recent RBT project where the five authors of this piece participated as researchers and artists.

Contact!Unload

In the winter of 2015, University of British Columbia researchers brought together military veterans, artists, and community members to participate in a series of drama-based workshops for four months in Vancouver, BC, Canada, in order to develop the play *Contact!Unload* (Lea, Belliveau and The Company, 2020). The theatre initiative invited veterans to share stories of trauma, their transition to civilian life, and, as importantly, identify pathways towards healing and recovery. *Contact!Unload*, performed by veterans with civilian actors, depicts what it means to return home after suffering trauma-related injuries while in combat.

The play emerged out of the research and therapeutic work led by Dr. Marv Westwood, who co-developed the Veterans Transition Program (VTP) with Dr. David Kuhl. As of 2019, this highly successful group therapy programme, designed specifically for Canadian veterans, has seen over 1,000 returning military members participate. A central focus of the VTP is therapeutic enactment (TE), a somatically-rooted counselling approach that holds many antecedents to role-playing and improvisational theatre (Westwood and Wilensky, 2005). All military members of the *Contact!Unload* team took part in the VTP. The compelling stories of the veterans' transitions to civilian life and the hope offered through the VTP approach became the core content used to develop the theatre piece.

Since the play's development in 2015, variations have been performed over 40 times for various audiences and with different cast members, reaching over 3 000 spectators. A number of scholarly publications have emerged from this initiative discussing the development of the play (Lea, Belliveau and Westwood, 2018) and its impact on the veterans (Belliveau et al., 2018) and audiences (Belliveau and Nichols, 2017). However, little to no scholarly discussion of the ethics shaping the process and production has taken place. By sharing some of the ethical issues encountered in *Contact!Unload,* we aim to catalyze dialogue among researchers and theatre practitioners to discuss ethical considerations through six typical, and often interweaving, phases of RBT.[1]

In the following sections, we provide specific examples from *Contact!Unload* where ethical considerations arose during six overlapping phases of the project:

(i) *conceptualizing* and *researching* is when frameworks for the project are established and the process of generating new research and narratives takes place.
(ii) *creating* and *developing* occurs when the creative team, often alongside the researchers and participants (e.g., in *Contact!Unload* the veterans were research participants and co-creators), determines what aspects of the research will be featured and how they will be theatricalised.

(iii) *producing* involves the team bringing the script or performance to life through rehearsals and making key decisions about the performance (e.g., where the performance takes place, how it will be advertised, whether to include a talkback).
(iv) *performing* the play along with any additional elements (e.g., lecture, talkback) for an audience. This phase brings to light ethical questions including whether or not the research participants are involved as performers.
(v) *witnessing* occurs as people watch the production. This draws focus to ethical questions, such as how to prepare audiences to witness a performance that may trigger emotional responses.
(vi) *evaluating* is an ongoing process that involves the team collecting information to learn and make decisions about the RBT process as well as its impacts on spectators.

The six sections below shed some light on ethical considerations that may be encountered during each phase, and the discussion is designed to begin conversations around ethics in RBT, rather than to be exhaustive. The questions and issues raised do not provide solutions, instead they are intended to draw awareness to some of the ethical considerations that may be encountered while developing other RBT projects.

Conceptualizing and researching

Prior to beginning the development process, the *Contact!Unload* team met to lay out a four-month development and rehearsal schedule, which saw the group working mostly on weekends. Knowing that this would be a short timeline for mounting a one-hour theatre production, the team also discussed possible narrative frames to structure the final script as well as key themes identified during previous research on veterans returning to civilian life. This left many questions including:

- Might a narrative frame and key themes predetermine the artistic outcomes of the research? Shape what the lead playwright observed?
- How might narratives that do not fit the frame be incorporated?

Those in the academy rely heavily on academic traditions, where they read literature, develop themes, and write narratives based on these themes. But these are abstractions. It is the veterans' stories and their lived knowing of trauma that lend authenticity to the script of *Contact!Unload*. As such, it became important for the lead playwright and members of the creative team to be mindful not to become bound by the frame during conceptualization. Yet, no matter how cautious, the act of developing the frame necessarily, even if unconsciously, shaped the observations and the resulting work. This then begs the questions:

- Does making such a practical decision for the necessity of play development put the art-making ahead of the research?
- How can a balance be established between the needs/demands of the art-form, the research, and the participants?

Developing

Addressing these questions became increasingly complex through the development of *Contact!Unload*. During one of the first development sessions, a veteran expressed his concern that he did not want this production to turn into "war porn": objectifying stories of horrific

events and trauma for a vicarious release or catharsis of the audience. His comment highlights the importance of the narratives gathered and the necessity that they be used not as "juicy stuff" (Saldaña, 1998) for shock, but instead to benefit the veterans and to highlight the needs and challenges they face.

Yet, the narratives told by the veterans were very distant from the realities of many members of the research team and potential audience members. Few have direct experience with war and combat. It is easy to distance ourselves from the struggles of the men and women who have seen combat. But many have experienced loss and challenging periods of transition in their lives. As playwright Linda Hassall (2012) discusses, "from the consciousness of the playwright phenomenological discoveries … emerge. These discoveries are creatively contextualized into dramatic writing" (p. 161). Thus, the dramatic writing became a transmediation of the veterans' narratives through the consciousness of the lead playwright and the creative team. The role of RBT practitioners then shifts from listening to the veterans' stories to listening *through* them; to find points of intersectionality (Charles, 2018), moments within the particulars of the "shock and awe" of their stories where universalities of struggle might shine through. The lead playwright became a conduit, a link between the stories of the veterans and those of the audience. This raises the following questions:

- How much artist/researcher experience can be placed into this work, and how much can be taken out? How can a playwright and other RBT practitioners see themselves in the research without losing the stories of the participants?
- How can RBT practitioners avoid over-privileging narratives they resonate with? How might they ensure all narratives are honoured?

Producing

Producing encompasses all of the practical choices that move an RBT piece from initial conceptualization to performance including, for example, personnel, budgets, rehearsal and performance venues, and marketing. Production choices come with various ethical implications, including the selection of venues and how a show is advertised. Choosing venues must include consideration of which spaces are practically accessible to research participants and community members, as well as which spaces different groups are likely to feel comfortable accessing. *Contact!Unload* has been performed in university classrooms, hotel conference spaces, museums, art galleries, traditional theatre spaces, and armouries. By producing the show in a range of venues in different cities, the research and artistic team intended to promote access to the show by diverse audiences. Armouries, for example, were selected as a performance venue with the objective of making the production more accessible to those who are currently serving in the Canadian military, veterans who served, and their families. If the production had only been performed in university settings, it would restrict potential audiences. This would be akin to only publishing research results in an academic journal, thereby limiting the chances that veterans and community members outside of a university setting would have access to it.

The publicity of an RBT production is also linked to knowledge translation. Although a recording of *Contact!Unload* is freely available for viewing online (youtu.be/Qjbfz_wReLI), to access a live performance of the show, audience members had to know it was happening and had to want to come. Producing choices for advertising *Contact!Unload* included ensuring the show was publicised to veterans and their families through the VTP. The marketing material aimed to create buy-in from veterans by making it clear that veterans would be on stage performing their own stories. Key questions we grappled with were:

- How do venue and advertisement choices impact the accessibility of a show to diverse audiences?
- How can the production be made available for potential audience members who are unable to access a live performance?

Performing

Performances of RBT are usually public, and if research participants take part in them, confidentiality and anonymity can no longer be offered. Informed consent for research participants must include acknowledging the lack of anonymity for those who chose to perform so that they can make this choice knowledgeably. In *Contact!Unload*, the research participants were performing, some sharing personal trauma narratives. The veterans who appeared in the production considered performing an act of service (Belliveau et al., 2018), and they were willing to publicly acknowledge the operational stress injuries they experienced due to their service.

Because *Contact!Unload* includes veterans performing stories of trauma, the possibility of re-traumatization through repetition over multiple rehearsals and performances was a risk (Lea, Belliveau and Westwood, 2018). To minimise this risk, all participants completed the VTP before participating in *Contact!Unload*. In addition, psychologists and counsellors were present during all phases to monitor for signs of re-traumatization, with protocols to support triggered performers. Furthermore, this mental health support team worked with the RBT practitioners to develop and perform in scenes showing the narrative of several veterans' therapeutic journeys. In this way, the veterans were performing stories of trauma alongside stories of healing. Finally, the veterans knew the show "by heart": they memorised the script and rehearsed to such an extent they could perform the piece in diverse playing spaces, as well as shorter versions of the piece when facing scheduling time-constraints. Knowing the show "by heart" likely supported their ability to self-monitor and emotionally regulate while performing, as they always knew what was coming next, and could prepare themselves accordingly. Ethical questions that arise within the performance phase include:

- How can an RBT team minimise harm for all of those working on the performance, especially those with lived experience of the topic?
- In what ways can performer supports, such as counsellors, be integrated throughout the RBT process?

Witnessing

A procedural ethical issue is to ensure informed consent is obtained before a person witnesses the performance. Individuals must understand what they are about to see along with potential risks and benefits to witnessing. The trauma-focused subject matter made this especially crucial for *Contact!Unload*. Also, part of our intended audiences included veterans and their families who would have personal experience with the themes of the performance and may be uniquely impacted by them.

In *Contact!Unload*, audience informed consent involved content warnings on advertising for the production and a pre-performance announcement that briefly described the creation process, key themes in the performance, and the intense nature of the performance. The pre-performance announcement also revealed that some performers were veterans performing their own stories. The announcement made clear that, as mentioned above, the veterans had com-

pleted a therapeutic process to address psychological injuries and were sharing their stories as a continuation of their therapeutic journey while being monitored by a team of physiologists and counsellors involved with the production. We did this so that the audience would not worry about the actors' wellbeing during the performance and therefore would be better able to witness. Informed consent could be further enhanced by including this information on signs coming into the theatre as well as putting key information into the programmes.

A second major ethical concern for witnessing is minimizing harm. While it will never be possible to predict all the different audience reactions to a performance, explicit consideration should be given to how the production is designed to minimise harms for anyone witnessing. In *Contact!Unload*, we started most performances by identifying trained clinical counsellors available in case someone felt triggered by the performance. Where possible, we also provided contact information for general and veteran-specific supports in programmes for the production and projected them on a screen at the end of the performance. Finally, we created numerous opportunities for individuals to debrief after witnessing by hosting facilitated talkbacks, collecting open-ended feedback post-performance, and informing audience members of counselling supports both in the space and in the community. We also held post-performance socials so audience members could speak directly with the actors and other team members. Key questions we considered were:

- How do RBT practitioners minimise harm for those who witness the performance?
- How can RBT productions create opportunities for people to debrief after the performances?

Evaluating

Evaluating entails ongoing learning about the processes and outcomes of a project. Ideally, it starts during the project design by defining project objectives. While these may evolve during the project, evaluating aims to make project objectives explicit so that they can inform decision-making during the other RBT phases. To evaluate the impacts of RBT requires collecting data throughout the process, as well as during and after performances. One of the intended outcomes of the *Contact!Unload* project was to understand immediate changes in audience knowledge and awareness of themes in the performance. To examine this, during most productions of *Contact!Unload,* we collected data from the audience before and after the performance. To do so, we had a member of the production team come on stage before and after the performance to get oral consent. The evaluation activities were described, emphasizing confidentiality and anonymity as well as potential harms and benefits. Participation was voluntary and, by participating in the data collection activities, the person was consenting to be part of the research (Belliveau and Nichols, 2017).

Other ethical considerations arise when trying to integrate evaluation into the production and performance. Evaluation activities should be designed to minimise distractions from the audience's theatre experience. This requires creatively interweaving the responsibilities of institutional ethics into the production in ways that align with theatre's aesthetics and norms. In *Contact!Unload*, this included having someone who was involved in the production obtain consent and lead the data collection on stage in order to better integrate data collection into the overall theatre experience. We also designed some data collection activities based on the performance's themes. For example, we used an art installation that aligned with the military theme to collect open-ended qualitative data post-performance from audience members (Valdez and Nichols, 2020). Questions we grappled with included:

- How can RBT practitioners ensure informed consent is present before each data collection activity, especially if multiple evaluation activities are occurring over the course of a single performance?
- How can RBT productions integrate the evaluation into the overall theatre experience in ways that enhance (rather than detract) from the experience?

Conclusion

The six phases we explore offer places where research team members, artists, and participants might engage in discussions around the ethical implications of the work they are undertaking. In transmediating research into an artistic form such as RBT we invite new understandings and insights about the research, but we also open the door for new risks and unintended potential harms to participants, practitioners, and audiences. To minimise these risks and maximise the possible benefits for all involved in the lifecycle of an RBT project, we urge RBT practitioners to proactively emphasise the need for ethical reflection throughout all phases of the work. This should also entail consideration of how best to share "stories from the field" with other RBT practitioners so that the community as a whole can benefit from an emerging collective wisdom about how to do effective and ethically sound RBT (Cox et al., 2015).

Note

1 Cox and Nichols are working with Marilys Guillemin to lead the development of a series of ethical guideposts for RBT. The guideposts will be illustrated with examples drawn from several RBT projects and are modelled on a similar project resulting in ethical guidelines for visual methods (see Cox et al., 2014).

References

Belliveau, G., Cook, C., MacLean, B. and Lea, G.W. 2018. Thawing out: Therapy through theatre with Canadian military veterans. *The Arts in Psychotherapy*, 62, 45–51. doi:10.1016/j.aip.2018.11.001.

Belliveau, G. and Lea, G.W., eds., 2016. *Research-based theatre: An artistic methodology*. Bristol, UK: Intellect.

Belliveau, G. and Nichols, J. 2017. Audience responses to *Contact!Unload*: A research-based play about returning military veterans. *Cogent Arts & Humanities*, 4(1), 1–12. doi:10.1080/23311983.2017.1351704.

Boydell, K., et al., 2012. Ethical challenges in arts-based health research. *International Journal of the Creative Arts in Interdisciplinary Practice*, 11, 1–17. Available from: http://www.ijcaip.com/archives/IJCAIP-11-paper1.html.

Charles, G., ed. 2018. *'Speaking my truth': The journey to reconciliation*. Winnipeg, Canada: Aboriginal Healing Foundation.

Cox, S.M., Drew, S., Guillemin, M., Howell, C., Warr, D. and Waycott, J. 2014. *Guidelines for ethical visual research methods*. Melbourne, Australia: The University of Melbourne.

Cox, S.M., Guillemin, M., Warr, D. and Waycott, J. 2015. Visual methods and ethics: Stories from the field. *Visual Methodologies*, 3(2), 1–3. doi:10.7331/vm.v3i2.78.

Guillemin, M. and Gillam, L. 2004. Ethics, reflexivity, and "ethically important moments" in research. *Qualitative Inquiry*, 10, 261–280. doi:10.1177/1077800403262360.

Hassall, L.M. 2012. *Evoking and excavating representations of landscape: How are experiences of landscape explored in the creation and development of a new play: Dawn's Faded Rose?* Ph.D. thesis. Griffith University. Available from: http://hdl.handle.net/10072/365436 [Accessed 30 December 2019].

Lea, G.W. with Belliveau, G. and The Company. 2020. Contact!Unload. In: G. Belliveau and G.W. Lea with M. Westwood, eds. *Contact!Unload: Military veterans, trauma, and research-based theatre*. Vancouver, Canada: UBC Press.

Lea, G.W., Belliveau, G. and Westwood, M. 2018. Staging therapeutic enactment with veterans in *Contact!Unload*. *Qualitative Research in Psychology*, 1–20. doi:10.1080/14780887.2018.1442776.

Saldaña, J. 1998. Ethical issues in an ethnographic performance text: The 'dramatic impact' of 'juicy stuff'. *Research in Drama Education*, 3(2), 181–196. doi:10.1080/1356978980030205.

Valdez, J. and Nichols, J. 2020. Vulnerable strength seen. *In:* G. Belliveau and G.W. Lea with M. Westwood, eds. *Contact!Unload: Military veterans, trauma, and research-based theatre.* Vancouver, Canada: UBC Press.

Westwood, M.J. and Wilensky, P. 2005. *Therapeutic enactment: Restoring vitality through trauma repair in groups.* Vancouver, Canada: Group Action Press.

White, V. and Belliveau, G. 2010. Whose story is it anyway? Exploring ethical dilemmas in performed research. *Performing Ethos International Research Journal*, 1(1), 85–95. doi:10.1386/peet.1.1.85_1.

13
WE ARE HERE
Glyphing a re-creation story through waterways, bloodlines and constellations

Jill Carter

You are here: remembering the bitter Earth

Jarvis Street in Toronto is a well-travelled, urban pathway running from Bloor Street to Lake Ontario. A fraught thoroughfare, it seethes with the extremities of urban existence: privation and privilege each stake their claim to this bitter ground, travelling shoulder to shoulder as they avoid each other's eyes. As a young woman, while living on Jarvis Street, I strolled unsuspectingly into the aftermath of a fatal accident. The crowd, which blocked the sidewalk in front of me, had already begun to thin. The body of a homeless man (as I was later told he was) had, by now, been removed from the place where he had been struck and killed by a speeding car. The police were removing their crime-scene tape; cars were beginning to move in both directions; and in the gutter, running southward with the traffic, a thick, darkening river—the liquid trace of one human life on this street—completed a final, unhurried journey towards the body of water that has sustained all life in Tkaronto (Toronto) over thousands of years. "Yet who would have thought the old man to have had so much blood in him?"[1]

Who would have thought? A river of blood, flanked by the fading grandeur of colonial mansions now converted into expensive restaurants and businesses struggling to retain and express their former dignity and elegance amidst the tawdry, the condemned, the crumbling and the desperate. My personal memories of living on Jarvis Street are crowded by ghosts: shades of Indigenous hunger and dispossession in Allen Gardens; familiar faces of the homeless suddenly vanished; a sex-worker beaten and left for dead by her pimp; a neighbour stabbed to death in her bed.

These stories—the ones populated by my personal ghosts—are not the stories I tell about Jarvis Street when I am leading or co-leading a First Story, Toronto tour of the city's downtown core. My fellow guides and I call upon much older ghosts than my own to spark awareness of and engineer a deeper connection to the fraught history that has shaped the relational DNA between Indigenous peoples and those who have settled these lands. We "excavate" the popular St Lawrence Market (located at the foot of Jarvis Street), restor(y)ing it in living memory as the site of the brutal murder of Michi Saagiig Anishinaabe Chief Wabakinine and his wife,[2] and reconfiguring it as a hub of an unfathomable web of frauds and deceits perpetrated upon Indigenous peoples of these territories. We remember, too, Samuel Jarvis (1792–1857) for whose estate this downtown thruway is named. He stands indicted in historical memory as

one who took a life (in a "legal" duel), rather than repay a debt and as one who vandalized the home and terrorized the wife and children of journalist William Lyon Mackenzie to muzzle him (Davis-Fisch, 2014: 31–33). Further, Jarvis was dismissed (in 1845) from his post as Chief Superintendent of Indian Affairs, under accusations that he had used his office to defraud the Indigenous people whose interests he was supposed to be representing (Freeman, 2010: 117, 128fn). As we invoke his name, then, I ponder the extent to which trace-echoes of his actions reverberate upon the life of the street today. How much of the hunger and the desperation moving in and out of the shadows cast by the façades of decaying "gentility" linger as after-effects of events set into motion by a bygone city-scion?

Try as we might to "pretty up" a place with our imposing mansions, edgy condominiums, rooftop gardens, quaint shops, inviting community centres, peaceful green spaces or stately memorials, hungry ghosts still cry out from the sour earth upon which we build. *Old stories will not be written over.* We may cover them with our silence, refusing to lodge their actors in living memory or to breathe life into past misdeeds by speaking them out into the present world; still—like Toronto's 50 buried waterways that, refusing to lie still in their interment, bubble up to gently tease out fissures in city roadways, to breach the foundations of municipal buildings, and to flood the basements of private homes—they continue to plot a course through which new stories unfold and new ghosts are brought into being. Without intentional redress through an ongoing practice of activation (an encounter with the land through which treaty-relationships may be reanimated through remembrance, acknowledgement and somatic engagement with long-abandoned protocols), our relationships with the soured earth of such places remain troubled and newly birthed ghosts inherit the bitterness of those who walked this earth before them.

You are here: re-emplacement as survivance-intervention

First Story, Toronto began in 1994 as the Toronto Native Community History Project (TNCHP)—an activation that was set into motion by the late Michi Saagiig Anishinaabe scholar and activist Rodney Bobiwash. Bobiwash, a prolific writer and researcher, was an early-adopter of and lifelong contributor to a now-ubiquitous model of survivance-research. Through his work, Bobiwash intervened upon the dominant mythos that has long continued to disseminate tragic fictions about a vanished/ing, "primitive" People, *present*-ing Toronto's Indigenous denizens as productive, thriving contributors to the life of a contemporary metropolis. Such is the work of "survivance" (Vizenor, 1999: vii), and through the survivance-*intervention*, Indigenous Peoples can fully realize and declare our existence in the present moment and so imagine ourselves and our nations in the future. Indeed, the future imagined within the survivance-intervention contains the "reversion of an estate": a sovereign return to the rites, languages, lifeways and application of knowledge systems that constitute the birthright of a living, active People (Vizenor, 1999: vii).

Through his considerable outputs, which include publications, public lectures, teach-ins, walking tours and the Great Indian Bus Tour, Bobiwash mapped Tkaronto as an Indigenous "place-world" (Tuck and McKenzie, 2015: 130). With the Great Indian Bus Tour—a three-to-five-hour excursion through the Greater Toronto Area during which Indigenous place-names, people and doings were restor(y)ed in their proper place—Bobiwash effected an Indigenous reclamation of territory, placing the Settler and Indigenous body alike into direct confrontation with a difficult history that has been "written over" by colonial occupation and invention. Further, Bobiwash's strategy of re-emplacing the Indigenous *body* (ancestral and contemporary) into an ancient and complex web of land-directed interrelationships and kinship responsibilities continues to effectively counteract colonial erasure. Indeed, corporeal engagement is a *critical*

aspect of the survivance-intervention, required to simultaneously break the paralysis of the disoriented and dislocated as it activates purposeful movement towards Indigenous futurity (Simpson, 2017: 193).

Since Rodney Bobiwash's untimely death in 2002, First Story, Toronto has continued to curate embodied encounters on an ancient, storied landscape through bus tours, themed peripatetic teachings and workshops. But where earlier iterations of the Great Indian Bus Tour were largely sedentary affairs during which audiences settled themselves into a moving *theatron* to be educated and perhaps entertained, First Story, Toronto Tours are, with increasing frequency, being dramaturged to draw their sojourners into a collaborative project of embodied place-making. It is no longer enough simply to read the land and give voice to the memories it holds. To meet the challenges of this historic moment and to effect a convergence between diverse actors, many of whom are driven by dis-ease born of dislocation, isolation and disorientation (Chambers, 2009: 260–261), the "tour guide" is called upon to facilitate a perlocutionary moment in which "[a]ction and awareness are merged" (Csikszentmihalyi, qtd. in Preston, 2016: 39), as audience-members present themselves and performatively reconfigure a relationship long skewed by the complacency born of settler-privilege and wilful disregard.

You are here: remembrance, acknowledgement and re-orientation

Across Tkaronto, Indigenous organizations are overrun daily with requests from settler-run organizations for aid in crafting accurate and appropriate land acknowledgements to be disseminated in written and oral forms as markers of their involvement in the process of "reconciliation." Who, these organizations want to know, are the original stewards of the territories upon which they conduct daily business? What is the correct pronunciation of names? In what order should they be acknowledged and by whom? These initiatives and questions bespeak a sincere desire to engage in the project of (re)conciliation between settlers and Indigenous peoples; nonetheless, over time, such projects could devolve into prescriptive speech acts—empty utterances that *signal* a paradigm shift without actually effecting one. How are we affected when we utter or witness such acknowledgements? What do we affect through our words or our silences? How do we carry the land acknowledgement into the way we "do life?" *How might this speech act transform us?*

The land acknowledgement perfunctorily performed by rote across this nation will not serve the delicate project of relationship-building; indeed, it may render such an endeavour an exercise in futility. It cannot facilitate the transformation of the individual speaker or listener; it cannot generate conversation or goodwill between settlers and their Indigenous hosts; nor can it facilitate a necessary, collective, seismic "shift" in Canada's body politic (Saul, 2009: 281) because it requires little-to-no *personal* investment on the part of those who recite an "official script."

The activations that have increasingly begun to punctuate First Story, Toronto Tours move participants past the acquisition of facts—past the historical event, the name, the geography. These activations require participants to *re-imagine* themselves in light of this learning (Saul, 2009: 287), to re-imagine their relationships with the biotas upon which they live and work and love; and to re-imagine a way of doing life that honours the treaty-relationships into which they have been born or (in the case of new Canadians) into which they have been "adopted." As non-Indigenous peoples invest time and energy in re-educating themselves, in listening to and learning about the lands upon which they live and the Indigenous peoples who continue to steward these lands, *they must take care to remember themselves.* How is it that they come to be in this place at this moment? From what "boat" did they (or their ancestors) disembark on these shores? On what shore did they first arrive? From what nations? What has been left behind?

Which languages, spiritual beliefs and practices, attitudes, lifeways and knowledge systems have been forgotten, ignored or discarded? Why? What may be worth retrieving and preserving and sharing with (*not imposing* upon) others? This process of remembering and restory(ing) the self, re-emplaces the settler within a ceremonial encounter at the "edge of the woods," soliciting a welcome to territory. The activation that is engendered by these questions, then, is designed to engineer spaces of radical redress and relational re-creation:

> We build a relationship to the lands by activating it, in similar ways to how we build radical relationalities through radical love with each other as human and non-human beings. I believe that this activation can come in the form of choreographic fugitivity, as a process of glyphing, an ancient futurity practice of imprinting futures on rock—as territories that hold spaces as acts of remembrance.
>
> *(Recollet, qtd. in Carter, Recollet and Robinson, 2017: 217)*

We are here: the personal cosmography as contemporary "futurity practice"

In an attempt to deepen the *affect* of the land acknowledgement (dramaturging it as a perlocutionary event), I devised You Are Here: Charting a Personal Cosmography through Waterways, Bloodlines and Constellations to conclude First Story's Routes and Roots tour along the Humber River in the summer of 2017. An early exercise in a series of activations, it emerges from an understanding of waterways as Earth's vascular system and engagement with the heavenly bodies that govern the flow of Earth's waters, as they orient Earth's creatures. Wherever we stand, we are navigating the waters (above and below) of an ongoing creation story. The waters that form cloud-shapes above us, that carry us to new homes, that bubble up from beneath desert rocks, or that rage below city streets comprise the first stuff of creation: they usher us into the world and they sustain our lives while we are here.

The Humber River, an important migration corridor for birds and pollinators, extends 903 kilometrers and is one of three crucial waterways in Tkaronto/Gchi Kiiwenging connecting Georgian Bay to Lake Ontario. As such, it has always been a key trade route, carrying humans and their goods from place to place. On the stretch of this corridor at Toronto's Old Mill where the Routes and Roots tour begins, a series of scenes from the Anishinaabe creation cycle has been "glyphed" onto the walls of the subway underpass by Anishinaabe Artist and Elder Philip Cote, reminding us all that our arrival is part of an eternal plan, emerging from the first thoughts that the Creator of life sent out into the void to become countless points of light situating us in time and space.

The Routes and Roots series featured both afternoon and evening tours punctuated by activations: You Are Here was designed as a daytime activation to emphasize terrulian relations, as participants charted terrestrial crossings. Meanwhile, evening tours concluded with Nehiyaw scholar Karyn Recollet's Indigenous Star-Mapping, which took participants through the process of glyphing the configuration of the stars above our heads, through various media, to chart "the fluidity and collapse of time/space to consider our future ancestors" (Recollet, qtd. in Carter, Recollet and Robinson, 2017: 217) (Figures 13.1–13.3).

A collaborative mapping exercise, such as You Are Here, serves two key functions[3]. First, participants are given the space and the tools to reflect upon their bloodlines (their own sources of life) and the flow of those bloodlines into whichever watershed they are living and where their lives are sustained. Through this work (and in conversation with their Indigenous hosts and with the non-human relatives with whom we live in reciprocal relationship), participants can avail

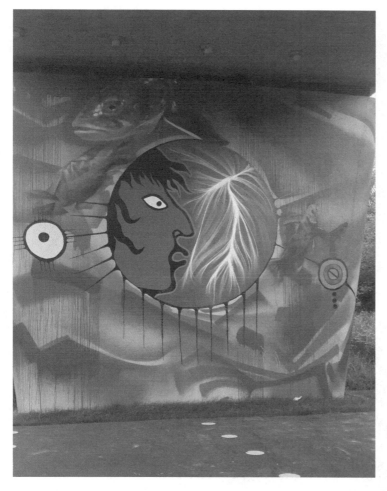

Figure 13.1 Creator's First Thoughts (Philip Cote). (Photo: Jill Carter, July 2017.)

themselves of the opportunity to map out their own origin stories, discovering their shape and considering their trajectory.

Ultimately, my hope is that, through this glyphing exercise, participants will be able to craft a ceremonial telling of their own roots and ancestral routes, the collisions and the convergences that occurred to make a way for their emergence and to reflect upon the parallel lines and intersectional encounters that exist between their ancestral crossings and those of fellow participants. These stories of multiple crossings and ongoing arrivals live, ultimately, within the larger cycle of creation that marks the storied earth on which we stand. The opportunity to chart these crossings constitutes an invitation to take that tentative first step towards that *edge* that separates "*terra nullius*" from *territory*, to signal presence, to declare intention and to *request* welcome, as remembrance and acknowledgement evolve into a *thing done*—a performance of commitment to redress a past and re-story a future in which the ancient treaty relationships existing between human and non-human relatives are repaired and honoured across seven directions (Figures 13.4 and 13.5). In Figure 13.4, during a Routes and Roots tour, artist Philip Cote interprets the third

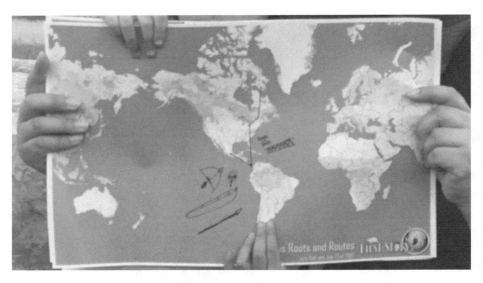

Figure 13.2 You Are Here. (Photo: Jill Carter, July 2017.)

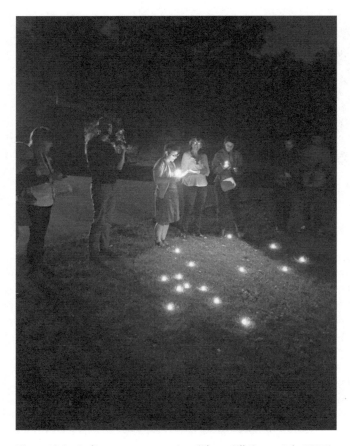

Figure 13.3 Indigenous star mapping. (Photo: Jill Carter, July 2017.)

We are here

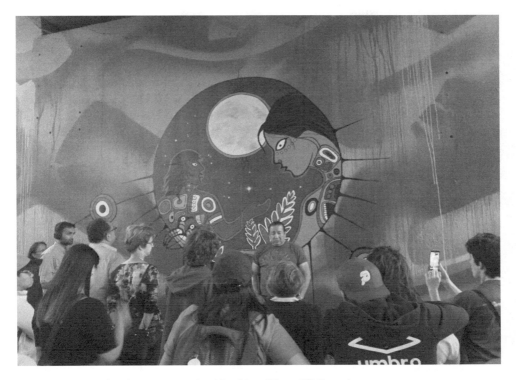

Figure 13.4 Grandmother Moon teaches First Man. (Photo: Jill Carter.)

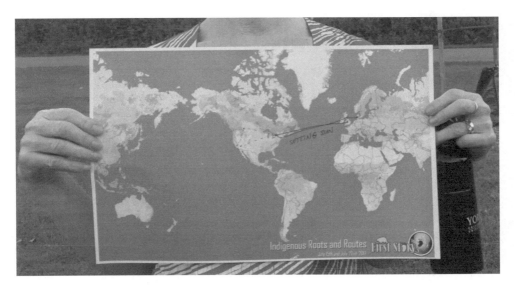

Figure 13.5 Routes and Roots workshop participant. (Photo: Jill Carter.)

mural of his creation series. Here, Grandmother Moon (who lights our way in our darkness) shares her knowledge of botanical medicine with First Man. Within this phase of his growth, First Man also learns key lessons about reciprocity, as he is taught to declare his intentions (i.e. to heal) and to ask the plant's permission before harvesting it. He is to take only what he needs, so as not to utterly decimate a species. And he is to give something in return for what he takes (i.e. to lay tobacco on the earth where he harvests). In Figure 13.5, this Canadian introduces herself to her guides, fellow sojourners and to the waterway, locating herself within the constellation she has mapped. As she interprets her map and "performs" the story of her coming, she locates herself in relation to the lands and waters that now support her life and articulates her commitment to initiate and maintain relationships with the original stewards of this biota—relationships that are grounded in respect, reciprocity and gratitude.

> I asked the bare land, 'Do you want me to stay here with you?' [...] Will our seasons meet again under the promise of beautiful change? My promise: I will visit you dearest dear Red Oak to let you know if I am chosen to stay. I shall imagine success for myself and this tree [...] As the melting snow nourishes your roots, I search for a way to plant my own roots in this beautiful new land.
>
> (Berna Celikkaya DRM3901, 2017)[4]

Notes

1. Shakespeare, William. *MacBeth* (V, i, 41–42).
2. In 1796, Wabakinine, his wife and sister travelled from the Credit River to (what we now call) the St. Lawrence Market to sell their catch of salmon. Here, British soldier Charles McCuen propositioned Wabakinine's sister, offering her one dollar and a bottle of rum for her sexual favours (Smith, 2013, ch.2). She declined his offer. Thus spurned, McCuen gathered some friends and followed the family across the peninsula (no longer existent) to the Toronto Islands where they had made camp. As they dragged Wabakinine's sleeping sister out from under her canoe, Wabakinine and his wife rushed to defend her. McCuen and his friends beat Wabakinine to death and then beat his widow, leaving her to die from her injuries shortly thereafter (Schmalz, 1991, pp. 109–111). To assuage Indigenous anger and the possibility of an uprising of Anishinaabeg in alliance with the Haudenosaunee, the Crown brought McCuen to trial in 1796, immediately acquitting him for "lack of evidence" (see Smith, 2013).
3. *Participants track their* ancestors' crossings, following familial bloodlines to find themselves in the territory they now occupy. According to Anishinaabe cosmology, stars are the ancestors of those who live today. These ancient far-seeing bodies orient us spatially (as we move across the lands and waters) and temporally (as we prepare for seasonal changes). Hence, participants are given world maps (without place names) and asked to represent each of their ancestors and/or living relatives as a star travelling in its orbit. Each "star's" place of beginning is marked by a symbol on their maps and its course to the next star is carefully charted (i.e. one travelled from London, England to marry another in Tokyo). Thus, participants chart the pathways taken by these star-relations, the collisions and the convergences that occurred to make way for their own emergence in Tkaronto in this historical moment. Once each person's personal constellation has been mapped, each is asked to name it, to story it and to present themselves (via a speech act) as a member of this constellation and a keeper of this history to the group. As each individual presents her terrestrial "star map," remembering the crossings and waterways that have brought us all together in this particular moment, we are able to collectively reflect upon the ways in which our "constellations" intersect and to consider our personal responsibilities to the ancient treaties (between human and non-human) and to the historical treaties whether we are territorial stewards, visitors or guest.
4. This is an excerpt from the journal of Berna Celikkaya, an international student and former PhD candidate at the Centre for Drama, Theatre and Performance Studies (University of Toronto). Here, Celikkaya communicates her deepening relationship with the land in DRM3901 (Indigenous Place-Based Dramaturgies) in Feburary 2017. (Used with permission.)

References

Carter, J., Recollet, K. and Robinson, D. 2017. Interventions into the maw of old world hunger: Frog Monsters, Kinstellatory maps, and radical relationalities in a project of re-worlding. *In:* H. Davis-Fisch, ed. *Canadian performance histories and historiographies.* Toronto: Playwrights Canada Press, 205–231.

Chambers, N. 2009. Reconciliation: A "dangerous opportunity" to unsettle ourselves.' *In:* G. Younging, J. Dewar, and M. DeGarné, eds. *Response, responsibility, and renewal: Canada's truth and reconciliation journey.* Ottawa: Aboriginal Healing Foundation, 257–278.

Davis-Fisch, H. 2014. Lawless lawyers: Indigeneity, civility, and violence. *Theatre Research in Canada – Recherches théâtrales au Canada (TRIC/RTAC)*, 35(1), 31–48.

Freeman, V.J. 2010. *Toronto has no history: Indigeneity, settler colonialism, and historical memory in Canada's largest city.* Toronto: University of Toronto. T Space. Available form: http://hdl.handle.net/1807/26356.

Preston, S., ed., 2016. *Applied theatre: Facilitation—pedagogies, practices, resilience.* London: Bloomsbury.

Saul, J.R. 2009. Reconciliation: Four barriers to paradigm shifting. *In:* G. Younging, J. Dewar, and M. DeGarné, eds. *Response, responsibility, and renewal: Canada's truth and reconciliation journey.* Ottawa: Aboriginal Healing Foundation, 279–292.

Schmalz, P.S. 1991. *The Ojibwa of Southern Ontario.* Toronto: University of Toronto Press.

Simpson, L.B. 2017. *As we have always done: Indigenous freedom through radical resistance.* Minneapolis: University of Minnesota Press.

Smith, D.B. 2013. *Sacred feathers: The reverend Peter Jones (Kahkewaquonaby) and the Mississauga Indians.* 2nd ed. Toronto: University of Toronto Press. Kindle Edition.

Tuck, E. and McKenzie, M. 2015. *Place in research: Theory, methodology, and methods.* New York: Routledge.

Vizenor, G. 1999. *Manifest manners: Narratives on postindian survivance.* Lincoln: University of Nebraska Press.

14
APPLIED PERFORMANCE PRACTICES OF THERAPEUTIC CLOWNS
A curated conversation with Helen Donnelly

Julia Gray, Jenny Setchell, and Helen Donnelly

Introduction

In this chapter, we explore the ways that therapeutic clown practices in a rehabilitation hospital emerge from artistic practice, including theatrical clown and circus clown. This curated conversation takes place among therapeutic clown practitioner and teacher Helen Donnelly, applied performance and health humanities scholar Julia Gray, and critical qualitative health researcher, physiotherapist and former physical theatre practitioner Jenny Setchell. We sat down in person to discuss Donnelly's practice (which was audio-recorded and transcribed verbatim), and followed up with a back-and-forth process among all three contributors to refine the written text. Through her clown persona of Dr. Flap at Holland Bloorview Kids Rehabilitation Hospital in Toronto, Canada, Donnelly discusses the ways she and her clown partner provide liminal spaces for disabled children to instigate play with agency; engage aesthetically, imaginatively and relationally; and up-end traditional adult/practitioner – child/client hierarchies. We use the term "disabled children" rather than "children with disabilities" in keeping with current usage in critical disability scholarship (see for example Kafer, 2013; Shildrick, 2009). Disability is not considered a condition of individuals, as is implied by the phrase "with disabilities," but rather something experienced as a result of prejudice, discrimination, and social exclusion. Centered in artistry rather than traditional medical or therapeutic approaches, the "aesthetic" care provided through clowning focuses on aspects of a child's body, emotions, and relationality.

Julia: Tell us about your experience in clown. You are not only a therapeutic clown, but also a circus and theatrical clown.

Helen: My clown roots are theatrically-based, specifically physical theatre. The circus aspect came later. I did a circus show at Ontario Place in Toronto [Canada], and that's when I got scouted by Cirque du Soleil. I worked with them, touring and performing special events worldwide over a six-year period. After Cirque, I was the resident clown of Circus Orange, which is a pyro-technic dance-based circus, for ten years, until 2017. I am still involved with theatrical-clown in theatres and festivals, and through teaching too. Doing my own shows and creating cabaret nights with my students.

With both theatrical and circus clown you are using a lot of the same clown-based muscles. But the kind of energy that you need to generate in order to start up a circus show is very, very different from the type of energy that is required to pull off a good theatrical clown show. With circus, it's much more "360" and your role is to carry the show forward; you're there to be the storyline, or the glue that fits the whole show together. Whereas in a theatrical clown show, it's usually a one-woman show or a cabaret night where you're with other physical theatre performers, your "kin" if you will. So you're using different artistic muscles. You can start very subtly in theatre – you can start with a whisper. It's a different kind of listening to your audience. It's very, very difficult to be subtle as a circus clown.

Julia: How does that move into therapeutic clown, in terms of listening to audience, or using particular clown-based muscles?

For more insight into the process of transitioning from a circus or theatrical clown to a therapeutic clown, please see the documentary *A Therapeutic Clown Emerges: Our Story of Recruitment and Training* (Donnelly and Vanden Kroonenberg, 2018).

Helen: The obvious differences are the agendas. So in shows, whether it's a circus or theatre show, your agenda is to entertain. And that's it: Full stop. You have a particular kind of relationship with your audience. Whether you're in a theatre or performance space, or they're coming to a public space, they're usually expecting some sort of entertainment.

And when you're moving into a therapeutic context, so many things are different. First of all, your audience might be an audience of one. The context is more private, and your audience may not be expecting you or even know of your existence. They're also potentially more vulnerable in ways that a public audience typically isn't.

I am very aware when I am doing my theatrical or circus shows that there could be people out in the audience who have a cancer diagnosis. And maybe I've made their day a little lighter. I'm very aware that there are therapeutic benefits to putting on a good clown show.

But when you have someone in a hospital who isn't expecting you, you might have someone who could be vulnerable physically, mentally, emotionally – all kinds of ways. Even if they are, you need to be ready for anything. Maybe it's not the best time for them, or they change their mind half-way through, or *you* might be triggered and you have to leave, or you're interrupted by something medically-based, or a family visitor comes in the room and you graciously step aside. It's a different kind of attention.

Julia: And what about the children? What do they bring to your work as a therapeutic clown?

Helen: They bring so much. Much like a theatre or circus audience, but in a different way. Let's say there's a teenager who purely wants to be entertained. He's asked for it: "What have you got for me?" And you give him the goods – not the cheap stuff! So, you might perform an improvised soap opera, or a hip hop song which has to do with him in the hospital – that kind of thing. And he is totally satisfied because he is receiving a full, ridiculous, and entertaining experience. Compare this to a very

tender moment with a child, where maybe you're talking someone down from a crisis. And you're doing it artfully, making up a song about how weird this moment is, or how we are feeling – that kind of thing. The practice is that varied, and there are different approaches that are appropriate for different scenarios. We need to be trained and ready for *the client to choose* what kind of clown they get in that moment. I've also taken totally different approaches with the same client. They recognize that, and they drive that boat.

Clients are really smart about how to manipulate their clowns, and how to do it for their benefit. They know how to get the goods from their Fools, and it's really clever.

In a contemporary health care settings, there are ongoing extensive discussions about the nature of the client–practitioner relationship. There is now a widespread acknowledgement of the considerable harms of the traditional paternalism of Western health care approaches where the health practitioner unilaterally makes decisions on behalf of the person they are caring for (Bensing 2000). In the past few decades, a response to these concerns has been to attempt to shift the nature of health care interactions to a "person-centred care" approach (often this is called "child-centred" or "family-centred" in childhood health care) which involves efforts to make care more collaborative (McCormack et al., 2015). There are a number of different person-centred approaches underpinned by different ways of thinking about how to address these issues (for more details, please see Pluut, 2016; Leplege et al., 2007). Although there have certainly been some shifts in practice to more collaborative approaches, there continue to be difficulties implementing this type of care in practice. There is also considerable research highlighting that most health care practices continue to be health practitioner driven and led, rather than collaborative (Hiller et al., 2015; Naldemirci et al., 2018; Gibson et al., 2019).

Jenny: It's interesting to think about that in a health care context. What you're describing sounds quite different from most health care provider–client relationships. Most doctors or other health care providers don't expect children to drive the boat to the same degree that you are describing.

Helen: Yeah, I can see that. We're unique in that way in a hospital setting.

Julia: And how do you place yourself in that relationship with children as a therapeutic clown?

Helen: In this particular therapeutic context, it's not about you. So it takes a huge amount of humility – the ability to set your ego aside. Your "brilliance" as a clown is secondary to their well-being, to their comfort, to their choices. It's a different kind of togetherness, riding that particular wave when things are going well with a particular child, and seeing where that wave can take all of us, sharing that ride together. But, also the ability to admit when it's not working.

Of course, the roots of therapeutic clown practices are in the art of clown itself. There is a lot of cross-over, and you're riding a wave all the time when you're in live theatre and a circus too. You can hear the audience, you can repeat the same line, or you can repeat the same gesture and get a bigger laugh.

In therapeutic clown, we employ those techniques too, but only when appropriate. We don't push. There are lots of other things that we need to have in our minds

– things like not to over-excite. For example, I've never thought in a circus or theatre show: "Oh, am I going to over-excite them? What will happen if I'm too funny right now?" That's never been a concern. But over-stimulating someone with stitches after surgery – that is a real concern. Over-stimulating someone with a certain diagnosis, like autism, could be problematic where there may be sensory issues. You just need to be aware that the artistic choices are going to have a potentially big impact on the moment; so you attend to the relationship differently.

Jenny: How do prepare yourself to start? Is it different with therapeutic clowning, when compared to theatrical or circus clowning?

Helen: Yes. Preparation is very different. I have rituals for both; warm-up rituals. Usually when I'm preparing for a circus or theatre show I'm doing solo work. So, a warm-up is a thing that I do with myself; a physical, vocal warm-up.

Jenny: And that's just before you go on stage?

Helen: It is. But then I also breathe in the audience just outside of their view, off stage. I breathe them in and I wish them well – it's a little well-wishing thing I do.

But with therapeutic clowning, although there's still the physical, vocal warm-ups, you're working in partnership. Working with a partner is really important. It offers more choices for the client – artistically more is possible with two clowns; you can set up amusing conflicts, harmonize while singing, use slapstick routines, stuff like that. As well, working in duo helps to make sure children never feel obligated to engage since they see there are two of us. They have more time and space to "get to know" us as they decide about inviting us inside their room to play. It's also helpful for us as clowns to have an extra pair of eyes on what we're doing when we play with children – it's a kind of safety to have someone else witness the work, and even an accountability. This is also important because after our shift we provide feedback to each other, where we exchange artistic and logistic ideas, so we can learn from what we're doing in the hospital units and improve for next time.

But, I digress. Back to preparation! Together, my clown partner and I settle on a focus of the day. It might be, "Because I've been so verbal these days, I want my focus of the day to be the most non-verbal clown ever! Dr. Flap is going to have no opinions at all!" And then my partner will say, "That's good to know. I will support that by not asking a whole bunch of questions, and I'll be just as curious." So by voicing our focus when we prep, we try to support each other as clown partners, to help each other get through the day. We find that by saying a concrete focus out loud, it helps us tune into each other. This is vital; listening and being present with each other as clown partners. It's vital because it's the corner stone of everything, from being an excellent listener on the units, to not missing out on some obvious things, like paying attention to a family who is struggling emotionally or an opportunity to connect with a child who takes longer to communicate verbally because of a brain injury. Being tuned into each other grounds the work as a therapeutic clown.

So, then as a duo, we usually do a silly warm-up. Like Nurse Flutter[1] and I do this kind of "10, 9, 8, 7, 6…", a kind of clapping, schoolgirl thing that I made up. She loves it! And she always loses, so she giggles going into it, knowing she's going to be a big loser. Getting the laughing going is really important. And it's authentic – based on real stuff, our own stuff, rather than laughter coming from nothing.

Julia: I love what you're saying about what the audience brings and your relationship with them. Even using language like "breathing in the audience." I know you do that with

the circus clown and the theatrical clown. And it sounds like you do that, or a version of that, within the therapeutic setting as well.

Helen: We do! In a bunch of different ways. For example, the first half of our day is looking up clients, their charts, talking to other health care providers. One could say we're kind of "breathing in" all of that information about what the clients are up to. And what is their weekend like? And have they been sleeping? Or are the parents at bedside? Or no, they're missing their parent. Or they're really bummed out because their best friends haven't visited yet. This is their third week in rehab and they're really, really super lonely and scared.

So you're taking in all the psycho-social trauma, plus their physical situation and what's happening with their bodies. And you can kind of "breathe that in" and pay attention to that when you play with those children.

And you get deep, deep, deeply into the family situations. Of course, we are always paying attention to the whole family (parents, grandparents, siblings) – they need us too. It's a real privilege to serve the parents, guardians, siblings, and all sorts of people at a time when lightness and joy can seem miles away. Sometimes it can be very difficult because of challenging family dynamics, or what the whole family is going through emotionally – if a child's been in an accident, let's say. It's the whole family that's dealing with it. As a therapeutic clown, you're carrying the responsibility of being a caregiver, you're a kind of artist-caregiver. So, you can imagine what it's like for any caregiver, like a teacher or another health care provider. You know the whole family's situation, all their dirty laundry. As a therapeutic clown, your job is to be this instrument of joy and lightness. And you have to present yourself in this non-judgemental, completely open, curious form of play-dough. And it has to be honest: That laughter and joy have to be authentic. And we get there – we can do it, because of our training. All of that is a part of "breathing them in." You're breathing everything that they are suffering with.

And you're also delighting in all of the triumphs. And there are so many, oh my God! On a good day, that far outweighs all of the challenges, as we know.

Julia: What do you mean by honest, when you say "it has to be honest"?

Helen: You can't fake honesty when you're clowning. Because people will sniff that out right away.

It's about seeking out a real, honest connection. To be called upon as a therapeutic clown is to be authentic, real, loving, patient, and non-judgmental, even when sometimes the situations are very difficult to deal with – some of the things you overhear staff or families say can be very challenging. But I'm able to do that; authentically and honestly, I'm able to love and forgive things I hear or see because our focus is on what is "working" rather than what is dysfunctional.

Of course, there have been times when I've failed. And that's when I remove myself from the unit. I turn to my clown partner and say, "My gosh, it's break time!" We rely on each other in that way. One of us is triggered, and we know we're flipping out of clown. That's when you take a break. Because, after all, you're only human.

Jenny: Does that also happen with young people who you work with? The triggering, the flipping out of clown?

Helen: Oh yeah. I get hopping mad about all kinds of things. It's hard to blame children for anything. I might get irritated by some of the choices they make. But there can be difficult family dynamics, sometimes. Things like when parents let their children play

really excessively violent video games. That's really hard, to be in the room during that, and you're seeing it more and more. It's brutal. We'll leave the room if that happens, but it will certainly take you out of your clown.

Jenny: It's harder to connect.

Helen: Completely. Well, actually, we did wean a boy off of his video-game device. With him, we had assumed that the parents had caved early; like "Oh, he loves devices, so we're just going to plug him in!" And frankly, what exhausted parent hasn't done that? But they were so shocked that he kept stealing glances up at us. And as the weeks went on, he eventually just put the device down, which apparently was a huge change for him.

Jenny: And, of course, being in a rehab hospital, your audience may be there for weeks! There's a courtship that happens over quite an extended period to time.

Helen: That's a good way of putting it. And relationships with children build differently. Sometimes it will come together in a flash. I'm thinking of one child, I think he was three years old. All he had to do was look at us and go "Bam bam, you're dead!" And we would go, "Aghhh!" We were just his forever. And then he just followed us around and that was it. We tried to alter the game, but he wouldn't have it. For three months, that was the game.

Then, you know, we had this other little one whose parents were really cautious about us, saying, "You know, he's always hated clowns." And our response, of course, was, "No problem. We'll never approach him. But you know we are around, you might see us." So, it went from him panicking when he saw us, like visible panic, to eventually never, ever leaving us alone over a course of a few weeks. He literally followed us into every room.

And everything in between!

There are emerging discussions around the interrelationship among aesthetics, relationality, and care across disciplines. As one example, applied performance scholar and practitioner James Thompson discusses *an aesthetics of care* as a "quality in the touch, the attentiveness, and the focus of the relationship..." as part of health care practices that might "more usually [be] associated with artistry" (2015, p. 432). He additionally queries the ways that applied and social justice-oriented theatre practices might be re-oriented within a framework of care emerging from feminist ethics, including mutuality, reciprocity, and personal and political interdependencies (see also Gray and Kontos, 2018; Gray, 2019). Similarly in dementia care, the notion of *relational care* has been suggested as an ethical re-centring of caring practices around relationships beyond individually-oriented patient-centred care, to include how persons living with dementia might be cared for and supported in a range of contexts including familial, environmental, cultural, social, aesthetic, spiritual, as well as biomedical (see for example Kontos et al., 2016; Greenwood, 2007; Kontos et al., 2017). From the visual and avant-garde arts, art critic and scholar Nicholas Bourriaud's (much critiqued) *Relational Aesthetics* can be understood as engaging in artistic practices "which take as their theoretical and practical point of departure the whole of human relations and their social context, rather than an independent and private space" among artist, artistic technique and artistic form (2002, p. 113).

Julia: What would you say is the kind of care you provide? You talk about being an "artist-caregiver," or that a child is "looking for certain things" from you as a therapeutic clown. What are those things? What you provide to children is different from, say, a medical doctor, or even an occupational therapist, where there's a particular focus or approach to "care."

Helen: We're not focusing on the diagnosis of the child. We have to be aware of it, sure. In order for the good care to happen, we need to protect them from harm. So being aware of triggers and the diagnosis, different ways of communicating, and likes and dislikes, and all that kind of stuff, is so important. And that is a part of being a caregiver.

It's attention to particular kinds of details, as well. We observe the children carefully. The more present we are with them, the more precisely we're attending to minute alterations in their mood, in their breath, in their body language, in *how* they respond to us, and to *what* they're responding to.

But there's also a presence with my clown partner. I might signal to her in the moment of play that I just saw something that I know she missed. Or vice-versa. How does the practitioner underneath the nose make sure that everyone's on the same page, and not lose the thread of the play? So it's very complex.

You're working in the moment, being present. It's spontaneous; there's no plan, other than how can we tend to the healthy part of this individual child that we're serving through clown? What does that look like, in this moment? Do *they* need *us* in *this moment*, and if so, *what does the need look like*? And how do we, as clown partners, agree on that need and what it will look like through a silent negotiation?

A big part of being a good artist-caregiver is tending to those really specific, subtle signs.

Julia: Like those signs from a child's body and movements.

Helen: Yeah, all that. You have to be present, so you can pay attention to that stuff in another person.

Julia: In our paper with Barb[2] about therapeutic clowns and foolishness (Gray et al., 2019), we wrote about "aesthetic attention." We had discussed how, when clowns play with children in a hospital, there's a kind of sensory engagement and emotional awareness, but that happens through playing and through *doing*, not through talking or too much "in-your-head." That can open up creative and imaginative possibilities for that child.

Helen: Yes, exactly. And that happens because we pay attention in those ways. We are trained to do this as artists.

Notes

1. Nurse Flutter is Dr. Flap's clown partner. Nurse Flutter is the clown persona of therapeutic clown practitioner Suzette Araujo. For additional information about Holland Bloorview's duo clown model please see Gray, Donnelly and Gibson, 2019; Donnelly and Vanden Kroonenberg, 2018.
2. Dr. Barbara Gibson, Senior Scientist at Bloorview Research Institute, Holland Bloorview Kids Rehabilitation Hospital, and Professor in the Department of Physical Therapy, University of Toronto.

References

Bensing, J. 2000. Bridging the gap: The separate worlds of evidence based medicine and patient-centered medicine. *Patient Education and Counseling*, vol. 39, no. 1, pp. 17–25.

Bourriaud, N. 2002. *Relational Aesthetics*. Dijon: Les presses du réel.

Donnelly, H., and Vanden Kroonenberg, G., 2018. *A Therapeutic Clown Emerges: Our Story of Recruitment and Training*. Documentary Film. Donnelly-Vanden Kroonenberg Production, in association with Holland Bloorview Kids Rehabilitation Hospital: Canada. Accessed August 17, 2018. http://www.helendonnelly.com/store/p2/A_Therapeutic_Clown_Emerges%3A_our_story_of_recruitment_and_training%3A_the_DVD.html.

Gibson, B. E., Terry, G., Setchell, J., Bright, F. A. S., Cummins, C., and Kayes, N. M. 2020. The micropolitics of caring: Tinkering with person-centered rehabilitation. *Disability and Rehabilitation*, vol. 42, no. 11, pp. 1529–1538. doi:10.1080/09638288.2019.1587793.

Gray, J. 2019. Working within an aesthetic of relationality: Theoretical considerations of embodiment, imagination and foolishness as part of theatre making about dementia. *Research in Drama Education: The Journal of Applied Theatre and Performance*, Special Issue on Theatre, Dementia and Relationality, vol. 24, no. 1, pp. 6–22. doi:10.1080/13569783.2018.1535270.

Gray, J., Donnelly, H., and Gibson, B. E. 2019. Seriously foolish and foolishly serious: The art and practice of clowns in children's rehabilitation. *Journal of Medical Humanities*, First on-line July 23, 2019. doi:10.1007/s10912-019-09570-0.

Gray, J., and Kontos, P. 2018. An aesthetic of relationality: Embodiment, imagination and the centrality of playing the fool in research-informed theater. *Qualitative Inquiry*, vol. 24, no. 7, pp. 440–452.

Greenwood, D. 2007. Relational care: Learning to look beyond intentionality to the 'non-intentional' in a caring relationship. *Nursing Philosophy*, vol. 8, no. 4, pp. 223–232.

Hiller, A., Guillemin, M., and Delany, C. 2015. Exploring healthcare communication models in private physiotherapy practice. *Patient Education and Counseling*, vol. 98, pp. 1222–1228.

Kafer, A. 2013. *Feminist, Queer, Crip*. Bloomington and Indianapolis: Indiana University Press.

Kontos, P., Grigorovich, A., Kontos, A., and Miller, K.-L. 2016. Citizenship, human rights, and dementia: Towards a new embodied relational ethic of sexuality. *Dementia: The International Journal of Social Research and Practice*, vol. 15, no. 3, pp. 315–329.

Kontos, P., Miller, K. L., and Kontos, A. P. 2017. Relational citizenship: Supporting embodied selfhood and relationality in dementia care. *Sociology of Health & Illness*, vol. 39, no. 2, pp. 182–198.

Leplege, A., Gzil, F., Cammelli, M., Lefeve, C., Pachoud, B., and Ville, I. 2007. Person-centredness: Conceptual and historical perspectives. *Disability and Rehabilitation*, vol. 29, no. 20–21, pp. 1555–1565.

Mccormack, B., Borg, M., Cardiff, S., Dewing, J., Jacobs, G., Janes, N., Karlsson, B., Mccance, T., Mekki, T. E., Porock, D., and Van Lieshout, F. 2015. Person-centredness: The "state" of the art. *International Practice Development Journal*, vol. 5, no. Suppl.1, pp. 1–15.

Naldemirci, Ö., Lydahl, D., Britten, N., Elam, M., Moore, L., and Wolf, A. 2018. Tenacious assumptions of person-centred care? Exploring tensions and variations in practice. *Health*, vol. 22, no. 1, pp. 54–71.

Pluut, B. 2016. Differences that matter: Developing critical insights into discourses of patient-centredness. *Medicine, Health Care and Philosophy*, vol. 19, pp. 501–515.

Shildrick, M. 2009. *Dangerous Discourses: Subjectivity, Sexuality and Disability*. London: Palgrave Macmillan.

Thompson, J. 2015. Towards an aesthetics of care. *Research in Drama Education: The Journal of Applied Theatre and Performance*, vol. 20, no. 4, pp. 430–441.

15
PLAYBACK THEATRE CONDUCTOR AS RITUAL GUIDE

The artful and sensitive job of extracting personal stories

Hannah Fox

Playback Theatre, an applied performance form in which audience members' stories are acted out on the spot by a team of actors and a musician, is currently practiced across the globe in 70 countries. Playback Theatre, at once ritual and performance, has both entertainment and transformative elements. It is interactive performance which aims to build empathy and connection through personal story. Telling and then watching our life stories reenacted on a public stage is often uplifting and redemptive. The role of the *conductor,* or the master of ceremonies (akin to the joker in Theatre of the Oppressed) in a Playback performance, requires a complex set of skills ranging from inter-personal to theatrical. The Playback Theatre conductor serves as the liaison between the audience and the actors, and is required to confidently, yet sensitively, solicit sometimes delicate or traumatic life stories from a group of strangers and then artfully pass these stories on to a group of expectant actors. In that sense, the Playback conductor becomes a conduit through which the stories pass. Other metaphors that apply are: the conductor of the orchestra (a Playback conductor needs to make sure the ensemble of actors work together harmoniously) and a train conductor (a Playback conductor needs to keep the event in rhythm and on time). This demanding role requires the ability to multi-task, to have a heightened sensitivity to people's emotions, a keen ear for listening, and a firm understanding of story-shaping.

Playback Theatre, created in the 1970s by my parents, Jonathan Fox and Jo Salas, along with the original Playback Theatre company, was based in upstate New York. was based in upstate New York. Nowadays, there are hundreds of Playback Theatre companies and practitioners across the world. The method was born out of the experimental theater movement, and influenced by J.L. and Zerka Moreno's Psychodrama, and the indigenous storytelling tradition of rural Nepal where my father spent two years in the Peace Corps. The goal early on was to create a forum for community stories. My father was the main conductor in the original company and brought definition to the role. These days, there are as many kinds of conductors as there are practitioners, but the basic set of skills and tasks remain the same. My mother and Playback Theatre co-founder, Jo Salas, writes,

> Most of all, it is the task of the conductor who must use all her or his resources—her presence; her words and gestures; her eye contact; her warmth; her ability to notice,

> listen, accept, and include; her confidences; and her strength—to generate a mood where audience members are ready to embrace their role as co-creators of this event.
>
> *(2015: 194)*

In Playback Theatre, prompted by questions from the conductor (sometimes around a theme), audience members volunteer stories from their lives that range from the mundane to the extraordinary. The telling—and acting—of the stories is improvisational and part of a spontaneous ritual. Typically, Playback is not performed in traditional proscenium theaters which tend to separate the actors and the audience, but instead in smaller theaters, classrooms, or community centers. Playback Theatre is intimate theatre, and in order for the ritual to be successful, the container that is holding the ritual needs to be carefully constructed and cared for throughout the performance. This is the conductor's responsibility. The conductor first solicits and then reshapes tellers' stories so that they are clear and concise for both the actors and the audience. One of the essential skills of the conductor is to listen for the essence of the story as well as for the given circumstances. The story may ultimately be about freedom from an oppressive relationship, but the details of the story—the who, what, where, why, when, and how—are equally important so that a dimensional piece of theater can be created by the actors following the story telling.

In Playback Theatre, there are short forms, i.e. Fluid Sculptures, Pairs, Three-Part Story, Tableau, The Beat, etc., which call for moments, feelings, and shorter stories from the audience and serve to warm up the room for the long form, or Stories, when an audience member is invited on stage to tell and cast a longer story from her/his life. This person sits in the "teller's chair," next to the conductor (two chairs placed downstage right). The actors stand in front of (or sit on) wooden boxes upstage center and the musician sits downstage left, across from the conductor. The house lights never go down all the way at a Playback venue because the audience members are invited to be "*spectactors*" (to use Boal's term) involved in the "*play,*" and feeling connected to the other people in the room or theater is crucial (1992: xxiii).

The conductor, or ritual guide, must be disarming enough for strangers to want to divulge their life experiences, yet authoritative so that the guidelines of the ritual are followed. Some of the "rules" in Playback Theatre are that tellers need to *volunteer* their own stories and the stories must be true. The conductor does not interfere once the story is passed over to the actors (unlike psychodrama). The teller is prompted to cast herself/himself and sometimes other important characters in the story. And, importantly, the exchange of stories is conducted to generate connection, catharsis, and inclusivity and not meant to be divisive, judgmental, or damaging in any way.

There are several considerations in play for a Playback conductor during a performance (practitioners refer to this as the "conductor's mind"): Is the audience warmed up enough to tell stories? Who in the room has already told? Whose voices have we not heard from yet? How can I inspire a diverse group of tellers? How do we achieve a satisfying artistic and emotional arc to the performance? Do the actors understand both the heart of story and also the important details? Is the conversation of stories flowing or is something else needed in order to build more trust? What has been the connection between stories (which we call the "red thread")?

When successful, the conductor nimbly guides the audience through the Playback ritual and is able to solicit a range of stories from the audience with sensitivity, efficiency, and finesse. Ideally, this is done in a way that the tellers as well as the other audience members, or witnesses, feel seen, heard, and artistically fulfilled. When unsuccessful, the conductor will struggle to build trust and connection with the audience, and people will be reluctant to raise their hands.

Experienced conductors are always equipped with certain prompts and community-building tools if the performance team is struggling to build a connection with the audience.

In his chapter on the role of the conductor in the anthology *Playback Theatre Practice: Selected Articles* (2015), Ukrainian Playback Theater practitioner Volodymyr Savinov outlines five roles that the Playback conductor must occupy at once: friend, psychologist, journalist, explorer, and artist (201). Although it is a role that requires wearing many "hats," when a conductor is able to excavate rich stories from a group and then quietly step into the shadows as the performers act them out, it is a powerful experience for everyone in the room. In her book, *Improvising Real Life: Personal Story in Playback Theatre*, Jo Salas states,

> As a conductor, your job is to ... draw the story out from its home in the teller's memory into the public realm, and to shape it if necessary before handing it to the actors, so that it becomes a living artifact that others can see, remember, be changed by.
>
> (1993: 74)

I have been conducting Playback stories for over 20 years and although it is the role in Playback that feels most comfortable to me, it is one that requires tremendous artistic, psychic, and emotional focus each and every time.

As a conductor, I usually find myself preparing emotionally for a performance several days in advance. And after a show, I am often exhausted from the job of facilitating stories and holding the Playback ritual (which typically entails some level of personal transformation and catharsis). Below are four examples from my own conductor experiences over the decades—two that were successful and two that posed specific challenges. In the first story, I learn how critical the *warm-up* stage of the ritual is in a performance workshop. In the second, as a conductor, I had to work hard to not re-traumatize the young teller. In the third story, because several of the fundamental elements of the Playback ritual were compromised, my role as the conductor was extremely challenging and even became superfluous. The final story illustrates how remaining authentic and transparent as a conductor can pay off.

A cold warm-up

My Playback company, Big Apple Playback Theatre (a multi-cultural professional Playback company established in 2002 in New York City) had been hired to do an eight-week series of Playback Theatre workshops at a domestic violence shelter in the Bronx. The objective was to build community at the shelter for the women and children. This was our first visit. We finally found the correct unmarked front door and filed into a small and cold front office area. After the typical screening, we were ushered down a long hallway and then down stairs to the basement to a small conference room. This is where we were scheduled to do a "welcome" performance. Down the hall was a playroom for the children. After setting up the stage and audience areas with chairs, and warming up, the mothers filed in at the appointed time with suspicious, even resentful, looks on their faces. The plan was for the kids to be down the hall playing until near the end of the session when they would join us for some games. We set it up this way so the women could feel free to tell difficult stories without their children within earshot if they wish to.

I was the main conductor of the company at that time and it was going to be up to me to break down the energetic wall that stood between us and this group of women, and try to build trust and connection so that they would want to tell us their stories. Without audience stories, we have no "play," there is no action on stage, and the ritual falls flat on its face. This is exactly

what happened. Because of time, we did not begin with a proper opening, which typically consists of each performer sharing some words from her/his own life which the rest of the actors embody, allowing us to role model the form and reveal our own humanity to the audience. This would have allowed the women (who were understandably preoccupied with much larger life events than an improvisational theater performance) to see that we are not only downtown actors, but real people with real lives and struggles of our own. The result of leaving out this important part of the ritual (actor introductions), was that the women had no interest in talking or participating in our game: they didn't know us, they didn't trust us, and they did not understand what we were asking of them. I threw out the usual preliminary questions, "Hello! How are you all doing? How has your week been so far?" There was no response. I tried again. Silence. I tried some sociometry (a group warm-up method from psychodrama), "Who has had a good day so far? Raise your hand. Not such a good one?" No hands. Zero response and participation. I remember looking over to the actors with an exasperated look on my face. I realized then, albeit late, that we had omitted a proper warm-up, or even an ice breaker. I asked everyone to get up out of their seats and temporarily dissolved the "stage" and "audience" areas. We stood in a circle and played three theater games. It took a few minutes, but by the end of the third game, the women were laughing and engaged. In a circle, where we can all stand and participate on equal ground, was a much smarter (and effective) way to build connection and trust in this context. We eventually invited the women to return to their seats as audience, and the first teller raised her hand with very little prompting. She told about the mounting fear and panic she has now that she and her children are displaced and living in the shelter. "I want to go home," she said. We played her feeling back. The subsequent workshops became easier and easier as we built genuine relationships with the women and children.

To be heard

The next conductor story happened recently at a school. We were doing a series of shows around bullying and harassment for the fourth and fifth grade classes of an elementary school in lower Westchester, New York. Many Playback companies around the world address bullying in schools by using a hybrid model that blends Playback and an adaptation of Forum Theater, a model created by Hudson River Playback Theatre (based in New Paltz, New York). In the program, students get to both tell and see their stories of bullying and harassment in school as well as brainstorm tactics for addressing future incidents of injustice. During the Playback story segment, a fifth grader raised his hand to tell a story. As he walked toward the stage, I noticed that he was smaller than the other children and I also noticed that he was visibly nervous, pulling at his clothes as he walked to the teller's chair. He told me his name and began to tell his story. He spoke with a stutter, and in fact this is what his story was about. He shared how hard it has been for him since he arrived at the school two years ago because other kids are constantly making fun of how he speaks. "I speak differently than they do," he told us, "but I am not dumb and I have opinions. It just takes me a little longer to say them." The little boy cried as he recounted some incidents of teasing and exclusion from other students. You could hear a pin drop in the room; his classmates were listening to him with an attentiveness that was palpable.

As the conductor, it was a delicate interview to navigate. This boy was both fragile and extremely brave as he slowly recounted his painful experience at school over the past year. I welcomed his vulnerability and raw emotion, and at the same time I was acutely aware that if there was any bickering or laughter at all in the audience while he told his story, he could be re-traumatized and the isolation he felt would deepen, which is the antithesis of what we are

hoping to achieve. One of the ways I addressed this was to repeat and underscore his words for the audience in order to validate his experience and indicate to his classmates in the audience that I, and the other actors on stage, were allies. I also continued to turn my focus, my gaze, out to the audience, the witnesses, while I listened to his story. This way the other students knew they were included in the conversation. I was also efficient with the interview; I asked whatever clarifying questions were needed, gave him the space he needed to tell, and then passed it onto the actors swiftly in order to take the spotlight off of him as soon as possible. The story was so poignant and moving (a boy with a speech impediment courageously coming up on stage to tell of his experience to his bullies) that as a conductor, I had to control my own emotional response. It is fine for the conductor to empathize and even become emotional but we need to stay steady in our voice and maintain control of the ritual. I heard sniffling in the audience and I knew I could sniffle later after the show. For the moment, I needed to stay strong for the teller.

It was clear that watching the enactment of his story was deeply validating for the teller. He seemed emboldened by the experience. And when he returned to the audience there were apologies and even hugs from his classmates. I found out later from the teachers who were present for the performance that they were not aware of this behavior by the other children. The onsite coordinator shared with me how valuable they felt it was for him to tell his story and be heard by his classmates in that it built empathy and, hopefully, will prevent further bullying.

Lost at sea

This is another example of when the Playback ritual can break down. We were asked by a large healthcare union to perform at one of their annual meetings with all of the organization's members. The performance was going to take place in a historic New York City proscenium style theater and with over 4,000 people in attendance. From the beginning, I was skeptical and concerned that with such a large audience it would be hard for us to create the container we need for people to tell, hear, and see their stories. We had several meetings with the director and executive director before the event. They were clearly nervous about the improvisational nature of Playback Theatre (in which tellers and stories emerge spontaneously) and eventually they asked if they could *pre-select* the tellers and the stories. We did not want to do this for several reasons—mainly it would mean that the experience would be something else, not Playback, if we control the spontaneity of the ritual. They insisted and we relented in the end.

We did a Playback performance with body microphones and a huge video screen behind us projecting our movements to a crowd of thousands. We could only make out faces of the audience in the first row. This already seemed like a serious departure from the necessary elements that are needed to create a successful Playback experience, i.e. a contained space and felt connection between actors and audience. The pre-selected tellers (selected and vetted by union management) read their stories from a piece of paper instead of speaking their truth in the moment and the actors and musician did their best to play the stories back, although the enactments were lackluster and emotionally flat.

It was an almost impossible task for me as the conductor. I was caught between a rock and a hard place: on the one hand I wanted to create a meaningful and authentic experience for the audience, which was full of hard-working and dedicated health care professionals; on the other hand, the people who hired us (and who are providing our paycheck) did not want their members to speak freely in case anything negative surfaced. In fact, if a teller is *reading* a pre-composed story, there is very little need for a conductor. The experience was stressful, not very successful, and we learned never to compromise on the values and ethics of Playback again.

Freedom

This last example of a satisfying conductor moment happened on a recent trip to the Middle East. I was in Lebanon offering two Playback trainings. At one of the trainings, a young female actor in one of the companies raised her hand to be a teller. She is Muslim and wears a hijab. Her story was about how, until that morning in the workshop, she had never physically touched a man who is not in her family (she is not married). Earlier that morning, I, as the trainer, had asked people to pair up with the person next to them for some physical warm-ups, which we often do in Playback. She had obliged and gone through the series of exercises with a male participant. As a teller, she recounted how she felt she crossed a boundary by partnering in this way with a man.

She told myself as the conductor, as well as her ensemble mates, that whereas she wanted to give herself permission to explore these boundaries, she learned through the experience that this kind of touch was uncomfortable for her and, going forward, she would like to invite physical touch with only women in the company. She added that she would like to "apologize to herself" for crossing this boundary. As I listened I was relieved that I had chosen her hand out of the many others who raised their hand to tell a story in that moment. I could tell by the manner in which she raised her hand, and the expression on her face, that she had something important, and even risky, to say. We also had not heard much from her that day yet. I was also aware of my own ignorance as a trainer in so casually asking people to find a partner, especially working in an Islamic culture. I was able to acknowledge and apologize for this out loud in the conductor role in front of the group, which was important. The actors played back her story with sensitivity and she seemed satisfied.

On a break, I went up to her to thank her for telling her story, and for raising my awareness in this multi-cultural teaching context. She let me know that she was relieved to tell her story in front of the group and grateful for the clarity the experience had brought her about her own physical boundaries.

Conclusion

Through the Playback ritual of telling and seeing community stories facilitated by the conductor, we create a sense of *communitas* in the room (anthropologist Victor Turner's phrase to mean a generic bond created in a group that participates in a shared experience) (Turner, 1969: 95–97). This sense of togetherness is what Martin Buber calls "the essential we" (Qtd. in Turner: 137). You can see that certain elements of the Playback ritual need to be in place (which are mainly the responsibility of the conductor) in order to achieve this empathic connection within the audience. In the Playback anthology, *Gathering Voices,* in his chapter on the ritual of Playback Theatre, my father claims that Playback is a new ritual for our times. He writes, "It is the ritual component of Playback Theatre that takes it to our core being, helping us feel newly alive; and it is this ritual component that allows the kind of discourse necessary to transform a dysfunctional or outworn social order" (1999: 134). I know for myself, I look forward to hearing many more tellers' stories as they enrich my understanding of the world, and I appreciate the complexity of the conductor's role with each story. Playback Theatre offers a means for people from all corners of the globe to feel validated in their personal experiences, tragedies, and triumphs, and there often is catharsis as we tell and then see our stories embodied on stage. But it goes further than that: Playback allows a group of community members, or even strangers, to identify and empathize with one another, creating a web of connection, which is critical in our current fragmented and divisive world.

References

Boal, Augusto. 1992. *Games for actors and non-actors*. New York: Routledge.
Fox, Jonathan and Dauber, Heinrich, eds., 1999. *Gathering voices: Essays on playback theatre*. New Paltz, NY: Tusitala Publishing.
Salas, Jo. 1993. *Improvising real life: Personal story in playback theatre*. Dubuque, IA: Kendall/Hunt.
Turner, Victor. 1969. *The ritual process*. Chicago, IL: Aldine.
Zagryazhskaya, Elizaveta and Zagryazhskaya, Zoya, eds., 2015. *Playback theatre practice selected articles*. Moscow: Vash Poligraphicheskiy Partner Publishing House.

16
THEATRE TO ADDRESS SOCIAL JUSTICE ISSUES WITH GATEKEEPERS IN CANADA

Lauren Jerke and Warwick Dobson

Capitalism produces and perpetuates social injustice. In the following passage, Karl Marx (1964) succinctly describes the disparities, caused by capitalism, between the owner of the means of production and the worker:

> It is true that labour produces for the rich wonderful things – but for the worker, it produces privation. It produces palaces – but for the worker, hovels. It produces beauty – but for the worker, deformity. It replaces labour by machines, but it throws a section of the workers back to a barbarous type of labour, and it turns the other workers into machines.
>
> *(110)*

Wages are set at a rate to enable workers with enough capital to marginally sustain themselves (Marx, 1964). In order to be successful, global capitalism relies on vast economic disparity.

Ideology – the dominant social consciousness – supports, rationalizes, and justifies capitalism (Marx and Engels, 1970). Dominant ideology serves the ruling class, but is manifest amongst all classes. Working class peoples' own experiences of alienation, exploitation, and poverty caused by capitalism can always be vindicated by ideology. Ideology can be hard to recognize. It is deeply entrenched within personal and cultural values. Modern day examples of ideological influence on a personal level are: impulse purchases, "retail therapy", or value judgements on one another's merit based on their materialistic and economic stature.

While social reality may determine and influence many of our thoughts (Marx and Engels, 1970), using dialectical logic, Marx (1971) argued that the base (the economic system) does not solely dictate the superstructure[1]. According to dialectics, both the base and the superstructure reinforce and influence one another. This relationship is where the hope for change lies. There is the possibility that a developing critical awareness of dominant ideology could influence the base: while a single person holds little or no power to make change to the economic system, following dialectical law of quantity into quality (Engels, 1939), a large number of people working towards a common goal can transform social power from insignificant to substantial. If enough people were critical of the base and corresponding ideological superstructure, social power may be able to bring about economic change (Marx, 1964).

Reform and revolution: approaches to addressing social justice

As we understand it, there are two approaches to addressing social justice issues: a reformist approach, which intends to make change where the issue is most visible, yet (perhaps unconsciously) maintains the *status quo* (similar to cutting off the leaf of a plant, but nurturing the flowers and other leaves, while watering the roots, and adding compost to the soil); and a revolutionary approach which addresses issues by focusing on ideological awareness as a starting point to get at its root cause of social injustice – capitalism, and the supporting ideological superstructure (akin to digging down far enough to pull the whole plant out of the ground – leaves, flowers, stem, and full roots) (De Leon, 1924).

Since the 1800s, when Marx wrote about the social injustice caused by capitalism, there have been significant reformist efforts within the superstructure to provide support for all classes, races, and genders that experience social injustice. In the twentieth and twenty-first centuries, governments, legal advocates, and human rights organizations created charters that accompanied national constitutions to provide equal rights to all. The United Nations (UN) countries, including Canada, signed the Universal Declaration of Human Rights in 1948. In 1982, Canada introduced another Charter of Human Rights as an addition to the Constitutions of 1867 and 1982. In 2008, the General Assembly at the UN also implemented the UN Declaration on the Rights of Indigenous Peoples.

Despite these national and international efforts to alleviate widespread inequality, as John Pilger (2002) demonstrates, actions taken to strengthen the Western capitalist economy and support the interests of the ruling class continually prevail over international and national human rights. The western superpowers go to extraordinary legislative lengths to protect, maintain, and support their capitalist economies. The result, unsurprisingly, is to privilege the pursuit of profit at the expense of international human rights, security, and social welfare.

Yet, the possibility to address social justice issues with a revolutionary approach still faintly glimmers behind the fluorescent fast food restaurant signs and the big box stores of Canadian suburbia. Many people in the capitalist economy are not taken in by the pervasive dominant ideology. Many are highly aware and critical of it, and may purposely hold positions of power within structural institutions and the state *because* they are passionate about addressing social justice issues, and aim to use their position to do so. As Noam Chomsky (2011) writes, "intellectuals have the choice to either accept the system they are part of or to challenge it."

Applied theatre to address social justice issues

All aspects of applied theatre can aim to address social justice issues with a revolutionary approach. Project design, form, and content all play a part in either supporting or challenging dominant ideology and the *status quo*. Project design can enact and support democracy (Nellhaus and Haedicke, 2001; Neelands, 2016). Bertolt Brecht demonstrated that content can be used to show contradiction between social reality and political and economic agendas, functioning to aid critical social analysis (Kelleher, 2009). The dramatic form can connect us to our intuitive and affective faculties that have been found to promote discovery of "our particularity but also our shared ontology" (Bond, 2010: 3), and by disruption, can ignite political action (Thompson, 2009).

The critical perspective that can be cultivated and nurtured in participants and audiences as a result of their involvement in applied theatre as participants and/or audiences *lingers* within them – and can impact the way they interact in the world (Thompson, 2009). Despite the prolonged time that it may take to develop, and the difficulty with which it is formally measured

and recorded, this new perspective is a momentous shift in mindset; and one that can be in direct opposition to the neoliberal values of commodification, individuality, and economic status that support capitalism.

However, the goal of ending social injustice is a colossal undertaking, and one that theatre cannot do on its own. Playwright Edward Bond, who has been invested in social justice issues throughout his career[2], said in conversation with Warwick Dobson, "It's not the business of theatre to change the world, that is the business of politics" (Dobson, 2013). Bond's perspective holds a lot of truth, given the complicated web of political and corporate infrastructure that maintains worldwide domination and control (Pilger, 2002; Klein, 2007). Despite the growth and development of applied theatre as a field, in the west, company CEOs and bank executives continue to prosper, even in times of social struggle. In the same year of the greatest economic recession since the 1930s, when many people lost thousands of dollars from personal investments, their livelihoods, and in some cases even their homes, Goldman Sachs, one of the top investment bankers in the USA, reported that they were profitable in 2008[3].

Tim Prentki often points out that applied theatre primarily addresses social justice issues by involving vulnerable and marginalized people – using applied theatre to promote pro-social outcomes (for examples, see Prentki and Pammenter, 2014; Prentki and Preston, 2009). Applied theatre for these ends, despite its good intentions, is largely addressing social justice issues with a reformist approach. Prentki and Pammenter (2014) alternatively suggest working with "power-brokers" and "gatekeepers" as a new tactic to address social justice issues. We use the term "gatekeepers" to refer to anyone who is in a decision-making role, and who has the authority to include and exclude others. We contend that members of the state act as gatekeepers on a number of social justice issues.

Like ideology, the state is a foundational and unique feature of the superstructure. Victor Ehrenberg (1969) details the subdivisions of the state. They are:

- Legislative: creation of policy and law;
- Judiciary: creation of law by precedent, and the enforcement of law through the courts; and
- Administrative: support to carry out laws and policies.

Police enforce law, and in times of crises, the armed forces, or "special bodies of armed men" (Lenin, 1994: 9) intervene. The relations between the subdivisions of the state and the police and "special bodies of armed men" are mutually reinforcing.

What positions the state as gatekeepers, is that it functions as "a product and a manifestation of the *irreconcilability* of the class antagonisms" (Lenin, 1994: 7), and acts as a "special coercive force" (Lenin, 1994: 17) and an intermediary, keeping the class struggle at bay while asserting ruling class interest (Marx and Engels, 1970). Ultimately, the state protects the interests of the corporations that fuel the economy – not its citizens (Lenin, 1994; Pilger, 2002; Prentki and Pammenter, 2014).

If quantitative change makes qualitative difference, might members of the state's efforts to address social justice issues be more fruitful if members of the state took up issue with dominant ideology and the state's own function?

Applied performance

As part of Lauren's doctoral research at the University of Victoria in Victoria, British Columbia, Canada, she has been undertaking a number of applied theatre projects with current and future members of the state to deepen, strengthen, and develop this branch of applied theatre. Below is

a scene improvised during a drama-in-education workshop Lauren facilitated for public administration graduate students. She intended for the workshop to consider the impact of ideology and show the contradictions between personal well-being and state interests. While it did address the former, it did not fully accomplish the latter.

The drama is based on a true story in which a mother sought justice for her daughter who was struck and killed by a car. The subsequent police investigation was later reviewed by a third party and was found to have been haphazardly conducted. As the case went to court, the mother visited provincial public administrators for support but, according to several news articles, she "felt like she got lost in the system". The workshop was structured to examine how the public service sector consistently chooses to protect the state, the police in this case, rather than its own citizens, and the value system that justified it.

One part of the workshop used the "circular teacher in role" performance convention to collectively examine the mother's encounters with several public administrative offices. Lauren played the role of the mother, and two students played the role of the public administrators.

> *The mother has already been turned away by the Attorney General and the Ministry of Public Safety and Solicitor General offices. Now the mother arrives at the Office of the Police Complaint Commissioner.*

Admin 1: Hi. How can we help you?

Mother: I was told to go to the BC police commission – for complaints. You may already know … it's been in the news; it's quite a well-known story. We had an issue with the police investigation…with the death of our daughter, and we are here because we have already had a review, it was found that…

Admin 1: Sorry – just hold on. What is your name? What's your complaint name?

Admin 1: Do you know the file number by chance?

Mother: Rifles through the papers in her bag, and pulls out a piece of paper. Could it be 01865?

Admin 1: Just give us a moment.

Admin 1: We're just going to go check. We'll be back soon.

> *The two administrators turn around to privately consult their advisors.*

Admin 1: Um yeah, it looks like this is the file…

Admin 1: Alright – so, an investigation was conducted, and here's what they found in their investigation…

Admin 1: Yeah – so that was completed. And, according to this, after the oversight everything was in accordance with the law and the police act.

Admin 1: And the file has been deemed "closed".

Admin 1: (To Admin 2) Yeah. It's been closed for a while actually … I'm not sure why she's here.

Admin 1: Well, we can recommend going to the Mayor because it's kind of a really big issue. Our hands are kind of tied. The file is already closed…

Admin 1: Hopefully the Mayor can help her out.

> *They turn back to the Mother.*

Admin 1: Hi there, so we see – yes – an investigation was carried out. We see that yes, there were some performance deficiencies, but as we see, there was disciplinary action carried out –

Mother: – all they got was a warning!

Admin 1: Everything was carried out according to the police act…

Admin 1: They did their due diligence, they did the process –

Admin 1: …there was some issue with the police officers' conduct during the investigation, and there was some disciplinary action taken…

Admin 1: and once the file is closed it's hard to for us to go back and overstep because that's been deemed – official.

Admin 1: And so unfortunately, you have to understand that we're an oversight body. We're an independent office of the legislature. We're not the actual police department.

Mother: Honestly, all that we want right now is access to the police files so that we can bring them into court and prove –

Admin 1: (*cuts her off*) Have you filed an FOI request?

Mother: …I don't think so … we may have … what is that?

Admin 1: "Freedom of information" request. Have you done that?

Mother: I think we will be doing that, yup.

Admin 1: You should go fill that out.

Admin 1: And we recommend talking to the Mayor because the Mayor is in charge of resolutions that have been deemed closed.

Mother: You won't be re-opening the file. I understand that. But what I'm looking for is some support. We've already contacted the local police. They have refused to give us any access to the files.

Admin 1: We understand your concerns … but as we say again our mandate is limited to being an independent office. I'm sorry.

Mother: We just need them for court proceedings so that we can…

Admin 1: Yeah. Unfortunately, the Mayor would have the authority to help you out.

Mother: In what way? How can they help me?

Admin 1: Well, they're concerned with due process, and effective governance, and resolutions for civil matters.

Admin 1: As we've said, we apologize. It's just not within our current mandate.

Mother: And there's nothing that you could do to support our case as we go forward?

Admin 1: As we said, an investigation was already carried out. Police officers were already reprimanded.

Mother: Would it help if our lawyer contacted you?

Admin 1: The only thing that we can recommend is that you fill out our complaint form and then it takes approximately three months to review on a panel and then a decision will be made. That would be the only thing.

Admin 1: In terms of efficiency, we really do suggest contacting the Mayor's office. Especially, as you said, because the community knows about this case. In terms of getting the fastest response…

Mother: Our case is well known in the community. But we haven't been helped out at all. I would assume that if the Mayor or the Mayor's office was interested or could do anything, that they would have already approached us or at least our lawyer.

Admin 1: Oh Ma'am, you have to understand, they have a lot on their desk. They're not going to come approach you. You need to go to them.

Mother: Ok. Thanks.

Admin 1: Sorry about that.

Admin 2: We're sorry.

In the drama, the mother was fobbed off and passed between five different administrative offices. We truly saw how protection of the state is valued above civil service and is played out in day-

to-day public administration operations. Like Bolton and Heathcote (1999), we purposely took an indirect approach as facilitators and did not presumptively shame the students for providing inadequate civic support. The students themselves demonstrated what happens when public administrators' belief is that the existing system is adequate and effective. This indirect approach made space for critical reflection. Here are some of the students' responses:

- I got so frustrated. I was like, someone please just have an answer! But no one did.
- We also talked about how she had to repeat her story every place she went. No one was communicating with each other.
- It was really easy to hide behind your jurisdiction, instead of actually emotionally connecting with that person.

A few students' final comments at the end of the workshop support the value of this work.

- I thought the arts-based practice was a good way to connect with a story and understand how the lack of empathy can affect our work.
- I appreciated the ability to see how systems are failing people and our role in it.
- Being able to slow things down and experience things and taking the time afterwards to reflect on what was done.
- This workshop was interactive and humanizing.

Although we understand that the students appreciated the opportunity to examine some of the ways in which the culture within public administration serves to strengthen the state, we also know that ideology not only presents reality in an inverted form, but that it also serves as apologia. Apologists can be of two types: the first takes the form of an unashamed champion of the state, whereas the second seems to take a more impartial stance. This standpoint begs the question: how does a supposedly disinterested observer unintentionally support a systematically biased way of thinking? An attempt to address this question would, of course, be a logical follow-up to this workshop since, although it is clear that the public administration students' eyes have been opened to the workings of ideology, much remains to be done in seeking to understand how unconscious systematic bias can be recognized and eliminated in their everyday working lives.

The use of this particular non-fictional narrative had the effect of limiting our ability to show the full picture, and open up broader questions about the lengths that the state will go to in order to protect its own ideological interests. The workshop was not successful in presenting one of the state's essential functions – ultimately serving the interests of the capitalist system.

For example, we could have woven another story into the existing one, in which a corporation glides through bureaucratic red tape to convince the same municipality to approve construction of a big box store on a street sanctioned for residential development. The contradiction would be even clearer if the mother also works for this corporation, and her ability to seek justice for her late daughter depends on her bimonthly pay cheque.

Most requests from gatekeepers ask for workshops that focus on teaching concepts and skills that participants can immediately put to use in their own professional contexts. A major challenge for applied theatre practitioners who wish to take a revolutionary, rather than a reformist, approach is to seek ways of bringing to the foreground how economic interests are often at odds with the personal values of the participants in the workshop – even when the gatekeeper partners have not requested it.

Notes

1 The superstructure is "non-economic phenomena, but only such phenomena as are economically relevant" (Wetherly, 2005: 5), such as the state, art, family, culture, philosophy, norms, expectations, law, politics, religion, media, and education (Marx, 1971).
2 *Look Back in Anger*, Edward Bond's first professional play, published in 1960 portrayed blue collar workers and their families in England, while his recent work focuses more on exposing ideology (Davis, 2014).
3 See paragraph 7, on http://www.goldmansachs.com/media-relations/in-the-news/archive/1-13-testimony.html

References

Bolton, G., and Heathcote, D. 1999. *So you want to use role-play? A new approach in how to plan*. Stoke on Trent: Trentham.
Bond, E. 2010. *State of drama*. Available from: http://www.edwardbond.org/Theory/theory.html [Accessed 25 January 2018].
Chomsky, N. 2011. The responsibility of intellectuals, redux: Using privilege to challenge the state. *Boston Review*, 36(5). Available from: http://bostonreview.net/noam-chomsky-responsibility-of-intellectuals-redux [Accessed 25 January 2018].
Davis, D. 2014. *Imagining the real: Towards a new theory of drama in education*. London: Trentham Books.
De Leon, D. 1924. *Reform or revolution: Address delivered under the auspices of the people's union, at well's memorial hall, Boston, January 26, 1896*. 2nd edn. New York: National Executive Committee, Socialist Labor Party.
Dobson, W. 2013. No happy endings: What can applied theatre *really* do? In: *Canadian Association for Theatre Research Annual Conference*, Victoria, BCN.
Ehrenberg, V. 1969. *The greek state: Griechische und der hellenistiche Staat. English*. 2nd ed. London: Methuen.
Engels, F. 1939. *Anti-Dühring: Herr Eugen Dühring's revolution in science*. New York: International Publishers.
Kelleher, J. 2009. *Theatre & politics*. Basingstoke: Palgrave Macmillan.
Klein, N. 2007. *The shock doctrine: The rise of disaster capitalism*. Toronto: Albert A. Knopff Canada.
Lenin, V. 1994. *The state and revolution: The marxist teaching on the state and the tasks of the proletariat in the revolution*. 2nd ed. London: Junius.
Marx, K. 1964. *The economic and philosophic manuscripts of 1844*. New York: International Publishers.
Marx, K. 1971. *A contribution to the critique of political economy*. London: Lawrence and Wishart.
Marx, K. and Engels, F. 1970. *The German ideology: Part one*. London: Lawrence & Wishart.
Neelands, J. 2016. Democratic and participatory theatre for social justice. *In*: K. Freebody and M. Finneran, eds. *Drama and social justice*. London: Routledge, 30–39.
Nellhaus, T. and Haedicke, S. 2001. *Performing democracy: International perspectives on urban community-based performance*. Ann Arbor, MI: University of Michigan Press.
Pilger, J. 2002. *The new rulers of the world*. London: Verso.
Prentki, T. and Pammenter, D. 2014. Living beyond our means, meaning beyond our lives: Theatre as education for change. *Applied Theatre Research*, 2(1), 7–19. doi:10.1386/atr.2.1.7_1.
Prentki, T. and Preston, S. (2009. *The Applied Theatre Reader*. London & New York: Routledge.
Thompson, J. 2009. *Performance affects: Applied theatre and the end of effect*. New York: Palgrave Macmillan.
Wetherly, P. 2005. *Marxism and the state: An analytical approach*. London: Palgrave Macmillan.

17
TENSIONS OF ENGAGEMENT
Oscillating between distance and implication

Yasmine Kandil

Introduction

In my practice and teaching of applied theatre, I have been concerned with the parameters that define our relationship with communities and participant groups. This was born from my personal experience and observation of projects that are designed with the community's best interest in mind, yet the process of executing the work finds creators falling into a number of ethical pitfalls of our practice. In my attempt to capture what our process of collaboration with participants could account for, I have examined the various protocols of engagement that define the parameters of these encounters. When undergraduate students embark upon this type of work, they encounter people and their stories that are outside of what they have witnessed in their often-sheltered lives. What is the ethical balance that an educator and practitioner of applied theatre can strike when prompting students to deal with difficult material? What are the tensions of representation that exist within these contexts, and can students aspire to implicate themselves in these narratives? I will delve into these topics taking inspiration from Tim Prentki's definition of "notion of distance," which he describes as,

> 'the detached eye,' that enables learners or TfD workshop participants to explore their lives with both the emotional integrity of lived experience and the critical analysis necessary for understanding that experience in relation to the governing forces of their society.
>
> *(2015: 69)*

In this chapter, I will discuss the tensions that exist when we allow ourselves to be drawn into the narratives we encounter with communities we work with. I will also explore our implication within these narratives, and how we navigate stepping back to bring in a detached perspective in order to account for the social and political constructs that govern the world that our participants live in. First, I will tease out the obstacles that stand in the way of students arriving at that level of engagement with communities, then I will offer some recommendations as to how they might develop these skills. I will discuss these recommendations in connection to a community-based participatory theatre research project I undertook with my students.

Grappling with the margins of society

As part of their course work, my applied theatre second-year undergraduate students[1] reach out to local communities, and through interviews, they construct devised performances based on the participants' experiences with a particular subject matter. This pedagogical experience is meant to make accessible to students the connections between the theory and the practice (praxis) of applied theatre. The life experiences of the students, and their emotional investment in the topics they explore play a role in the nature of their involvement in these encounters. For example, I observe a stark contrast between my students and the participants in Cairo-based workshops, especially after the 2011 uprising, where in Cairo individuals from all social classes in the city have been flocking to workshops that give them an opportunity to use the arts for self-expression and dialogue. In the Cairo-based workshop context, there seems to be an urgency and a need for participants to explore, genuinely and thoughtfully, the experiences of others.

I have often wondered if people who live on the margins of society, or those who experience systemic and political oppression, might experience life in a more radical way, where once accessed and harnessed, their energy and desire for social inclusion and equality drive them to seek creative ways for expression and community building. In my workshops with different groups who identify as being marginalized, I have found that they employ art-making mechanisms as a form of resistance and "radical possibility" (hooks, 1989: 20). Moving beyond the definition of marginality as a site for "deprivation," bell hooks offers a new awareness to it: "[marginality becomes] a site one stays in, clings to even, because it nourishes one's capacity to resist. It offers one the possibility of radical perspective from which to see and create, to imagine alternatives, new worlds [sic]" (hooks, 1989: 20). What then, is the missing ingredient for North American undergraduate students? What is at stake for them, and can they eventually give themselves permission to engage with the Other in an authentic and curious way that draws on the "emotional integrity of [their] lived experience" (Prentki, 2015: 69)?

Obstacles

Dwight Conquergood discusses four ethical pitfalls that practitioners of ethnodrama find themselves caught in. One of those is the "skeptic's cop-out," which is when practitioners decide that they can't and won't relate to the narratives of communities they are working with, enough to warrant performing them. Conquergood focuses on describing the traits of those who find themselves caught in this trap: "This corner of the map is the refuge of cowards and cynics," and describes it as "imperialism of the most arrogant kind" (1985: 8). While I appreciate Conquergood's identification of these pitfalls, I also can empathize with the students who, because of their extreme caution not to offend, misrepresent, or appropriate other people's cultures and experiences, have imprisoned themselves in this "no man's land of paralyzing skepticism" (Conquergood, 1985: 8). Wilkinson and Kitzinger discuss the flip side of this, when researchers refuse to speak on behalf of, or represent, the Other for fear of "the temptation to exaggerate the exotic, the heroic, or the tragic aspects of the lives of people with little power" (2009: 88). The result, according to the authors, is "a massive over-representation of the views of white, middle-class, western women."

> Speaking only from, about, and in relation to our own (untheorized) positions of relative privilege has, in fact, been part of the problem of feminism, contributing to its false universalizing and imperializing tendencies to the extent that it is hard to reconceptualize 'speaking only for oneself' as part of the *solution*.
>
> *(Wilkinson & Kitzinger, 2009: 87–88)*

Another obstacle I find that some students encounter, is an inability to explore their implication in the narratives of people who are marginalized; as a result, they often oscillate between avoidance and a tragic immersivity in the Other's suffering. For example, as part of their course work, a group of students decided to explore the opioid crisis and how it affects people in Saint Catharines, which is a small town of about 130,000 residents in Southern Ontario. Through a call on social media, the students made contact with individuals who were impacted by this epidemic, and they proceeded to interview them to generate material for their devised work. In this example, the students performed the narratives as they were relayed to them, and they chose direct address to narrate, in character, what had transpired in each story. Unfortunately, falling into the trap of becoming a "tragic witness" (Salverson, 2006), the students failed to distance themselves enough to see the contradictions that lay within these narratives, to tease out the social and personal dynamics that play a role in the opioid crisis, and to explore their implication in these narratives. As such, the performance ended up lacking theatrical creativity, and an artistic engagement with the material that would have otherwise given the artist permission to break the event down and replay it in more than one creative devised form.

Salverson explores the relationship between detachment and contact that occurs when theatre makers engage with survivors of trauma and violence through testimonial theatre: "When, I wonder, is the meeting of lives (the narratives we construct, intuit, and perform about ourselves) about a contact that consumes the other person and reduces them to our terms?" (2001: 119–120). She advocates for a process that takes into account the experience of the theatre maker and avoids making that invisible in the process of eroticizing the injury of the Other, what she calls "the erotics of injury" (Salverson, 2001: 122). Between the distance of the skeptic and the collapsing of oneself in the tragic witness, theatre students might be able to access a middle ground, of just the right amount of distance to be able to observe and analyze the issue they are exploring, and the right amount of immersivity in these narratives to allow themselves to be sufficiently invested in the issue. And within this balance they might be able to find a means to include their experiences in the face of what they encounter with communities. The following project is an example of a research-based initiative I undertook with my students, that was outside of their course-work, and which offers an example of how we arrived at that middle ground I speak of here.

Protocols of engagement

In the winter term of 2017, a group of six undergraduate dramatic arts students and I embarked upon a research project that examined the ethics of representation of the narratives of immigrant and refugee communities. This research was born from my and the students' course-based encounters with this community, and our discovery that the students' attempts to depict the harshness of the lives of this population ended up alienating the community (Kandil, 2016). Our inquiry was to ask, through participatory methods with six immigrants and/or refugees living in Saint Catharines, how they wanted their stories to be represented in theatre-based performances.

James Thompson draws our attention to the importance of understanding the "landscape [of the world that communities] inhabit" so that, through theatre and drama, we can create situations where they are able to re-imagine new ways of living in that world (1998: 125). Our first step was to explore this world from the perspective of the participants, and to find connectivity and implication within that world. As our participants began to communicate to the students their experiences of migration and immigration through image work, storytelling, and drawing, the students' views on migration, immigration, and refugeehood began to change. Some

of them began to recall memories of their parents or their grandparents' stories of migration, while others began to wonder why they had not heard much of these stories from their families. I observed that, slowly, the students began to implicate themselves in these narratives, finding connections between their experiences and the narratives our participants were relaying to them. By the third week of rehearsals, strong bonds began to form between the students and the participants, and I took note as the students allowed themselves to be drawn into these stories, experiencing a new kind of vulnerability I had not seen them risk in previous encounters in these types of engagements. What I believe they were experiencing was the power of witnessing; its effects and implications explored here by Salverson:

> First, to be a witness is to allow myself to be opened beyond myself, to be surprised: to listen for the evidence, the facts, and to hear what exists beyond language. This is particularly true with trauma, which asks us to witness the incomprehensible. Next, I must find the resources to respond. It isn't only passing a story that matters; I have to let the story change me. That's where the bearing of witness-the carrying of the event-comes in. By listening with openness and being changed I make myself vulnerable in the face of another's vulnerability. I participate in the relationship.
>
> *(2006: 33)*

Through this process of witnessing the students then began to explore the migration stories from family members, and they chose to include these narratives as part of the performance. The rehearsals saw us moving the participants and their narratives from the centre of the process to stand side-by-side with the experiences of the students. The end result was a compilation of short vignettes, where the stories of the students were relayed alongside the narratives of our immigrant and refugee participants. They were woven into each other so that the lines were deliberately blurred between the two, just as the students had begun to blur the lines of their separation from the participants.

Another important step in our process was to ask our participants how they wanted their narratives represented on stage. They had been frustrated in the past for having been represented as their stereotypes (for example, Arabs as terrorists and Islamic fundamentalists), and that the media continuously sensationalizes images of war and struggle from their respective countries (for example, images of rubble from war-torn Syria). This group wanted the performance to celebrate their cultures, histories, and traditions. The participants did not want their cultures erased as a condition of their settling in Canada, and they did not want Canadians to feel pity for them; the newcomers wanted their host country to see them in a light that acknowledged their potential and resilience. With this in mind, the students and I began to explore the participants' stories from home, ones that illuminated their heritage and culture, and that celebrated their positive memories from their native countries. Helen Nicholson writes about how exploring the past informs the present:

> Connecting to the past through recalling personal memories is [...] a process that invites people to make sense of the present, to locate their lives in relation to public events, and to share and re-evaluate their cultural beliefs, values and aspirations. In this way, memory is intimately connected with the complexity of personal and cultural identities. For those who have experienced geographical mobility and displacement in their lives-particularly through migration-issues of location, home, identity and belonging are often particularly acute.
>
> *(2009: 273)*

While we could see the participants light up as they constructed scenes relating to the river Nile, or family get-togethers in Lebanon, or farming practices in Zimbabwe, the students and I noted that the process was difficult for some who yearned to reconnect with their families and loved ones whom they had left behind. Once again, this process gave the students precious insight into how their parents, grandparents, and ancestors might have felt when they migrated to Canada. As a result, the students began to exude a new sense of pride and ownership of their immigrant heritage, one that they had not felt previously as they recalled wanting to hide any sense of being "different" from their schoolmates (for example, by trying to mask an accent, or resenting having pita bread in their lunch, etc.).

Finally, one of the most important steps we took in this process was to ask ourselves, and to make ourselves constantly aware of, what was at stake for our participants? A number of our participants were escaping difficult situations from home, and their refugee file was still in the process of examination by the Canadian Citizenship and Immigration office; as a result they did not disclose the circumstances of their migration. In this context, exploring these circumstances of forced migration would have subjected our participants to storylines that could be emotionally difficult for them to watch, and potentially harmful for their process of gaining legal status in Canada. Others were clearly in the early stages of settlement (only in Canada for a few months), and they wanted to envision a positive and optimistic future for themselves and their families. For this group, we felt uncomfortable exploring thoroughly the tensions surrounding issues of settlement, or the ways in which the Government of Canada could provide more in the form of services and support for newcomers. This awareness of what is at stake for our participants shaped our workshops and performance so that we became acutely aware of the ethical protocols of engagement with them.

"Return to the Nile"

What I describe above are the steps that the creative team and I developed as we explored, scaffolded, and made space for the layers of engagement that we discovered in our encounters with the participants. At the heart of this was our curiosity and acknowledgement that we too are in a territory that is foreign to us, and that an "ethics of response" (Salverson, 2006) was guiding our process. The result was a devised performance, which we called "Return to the Nile," that had the theme of the River Nile running through it, bringing together stories from Sudan, Lebanon, Zimbabwe, Syria, Indonesia, South Korea, the Netherlands, Portugal, the Dominican Republic, Poland, and Austria. Rich cultures, family connections, and hope for a better future were at the centre of these vignettes. The creative team was still able to touch upon the sudden and jolting effects of leaving home due to war, and the lost connections and broken dreams left behind when people leave home; but we did so in a manner that made the audience aware of these struggles without dwelling on the tragic nature of them. We highlighted the positive memories from home, the resilience of immigrants, the happiness they felt with their small milestones of achievement: getting their Canadian passports, landing their first job, and feeling the walls of an apartment expand to break monotony and reveal possibility from behind them.

Conclusion

Our research identified that there are more suitable ways of representing immigrant and refugee stories than the students had previously thought. This approach, which acknowledges how this population wants their stories depicted, does not water down their experiences, nor does it alienate them. I observed the students and the participants after our first community per-

formance, and how they felt proud and connected to the community whose narratives they explored. The audience, mostly composed of immigrants from the local community centre, greeted the performance with warmth and celebration. We had met our goal of representing the immigrant and refugee narratives with the "emotional integrity of lived experience;" but have we brought the "critical analysis necessary for understanding that experience in relation to the governing forces of [our participants'] society?" (Prentki, 2015: 69). One audience member who identifies as settler-Canadian remarked that we had gone "too easy on Canada," implying that we had not explored enough of the shortcomings of the Canadian Government towards immigrants. Perhaps so, and in this context, it was our intention not to do so. Sometimes the creative team decides to invest more in finding connectivity with participant narratives and forgoing the need for critical analysis (and representation) of the social constructs that contribute to the participants' marginalization. In these encounters with vulnerable populations, we must consider what is at stake for them, and at what expense do we forge ahead with our own agendas, "reducing them to our terms?" (Salverson, 2001: 120). I take these reflections with me to class, and I remain open and willing to learn from my students as I observe them grappling with their evolution, implication, distance, detachment, and skepticism towards narratives of people who access fewer privileges than those enjoyed by mainstream society.

Note

1 In this chapter I relay my pedagogical and community-based encounters while I taught at Brock University, in Ontario between 2014–2019.

References

Conquergood, D. 1985. Performing a Moral Act: Ethical Dimensions of the Ethnography of Performance. *Text and Performance Quarterly*, 5, 1–13.
hooks, b. 1989. Choosing the Margin as a Space of Radical Openness. *Framework: The Journal of Cinema & Media*, 36, 15–23.
Kandil, Y. 2016. The Art of Seduction & Provocation in Applied Theatre: A View. *Canadian Theatre Review*, 168, 86–89.
Nicholson, H. 2009. Re-locating Memory: Performance, Reminiscence and Communities of Diaspora. *In*: Prentki, T. & Preston, S. (eds.) *The Applied Theatre Reader*. London & New York: Routledge.
Prentki, T. 2015. Fool's Play or Juggling with Neoliberalism. *In*: Prentki, T. (ed.) *Applied Theatre: Development*. London & New York: Bloomsbury Methuen Drama.
Salverson, J. 2001. Change on Whose Terms? Testimony & An Erotics of Injury. *Theatre*, 31, 119–125.
Salverson, J. 2006. Witnessing Subjects: A Fool's Help. *In*: Cohen-Cruz, J. & SChutzman, M. (eds.) *A Boal Companion: Dialogues on Theatre and Cultural Politics*. New York: Routledge.
Thompson, J. (ed.) 1998. *Prison Theatre Perspectives and Practices*. London: Jessica Kingsley Publishers.
Wilkinson, S. & Kitzinger, C. 2009. Representing the Other. *In*: Prentki, T. & Preston, S. (eds.) *The Applied Theatre Reader*. London & New York: Routledge.

18
QUESTIONING SOCIAL JUSTICE
A dialogue on performance, activism, and being in-between

Asif Majid and Elena Velasco

Since the 1990s (if not before), the term "social justice" has come to be deployed in a range of contexts. It is often used to characterise change or progress-oriented endeavors, particularly in activist or artistic spaces. Yet the term has rarely been defined or critiqued in a way that specifies its intent, particularly as it relates to the artist-activist communities that use it freely, the fluidity of the concept, and its increasing neoliberalisation (Riguer, 2017; Smith, Stenning, and Willis, 2008; Wilson, 2007). How, then, can "social justice" be a useful term in applied performance, if it has not first been questioned? To that end, we (Asif Majid and Elena Velasco) have edited down three months of email exchanges between the two of us, authoring a dialogue that draws inspiration from other applied performance practitioners using correspondence as a way to ask important questions (Ahmed and Hughes, 2015; Heritage and Ramos, 2016). For us, those questions are: 1) What opportunities and challenges does applied performance face when embracing or rejecting social justice? 2) Following anthropological notions of self-reflexivity, how does our own positionality, relative to those with whom we work, shape what we see those opportunities and challenges to be? and 3) What possibilities for action emerge from our critical dialogue, action that is disseminated through artistic performance?

Our shared positions are as scholar-artist-activists who seek to facilitate performance processes and products that enhance social justice possibilities. At the same time, we often find ourselves in the position of sharing racial, religious, and/or ethno-national identifications with those with whom we work. For one of us, Elena Velasco, extensive and ongoing theater-making work with and about undocumented, Latinx immigrants in the United States has complicated the notion of "social justice" in theater, notably how to achieve that lofty ideal for those who have long been the target of xenophobia and highly politicised persecution. For the other, Asif Majid, the experience of devising with Muslim youth in the securitised and highly surveilled British context asks questions of power, as well as whose story is being told and in what manner. Our experiences have also overlapped when working with Convergence Theatre in Washington DC, a performance collective that examines many of the same questions that we ask here.

On Sat, Jun 16, 2018 at 4:17 PM, Elena Velasco wrote:
My dear friend,

I will do my best to keep my thoughts organised. This week has been quite thought provoking and challenging, and yet there are others more directly affected by these tragedies' causes that I wonder at my internalisation of these events.

Though I have long been committed to the immigrant community, particularly my Latinx community, the actions taken by those in power in the US have exacerbated my anger and desperation. Long before this current administration, I was aware of and affected by the raids conducted against my undocumented brothers and sisters. I have had students flee with families to avoid their last known address. These scenarios were only the prelude to our nation's current atrocities. I have shifted from desperation at the separation of parents from children, to sheer outrage at the justifications of these actions that bastardise religious text.

How in this can theater even matter anymore? How can I "apply" theater in a way that makes any impact? How do we engage those who have been hidden behind walls, under silver blankets, in emptied Walmarts?

To reach these communities, we must combine our efforts with those who work in the legal system. We must work with groups that have training in mental health, with non-profits who understand social services. And as much as it pains me, we must also reach those who capture, imprison, and blindly follow what "the law" dictates.

Applied performance must build coalitions. I want to believe again that applied theater is a rehearsal for the imminent revolution. I want to believe again that we can exercise free speech and it will matter. And I want so much to believe that we can move hearts and minds.

paz,
Elena

On Fri, Jun 22, 2018 at 10:07 AM, Asif Majid wrote:
Hi Elena,

So much to take from what you wrote, but I can work most productively with one word: coalitions. It brings to mind other "co" words, like collaboration, collective, co-performative, connection, contingent, and community.

As you know, devising is core to my practice. For many practitioners, it merely implies an uncertainty about performance. But for me, that uncertainty is not enough. It needs a "so what?" I find the "so what" is only apparent when radical potential is realised *in relationships*, in mucking through uncertainty with others. That is what is so powerful about what you wrote: not the plight of experience, but the standing with. When the nation, an "imagined political community" (Anderson, 2006: 6) collectively decides that separation of something so basic as family is not what this nation is – ironic, considering the US' genocidal history and its continued occupation of indigenous lands – it imagines itself in a particular way. It performs a specific identity.

We, with an activist politics, talk about social justice and change in the context of action; but what of the social? What of the relationships and people we hold dear? What of the fact that my

first performance teacher was my grandmother, who – with no performance background – saw me drumming on pots and pans as a two-year old and told my mother to ensure I continued performing throughout life? How do we maintain those connections? Social justice relies on the relationships we have. Too bad that it takes us until those are on the brink of destruction to act.

To push forward, challenge injustice, and enact change, we must have networks that work. We must have politics that uplift as much as they condemn. We must have counter-publics: "communities and relational chains of resistance that contest the dominant public sphere" (Muñoz, 1999: 146). The hope that we need springs eternal, but only when we build *with*, rather than *together*. That "with" returns us to the applied, always and forever embedded in relationships.

Sincerely,
Asif

On Sat, Jul 14, 2018 at 6:01 PM, Elena Velasco wrote:
This past week, Convergence Theatre opened *Guerrilla Theatre Works: A New Nation*, the third installment of a devising structure that can be broken apart and performed as pop-up activist art. The performance ends with audiences connecting to local leaders, linking the performative to direct action outside the theater. These leaders vary greatly in background, yet each emphasised the same point: story generates empathy, which builds community. When story is shared, the "co" appears. Most significant is that we are called in communion. I recognise the Judeo-Christian implications of that word, but something spiritual happens when a group of individuals sits together to witness another's story. That deepens when the group is asked to translate the story into action. Communion is the start of coalition. No longer does the individual think about what is done together, side by side, but rather acts in communion; their action is impacted directly by another's.

This is what theater must do if we are to function as a community that works with one another – we must act. The origin of the word "drama" comes from the Greek *dran*, meaning "to do" (Wallace, 2007: 204). That is the actor's job. The artist cannot merely indulge in inactive emotional purgation. One must do what the character is driven to do, prompted by a need or goal. If we focused more time on doing rather than witnessing, the stories we share would go outside the theater. Ironically, that is the issue with many spiritual communities today – the word does not give way to action.

paz,
Elena

On Sun, Jul 15, 2018 at 11:27 AM, Asif Majid wrote:
Hey Elena,

I'm struck by the (almost) formulaic nature of your statement about what story does: "story generates empathy, which builds community." Even more interesting was: "When story is shared, that 'co' appears." But is that always the answer? I think about situations in which sharing stories

isn't what's needed because they may reinforce the difficulties of those sharing. What if sharing silence, or a meal, or childcare responsibilities is preferred? Can these constitute applied performance? Perhaps that's where your second point about the etymology of "drama" comes in. Maybe, performance as a sense of creating community is about doing. But often, the emotion precedes any doing.

Applied theater scholar-practitioner James Thompson echoes this. While his early work highlights applied performance's "instrumental intent" (2006: 18), his later work emphasises the radical potential of creating beautiful things (2009). It's a messy space. But our decisions of what to do on stage, what types of communities to form, and what types of actions to undertake are not always driven by needs or goals. Underlying emotions may also drive them. Isn't theater aesthetic first? What might it mean to form an applied social justice performance community based on shared emotion?

Sincerely,
Asif

On Thu, Aug 2, 2018 at 2:13 PM, Elena Velasco wrote:
Migo,
Indeed, "sharing story" can appear a reductive term for what I envision. No, to "share story" is not enough, but let's examine what can transpire when embarking on this act of connection.

Sharing story is the entry way into the unknown by inviting, tempting, or even subversively luring the onlooker into an experience that must be seen and remembered. This is where I believe your "co" appears. When story is truly "shared," there is a partnership or unspoken agreement between artist and spectator (Brook, 1968). In oral storytelling societies, the storyteller emerges from among the masses and, though the text may reflect the past, actions within the narrative are present tense. Sharing story is a form of communion that informs and can generate empathy. Yet the act of storytelling is not limited to verbal text. Silence, sharing a meal, caring for a family member – these are shared actions and within them memories are created, becoming the heart of the story.

Sharing story is engagement that inspires action, as there is untold power within story. What I am proposing is harnessing the aspects of story that impact or demand action. If my goal is to affect change, then simply sharing story is not enough, no matter how elaborately staged or extensively designed. Drama requires action. Breaking bread can be a part of this act, as in Bread and Puppet Theater's work where the scent of baked sourdough and garlic aioli waft through the air (Estrin and Simon, 2004). Caring for a child is part of that sensory-friendly experience in theater, too. Inherent in all of our actions are the seeds of story, but purposeful awareness initiates empathy. Making space for that story to spark action or mobilise the masses is where applied theater can take story beyond the stage.

If in the end we are only our stories, then we have truly lost all when those actions and players are erased from memory. Story must become the change.

En paz,
Elena

On Fri, Aug 3, 2018 at 9:50 AM, Asif Majid wrote:
Hi Elena,

From this, I'm reminded of time spent working in Maine at a summer camp called Seeds of Peace. Seeds started as a camp for Palestinian and Israeli youth to engage in intensive daily dialogue sessions, facilitated by pairs of Palestinian and Israeli educators. The dialogue groups attempt to provide a platform for helping both sides understand one another, working towards more positive relationships. Ropes course activities, living together, and breaking bread complement dialogue. The young people are intentionally compelled to have conversations and share stories with people they might not otherwise meet. Seeds has other programming, but I want to attend specifically to the Palestine/Israel dimension here.

Two of the organisation's biggest critiques – from within and outside – are that it normalises the occupation of Palestine through its language of "the conflict" and that it fails to support Palestinian and Israeli young people after they have returned to "the region." It has been many years since I worked for Seeds, and I know that efforts have been underway to respond to the second critique (perhaps even the first). But what's relevant here is that sharing stories between Palestinian and Israeli youth was only good enough for so long. The organisation was founded around the time of the Oslo Accords, and I was 20 years old when I worked for them. Now, approaching age 30, even as Seeds continues its summer camp, the occupation of Palestine continues apace. There is no sign of Israeli land-grabbing slowing, nor is the country recognising Palestinian rights. I'm not pinning all hopes for change on Seeds. But the power dynamics of Israel's apartheid-like domination of Palestine with Western complicity are not questioned, challenged, or overturned by Seeds' commitment to sharing stories. If anything, they may in fact be normalised.

Think of Seeds as an applied performance intervention. Young people come to dialogue, perform particular stories, and are expected to affect change upon their return. This performance makes murky what those lived realities are, but it does not disturb overwhelmingly real power differentials. There may be a social dimension to the campers meeting new people and hearing new stories, but there is little justice and no equity. A common question campers would ask was: "So what?" Why talk ourselves to death but still return to a reality that does not live up to what we now think is possible? The sharing of stories can be unfair.

Is empathy enough? Part of this is in language. You used the singular "story" quite a bit, relative to multiple "stories." Novelist Chimamanda Ngozi Adichie's (2009) discussion of the dangers of the single story comes to mind, as do totalising singularities like "the region" and "the conflict." Multiplicity is the wonderful messiness where social justice and applied performance intersect. I want to live in and sit with that messiness, embracing its uncertainty. Better yet is if that messiness happens *with* one another.

Sincerely,
Asif

On Fri, Aug 10, 2018 at 4:17 AM, Elena Velasco wrote:
Language is complicated. In my physical theater work, I have become more convinced that the word is limited. I intentionally use the singular form here for, to your point, there are dangers in assuming a single definition. One must be cautioned in believing that a word possesses only one meaning. But I recall that dictionaries recognise that most words have multiple definitions.

Whether I refer to "the word" or "the story," there is far more to discover than one narrative. Then why use the singular?

Intersection. It is the *intersection* of a word's multiple understandings that comprises our present acceptance of it. What can and should be questioned are whose understandings and experiences are helping to define that word. It would seem that the intersectionality of definitions is the origin of empathy, not because there is one definition for a word, event, or – daresay – story, but because the multiplicity of definitions reveals commonalities.

As you note, sharing is not enough. And empathy? Sorry, but "empathy" has become the enemy. It has meant that in the wake of preventable tragedies, "empathy" should be enough. Too many affected by the mass shootings at Stoneman Douglas, Sandy Hook, San Bernardino, and elsewhere have dismissed the "empathy" of elected officials. "Thoughts and prayers" have proven no substitute for action.

I think of this in the same way I view catharsis. For the cathartic dramatic climax of a "story" to truly "move" an audience, the proof would be that the audience mobilises. However, the norm in US theater is audiences believing that the theater will "change" them, but their catharsis incubates inertia, creating a facade of action. Like your example with Seeds, the empathy amounts to little. It becomes the antithesis of social change.

I also recognise that "change" is not inherently positive or negative; it does not ensure "progress." Marginalised communities across the US witnessed "change" in November 2016 and continue to feel its effects. Your Seeds example excellently demonstrates how even the lofty goals of a well-meaning social justice program can instill a false hope of change. It is not enough to merely share story or break bread partly because the goals of these actions are not clearly defined. Instead, we must remember and push against the hundreds of years of colonisation and imperialism that have preceded recent moments of "change," moments that only reinforce systems of oppression. Our theater must be the "rehearsal of revolution" (Boal, 1979: 141). If we do not *act*, there are no forces to push them back.

paz,
Elena

On Thu, Aug 16, 2018 at 3:02 PM Asif Majid wrote:
Hi Elena,

Having previously argued for the potentially problematic nature of story, I now find myself troubling that idea. I'm a bit uneasy at your statement that "it is not enough to merely share story or break bread partly because the goals of these actions are not clearly defined." While I grant that doing both for their own sake might not be enough, defining the goals of those actions might be embedded in undertaking the actions themselves. What if breaking bread or sharing story leads to accidental creation of community, from which creating community *becomes* a goal? Creating community results in strong bonds, from which trust and work towards a shared future can emerge, or otherwise present a radical alternative vision of how things can be.

And, take that statement to its logical conclusion. Performance or social goals become so defined such that failure to hit them with 100% accuracy constitutes a failure of the process itself. I'm not convinced that such single-mindedness is necessary for a holistic striving towards social justice that invites multiple voices to take part in collective struggle.

The social change goals of a given applied performance experience may be more effectively left to a later moment, to emerge from within that experience. Holding space for that possibility is difficult, yet sorely needed. In an age when doing for the sake of doing is the norm, there is radical potential in stillness. Maybe, more than anything else, that is the revolution we need.

Sincerely,
Asif

On Wed, Aug 29, 2018 at 5:52 PM Elena Velasco wrote:
Buenas dias migo,

As is your nature to seek and search in divergence – an endearing quality that always prompts deeper discourse – I have taken time to let your words rest. These days, I stand between the impulse to take immediate action in extremes and the reminder to move forth in calculation.

The phrase that remains with me is "radical potential in stillness." While every generation has its own manifestations of "radicalism," there is something both exciting and threatening about it. Radicalism is a predecessor for and outcome of change, which seems to be the heart of applied performance. This presumes definition and objective, coming almost full circle to the catalyst for our inquiry. Freebody et al. write that applied theater practice "is relational" (2018: 2). But it must yield a visible effect. It must work towards a more just, equitable world that fosters intersectionality, guiding us towards local or global communion and community. Potential and stillness easily can shift into inertia – and they often do.

I can only hope that the stories I share will go forth, becoming the flint that sparks action. What I am writing may sound like the work of a missionary, yet I am plagued by the urgency of those who bear my skin, blood, and history. It is hard not to doubt the effectiveness of my actions as an artist when I see a social embrace of white supremacists' ideals. Perhaps I blur the purpose of applied performance with activism. Yet, shouldn't our art move others to action? Is theater not inherently political, as we are political beings? Applied performance may begin with the simple acts of breaking bread and sharing story, but the process must take effect beyond the converted. Collaborative performative actions need to pave intersectional paths leading us to greater peace, not become words that fade in an echo chamber.

paz,
Elena

References

Adichie, C. N. 2009. *The danger of a single story*. [online]. Trans EDUC Available from: https://www.ted.com/talks/chimamanda_adichie_the_danger_of_a_single_story [Accessed 26 October 2018].
Ahmed, S. J. and Hughes, J. 2015. Still wishing for a world without 'theatre for development'? A dialogue on theatre, poverty and inequality. *Research in Drama Education: The Journal of Applied Theatre and Performance*, 20(3), 395–406. doi:10.1080/13569783.2015.1059265.
Anderson, B. 2006. *Imagined communities: Reflections on the origin and spread of nationalism*. London: Verso.
Boal, A. 1979. *Theatre of the oppressed*. London: Pluto Press.
Brook, P. 1968. *The empty space*. New York: Touchstone.
Estrin, M. and Simon, R. T. 2004. *Rehearsing with gods: Photographs and essays on the bread and puppet theatre*. White River Junction: Chelsea Green Publishing.

Freebody, K., Balfour, M., Finneran, M. and Anderson, M., eds. 2018. *Applied theatre: Understanding change*. New York: Springer.

Heritage, P. and Ramos, S. 2016. Dear Nise: Method, madness and artistic occupation at a psychiatric hospital in Rio de Janeiro. *In:* Jenny Hughes and Helen Nicholson, eds. *Critical perspectives on applied theatre*. Cambridge: Cambridge University Press, 82–104.

Muñoz, J. E. 1999. *Disidentifications: Queers of color and the performance of politics*. Minneapolis: University of Minnesota Press.

Riguer, L. W. 2017. Neoliberal social justice: From Ed Brooke to Barack Obama. [online] *Items (Social Science Research Council)*. http://items.ssrc.org/neoliberal-social-justice-from-ed-brooke-to-barack-obama/ [Accessed 30 May 2019].

Smith, A., Stenning, A. and Willis, K., eds. 2008. *Social justice and neoliberalism: Global perspectives*. London: Zed Books.

Thompson, J. 2006. *Applied theatre: Bewilderment and beyond*. New York: Peter Lang.

Thompson, J. 2009. *Performance affects: Applied theatre and the end of effect*. Basingstoke: Palgrave Macmillan.

Wallace, J. 2007. *The Cambridge introduction to tragedy*. Cambridge: Cambridge University Press.

Wilson, B. M. 2007. Social justice and neoliberal discourse. *Southeastern Geographer*, 47(1), 97–100. doi:10.1353/sgo.2007.0016.

19
TIMELY HOMECOMINGS

Carrie MacLeod

Improvised entry points

After the resettlement of more than 40,000 Syrian refugees in Canada (Government of Canada Immigration and Citizenship, 2019), the bureaucratic matrix of settlement politics continues to unfold. There is an underlying assumption that organizations can quickly respond to worldviews converging and colliding in host communities. Yet, undercurrents of tension and suspicion continue to permeate all sectors of society. Bodies moving across borderlands have become sites of interrogation and targets for intimidation. Most of these daily negotiations within "zones of transmigration and statelessness" (Demos, 2013: xiv) have strategically been removed from the public eye. It is rare to encounter what philosopher Giorgio Agamben calls "bare life – that is, life stripped of political identity and exposed to the state's unmediated application of power" (*ibid:* xiv) in one's own neighbourhood. Bare life tends to be extricated from public spheres and relegated to distant proximities. In the *International Review of the Red Cross*, Elena Isayev reinforces this dilemma in her observation that "[p]roximity to those seeking protection is increasingly lacking, as the buffer zone of intermediaries and the bureaucratic apparatus, with its expanding document procedures, all but removes accountability in a process of dehumanization" (Isayev, 2017: 93). This distancing ironically persists when the immediacies of forced migration are literally at our doorstep.

Although the mainstream media have highlighted Canada's inclusive immigration policies, the securitization of forced migration tends to be problematized before the social imagination is catalyzed. Candid perspectives from a Syrian youth consultation at Immigrant Services Society in Vancouver revealed that "some don't understand our culture and therefore make assumptions that we are dangerous and scary" (Immigrant Services Society of British Columbia, 2017: 8). This underlying fear creates a voice-over effect of intolerance that reverberates throughout society. Who speaks for whom? Whose voices are inflected in the normative white noise? As most migration theories are constructed around who is moving across the horizon, it is also worth asking who is assuming aesthetic responsibility for our shared human condition. A limited spectre of the horizon minimizes the multiple lenses that are needed for a wide-angle view of displacement.

A series of candid conversations with frontline settlement colleagues brought the immediacies of the Syrian crisis into the forefront. These exchanges quickly led to the formation of a

facilitation team with professional expertise in refugee resettlement, primary health care, and community arts. As we shared our respective experiences on the mounting intolerance around the "flood of Syrians" (Abid, Manan and Rahman, 2017: 121), we agreed that it was time for an imaginative response. Deliberating and waiting for the next cycles of programme funding would take too long. In acknowledging this social impasse as time sensitive, we proposed a community-wide partnership between local artists, residents, and a settlement organization. With an aim to catalyze a paradigm shift in settlement interventions, we wanted to extend our scope of engagement beyond refugee target populations. Our intention was to mobilize a variety of sectors in society through weekly arts-based workshops and a culminating public performance. With our combined years of experience as intercultural facilitators, we knew that the narratives, culture, and histories of the participants would influence our planning. Given our ambitious aspiration to embrace counter-hegemonic processes, we wanted to include the "symbol of objects, events and experiences that a community considers worth naming" (Chilisa, 2012: 57) before naming them ourselves. To embody this ethos in our planning, we actively interviewed newcomers and local residents on how mutual accommodation might be co-generated via the arts. We first wanted to listen to their perspectives without imposing an agenda on a process that would speak for itself.

Our sincere intentions to be inclusive were thwarted when forty-five participants rushed through the doors on the first night. Carefully devised plans to facilitate a participatory circle of community intentions dissipated when the group vehemently moved their attention elsewhere. The neatly stacked theatre props, art supplies, and drums were quickly overturned by a fervent surge of collective energy. Our preconceived strategies to keep the space relatively contained proved to be futile as participants gravitated to the creation of imaginary worlds. This unexpected turn of events first appeared to unfurl as chaos. However, inherent systems of meaning-making surfaced from seemingly illogical scenes. The creation of performative prototypes produced recognizable archetypes that spoke of heroes and villains. Oversized hats and cloaks were usurped into fictional characters that inverted societal hierarchies. The logic of improvisation offered vital cues for navigating the underlying power dynamics of resettlement. In the blink of an eye, fictive revelations led to a reordering of relations, and the presence of the collective imagination bypassed our need for verbatim translation. Community intentions surfaced on their own terms and in their own time. Without any external prompting, several youths diligently marked their version of a proscenium stage with sections of yarn. The facilitation team was then promptly directed to take a place in the audience for each scene. The tables of hospitality turned on us before we even had a chance move the chairs. This carefully crafted "ethical space" (Ermine, 2007: 193) served as a living barometer for our sessions going forward. The improvised "contact zone" (Pratt, 2008: 8) emerged as a makeshift performance space that was filled with symbolic currencies of communication.

After this initial workshop, it was apparent that we needed to reconfigure our presumed roles and aesthetic responsibilities. This involved unsettling some of our static ideas of resettlement. Even with the best of intentions to create a participatory process, we were implicated in projecting a reductive lens on a complex and shifting social reality. The provocations from the group challenged our positions and proximities in subversive ways. We needed to find new entry points where it could be possible to explore our human vulnerabilities *with* one another. Perceiving ourselves as invulnerable hosts would only distance us further from the very process we were initiating. We were not merely curating resettlement strategies for a specific demographic, but were being asked to collectively reimagine how to bridge linguistic and cultural divides. However, making space for disorientation and discomfort was a challenging proposition

to uphold. To be unmade in the making involves risk; there are repercussions from traversing unmarked terrain. As Tim Ingold suggests, "To improvise is to follow the ways of the world, as they open up, rather than to recover a chain of connections, from an end point to a starting point, on a route already travelled" (Ingold, 2011: 216). Adhering to the principles of improvisation in our facilitative approach challenged our perceptual defaults. In reflecting on the rigour that this entails, performance theorist and practitioner James Thompson subscribes to the notion that "through sensory or aesthetic encounters with others, we can become more aware of the demand that it makes" (Thompson, 2009: 176).

As our core facilitation team reviewed our capacities for a reflexive response, it was clear that our stance needed to shift from sentimentality to sensory engagement. This shift did not propagate an absence of language, but prioritized modes of articulation that came from interfacing with the arts. The textures of these sensory experiences were markedly different from sensationalized media depictions. Voices, gestures, and rhythms set a phenomenological tone for reframing the imperceptible aspects of displacement. A sensory framework gave us a more acute appreciation for the spatial, temporal, and corporeal negotiations that were happening in real time. Decentring from the prescribed binary roles of "guest" and "host" opened up a space for us all to be hosted by the subtle intricacies of improvisation. The categories of guest and host could not remain mutually exclusive when immersive collaboration demanded everyone's full presence and attentiveness. The presumed authority of polarities was challenged when embedded roles were dispersed in performative realms. As cues for resilience and conflict transformation were inherently built into multimodal performance repertoires, new bodies of knowledge for resettlement surfaced, one gesture at a time.

Interval passageways

We originally planned to offer a series of intensive workshops on theatre, art, storytelling, music, and dance with local artists from each respective discipline. However, the group's inclination to interweave a range of art modalities yielded a different trajectory. We noticed strong percussive beats unravelling from subtle movement phrases. A montage of visual art inspired the creation of musical refrains. Polyrhythms inherently surfaced from theatrical provocations. There wasn't a preconceived formula for what art form should come first or second, or how one modality might lead into the next. This overlapping of modalities had a cumulative effect in the workshops; each art form added another perceptual dimension to the unfolding scenes. This opened up novel ways to explore symbolic narratives from a range of positions and proximities. Embracing this aesthetic milieu was a way to move *through* the various dimensions of resettlement. These enactments led to the creation of several mini-performances in each workshop. Their insistence on summoning an audience as an affective placeholder was not to be missed. This careful arrangement of aesthetic conditions served as a counterpoint to the institutional regimes of recognition that are enforced along migration routes. The scope of visibility was literally in the hands of participants as they reconfigured audience sight lines according to how they wished to be seen.

In the fifth workshop, one of the parents offered a poignant observation after delving into the improvisations with their children. They described the spacious invitation to experiment with multiple art forms as a "qanun" experience. The musicality of the traditional Arabic qanun instrument relies on the spaces around the notes to inform the textures of the composition. To linger in these spaces *just* long enough is to honour what has come before and simultaneously welcome what is not yet known. This space is not static or devoid of meaning, nor is it a space to be prematurely filled with notes. To enjoy the full range of the qanun is to fully inhabit the

space around each note. The depth of the space implicitly and explicitly informs the breadth of sound.

The practice of tending to the in-between spaces was a timely gift for our process as facilitators. Turning our attention to the intervals as dynamic spaces of meaning making expanded our fields of perception and reception. It was all too easy to project our sense of "spatial justice" (Soja, 2013: 6) onto the participants. We noticed that our default position was to micro-manage awkward spaces as a way of hastily locating ourselves in ambiguous spaces. This mirrored the spatial politics that were happening on a macro level. Expedited settlement processes have often negated the unfolding dynamics in the interim spaces. With the lengthy and arduous waiting times that coincide with refugee determination systems, the spatial and relational negotiations in between departures and arrivals deserve a rigorous inquiry. It was time for us to make room for an "aesthetics of discomfort" (Aldama and Lindenberger, 2016) in order to understand how we were shaping spatial relations. Our identities in formation shaped our capacities to navigate uninformed passageways.

Concrete arrivals

The spatial dimensions of our workshop shifted when the community hall could no longer accommodate the growing number of participants in our workshops. We collectively made the decision with the participants to transfer the workshops outdoors to the adjacent parking lot. As we transitioned from an enclosed space to a visibly public space, we created what Trinh Minh-ha describes as a "boundary event" (Minh-ha, 2011: 63) in the surrounding neighbourhood. Minh-ha's insight that "every voyage can be said to involve a re-siting of boundaries" (*ibid.*: 27) reflected our inclination to explore the boundaries of identity and mobility through site-specific performances. Our purpose for moving the workshops into the public sphere was not to convince residents to adopt a certain stance on immigration, nor was it to produce performances illustrating different facets of the migration journey. Rather, our living inquiry centred on how existing proximities between so-called settled and settling communities could begin to shift from other points of reference. Transitioning from an enclosed environment into a wider socio-cultural sphere was a natural next step in repositioning ourselves. Ironically, many programmes and resettlement practices "take place behind closed doors" (Dahlvik, 2017: 372) and remain inaccessible to the public.

As soon as we expanded our range of play into the neighbourhood, the participants were drawn to explore the soundscapes of the city. Many recent arrivals had not heard an urban environment similar to this one. Curiosity around the unfamiliar tones became a natural entry point for voice and musical improvisations. We began by exploring how the pulse of our respective heartbeats could be synced to the wider pulse of the city. Monitoring our pulse served as an internal metronome and place of return; the constant refrain in a city laden with interruptions. The acoustic ecology of the cityscape was a soundtrack just waiting to be transposed with call and response patterns. Humming sounds of motor vehicles and the wail of sirens inspired vocal experiments. The sharp staccato pitch of traffic lights summoned a range of atonal sounds. The parking lot was filled with an array of natural prompts to create a percussive baseline. Rocks, sticks, and found objects strewn along the pavement were gathered to form an acoustic rock and roll ensemble to accompany the voices. These audible entry points served as a primary mode of orientation to experience the sound palette of the city.

The starts and stops of these sonic inquiries interrupted the haze of anonymity in the streets. A noticeable shift happened in the parking lot when residents from the neighbourhood started to gravitate toward the improvisations. After fielding the predictable question, "What's happen-

ing here?", several bystanders joined in as experimental sound makers. A palpable excitement moved through our group when strangers entered and exited the jam sessions on their own accord. Their engagement was completely voluntary and did not stem from an imposed obligation to welcome newcomers. People simply responded to an audible invitation that reverberated from all sides of the "fourth wall". The pull toward resonance naturally attracted a constellation of new relations in the neighbourhood. Re-sounding compositions created imaginative ports of entry for exchanges between local residents and newcomers.

Multivocal experiments catalysed a pivotal platform for spoken word and hip-hopscotch improvisations. A kinaesthetic grid for hip hop performances began to emerge when several youths started to trace the cracks in the pavement with corresponding dance moves. The winding and jagged lines of the splitting earth led to an original movement and sonic score that emerged from the ground up. Hip-hopscotch was literally set in stone as the uneven cracks defined the parameters of the makeshift stage. Those from the neighbourhood who were well versed in hip hop jumped in and sketched large numbered squares at each turning point in the cracks. Rhythms and words were exchanged in both English and Arabic as bodies moved fluidly from square to square. Being "out of step" catalyzed moments of humour and humility, and subtle allegiances started to surface through a growing commitment to the emergent art forms. The dynamics of inclusion and exclusion surfaced through the push and pull of movement phrases. Rather than composing livelihoods on someone else's watch, we were all time-keepers here, both rhythmically and kinaesthetically. There was an ease in navigating intercultural communication when resonant beats spilled out from sonic somatic scores. We found new ways to be in time with one another when the poetic and the prosaic crisscrossed back and forth across the dishevelled parking lot.

As these sonic sensations attracted a growing number of local residents each week, it became clear that when "personal languages become languages of work … these in turn become common languages" (Barba, 1995: 41). Hip-hopscotch became a vibrant space where rhythm and resettlement were intertwined. New relations became possible somewhere in between cacophony and consonance. We named our title track performance *Home Free* after weeks of remounting and remixing synchronic scores. Through the temporal and spatial cues available through the aural agency of listening, we were "co-constructors of an aesthetic milieu in service of intercultural communication" (Woodrow, 2017: 788). These free form performances on the pavement offered a contrast to the daily constrictions that coincide with forced mobility.

Unsettling resettlement

After implementing this pilot arts-based initiative for one year, the core facilitation team harvested the learnings with participants, guest artists, and local residents. We found that individual and collective identities shifted for both newcomers *and* long-term residents through the art making. Residents from the neighbourhood who participated in the project reflected on their increased awareness of the contingencies and instabilities that coincide with forced migration. They were grateful to have an accessible interface to engage with newcomer communities. The improvisational approach proved to be a generative starting point for spontaneous community engagement. The improvised performances in the parking lot were commonly referenced as a key turning point for breaking down barriers between strangers. It was noted that performance making did not promise a recipe for conflict resolution, but started to break down the physical and symbolic silos between settled and unsettled communities one act at a time. Aesthetic passageways inaugurated innovative forms of collaboration and coexistence. These tacit interfaces created momentum around facets of resettlement that were halted by bureaucratic inertia. A

performance-oriented approach to knowledge creation and mobilization shifted the epicentre of settlement strategies from institutions into neighbourhoods. Gestures of mutual hospitality became possible when the responsibility of perception and reception could be reimagined in the streets with a distinctive musicality.

An affective system of relations thrived on patterns of recognition and syncopation. The performance scores clearly demonstrated how frames of recognition are inextricably linked to forms of reception. The instabilities of displacement could not be solely addressed by "durable solutions" (United Nations High Commissioner for Refugees, 2003) derived from checklists and evidence-based forms. We embraced resettlement as a kinaesthetic, proprioceptive, and rhythmic phenomenon. Homemaking emerged as a poietic script that was always under constant revision as habitual patterns were unsettled one act at a time. Proximities between bystanders, spectators and performers shifted when a heightened sense of attunement and accompaniment infiltrated into the public spheres. We needed to welcome the spatial, temporal and relational unknowns in order to recompose a shared script for resettlement. Tending to the intervals with postures of readiness became an aesthetic responsibility for us all. As site-specific improvisations led to unlikely collaborations, it was possible to bend time and shape space *with* one another.

A series of cross-sectoral dialogues have continued from this pilot project to determine prospective trajectories for the next phase of engagement. Ensuing recommendations have been made to local settlement organizations based on the findings that emerged. The gaps between organizations, host communities, and newcomers continue to be a significant barrier in settlement initiatives. Tending to these gaps requires a malleable facilitation team that can be in close proximity to the expressive repertoires and relations that surface at street level. This requires the presence of human resources in unconventional spaces to determine the creative capacities of informal neighbourhood networks. Setting up peer-to-peer mobile mentorships in public spaces will ensure that ideas proposed for resettlement are stemming from creative community exchanges. Displacement is not merely a private experience that takes place in predetermined social locations. Rather, it is a public story that is interwoven into the pulse of neighbourhoods. Social polarization will only increase if resettlement solely targets displaced populations. The re-staging of resettlement is a collective endeavour that belongs to settled and unsettled communities. Deliberately working to strengthen community partnerships via the arts offers alternative resources for settlement sectors that are commonly laden with fears of scarcity.

Interweaving social aesthetics into the fabric of resettlement offers a timely paradigm shift for community-initiated projects. Rigid programmes that have been calcified by refugee determination protocols will be challenged to generate life-giving relationships in communities over time. Fear and suspicion will permeate if normative regimes of recognition continue to dominate how newcomers are perceived and received. Creating distance from presumed identity constructs can begin to reset the tone for generative relations across socio-political and cultural divides. Although performances tend to be relegated to the end of a project cycle as a culminating event, indicators from this pilot revealed how performance practices can serve as a barometer for monitoring and evaluating relations at every stage of resettlement. The art of refuge involves sensory provocations that extend beyond bureaucratic representations. In this sense, performance practices can offer culturally fluent entry points for unlikely encounters between strangers. Seeking sanctuary is an incremental process that relies on the navigation of visceral cues and spacious intervals. Carving out spaces for collaborative improvisation in communities will extend the culture of hospitality beyond the walls of institutions. Cultivating a "qanun" sensibility is optimal as we endeavour to make ourselves at home with one another on uncommon ground.

References

Abid, R. A., Manan, S.A., Rahman, Z.A.A.A. 2017. A flood of Syrians has slowed to a trickle: The use of metaphor in the representation of Syrian refugees in the online media news reports of host and non-host countries. *Discourse and Communication*, 11(2), 121–140.

Aldama, F. and Lindenberg, H. 2016. *Aesthetics of discomfort: Conversations on disquieting art*. Ann Arbour, MI: University of Michigan Press.

Barba, E. 1995. *The paper canoe: A guide to theatre anthropology*. London: Routledge.

Chilisa, B. 2012. *Indigenous research methodologies*. Thousand Oaks, CA: SAGE.

Dahlvik, J. 2017. Asylum as construction work: Theorizing administrative practices. *Migration Studies*, 5(3), 369–388.

Demos, T.J. 2013. *The migrant image: The art and politics of documentary during global crisis*. Durham and London: Duke University Press.

Ermine, W. 2007. The ethical space of engagement. *Indigenous Law Journal*, 6(1), 193–203.

Government of Canada Immigration and Citizenship. 2019. *Syrian refugee resettlement initiative – Looking to the future* [online]. https://www.canada.ca/en/immigration-refugees-citizenship/services/refugees/welcome-syrian-refugees/looking-future.html [Accessed 12 January 2019].

Immigrant Services Society of British Columbia. 2017. *Syrian refugee youth consultation summary report* [online]. http://issbc.org/wp-content/uploads/2016/10/SUMMARY-REPORT-Syrian-Refugee-Youth-Consultation-.pdf. [Accessed 15 December 2018].

Ingold, T. 2011. *Being alive: Essays on movement, knowledge and description*. New York: Routledge.

Isayev, E. 2017. Between hospitality and asylum: A historical perspective on displaced agency. *International Review of the Red Cross*, 99(1), 75–98.

Minh-ha T.T. 2011. *Elsewhere, within here: Immigration, refugeeism and the boundary event*. London: Routledge.

Pratt, M.L. 2008. *Imperial eyes: Travel writing and transculturation*. New York: Routledge.

Soja, W.E. 2013. *Seeking spatial justice*. Minneapolis, MI: University of Minnesota Press.

Thompson, J. 2009. *Performance affects: Applied theatre and the end of effect*. Basingstoke: Palgrave MacMillan.

United Nations High Commissioner for Refugees. 2003. *Frameworks for durable solutions for refugees and persons of concern*. [online]. Geneva: UNHCR. https://www.unhcr.org/partners/partners/3f1408764/framework-durable-solutions-refugees-persons-concern.html [Accessed 20 December 2018]

Woodrow, N. 2017. City of welcome: Refugee storytelling and the politics of place. *Continuum*, 31(6), 780–790.

20
THE ARRIVALS LEGACY PROCESS
Reviving Ancestral stories of recovery and return

Diane Roberts

Introduction

For the past 30 years, I have been developing my voice and vision as a practicing theatre artist, director, dramaturge, teacher, mentor, writer, and what I've come to term "cultural animator". When I began my career in the late 1980s and early 1990s, I was heavily influenced by European theatre visionaries Peter Brook, Jerzy Grotowski, and Konstantin Stanislavski (from my undergraduate theatre training). The first Black playwright I read and studied was African-American poet/playwright Ntozake Shange. Her choreopoem *For Colored Girls Who Have Considered Suicide When The Rainbow is Enuf* (New York, 1989/2010) was, for me, a gateway to the liminal space of "knowing and unknowing" as a form of artistic expression. Throughout the years, I have been drawn to these liminal spaces, gaining skills in how to navigate using my culturally rooted instincts and curiosities.

There is no bypassing loss. Loss of language, culture, dance, songs, history, memory, home. For those who remain, there is a continual longing for a forgotten past. For those who leave, there exists a sometimes-unspoken longing to return (Baumann, 2000). Founded in 2003 as a creative engagement tool for displaced Indigenous and migrant artists and communities, The Arrivals Legacy Project (Arrivals) was designed to unearth embodied root cultural practices and authentic creative impulses through ancestral connections. The strength of the Arrivals process lies in its application as a story generating and community development tool designed to ignite, negotiate, and reconcile diverse cultural perspectives. It has proven itself to be a powerful initiator and developer of collaborative artistic creations that address transdisciplinary, intergenerational, and cross-cultural concerns.

My intention in this chapter is to shed light on how the Arrivals process has become a creative and transformational tool for Indigenous and diaspora artists to decolonize our arts practices, providing unique opportunities for collaboration across difference. I navigate between my voice as an artist and as a researcher in dialogue with the voices of past participants. In so doing, I construct a profile of Arrivals as a viable tool for addressing the ruptures caused by colonization and migration (forced or otherwise) and for creating new epistemologies that might inspire a future imaginary that is rooted in the past but not bound by it.

The process

Michael Rothberg asserts in his book *Multidirectional Memory* (Rothberg, 2009) that "all articulations of memory are not equal. Powerful social, political, and psychic forces articulate themselves in every act of remembrance" (2009:15–16). I recognize Rothberg's notion of multidirectional ethics as one of the key foundations in the six steps of the Arrivals process—a practice that has been developed and refined over the past 16 years through application, experimentation, and research with participants, collaborators, and co-facilitators Heather Hermant, Danielle Smith, Rosemary Georgeson, Jude Wong, and Liliona Quarmyne (Arrivalslegacy.com/process).

The Arrivals process enacts an approach to collaborative responsibility that is geared toward particular centres of gravity that are rooted in the body and infused by the spirit. As a result, the process itself demands a level of engagement that contradicts the traditional role of the artist or researcher as knowledge producer by asking them to step into a state of unknowing and to grapple with what is potentially unknowable. As participants and co-facilitators, we strip ourselves down to face, experience, and embody our own ancestral legacies and mythologies while deeply witnessing this process in others. The practice of deep witnessing implicates us in each other's stories—causing us to sneak under each other's borders and to compassionately entangle ourselves in the histories or legacies that might otherwise divide us. As witnesses, the Arrivals co-facilitators take in, observe, record, and interpret the responses of participants and feed their observations and interpretations back to participants during and after their deep immersive process. They also learn or hone their skills to see beyond the obvious—to read patterns without jumping to deductive story-making—to use their own sensory impulses to interpret what they see/hear/feel in active witnessing.

In the Arrivals process, we believe that everything we need to know is buried in our bones as story fragments. We recognize that our bodies naturally make images consciously and unconsciously. This is not only for communication but in response to our environment, our history, and experience; our needs and desires; and our fears and obstacles. When we create story from these images, we increase our ability to see and capture them in space and time.

The village journey

When we assemble in the work, we embrace the term "village"—knowing that the stories that emerge through research, creation, and exchange will impact this makeshift village. We create protocols and ceremonies to prepare the stage for compelling stories to arrive and find their place to land. How do I know, when I enter the room to work with Arrivals participants and their Ancestors, that my Ancestal story will be welcomed, heard, valued, or understood? What is the role of the witness? How do I carry the pain and/or joy of my ancestral story, knowing that it may have had a negative impact on the lives and stories of others? (Figure 20.1)

> *Jude Wong (Jude):* At the beginning of my Arrivals journey, I had little knowledge or sense of connection to my family—I am an only child, raised largely in isolation from any extended family, and with little ancestral knowledge or cultural identity passed on to me. Throughout my life, there has been the question within: Where is my tribe? Where are my people?
>
> Where is my face in the world? As a Chinese descendant, the significance of this question does not escape me. My family has a collective identity in the world, as one without face, as one estranged or perhaps exiled from its tribe. Where did this legacy begin for us? Which ancestor lost face? By living these gifts and challenges, we receive,

The arrivals legacy process

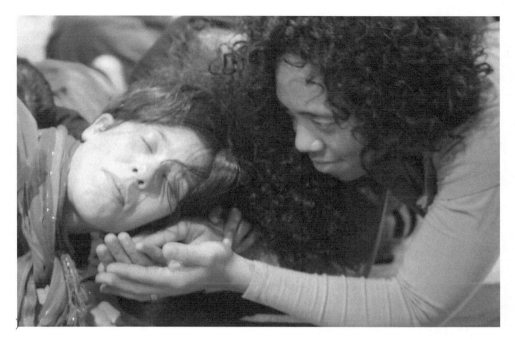

Figure 20.1 Jude Wong, Danielle Smith (head down) & Liliona Quarmyne. Archive of The Arrivals Co(Lab), Vancouver 2009. (Photo: Diane Roberts.)

carry, and pass on the metaphorical baton of our family legacies, just as they were passed on to us. I am here to find face, transcend, and transform the social class of my family and bring healing to it.

As we work to uncover story fragments, we are faced with the challenge of grappling with the historical consequences passed on by our Ancestors. We are in constant negotiation between the diverse and potentially contentious histories we bring into the room and this can put us on unsteady ground. We hold ourselves together by staying in the centre moment of discovery. When we act as witness to our own emerging fragments and the fragments of others, we balance our desire to know the bigger story with the delicate wisdom that comes from noticing what's just in front of our faces. This is a constant negotiation between facilitator witnesses, internal witnesses, and performers—and, in a vibrating intercultural collaborative environment, we are ever more vigilant about searching for the openings where deeper meanings lie waiting to be revealed.

Sharon Jinkerson-Brass (Sharon): [The process of exploring my] "spirit bones" [through Arrivals] is like living in a cyclical consciousness (like my Ancestors) rather than a linear construct where I think of myself as just me. I carry unique aspects that are mine, but the greater part of my being-ness comes from a long, loooo-ng journey. I hope and pray that some of our Earth time together will help bring to light the song, the dance, the gestures that return us to a place where our full potential can be explored and expressed. Intimacy with others, nature, and the universe is deeper when we leap (or carefully step) into the unseen world and dare to dance, sing, and embrace the ghost nation. My grandmother used to say, "The Ancestors are so lonely in the spirit world, they are waiting for us to call on them!"

The mapping of histories and memories emerges in the process as an important protocol that invites participants to see how their individual stories intersect with world events, creating a universal story drawn from particular or individualized fragments. This is a critical tool, especially for artists whose histories have been marginalized or in some cases violently erased from the popular archive.

Zainab Amadahy (Zainab): As a storyteller I've always been taught to use plot points to challenge my characters to change and grow. One might consider them crossroads. Every obstacle, problem, or setback is encoded with opportunity for a character. Sometimes many. From their vantage point, Ancestors understand the hero's journey better than we who are living/writing it. They see the opportunities and pitfalls alike. They are the audience that has information that we, as protagonists/authors of our own lives, do not. In fact, they may often have advice, guidance, and feedback for us. If only we could connect to them. And it feels as though the optimum time to do that is when we are at those perceived crossroads.

Decolonizing strategies

The context for the Arrivals Personal Legacy work is, has been, and will continue to be the colonized body. And although I begin from a personal contextual framework, the Arrivals Personal Legacy process, in its development, reveals its universal application for cultural reclamation (Roberts, Hermant, and Sircar, 2011). This type of deep cultural reclamation can manifest as potential danger zones where fears, resistance, and deep openings occur. As we enter into the creation and negotiation of our cultural protocols in the work, the doubts creep in. Am I worthy enough to embody the story of my ancestor? What if I'm not enough for him/her? Can I contain the fullness of the story I'm being given? How do I know what is mine and what is theirs? What is invented and what is really truly my ancestor's story? Where do I go from here? (Figure 20.2)

Rosemary Georgeson (Rose): I have spent a lifetime looking for my grandmothers who were omitted from history. From the time they met and became the mothers and grandmothers to our family they ceased to exist. We were always just given vague accounts of where they came from or who their family might be. There was nothing real that we could follow up on, no connections to anywhere or anyone. All prior knowledge about them before entering into our bay and having children there was erased. It was as if they never existed. I am here as proof that they did exist. The Arrivals process speaks strongly to much larger conversations today. It makes us look at our history and understand some of the brokenness of today. It's hard to walk through life with that nagging feeling that a piece of you isn't there, that you are not complete and have no idea what is missing. I need to know their stories and how they still affect us all today. Telling their stories, talking to people, sitting with the old ones, meeting my family keeps driving me forward. After many years of wondering, I have finally met my grandfather's family, the family that we were all separated from, who knew nothing except maybe the odd vague story from a long time ago of another child who was taken. What I have been researching around my grandmothers, is healing 120 years of brokenness that is still felt today by all of us. I need to walk where my grandmothers walked, to know their language, to understand how this all came to be.

World-renowned Haitian anthropologist, historian, and writer Michel-Rolph Trouillot (1949–2012), whose interests lie in the silences that arrive in the spaces between archival narrators of

The arrivals legacy process

Figure 20.2 Rosemary Georgeson. Archive of The Arrivals Cross Canada Workshop Series, Vancouver 2009. (Photo: Diane Roberts.)

the past and present, asks the question: "How do we recognize the end of a bottomless silence?" (Trouillot, 2015: p. 30). With his keen interest in the masking of history, Trouillot is concerned with how history works as opposed to what history is. His seminal work *Silencing the Past: Power and the Production of History* (2015) provides strategies for countering inequalities of power in our knowledge of the past. Like a porthole to the past, the Arrivals Personal Legacy process navigates these silences by helping artists discover and make sense of the histories stored deep within. For participants, it can be an ancestral anchor that grounds them, giving them a framework to articulate their practice as decolonized artists, facilitators, and community leaders. As we enter into the process, we agree to accept what comes and to maintain a vibratory space[1] within our village circle to contain the conflicting stories, emotions, and resistances that might emerge. Up until now, this process of management has been instinctual. In the Arrivals Legacy workshop bubble, I control who is accepted into the work. Those accepted know that they are entering a decolonial space where anything can happen. In this space, we instinctively support each other understanding that the stories that emerge are fragments that might connect us with painful histories of colonization. We also learn and come to accept that we are not our histories.

Sharon: Colonization has robbed most people on this planet of their tribal ways of being in the world. We can have commissions and create policies to implement social change,

but this doesn't help us to fill the emptiness left by war on Indigenous values, intelligence, and spiritual practices. Our Ancestors allowed themselves to explore the magical, mystical world of our souls and they made up ceremonies, dances, and songs to share the richness of this world. Some of us have the good fortune to have a culture [to connect to] but most of us do not.

The arrival of trauma in the Arrivals Legacy process is always a tenuous and delicate possibility. As we mine deeply into the worlds of our Ancestors, it is inevitable that we will uncover truths that are uncomfortable or traumatic. We, as the facilitation team, navigate these emerging truths with sensitivity considering how one ancestor's or relation's truth can impact another's. The process itself has protocols in place to minimize the potential damage, and one of these protocols has to do with the deliberate and active practice of acceptance. In a practical sense, this might mean reconfiguring the journey of the workshop by deeply listening to what is needed next.

The body's wisdom

Liliona Quarmyne (Liliona): The Arrivals process has cracked me open as an individual and as an artist, allowing me to hold and honour the complexity and fullness of my body as a creative vessel. It [Arrivas] has and continues to be a challenging, inspiring, beautiful journey of being both myself and part of a larger story of journey, arrival, loss, and recovery. It asks me to constantly question my understanding of the notions of integrity and truth.

The gestural language we create/reclaim enlivens our body's ability to remember—training our two-thirds water body as a receptacle for memory (Figure 20.3). Our praxis is governed by three aesthetic values first coined in 2001 by Rawle Gibbons, director, playwright, and former head of the Department of Creative and Festival Arts at the University of the West Indies. Gibbons proposed that these aesthetic values—*expressions of ancestrality, communal expression,* and *affirmation through improvisation and adaptation*—could be traced through our work as African diaspora artists. Through the Arrivals process, we cultivate a strong relationship between these aesthetic values and the key building blocks for performance creation: mind, body, breath, and spirit.

Mayahuel Tecozautla: The memory in my body, in each of my cells, and in my soul is manifested through movement. I call upon my ancestral memory to understand my journey and the essence of my being in this lifetime. In movement, I embody the essence of my Ancestors so that when I move, I am at the same time myself, my mother, my grandmother, my great-grandmother, and the lineage of my female Ancestors.

Through Arrivals, we collectively and individually reclaim gestures that give us a sense of deep knowing—valuing the wisdom of embodied archives in dialogue with those written. The final stage of the process invites us to walk in our ancestor's feet as we enter the crossroads where memory, inuition, imagination and spirit lead. By this stage of the process when most of the filters and resistances have been stripped away, the body's wisdom takes over, and participants arrive physically and mentally into at a moment of truth.

Olivia Davies: Movement is the vocabulary of my heart's expression. I allow memory to move through me and by doing so, I engage in a new somatic awareness of the intrinsic patterns and habits that had formed over time in my skeletal framework, neurological path-

The arrivals legacy process

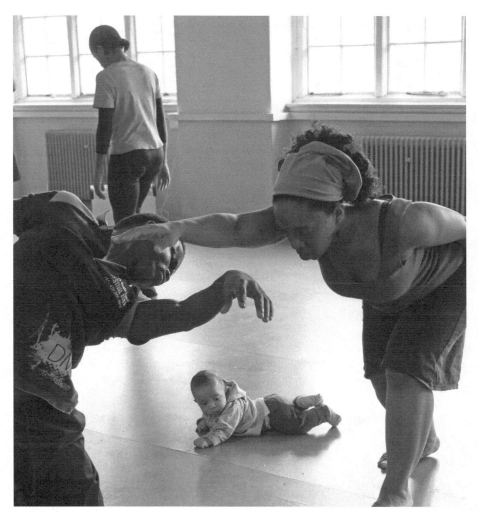

Figure 20.3 Augustine Efe Olaijo, Ny Langdon, Liliona Quarmyne. Archives Arrivals Atlantic Project residency, Cardiff, Wales, 2011. (Photo: Diane Roberts.)

ways, and musculature. The action of bringing my ancestor into the rehearsal studio with me sometimes leaves me feeling drained—as though the depression he experienced in his own timeline is woven into my own, and this is a heavy burden to carry. And so, I give myself up to be that vessel for that moment in both of our timelines. Afterwards, I bring myself back to the present by feeling the ground beneath my feet and walking through space, making clear decisions of where I am going and how I am going to get there.

Where are we now?

After 16 years of practical research into the Arrivals methodology, I am still surprised by the depth and breadth of the discoveries and by the lasting impact they have on the participants. The stories that emerge are inevitably stories that the performer/researcher needs to grow to

understand the deep roots of their cultural and creative practice. When we uncover what we need to navigate our root cultural traditions, we recall and engage with our inherited practices and find/create/discover new practices that address our contemporary and ancient longing for connection.

Liliona: On a communal level, Arrivals carries an ability to interrogate the legacies of slavery, of colonialism, of genocide, of displacement. It can be part of a conversation around how and if we heal from these legacies. The Arrivals process also asks us to be accountable—to ourselves, to generations that have gone before, and to generations that will come after.

As we continue along our journey, we consider the process of landing; we witness our Self through our chosen ancestor, who in the process of landing might reconstruct new identities. We weave a new kind of knowing, developing ways of seeing our Self in an Other; our Self in an Other's land. I propose that as we navigate our constant state of 'between-ness', or "betweenity" as poet NourbeSe Philip has coined it (Philip, 1997), we gain new insights about our relationship to land. This is particularly important in the context of Indigenous land claims and the global call for reparations (Figure 20.4).

Starr Muranko: This process deepened a desire that had been stirring inside of me for many years. It gave me an entry point to be able to create a container in this time and space where I could dive deeper into the questions, yearnings, and incomplete parts of the puzzle. It was an intersection of creativity, spirituality, self-reflection, and ritual all woven together. It brings deeper textures to my work as a choreographer and a deeper

Figure 20.4 Protocols table. Archive of The Arrivals Legacy Project workshop, Toronto 2016. (Photo: Diane Roberts.)

sense of knowing who I am as a woman. It has helped to greater situate me and my story into the lineage of my Ancestors.

In our need to navigate the conflicting cultural protocols that emerge and are demanded of us, we find ourselves uncovering deeper truths—translating them from contemporary gestures into ceremonies and rites of passage. In so doing, we learn to embrace the stories that arrive under our skin, mingled in blood, unearthed from bones and in breath. As I continue my research into comparative ancestral creative processes, I draw on the wisdom of those who came before me who suggest that we are called to carry these stories and to provide a clear path for those who follow.

Note

1 I use the term "vibratory space" as a substitute to the popular and, in my mind, somewhat desensitized parlance of "safe spaces." In so doing I hope to interrogate the idea of safety in this work—acknowledging that the protocols of safety need to be an ever-evolving negotiation by the individuals in the room. In a vibratory space, where all of the protocols are in place, the question of safety becomes an internal one. For example, if I feel unsafe in one moment or another, what does this tell me about the story that is emerging? What might I be resisting? What is the source of this pain?

References

Baumann, Martin. 2000. Diaspora: Genealogies of semantics and transcultural comparison. *Numen*, 47(3), 313–337.

Philip, Marlene Nourbese. 1997. *A genealogy of resistance: And other essays*. 1st ed. Toronto: Mercury Press.

Roberts, Diane with Hermant, Heather and Sircar, Lopa. 2011. The lost body — Recovering memory: A personal legacy' (Expanded). In: D. Barndt, ed. *"VIVA" : Community arts and popular education in the Americas*. SUNY Series, Praxis: Theory in Action. Albany, NY: State University of New York Press.

Rothberg, Michael. 2009. *Multidirectional memory: Remembering the holocaust in the age of decolonization*. 1 online resource (xvii, 379 pages): illustrations. vols. Cultural Memory in the Present. Stanford, CA: Stanford University Press.

Shange, Ntozake. 1989/2010. *For colored girls who have considered suicide when the rainbow is enuf : A choreopoem*. 1st ed. New York: Scriber.

Trouillot, Michel-Rolph. 2015. *Silencing the past: Power and the production of history*. E-book. Boston, MA: Beacon Press.

21
APPLYING *HAMILTON*

Hana Worthen

As a Broadway musical, the epitome of commercial theater, Lin-Manuel Miranda's 2015 *Hamilton: An American Musical*[1] escapes the category of "applied theatre." And yet, locating a complex performative event, the production constellates a range of *applied*—professional, cultural, and political—*performances* and is itself *applied* in intricate social and educational-performative settings.

Providing a multiplex site for the interrogation of the intersection of applied performance and popular theater, *Hamilton* applies the structures of the musical to a consideration of the implication of race and culture, using the eighteenth century American setting to foreground the application of history as a means to engage with representational politics and social attitudes. Thematically, *Hamilton* thrives on a liberal populist narrative. It depicts a founding father of the United States, and America's first Secretary of the Treasury, Alexander Hamilton (1757–1804), as a poor immigrant whose force of will, self-acquired skills, and public code of honor shaped his life trajectory, leading him to develop the monetary policies grounding the future prosperity of the United States. Implicitly prospering from the reification of individualism, *Hamilton*'s profit also depends on a foregrounding of contemporary pro-immigrant and #BlackLivesMatter sensibilities. Employing a "diverse cast to explore American history" (Paulson 2006) integrating—in both historical and material terms—sidelined Latino, African American, and Asian American performers, it constellates the protagonists as motivating a redefinition of singularizing and racializing national identities.[2] Moreover, interweaving the dissenting musical styles of hip-hop, rap, and blues into the mainstream aesthetic of the hegemonic Broadway musical, *Hamilton* intersects "popular and Broadway idioms," to use Brian Eugenio Herrera's phrasing, helping "to instruct the aficionados of one in the aesthetics of the other and thus broaden the audience for both," and revising audiences' "expectations of what either pop music or Broadway can accomplish as modes of popular communication" (Herrera 2017, p. 28). Trading in ideological (individualism) and musical conventions, *Hamilton*'s performance applies foundational history to overcome the contemporary social, political, and professional (prevalently white casting) forms of injustice.

Disrupting the "distribution of the sensible" (Rancière 2009, p. 12) of the professionalized American musical, moving beyond the alignment of white history with theatrical representation by hybridizing the ocular and aural stage-scape, Miranda also applied performance to point out the racializing concepts governing the casting process itself. In first casting for the Public

Theater production, *Hamilton* called for "non-white" performers, a call that became controversial, incommensurable with New York City's Human Rights Law, when the regional and touring productions were being auditioned: as Herrera asks, was such a casting policy discriminatory or foundational to the "creative vision" of the show? *Hamilton*'s casting call was doubled, as in venues such as *Backstage* the producers chose to list all "ethnoracial options" rather than using the term "non-white." I see this doubleness to summon, along Herrera's lines, a "coalitional nonwhiteness" that specifically queried "the tacit normativity of whiteness in the casting process," and the "tokenist tautologies of prior models of nontraditional casting, wherein the presence of a minority actor in a presumptively white role demanded explanation" (Herrera 2017, pp. 29, 30).[3] In the applied ethics of its casting calls, *Hamilton* intervened in Broadway business as usual, troubling the conjunction between the historical and the contemporary "white space" of American theater, a space perceived as off limits to black people and "a condition of their existence" (Anderson 2015, p. 10).

Hamilton registers an additional understanding of applied performance, insofar as one widely visible application arose in relation to the production's figuration of the theater as public space, but only indirectly from the agency of its makers. Barely a week after the contentious 2016 US presidential election, on November 18, Vice President Elect Mike Pence visited a performance of *Hamilton* at the Richard Rodgers Theatre in New York City, where his arrival in the auditorium prompted spectators to signal disapproval or support for the incoming regime, to apply performance to form an *ad hoc* assembly. As was widely reported, when Pence entered the auditorium, he was met with boos and some applause from the audience before the show began. Voicing their diverse political views—applause and booing—as a response to Pence's politics, the *Hamilton* spectators engaged in what Chantal Mouffe terms the "agonistics" of democracy, expressing their social and political attitudes as plural, non-consensual, and indeterminate (Mouffe 2013). Applying the practice of agonistic democracy, the spectators' fleeting, embodied actualization of political assembly witnesses the fluidity of applied performance, how applied performance can be activated within alternative performative frames, and by alternative agents or agencies, even in the heart of the commercialized cultural industry.

At the curtain call, Brandon Victor Dixon, the African American actor playing Vice President Aaron Burr, read a statement from the cast to the Vice President Elect. Dixon's remarks, called "a plea for tolerance" in the press, addressed Pence and "your new administration" from an all-inclusive and plural, "alarmed and anxious" *we*, cataloguing the trepidation that the upcoming government "will not protect us, our planet, our children, our parents, or defend us and uphold our inalienable rights." Supported by what the *New York Times* described as the audience's "enthusiastic applause and cheers," both the statement and the reaction in the theater register an apprehension that liberal "American values" (civil liberties and rights guaranteeing equality in terms of identity, race, and gender) and the universal human rights understood as cognate with them ("our inalienable rights" to have equal access to a livable life, including equal access to clean water, soil, air) had not been represented in Pence's history of opposition to LGBTQ civil rights, and by extension might not be upheld in his or President Elect Donald J. Trump's service to American citizens (Mele and Healy 2016). Indexing the activation of *civics,* Dixon's address can be seen as another instance of applied performance—Dixon's, the cast and production team's, and the audience's—that was galvanized by the musical's activation of the present through the past, troped by its visual and aural hybridized aesthetics, opening the genre of musical theater to the theater as a forum *in*, not secluded from, the world.

Yet while the *Hamilton* spectators and creators appealed to individual and collective liberties and rights, their expression was re-contained by a sense of theatrical propriety innate to the prosumer, an ironic reproduction of Judith Butler's (2015, pp. 7, 85) "theater of legitimacy"

urgently asserted in President Elect Trump's two Twitter posts of later the same evening. The tweets insist on a universalizing binary between what is good and wonderful ("Our wonderful future V.P. Mike Pence" and "a very good man, Mike Pence") and what is offensive, both socially unacceptable ("very rude"), and lawfully punishable, harassment ("Pence was harassed ... at the theater by the cast" and "the cast of Hamilton was very rude"). Tellingly, both tweets identify Trump's *our* as merely ornamental, a rhetorical means to assert an authoritarian imperative, intensified by an exclamation mark. "This should not happen!" summons a future prohibition and "Apologize!" commands the submission of the perpetrator of a criminalized act, though no such act had been committed (Trump's tweets are reprinted in Mele and Healy 2016). Insisting that Pence was "harassed" by the cast, Trump also claimed, "The Theater must always be a safe and special place." Concretizing how conceptions of the assembled theatrical public are shaped within and against a relation to state power, the tweets—from the future president of a post-democracy, disseminated by proprietary technology and a commercially structured instrument to reach as many citizens as possible—do not merely register an exercise of pre-executive authority, but instantiate a mode of counter-applied medial performance, as well. They purposed to adjust, even to suppress, the spectators-as-citizens' applied expression of the right to co-govern, their right to appear and to appeal publicly as a spontaneously constituted political assembly, to enact a potentiality latent in the function of the theater.

In asserting "The Theater must always be a safe and special place" (Mele and Healy 2016), Trump's second tweet addresses a political as well as a theatrical event, incidentally revealing the ideological interaction between conceptions of applied performance, the theatrical public, and the public assembly. Trump's assumption of a constitutively anodyne "Theater" (which in his orthography assumes the governing nominality of the Althusserian Subject) at once falsifies the historical role theater has played in defining popular sovereignty (the spectrum running from the arrest of the African Theatre Company to the Astor Place riots is typical of the interplay of theater and political action in the early nineteenth century United States) and collapses the always present politicality of theater into a neoliberal imperative of corrupting state forms and political practices sustaining liberal democracy. Here, "safe" equates to *non*-agonistic and "special" with uncritical, anti-intellectual consumption, the consumption of art and of citizenship alike. If in progressive discourse a "safe" space is a space that protects and enables difference, the protection to which Trump's discourse refers is at once a safeguarding *from* difference and *from* the political, *from* constituting oneself in a socio-political, socio-economic, and socio-cultural relation to another co-citizen as a political subject. It is a protection *from* the set of civic and human rights the spectators and the creators of *Hamilton* evoked in their cultural, social, and political acts, before, during, and after the performance. It is a protection *from* the fundamental liberties and rights that are constitutionally (though not unproblematically) guaranteed to the citizens of the United States. *Hamilton* applies a critical and hybridizing repurposing of popular theatrical and nontheatrical performance, and of racialized practices indigenous to American theater; Trump applies a restrictive notion of "safe space" to limit *Hamilton*'s labor, its application to contemporary life.

But there is a further form of application at work through *Hamilton*; much as these performances—the audience's, the cast's, and Trump's—applied the occasion of a specific evening's event to frame a political discourse with and about the use of theater, the musical and the theater itself have also been reconceived as the instruments of educational and motivational performance. Given what has been described as the younger generation's obsession with the musical and its economic inaccessibility (a ticket can cost as much as $2,000), Miranda, producer Jeffrey Seller, the Rockefeller Foundation, the New York City Department of Education, and the Gilder Lehrman Institute of American History have harnessed the musical to "an educa-

tional partnership to provide 20,000 NYC Title I public school students with the opportunity to see *Hamilton* on Broadway and integrate the show into classroom studies" (Gilder Lehrman Institute of American History 2019a); starting in 2016, "high school students in Title I schools in New York City, Chicago, and selected cities will each pay just a 'Hamilton' ($10) to see the performance" (Gilder Lehrman Institute of American History 2019b).

The Hamilton Project, or EduHam, integrates *Hamilton* into an "in-class history curriculum" envisioned to further the students' education and to enhance their career development; the students learn about the founding of America and are encouraged to work with relevant primary sources. The project supplies a set of documents, including the *Federalist Papers* and Thomas Paine's *Common Sense*, and a teacher's guide. After comparing the difference between primary documents and their adaptation by selected *Hamilton* songs, the students apply their learning to create their own performances (songs, poetry, monologues, dramatic scenes), using Revolutionary Era documents to engage contemporary public, civic life. As a capstone to the school project, several school groups are invited together to a theater presenting *Hamilton*, where they meet with the cast, show their performances, have lunch, and see the show itself, now framed by their own application of its inspirational work (D'Orio 2017, p. 10). Mobilized in a national effort to motivate students to higher performance in American history, fostering the students' confidence and socializing them to the musical's vision of diversity, EduHam encourages an active participation in an educational, social, and psychological self-improvement that simultaneously pursues an affective alignment with a "critical" commodity harnessed to the neo/liberal projection of individualism.

Indeed, foregrounding that Hamilton's "life is exactly that rags-to-riches story that immigrant or poor children in our classrooms hope to recreate," the Gilder Lehrman Institute's application of the musical subverts the hybridized visual and aural aesthetic possibilities that the applied creative tactics of *Hamilton* set in motion, instead applying the musical as a site for the affective interpellation of an admitted fantasy: The rags-to-riches story. As the editor of *History Now*, Carol Berkin continues framing Alexander Hamilton as a celebrity avatar:

> [E]ven his political enemies acknowledged that his *genius*, his *talent*, and his drive were the source of his success. His *boundless* ambition was not to achieve *great* wealth; it was to play a central role in the creation of a *great* nation. Thus, although he is often praised for his practicality, Hamilton was really a *visionary*. Modern America is, in many ways, that vision come true.
>
> *(Berkin 2019;* my emphasis*)*

While students apply the hybridizing methodology of *Hamilton*, using the artistic rhetoric of the present, assimilating the colonial documents to the foregrounding of contemporary urgencies, what both EduHam and the media representation of the project value is the musical's thematics of stardom: The student performances are typically represented in that register, as motivated not by the content of their academic work, but as the instrument to replicate Miranda's success, to confirm the Hamiltonian, individualist American dream.[4] The media representing the project align with this fantasy of unfettered national character, using interviews with students to underline less their critical achievements as historians than the paralyzing seduction of fame. As one student in Florida is reported to have said, "I would like to create music, be a personality, be an [inspiration] to the youth because I'm one of you guys" (Hagwood 2019).

The network of applied performances derived from an encounter with *Hamilton* witnesses a process within which the meanings of each application are interdependent with the ways *Hamilton* is applied. Although *Hamilton*'s stage performance may trace the neo/liberal agenda

of individualism, this set of applications developed around it—the hybridized aesthetic application of American history; the ethically aware intervention in the casting process; the interaction between the audience and Pence; the cast statement's engagement of the audience and the Vice President Elect; the political containment of the theater enacted by Trump's retrospective tweets; the EduHam project; the student performances—potentially reshape the performance to alternative labor, mobilizing it within the framework of socio-cultural and socio-political urgencies of precarity, localizing and rendering precarious relations significant and actionable.

Notes

1. *Hamilton* opened at the New York Public Theater in February 2015 and moved to the Broadway Richard Rodgers Theatre in July 2015.
2. While the theatrical performance is sustained by actors of color, the dramaturgical concept continues to silence "the presence and contribution of people of color in the Revolutionary era," through "its focus on the deeds of 'great white men'" as Lyra D. Monteiro (2016, p. 90) suggests, rendering the women in supporting roles *vis-à-vis* the men taking center stage.
3. The *Backstage* call for Angelica Schuyler, for example, was not listed as "[n]on-white," but as "African American, Hispanic, Asian, South Asian, Native American, Middle Eastern, Southeast Asian / Pacific Islander, Ethnically Ambiguous / Mixed Race, African Descent" (Herrera 2017, p. 30).
4. Andie Silva and Shereen Inayatulla (2017, p. 191), however, engage a significantly more complex account of the production's figuration of Hamilton as a paradigm of meta-temporal identification, arguing that the production is "less a glance back at a historical figure and more a future projection of an immigrant 'messiah' of sorts, a person of Othered origins who (re)defines US nationhood in significant ways (for better or for worse)," and so provides a figure of how "bodies shift temporally and spatially" (2017, p.191).

References

Anderson, E. (2015). The white space. *Sociology of Race and Ethnicity*, (1)1, pp. 10–21.
Berkin, Carol. (2019). Alexander Hamilton and the American imagination. *History Now: The Journal*. Available from: https://www.gilderlehrman.org/history-now/2016-03/alexander-hamilton-american-imagination [accessed 18 March 2019].
Butler, Judith. (2015). *Notes toward a performative theory of assembly*. Cambridge, MA: Harvard University Press.
D'Orio, Wayne. (2017). Hamilton goes to high school: how students are learning U.S. history from the hottest show on Broadway. *Education Next*, 17(3), pp. 4–12.
Gilder Lehrman Institute of American History. (2019a). *About the Hamilton Education Program*. Available from: https://www.gilderlehrman.org/content/about-hamilton-education-program-0 [accessed 18 March 2019].
Gilder Lehrman Institute of American History. (2019b). *Hamilton Education Program*. Available from: https://www.gilderlehrman.org/content/hamilton-education-program [accessed 18 March 2019].
Hagwood, Rod Stafford. (2019). Students show 'Hamilton' cast what they've learned in EduHam. *South Florida SunSentinel*, 16 January. Available from: https://www.sun-sentinel.com/entertainment/theater-and-arts/fl-et-viz-fort-lauderdale-hamilton-students-edu-ham-20190116-story.html [accessed 19 March 2019].
Herrera, Brian Eugenio. (2017). Miranda's manifesto. *Theater*, 47(2), pp. 23–33.
Mele, Christopher and Healy, Patrick. (2016). 'Hamilton' had some unscripted lines for Pence: Trump wasn't happy. *New York Times*, 19 November. Available from: https://www.nytimes.com/2016/11/19/us/mike-pence-hamilton.html [accessed 26 August 2020].
Monteiro, Lyra D. (2016). Race-conscious casting and the erasure of the black past in Lin-Manuel Miranda's Hamilton. *The Public Historian*, 38(1), pp. 89–98.
Mouffe, Chantal. (2013). *Agonistics: thinking the world politically*. London: Verso.
Paulson, Michael. (2016). 'Hamilton' producers will change job posting, but not commitment to diverse casting. *New York Times*, 30 March. Available from: https://www.nytimes.com/2016/03/31/arts/union-criticizes-hamilton-casting-call-seeking-nonwhite-actors.html [accessed 28 August 2020].
Rancière, Jacques. (2009). *The emancipated spectator*, translated by Gregory Elliott. London: Verso.
Silva, Andie and Inayatulla, Shereen. (2017). Who *tells* our story: intersectional temporalities in *Hamilton: An American Musical*. *Changing English* 24(2), pp. 190–201.

PART IV

Latin America

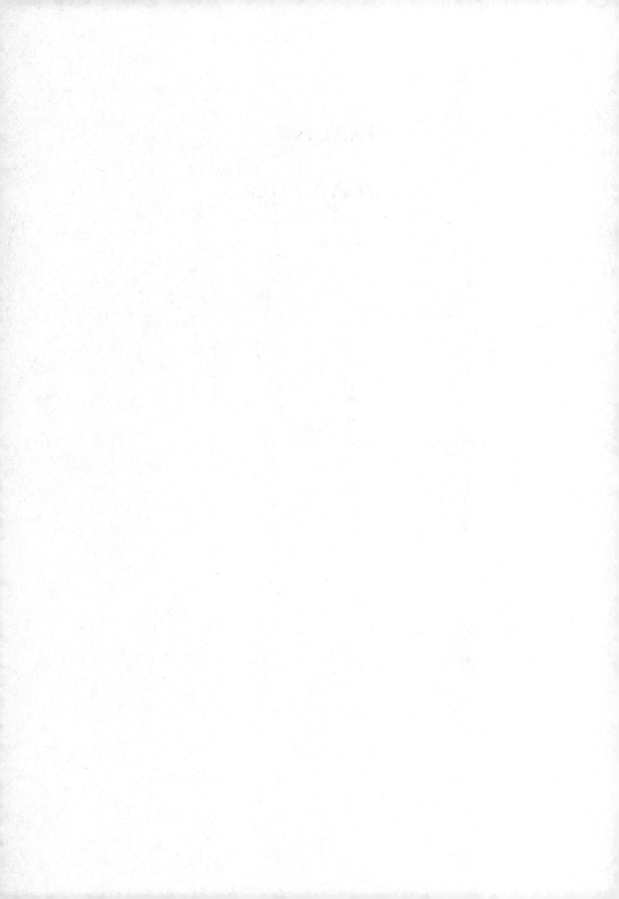

INTRODUCTION TO PART IV
Applied performance in Latin America

Paloma Carpio and Rodrigo Benza

To understand the practices of applied performance in Latin America, it is particularly important to take a look at three key moments or phenomena that date back to the Spaniards' arrival in the Americas. First, there is the colonial past and the indigenous peoples' ensuing struggle for justice and recognition. Second, and more recently, are the dictatorships suffered in several of the region's countries during the twentieth century, many of them backed by the United States. Finally, there is the 'internal violence' that occurred in countries such as Peru, Colombia, and Mexico, often tied closely to drug trafficking.

These and other factors have shaped societies, leaving them with a marked colonial heritage and a well-cemented patriarchal and authoritarian foundation. It is for this reason that recent decades have witnessed social, political, and cultural movements that have demanded different ways of exercising power, representing ourselves and relating to our surroundings and nature. For example, feminist, environmental, and cultural movements have been influential in the creation of contemporary applied performance expressions in Latin America.

Politico-historical context

Prior to the Spaniards' arrival in the Americas, there were a number of artistic expressions that blended dance, theater, and music, staged mainly during festivities or rituals. According to Juan Villegas (2005), both the Inca Empire—which dominated large swaths of South America—and the Mesoamerican cultures used theatrical manifestations connected to official rituals and ceremonies, which were often quite elegant and imposing, along with 'minor' expressions intended for leisure and enjoyment. With the arrival of the Spaniards, these performances were subjected to persecution, undergoing a process of syncretization that persists to this day. Even the church used these cultural manifestations to attract the indigenous population.

Luis Millones (1992: 15) presents us with a fragment of the edict issued by José Antonio Areche, a *visitador*, or royally appointed inspector, in which he attempts to prohibit theatrical functions in the Viceroyalty of Peru in the eighteenth century: 'Let there be no staging, in any town of your respective provinces, of comedies or other public functions, which are so often used by the Indians to commemorate their said ancient Incas.' Obviously, this edict never achieved its intended effect, but as Millones (1992) puts it, it reflects the belief of the colony's authorities regarding the potential 'danger' inherent in theatrical depictions of a glorious past.

The other strategy of conquest involved the use of local theatrical expressions to spread the message of the Conquista and the Catholic religion. From Mexico to Peru, the church used local songs and dances to evangelize the 'Indians,' as well as adapting dramas depicting the struggles between the Moors and the Christians, which featured the conquistadors and the local leaders as protagonists, with the action ending in a scene of reconciliation (Millones, 1992).

As noted by Miguel Rubio, director of the *Yuyachkani* group:

> During the Conquista and the colonial period, the exclusion of the indigenous peoples ... included the exclusion of their artistic and cultural practices. Even today, these processes cannot be said to have concluded. In the colonial mission, whatever could not be eradicated was incorporated so that the values of Catholicism could be internalized using the elements of representation found in dance, music, and images, which were later assimilated into great festive displays. This led to differing degrees of commingling and syncretism with which we coexist today, establishing the foundation for the encounter between pre-Hispanic and Christian elements in a conjunction of rites of varying provenance.
>
> *(Rubio Zapata, 2011: 17)*

On the other hand, the locals' performative expressions, festivities, and rituals often developed a political content of resistance during colonial times. According to the Peruvian anthropologist Gisela Cánepa (1998: 94), 'the political content of pre-Hispanic dances was likely camouflaged in two ways: in the form of clandestine performances or by participating in Catholic festivities through dance.'

The indigenous populace of the Americas was subjugated or exterminated by the European conquistadors. As a consequence, the development of our identity—even in the twenty-first century—is marked by racism and discrimination. Historically, the indigenous populations have been discriminated against or subjugated by the white elites, whether European or of European descent, who hold power. As a result, the resistance and struggle of the indigenous peoples is an important component of our identity.

During the nineteenth century, most of the countries dominated by Spain achieved their independence. However, this failed to change many of the internal dynamics, since power was assumed by the *criollos*, descendants of the Spaniards who were more concerned with their own economic benefit than developing any form of social justice. Meanwhile, the indigenous and black populations remained subjugated.

Against this backdrop of social fragmentation, two parallel lines of dramatic expressions developed: official manifestations, with a clearly European tendency; and popular and folk expressions, which were (are) considered of lesser importance. In Peru and other countries where the majority of the population are descendants of indigenous peoples (such as Mexico, Guatemala, Ecuador, and Bolivia), this has resulted in tensions that have highlighted the urgent need to incorporate an intercultural approach into the state's policies, and particularly its cultural policies.

These tensions resulting from the colonial legacy were further complicated during the twentieth century by the alternation between democratically elected governments and incessant civic-military dictatorships. Many of these dictatorships were supported or promoted by the United States government,[1] and clearly go hand-in-hand with the so-called development policies begun by President Truman in 1949 when he divided the world into 'developed countries' and 'underdeveloped countries' (Esteva, 1996).

In our region, there was (is) a subjugation, both cultural and economic, to the United States of America. Perhaps one of the clearest examples of this subjugation is 'Operation Condor,'[2]

which was supported or promoted by the United States with the goal of rooting out communism from the region. These authoritarian regimes, together with the need to form a resistance, led to a series of trends in the development of performance arts in Latin America, as discussed in Andrés Grumann Sölter and Francisco González Castro's text, '*Conflicto latente o latencia en conflicto. Campo liminal entre acciones de arte y dictadura cívico-militar chilena*' (Latent conflict or latency in conflict: the liminal space between art actions and the Chilean civic-military dictatorship).

The development of these right-wing authoritarian regimes occurred simultaneously, during the 1960s and 1970s, with the leftward politicization of part of the population, mainly the youth (which included members of the region's most emblematic theater groups, such as Yuyachkani, La Candelaria, Teatro Experimental de Cali, and others). Within the left-wing movement in Latin America, certain factions viewed armed resistance as the only way to free themselves from oppression. Such was the case with the Tupamaros in Uruguay or the Movimiento de Izquierda Revolucionaria (MIR) in Peru, organizations that were heavily suppressed by the authoritarian regimes, leading to deaths, disappearances, and serious human rights violations. The examples of Uruguay (1973–1985), Chile (1973–1990), Brazil (1964–1985), and Argentina (1976–1983)[3] are highly significant. However, other countries in Latin America, including Nicaragua, El Salvador, and Honduras, fared little better.

It was against this backdrop that internal armed conflicts broke out in countries such as Peru (1980–2000) and Colombia (1966–2012).[4] It could be said that there is a through-line from the inequalities fostered during colonial times to the military dictatorships and then to these conflicts, given that issues such as social inequity and racism cut across all of these phenomena and create gaps, making peaceful coexistence impossible.

Taking into account these events that have shaped Latin America as a region marked by inequality and violence, many current performance movements that seek to achieve effects beyond mere entertainment have worked to simultaneously inspire both resistance and hope. Resistance against oppressors (colonizers, the church, dictators, large landowners, etc.), which manifests itself in different performative expressions, goes hand-in-hand with a collective need to build a great Latin American fellowship with the hope of a better future, self-determined and sustainable for both human beings and nature. Accordingly, many artistic and cultural practices in Latin America today seek to vindicate ancestral principles such as *el buen vivir*, translated to 'living well' (*suma qamaña* in the Aymara language, and *sumaq kawsay*, in Quechua).

Based on a reference framework of historical factors that have shaped the identities and characteristics of Latin American societies, we propose certain focal points for analysis that will help illustrate the relationship between performative practices, and the political and social struggles in which they are rooted. These focal points are:

- Community theater/theater in the community
- Performance, memory, and politics
- Communal living culture
- The body

Obviously, these categories overlap to varying degrees in different performative practices. More than parameters, however, they are points of view that help us organize the different practices.

Community theater/theater in community

The concept of community in Latin America is directly tied to indigenous or peripheral populations. According to Gabriel Liceaga (2013: 66), 'In Latin America, the term *community* is typi-

cally associated with traditional, ancient, and rural ways of life. The poor neighborhoods or areas on the edges of cities are also often characterized as communities.'

Theater in communities in the region is closely tied to the construction of peripheral communities in cities consisting of migrants from the countryside or those displaced by violence. Groups such as *Corporación Cultural Nuestra Gente* (Medellin, Colombia) and *Vichama* (Lima, Peru) have been working for decades in their respective communities, using art to achieve better living conditions for people. The situation is different in Argentina, where the middle class has defended the concept of community, linking it to the reclaiming of 'the public' and fostering identification with common stories and memories that create a sense of belonging and shared struggle.

Regardless of the specific context of community theater groups, both their performances and the workshops and courses they offer to the community frequently include circus arts, music, painting, film, embroidering, sewing, and more. These groups' locales thus become a space for their communities' comprehensive cultural development.

Another characteristic is the value placed on local languages and issues. Each one of these groups, in their respective regions, values and promotes the artistic and cultural expressions of their members and the community—which, as we noted above, often consists of migrants or the children of migrants who continue to preserve the art of their places of origin. Therefore, memory and celebration are substantial components of the work done by groups that define themselves as 'community theater.'

In Edith Scher's text, '*Una mirada de la comunidad: teatro comunitario argentino*' (The community and its gaze: Argentine community theater), the author discusses this phenomenon in her home country. Community theater in Argentina is unique in that it is conceived as art made by neighbors, for neighbors. While she talks specifically about the Argentine phenomenon, several of the principles laid out in the text also apply to community art in the rest of Latin America.

Elsewhere, the experiences narrated by Rafael Murillo Selva of Honduras capture the richness and potential of community theater work; in this case, with a special emphasis on intercultural aspects.

Performance, memory, and politics

It is often said that performance is, in itself, a political act. However, there is a series of expressions that can be identified that is underpinned by an explicit intention of political positioning. In these expressions, there is a very clear character of resistance to the oppression exercised largely by the dictatorships that emerged in different parts of the world during the twentieth century, or the consequent implementation of economic and political models that restrict liberties and rights. These performing arts also sit on a clear continuum between entertainment and protest.

Throughout the twentieth century, there were dramatic expressions and theatrical texts with a political undertone, critical of the system, such as those staged by Leónidas Barletta and *Teatro del Pueblo*, founded in 1930 in Argentina; or the works of Leónidas Yerovi (Lima, 1881–1917) and Rodolfo Usigli (Mexico City, 1905–1979). However, the 1960s saw the rise of a profoundly political theater, with the emergence of the collective creation movement in Latin America. This movement sought to develop its own languages, methodologies, and themes, always with a deep commitment to the social role of the performing arts. Miguel Rubio offers the following description:

> To find the connections that permit us to talk about a Latin American theater, we have to take a critical look, with as few prejudices as possible, at our nearly forgotten recent

history. There, we can see how the great force and vitality of our theater was essentially founded on the unprecedented confluence of movements led by actors, authors, directors, playwrights, and artists from all disciplines. The group was the stem cell in which we organized ourselves for this new theatrics for which we were crying out, one that had to reflect the times we were living in, with its prevailing collective sentiment. This happened in parallel with other creative areas that were beginning to show signs of their impassioned presence, such as the so-called boom of Latin American literature, along with dance, the new Latin American cinema, photography, documentaries, the visual arts, etc. This, it should be noted, was an aesthetic and fundamentally political event, situated against an intense political and social backdrop. Whether explicitly or not, artists were reflecting the hopeful call to action of our peoples, who were determined to take the reins of their history. And there we were, the theater people, beside them all, and not by accident, 'inventing auroras,' as it is put in a popular Nicaraguan song of the time.

(Rubio Zapata, 2011: 13–14)

Today, throughout Latin America, there are many liminal political performance experiences. The Cuba-born, Mexico-based researcher Ileana Diéguez is one of those who has perhaps done the most investigation in this area. In her book *Escenarios Liminales: Teatralidades, Performatividades, Políticas* (*Liminal Stages: Theatrics, Performativities, Politics*), she examines a series of performative manifestations in different countries that are not only aesthetically developed, but aim to achieve an impact on the social sphere. According to Diéguez (2014: 18), these practices 'are not necessarily based on or intended to represent a previously composed dramatic text. Rather, they are conceived of as experimental theatrical and performative writings, tied to investigative processes, on the fringes of the theatrical, exploring strategies of the visual arts within the tradition of independent art, unrelated to official institutional undertakings.'

Publications such as Dieguez's *Escenarios Liminales* (2014), *Performance y Arte-Acción en América Latina* (*Performance Art and Art-Actions in Latin America*) (2005) by Josefina Alcázar and Fernando Fuentes, or *Perspectivas Políticas de la Escena Latinoamericana. Diálogos en Tiempo Presente* (*Political Perspectives of the Latin American Scene: Dialogues in the Present Tense*) (2017) by Lola Proaño-Gómez and Lorena Verzero offer various examples of these types of political performances that have been developed in the region.

One interesting characteristic of these performances is the use and transgression of symbols such as the national flag. In Peru, the *Sociedad Civil* collective put on the civic performance *Lava la Bandera* (*Wash the Flag*) near the end of the Alberto Fujimori government (2000). This performance consisted of washing the flag in fountains in public squares to symbolize the need to cleanse the country of corruption and crimes against human rights.[5] In Argentina, on July 9, 2002, the *Arde!* collective put on the *La Bala Bandera* (*The Flag Bullet*) performance to protest the suppression of demonstrations in 2001. For this performance, the group dyed a public fountain red and submerged Argentine flags in the water, turning their white and sky-blue colors red.[6] In Venezuela, in 2003, an artistic activity was carried out in which the 'Venezuelan flag was dyed black, a flag of mourning for the innocent who have been murdered at each march or gathering of those affected by the government' (Zerpa, in Alcázar and Fuentes, 2005: 45).

Those engaged in political performance art, or those whose theatrical activities are infused with a political intent, on the other hand, place great importance on memory. They seek to reconsider and re-symbolize the oppression of the colonial era, for example, or lay bare the ways in which discourse and history have generally been forged by the voice of the conquerors, by those who wield power. Here, works such as those of the *Yuyachkani* group or the community works by the Honduran teacher Rafael Murillo Selva are of particular interest.

Communal living culture

A critical gaze on the situation in Latin American and the urgent need to foster processes of transformation 'from the bottom up,' as suggested by Célio Turino (Brazil, 2009) in his book *Ponto de Cultura: O Brasil de Baixo Para Cima (Culture Points: Brazil from the Bottom Up)*, has been taken up by a broad range of organizations and people who are demanding action and reflection centered on 'communal living culture' (or CVC for its acronym in Spanish). This concept emerged as a response to the way in which the market and the colonial past have created inequality and rendered peoples invisible. In a world where bonds with others have become fragile, where individualism and competition are upheld as the formula for subsistence, the CVC movement seeks to recover the 'common good,' linking cultural action with political influence. As explored by Nogales and Carpio in '*CULTURA VIVA COMUNITARIA de más a menos, de menos a más*' (Communal Living Culture: From the Many to the Few, From the Few to the Many), CVC seeks to help imagine and construct 'other possible worlds,' in an effort to establish a harmonious balance between ancestral knowledge, contemporary artistic practices, education, and communication. In the words of Célio Turino:

> Communal living culture extends throughout Latin America as a macro-network in which community cultural groups use their emotions, hopes, and wills to forge a vast interconnected network. Although it is macro, it is also micro at the same time, carried out in communities in an effort to identify and strengthen 'points of culture.' This combination of micro and macro permits an exponential reproduction of the contacts and affinities between different points, each one with its own characteristics, opening new pathways and interlinking multiple functions, harmonizing culture with economics, education, and new forms of relations between state and society, more balanced and placed in the service of life.
>
> *(Turino, 2017: 184)*

This articulation of collective cultural processes marked by their diversity seeks to influence public issues and forms of political representation, encouraging the empowerment and prominence of people organized collectively through culture. With the influence of revolutionary practices such as the theater of the oppressed, community theater, and many other emancipatory cultural expressions, CVC occupies a necessary place in the cultural debate, which—in Latin America—has been rooted in the hegemonic, exclusionary gazes of the culture industry, the fine arts, and patrimony. For this reason, CVC is based on an understanding of culture as a process and not a product. As declared by the 'Pueblo Hace Cultura' collective in Argentina, 'The market produces commodities. The people make culture.' Based on collaborative logics of exchange and creation, communal living culture is an integrative concept that encompasses different practices, which are brought together and developed with the shared goal of seeing ourselves as a community and as agents for the transformation of reality.

To conclude the introduction…

The body is the protagonist of all these practices. A body that, even today, is perceived as colonized, not only due to the colonial legacy, but because of the repression of freedom at all levels. As Alcázar and Fuentes (2005: 11) put it, in performance art, 'the body expands its meaning, becoming metaphor and matter, text and canvas, raw material and product, signified and signifier.'

Augusto Boal once said that 'the first word in theater's vocabulary is the human body, the primary source of sound and movement' (Boal, 2009: 24). Similarly, Miguel Rubio sug-

gests that 'the actor's body is the place where the stage is concentrated, from which it is born' (Rubio Zapata, 2008: 35). Bearing in mind that bodies in Latin America are also charged with memory and violence, performative action is needed to turn them into political, community-based bodies; bodies that incarnate and carry out actions aimed at creating an impact on the public sphere, in pursuit of social justice, that longed-for concept that is still, in our societies, a utopian idea.

Conscious of the challenges inherent in any discussion of applied performance practices in the region and the importance of retelling history through a diversity of stories, we have worked hard, in this section on Spanish-speaking Latin America, to achieve a balance, both in geographic terms and in regard to the authors' experiences and genders.

The text authored by Edith Scher (Argentina), '*La mirada de la comunidad. Teatro comunitario argentino*' ('The community and its gaze. Argentine community theatre'), presents the development of this movement, which emerged in 1983 at the end of that country's dictatorship, as part of neighbors' need to recover the public space, to express themselves and speak out, creating a form of theater that was made by neighbors, for neighbors. This rootedness in community is also found in the texts by Rafael Murillo Selva (Honduras), '*Tres experiencias comunitarias y una renuncia*' ('Three community experiences and a resignation'), which present three different experiences: one in which the director and playwright worked with groups of youth from three different cultures on the issue of HIV; one involving the creation of a montage based on memory in a mining community; and one involving work with Garifuna women.

With regard to political performance art, we have the text by Andrés Grumann Sölter and Francisco González Castro (Chile), '*Conflicto Latente o latencia en conflicto. Campo liminal entre acciones de arte y dictadura cívico-militar chilena*' ('Latent conflict or latency in conflict. The liminal spaces between art actions and the civil-military dictatorship in Chile'), in which the authors present and reflect on different performative experiences of resistance against the Pinochet dictatorship in Chile.

An emphasis on the body can be found in the text by Ana Carolina Ávila (Colombia), 'Dance as an instrument for the construction of peace and identity,' in which she presents two dance experiences: one with ex-members of the FARC guerrilla group as a space for social reinsertion, and the other with municipal schools in Colombia. Both share the underlying idea that working with the body offers enormous potential for development and transformation. Along these same lines, we have the text by Josefina Alcázar (Mexico), '*Cuerpo, mujeres y performance en América Latina*' ('The body, women and performance in Latin America'), in which she presents different performances put on by women in the region under the slogan of 'The personal is political.'

Finally, we present the text by Iván Nogales (Bolivia) and Paloma Carpio (Peru) titled '*Cultura Viva Comunitaria. De más a menos, de menos a más*' ('Communal Living Culture. From the many to the few, from the few to the many'), which examines the foundations of this continent-wide movement that seeks to forge networks which vindicate our identity, using art to create hope.

Before ending this introduction, a special tribute must be paid to Iván Nogales (1963–2019), who sadly passed away while we were putting this publication together. We would like to take this opportunity to share, and second, the words of the members of *Teatro Trono*, the group that Iván founded in El Alto (a suburb of La Paz, Bolivia), which were published on March 21, 2019—the day of Iván's death—on the group's Facebook page:

> The continents weep over your loss and thank you immensely. You have changed our lives and left us with many tasks yet to be done; wonderful tasks that we will carry out

with our hearts, aiming high, because we are idealistic, mad beings with 30 years of education, of cultivation. Now we are all grown up, Ivancho. Now we are old geezers, just like you used to say to us. Now we must continue on with our consistent and coherent actions, with loving languages that change lives. You have left behind a strong foundation, hardy roots, because you have touched our hearts. You have healed our bodies through art, with your crazy passion for making dreams come true. Through your actions and your experiences, you have raised our political consciousness. And so it should be, TEACHER. May your path be joyous, may the heavens quake with the reunion of two great guerrilleros, your father Indalecio and you. Now you can rest peacefully, because each one of us carries you inside us.

#TheStruggleContinues

Notes

1 Venezuela 1948/2000, Paraguay 1954, Guatemala 1954, Dominican Republic 1963, Argentina 1966/1976, Bolivia 1971, Uruguay 1973, Chile 1973, Panama 1989, Peru 1992, Haiti 2004, Honduras 2009.
2 'The military governments of Latin America organized Operation Condor to carry out assassinations and so-called "hunt and kill operations," which were intended to silence political opponents who had fled their countries of origin' (McSherry, 2012: 33–34).
3 While there were other periods of dictatorship, these are the most notable due to their human rights violations.
4 Although these are the 'official' dates for both conflicts, in which war was waged between guerrilla or terrorist groups such as the Shining Path or the MRTA (Peru) or the FARC (Colombia) and the state, guerrilla activities and skirmishes had been occurring for decades, rooted in a refusal to accept the different states' regimes, many of which were authoritarian. In both countries, the violence continued in a number of ways even after the official end dates of the conflicts.
5 See Diéguez, 2014.
6 See Vasquez, 2013.

References

Alcázar, J. and Fuentes, F. (2005). *Performance y Arte Acción en América Latina*. Mexico City: Ediciones sin nombre.
Boal, A. (2009). *Teatro del Oprimido*. Barcelona: Alba Editorial.
Dieguez, I. (2014). *Escenarios Liminales: Teatralidades- performatividades- políticas*. Mexico City: Paso de Gato.
Esteva, G. (1996). "Desarrollo". In Sachs, W. (ed.). *Diccionario del desarrollo. Una guía del conocimiento como poder*. Lima: PRATEC.
Liceaga, G. (2013). "El concepto de comunidad en las ciencias sociales latinoamericanas: apuntes para su comprensión". *Cuadernos Americanos Nueva Época*. Universidad Nacional Autónoma de México, 3-2013, pp. 57–85.
McSherry, P. (2012). "La maquinaria de muerte: la operación condor". *Taller (Segunda Epoca). Revista de Sociedad, Cultura y Política en América Latina*, 1(1), pp. 33–45. Available at: https://www.researchgate.net/profile/Caroline_Bauer2/publication/265728995_O_controle_sobre_argentinos_no_Brasil_e_brasilenos_na_Argentina_vigilancia_e_repressao_extraterritoriais/links/541a3ed10cf25ebee9888c21/O-controle-sobre-argentinos-no-Brasil-e-brasilenos-na-Argentina-vigilancia-e-repressao-extraterritoriais.pdf#page=35.
Proaño-Gómez, L. and Verzero, L. (comp.) (2008). *Perspectivas políticas de la escena latinoamericana. Diálogos en tiempo presente*. Buenos Aires: Argus-a, 2017.
Rubio Zapata, M. (2008). *El cuerpo ausente (performance política)*. Lima: Grupo Cultural Yuyachkani.
Rubio Zapata, M. (2011) *Raíces y Semillas. Maestros y caminos del teatro en América Latina*. Lima: Grupo Cultural Yuyachkani.
Turino, C. (2009). *Ponto de Cultura: O Brasil de baixo para cima*. Brazil: Ed. São Paulo: Anita Garibaldi.

Turino, C. (2017). *Cultura a unir as povos: a arte do encontro*. São Paulo: Instituto Olga Kos.
Vasquez, C. (2013). "Performances artísticas callejeras en Argentina y Perú. Dinámicas del arte y la intervención política en contextos recientes de crisis económica y sociopolítica". *Universidad de Málaga: Arte y Sociedad revista de investigación*, No. 5, October 2013. Available at: http://asri.eumed.net/5/dinamicas-arte.html.
Villegas, J. (2005). *Historia Multicultural del teatro y las teatralidades en América Latina*. Buenos Aires: Galerna.

22
THE BODY, WOMEN, AND PERFORMANCE ART IN LATIN AMERICA

Josefina Alcázar

Introduction

After emerging in the second half of the twentieth century, performance art has grown to encompass a complex and heterogeneous spectrum of art that transcends artistic boundaries and disciplines in search of new languages, new spaces, and new materials with which to create unprecedented experiences that emphasize the process of creation and conceptualization, using the artist's body as its raw material. Amelia Jones notes that,

> through history, artists have drawn, sculpted, and painted the human form. Recent art history, however, reveals a significant shift in artists' perception of the body, which has been used not simply as the 'content' of the work, but also as canvas, brush, frame, and platform.
>
> *(Warr and Jones, 2000: 11)*

In Latin America, performance art gained momentum in the 1970s, and has spread far and wide in the region ever since. Each country has its own particularities, and performance art—or action art, as it is also known—treads its own path in each one of them. A look at the work being done by artists in Latin America reveals the plurality of methodologies and approaches used to address a broad and heterogeneous set of themes, from discrimination, sexism, religion, love, sexual repression, and marginalization, to pain, identity, dreams, racism, death, and art itself. In each era and in each country, artists have emphasized and addressed these subjects according to specific circumstances.

The 1960s and 1970s were marked by political turmoil and burgeoning social movements fighting for democracy across the Americas. Some countries were under the control of military dictatorships or undemocratic governments. In response, there arose student movements, protests for workers' rights in the countryside and the city, feminist struggles, and demonstrations against the Vietnam War. It was in this social context that performance art developed, often going hand-in-hand with political movements. It is perhaps because of this that the political current within Latin American performance and action art has been so forceful, serving as a vehicle for expression and condemnation in an effort to open up the political debate.

One of the most significant traits of performance art has been the manifest inclusion of many female artists. Performance art has played an extremely important role in all kinds of protests,

and especially in the struggle for feminist demands. It has become increasingly clear that the problems women face are not personal, but rather social in nature, as expressed in the famous slogan, "The personal is political." This immediacy and direct confrontation with the public has allowed artists to freely express their discourse without being subjected to traditional cultural patterns. The performance artist's body is the work's supporting medium; as both a means and an end, the body is simultaneously an artistic creator and creation. By taking elements from everyday life as their working materials, performance artists explore their personal, political, economic, and social problems. They reflect on art itself, on the artist's role, and on the product. They analyze its limits, its scope, and its objectives. They question the separation between art and life, as they establish a complex relationship with the audience. The various strategies that performance artists use to stimulate reflection and revitalize public awareness are multiple: They often play with paradox and contradiction, with pastiche and juxtaposition of images and objects to subvert the ideas and concepts they question. Parody, irony, and recycling become means of resistance and transgression. Performance artists become perception researchers due to the relationship established with the public, a relationship that the artist determines when establishing perception strategies that are fundamental in performance art. The artists wonder what the limits of the spectator are—their powers of attention, empathy, rejection, and boredom. They wonder what interest the viewer has for colors, smells, movement, and sound. Artists use various resources, such as deceleration, repetition, deconstruction, duplication, or resignification. What the artist seeks is to alter the public's perception to force them to reflect. In performance art, artists present *themselves*. In this action in real time, they turn their body into signifier and signified, into object and subject of the action. Performance art allows us to experience the moment. It is an artistic expression in which immediacy takes on significance. The artist's body cannot be separated from its social context. It is a symbolic body that expresses problems tied to identity, gender, and politics. We cannot speak of "the body" in general without mentioning the social and cultural conditioning that shape human corporeality. The body is a symbolic structure that is socially constructed.

In authoritarian societies in which even desire itself is repressed, it has been essential to address taboo topics. The transgression of a hypocritical and vicelike moral system forms one extremely important movement within performance art. The body broadens its meaning, becoming metaphor and material, text and canvas. The exploration of the body and the search for a free sexuality is addressed from the standpoint of feminism, the lesbian/gay struggle, the questioning of religion, and an examination of public and private behavior, all of which are significant subjects in autobiographical and intimate performance art. By probing and exploring the body, some seek the exaltation of the senses, taking the body to its physical limits.

The ritual aspect is also very important in Latin American performance art. The recovery of ancient traditions, religious ceremonies, and shamanic acts are themes that are encountered time and again. The subject of identity is frequently addressed in relation to ethnocultural roots, revisiting the imagery and cosmogony of our ancestors, as found in actions performed in Cuba, Brazil, Mexico, and Venezuela, which contain strong echoes of the past, presenting the body and its relationship to the supernatural. A sacred space is created, incorporating elements pregnant with mystical significance, such as blood, earth, water, flowers, candles, and copal wood. For example, in Cuba, the strong presence of African culture is retaken in the performance art and this is observed in the frequent use of voodoo rites and symbology. In Mexico, for example, it is common to use these elements to talk about the pre-Columbian origins of the country.

But the rites not only refer to traditional acts that deal with the sacred, but secular rituals also appear. By going beyond the religious sphere, the concept of ritual has expanded. Artists create their own rituals to face the dangers, tensions, losses, fears, and conflicts either personal or that

affect society or a part of it. When the channels to perform the rites of passage are rusty and worn out, the artists lead collective rituals that allow them to feel some control over conflicting situations, such as artists in Mexico or Colombia who organize rituals for the mothers of daughters or sons killed by organized crime.

Identity in Latin America is assembled by the different groups that comprise it: The indigenous inheritors of pre-Columbian civilizations; those of African heritage; the *mestizos*; the *criollos* with their European roots; and nowadays, the emerging identities shaped by migratory movement and the crossing of national, cultural, and linguistic boundaries, such as Latinos in the United States. To recover the cultural legacy of these groups that form part of our identity, performance artists not only make use of rites, but popular celebrations and games. Thus, for example, they have revived the imagery of carnival, circus, carpa (Mexican vaudeville), lucha libre (Mexican wrestling), *merolicos*[1], and town criers. Action art, ritual, and healing are combined in tribal actions, in a neo-primitivism that uses the body as a space for transformation and experience.

Women and violence

One of the most profound changes in performance art over the last 20 years has been the marked inclusion of many female artists. Performance art has played a very important role in all sorts of protests, and especially in the struggle for feminist demands. Sexual harassment, domestic violence, the kidnapping of women, and femicides have risen in recent years, or maybe now they are actually being reported when previously they went unnoticed. The facts and figures are devastating. In Mexico, for example, over 23,800 women have been murdered in the last ten years, according to the National Citizen Observatory on Feminicide (Reina, 2018). More than seven women are murdered every day. Between January and August 2019, under the López Obrador government, 2,504 women were murdered in the country, according to National Public Safety System data. It is for this reason that many female artists have joined the struggle to condemn this barbarity (Aguilar, 2019).

Back in 1978, Mónica Mayer (born in Mexico, 1954) created the piece *El Tendedero* (The Clothesline) to provide women with an outlet for denouncing the sexual harassment they had experienced at some point in their lives (Alcázar, 2014). After erecting a clothesline, Mónica gave women pieces of pink paper so they could write down the gender violence they had suffered, and then she asked them to hang the piece of paper on the clothesline. The clothesline was soon filled with stories of harassment and gender violence suffered by the women over the course of their lives. In 2016, Mayer launched the campaign *Mi Primer Acoso* (My First Harassment), and *El Tendedero* began to be replicated everywhere, both in Mexico and abroad. Later, the Time's Up or Me Too[2] movements burst onto the scene in various countries. Women have also risen up to the cry of the ¡*Ni Una Más*! (Not Even One More) movement.[3]

Many women create performance art to denounce gender violence. This has led to an intensified relationship between performance art and activism over the last 20 years, in a fusion known as "artivism." For example, Lorena Wolffer (born in Mexico, 1971), a noted performance artist, makes artivism to fight violence against women. In 2002, at the Museo del Chopo in Mexico City, she presented the performance piece *Mientras Dormíamos* (*El Caso Juárez*) (While We Were Sleeping [The Juárez Case]), where she used her body to speak out about the hundreds of women who have been murdered or gone missing in Ciudad Juárez, a city in northern Mexico, on the border with the United States. Wolffer turned her body into a symbolic map, using police reports to document and narrate this violence through 50 murders. Rather than focusing on her own personal story, the artist instead gave a voice to those who have none,

acting as a chronicler who condemned what had happened to other women. Using a surgical skin marker, she pinpointed on her body the location of each one of the blows, cuts, and bullet wounds suffered by these women, drawing on her own body the marks of the violence exerted against women.

Despite the national and international outcry, very few of these cases were solved. Worse yet, the problem persists. From 2008 to 2017, a total of 8,495 women were reported missing across Mexico. From 2008 to 2017, 4,230 women were victims of human trafficking, of which 466 were minors, according to the National Citizen Observatory on Feminicide. This violence against women in Mexico is not an isolated case; unfortunately, it is also found in many Latin American countries.

In addition to violence against women, there is the violence caused by drug trafficking. Hitmen, kidnappings, torture, mutilation, murders, missing persons, protection rackets, hangings and decapitations, victims drawn, quartered, and skinned: all these terms have sadly become part of our everyday language, expressing the tragic situation of desperation and anguish experienced in many Latin American countries. This terrible panorama has been denounced, in many cases, through performance art. In 2007, Rosa María Robles (born in Mexico, 1963) began her series *Navajas* (Knives) with the piece *La Alfombra Roja* (The Red Carpet), made from eight blankets stained with the blood of drug trafficking victims. Robles calls on us to reflect on the violence that is now battering Mexican society, shocking and provoking the spectator, confronting us and reminding us of the situation of social and moral deterioration in which we live.

In the actions of Regina José Galindo (born in Guatemala, 1974), the artist addresses violence against women, torture, the abuse of power, and social injustice. She takes her body to the limit to convert it into a condemnation of Guatemala's reality. In 1999, in *Lo Voy a Gritar al Viento* (I'll Shout It to the Wind), Galindo suspended herself from the famous arch of the post office building, from where she recited her poems, casting them into the air. In her work *Perra* (Bitch or Slut), from 2005, Galindo appears dressed in black, seated in a chair. Using a knife, she carves the word "perra" into her thigh. When gangs in Guatemala murder women, they tattoo messages on their bodies such as "Here lies this bitch" or "One less bitch." In 2003, in *¿Quién Puede Borrar las Huellas?* (Who Can Erase These Traces?), Regina walked from the Constitutional Court to the Presidential Palace carrying a washbasin filled with blood, in which she soaked her bare feet so that she could leave behind traces of the violence suffered by women.

The reaction of the spectator who faces this type of performance is very diverse. On the one hand, there are audiences who identify with the artist, and feel her pain and become indignant; these people are aware of the aggressions suffered by women, know the violence they live in, and sympathize with the complaint. On the other hand, there is a minority of spectators who get upset when they are exposed to the pain of others and do not identify with the artist; they would rather not see and they move aside.

Stereotypes and socially imposed roles

Today's cultural boundaries are no longer clearly defined by geographic borders. To use Zygmunt Bauman's term, we might say they are "liquid boundaries." Many Latin American artists currently reside in the United States, where California is home to the city with the second-largest population of Mexicans or people of Mexican descent. Nao Bustamante (born in California, United States, 1969) is a Chicana[4] artist who works in both the United States and Latin America. Karina Hodoyán (2005) has written that Bustamante uses her body as a source of image, narrative, and emotions in performances that communicate a subconscious language, leading the spectator through an experience of estrangement that shatters all stereotypes or conventional readings. In

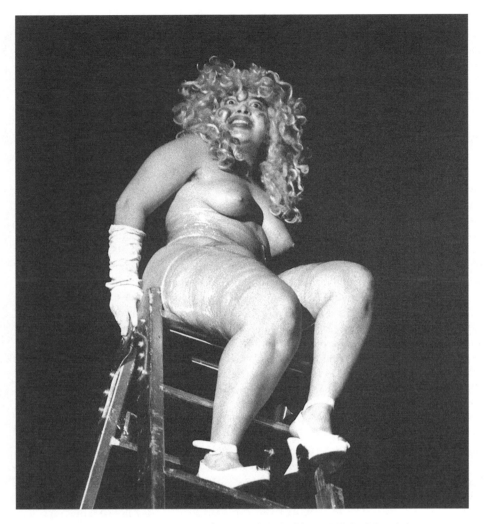

Figure 22.1 Nao Bustamante in *America the Beauty* (1995). (Photo: Mónica Naranjo.)

America the Beautiful, Bustamante employs a grotesque and sarcastic tone to challenge imposed stereotypes of beauty. Climbing a ladder—a metaphor for success—while donning a flowing blond wig and wearing exaggerated makeup, ultra-high heels, and white gloves, with her naked body covered in meat-wrap film, she turns the ascent into a dangerous adventure that traps the spectator between tension and laughter (Hodoyán, 2005: 72). This challenging of women's stereotypes and assigned roles is a recurring theme in many performances. (Figure 22.1.)

Everyday life

In recent years, women's work in art has placed renewed value on the everyday. Antonieta Sosa (born in 1940), winner of the Venezuelan National Visual Arts Prize in 2000, is an artist whose works focus on the gestures of day-to-day life. In 2003, she presented the performance piece *Tejido Amarillo, Azul y Rojo al Infinito* (Knitting Yellow, Blue, and Red Forever), in which she used two

needles to knit and unknit an extremely long scarf with the colors of the Venezuelan national flag, suggesting the need to sit down and patiently knit together the country. Here, Sosa makes use of the stereotypically feminine activity of knitting in order to revalue and reframe it (Zerpa, 2005: 42).

In Colombia, María Teresa Hincapié (born in Colombia, 1956–2008) was initially involved with the world of theater, but later became an outstanding performance artist. Her actions involve a powerful intertwining of art and everyday life, addressing the problems faced by women and the world around them, a world that the artist analyzes by extending time, slowing it down to create an oppressive atmosphere. Hincapié won first prize in the Salón Nacional de Artistas in 1990 with the performance *Una Cosa es Una Cosa* (A Thing Is a Thing), an eight-hour piece that made waves internationally. This paradigmatic work addresses the relationship between art and life that characterizes all of María Teresa Hincapié's oeuvre, consisting of the silent, methodical, and obsessive arrangement of everyday objects over a large area for a seemingly interminable length of time. José Roca explains how Hincapié brought all of her belongings to the exhibition space and proceeded to organize them based on different, unpredictable patterns. Each object, no matter how humble it might be, is treated with the same concentrated, individual energy, infusing it with an aura of an almost precious nature. The relationships between the objects begin to emerge spontaneously in a chain of associations based more on our real experience of things than on their formal or functional characteristics, which is the way we habitually tend to categorize them. The spiral of things that is gradually created over the endless duration of the action brings to mind the cyclical and reactionary nature of time, the repetition of actions and gestures, always different but strangely familiar (Roca, 2008). Among the objects that surround Hincapié's daily life, and that she tenaciously organizes, we find shoes, plates, dresses, a bag of flour, paper bags, lipstick, a packet of salt, boxes, combs, toothpaste, cloth to shake, a bag of sugar, pajamas, toothbrushes, skirts, a blanket, slippers, scarves, pots, t-shirts, a pan, an eyeliner pencil, and many other things. By giving visibility and value to objects, she makes visible and resignifies the daily work of women; denouncing the role society has assigned them and, at the same time, dignifies it. To do this, she uses different strategies, such as repetition, deceleration, and duration, giving each object a specific value. The dialogue she establishes with the objects changes as she orders them: Sometimes by size, sometimes by color, sometimes by the material they are made of, and repeats this task for a full day, making the monotony of domestic work evident. Each object has a place, either in the center, in the corner, next to, closer to, or further from. Each time she organizes them, a different design appears, a different order. She emphasizes the importance of valuing the objects with which we interact, reassessing the actions we do every day. Hincapié makes visible and resignifies what goes unnoticed.

María José Arjona (born in Colombia, 1973) is a disciple of María Teresa Hincapié and Marina Abramovic, and her actions tend to be drawn-out processes that occur over long periods of time. Her intent is to analyze time and its effects on the body; the time necessary to rebuild, to pick up the pieces, to keep a memory alive. Arjona believes that performance art, despite its ephemeral nature, leaves us with an experience that lasts a lifetime. Natalia Roldán Rueda explains that,

> Arjona trained her body and her mind to remain standing for hours, barefoot, on an enormous block of ice filled with tacks that continued to melt with each passing second. She also kept her balance, shoeless, standing on six glasses filled with water; she held a diamond in her mouth while the audience did everything imaginable to try and remove it; she spent entire days blowing bubbles against a wall without losing her breath.
>
> *(Roldán Rueda, 2018)*

Through her work, Arjona reflects on the time necessary to rebuild Colombia's social fabric, which has been torn apart by violence, kidnappings, terrorism, machismo, drug trafficking, and guerrilla warfare.

Art and the media

Marta Minujín (born in Argentina, 1941) is internationally recognized as a pioneering performance artist. The Argentine essay writer Rodrigo Alonso notes that Minujín absorbed hippie culture and the theories of Marshall McLuhan in the United States, leading her to extol the mediatization of everyday experience and submerge the spectator in the hyper-fragmented visual universe of the mass media (Alonso, 2005a: 78).

The first of such works was *Simultaneidad en Simultaneidad* (Simultaneity in Simultaneity), performed in 1966, together with Allan Kaprow (in New York City, United States), Wolf Vostell (in Cologne, Germany), and Minujín (at the Instituto Torcuato Di Tella in Buenos Aires, Argentina). Each one of the three participating artists organized a happening that the other two were supposed to replicate on the same day and at the same time in their own countries. The result of the simultaneous actions was transmitted via the Early Bird[5] satellite to the three countries. Rodrigo Alonso states that for this action, Minujín invited 60 guests, who were then bombarded with every possible medium available: They were filmed on closed circuit television, they received instructions via radio, and they were recorded and photographed. Eleven days later, the same people were confronted with the images of themselves taken at the first gathering. Sixty television sets were set up in the auditorium of the Di Tella, while slides were projected on the side walls and a film was projected on the stage. At the same time, 500 telephone calls were placed and 100 telegrams were sent to spectators watching the recording of the event transmitted by television with the message, "You are a creator." Minujín plays with the idea of the spectator transformed into a media personality who observes himself, at a point in time when everything has become a spectacle (Alonso, 2005b).

In Brazil, which has a long tradition of avant-garde art, Lygia Clark (born in Brazil, 1920–1988) explored the displacement and deconstruction of the concepts of artist, work, and spectator. Clark's intent is to get spectators to cease being passive, instead turning their relationship to artworks into a personal experience. Later on, she would turn the spectator into a "patient," with her work situated between art and the medical clinic. She was interested in doing away with the dominant way of looking at art and helping spectators to recover a critical gaze.

By breaking down barriers between the artist and the spectator, Clark explored the multiple meanings of the body. Guy Brett notes that she anticipated current preoccupations with the body and examined the relationship between art and society. She explored sensory perception and its psychic correlation, which she referred to as "rituals without myth." Traditionally, the artist sends a message and the spectator receives it through the work of art, which is perceived using the sense of sight. Typically, art is received through sight, isolated from the rest of the senses and independently from the body as a whole (Brett, 1994: 59). Clark sought to change the role of not only the artist, but the spectator and the mediating work of art.

Ritual

In Cuba, performance art is infused with distinct ritual overtones, as found in the work of Tania Bruguera (born in Havana, 1968). In 1997, Bruguera began one of her most controversial and well-known series, *El Peso de La Culpa* (The Burden of Guilt), at her house in Old Havana, after her work was rejected for inclusion in the Sixth Havana Biennial. As part of this action, she

opened the doors of her house to the public, allowing the international crowd that went to see the work to mingle with neighbors and locals.

Barefoot, dressed in white, Bruguera stood in front of a Cuban flag that she herself had made from human hair. On her chest there hung a headless lamb, as if it were a shield. On the floor was a flowerpot with soil in it and a bowl filled with water. Bruguera would grab a handful of dirt, mix it with water, and then proceed to slowly eat it with an attitude of resignation and resilience over the course of 45 minutes. According to José Ramón Alonso, the flag situates the action in Cuba; the lamb is a symbol of sacrifice, although it also expresses innocence, submission, docility, indulgence, and clemency; "to eat dirt" is a Cuban idiom meaning to suffer from a lack of economic prosperity, which the artist appears to take literally. The action also recalls a rite of purification associated with the imaginary of local syncretic religions. In the end, concludes Alonso, it is art all the same, with a polysemic facet that allows Bruguera to achieve the most dissimilar of interpretations (Alonso, 2006). The use of rituals in performance art is quite widespread in Latin America.

Conclusion

Performance artists in Latin America have converted the female body into an expression of freedom, a rebellious act in societies that have traditionally repressed it and, in many cases, reduced it to a sexual object. In Latin American performance art, different approaches, varied strategies, and multiple schools coexist. In these diverse proposals and aesthetic tendencies, the body becomes a space of resistance and a means of expression, a site for experimentation and exploration. The artist's body expands its meaning. But within this multiplicity, there are clear commonalities marked by the spirit of the time, which transcend borders and languages.

Performance art establishes a complex relationship with the audience because what artists are looking for is to make the viewer reflect. Through different strategies, the artist tries to disturb the public, remove them from their comfort zone to awaken their conscience. Sometimes they are invited to be part of the action, but what the artist wants is to provoke the public, scare them, or annoy them to make them reflect, to shake their consciences. For this, the artist generates fear, disgust, morbidity, surprise, even boredom, and in this way, it makes the public doubt about their certainties and question everything, even art itself. The influence of performance art today is undeniable. Its reverberations can be found in the theater and in visual arts, in dance, video art, and literature, but also in politics, on the television, in advertising, and in protests. In other words, performance art has not only permeated the arts, but all of culture. Performance art has acted as a passport that has allowed female artists to submerge themselves in the unknown, undertaking journeys into themselves and their surroundings, making discoveries within and without. Bodies that take all of the senses to their limits in an effort to once again awaken them to life. Rites of passage, the initiation of a new state of consciousness.

Notes

1 The *merolico* is a street vendor who attracts passersby with a charlatanic sales pitch.
2 "Me Too" and "Time's Up" are women's movements against sexual harassment that emerged in 2017 and 2018, respectively, as a result of the sexual assault allegations made against the US movie producer Harvey Weinstein, causing an international impact.
3 In countries such as Peru and Argentina, the "*Ni Una Menos*" movement arose in much the same spirit.
4 The term "chicano" is used to refer to Mexicans who live in the United States.
5 Early Bird was the first commercial communications satellite, launched into orbit on April 6, 1965. This historic event allowed an estimated audience of 400 to 700 million people to watch the Beatles perform "All You Need Is Love" as part of the first live satellite transmission, broadcast to 24 countries.

References

Aguilar, R. (2005). *"El asesinato de mujeres"*, October 22. https://www.animalpolitico.com/lo-que-quiso-decir/el-asesinato-de-mujeres/.
Alcázar, J. (2014). *Performance: un arte del yo. Autobiografía, cuerpo e identidad*. Mexico City: Siglo XXI.
Alcázar, J. and Fuentes, F., eds. (2005). *Performance y arte acción en América Latina*. Mexico City: Ediciones Sin Nombre, Citru, Ex Teresa.
Alonso, R. (2005a). "Entre la intimidad, la tradición y la herencia." In Alcázar, J. and Fuentes, F., eds. *Performance y arte acción en América Latina*. Mexico City: Ediciones Sin Nombre, Citru, Ex Teresa.
Alonso, R. (2005b). "Arte y tecnología en Argentina: los primeros años." *Leonardo Electronic Almanac*, 13: 4, April. Digital file available at http://www.roalonso.net/es/pdf/arte_y_tec/leonardo.pdf.
Alonso, J. R. (2006). *Tania Bruguera o el performance como medio de reflexión*. Madrid: Estudios Culturales. http://www.estudiosculturales2003.es/arteyarquitectura/taniabruguera.html. Last retrieved August 2007.
Brett, G (1994). "Lygia Clark: In Search of the Body." *Art in America*, 82(7), pp. 56–63.
Hodoyán, K (2005). "Las fronteras del performance latino en California." In Alcázar, J. and Fuentes, F., eds. *Performance y arte acción en América Latina*. Mexico City: Ediciones Sin Nombre, Citru, Ex Teresa.
Reina, E. (2005). "¿Cuántos feminicidios más puede soportar México?", *El País*, 7 marzo 2018. https://elpais.com/internacional/2018/03/07/mexico/1520414016_971998.html.
Roca, J. (2008). "María Teresa Hincapié (1954 - 2008)." *Esfera Pública*, January 18. http://esferapublica.org/nfblog/maria-teresa-hincapie/.
Roldán Rueda, N. (2018). "María José Arjona, la artista que reta al tiempo." *El Espectador*, May 4. https://www.elespectador.com/cromos/cultura/articulo-148672-maria-jose-arjona-la-artista-reta-al-tiempo.
Warr, T. and Jones, A. (2000). *The Artist's Body*. London: Phaidon Press Limited.
Zerpa, C. (2005). "Lo que vi, lo que escuché, lo que viví, lo que rozó mi piel." In Alcázar, J. and Fuentes, F., eds. *Performance y arte acción en América Latina*. Mexico City: Ediciones Sin Nombre, Citru, Ex Teresa.

23
DANCE AS A TOOL FOR THE CONSTRUCTION OF PEACE AND IDENTITY

Ana Carolina Ávila

Before I develop the arguments of this chapter, I want to point out three aspects surrounding its creation. First, I am a dancer. I was trained as one. I come from a country that dances every day, for any reason. Everything that I've learned through my journeys in the pathways of dance, I've learned with mind and body, and my reflections emerge both in words and movements. I don't want to say with this that those voyages constitute an exercise for me as an artist, but rather that I undertake them with my whole self. I am convinced that it cannot be done in any other way.

Second, what I'm about to relate comes from a work of intervention in vulnerable communities, through workshops, that was developed at two different times, in different environments and with human groups of very different kinds. However, these two projects were based on the same hypothesis: the use of traditional dance as a tool that builds identity, reconciliation and reparation through the bodies of the participants at the workshops: ex-combatants that have been demobilized from illegal armed groups, young men and women of vulnerable communities that live at risk of being recruited for the war, leaders of grass-roots movements, rural teachers, displaced populations, direct and indirect victims of the armed conflict. The idea is very simple: what is learned by the body, what is written on it, what is torn to pieces through it, can be unlearned, repaired and rebuilt through the same route.

Third, the ideas that I want to share are the result of my analysis and reflection on the fieldwork carried out with these communities. They are not guided or in any other way related to theoretical works, nor the vision or mission of any institution. They are the product of hours of discussion around a table, of hands-on work with bodies and people, of extended conversations and moments of conviviality with those involved, but mainly of a lot of observation and note taking. I kept a log to track my thoughts as they developed and this was of great help along the process. This text can be seen as a fabric of ideas from a reader of bodies.

Throughout my life, I have become more and more aware that we have just one body for every vital experience. Our body is the place where our experiences are written, both in the physical and the emotional sense. That body that is also man, woman, or gender-in-transit; it is the body of a mother or father, a son, a daughter; a body that is young or old, student or teacher, political or apolitical. All of these form a compendium of feelings and ideas, and also the canvas where we paint the image we assign to ourselves when we build the notion of 'I', of identity. The body is the structure that contains our mobile self-portrait, indeed a mutable one. This whole

dimension of the body was implied in the daily life, education and rituals of the indigenous communities of America, and those coming from Africa, even before any anthropological study identified it; it is especially alive in the symbolic content of the traditional dances of Colombia that come from centuries of a slowly-cooking melting pot, and are still alive in the culture of my country.

Dance can be seen as a need of a body that moves; it makes its way as a revelation of a common language with others, which is also owned by the individual. Dance is an infinite channel that connects the personal universe and the collective one. The possibility of dancing is to a people or group what the possibility of moving is to the individual body. The individual needs to move to claim the spatiality that he or she is entitled to as a physical body in the world. Man is constituted as a physical presence. People dance as a territorial declaration, marking the space with their steps and figures, and they become a collective that configures a symbolic space which reunites them as one; a community. The clearest evidence of the wisdom that lies in these collective bodies is given by the traditional dances of the indigenous peoples of the Americas, of those transported from Africa, and of the Mestizo communities that rapidly developed, which are mainly performed by large groups.

For example, a march in a long line (like military, student and funeral marches) is a movement in unison, with cadence and insistence that bursts into space as an existential statement of a group in motion. Dance: popular or highbrow, from the school, ancestral or professional, are all symbolic treatises in movement. Our natural and everyday gestures, those that have been learned without us even knowing, become symbols and reappear in complex aesthetic elaborations in our dancing bodies. They tell a lot about who we are, where we come from and how we understand ourselves. This underlines the importance of collective manifestations, especially of those that reunite bodies around the idea of building an identity. The aim of this text is to present the path into the practice of one idea: to build new ideas around identity, reconciliation and the body as a territory and engine of peace; starting from bodies in motion and through the means of dance.

Political context

Colombia has lived in a dire internal armed conflict since the 1960s, but the situation that made this conflict possible is much older. In the last 35 years, new groups, like the paramilitary squads, have joined the rebel organizations and the state army, making the bloodletting even worse. All these groups operate with different mechanics, philosophies and strategies, but are similar in other aspects. The insurgent faction, Revolutionary Armed Forces of Colombia – People's Army (FARC-EP) and the Army of National Liberation (ELN) have a far-left ideology, and use a military path to achieve the revolution that would bring about social justice, in the form of a socialist or communist regime. Both groups have been active from the mid-1970s and have structural organizations that respond to the model of 'voracious institutions', as defined by Coser (1978). These are institutions that control every aspect of a member's daily life in order to influence the individual with its goals and ideals. According to the statutes and training of the rebels, the relationship of their combatants with the civilian population should be as one among equals and allies. The enemy is defined as the State, and its members, both armed and not, are considered 'targets'. Even if in the reality of war their actions don't correspond to their statements (for example, the civilian population is a frequent victim of their military actions), it is vital to understand the definition of the combatant as a body for the war and his relationship with the other sides. I am not suggesting the practice of conscious double speech in these groups, I'm only pointing out how the practices of war affect the ideas of the groups that are immersed in it.

The groups that counteract the rebels, widely known as 'paramilitares', are, from their origins, illegal armed groups, constituted to stop the consolidation and advance of the insurgents. The literature that has been written to analyze the conflict suggests that their relationships with any political project are vague and ambiguous; they don't have organized hierarchies, and basically operate and combat for territorial control and resources. They can be identified from the middle of the 1980s, first in regions with big private estates, where landowners chose to arm themselves in the face of being abandoned by state forces. Paramilitary groups, due to the tactical impossibility of defeating the left-wing 'guerrillas', adopt as a strategy 'taking the water out of the fish', which basically means attacking and dismantling the support net that guarantees supplies to the rebel organizations (e.g. food, medicine, communications). This net is mainly composed of civilians that willingly or unwillingly help the guerillas in their zones of influence, and therefore the main victims of the paramilitary group are civilians not involved directly in the conflict.

The actions of every group or side of the conflict (i.e. rebels, paramilitaries, state forces) exceed the limits of imagination and horror. It is possible that in these 40 years of history in Colombia, more has been written, spoken, argued or invested in this conflict than in any other single reality of our lives. Our internal armed conflict has influenced each Colombian at least in one aspect of their daily life. The victims, actually, are all of us. And in the body of each one it is written that there is an armed conflict, as a beating reality, sometimes not so evident. Violence is stamped, marked, imprinted indelibly on the inhabitants of war-torn territories, in rural populations that have seen combats over and over, and in the people that have been displaced from their land by any of the sides in the conflict.

If a human being is educated for war through the modeling of his or her body as a weapon, it may be possible to unlearn the dynamics of war through the reinvention of the notion of that body as something else, something unlethal, not an instrument of war, maybe an instrument of peace. If the world of a human being is forced with violence, his body beaten, wounded, raped, mutilated or displaced, trauma will break the spirit; maybe it can be relieved, reconciled, consoled, comprehended and accepted through another reading of the body, a body-being that is not alone in pain and sorrow, a body that returns to its territory through dance.

Experience 1

The first intervention process that I want to comment on was a pilot project of arts education for young men and women in the process of reintegration to society, implemented by the Office for Reintegration of the Presidency of Colombia. In the final document of the research that preceded this project, anthropologist Camila Medina (in Arbeláez, 2010) writes:

> Human beings are the product of socialization processes and mechanisms of concrete discipline, that are practiced in a systematic and daily way over the body, to construct subjects, products and producers of a particular social order ... we recognize that our body is not merely a biological entity, it is a social, political and symbolic construct. In this line of thought we state that we don't own a body, we are body; a disciplined body, in which multiple relationships of power and exclusion are incorporated, naturalized and reproduced. Particularly we recognize that in training of the armed groups, radically strong corporalities and relationships of opposition and denial of the others are built through complex and particular socialization processes. That is why ex-combatants (of all armed groups in general) have written in their bodies their passage through the armed organizations, a transit that exacerbates and naturalizes a lack of trust which precludes the recognition of the difference and legitimates violence.

However, it is important to make clear that, if in the members of armed groups we find stronger dichotomies and antagonisms, it is because these are part of the social order in general; because we are a society that reproduces multiple forms of violence, not only the participants of these processes build in themselves subjective corporalities with traces of combatants.

The main objective of this project was to prove that art can be a tool of social change and a generator of second opportunities in the perception of the participants over their immediate reality, through processes of sensibility-awareness and recognition of themselves and the other in an environment where tolerance and equality is privileged among a mixed community. The attendees at the workshops were male and female ex-combatants of illegal armed groups, mainly 'ex-guerrilleros', young men and women of communities at risk of imminent recruitment by these armed groups, and the families of both sides. Absolutely every person came from a violent environment, either socially or in their families, and has been or probably will be involved in any of the organizations outside the law in direct contact with the armed conflict.

The starting point of this process was a schedule of workshops in music, dance, theater and literature for the midsize cities of Ibague and Santa Martha, with an intensity of four hours each week for six months. My participation started with the writing and proposing of the contents of the modules for music and dance in the city of Ibague, later taking on the general coordination of the workshops. Once the journey started, I tried to walk with open eyes and a firm footing to investigate and understand the social context and the participants themselves. I needed to be able to model the contents in order that they served as a vehicle of experiences, rather than as obstacles to overcome with the acquisition of corporal and rhythmic skills. As is usual in these types of projects, it couldn't be a workshop to train musicians or dancers; it had to be a workshop to reshape a community around music and dance. This became an excuse to explore communication skills and open the space to get in touch with every person that was involved in the process. I know that workshops, even a large series of them, can't be used as a formula to instantly transform communities. Workshops are spaces that allow the individuals to find themselves and recognize others in the same quest, under the same light; the process to learn something new. In many cases, even when the goals are not accomplished, the mission of reuniting a community around a common purpose is an achievement in itself, in terms of building a culture of peace that opens new ways to relate with other human beings.

My first realization on having entered their world was the deep and tight relationship that exists between the physical activity of the combatant in his or her daily life and the implications that this has in the symbolic comprehension of the world for the retired members of the armed groups. In these groups, both in and outside the law, the routine of physical training, the supremacy of force, the territorial control exercised through the physical occupation of a space, the intervention in others' spaces and the body as a weapon are realities and needs in the construction of the notion of a fighter. The body is re-educated with a purpose: combat, resistance and absolute control of emotion to serve the purpose of action, as defined by the collective to which the fighter belongs. I concluded that for them, the body and its symbolic use are extremely important and, far from conceptual elaborations, they answer simply to an obvious pairing: body/territory, body/weapon. The body is used as an instrument of control through social and physical practices, as a symbol of terror through the exhibition of corpses of those killed in battle, and as an instrument of domination through sexual and other forms of violence in war.

The challenge was to propose to them through the experience, the idea of the body as a territory of peace. I mean peace not as an absence of conflict, because human beings are full of

inner conflicts, but as a territory for the individual and his or her sensitivity that makes it possible to relate to others, far from a relationship of dominion, closer to a life between real equals, and therefore, in absolute opposition with everything that was instilled in their bodies by the war.

What place does dance occupy in this landscape? Can someone dance after being used as a tool and as a battlefield? Dance, because of its collective and non-verbal nature, offers an encounter with what we all have – a body – and what we are all looking for – 'the collective / the others'. To enter a classroom to dance and make music with the same body that was once the property of war was a huge step in the construction of a subject that can reinstall himself or herself in a social frame, one that usually receives him or her as a stranger, an outcast, an inconvenient truth. The workshop opened a space where music and dance received them, as they would any other person coming to a celebration. When you go inside a dance class to dance with others, you sometimes meet foreign people, but you learn to move together, to sing together, to laugh in unison. What is most significant in this process, in terms of the human and spiritual development of the participants, not just the ex-combatants but all of them, was that it allowed a new reading of the body as a tool of good to others. The arms that once used to strike blows are now used to hug, to hold one another as a dance couple. The extenuating march that previously symbolized the constant and heavy walks on the mountains is now a circle at the pace of *cumbia*[1] that never stops.

The music and dance workshops were built around the thematic axis of the dances and rhythms of the carnivals of the Atlantic coast of Colombia, because they are a common point of reference to most Colombians; they mix influences from several ethnic groups, and thus would offer a common ground between people with different cultural backgrounds. Besides, these rhythms allow an important number of methodological variants related to the training of the body. In the case of the ex-combatants and young people at risk of being recruited, expecting a sense of identity coming from these symbols, which can seem foreign to some, is especially difficult. There were multiple and contradictory reactions in the same group, but everyone had a sense, at least, of the significance of this music.

The symbolic construction of identity in what pertains to the sense of belonging to a human group – we can name it nation, region, family – directly depends on the identification of these groups as something we own: 'to be part of' is 'to be of'. The national hymn and the national flag may not say a lot to some in terms of identity, but the *cumbia*, *chandé* and the *garabato*[2] can become their territory and mother land because they occupy them with their bodies and spirits when they dance. From popular festivities to radio songs, what a society dances to becomes a part of its members. This made me conclude that in terms of their constitution, we can only take these groups through the process of building an identity if it happens through and in their bodies.

The first process revealed an evident need of new pathways, imagined and built around the language of art, which would allow the encounter between the worlds of the victims and the worlds of the actors of war, without disregarding those who are merely spectators of the conflict, the overwhelming majority. These pathways should help the building of a notion of community that seeks to unite or at least listen to the testimonies of every side, as a fundamental step towards a transit from war to peace. The reason why this approach seems to work, even in the cold institutional framework of a government office, is that it is based on the senses: the body is taken as an epicenter of meaningful experiences which are conducted through music and dance, and seek above all the reassignment of the body itself from tools of war or battlefield to persons of peace. The possibility to decide about himself or herself is placed in the hands of the individual and of no one else, and he is empowered by his own vital experience of conscious movement

that opens for him the possibility of entering into new human groups that now claim him as an equal; the brotherhood of dance partners.

Experience 2

The second process I want to share as a source of my reflection is the strengthening of the training process of teachers in municipal dance schools situated in four vulnerable communities. The workshops focused on psychotherapy techniques using dance and movement, and they were carried out by the organization Dunna: Creative Alternatives for Peace. In contrast to the example above, this project came from the initiative of Dunna, as an answer and continuation to two separate processes it had been working on, and it was developed with the support of the Ministry of Culture through the National Plan of Dance. The main recipients were people who had been directly or indirectly affected by the armed conflict. In this process, I worked in the structuring and formulation of the program, and in the development and implementation of the second module of workshops, 'Traditional Dance as a Source of Identity and Collective Reconciliation'.

The most significant characteristic of this group is that it is composed of teachers, community leaders, directors and members of artistic and school groups from the regions where the workshops took place. Most of them are direct or indirect victims of the conflicts, unwilling witnesses of the actions of the illegal armed groups. The workshop was made up of three modules, and each module lasted two days. The locations were an example of the diversity of the Colombian landscape as well as of the far reach of the armed groups: Sincelejo in the Sucre Department on the Atlantic coast; Carmen de Bolívar in the Bolívar Department on the Atlantic coast; Orocué, a small town in Casanare in the Llanos; and Corinto in the Andean plateaus of Cauca. In San Basilio de Palenque, which was to be the fifth municipality, our work was cut short to one workshop. This is a community that is hugely resistant to processes conducted by outside persons, and still fights for its African heritage and freedoms as in Colonial times.

These four instances offer very different ethnographic and social components, and face different conditions regarding the armed conflict. In Sincelejo and Carmen de Bolívar, located in the north of Colombia, the actions of the 'paramilitary' groups, mainly massacres and terror acts committed against the civilian population, have been devastating in terms of their impact on the social fabric. In the cases of Corinto and Cauca, in the south-west of the country, the region has long been immersed in the conflict. It has a high presence of FARC guerrillas, with constant combats in the urban perimeter. One of the biggest indigenous groups in the country, which has lived in this land for centuries, tries to stay out of the war as far as they can. Orocué, in the Casanare, in the middle of the plains in the east of Colombia, is also neighbor to an indigenous reservation and is located just in the middle of the development of a new oil field. The money associated with the field has had a direct impact on the daily life of the town. It can be read as a population in social decomposition.

The core of the learning process was, in this case, the application of techniques of psychotherapy using dance and movement, which were structured in the academic plan of the Dunna organization. The main objective is the work of the body with movements and dance as a tool to reconcile the inner and outside worlds of those involved. The project was addressed to teachers and leaders of community processes in the region, which we conceived as the first group that should receive artistic, pedagogic and management tools, with new perspectives and views to allow sensible dialogue within vulnerable environments.

The starting point to reflect on this intervention and the relevance of traditional dance, particularly as a source of tools that empower identity and collective reconciliation, is directly

related to the notions that live and are constructed from our bodies in the cultural and familiar history that each of us owns. What we learn to dance and perceive as our own in terms of movement is intimately linked to the fabric of emotional memory and places us inside the notion of territory. The body is the repository of our complete history, and in this sense the bodies of these teachers and the bodies of their students are repositories of the violence that has daily and systematically surrounded them. Unlike the process with ex-combatants, the main challenge here wasn't to replace a notion of the body, but to rebuild from the reparation of what has been damaged by direct or indirect action of the armed conflict. What has been displaced, terrorized, controlled, subdued, should be seen, recognized, valued and educated again with new eyes in the teachers, with a perspective full of generosity and a clear idea of what a respectful education of the senses should be.

One of the most serious consequences that the populations that have been victims of the armed conflict face is the loss of their identity and territory, which can leave more than a dent in the psyche of a community. This is even more serious when it is recognized that a majority of cultural practices are supported on both notions. The empowerment of the new generations, the teachers and the community leaders that take care of these tasks and guard the heritage of cultural values is very important in the construction of guarantees for a process or reparation and reconciliation. In the middle of this process, ethical and aesthetic questions surrounding the profession of teachers and artists in a reality of war and social decomposition also emerged. There are many similarities between the different regional identities and huge coincidences in the problems they have to solve, even if they are separated by thousands of kilometers. Similar doubts from teachers of the four regions surfaced: they are worried about the impossibility of working in opposition to the social frameworks they are immersed in. In each region, we find the figure of the performing arts teacher as a single voice, as an outcast that tries to rebuild his or her community through the world of sensitivity, always trying out alternatives to improve coexistence in their communities.

In the four locations, negative prejudices surrounding the bodies of children, teenagers and adults also appear, where certain standards of beauty are preferred over more comprehensive values in the education of performers and audiences. There is criticism of the supremacy of stylized or 'projection' dance over folkloric dances with a grass roots origin, usually lacking in adornment, but that appear when people gather together to share the same time and space. The same concern about the objectification of the body surfaces again and again. Conciliatory and positive stances regarding the training of children and teenagers are very rare in these regions, where everything connected with the body and touching is seen as pertaining to sex.

One of the most important breakthroughs from this experience is the work using physical contact as a vehicle that stirs communication between individuals. First, we have to place ourselves in a context where physical contact, even outside vulnerable or hostile environments, is problematic, because it is relegated almost entirely to the sexual sphere and loaded with negative connotations. To open one's body to others, to open channels to make physical contact a path to sensory communication, is one of the main achievements of this work. We opened roads for the participants to experiment with transformations from their own bodies in the perception of others as realities that also belong to them. They learned not to be foreign to others. This inaugurates very interesting conversations and discussions about the sexual content that is found in non-verbal communication and how this influences our way of speaking. This opens a door to reflect about gender violence, about how the roles of men and women are legitimated through our dances and cultural teachings, and how they change subtly from region to region.

In each of the four locations, I concluded with the same sense of clearness and intensity that in a country that dances before, during and after the war, we dance to remember our bodies, to

reconnect ourselves with who we are, to survive the horror, to mourn the ones who passed away, to reconstruct what has been broken, to invent and imagine peace. These teachers and leaders know that, and they persist in their duty of teaching. We dance because through dance we weave the fibers that connect us with notions that guard our hope – identity, territory, collective – and each one of them is built with and through the bodies of dancers and apprentices. Once I asked an old man, a survivor of a massacre who dances every year in a festival of drums, why he hasn't stop dancing, even after everything that he had witnessed and after living through everything that he had lived through. His answer was striking and firm: 'If we don't dance, we die'. There I understood: what for me was a mere supposition in the academy, or a reference to my profession, constitutes a vital need for them.

Conclusions

Based on the reflections and conclusions from each process, I am able to track down some common points that are important in their connections to the learning process, and lie in the path of giving dance a place in these realities, one that is akin to the central place that it has had traditionally in the heart of people from all around the world, as a vehicle of reconciliation and reparation for communities that have been in direct contact with armed conflict.

It is undeniable that dance offers a fertile field for dialogue, and for approaching and recognizing different worldviews, because it unites the inhabitants of a country that has a place of privilege for celebration as a manifestation of life and death. We are culturally educated to dance in times of abundance and in times of shortage, to mourn, to celebrate and to let go. There is also a place for dance in the process of rebuilding of a people, of victims' reparation, of piecing together the memories and the wounds of war. As everything happens first in the body of an individual, and dance being a place for the gathering of bodies, it's possible to think that dance is able to restore links among people. Maybe it's not just dance as an exercise; maybe it's the opening of a space to recognize in others the same path of self-reparation.

This need of feeling part of a collective pushes us to others, to the bodies of others. The need for physical contact as a poignant reality appears time and time again in my dialogues with the participants of both processes, in their spontaneous exercises and reflections. The slow rebuilding of a broken universe, through the reconstruction of their individual 'I', is something their shy words don't convey but is generously translated in the gestures and expressions of their bodies.

Dance generates encounters between different worlds, and allows the construction of possible universes where each member of a choreography, a line, a circle or a march is an equal. This is particularly true in the ethos of traditional dances, where collective spaces are preferred to the skills of the soloist. It's wonderful to see a graceful and skilled body, but to see a group moving in unison, to one beat, is touching. The delicate symbolic fabric that lies in traditional dances, moves, more than physically, the dancers and apprentices, and takes them to this group consciousness without verbal negotiations or impositions. It simply happens through the body and its gathering with others.

Because of who we are, and what we historically configure as an identity in the middle of an armed conflict, we keep on dancing. We dance to celebrate and to mourn, we dance to get together as equals, even with the enemy in the middle of a truce. Dance becomes a place to resist the horror of the war. It's a source of hope. The connections between who we are and how we dance are as close as the relation between our identity and the movement of our body.

As long as we are capable of understanding ourselves as a totality, a fabric made of ideas, pulses, movements, expressions, it will be possible to understand how all of us, fighters, victims and spectators of the armed conflict are only constellations of experiences that give shape to

our actions in life. When we begin to look for peace, we ask for answers. We are obliged to look back and inside to find them. I know that politicians propose diverse ways to approach the end of the conflict, but it's inside the communities and among human beings that peace is made. I've discovered that art, in this particular case, dance, can perform the part of conciliator: offering respectful views over bodies and their stories, and the possibility to gather around nothing but music, gives people a chance to find a way out of the conflict.

It is written in my body that my history makes sense when I dance. Sometimes it takes me days to give shape to ideas, months to decide to write, and lots of times reading what I've written to really understand the direction of my thoughts … but it just takes a couple of hours of dancing to breathe better and feel certain that these journeys have a meaning and a purpose, that this work is useful to someone else besides me.

I like to imagine that the same thing may happen to my country. It will take years to find legal and political ways to reach a stable peace, but maybe that time is not so far away, when we start to live as communities that look for reconciliation and peaceful ways to live with each other … living and dancing.

Author's note

I wrote this chapter in 2012, when Colombia was crossing a complex but promising scene. We had elected a new president, whose purpose was to sit down and put an end to the inner armed conflict that started in the 1960s with the oldest guerrilla war of the continent. But not without many kinds of difficulties: from the resistance of some civil groups and interests to give any concession to the rebels, to several complex constitutional puzzles that made it tremble. But he made it.

The peace agreement was signed on 26 September 2016. From that moment until now, we have been walking the most difficult path. We as a society are trying to understand what happened in those 60 years of armed conflict, not from one single voice, but from voices of every side. We are trying to adapt to this new scene where we have a new president, elected in 2019, who reached this office with an open resistance to do what was agreed between the State and the armed group that demobilized. The agreement was signed by a chief of State, not by a single man. It seems now that those civil groups that have political representation, that opposed the peace process, have gained strong positions, from where they are presenting every obstacle to push this gained peace forward.

There are those of us who still believe that the only way to make that peace happen is to look ourselves in the mirror of history, the one that was silenced for decades of official versions of the war. We, who believe that bodies are the books on which these years were carved and painted, said that we need to look deep down into ourselves as social bodies, to understand how bad it was, how we need to move to heal and go forward. In 2017, I presented this text with a sense of hope in these words. The ones that I wrote in that moment convinced me of what I was saying, and I'm still hoping that they can be of some use in this moment. As dark as it may seem, there's always a need to keep moving forward. Our bodies know.

Notes

1 *Cumbia* is a drum-based form of music and dance that combines long wooden flutes named *gaitas*, with three types of drums, chants and different kinds of dance steps. Its most important signature is the gathering between all dancers in one big circle, the couple dance figures, at on a common simple step that just marks the beat of the *llamador* or drum base. This music and dance form has been presented in the collective memory and bodies of the Caribbean coast people, back in time since the eighteenth

century in cities like Cartagena, main slave trade port of the Nueva Granada Viceroyalty in South America. This music and dance form combines sounds and corporeal gestures from the various social groups that had presence, or dominance or submission, in the society of the colonial world of this territory. It survives and endures until now as a cultural, popular and live manifestation.

2 *Chande* and *garabato* are drum-based dances that are related to the same Caribbean cultural territory described earlier. The main difference is that *cumbia* presents a couple courtship scene, while *chande* and *garabato* are faster and stronger, both of these require strength, speed and other corporal abilities to surprise, amaze and play with other dancers in the scenic display. These two dances are used in the carnival parades to represent joy and celebrate the pleasure of movement and sound. *Garabato* specifically represents the eternal conflict between life and death in a battle were the best dancer defeats death with his/her dance abilities.

References

Arbeláez, C. M. (2010) *Informe final. Proyecto Piloto de Educación Artística para jóvenes den proceso de Reintegración. Alta Consejería para la Reintegración, Presidencia de la República*. Unpublished.

Coser, L. (1978) *Las instituciones voraces*. México: FCE.

24
WE PLAY AS WE MEAN TO RESIST
Theatre games as political participation

Matthew Elliott

There are 25 of us standing in a circle. One person stands in the centre. The majority of participants are young people accompanied by theatre workers, educators and co-ordinators. A young person frantically runs between his peers in the circle and shouts, '¡*Yo necesito un espacio!*' (I need a space), to which another participant responds, '*Pregunta mi amigo*' (ask my friend) and points to someone else. As the young person dashes around the circle, other participants need to exchange spaces with only the consent of eye contact. The aim of the game: not to become the person in the middle. Bodies almost collide, the young people invent their own rules and the stakes are raised with an array of new playing tactics. The focus is exceptional and the only thing to disrupt attention is the laughter, jokes and enjoyment that are shared by all members of the group. This experience embodied Chris Johnston's (1998: 5) description of play as 'directed activity, engendering liveliness, interaction, imaginative excitability and the reduction or removal of conventional spatial and temporal boundaries, in an exercise which is releasing and rewarding, often merely for its own sake'.

The discussion of play within the unique context of this case study requires an understanding of the contemporary state of the Chilean penal system. The participants of the project were detainees of CIP San Joaquin, a juvenile detention centre based in the San Joaquin *comuna* (district) of Santiago, Chile. The centre accommodates male teenagers aged from 14–20 years, who have either been convicted or are on remand. It is operated by the government office of El Servicio Nacional de Menores (SENAME), the national service for minors.

Prior to the centre detaining young people, it was used as one of the many camps to detain and torture 'dissidents' under the dictatorship of Augusto Pinochet. In recent history, a legacy of brutal oppression and deaths endures within SENAME and its numerous detention centres. A freedom of information request found that 865 children died whilst under the care of SENAME from 2005–2016. 'The reported causes of death included infants and young children drowning in their own gastric or respiratory fluids, suicides, and delayed medical attention to injuries' (Human Rights Watch, 2017). Pinochet's legacy truly inhabited the walls of CIP San Joaquin. The revelation of SENAME's negligence sits against a backdrop of damning statistics and attitudes towards incarcerated persons in Chile. In 2010, a fire in San Miguel prison whilst it was operating at 280% of its capacity, led to the death of 81 prisoners (Human Rights Watch, 2010).

My case study is analysed against the backdrop of children's rights abuses by SENAME. The project included the employment of drama exercises and games, for two months on a weekly basis, with a range of groups across the detention centre. I led on the playing of theatre games, which was part of a bigger scheme of work designed by educators from Tierra de Esperanza. Tierra de Esperanza is a national NGO that provides educational support for young people in centres such as CIP San Joaquin. The educators deliver an annual festival called *Cip a Luca* in partnership with the young people. *Luca* is Chilean slang for 1000 pesos, the festival name being a pastiche on the inaccessibility of the international arts festival Santiago a Mil. The festival culminates with a performance from a local band and the sharing of food. Early in the process a set of 'assemblies' are held with the young people to begin discussions on organising the festival. It was agreed with the educators that theatre games would be utilised within the assemblies as a means for young people to explore collective participation and to 'simply have fun'. The offer of fun formed an interruption to the dehumanising and oppressive narratives of CIP San Joaquin. The main aim of the project was for the young people to learn about children's rights and political participation via the organising of the festival. This was a radical opportunity within an environment of overcrowding, excessive medication and violence (Figure 24.1 and Figure 24.2).

The case study will explore three main elements of the project: the benefits and problems of 'play', the relationship between effect and affect, and the complexities of creating autonomy and resistance from within state institutions. The playing of drama games worked effectively within the affective register as opposed to focusing on effect. I argue that the playing of drama games worked within the affective register and acted as a form of resistance by disrupting the narrative of oppression orchestrated by SENAME. My argument explores how affective ideas of beauty and joy are related to dialogical educational processes, specifically influenced by the work of Paulo Freire.

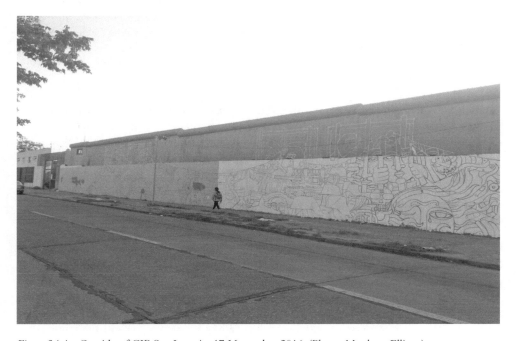

Figure 24.1 Outside of CIP San Joaquin, 17 November 2016. (Photo: Matthew Elliott.)

Figure 24.2 Floor plan of CIP San Joaquin, 15 December 2016. (Photo: Matthew Elliott.)

The potentials and problems of play

'¡Yo soy Pollo!' I exclaimed as I jumped out of my chair. The young men of *Casa 8* fell about the floor laughing hysterically and pointing at me. The laughter continued for several minutes whilst I tried to make sense of what had happened. The game being played entailed one member of the group trying to sit in an empty chair whilst the rest of the group who were seated prevented him from doing so by occupying the vacant chair themselves. I play a clowning version of the exercise where the person standing would usually be referred to as the 'chicken' and walk with their knees together. I asked the young people, 'Who would like to be the chicken?' No one responded. To simply begin play, I volunteered to be the chicken – '¡Yo soy Pollo!' Laughter ensued until one of the young people explained to me that to label oneself or someone else as an animal is a playful insult in Chilean culture. No one wanted to be the 'chicken' which raised the stakes of the game. A lengthy time of play followed with strategies, jokes and words of encouragement ricocheting off the walls of *Casa 8*. The moments of joy and happiness occasioned by playing games offered a freedom from the reality of the detention centre. However, such freedoms would only be ephemeral, as a return to the reality of the centre was an unfortunate certainty. From this experience, I argue that there is efficacy in affective theatre practice, but there are limitations and its relation to critical consciousness is unclear as it depends on the particular context of any given project.

In his writings on play, Johan Huizinga (1872–1945) places the concept of 'freedom' in the centre of his analysis:

> Here, then, we have the first main characteristic of play: that it is free, is in fact freedom. A second characteristic is closely connected with this, namely, that play is not 'ordinary' or 'real' life. It is rather a stepping out of 'real' life into a temporary sphere of activity with a disposition all of its own.
>
> *(Huizinga, 1949: 8)*

In relation to the practice, there is little to contest when applying the statements of Huizinga to playing theatre games in CIP San Joaquin. In the limited interviews that took place (due to a range of restrictions on the research both direct and indirect), Fernando (2017) said that playing enabled an opportunity to transcend the oppressive nature of the detention centre; 'it frees us'.

Thompson (2009: 6–7) states that 'by failing to recognise affect – bodily responses, sensations and aesthetic pleasure – much of the power of performance can be missed'. The use of the term 'affect' derives from his argument that applied theatre is weakened by its focus on effect – 'identifiable social outcomes, messages or impacts'. I argue that the experience of the young people in CIP San Joaquin could be used to further advocate for the affect model that is commonly being adopted and utilised by applied theatre practitioners.

The educators and the young people recognised the 'power' of play and the bodily responses and sensations it provided. Play acted as an opportunity for the young people to reclaim aspects of their life they felt they had missed due to their involvement in crime. Many of the young people described in the group interviews how they had 'skipped childhood'. Gabriel (2017) elaborated on this by saying 'we lost this stage because we were forced to seek what we needed'. The sensory, cognitive and emotive engagement with the aesthetics of play enabled the young people to 'construct meaning' and led to moments of reflection (Cohen, Varea and Walker, 2011: 6).

The momentary 'freedom' that play offers is a radical act in the context of CIP San Joaquin. But its relation to the prison system problematises such elements of play. Balfour (2004: 11) contends that theatre within prisons 'can be put to use' by the prison authorities themselves. Within the example of CIP San Joaquin, the elements of play and joy that drama games provide could be perceived on some level to serve the dominant agenda of containment. The young people would refer to the playing of games as a 'distraction'. For example, Javier (2017) commented, 'Yeah, it is good, because it is a distraction from the routine, because doing the same thing all the time is boring'.

I argue that the playing of games may have acted as a form of appeasement to SENAME management through distraction. To appease the young people's grievances about the centre, time is made available for such 'distractions'. The limitation of one hour per workshop did not provide sufficient time to develop advanced discussion or play. The ephemerality of play and the freedom it offered was not wholly able to counter the dominant narratives of CIP San Joaquin. However, the playing of games within the affective register enabled an emotive and sensory engagement with the young people. The dualist nature of my practice as resistance to, and reinforcement of, dominant agendas was present.

As exercises were played and notions of *affect* became clear, I began to question whether working in the affective register assisted notions of individual change, which are favoured by the prison. Thompson (2009: 118) argues that applied theatre's 'attention to affect ... can, in fact, become a generator of its radical intent'. He claims that affective practices can 'create an ethical demand on a person that is both specific and general' (Thompson, 2009: 176). However, the ephemeral and individualised modes of freedom enabled by affective practice contradict the reflexive process of acquiring meaningful freedom described by Freire, specifically the process of conscientisation (Freire, 1996: 17).

The difficulty for the practice was to transition from moments of ephemeral freedom to a continuous process of critical interrogation. How to develop a practice with such an aesthetic engagement as play whilst enabling a critical reflection on lived reality, was a question raised with the educators. The discussions were based on logistics as well as pedagogies. The playing of games created moments of freedom and alludes to Thompson's idea that 'hedonism is a bunker' that 'protects people from the worst of the situation' (2009: 2). However, I argue that there are

instances where hedonism is a 'distraction' that can become complicit in the agendas that my practice is seeking to oppose.

Joy as resistance? At the crossroads between affect and effect

The study of affect and beauty within applied and community theatre scholarship has become prevalent in recent years (see Thompson, 2009; Hughes and Nicholson, 2016; Winston, 2006). To avoid reductionism at the start of the process, I was wrestling with how to develop effect whilst the practice was firmly positioned in the affective realm of games. The collaboration with the educators from Tierra de Esperanza was central to this process. The discussion of the relationship between affect and effect came to prominence through the absence of effective practices when solely playing games.

The evaluation of the *Cip a Luca* festival from the previous year had raised issues experienced by the young men regarding individualism, *machismo* and the lack of 'fun'. This was where the discussion of games and exercises began, through a need to address the lack of 'joy' or affect within the programme as well as engaging participants in a collective manner. I initiated conversations by proposing a range of participatory discussion exercises borrowed from Boalian frameworks. The educators pointed out that such an approach might not work due to the participants' reluctance to discuss ideas because of their ambivalence towards authority figures. There was a need for the young people to purely 'play'. The discussions shifted from suggestions of image theatre to high-energy warm-up games such as fruit bowl, zip zap boing and ¡*yo necesito un espacio!*

After many planning sessions, the educators proposed an experiment of delivering sit-down discussions immediately after the playing of games had been completed. There was an interest to see whether the experiential and kinaesthetic learning of play could be transposed to discussions on children's rights or other subjects chosen by the young people. The discussions were heavily influenced by popular education and akin to Freirean culture circles. Freire (2013: 40) described his early experiments as follows: 'In the culture circles, we attempted through group debate either to clarify situations or to seek action arising from that clarification. The topics for these debates were offered us by the groups themselves'.

I had reservations regarding the dramatic change in energy and whether the young people would be able to focus on verbal discussion immediately after a round of high-energy exercises. This concern was strengthened as a Tierra de Esperanza worker commented that prior to their arrival at the centre 'the concept of participation didn't exist' (Tierra de Esperanza worker, 2017). The two approaches developed an environment where the young people discussed issues with the educators which previously, they may not have felt comfortable with. At this juncture, the principles of Freirean pedagogy became prevalent as the young people critically engaged with their lived reality. An example of the project's effect was in the awareness of rights, as Luis from *Casa 8* said, 'We have the right to have an opinion, it is one of our rights. And, it is taken into consideration in the assemblies' (Luis, 2017).

The *Cip a Luca* process proved that the sense of individual and collective freedom enabled by play fostered an environment for critical awareness and skill development. Winston (2006: 45) contends that moments of joy and beauty advance 'an aspiration towards social life as we would ideally live it −/fair, just and joyful'. I would like to extend Winston's statement through inclusion of effect. The mapping of games and culture circles developed a realisation as well as an aspiration; the participants' critical realisation of their concrete reality, alongside the aspiration towards a more 'just' and joyful' way of being.

There is a differentiation to be made between the instrumental use of effect in the UK and its political role in Chile. Snyder-Young (2013: 5) argues that the dominance of community theatre practice based on effect results from practitioners' 'anxiety' regarding evidencing the value of their work, a pressure which stems from funding bodies and policy makers. Whilst I agree with this argument in relation to my UK practice, in Chile, to focus on effect was a political decision. I argue that the difference between the imposed effect agenda in the UK to the political focus of effect in Chile is ownership. I, the educators and the young people had ownership over the effect of the project at CIP San Joaquin. For young people to negotiate opportunities for humanisation within the oppressive environment of CIP San Joaquin there is a need to develop awareness and skills. The ephemerality of play does not provide such prospects. There is a tangibility to effective practices which is absent from the affective register. The unique position of the educators as employees of an NGO, as opposed to SENAME, enabled elements of effect to act as resistance, without succumbing to the 'strategic manipulation' of the host institution (Thompson, 2009: 41).

I will conclude this section with an example of the relationship between affect and effect. The festival culminated with a visit from a local band and the sharing of food within the detention centre walls. For an hour, the band played a ska-punk set whilst the young people jumped and danced unreservedly. *Italianos* (Chilean hot dogs) were consumed and jokes were shared. The young people even instigated a game of *¡yo necesito un espacio!* which everyone, including the band, had to participate in. Although the *gendarmes* (guards) could oversee all of this from their viewing tower, their power was absent. A circle of reflection took place to finalise proceedings, where everyone was invited to discuss their experiences of the project. The young people discussed with eloquence their own journey, their heightened awareness and their enjoyment of the project. I argue that these moments can only be described as a form of 'chaotic critical joy'. My experience demonstrates the need for a dialogical discussion between affect and effect, as opposed to a dichotomised framing of the terminologies. For this project to resist the unpredictable and hostile nature of the detention centre, the beauties of affective practices were required, alongside the effective elements of critical education.

The invisibles: to resist from within

As we arrived at *Casa 4* for the afternoon workshop on Tuesday, 6 December 2016, the young people were not present at the gate. Their presence was a usual part of the routine when we arrived to start the workshop. Upon questioning, the *casa* co-ordinator said that they had been locked up in their cells for the afternoon. This violated basic principles of practice within the detention centre, as the young people should only be confined to their cells at night. The explanation for this? There was none. The co-ordinator appeared nonchalant about our questioning. The cells were unlocked and the young people entered the main space disgruntled, tired and stressed. The workshop was cut short because of the co-ordinator's actions. This experience formed part of a wider picture, including stories of co-ordinators stealing clothes and items from young people that family members had provided during visits. The arts-based and education engagement, regardless of critical intention, was constantly met with challenge and confrontation from *casa* co-ordinators and senior members of SENAME staff. To advocate dehumanisation by punishment and control was the priority in the centre as evidenced by multiple incidents similar to the one in *Casa 4*. The manoeuvring, subversion and rebellion of the educators was a prerequisite for our practice; any more rigid or procedural approach would have rendered the project impossible.

The possibility for criticality in the face of such oppression was due to the educator's alignment with the autonomous socialist and Marxist movement. Holloway (2010: 9) describes autonomous resistance with the analogy of the 'crack':

> The method of the crack is the method of crisis: we wish to understand the wall not from its solidity but from its cracks; we wish to understand capitalism not as domination, but from the perspective of its crisis, its contradictions, its weaknesses, and we want to understand how we ourselves are those contradictions.

The autonomous approach to social change is based upon the idea that, for a truly emancipatory process to take place, it must be independent of the state. Autonomous modes of change believe that the state is embedded in a 'web of social relations' relating to labour and that its anti-capitalist potential is limited because it is itself a 'system of capitalist organisation' (Holloway, 2005: 13–14).

The autonomous movement in Latin America has a long and well recorded history. Movements such as the Mexican Anarchist Federation (1941) and the Uruguayan Anarchist Federation (1956) laid the foundations for more contemporary movements such as the Zapatistas in Mexico (1994) and the Piqueteros in Argentina (2002). Such movements believe in principles of autonomy as well as 'horizontality, self-management and decentralism' (Lopes de Souza, 2016: 1293–1294). In relation to community theatre practices in Latin America, Prentki (2015: 54) argues that 'community theatres have been accustomed to adopting an oppositional stance in relation to the prevailing government', with the exception of Cuba where community theatre was utilised to support the government.

In relation to the practice at CIP San Joaquin and autonomous change, the workers employed the following term to describe how they envisaged their own work – *the invisibles*. By finding allies within SENAME staff, the educators found that they could undertake work that would not be possible under standardised programmes. The allies demonstrated that there were major differences between the ideologies of individual SENAME workers and SENAME management. The workers from SENAME who supported the project and its ideas were predominantly project facilitators and did not hold managerial positions. It was this nuance that enabled the educators from Tierra de Esperanza to strengthen their efforts at developing popular education programmes.

The discovery of a common adversary led workers from SENAME and Tierra de Esperanza to develop a collaboration:

> as a result of this evil dynamic of running the detention centres, we began to talk to each other and to understand that we have many points in common. We talked in parties, reflexive discussions, and we ended up understanding that our political and social base was very similar and was very close to what we understood as our work on a social level, and we began to generate spontaneous actions.
>
> *(SENAME worker, 2017)*

It is the logistics of forming *the invisibles* that is of significance to this article. The prominent point to be discussed is one of managerialism and bureaucracy. The three-tiered management of the centre was chaotic and unpredictable. The triangulation of Gendermaria, SENAME and Tierra de Esperanza had detrimental effects on the practice on numerous occasions, with one branch exerting its authority over the other organisations. Generally, no explanations were provided for the actions undertaken by any one department. However, amidst the negativity that

such chaotic systems inevitably produce, there were also a range of positives. A worker described how the notion of being *invisible* functions:

> in theory we say one thing, but in practice, we do another. And always with the precaution that our work does not create suspicion between our superiors. Because if that happens, we will be summoned to the bosses' office and they are going to ask 'what's happening?'
>
> *(SENAME worker, 2017)*

The project created a paradigm shift for my research whilst in Chile, from a model of critical agonism to autonomous critical antagonism. Mouffe (2013: 7) identifies that conflict in agonistic politics is based on the opponent as adversary as opposed to seeing them as an enemy. Given the dehumanising and oppressive treatment of the young people by SENAME, it would have been difficult to perceive them as adversaries. While there are a range of criticisms regarding the autonomous approach, the project illustrates an example where practice is 'mediated' by 'realities of the place, time and society' (Plastow, 2009: 301). The Chilean neoliberal context necessitates a political position of antagonism and opposition. Mouffe's notion of 'engagement with' state institutions entails a level of complicity which was not deemed ethically or pedagogically appropriate by myself or the educators.

Conclusion

My experience of the practice at CIP San Joaquin demonstrated the significance of dialogue and ethics. The relationship led me to the important decision of prioritising ethics over youth theatre aesthetics and to considering the importance of a dialogical pedagogy in making such judgements. Dialogue was at the centre of this project. The anti-dialogical nature of the institution emphasised the necessity for dialogical artistic practice. The experience at the centre evokes the following anecdote by Freire (2016: 59):

> My friend had come to hear that, in spite of everything, my hope and my optimism are still alive. His question increased my responsibility because I realised that, in my hope, he was seeking support for his. What he may not have known is that I needed him as much as he needed me. The struggle for hope is permanent, and it becomes intensified when one realises it is not a solitary struggle.

As Freire said, the concepts of hope and struggle are inseparable. My experience in Chile made me understand how meaningful collaborations not only transcend educational expectations but provide hope in an environment that exists to dehumanise and oppress young people. This was a unique experience of hope and dialogue.

The depoliticisation of community theatre and the rise of instrumentalism has changed the nature of arts collaborations in the UK. Working relationships are usually based on the mutual interests of achieving governmental and institutional agendas as opposed to the needs and concerns of the young people. My practice in Chile with the educators at CIP San Joaquin proved that a collaboration can be reframed to focus on politics, pedagogies and ethics. The collaboration was founded on this set of mutual ambitions and led the practice to become a form of political action. I am not arguing that all UK practice is devoid of political action. However, I am arguing that the political efficacy of theatre practices with young people could be advanced through conversations motivated by the political and the ideological as opposed to the instru-

mental. The explicit political position of the Chilean educators enabled me to have an open and honest conversation about the political intentions of practice. I believe it is this mutual understanding that led to our practice of challenging the atrocities and adversities of CIP San Joaquin.

Freire (1998: 38) argues that the process of 'educational praxis … cannot avoid the task of becoming a clear witness to decency and purity'. The affective practice of play in tandem with the effective work of critical discussions demonstrated the humanising and ethical possibilities of praxis within a dehumanised context. Therefore, I hope that by discovering solidarity with the educators at CIP San Joaquin and being responsive to the challenges presented, my practice in Chile adhered to the principles of ethical decency.

References

Balfour, M. (2004) *Theatre in Prison: Theory and Practice*. Bristol, Intellect Books.
Cohen, C. E., Varea, R. G. and Walker, P. O., Eds. (2011) *Acting Together: Performance and the Creative Transformation of Violence: Volume 1: Resistance and Reconciliation in Regions of Violence*. New York, New York Village Press.
Fernando (2017) *Group Interview with M. Elliott*. 13th January. Santiago, Chile.
Freire, P. (1996) *Pedagogy of the Oppressed*. London, Penguin.
Freire, P. (1998) *Pedagogy of Freedom – Ethics, Democracy, and Civic Courage*. Oxford, Rowman & Littlefield Publishing Group.
Freire, P. (2013) *Education for Critical Consciousness*. London, Bloomsbury.
Freire, P. (2016) *Pedagogy of the Heart*. London, Bloomsbury.
Gabriel (2017) *Group Interview with M. Elliott*. 13th January. Santiago, Chile.
Holloway, J. (2005) *Change the World Without Taking Power*. London, Pluto Press.
Holloway, J. (2010) *Crack Capitalism*. London, Pluto Press.
Hughes, J. and Nicholson, H. (2016) *Critical Perspectives on Applied Theatre*. Cambridge, Cambridge University Press.
Huizinga, J. (1949) *Homo Ludens – A Study of the Play-Element in Culture*. London, Routledge.
Human Rights Watch (2010) *Chile: Overhaul Prison System*. (Online) Available at: https://www.hrw.org/news/2010/12/09/chile-overhaul-prison-system (Accessed 9th January 2019)
Human Rights Watch (2017) *Chile – Events of 2016*. (Online) Available at: https://www.hrw.org/world-report/2017/country-chapters/chile#c007ac (Accessed 11th June 2017)
Javier (2017) *Group Interview with M. Elliott*. 13th January. Santiago, Chile.
Johnston, C. (1998) *House of Games – Making Theatre from Everyday Life*. London, Nick Hern Books.
Lopes de Souza, M. (2016) Lessons from Praxis: Autonomy and Spatiality in Contemporary Latin American Social Movements. *Antipode*, 48(5), pp. 1292–1316.
Luis (2017) *Group Interview with M. Elliott*. 16th January. Santiago, Chile.
Mouffe, C. (2013) *Agonistics – Thinking the world politically*. London, Verso.
Plastow, J. (2009) Practising for Revolution? The Influence of Augusto Boal in Brazil and Africa. *Journal of Transatlantic Studies*, 7(3), pp. 294–303.
Prentki, T. (2015) *Applied Theatre: Development*. London, Bloomsbury Methuen Drama.
SENAME worker (2017) *Interview with M. Elliott*. 7th January. Santiago, Chile.
Snyder-Young, D. (2013) *Theatre of Good Intentions – Challenges and Hopes for Theatre and Social Change*. Hampshire, Palgrave Macmillan.
Thompson, J. (2009) *Performance Affects – Applied theatre and the end of effect*. Hampshire, Palgrave Macmillan.
Tierra de Esperanza worker (2017) *Interview with M. Elliott*. 7th January. Santiago, Chile.
Winston, J. (2006) By Way of an Introduction, Some Initial Reflections on Beauty. *Research in Drama Education: The Journal of Applied Theatre and Performance*, 11(2), pp. 43–45.

25
COMMUNAL LIVING CULTURE
From the many to the few, from the few to the many

Iván Nogales and Paloma Carpio

Introduction

This chapter focuses on a process led by organizations and people in Latin America who started to work together, through networks and collectives, out of the need to promote joint actions and policies that guarantee participation and the enjoyment of a wide range of expressions of culture at the community level. Since 2010, the concept of 'communal living culture' (*Cultura Viva Comunitaria*, or CVC, as it is known in Spanish) has brought together those of us who have felt called upon to imagine and create other possible words through art and culture. Iván Nogales and I (Paloma Carpio) have formed part of the CVC movement through the collective work we have done with the Latin American Network of Art for Social Transformation (*Red Latinoamericana de Arte para la Transformación Social*). Starting in 2007, we participated in and promoted a number of initiatives in which we joined forces. Sadly, as this text was in the process of being written, Iván Nogales passed away. As a result, I decided to use some of the reflections that Iván shared with me as raw materials, supplementing them and presenting them here as a tribute to him in an effort to share his valuable approach.

Iván Nogales (1963–2019) was an actor, director, sociologist, organizer, and promoter of the Latin American CVC movement. In 1989, he created the *Teatro Trono* group in the city of El Alto, a suburb of La Paz, Bolivia. Through this organization, he promoted the *Comunidad de Productores en Artes* (COMPA) and multiple other projects that gave hundreds of young people living on the streets a chance to dream, to create, and to achieve better living conditions for themselves and others. As the ever-generous connecting node for networks for the arts and community work around the world, he was the driving force behind the First Latin American Congress on Communal Living Culture (La Paz, 2013). His reflections and practices regarding the 'decolonization of the body,' 'depatriarchalization,' 'living well,' and his long career as an artist and a teacher have helped foster valuable cultural initiatives in Bolivia and the rest of Latin America. Nogales was a passionate dreamer who transformed the lives of thousands of people around the world. He broke through boundaries, forging new bonds between Latin America and Europe, bonds that reverse colonial logics and allow us to look upon one another as equals, based on our emotions and our art. Iván's legacy is still alive, and will remain so through *COMPA-Teatro Trono*.[1] In El Alto, as well as the 'town of creators' that he worked on during his final years, not to mention the many schools that Iván visited around the world, the echo of Iván's life still rings

out, and will continue to provide guidance and set goals for a better humanity. The text shared here offers a look at the performance art of the CVC movement throughout Latin America, identifying that which makes it so powerful, along with the challenges it faces.

Communal living culture

The concept of CVC is the result of a profound debate and exchange of ideas among cultural organizations and networks in Latin America, which had repeatedly come into contact with one another thanks to the affinity of their ideas and their shared goal of achieving processes of social transformation through art and culture. CVC is a response to the concept of 'culture industries,' in which culture is conceived as goods that circulate under the logic of the market. In opposition to this approach, CVC fosters processes rather than products; processes of collective organization, popular education, empowerment, and the vindication of cultural rights and each person's right to imagine and create 'other possible worlds.' It is an emancipatory call from a region that, for five centuries now, has resisted the imposition of Western models of development and now seeks to reconnect with its ancestral origins in order to project a future defined by greater harmony with nature and the diversity of cultural expressions. This process has connected hundreds of organizations in over 17 countries, which have made significant progress through dialogue between the state and civil society in order to put forward policies for the promotion of communal living culture.

According to the document[2] drafted during the First Latin American Congress of Communal Living Culture, held in the city of La Paz, Bolivia, in March 2013, the movement defines CVC as follows:

- We are community expressions that prioritize a culture marked by processes above products, consisting of collectives and people engaged in the realization of emotion and beauty.
- We are a continent-wide movement rooted in the community. We are local, ever-expanding, and convergent, embracing culture and its expressions as a universal asset and an important pillar of human development.
- CVC is also a struggle, an effort to achieve public policies created from the bottom up.

(First Congress on Communal Living Culture, 2013: 8)

In an era in which the economic model has shaped the way we live, encouraging individualism and competition, CVC emerged as a political effort to vindicate collectivity. This process has involved a new form of representation and action rooted in the force of collectives organized through the imagination, creativity, and the capacity of agency to transform reality. To spearhead this movement, the Bridge Platform for Communal Living Culture (*Plataforma Puente por la Cultura Viva Comunitaria*) was articulated across Latin America as a network of organizations with a shared agenda, allowing for the emergence and strengthening of the sustained work being done by thousands of organizations with the goal of overcoming inequality and improving communities' living conditions.

The journey thus far

The *Comunidad de Productores en Artes COMPA-Teatro Trono* in Bolivia has made connections with different community-based cultural organizations throughout Latin America in a kind of 'crusade' for CVC. Thanks to the work being done by community theater, art and social transformation, education, and communication networks, advocacy work is now being done with

local governments, while also establishing an articulated continental force united by its diversity. Tackling this challenge has also fostered growth toward and within our own selves. It has helped us to identify tools for engaging in dialogue, building and going deeper into our own communities, as we make great strides toward the horizon of the societies we dream of, the same ones dreamt of by our grandparents and countless others.

Yes, the ancestral communities from which we come are reborn and redreamed, expanding their utopic possibilities through us. We are a channel, a transmitter, and also the creators of everything new that we contain and embrace when we bring our communities together to dialogue amongst themselves. Dialogue with the state, for its part, also strengthens us and reaffirms our path.

From the denial of our existence to which we had grown accustomed; from being told to act as an ornament, the state's aesthetic echo; from being perceived as the 'beneficiaries' of the poetics of the café and the cantina, *we now transition to the need to come together*, to transcend our invisible boundaries and become protagonists. Now ceasing to act as a backdrop, a painting on the wall, the voiceless, we begin to embrace ourselves, weaving our own networks of emotions, tenderness, narratives, encounters, and new 'old' forms of sharing: democracy, art, philosophy, coexistence, past, present, future, time, space. We start to build another society, a revitalization of the communal living culture that exists in the hearts of our territories.

We transition toward explosive moments of reconciliation, debate, and joint actions. We transition toward imagining how to dialogue with states and supra-states to create public policies, or rather, to recognize the public policies that we have forged in our everyday practices, in our own communities. To this end, we have created caravans, organized preliminary encounters, and held the First Latin American Congress of Communal Living Culture (in La Paz, May 2013) to prove to ourselves that the articulated raising of visibility fosters a different type of dialogue with those entities that, for the time being, unlawfully retain the concept they stole from us long ago: that of the public.

With appeals originating from our deepest collective memories, we sat down with local, national, and supranational governments and we designed municipal ordinances and projects with a continent-wide impact to ensure that Points of Culture[3] are mainstreamed through specific programs. We sought to return an infinitesimal piece of the pie (0.1% of national budgets) to community management, a goal that has yet to be realized because the authorities are afraid that this would only open the door for the house to be ransacked with official support. In spite of the barriers, we have succeeded in creating a broad set of legislation, with a national law in the region's largest country, Brazil[4]; a municipal agreement in the city of Medellín[5], Colombia; and an Act for the Promotion of Points of Culture in Peru[6] and an ordinance on communal living culture in Lima[7], its capital. These laws and norms on communal living culture in cities of different sizes are joined by a supranational program on 'living Iberian culture.'[8]

In short, we have gone beyond our community circles and negotiated with pyramidal hierarchies. At the same time, we have negotiated with ourselves, observing, slowly sounding out our own hierarchical obsessions and seeking some sort of foothold in officialdom that is truly willing to build community with us. In fact, we have made a great deal of progress. Communal living culture was born as an approach within communities, and seeks to promote the state's humanization and transformation: managing the state together with the community. Thus, CVC becomes a kind of guarantor of public policy achievements. This means assuming the role of liaison in managing the state's administration, opening doors, forging processes of intercommunity dialogue, and expanding opportunities in social areas such as education, culture, and health. It means putting a new face on the state, one that is more willing to dialogue with society, with communities.

The theories that emerged from the First Latin American Congress on CVC have marked a political route for the movement, one that is clearly oriented toward a society rooted in equity,

justice, and community-based deliberative democracy. All of this constitutes an imaginary that stands in contrast to the state logics currently in force. We have gone from denial by the state to transforming it through this management, inserting communities into the state's logic and ensuring that they permeate it. If CVC is now a process that has emerged victorious over its obstacles, transcending the micro-communitarian, if today we dream of community networks and fabrics, it is because we always dreamed of reconciling with the other, a dream that has defined us as community action in search of other communities. Communal living culture cannot be understood without the concept and practice of caravans, which demonstrate the strength of the fabric that crisscrosses the entire continent, the capacity of artists to reduce distances and unite peoples so that they can dream together.

Before the first congress, the *Caravana por la Vida* (Caravan for Life) was organized as a performance project that arose from the continental CVC network. This caravan, undertaken by Bolivian artists during the Río+20[9] climate summit, connected two geographically opposed cities: on the one hand, Copacabana, Bolivia, which sits on the shores of Lake Titicaca at 3,841 meters above sea level; and on the other, the seaside resort of Copacabana, on the coast of the city of Rio de Janeiro, Brazil. This caravan proved the strength and commitment of artists and cultural creators to a different vision of development, one that reclaims the rights of the *Pachamama* (Mother Earth). At the same time, it proved art's ability to influence public issues and bring together peoples through concepts such as 'celebration' and 'reciprocity.' It is through this possibility of celebration and exchange that CVC continues to organize caravans, congresses, and encounters that encapsulate the mobilizing power of culture in the quest for 'living well.'

The journey ahead

Below are some ideas based on journeys begun by *COMPA-Teatro Trono*, which have offered and will continue to offer future paths for the CVC movement.

Latin American-European bridge

In 1997, *COMPA-Teatro Trono* began its first tour through the capitals and communities of Europe. The next year, it used the caravan concept to found the *Kinderkulturkarawane* (Children's Cultural Caravan), based in Germany. This experience builds bridges for intercontinental dialogue and positions artists as ambassadors for our communities, bringing together experiences and sensibilities, using the resources provided by globalization to facilitate communication while placing humanity above all. This is the precedent that led, in 2012, to the aforementioned *Caravan for Life*.

The *Kinderkulturkarawane*, with *COMPA-Teatro Trono* as its facilitator, has created a fluid bridge with Europe (based primarily in Germany) for Latin American groups such as *Crear Vale la Pena* from Argentina, *Arena y Esteras* from Peru, *TNT* from El Salvador, and many more. Now, more than 20 years after this experience and 30 years after the founding of *COMPA-Teatro Trono*, with 30 European tours, we are able to conceive of a bridge for continuous dialogue between Europe and Latin America, rooted in community culture. A bridge built on action, on performance, and on the creative fabric; rather than concepts.

Community passport

The experience of immersing ourselves in the world through art and culture allows us to imagine infinite possibilities of interrelation and exchange. Is it possible, then, to imagine a

passport that enables us to transit freely throughout the world? Better yet, no passport should be necessary to circulate, walk, run, fly, and navigate the entire globe. The experience of *COMPA-Teatro Trono* calls on us to think of forms that permit communities to transit freely, to imagine a community passport that bonds us together as creators of encounters and aesthetic interactions. The other passport, the 'official' one, will be relegated to mere bureaucratic paperwork. The real passport, the one we carry stamped on our bodies, in our inner selves, our *ajayu*[10], is the one that laughs, that sneers, that revels in mischief whenever those in power, in any part of any country, believe themselves to be the ones who define us. Our true passport is the strength contained in our body, the memory of generations of our ancestors. No *poli*[11], no *milico*[12], no bureaucrat can halt or prohibit—to say nothing of define—the collective force contained in our gaze. The illusion of national passports is only fleeting. The real circulation of cultures travels the world round.

> Yes, we will issue a community passport. We will begin here, in Latin America. We don't need it, it's true, but we will raise its profile in recognition of ourselves as carriers of a collective will to possibility. We are capable of playing, of engaging in an act that symbolizes the acknowledgment of our communities. We have the political force to permit ourselves a piece of paper that proclaims our place within the global community from which each one of us comes.

Pluriversity

Knowledge does not belong to the academy. It exists in the people and their ability to preserve and exchange knowledge horizontally, in conditions of mutual support and reciprocity where not only university students, but woman textile workers, peasant farmers, and urban activists who seek forms of horizontal dialogue with communities can allow themselves to construct another way of sharing knowledge and wisdom, in the search for a more communal horizon. Let us imagine and exercise the co-determination, co-responsibility, co-creation of the public, not only in public policies but in knowledge management too.

Certification

For decades, we have sought state and university validation and certification. We believed that the institutional gaze, its definition, would give us a tremendous boost. It is a true challenge for the recognition of different ways of thinking and different practices to gain social acceptance and valorization. We as cultural creators are once again responsible for building bridges and bringing together different ways of looking at the world, forged by different life experiences, promoting the value of the knowledge that underpins them. Just as in the Peruvian and Bolivian Altiplano, people's desires are expressed through their manifestation in small objects found at celebrations such as 'wish fairs' or '*alasitas*,'[13] so too can we create forms for the self-certification of our peoples' different knowledges and practices. We can do so as a production, a send-up, a satire, a collective game, a political game, as a highly useful symbolic tool for overturning the ways in which power denies the people's strength.

Embassies of community culture

Our houses are beacons where people and groups in search of hidden worlds—people who protect, cultivate, and care for the community's treasures—come to leave and take away experiences that nourish their own travels and creative paths. We are a place for the new generations to gather their forces, to dream as they prepare to exercise community, to act as arrows that will cross all possible borders. With art, education, and play, with a new ethics, we create fronts through which we resist and transform any sign, whisper, or gesture of authoritarianism. We are the points of culture of the body domesticated by fear that opens, little by little, to the rhythm of red noses, uninhibited gestures, and shouts in new and unimaginable settings. We do much more to foster the embrace between cultures than any official body. It is for this reason that we are now the true guardians of the fellowship of peoples. We are the true consulates and embassies of living culture.

Summary

As a kind of continent- and planet-wide production, game, performance:

1. We declare ourselves to be embassies, consulates of living culture.
2. We will issue a community passport as a symbol of our decision to travel and connect the world through creativity and liberty.
3. We will build pluriversities (multiversities) where knowledge and wisdom engage in dialogue and offer feedback as equals.
4. We will certify ourselves and our visitors on multiple levels, validating different forms of knowledge and experience outside the scope of 'officiality.'

This text was written by two hearts together, transcending space and time. Iván Nogales' dreams will continue to spread the vital hopes and struggles of those of us who are united in our work for CVC from wherever it is that we happen to be.

Notes

1. http://www.fundacioncompa.com/
2. The complete document is available in Spanish at https://es.scribd.com/document/147877286/Conclusiones-Final-4
3. Public program started in Brazil that has spread to different countries around Latin America, based on the state's recognition and backing of community cultural organizations.
4. Brazilian Living Culture Act: http://culturaviva.gov.br/sobre-a-lei-cultura-viva/ http://iberculturaviva.org/lei-cultura-viva-de-programa-de-governo-a-politica-de-estado/?lang=es
5. https://www.medellin.gov.co/normograma/docs/a_conmed_0050_2011.htm
6. https://busquedas.elperuano.pe/normaslegales/ley-de-promocion-de-los-puntos-de-cultura-ley-n-30487-1404903-1/
7. https://busquedas.elperuano.pe/download/url/instituyen-como-politica-publica-de-la-municipalidad-metropo-ordenanza-n-1673-913136-1
8. Program that binds together different member countries of the Organization of Ibero-American States (http://iberculturaviva.org/?lang=es).
9. www.un.org/es/sustainablefuture
10. 'The *ajayu* is understood in the Andean world as the force contained in feelings and reason. It is also understood as the core of a being who feels and thinks. It is the cosmic energy that creates and vests life with movement.' See: https://www.servindi.org/actualidad/38388

11 Policeman.
12 Member of the military.
13 https://www.youtube.com/watch?v=aeh7nqNNY4I

Reference

First Congress on Communal Living Culture, Resolutions and Work Plan, 2013. Available in Spanish at: https://es.scribd.com/document/147877286/Conclusiones-Final-4.

26
LATENT CONFLICT OR LATENCY IN CONFLICT

The liminal space between art actions and the Chilean civic-military dictatorship

Andrés Grumann Sölter[1] *and Francisco González Castro*[2]

Latency in conflict and the liminal space of 'applied performance'

When it comes to discussions of performance art, the notion of 'applied' refers to a broad group of cultural phenomena that seek to use the processes of performance art in a way that goes beyond the mere entertainment of audiences and raises questions regarding how these practices are implemented, and their 'practical use' in extra-artistic contexts (understood as modes of entertainment and representation). This is precisely how this concept was understood and practiced by Bertolt Brecht in his *Lehrstücke* (learning-plays[3]), which he defined as an 'active' political theater that does not aim to entertain spectators. This 'active' viewpoint can also be found under Latin American dictatorships, recalling certain liminal practices with a direct social influence, such as Paulo Freire's critical pedagogy or Augusto Boal's *teatro invisible* (invisible theater) and *teatro del oprimido* (theater of the oppressed), which seek to make the community an active participant with the goal of effective transformation in a specific social context. The applied nature of performance art in Latin American contexts is demarcated by both the desire to foster a critical point of view in the collective with the goal of introducing the experience of conflict into precarious cultural contexts and its latent character in public debate; and the need to propose strategies for the development of personal and social change in a given community. In the words of Janet Toro:

> the river arrested, the river
> of the history of pain, the wounded body. The
> blood set fast on cloth and in time
> as testimony to the memory repressed in the
> collective unconscious

(Toro, 2012:17)

This chapter will seek to analyze certain artistic practices of applied performance (which will be presented under the name of 'art actions') that took place under the Chilean civic-military dictatorship, and which had a concrete political objective in the form of the *llamamiento*[4] (call

to action) as a strategy for concrete collective resistance and contagion against the sociocultural context imposed by the civic-military dictatorship. By concrete political objective, we understand the form in which a given historical epoch's social and cultural context creates strategies for ensuring the latency, as Chantal Mouffe terms it, of conflict, but also collective agitation as a battlefield for democratic hegemony. According to Mouffe (2007), the political forces based on the democratic consensus and diplomacy of 'the third way' are the site of a political agonism that is disputed in a *liminal space* comprising both strategies of collective agitation and artistic action. Therefore, she says, politics must be addressed via a set of practices that ensure the latency[5] of the conflict, to which we here add the aforementioned liminal space.

The practices we will discuss include *NO+* by the *Acciones de Arte* collective; *La sangre, el río y el cuerpo* by Janet Toro; and the actions SOMOS+ and *No me olvides* by *Mujeres por la Vida*. In doing this, we will focus on three aspects that reveal the particularities and strengths of these undertakings: their deployment in the public space, thus expanding the limits imposed by art; the use of one's own body, as a constituent element of art actions, and the intention to cause a specific change in reality, taking up the logic of the event which subverts the artistic dimension proper in favor of political conflict.

Carrying out art actions under a dictatorship raises a twofold challenge: a critique of the tradition of art, on the one hand; and a critique of the limits of this field, on the other. Jacques Derrida has reflected on this matter in his exploration of the 'limit' of works, using the frame as his core concept. He concludes that the frame is part of the work, on the one hand, by constituting it as such, since without the frame, without context, it could not be considered a work of art; while on the other hand, the same frame that imbues a painting with the status of a work also encloses within itself. It could be said that the frame is both inside and outside the work at the same time (Derrida, 2001: 23, 65). Those practices that choose the public space as a constituent part of their implementation expand the very structure of the work, including its reality, and place a strain on the frame imposed by the field of art with an autonomous system that governs their actions.

In regard to the use of the body, Michel Foucault states that body is the 'inscribed surface of events (traced by language and dissolved by ideas), the locus of a dissociated self (adopting the illusion of a substantial unity), and a volume in perpetual disintegration' (Foucault, 2014: 23–27). He views all of this through the lens of micro-politics, taking the body to be an agent of political change. In this approach, we can already begin to intuit the importance of using the living body in artistic actions aimed at a concrete political objective.

A third problem presents itself in the intention to cause a concrete change in reality. This is linked to politics understood on the basis of conflict, and to the deployment of these practices via their emerging agonistic occurrence in different contexts. Here, it may be useful to consider Alain Badiou's thought, since for him, one particular feature of the current (traditional) situation is the understanding of politics as an issue of management, when in fact, he says, it is an issue of the possibility of the impossible: 'Politics is, then, all the processes by means of which the human collectivity becomes active or proves capable of new possibilities as regards its own destiny' (Badiou, 2010: 16). This is achieved through the artistic event that fosters political conflict.

Contextual emergency: the civic-military dictatorship in Chile

The bibliography on the reign of the dictatorial regime in Chile, as well as the series of Latin American dictatorships that arose over the course of the twentieth century, is broad and highly diverse. In Chile, there is a certain degree of consensus among the academic community with

regard to a set of topics that must serve as the basis (human rights, social freedoms and freedom of expression, treatment and valuing of indigenous peoples, etc.) for both the cultural definitions and practices of our society. These matters were swept under the rug by mutual accord among the members of civil society and the military during Augusto Pinochet's 17 years in power. It is for this reason that we, as in other Latin American countries, more accurately speak of this period in retrospect as a civic-military dictatorship.

In his essay *El cuerpo en acción: arte y protesta bajo la dictadura militar en Chile* (*The Body in Action: Art and Protest under the Military Dictatorship in Chile*), Alejandro de la Fuente astutely argues that the mechanism of civic-military action for the regime's control and erasure of the cultural imaginary—known as 'Operation Clean-Up' (Errázuriz, Leiva, 2012: 14)—was a:

> machinery of repression that trampled and violated the rights of the country's citizens … For such purpose, the dictatorship's police force designed the distribution of bodies in the public space, installing a regimen of repressive spatial occupation, as well as controlling and organizing the circulation of images and slogans, taking charge of the regimen for the enunciation and visibility of the public sphere.
>
> *(De la Fuente, 2017)*

This mechanism of control, systematically ideated and continually oiled by 'the magnitude of the factual and symbolic terror' (Correa, Figueroa, Jocelyn-Holt, Rolle, and Vicuña, 2001: 279) imposed on the population by both the coup d'état and the civic-military regime, contained violent strategies on the part of state agents who implemented practices for the limitation of rights. In particular, the limitations related to the free use of public space by citizens through regulations such as the curfew, and thus redesigning, in the terms used by Errázuriz and Leiva (2012) and De la Fuente (2017), the distribution of bodies in the public space. Those who dared to break such rules, or those who simply thought differently, were invited to leave the country, or else they were repressed, tortured, and disappeared. Additionally, 'the Congress was closed, political parties were prohibited, constitutional guarantees of individual rights were suspended, and the country was proclaimed under siege' (Correa, et al., 2001: 280). In this manner, the political agonism posited by Chantal Mouffe was extirpated by official institutions, while inspiring the resistance of a large swathe of the population who would begin to be heard and to express itself in the Chilean public space starting in the 1980s. The conflict was focused on a single enemy, represented by the dictatorship's civic-military agents and the figure of Augusto Pinochet Ugarte. Groups of artists and relatives of those who had been arrested or disappeared began to counteract the politics of fear and the moral system through which the regime had acted so brutally. The social and artistic community was now subtly and cautiously beginning to stir (in those cases where it was not repressed or disappeared) in a public space demarcated by a resumptive, 'restorative cultural policy' that recovered 'the country's moral (and economic) body' (Errázuriz and Leiva, 2015: 27). Dissidence began, although apprehensively at first, to articulate itself against the regime by establishing multiple strategies of social and political action. Among these was performance art or, according to a phrase more typically used back then, 'art actions.'

The achievements of Unidad Popular (UP) and President Salvador Allende between 1970 and 1973 in terms of culture for all, rooted in the country's own history (Medel, 2005: 67), were undone by the dictatorship but not forgotten. Indeed, different groups and individuals made use of practices that aided in the recovery of the public space by using their bodies and deploying themselves as events, struggling against the dictatorship in search of that conflict gone missing.

Conflict in latency: art actions, the CADA, Janet Toro, and *Mujeres por la Vida*

During the 17 years of civic-military dictatorship in Chile, the possibility of once again recovering the uses of public space became a constant in the urge to salvage a sense of community in response to the abuse of power and violence. At the same time, both the violence exerted against the bodies of those who opposed the civic-military dictatorial regime, and the supporting media on which the artistic canon materialized the representation of the body, were brusquely called into question, or simply eliminated from the public sphere. Here, the body as surface for practices against the common enemy takes on a value of emergence and identity. Our thesis ratifies these aspects, situating the practices of the body in the public space as a strategy for condemnation that reactivates agonism and ensures its latency (Mouffe) for the purpose of overthrow and liberation.

As such, the proposals that we will examine here distance themselves from the paradigm of representation as an articulating element of the meaning of their actions. Although they do not completely eliminate or reject this aspect—understanding as they do that representation is centered on the reading of the work, and that this reading takes place in the sphere of art—it was presence and action, with their liminal effects on reality, as occurs with any action seeking an effect, that were the primary emphases of these works.

An example of this can be seen in the artistic production of the *Colectivo de Acciones de Arte (Collective of Art Actions)* (CADA)[6]: *Art Actions*[7] developed since the end of the 1970s and during the first years of the 1980s that 'intervene the city of Santiago' (Neustadt, 2001: 13) with the objective of diluting and transforming the division between art and life, placing actions with an evident social commitment. In this way, the *art actions* of CADA, effectively produced from the field of art, are installed in the Chilean dictatorial context and directly linked to social reality, with an intentionality lodged in the presence and action, rather than in the image or representation that can be detached from these art actions.

On the other hand, theoretical reflections also emerged in different circles with regard to some of these practices of action art. Particular note should be made of the *Escena de Avanzada*, or New Scene', a name that Nelly Richard used to group together a diverse set of artists under a framework of theoretical reflection that positions this national artistic 'avant-garde' in times of dictatorship in direct relation to the crisis of representation.[8] In her book *Márgenes e instituciones (Margins and Institutions)* (2007), Richard describes how a group of Chilean artists pursued 'the (anti-historicist) deployment of the ephemeral as a poetics of the event' (Richard, 2007: 22–23) by positioning their body, their flesh, in an ephemeral way (in terms of exhibition) in the public space. It is here that we find their connection to one aspect of the political. In this regard, Richard (2013) highlights 'the political facet of art' that aims at "an internal articulation of the work that reflects critically on its surroundings using these surroundings" own organization of meanings, the same rhetoric of their media' (Richard, 2013).

Seen through the lens of our own interpretation, the interesting thing about Richard's argument is the notion of the 'critical force of interpretation and disruption' (Richard, 2013) exhibited by this aspect of politics in art. We must beg to differ, however, with the idea that this is centered on the image, and not on other aspects of these practices, such as, for example, a phenomenological body and its effective relationship in space as a zone and materialization of conflict as an emerging experience of agonism among bodies in the public space. This discourse also established a kind of hallowed history over the years that has only recently been called into question by different researchers. This canon situates representation as its core element by leaning heavily on a doggedly hermeneutic, semiotic, and psychoanalytic analysis, wherein works are read while ignoring the evident fact that there are one or more bodies performing actions.

Contrary to this argument, however, there is, in the context of the Chilean dictatorial regime, a series of practices and/or art actions that attempted to influence reality not only through a representation of conflicts as a mediation between the artistic and the social, situating the 'image of ideological/cultural conflict of the commodity of mediatic globalization' (Richard, 2013) as the lens through which to be read, but these practices and/or actions went beyond the field of art to situate themselves in life itself; once again relocating the conflict in the body. Below, we will take a closer look at three of these (art) actions.

1) NO+ *by the CADA and its public diaspora*

The CADA group consisted of Fernando Balcells, Juan Castillo, Diamela Eltit, Lotty Rosenfeld, and Raúl Zurita, and was active between 1979 and 1985. Among the art actions they performed, one of the most iconic and most forceful was *NO+*, in which they successfully situated themselves 'in social quotidianity as a space for the work's existence' (González et al., 2016: 92), understood as a work that was part of the social fabric while this social fabric was at the same time part of the action. Put briefly, in this action the collective's members acted together with a group of collaborators, setting out at night to scratch the phrase 'NO+' (No More) onto the walls of Santiago between 1983 and 1984. The phrase 'NO+' was left open, to be completed by the city and its inhabitants.

Considering that the CADA sought to use this action to achieve a concrete effect on reality and once again situate politics in the social sphere, we can once again look to the characteristics that we have established in order to understand this action. To start with, the use of public space is no coincidence. As Derrida might put it, the public space is simultaneously the action's frame and a part of the action, understanding the social as the framework on which the practice is based. We can also see how this problematization in some ways transcends the field of art, situating itself, in this action at least, in social quotidianity, well outside any artistic institution. The expansion of the limits imposed by art, in this case, bolsters its social power, given that this expansion is a 'recovery' of the public space cordoned off by the dictatorship.

With this gesture of inscribing a slogan yet to be completed, *NO+* bears the mark of an action in this territory on the part of its very inhabitants. It is, in fact, a call to action. Thus, a body that was supposed to have been annihilated—the social, but also the individual body—once again emerges in the physical action of writing on the city's walls. As a result, the proposition does not remain enclosed in its image, instead overflowing in the actions of a series of bodies constituting the social body that incites conflict, latent for years, in Chilean society. By extension, the bodies of the members of the CADA and their collaborators, as well as those of the city's inhabitants, displace the canonical conception of 'work of art,' making use of the applied facet of 'performance art.' Furthermore, the inscription of this proposition as an event is relevant to understanding its political power. The action creates an intensity in the present that modifies reality; it occurs in an unexpected way that fell outside the control of the powers that commanded Chilean society. Its effectiveness is also revealed by the fact that the '*NO+*' slogan remained in use long after the initial project: it has been used in the 1988 plebiscite and again in a wide variety of demonstrations ever since. Initially an art action, *NO+* was thus inscribed in the social quotidianity, losing its classification as 'art' but gaining in political efficacy.

2) *Wounded body, public pain, and the Mapocho River: Janet Toro*

Next to the Estadio Nacional[9] runs the Mapocho River, a natural site that continues to navigate through the architecture of human demarcation in which photographic experiences of

extreme violence were materialized, and from which multiple symbolic perspectives have been constructed that haunt Santiago's cultural imaginary. The flowing water and the thousands of people who passed by it after September 11, 1973[10] bore witness to the bodies of mutilated Chileans, lying dead on the banks of Santiago's main tributary. In the words of Janet Toro, 'the river arrested, the river of the history of pain, the body wounded. The blood set fast on cloth and in time as testimony to the memory repressed in the collective unconscious' (Toro, 2012: 17).

In the late 1980s, Janet Toro began her engagement with performance art in an effort to challenge the dictatorship, while at the same time—because she is a woman—facing down a patriarchal system in the arts. One of her first pieces was *La sangre, el río y el cuerpo* (*Blood, the River, and the Body*), which was performed in 1990, when the dictatorship was coming to an end and the country was starting its transition towards an agreed democracy. In this action,

> Toro, with her body nude, stretches a white canvas along the riverbank and wraps herself in a canvas soaked with the blood of an animal from El Matadero.[11] She then lies down on the white canvas, leaving a bloodstain on it, imprinted by her body. In this work, there begins to appear the theme of memory against the backdrop of forgetting on the part of the country's political institutions that occurred during the transition.
> *(González et al., 2016: 126)*

As Toro herself put it, her practice 'is always a search for the extreme. I should note, however, that it is a refined rather than brutal form' (Alvear; Toro, 2015). This search for the extreme means surpassing a number of limits, both in the use of public space and the uses of the body, so as to modify reality. In Toro's work, the public and the private, the collective space, and one's own body are placed in tension with the goal of once again rendering flesh a conflict that official memory attempted to cover up by forgetting.

This transgression of limits pushes the artist to 'get out,' to carry out her ideas. These are not expressions in a museum or a gallery, but an act of getting out, which—like the CADA—entails the recovery of a space that has been snatched away; but which also incites conflict in those places that official institutions sought to make disappear, just like the thousands of bodies whose lives they erased. In this way, the use of public space is transformed into the supporting medium for a memory that refuses to vanish.

In her introduction to *El cuerpo en la memoria* (*The Body in Memory*), Soledad Novoa describes the journey of Janet Toro's performance, noting that 'the path through the city required by Janet Toro's work acts as the suture and scar of a collective wound, a wound inflicted on the social body that inhabits the city, combining the individual body with the collective body' (in Toro, 2012: 4–6). Continuing along these same lines, the visual artist and writer Guadalupe Santa Cruz says that in her transit, Toro renders her body a point of confluence in a city that has been emptied of itself. Santa Cruz speaks of a 'blotting body,' in allusion to the blotting paper used to absorb moisture and set handwriting. The artist's walk acts as a cauterizer, a heat that burns, hurts, and heals, once again touching on the therapeutic aspect of this work. In both readings of Toro's work, the public space, the artist's body, and the collective work are intertwined, speaking, on the one hand, to the relevance of Toro's use of her own body, since it is ultimately in the body that political processes are situated, enabling her to forge a relationship with the other bodies that surround the action, both physically and metaphorically. On the other hand, it highlights the inscription of an action which, like *NO+*, occurs in the social quotidianity, unexpectedly impressing upon the very same river in which the bodies floated in their own blood a new body that is smeared with the blood from El Matadero.

The recent recovery of Toro's work by people such as Novoa and Santa Cruz comes at a time when the consensual exit from the dictatorship toward a 'democracy,' that is nothing more than a continuation of what came before it, is being increasingly cast into doubt, laying bare its crimes. Toro's corpus takes the form of a malaise that has lingered from the late 1980s on a conflict that remained latent and which Toro situated in the very same places where the dictatorship unleashed its terror, a terror that endures, in the form of fear, to this day.

3) *SOMOS +* and No me olvides: *social agitation and latent conflict in* Mujeres por la vida

As Isabel Gross argues in her study *Por la vida: las agrupaciones de mujeres durante la dictadura militar chilena* (*For Life: Women's Groups During the Chilean Dictatorship*) (2015), while the roots of women's mobilization in Chile can be traced back to the late nineteenth century, with their struggle for the right to vote, 'the peak of the Chilean women's movement came during the military dictatorship. Women's activism flourished not under a democratic government, but in the midst of the most extreme repression Chile has ever experienced' (Gross, 2015, 4–5). Gross describes this peak by studying eight Chilean women's groups that situated themselves in public and private space with the unwavering goal of erecting a defense against the violence exerted on their children, and in favor of peace and solidarity, although they also protested 'against the disappearance and execution of prisoners' (Gross, 2015, 11). '*Por qué damos la vida, la defenderemos*' (Because we give life, we will defend it), '*SOMOS+*' (We are the majority), and '*No me olvides*' (Don't forget me) were some of the slogans and chants they used during their actions in the public space in Santiago. In this way, the collective impetus and (art) actions deployed by the collective *Mujeres por la Vida* (Women for Life),

> were an active response to persistent repression by Augusto Pinochet's dictatorship, in the form of flash actions including marches that converged on an unexpected point in the city, signs, traffic blocks created by human chains, banners featuring demands, and the use of constant refrains to link denunciations to the repetitive cadence of the voice.
> *(Varas; Manzi, 2016, 55)*

In his essay *El cuerpo en acción: arte y protesta en la dictadura militar chilena* (*The Body in Action: Art and Protest under the Chilean Military Dictatorship*), Alejandro de la Fuente discusses some of the most notable actions by the *Mujeres por la Vida* group. In his reading of these liminal actions, De la Fuente argues that their twofold intention establishes a *liminal space* between the *llamamiento* as an act of resistance and the collective art action in the public space. 'They call on the spectator to freely participate as an active part of the process, where authorship becomes blurred among the participants and the formal factors of creation (such as composition, style, etc.) are completely irrelevant in the final result' (De la Fuente, 2017).

It is this logic that underlies the action *SOMOS+*, a call to march from different points in the commune of Providencia, in Santiago, in 1985. The defining feature of this call to action was that it occurred on three fronts.

> The first front, from the east, marched toward the main square under the title of *Unidad y solidaridad* (Unity and Solidarit). The second front marched from the west, under the title of *Paz y justicia* (Peace and Justice), while the third front marched from the south, under the name of *Por la libertad y la democracia* (For Liberty and Democracy).
> *(De la Fuente, 2017)*

Thus, these three columns erupted into the public space, modifying it with their collective body and their action, under the banner of *SOMOS+*, which finds its precedent in the CADA's *NO+* action discussed above. *SOMOS+* situates conflict in the public sphere by retaking the public space and demanding to see the bodies of the prisoners disappeared by the regime. In this way, they challenged the limits imposed by the dictatorship, highlighting a collective body in search of truth and justice.

The daily violence exerted in the public space, the acts of torture, and the unknown whereabouts of thousands of detained and missing individuals gave rise, once more, to the voice and action of *Mujeres por la Vida* in 1988, this time with the *llamamiento* for an (art) action to be carried out in alliance with the *Movimiento contra la Tortura Sebastián Acevedo* (Sebastián Acevedo Anti-Torture Movement). The slogan was '*No me olvides*' (Don't forget me), which aimed to 'undertake a joint campaign to raise the visibility of missing prisoners' (De la Fuente, 2017), establishing collective agitation as a practice of memory with regard to those who had been disappeared by the dictatorship. The campaign was tied to the preparations for the elections planned for the following year, in which citizens would vote 'yes' or 'no' on Pinochet. As De la Fuente (2017) recalls:

> 'No me olvides,' which started in July of that year, consisted of a series of actions and interventions in the public space. Among other things, they cast moving silhouettes on certain iconic buildings, hung up screen-printed silhouettes, and marched while carrying these same silhouettes. The black silhouettes were life-size and bore the names of some of the victims of state terrorism. Written in large letters on these silhouettes was the phrase 'Have you forgotten me?' with which protesters demanded answers.

Conflict remains latent still in the memory of a Chilean society that has experienced the consequences of a democratic pact by the higher ranks of civil, political and military power but has recovered the use of public space. Under the title of 'latent conflict – latency in conflict,' we wish to propose a reading of a group of art actions and/or performances carried out largely by women during the civic-military dictatorship in Chile. The principle of life and the expression of a search for liberation under the name of *llamamientos*, or 'calls to action,' morphs into the horizon where the CADA's *NO+* occupies the public space and interpellates society to recover the flames of this latent conflict. For her part, Janet Toro situates her body in this same space as an *llamamiento* for the testimony of repressed memory personified. Finally, *Mujeres por la Vida* combines both tactics, leaving the stamp of latent conflict as a political action for vindication and human dignity that still profoundly afflicts much of Chilean society. We propose a reading of this liminal space between applied performance and conflict as the latent incubation that was materialized by *llamamientos* in the form of (art) actions in Chile from the time of the civic-military dictatorship right through today's Latin American democracies.

There is no doubt that the aforementioned not only revives the historiographical reflections on the ways in which Chilean artistic practice was presented in dictatorial times, but also reaches another important urgency today, where various governments of the right and extreme right have come to power in different Latin American countries (Argentina, Brazil, Chile, etc.), generating a phenomenon in which far-right groups have returned to mobilize in the public space and have even reappeared in demonstrations with artistic court actions in which they seek to impose their fascist vision of society. An example of that is the Chilean Patriot Social Movement, a Chilean extremist group that has positioned itself in the public space intervening in various

manifestations in the city of Santiago, such as a feminist march where they stormed the demonstration staining the street with red paint, with the aim of distorting the legitimate slogans and re-delimiting, with their sexist slogans and laws, the use of the street by women. Although the strategies and materialities used are related to the artistic, a clear differentiation that makes even more extreme the way of acting of these right-wing groups was their use of violence and physical aggression positioning their power hegemony: in the feminist march the extremist group not only stained the street, but also harassed, beat and stabbed a couple of women without further mediation from the public force.

Therefore, we must ask ourselves what we have learned from all these procedures of art action and performance applied in extra-artistic contexts against the dictatorship, so that in these times of a sheltered democracy where movements of the extreme right reappear, we have the capacity not only to react to violence, but to propose and install modes of action that point to the active and conscious state of the community with the aim of achieving an effective transformation of the society we want to build and inhabit today.

Notes

1. PhD in theater and dance studies from Freie Universität Berlin. Professor at the School of Theater, Faculty of Arts of Pontificia Universidad Católica de Chile. http://escueladeteatro.uc.cl/escuela/profesores/88-andres-grumann-soelter
2. Artist/researcher. PhD in Art and Core Faculty, Global Center for Advance Studies. Co-author of the book *Performance Art en Chile*. Ediciones Metales Pesados, 2017. www.franciscogonzalezcastro.com
3. Brecht wrote his *learning-plays* so that the experience of staging these pieces would allow groups of workers to discuss society's contradictions.
4. In the exhibition catalogue for *Poner el cuerpo. Llamamientos de arte y política en América Latina en los años ochenta*, Paulina Varas and Javiera Manzi describe the *llamamiento* as 'the name given to declarations seeking to agitate and issue a call for collective position-taking and action in the fight against the regime in power. These were not discrete calls; on the contrary, their name refers to a call that never grows quiet, that has not triumphed but at the same time refuses to be shut out or surrender' (Varas; Manzi, 2016: 3).
5. The term 'latency' refers to the idea of a 'latent state,' the state of something that is hidden, that cannot be easily perceived, or that appears not to be active, but which is nonetheless unsettling because of its vaguely discernible presence.
6. Later, the artistic work of the *Collective of Art Actions* (CADA) will be reviewed with more attention.
7. The term 'art actions' was used both by artistic practice and by theoretical reflection on art during the Chilean military dictatorship. Although it was the Collective of Art Actions (CADA) who placed it in its modes of artistic intervention, the referents of use in the Chilean artistic context can be found in the reflections that both Ronald Kay and Nelly Richard generated in different contexts and groups within the seventies. An example of the above is the link and influence that Wolfgang Vostell's actionism generated with Chilean art in the late 1970s. In particular, his epistolary and thoughtful exchange with Ronald Kay in the framework of his exhibition 'The Egg' in 1977 in the extinct Época Gallery.
8. *Escena de Avanzada* is a term for the art scene of the 1980s coined by Nelly Richard, in which she positions a series of artists as part of a neo-avant-garde that has distanced itself from the official arena of the arts, situating her discussion as a dialectic between the 'margins' and the 'institutions.' After the end of the dictatorship, this scene transformed into a canon of the arts in Chile.
9. The Estadio Nacional in Santiago, Chile, was used by Pinochet's military regime as a center for detention and torture between September 12 and November 9, 1973. See Grumann, Andrés. *Anfiteatro Estadio Nacional*. Santiago, Chile: Cuarto Propio, 2013.
10. On September 11, 1973, a coup d'état was staged by the military junta under the command of Augusto Pinochet, Gustavo Leigh, José Toribio Merino, and César Guzmán, overthrowing the government of Salvador Allende.
11. A traditional place in the Franklin neighborhood of Santiago that served as the center of the meat trade and a slaughterhouse for animals in Chile's capital.

References

Alvear, L. (2015). 'Janet Toro | "Las performances y el arte transforman la sociedad, aunque sea por un Segundo"'. Available at: https://www.arteallimite.com/2015/10/13/janet-toro-las-performances-y-el-arte-transforman-la-sociedad-aunque-sea-por-un-segundo/.
Badiou, A. (2010). *La filosofía y el acontecimiento*. Madrid: Amorrortu.
Correa, S.; Figueroa, C.; Jocelyn-Holt, A.; Rolle, C.; Vicuña, M. (2001). *Historia del siglo XX chileno*. Santiago, Chile: Editorial Sudamericana.
Derrida, J. (2001). *La verdad en pintura*. Buenos Aires: Paidós.
Errázuriz, L.; Leiva, G. (2012). *El golpe estético. Dictadura militar en Chile 1973–1989*. Santiago, Chile: Ocho Libros Editores.
Foucault, M. (2014). *Nietzsche, la genealogía, la historia*. Valencia: Pre-Textos.
De la Fuente, A. (2017). 'El cuerpo en acción: arte y protesta bajo la dictadura militar en chile'. *Ecfrasis: Revista estudios críticos de arte y cultura contemporánea*. Available at: http://revista.ecfrasis.com/2018/03/19/cuerpo-accion-arte-protesta-la-dictadura-militar-chile/.
González Castro, F.; López, L.; Smith, B. (2016). *Performance Art en Chile: historias, procesos y discursos*. Santiago: Metales Pesados.
Gross, I. (2015). 'Por la vida: Las agrupaciones de mujeres durante la dictadura militar chilena'. *Paper written as an intern at the Museo de la Memoria y los Derechos Humanos*, Santiago, Chile. Available at http://www.cedocmuseodelamemoria.cl/wp-content/uploads/2015/12/Isabel-Gross_20151.pdf.
Grumann Sölter, A. (2013). *Anfiteatro Estadio Nacional*. Santiago, Chile: Cuarto Propio.
Medel Valdivia, I. (2005). 'El discurso del silencio (borraduras y apariciones en la Historia)'. Master's Thesis in Latin American Studies. Santiago, Chile: Universidad de Chile.
Mouffe, C. (2007). *Entorno a lo político*. Mexico City: Fondo de Cultura Económico.
Neustadt, R. (2001). *CADA DÍA: la creación del arte social*. Santiago, Chile: Editorial Cuarto Propio.
Richard, N. (2007). *Márgenes e Instituciones. Arte en Chile desde 1973*. 2nd ed. Santiago, Chile: Metales Pesados.
Richard, N. (2013). 'Lo político en el arte: arte, política e instituciones'. *Hemispheric Institute E-Misférica*. Available at http://hemisphericinstitute.org/hemi/es/e-misferica-62/Richard.
Toro, J. (2012). *El cuerpo en la memoria*. Czech Republic.
Varas, P.; Manzi, J. (2016). *Poner el cuerpo. Llamamientos de arte y política en los años ochenta en América Latina*. Exhibition catalogue. Santiago, Chile: Museo de la Solidaridad Salvador Allende. Available at https://mssa.cl/mssa3/wp-content/uploads/2016/02/PONERELCUERPO.pdf.

27
THE COMMUNITY AND ITS GAZE
Argentine community theater

Edith Scher

In Argentina, community theater is a practice defined by those who form part of it and perform it; the local residents of a given neighborhood. Large groups made up of people of all ages, groups that endure over time, that constitute not isolated experiences but projects that grow and expand. Groups of amateurs directed by professionals, groups that act as cultural hubs for their particular territory. As such, community theater in Argentina is not the activity of actors aimed at people who do not normally have contact with the arts, nor a theater practice solely preoccupied with addressing themes or problems that may interest or concern a given population. Nor is it necessarily street theater (it may be, but it can also take place indoors), nor an incursion into at-risk communities. What it is, is a theater that conceives of art as the right of all, and not merely the property of artists. Therein lies its transformative nature.

The gaze

A territory gazes at the world. A neighborhood questions, narrates, speaks. It is not, however, transformed only by what it says, but by how it expresses it, rendering the artistic as something inescapable. Art is the 'how' and not the 'what.' Artistic practice can be conducted by the neighbors, for the neighbors. A poetic gaze can be shaped in the heart of the community. This practice is not (or not only) a tool, an instrument, a channel, a vehicle; rather, it is transformative in and of itself. It is not a mere supporting medium for content (it tells stories of interest to the community, and it is strongly imbued with memory and identity), it is also more than that. Acting, singing, and playing to free bodies from social obedience, to help explore possibilities, to imagine together with others, and to take part in a theatrical production: these are actions that transform us and invite us to conceive of life and human relations in a way that differs from the seemingly exclusive, static form we sometimes fall back on. This creates another perception of reality that ceases to be an immutable knot and becomes a human construction on which it is possible to exert an effect. A community's creative development broadens the horizons of the possible; it empowers. The creation of a fiction, a tale, makes it possible to imagine other worlds instead of passively accepting the idea that we have only one single possibility. This is essential to the conception of community theater in Argentina: art as the right to fiction, rather than an attempt to faithfully parrot history. This idea raises the question of the gaze on the world. A community with a gaze is not a passive, obedient community. That gaze

is expressed, too, in the aesthetics at which the group arrives after a lengthy process, with an artistic direction that achieves a poetic synthesis of all that arises during the rehearsal period; a synthesis that is tinged from the start, inevitably and necessarily, with the subjectivity of those who direct and guide it, which must inarguably resonate with the community's universe and its collective contributions. The coordinator's work means bringing out the best in each of the participants and trimming the material, polishing it, and making it say something to the world, something moving, something aesthetically exciting, something that makes a poetic impact, creating another world. It is in this way that the 'we' is transformed, dignified, and given the ability to shift boundaries.

Art is the foundation of all undertakings. Only the challenge of an edifice that contains the knowledge and imagination of the many—the awakened desire to explore outside the boundaries—has the ability to forge a revitalized gaze on reality. If this does not happen, we run the risk of changing the route in a different direction, leading to short-term exhaustion (the desire to create, on the other hand, is inexhaustible) and falling once again into the false dichotomy between life and art, in the belief that the latter is a sumptuary activity to be left until after more important matters have been resolved; that it is some kind of entertaining appurtenance to life. Dignifying the community's human condition, its active character, the knowledge of the other, the bonds of solidarity that are created through the need for each one to do his or her part, the emergence of a creative partnership: these are not questions that fall outside the artist's task, but rather, they are inherent in it.

The history

There is always a before: there are always traces, signs, antecedents. The official start of this movement, which now includes over 50 groups throughout the country, was the birth of the Grupo de Teatro Catalinas Sur (Catalinas Sur Theater Group), directed by the Uruguayan Adhemar Bianchi, in 1983, in a neighborhood called La Boca in the southern part of Buenos Aires. The date is telling, since at that time society was experiencing a profound need to mend broken bonds following years under a dictatorship (1976–1983), at a moment when hope was once again becoming a possibility. This period saw the creation of the Movimiento de Teatro Popular (People's Theater Movement, or Motepo), made up, among others, by Agrupación Humorística La Tristeza, Los Calandracas, La Runfla, Diablomundo, Otra Historia, and Catalinas. Some of the groups of the Motepo survived over time. This was not an easy task in an Argentina that had been devastated in so many ways, including its collective culture, the act of building together with others. From the very start, even without the conceptual framework that the movement would later develop, community theater fought against the culture of individualism and focused its energies on constructing a plural subject that acted as the voice of the story in its performances. That plural subject is one of the reasons it was able to endure over the course of more than 35 years, with a contagious enthusiasm that helped it to spread. 'We! We, the neighbors,' community theater proclaims, 'we who act from within our neighborhood, gazing, speaking, narrating, expressing opinions, and creating.' It affirms itself, too, in the multiple 'Wes' of fiction, the chorus that takes on the different identities so essential to a play. So it was before, and so it is now. Today more than ever, community theater is rooted in the first person plural. This is its standard, starting with its very birth, and it continues to uphold and defend this commitment today, in the frightfully individualistic and meritocratic circumstances of Argentine reality in 2019. Yes, to speak of this practice is also to speak of the context in which it occurs. It is a core principle of community theater that art and politics, art and social transformation, are inseparable, reconstructing and valuing the knowledge of neighbors, bolstering their creativity.

This development represents an active mode of community, alive, standing before the world. Community theater is firmly aimed at awakening this slumbering creativity, the passivity resulting from the profound cultural rupture suffered by society; a rupture that has a multiple and far-reaching scope, a rupture that was intensely felt in 1983 at the birth of this practice that never disappeared, a practice that today deeply inhales and exhales the current of air sweeping across the Global South. So, too, in these difficult times, the community theater movement continues to grow, strengthen, and build with a counterhegemonic force, running in complete opposition to the dominant culture's belief system. The community theater found in these lands has been marked by several distinctive, forceful traits since the very start: the determination to sustain and enrich a collective subject; to never decouple art from politics; not to give up the desire for a better society (which is the mark of those, as we said, who began to shape community theater based on their background and life experiences). It forges an unbreakable bond between the artist's task and social change, understanding, on the one hand, that community theater does not consider that art is isolated from its surroundings and, on the other, that the same task of doing community theater is political.

The Grupo de Teatro Catalinas Sur blazed a path and left its indelible mark on all others, not only in an aesthetic sense (many of the functional criteria are based on the practice begun by those in La Boca in 1983, although many groups would go on to create their own aesthetic influenced by popular genres such as the *sainete*, the *murga*, the use of giant puppets, the circus, etc.), but in its general conception of art and its relation to the world. In 1996, the Circuito Cultural Barracas (Barracas Cultural Circuit) was born. Los Calandracas, under the direction of Ricardo Talento, also decided to create a community theater group in a neighborhood bordering La Boca. They did so at a time when the values of the 1990s were at their height, and 'every man for himself' had come to seem a natural law. It was under these circumstances that the second group emerged, also in the city's south, and thus community theater began to grow stronger.

A few years later, with the encouragement and help of the Grupo Catalinas, two more groups were born in the province of Misiones: Murga de la Estación (1999) in Posadas, and Murga del Monte (2000) in Oberá. Argentina was marching toward a major crisis that would finally erupt in December 2001. A few months after the social outburst that occurred at that time, the Red Nacional de Teatro Comunitario (National Community Theater Network) was born. Organized by two directors (Bianchi and Talento), at first it consisted of only a handful of groups. Transmit, inspire, share: these verbs were the leitmotiv of that starting point. That was the legacy that was bequeathed to all those who became involved at that time, and for those who would come later. 'If this activity transformed our neighborhoods, our communities,' said Adhemar Bianchi and Ricardo Talento at the time, 'why keep it to ourselves? There should be at least ten groups more.' Today, the network is enormous. There are about 60 projects of this nature in the country. The groups all have their own particularities rooted in their specific territories, their directors' characteristics, their aesthetic decisions, but all of them share one trait, and that is the performance of theater by neighbors, for neighbors.

The proponents

Community theater was not created out of thin air. Indeed, it is heavily marked by the history of its time. It engages in constant conversation with that history. Adhemar Bianchi and Ricardo Talento belonged to a certain generation. They were young men in the 1960s and 1970s, part of a generation that believed in the struggle, in the transformation of society. This generation lived and breathed the demonstrations in the street, the desire for a world that was more

just. Then came the dictatorship and everything fell to pieces. But the two directors, like so many others, were survivors of utopias and they eventually found a way to imbue their artistic activities with that trust in the collective, that desire for a better society. This is no small thing. All these years of history (from 1983 to the present) have served as proof that community theater groups need directors with that unrestrained gaze, that conviction that together we can achieve things that would be impossible for us as individuals, that ability to imagine beyond that which reality seems to permit. And this is the legacy of this movement's proponents in Argentina. Everything comes about in a given context, and aside from these proponents' inclusive, generous, and contagiously enthusiastic attitude, they also proved quite adept at reading their historical moment (for example, December 2001 was a time of deep crisis in Argentina, a time when there was a social uprising). Thanks to this ability and their constant mentorship and encouragement, this practice began to multiply exponentially from 2002 onward. It has grown so much that it is now difficult to measure. Ever since then, we have seen the publication of books on community theater, thesis papers, and dissertations by students from a number of academic areas (in both the arts and the social sciences). It was essentially in 2009 that the conceptualization of community theater began to expand, with a notable number of foreigners coming to study this phenomenon, some of whom confessed that they could never have grasped the magnitude of Argentina's community theater without seeing it for themselves *in situ*. This enormity is not the result of chance or coincidence. It is the consequence, whether intentional or not, of a way of conceiving reality that was and is fostered by those who initiated this practice in this country in the Global South.

The epic, the aesthetics

Community theater tells collective stories. It is not an intimate theater, with a limited number of characters. It is large in scale, with a cast of many. It is epic. It has no individual protagonists (if there can be said to be a protagonist, it would be the chorus) and its tales do not deal with the private sphere, stemming instead from the collective memory. Generally speaking, it works within the realm of tragedy and comedy, and rarely takes the form of drama—specifically bourgeois drama. It tells stories of the community, not always in a linear fashion. It does not necessarily deal with neighborhood problems to be resolved, or tell a local story in a literal sense. All of this is possible but not indispensable. Community theater is not transformative because of any sort of instrumentality, or because it acts as a container with a given content, but because this artistic practice has specific characteristics that broaden horizons and construct other expectations for life that can modify a community's subjectivity, and that constantly invite us, through the translation of these expectations into action, to rethink the belief systems vanquished by the hegemonic value system. Art as a right of all thus becomes a categorical hallmark.

Community theater takes inspiration from popular genres. In it we can recognize traces of the *grotesco criollo* (Criollo grotesque), the *sainete* (one-act farce), the *murga* (typical of Carnival in the River Plate area), the *zarzuela* (operetta), and giant puppet theater. All of these are well-defined genres in their own right, although in this case, mixed into a new genre that contains them all: community theater. We can also note Brechtian influences, along with the heavy use of singing as the great agglutinant of the 'we,' a largescale catalyst of the collective memory (in many cases taking pre-existing melodies and changing the lyrics), a vigorous condenser of poetic meaning (given that poetry condenses meaning and song is poetry), and a procedure of poetic estrangement that highlights representation, the theatrical nature of the proposition, and distances it from 'fourth wall' realism. These genre traits, too, are memory and identity. Memory and identity of popular forms.

Inclusion, celebration

Inclusion is one of the distinctive traits of this practice. Anyone who so wishes can join these groups, which tend to be multitudinous. No prior experience is needed, nor any special talents, since the proposition is rooted in the belief that everyone is able to develop their creativity within a framework that permits it to flourish. This leads to the gradual incorporation of many, many neighbors: the same project brings together mothers and their children, youngsters, teens, the middle-aged, and the elderly. This broad inclusiveness does battle with the culture fostered by consumer society, which divides everything by age (50-year-old single men looking for 40-year-old single women, the young with the young, seniors with those of their own age), as well as attacking the idea that only certain individuals, inspired by the muses, can be creative. Anyone can take part, regardless of political party, religion, or anything else. Some participants are professionals, others are students; and there are people from a wide array of trades, some employed, others not. Of course, this inclusion of anyone who wants to be involved results in a high degree of heterogeneity among members. In order for this practice to work well, it undoubtedly requires a certain kind of direction that is able to coordinate such different energies—a person or team with an artistic background and a vocation for social work. Directing community theater is not a decision that one arrives at after experiencing failure on the path to a more prestigious form of theater; it is a life choice.

Each gathering and each play involves a kind of ceremony. The art in which community theater is engaged is not the sort to be locked up in a basement. Rather, it is a ritual encounter among neighbors, a resignification of spaces that are not hegemonically viewed as places in which cultural practices can be carried out. It is an art that grows in unconventional spaces in the neighborhood, including schools, public squares, clubs, and spaces inhabited by the community. Places fit to host a multitude of people, to celebrate. Community theater also never separates art from food. The audience can often be seen eating while they watch the play, or drinking *mate*, a kind of tea popular along the River Plate. The groups often set up a snack bar with different homemade treats prepared by many of the members, thus fostering a relationship with art that avoids being weighed down by solemnity, but instead strengthens the concept of theater as a celebratory ceremony (Figure 27.1).

Relations with the state

The majority of groups that belong to the Community Theater Network in Argentina started out as self-supporting projects promoted by the community itself. This does not necessarily mean that each group of neighbors in each area decided to organize the community theater in their neighborhood. There were often calls for participants launched by those who wanted to start the project and act as coordinator. There has always been a major community management component, however, that ensures each project's sustainability over time. The tasks required in an undertaking of this kind are varied (some of them artistic and others not so much). It is also critical to cover the overhead expenses, which may be higher or lower depending on each neighborhood arts collective. Some groups rent spaces, or have expenses tied to their official status as non-profit organizations. Many pay salaries to their directors and those responsible for other professional areas (it is important to allow professionals to dedicate as much time as possible to the project's growth). All of this requires money. Part of this money is obtained through self-management, from the dues paid by each neighbor (each group agrees on the amount of these dues, which is updated from time to time and obviously, if someone is unable to pay, they do not pay) to whatever money is raised from performances, along with the many other crea-

Figure 27.1 *Herido Barrio* written and directed by Edith Scher. (Photo: Julio Locatelli.)

tive ways of raising funds. The Network (continuously) seeks to influence public policies with the goal of obtaining government support, thus helping to pay for such largescale undertakings. Some success has been achieved in this regard, and persistence is key. One such achievement is the amendment of the law for the promotion of independent theater in the city of Buenos Aires. After a long fight, this law has also covered community theater since 2014. Each year, the groups in this city submit a plan to the agency in charge of this task, and receive money to help sustain this practice in their neighborhood. While this does not cover all of their expenses, it is nevertheless important since it is covered by law, thus legitimizing and valorizing the practice. It is important to get the government to support community theater, while also recognizing that the more active and ambitious the community is, the more alive it will become. The Network argues that the government should provide subsidies without exerting any internal influence on the dynamics and logics behind the groups.

Community theater and social transformation

Fostering an active imagination necessarily requires a movement, a concrete possibility of perceiving and thinking of the world beyond externally imposed limits. And that is where transformation begins. Community theater highlights the right of every neighborhood's residents to create fiction, to devise tales that speak about the world, a gaze from the perspective of their own territory. To speak of a desire for 'social transformation' means believing that the state of things is not right, that everything could work in some other way. It means believing that there is injustice, oppression, misfortune that must be challenged. The system convinces us that the world is the way it is, and that it is only natural that it works this way. But what change can there be in the world if we persist in the belief that things are as they are and there is nothing that

can be built or changed? Community theater tirelessly strives, through its practice, to undo this belief. Because the artistic gaze generally tends to alight upon places where we do not habitually focus our attention, offering a revitalized point of view regarding that which goes unnoticed or seems normal, it applies this kind of attitude to life and its given conditions. If the community as a whole is able to engage in this practice, an immense transformation can be achieved. When a community develops its creativity, with the full breadth implied by this concept, it begins to leave behind its role as a spectator of its destiny, instead becoming an active part of social life. Art is one of the key aspects in this transformation.

The movement

Community theater in Argentina is one of the most important cultural occurrences in the last 40 years; a true movement. Its existence and way of conceptualizing artistic practice have led to the inclusion of orchestras, casts of puppeteers, percussion ensembles, community acrobats, and more. These groups tend to be increasingly large in number, meaning that this practice is on the rise. As such, Argentina's community theater movement is a way of understanding culture and its influence on a society, a way of implementing transformations in the collective subjectivity, a way of creating an impact on reality, a powerful opinion on what it means to live well.

Bibliography

Bidegain, M. (2007). *Teatro comunitario. Resistencia y transformación social*. Colección Biblioteca de Historia del Teatro Occidental (Serie Siglo XX, director: Jorge Dubatti), Buenos Aires, Editorial Atuel.
Proaño, L. (2013). *Teatro y estética comunitaria. Miradas desde la filosofía y la política*, Buenos Aires, Biblos.
Scher, E. (2010). *Teatro de vecinos de la comunidad para la comunidad*. Ilustrado por Jorge Vallerga. – 1a ed. Buenos Aires, Inteatro.
Zarranz, L. (2015). *Actores sociales*, Buenos Aires, La vaca.

28
THREE COMMUNITY EXPERIENCES AND A RESIGNATION

Rafael Murillo Selva[1]

Dingki–Dingki in the Time of AIDS (2003)[2]
Three cultures: sexuality as a theme (surprise and the stage: on tour in places where no one knows what 'theater' is)

It was an intense learning experience integrating three cultures, each with their own codes, in this work in a single theatrical corpus and harmonizing them simultaneously. The cast consisted of 12 artists, four from each of the 'ethnicities' involved: Miskito, Garifuna, and Ladino. On the stage, there was a wide array of vocal ranges, bodily rhythms, and tones and colors, all of them theatrically intertwined and unified. The same went for the different musical accompaniment in the respective languages: although they were very different in terms of their phonetics, once integrated on the stage, they became part of a whole that enveloped the room in a single melody.

This was the first time that I had dealt with a culture (the Miskito) about which I had no knowledge, even in its most basic expressions. Before beginning the stage work, we performed field research, visiting several communities in that region. Over the course of this undertaking, it became clear to me that this was a society in which the 'mythical' is the real, i.e., that which determines much of the direction taken by everyday actions. All of this was mixed in, of course, with the 'gifts of progress' that inevitably come with the globalized world, from which not even the isolated Miskito of Honduras have been able to escape.

With *Dingki–Dingki in the Time of AIDS*, our goal was to get the contradictions between ancestral beliefs, on the one hand, and the emergence of new needs created by the machinery of globalized production, on the other, to show through on the stage in the most objective, creative way possible. In this case, those contradictions are synthesized through a core concept that unites them: sexuality.

In addition to the usual spaces, I have always been concerned with putting on our performances in the most out-of-the-way towns and locations: jungles, deserts, beaches, mountaintops, forgotten neighborhoods, nursing homes, prisons, juvenile detention centers, and indigenous settlements. There are really very few spaces that have escaped my theatrical voracity. And it has been in spaces like these, paradoxically, that I have felt encouraged in those moments of uncertainty and doubt that make us ask ourselves what kind of meaning the

theater arts can possibly have in these times (with the ongoing push to make even life itself into a commodity). Our work seems destined to serve as a digestif for the 'chosen minorities' that experience it. Under such conditions, our profession often starts to feel outdated and anachronistic.

With *Dingki-Dingki in the Time of AIDS*, we put on a tour that covered most of the La Mosquitia region of Honduras, as well as the section situated to the east of the Department of Colon, which continue to be the poorest and most excluded areas of a country which is itself only marginally less so. In most of these places, the residents have no electricity, no drinkable water, and they have never in their lives seen a theater production. Many of them do not even know what the term 'theater' means.

When staging productions for this kind of public—at least in my experience—theater takes on a revelatory aspect. For some time now, the stage arts have degraded this capability to the point that their capacity to astonish (which should be part of their very essence) has been replaced with mechanics that are so similar amongst themselves that they instead cause a fatal boredom, or at best, provide moments of 'great culture' stripped of meaning. If quality is lacking, it is best not to bring theater to places such as these because the audience is 'virgin'. If the play is boring, there is a risk that the audeince may end up viewing theater as some kind of depressing mortuary hall, as it indeed becomes when the production is 'culturally' soporific. In these parts of the world, however—assuming that what is presented is of satisfactory quality—that vigorous pulse, so prized by Antonin Artaud, that must be created between the stage and the audience becomes so real and spontaneous that the stage and the hall are 'truly'—that is, through reason and body—transformed into spaces of communion, revelation, and astonishment.

When this work was staged, we had not yet found the right name for it. That day (in 2003), the young audience 'packed' the hall in the regular co-ed school in the city of Trujillo. After the play was over, we held a question-and-answer session with the audience, where someone asked about the name of the work. We answered that it didn't have a name yet, and asked the audience to help us think of one. A number of suggestions were made, nearly all of them with implicit moral overtones, such as 'Inattentive Parents and AIDS,' 'Education Helps Prevention,' 'The Risks of Disobedience,' etc. And then it occurred to someone to call it 'Dingki-Dingki.' The audience immediately burst into complicitous laughter, since this word—which is used frequently during the play's action—is the Miskito term for 'having sex.'

Note on the program

The cultural codes used by social groups model conducts and thoughts. They are the result of long processes, characterized above all by their complex and contradictory intertwined nature. It is frequently possible to perceive transitions, in these cultural substrata, from the static to the dynamic, from the 'traditional' to the 'modern,' and from the complex to the straightforward, and vice versa.

With regard to the subject at hand, i.e., AIDS, these attitudes, forms, and beliefs are especially relevant, given their overlap with a fundamental fact of life: sexuality. In sexuality, these cultural substrata are lodged in the deepest parts of our unconscious, be it individual or collective.

In the play that you will see, it is precisely the relationship between sexuality and culture, between AIDS and attitudes and beliefs, between life and death that we have tried to decipher, although it should be said that we have barely scratched the surface of the problem.

We are working together to fight the widespread negative idea that acceptance of the 'other' means the weakening of 'our own.' Rather, we believe that these exchanges (that of the three cultures) represent just the opposite: we all become enriched and reaffirm ourselves.

Tree That Tells Stories, or, the Mining Illusion (2000)[3]

(Two productions: one with a group of children and another with a college-age group)

Note: This work has gone by a number of names over the course of 17 years. It was originally called *Before the Hurricane*. Then, *Scenes from a Mining Town*, and then *The Story of a Ceiba Tree*. It is now presented under the name (perhaps definitive) of *A Tree That Tells Stories, or, the Mining Illusion*.

The spirit of a tree

On 30 October, 1998, Hurricane Mitch devastated almost all of Honduras's territory. One of the communities that suffered most from this impact was the small town of San Juancito, situated at the bottom of a vast, densely vegetated mountain known as La Tigra, 32 kilometers from Tegucigalpa. For nearly a century (1880–1960), San Juancito was the most important mining enclave in all of Central America. After the foreign company that exploited the minerals there fell on hard times, however, San Juancito soon became one of the most destitute towns in the area. It was there—in that place invaded by ghosts, with its steep, narrow streets, its hundreds of condemned old houses, frequently enveloped in fog and rain—that I started to build my house in 1986, including an indoor amphitheater with a capacity of 200 people. One day in 1989, the amphitheater were inaugurated with the presentation of two short works put on by a theater group featuring local community members, the La Cantera Children's Theater.

The two works, *The Evil Queen* and *The Right to Life*, were staged at festivals, one of which was broadcast on the radio on multiple occasions by different radio stations around the country. After this cycle of performances, the original group dissolved.

In the middle of the town stood a ceiba tree whose enormous labyrinth of branches gave it the appearance of a protective totem. The locals and the ceiba tree had been tied together for hundreds of years by the veins through which history courses. In a sense, history was almost like the tree's memory.

For 300 years—for that was the age that many attributed to the ceiba tree—neither nature nor predators could fell it. When I first saw it in the early 1980s, there were numerous birds who called it home. The tree remained aloof yet affectionate. Before it, as if it were an altar, our spirit was invaded by an inexplicable reverence.

When Hurricane Mitch hit San Juancito, it leveled houses, power lines, businesses, schools, and more, after which it was met for several hours with the tenacious resistance of the ceiba tree. With its roots exposed by the overflowing water and its branches whipped about by the hurricane winds, the tree gradually gave way until finally collapsing.

Those who saw it happen say that at that moment, tears rolled down the cheeks of some of the town's residents, for whom the loss of the ceiba tree was more painful than that of their own material goods.

Days after the tragedy, I travelled to San Juancito. In response to the horrors witnessed by my eyes, I could think of nothing else than to revive the La Cantera Children's Theater to dramatize not only that which had happened during the natural disaster, but the town's own history. And who better than the old ceiba tree to tell that story?

And so it was that a dramatic narrative starring the spirit and the body of the tree brought the history of the community back to life, along with its centuries-old symbol.

About the work

A Tree That Tells Stories, or, the Mining Illusion is a text originally written to be performed by a group of children between the ages of 9 and 12 from the village of San Juancito, who formed part of the La Cantera Children's Theater.

The first version of this musical premiered in February 2000 in the convention hall of the restaurant La Hacienda in the city of Tegucigalpa, Honduras.

What was originally conceived as a play for an audience of children ended up becoming a performance that, while put on by children, was aimed at the general public. Between January 2000 and 2007, the piece was performed by the cast of children in countless cities and communities around the country, along with a series of performances in Costa Rica.

In 2010, the work was revived by a cast consisting of students from the Universidad Nacional Autónoma de Honduras. As of November 2012, this cast has put on approximately 100 performances, including in Panama City as part of a Central American and Caribbean University Festival, where both audience and critics named it the event's most outstanding play. This later version of the text, along with its staging, included the participation of trained actors. As such, certain changes were made to the script, including in the final scene, which includes references to new technological developments.

The Dance of Souls (1996)[4]

Introduction I: A ceremony on the stage, the strength of the Garifuna woman

One day I was relaxing on the beautiful beaches of the Garifuna community of El Triunfo de la Cruz. That morning, Ernestina Fernández, better known as Neta, came looking for me at the little hotel that professor Margarito Colón had opened in town. At that time, Neta was part of a group of women (called Club Sacrificio) who met in the afternoons to practice traditional songs and dances. She invited me to watch one of their rehearsals so I could 'help them improve the quality of their performances,' which they typically put on one day a week at a big hotel in the city of Tela. There were 40 women at the meeting, most of them middle-aged, who formed part of the club's hundred-and-something members. I observed everything they showed me, offered some suggestions, and it was then, in front of that group of women, that Neta cleverly proposed that I work on a theatrical piece with them.

I have always felt an affectionate admiration for the Garifuna women of Honduras. Their tireless efforts to keep the artistic traditions of their culture alive are legendary. In all of their communities, the women's clubs are the soul and the nervous system of the historical memory of their body and their language. It is from among these women, generally speaking, that exceptional singers and skilled dancers and drummers have emerged. They are also the center of the community's festivities. They accompany wakes, deaths, novena rites, and the cosmogonic ceremonies of the *chogü* and the *dogü*. They sing at church and other places of worship, at baptisms, weddings and more. It could be said that without their participation, the feasts and celebrations that form the backbone of their culture would not exist. In addition, most of them are the main providers for their families. They are often single mothers with many children, and even with all these responsibilities they are able to tap into an exceptional fount of energy to spearhead collective events, some of which last for days. They are truly extraordinary, outwardly relaxed

and affectionate with an immense inner strength that, despite the overwhelming poverty around them, keeps them standing, active, and smiling. Although at the time I had sworn to myself 'no more Garifuna in my theatrical activities,' I couldn't resist the temptation to do something out of the ordinary with those plump women of Club Sacrificio.

When I lived in Guadalupe, I had the chance to spend several days at a very intimate (but at the same time open) ceremony typical of the Garifuna culture: the *dogü*. Ever since then, I had thought of the images of this ritual (with its even, unbroken drum beat, and the feet gently coming to rest on the earth before softly dragging along it) as inspiring material for a singular performance. I told the women so, and I proposed to them that we put together a work centered on the *dogü*. It was a delicate proposition, given that this ritual encapsulates the most organic, intimate, and profound religiosity. Nevertheless, Neta gave her approval, and along with her, a solid group of women. The *LanigüiMua* (Heart of the Earth) theater group thus set off on an adventure that has been going, at the time of this writing (2005), for nine straight years.

We had an exceptional collaborator in that first production: the Costa Rican artist and sociologist Alejandro Tosatti, who gave himself over to the 'cause' voluntarily, openly contributing his knowledge and his enviable tolerance and patience. Having shared a good number of years of my life with Garifuna society, the experience I had accumulated probably helped me to some extent on this occasion. The seven months I spent living in the community of El Triunfo de la Cruz were not, in terms of life experience, as bumpy as my time in Guadalupe. On this occasion, I made fewer mistakes. This time, the work was more or less voluntary, and I say 'more or less' because the Tourism Institute of Honduras gave me 30,000 lempiras for my living expenses, which came out to 4,000 a month (at that time, the lempira was equivalent to 6 or 8 per U.S. dollar), with which I had to cover lodging, travel, meals, etc. This wasn't as 'dramatic' as it might seem. On the contrary, it contributed to the proper development of the work by creating a kind of economic equality, thus substantially diminishing the suspicions that so often arise when money is involved. On the other hand, I had reached the conclusion that my calling was that of a man of theater, and not an executor of 'development' projects. The dynamic of community theater, I decided, was a powerful and revelatory force capable of shaping changes in behavior and consciousness that ran deeper, perhaps, than those that can be made through social welfare projects. This doesn't mean that things were entirely relaxed during the process of preparing this performance. The work, as is typical, caused friction among groups with opposing interests. In Honduras, there are several non-governmental organizations (NGOs) that were established many years ago by Garifuna professionals. Some of these people consider themselves the owners and the only ones permitted to work on any project linked to the 'development' of these communities. This means that they are quite jealous and distrustful of others interfering in their territory, and if these others are not Garifuna, then this jealousy mutates into confrontation. That was exactly what happened with one of them, who took little time to pounce, leading to spiteful divisions among the population, along with heated discussions which oftentimes verged on all-out battles. A part of the population was opposed to the play's staging, on the pretext that it was 'commodifying something so revered.' Denunciations were made on the radio, libelous proclamations were written and published in the press, and I was decried as 'a vulgar marketeer of sacred matters.'

I must confess, however, that on this occasion, the affronts did not have much of an effect on me, perhaps because my skin had already grown thick against all kinds of misunderstandings. On the contrary, I tried to handle the situation as calmly as possible. With the goal of reaching a consensus, Neta and I traveled to La Ceiba, where the NGO in question has its main offices. We conversed with the directors and cordially invited them to come to El Triunfo so they could see with their own eyes what we were working on. We did the same thing with the *patronato*

(city council), with the directors of the other women's club in the town, and ultimately, with anyone else who wanted to find out what we were doing. After setting the date for the sample performance, none of those invited deigned to appear.

It was at that precise moment that Neta and her group, without any comment on my part, understood the true objective of the attacks (destroying the initiative) and decided to confront the detractors. I had little involvement in that fight. Things were tense in the community in those days. Several young men who had been deported from the United States went around sowing terror. Robbery and crime became everyday affairs. Traffic congestion and drugs were everywhere. The streets and beautiful beaches were empty. The habitual joy had evaporated, and in the midst of all that, the theater group persisted. I was married at the time, and my wife never understood how anyone could live in such surroundings. Everything was so 'dismal' that it struck fear in one's heart. That was one reason, among many, that led to our divorce. But one day, the residents, and particularly a group of young people, made a display of civic spirit of a kind never before seen, at least in Honduras. Determined to address the situation, they organized into defense and response groups, rooting out the delinquents one by one. The criminals, at least during the time I was there, never dared to return. The community had caught its breath.

One day, while eating breakfast at my home in Tegucigalpa, I was struck by a brain ischemia that sent me immediately to the hospital. When they heard about the incident in El Triunfo, several of the women proclaimed with utter conviction that the project's enemies had targeted me with witchcraft. Somewhat recovered from that short circuit, I returned to continue with the work, and some of the women—among them, the adorable Lala—decided to protect me, forbidding anyone else to make my meals. They also offered me concoctions (delicious and harmless) to protect me from 'any evil intentions.' *The Dance of Souls* premiered on the beaches of El Triunfo de la Cruz on 22 June, 1996. Since then, the group has run and administrated its performances on a self-managed, independent basis, to the point that they have not required my presence ever since. Formed by fisherwomen, homemakers, and farmers, the group has acted with exemplary propriety and solvency. They have been invited to festivals, traveling to several countries in the Americas, and they have even been hired to teach and attend workshops in Costa Rica, Panama, Guatemala, Brazil, and most recently, Cuba. These activities are coordinated by a homemaker (and wonderful lead singer), along with the aforementioned Neta and Júnior Clother, a carpenter, mason, musician, drummer, and dancer gifted by the gods. Based on this singular example, there can be little doubt that Garifuna society has begun to take the reins of its own history and destiny. May it always be so!

Introduction II: Conflicts between religiosities, The Dogü: *a stigmatized ceremony*

This work was done in the Garifuna village of El Triunfo De La Cruz. In this case, the idea was to revive and place renewed value on the ceremony known as the *dogü*, by raising the visibility of a ritual that forms the core of the Garifuna view of the cosmos.

The scene begins in New York City, where the main character lives. There, he becomes sick. He goes to multiple specialists who are unable to help him. A relative advises him to return to the community, to the town where he was born, saying, 'They'll cure you there.' He responds, 'If no one can help me in New York, how do you think they're going to help me in that town?' His relative insists, and so he decides to return. Back home, his family decides to hold a *dogü* ceremony (which lasts four days) so that their ancestors can come down to help. And the ancestors do indeed come down and cure the sick man. In the end, however, he is forced to return to the big city 'because there is no work in Honduras.'

The underlying idea is to defend any society's right to preserve its religious rituals (in this case, an open, joyful event of singular beauty), some of which—like the *dogü*—have been stigmatized by official religions, and were even forbidden for decades by dictatorial political regimes in Honduras.

This prejudice still persists in many sectors of the Honduran population, and in other, supposedly 'more developed' places like the city of Cancún in Mexico, where the performance, planned as part of an international cultural festival, was suspended due to pressure from church and civil authorities (when in fact they didn't even know what the performance was about, basing their decision on rumor alone). It is difficult to explain why such irrational acts continue to occur as the twentieth century draws to a close, but the fact is that they still exist.

The revival of this ceremony has helped foster an understanding and acceptance of this view of the cosmos, with its celebration of life and death, featuring a syncretic synthesis of the Christian and indigenous pre-Columbian and African religions.

The scene's format is a kind of 'opera,' sung and danced from beginning to end. It has been presented in Honduras and elsewhere in Latin America, including Brazil. To bring this work to fruition, I lived in the community for 11 months.

Grupo Lanigui Mua (Heart of the Earth) is the name of the collective that continues, to this day, to perform *The Dance of Souls*.

Letter of resignation[5]

Mr. Hermes BERTRAND ANDURAY

General Director of Culture

Dear Director Bertrand,

I am writing to inform you of the following events and observations regarding the staging of the work titled *Don José Cecilio del Valle and National Independence* being readied by the National Theater and Academy, the direction and realization of which have been entrusted to me.

Based on the work done thus far, there have been a number of apt choices and a number of shortcomings that are so often present in theater activities in our country, and in the National Theater in particular. I would like to briefly discuss some of them here.

I. Generally speaking, there is a distorted understanding of what is meant by theater work. Wherever we look in the world, and all the more so in Honduras, theater, by its very existence, fulfills a social function. Those of us engaged in these activities are part of society, and for that very reason we owe a great debt to it. If the meaning of all of this is not properly grasped, then it is almost a foregone conclusion that any performance that may be presented will not meet the requirements necessary to call it (without blushing) theater plain and simple. This consciousness regarding our work is lacking in some of the members of the company and the National Academy.

Understandably, this lack of consciousness is not limited to those who 'dedicate' themselves to theater activities. On the contrary, it is a consequence of the general state of the country. But it is precisely here that the problem resides: if the artist, the theater person, is not conscious of the fact that this is precisely what needs to be fought against and changed, then they run the risk of turning their work into a mere pastime.

II. Things are not all negative, however. There are people, in both the academy and the National Theater, who have grasped and taken up their commitment to society as human beings and

artists. A work such as the one we are trying to stage and present cannot be realized without the general intention of 'wanting to do something,' accompanied by an unflappable energy and generosity.

The figure of Valle the Wise and the events that form part of the struggle for independence cannot be treated lightly. They demand seriousness, disciplined study and work. It is time to strip our historical events of all corny sentimentalism and traditional sugarcoating, as well as the ideological dogmatism that seeks to overpower and change the facts of the matter. History is done no favors when we attempt to look at it and study it in this or that specific manner.

III. I presented this line of work, objective and rigorous, to the members of the Theater from the very start. I 'laid my cards on the table,' as they say. I told them that there were two choices: either we could prepare a traditional staging, which is not to say it would be any less worthy, or we could undertake the risk of an in-depth investigation into the life of José Cecilio del Valle, along with the appropriate theatrical forms for presenting it. From either of these standpoints, we were being given the chance to do work with significant consequences for the country. I insisted on making them reflect on the choice to be made, expressing to them the difficulties with which we would meet if we chose the second of these two paths, and I encouraged them to evaluate their time, their energy, and their commitments outside the theater. After they had weighed the possibilities, I said, we could make a decision. What's more, I suggested that those who did not want to or could not participate in the performance itself could step down and look for a less demanding, accessory way to help out. All of them, with one or two exceptions, chose the second alternative for the performance.

All is easier said than done, however. While it is true that we have achieved positive results in both human and artistic terms, they are not yet sufficient to meet the goals that we set for ourselves. The main reason for this, as I see it, has to do with certain distortions or inconsistencies that continue to arise in relation to several members of the group. These individuals' attitudes are delaying the work as a whole, at the risk of throwing it into an anarchical state. Theater, understood through the mentality of an evening out, as a mere pastime, and a certain degree of 'attention hounding,' are some of the traits I have observed. Thus, the difficulties inherent to stage work are aggravated by these human failings.

IV. On occasion, the situation has reached such extremes that I have contemplated resigning. If I did not, it was because of the formal promise made by the group members alluded to above to correct their behavior. Nevertheless, the issues continued, and—as is only natural as Guest Director—I could do nothing about the matter. My responses were limited to telling them that anyone who was not interested in the performance was free to leave. But they didn't. On the one hand, they insisted on reaffirming their desire to work, while on the other, they contradicted their words with their actions. They are the walking definition of what we might call a short attention span. I truly cannot fathom the reasons behind such perpetual inconsistency.

V. This situation has become even clearer in recent days, in which a decrease in the pace of work and studies has grown evident, precisely at the most crucial time when a big push is needed to carry things over the finish line. On the other hand, there have been certain setbacks attributable to the Director's Office and its theater section. One of these is the problem of transportation. Most of the Academy's students live in neighborhoods far from the city center, and are thus forced to leave early. As of October 26, this transportation issue had not yet been resolved, despite my insistence from the very beginning on the urgent need to do so.

Another matter of note is the locale where we are working. In addition to its stifling smallness, lacking the appropriate size for the type of performance foreseen, it also fails to meet the bare conditions necessary. Imagine, sir, a workday of three or four hours at an intense pace, without even a bathroom to help relieve the most pressing of needs.

It is also easy to spot certain aptitudes conditioned and entrapped by suffocating red tape. This puts a firm damper on the generous, flexible, and creative nature of any artistic undertaking. This reality is all the cruder and more lamentable in an activity such as theater, which involves people who must typically remain in an alert and permanent state of creativity.

VI. The abovementioned issues have hampered a work that, given its size and scope, deserves all the necessary facilities. It is my impression that not even the cultural authorities themselves have grasped the importance for the country of undertaking the historical and artistic investigation being done. Perhaps that explains the clear negligence in the conduct of certain officials.

In light of the foregoing, I ask that you accept my resignation from the position of Guest Director of the National Theater for the staging of this work, given that I do not feel that the conditions required for its realization have been sufficiently satisfied.

I would like to take this opportunity to thank you for the trust you have placed in me.

Sincerely,

RAFAEL MURILLO SELVA RENDON

Tegucigalpa, 28 October, 1977

Note: Despite all these setbacks, there are achievements that must be noted all the same. We have been able to gather an enormous number of documents. Seminars and intensive workshops have been held. The general outline has been prepared for the performance, and half the play is practically ready. In these efforts, I have been aided tirelessly by various members of the aforementioned institutions, who have continuously exerted a praiseworthy and reassuring effort. The help of Doña Mimi Figueroa and Doña Magda Alvarado has been tremendous. Their capacity for hard work and their love for the theater and the country are beyond reproach. To them and all those like them, I offer my sincere recognition. I trust that they will be able to forgive me and to understand my position.

Note 2: This resignation was not accepted, and the play ultimately premiered at Manuel Bonilla National Theater in January, 1978.

Notes

1 Other texts by Rafael Murillo Selva (1934–) can be found on his blog (https://rafaelmurilloselva.blogspot.com), along with photographs, videos, and various links.
2 See http://rafaelmurilloselva.blogspot.com/2017/10/el-dingki-dingki-en-los-tiempos-del-sida.html
3 See http://rafaelmurilloselva.blogspot.com/2017/10/un-arbol-que-cuenta-historias-o-la.html
4 See http://rafaelmurilloselva.blogspot.com/2018/01/la-danza-con-las-almas.html
5 See http://rafaelmurilloselva.blogspot.com/2018/11/jose-cecilio-del-valle-y-el-proceso-de.html

PART V

Southern Africa

INTRODUCTION TO PART V
Applied performance in Southern Africa

Alexandra Sutherland

The contributions in the Southern African section highlight the contested relationship between the neo-colonial state, and how applied performance processes disturb a neo-liberal order. The participants reflected in these diverse approaches to how theatre and performance is applied towards social and political change range from professional actors in Malawi, to applied theatre professionals working in corporate environments in South Africa, to amplifying the experiences of children in Lesotho and South Africa, to politically engaged performances in Zimbabwe. These locations evidence the British influence of drama-in-education in the 1970s and 1980s in certain Southern African countries that were part of the commonwealth, as well as the highly politicised nature of many countries in the region for whom performance has been integral to an emancipatory politics. Although the field/discipline of applied theatre has been theorised predominantly from the Global North, the nature of political resistance on the African continent has always been embodied, collective, dialogical, and the harnessing of arts and culture as a core mode of political resistance and imagination. This point is expanded on in Moyo and Sibanda's chapter, who introduce the ways in which applied performance forms have evolved on the continent. Post-colonial politicians and scholars have long recognised the role of culture in both oppression and liberation. For revolutionary leader Amilcar Cabral (1970), 'if imperialist domination has the vital need to practice cultural oppression, national liberation is necessarily an act of culture'. I suggest that countries in Southern African are, in varying degrees, under imperialist domination due to the neo-colonial economic and political dependence on countries in the Global North. Applied performance as an 'act of culture' leads, in micro ways, to liberation. Manji (2017:3) discusses the ways in which 'neocolonial regimes have attempted to disarticulate culture from politics, a process that neoliberalism has exacerbated'. Each of the chapters in this section evidence the ways in which theatrical performance speaks back to a neoliberal order that often legitimises abusive power, be that via the state, patriarchy, capitalism, or a colonising gaze.

Two contributions to this section (Petro Janse van Vuuren's chapter, and the play script collaborators Bongile Gorata Lecoge-Zulu, Cheraé Halley, and Jessica Lejowa) are linked to the Drama for Life (DFL) programme at the University of the Witwatersrand in Johannesburg. While I wish to guard against a 'South African exceptionalism' – an attitude of superiority in which South Africans set themselves apart from the rest of the continent – the significance of this programme in developing applied theatre practice and research in the region and the continent more broadly, cannot be under-estimated. DFL is rooted in the HIV/AIDS crisis

in Southern Africa and was initially created to research and develop ethical methodologies and processes that can harness the performing arts to address the multiple dimensions of this health crisis. DFL recognised the many arts practitioners in Southern Africa who were using a range of popular theatre forms to respond to the social, political and health dimensions of HIV/AIDS. However,

> The 2006 SADC3 Appraisal Mission concluded that the work produced by these theatre groups caused more damage instead of mitigating the impact of HIV/AIDS, because they were not trained to understand the sensitivity of the health issues that they were dealing with, particularly stigma around HIV and AIDS.
>
> *(Chatikobo & Low 2015:382)*

DFL was created in 2008 out of this context in recognition of the crisis of HIV/AIDs in the region, and the extraordinary work of many arts practitioners in trying to respond to this crisis. Its unique model ensures that artist-facilitators throughout the region (and the continent) can enter programmes based on their needs and work from their own experiences. For some, this may mean working towards a master's degree, for others, a recognition of prior learning approach means that even if someone does not have the necessary formal school qualifications, they may qualify to enter a diploma or certificate course. In a region where many post-school education institutions are in crisis and responding to a neo-liberal education agenda that devalues arts and humanities subjects, the opportunities and influence of DFL scholars in practicing, teaching, and documenting applied performance processes throughout the continent cannot be underestimated. Its model is radically inclusive, and funds are raised to provide scholarships for scholars throughout the region to access the programmes. Chinyowa (2015:119) notes that:

> Although DFL still focuses on enhancing the capacity of young people, theatre practitioners and local communities to take responsibility for the quality of their lives in the context of HIV/AIDS education and advocacy, it has broadened its scope to include other related social development questions such as human rights, social justice, cultural diversity, gender equality and conflict management.

DFL has recently become the only accredited provider of drama therapy training on the continent, pioneering the documentation of afro-centric embodied healing practices and models.

However, a reality in the region is that large-scale projects, like DFL that can attract and fund students outside of South Africa are only possible due to funding from European institutions. Partnerships between practitioner–researchers in a Southern African country and European institutions often become the only way to engage with rigorous, long-term performance projects. Amy Bonsall's analysis of the rehearsal process for the production of a Malawian version of *Romeo and Juliet* in this section is one example. Another is a project that I am embarking on in Cape Town that uses an arts based process with young people in communities experiencing gang violence to create a theory of change in a racially divided city. This project entitled Imagining Otherwise is viable because it is framed as a research project within a British university that funds the project and enables collaboration between South African and British organisations. While these collaborations have immense potential, as Bonsall suggests in her chapter, to alter the flow of knowledge creation from Africa *to* Europe rather than vice versa, it raises significant issues around the continued dependence of socially engaged theatre practitioners on donors and funding from the Global North. These applied performance projects will be docu-

mented and disseminated in ways that many others will not. Yet the two Zimbabwean theatre pieces analysed in this section (Moyo and Sibanda's discussion of *Rachel 19*, and Chikonzo and Makumbirofa's analysis of *Rituals*), and the script *Dear Mr Government* (Lecoge-Zulu, Halley, Lejowa,) all powerfully theatricalise experiences of violence and vulnerable people's capacity to imagine alternatives. These plays were produced with minimal or no funding – a situation that is characteristic of the precarious nature of artists in a region where the arts are under-funded and under-valued. In an authoritarian regime like Zimbabwe, financial support for political and socially engaged performance that challenges the status quo is non-existent given the high stakes of even putting on such performances. Each makes visible the lives of people on the margin and highlight diverse performance forms that are indigenous to the context in which they are performed.

One effect of living in a neo-colonial relationship with the Global North is an aspirational gaze towards the imperial centre as always 'better'. This continues to inform attitudes towards arts and culture, yet the contributions in this section highlight an application of an indigenous performance forms that are embodiment of resistance. By harnessing these performance forms that are specific to their context, these diverse practices disrupt a colonising gaze to reinstate the performance space as a site of change: the specific social or political change that each performance practice highlights, as well as how these modes of performance are an act of resistance to a neo-colonial/neo-liberal logic, in and of themselves.

As a way of introducing the different contributions, I will start with Petro Janse van Vuuren's chapter 'Applied arts in business contexts'. Her discussion of the ethical tensions involved when applied theatre artists work in corporate environments may seem removed from my argument about resistance to a neo-liberal order. However what she demonstrates is the ways in which an applied performance practice can strategically work within a hegemonic institution to centre human stories in a context that can often dehumanise. Applied theatre practitioners in South Africa are required to subsidise their income and some do so by offering workshops to businesses that can meet corporate requirements to address racial and cultural transformation. Her chapter documents ways in which practitioners can clarify their own values that may be eradicated or come in conflict with a corporate client's. She documents a collective embodied exploration of values and tensions inherent in applied performance in business contexts with a group of facilitators. Her chapter will benefit applied theatre practitioners in thinking through values that frame our work and how to integrate these values in institutions that are often oppressive and counter to the democratic and humanising principles of applied theatre.

Amy Bonsall's analysis of the rehearsal processes used to produce a Chichewa translation of *Romeo and Juliet* in Malawi shows how a fixation with categorising certain theatre types into 'applied' or 'mainstream/professional' can dilute the complexity of intercultural theatre forms. Her discussion of the sophisticated integration of Malawian and European contemporary performance forms highlights how using indigenous performance forms, characters and storytelling in the first Chichewa translation of this classical text decolonises and de-elitises the stage. For the professional actors, the rehearsal and performance was empowering and an opportunity to bring 'serious' drama to ordinary people. Her chapter complicates when and how 'applied performance' can be categorised, and the contribution dialogic processes can make to rehearsing complex theatrical experiments. The theatre form that resulted speaks to the ways in which cross over intercultural performance forms are an act of cultural resistance. As Duncombe (2002:7) emphasises, 'the very *activity* of producing culture has political meaning. In a society built around the principle that we should consume what others have produced for us … creating your own culture takes on rebellious resonance'. While *Romio ndi Julieti* may not be framed as political, its innovation of theatre form creates a post-colonial culture that is an act of politics.

Zimbabwe is a country that is in deep political and economic crisis. The overthrow of Robert Mugabe in November 2017 via a coup did not result in any political, social, or economic change. Political violence, human rights abuses, lack of basic service delivery, extreme poverty, and inequality continues. Despite this, protest theatre continues to be a feature of the artistic landscape in Zimbabwe. In a highly repressive political environment, arts and culture are used as a means of resistance and imagination of alternatives and speak to the resilience of ordinary Zimbabweans. Two chapters in this section document Zimbabwean plays that speak to social concerns: *Rituals* examines a critique of the state's narrative on dealing with political violence and reconciliation, while *Rachel 17* adopts a unique process to create a safe space for dialogue around gender and gender-based violence. Both discuss the use of contextually specific performance forms that skilfully merge form and content. Chikonzo and Makumbirofa's analysis of *Rituals* by Roof Top Theatre productions shows how indigenous forms of healing in the form of rituals offer a resistance from below to the anaesthetising grand narrative of the state in how political violence is dealt with. While the government pursues a restorative justice model that neutralises the state's complicity in violence, this production shows how communities deal with victims and perpetrators using indigenous ritualistic processes. These rituals acknowledge an African cosmology that integrates ancestors as part of community life. The play performs the struggles of ordinary people to provide an alternative approach to healing and reconciliation that is counter to the dominant domesticating narrative perpetuated by the government. The writers emphasise the plurality of voices in the play that 'exposed the role of the state in stifling community driven models of healing'. This production therefore centres indigenous knowledge systems (which in themselves are performative) and the power of communities to determine what healing and justice means on their own terms.

Themes of trauma and healing are also evident in Moyo and Sibanda's discussion of the play *Rachel 19* by the Victory Siyanqoba Trust. The uniqueness of this applied performance process is in the development of a grassroots platform called the Laundry Café that was created as a safe, culturally relevant space for women and girls to address gender-based issues such as HIV/AIDS, reproductive health, and domestic violence. The technique uses the gender-specific activity of women collectively doing laundry together by a communal water source, embracing this female space as a site of change. The writers document how the real activity of cleaning becomes a symbolic action of cleaning away problems through a collective encounter where women can speak through taboos and stigmas associated with gender issues. In this example, a washing activity that is seen throughout the continent as women collect around common water sources to do their family's laundry, is reformulated to become a context-specific participatory performance process. This space becomes a site of learning and change as women and girls are empowered through the theatre process to discuss issues that are usually seen as taboo.

The final contribution to this section is the contextual explanation and script of the production *Dear Mr Government, the children have something to say*. This two-hander uses poor and physical theatre to perform the artist–writer–researcher's results of process drama workshops with children in South Africa and Lesotho. These workshops and the production ask the powerful question: 'If children could speak to the government, what would they say?' The result is a theatre piece typical of a South African resistant devised theatre that evolved during apartheid: the centrality of the performer's body in creating meaning; a non-linear and episodic structure to ensure plurality; and the use of simple staging and props to transform into diverse roles and contexts. This piece powerfully evokes the fear, vulnerability, and resilience of young people in a region dominated by political, social, environmental, and economic uncertainty. Mr Government becomes any figure that has the power to determine the fate of youth. By focusing on two children who meet at a shelter, the play performs the hopes, dreams, and fears of young

people on the margins of society. The piece exposes the shame of xenophobic violence that is part of the fabric of every South African city, centring on the humanity of ordinary children trying to hope for a future.

Each contribution in this section brings to the fore the notion of playing in the borders as a site of resistance and imagination: the border between humanising performances and dehumanising capitalism; between African and European theatre forms; between the government's grand narrative and a grassroots counter-performance; between reductive and resistant gender performances; and lastly with children on the border between Southern African countries, performing the border between childhood and powerful adults. In each contribution, context-specific performance forms are used towards change. This demonstrates that 'despite the power of neo-liberalism … the people have not lost their desire for agency, for making history for engaging in struggles wherein they both demonstrate and invent their humanity' (Manji 2017: 11).

References

Cabral, A. (1970) History is a weapon: National liberation and culture. *Speech Given at the University of Syracuse*, Syracuse New York, 20 February.

Chatikobo, M, and Low, K. (2015) Applied theatre from a Southern African perspective: A dialogue. *Research in Drama Education: The Journal of Applied Theatre and Performance*, 20(3): 381–390.

Chinyowa, K. (2015). Case study 3: Drama for life. In T. Prentki (Ed.), *Applied Theatre: Development*. London, Bloomsbury: 117–122.

Duncombe, S. (2002). Introduction. In S. Dunbombe (Ed.), *Cultural Resistance Reader*. London, Verso: 1–17.

Manji, F. (2017). Culture, power and resistance: Reflections on the ideas of Amilcar Cabral. *State of Power Report 2017*. Transnational Institute. [online]. www.tni.org/stateofpower2017. Accessed 5 October 2017.

29
ROMIO NDI JULIETI (*ROMEO AND JULIET*)
Chichewa language production of a serious drama

Amy Bonsall

Applied theatre is a homogenising term for drama/theatre for therapeutic or educational purposes, as distinct from that of commercial enterprise or ritual performance. This chapter explores and examines some ways in which Malawian student actors from Chancellor College of the University of Malawi and Mzuzu University harnessed contemporary performance practices in Malawi, including Chichewa popular drama, to explore Stanley Onjezani Kenani's Chichewa translation of Shakespeare's *Romeo and Juliet* (*Romio ndi Julieti*) in 2015 and 2016. In so doing, the transformative impact for the Malawian actors engaged within this intercultural theatre experiment will be highlighted and the delineation between what is classified as 'applied', and that which is not, will be challenged.

By interrogating the methods and modes of working during our workshops, this chapter will highlight how the dialogical rehearsal practice used led to the following results: an empowering process for the actors, a furthering of the performative possibilities of serious drama in Chichewa, and the possibility of a production of a Shakespeare play that would be firmly grounded within the Malawian cultural landscape.

This chapter highlights how, within the preliminary explorative workshops and during the subsequent rehearsals, Shakespeare study converged with contemporary Malawian and European performance forms to create a rich learning environment for all involved in the process.

Within Western drama and theatre performance scholarship, there is commonly a delineation between work which is defined as 'commercial' or 'mainstream' – such as festival, regional and touring, or West-End productions (which largely adhere to the formula of a director-led, company-produced play where audiences buy tickets, and where the work can garner critical acclaim and acquire cultural capital) – and 'applied theatre' (Prentki, 2006: 142, 147).

Forms of drama such as theatre in education, community drama, drama for social and political change and, importantly for this chapter, Theatre for Development (TfD), which has also been described as 'Popular Theatre, [and] Community Based Theatre' (Plastow, 2014: 108). These generally all fall under 'applied theatre'. Alternatively, applied theatre is described as 'a term describing a broad set of theatrical practices and creative processes that

take participants and audiences beyond the scope of the conventional, mainstream theatre into the realm of theatre that is responsive to ordinary people and their stories' (Prentki and Preston, 2013: 9–10; Ackroyd, 2007: 7). The field of applied theatre, then, remains one of shifting ground with little scholarly agreement as Freebody, Finneran, and Balfour discuss at length in their recent paper (Freebody et al., 2018: 12). Nevertheless, I still find applied theatre to be a rather homogenising term for the vast spectrum of theatre/dramatic practice, which does not adhere to either the economic or artistic models of (Western) mainstream theatre.

Outside of the two main categories of 'commercial' and 'applied' theatre there may also be a third, less commonly considered category of 'ritual performance', which is concerned with the performative elements of the sacred, religious and quasi-religious. Even so, in 'The Problem of Definitions', Victor Ukeagbu makes a strong case that the ritual or traditional drama in the African studies he explored can also be brought under the umbrella of applied theatre (Ukeagbu, 2004), and I find myself in full agreement with him.

Now I wish also to introduce intercultural theatre to my framework. A useful explanation of 'intercultural theatre' is that it is a theatre practice specifically designed to draw from two or more different countries' cultures in its creation and delivery. This is clearer than other attempts to define the intercultural, including Patrice Pavis' opaque definition. A fuller explanation of my rationale can be found in *Exploring Intercultural Shakespeare Production for a 21st Century Malawian Audience* (Bonsall, 2017: 13).

How do these various terms impact on how a production such as *Romio ndi Julieti* (2015/2016), a production conceived of in the UK but rehearsed and performed in Malawi, is positioned within theatre scholarship, and what can be gleaned from such discourse? Does an exchange of money make something 'commercial'? Does having a clear social impact render something automatically exclusively 'applied'? Why does this matter? It matters because there remain deep misunderstandings as to the potential for crossover of theatre form and practice. I offer my own experience as just one example of this. I submitted an abstract to a conference in the UK in 2016, and my paper discussed the intercultural collaboration of Nanzikambe Arts and Bilimankhwe Arts, two commercial, professional theatre companies, on the same production I am discussing here. My abstract was placed, bizarrely, within a stream with Shakespeare and education as the focus. I challenged this but was unable to convince the organisers to change their minds. I presented within the allotted stream and my paper sat incongruously alongside the other research, so much so that it was immediately commented upon numerous times during the questions. My research was discussing professional collaborative practice. This scenario highlighted to me that UK scholarship still has much work to do in appreciating that work coming out of Malawi could be professional and should therefore have been discussed alongside other mainstream professional practice; that intercultural work similarly can be situated in both applied and mainstream, and that richer research could be gleaned if there was a greater appreciation of work that crosses the still-existing divide. As it is, works such as *Romio ndi Julieti* are essentially locked out of the discourse about mainstream theatre production merely because of a scholarly fixation on terminology.

The focus of this chapter is to interrogate particular instances from my own practice and process (including workshop, rehearsal, performance, and post-performance interviews) in detail to illustrate why such Western-centric constraints of theatre scholarship can become not only redundant but actively reductive when applied to the specific context of Malawian intercultural Shakespeare production. Full names of artists have been used where express permission for this publication has been granted, otherwise I have used initials.

I position myself as a practitioner/researcher; a theatre director who also researches. A particular focus of my research is concerned with intercultural theatre practice in Malawi and more specifically, productions of Shakespeare plays. I am also an artistic director of UK-based theatre company Bilimankhwe (founded 2006) along with my colleague and the founder, Kate Stafford.[1] Bilimankhwe exists to create intercultural theatre and we have a long-standing partnership with the Malawian theatre company, Nanzikambe Arts, also founded by Stafford in 2003. In 2016 I directed *Romio ndi Julieti* (*Romeo and Juliet* translated into Chichewa, a widely spoken indigenous language of Malawi).

The production was PhD research but was, at the same time, a mainstream production produced by Bilimankhwe. In preparation for the production, I undertook two weeks of exploratory workshops at Chancellor College of the University of Malawi in 2014 with final year students from the Department of Fine Arts and Performing Arts. *Romio ndi Julieti* was conceived to follow the 'commercial' artistic model of theatre production in both the Western and the Malawian understanding of the term. There was a set formal rehearsal period, which was director-led, and it culminated in three performances in formalised performance settings. Each performance was attended by audiences who had come to watch the play predominantly to be entertained rather than to learn about a particular issue, as would more commonly be the case with an applied theatre work. The cast comprised both student actors from Mzuzu University Theatre Acting Group (MUTAG) and two professional Malawian actors, Hussein Gopole and Misheck Mzumara. Fascinatingly, as the work unfolded and the methods of the work developed, it became clear to me that the neat(ish) definitions of what constituted 'applied theatre' and 'commercial theatre', as defined above, all but collapsed, to the betterment of the work and the process, within the Malawian theatre landscape.

To understand why this should be so, however, it is useful firstly to summarise the contemporary theatre performance in Malawi and how and why it came to be so. This is significant because performance in Malawi has been impacted by political, colonial, and economic interference. Such intrusions have shaped the unique identity of contemporary performance/theatre in Malawi. Indeed, terms that describe the various performative enterprises in Malawi must be clarified. The terms 'ritual', 'theatre', and 'drama' are used somewhat interchangeably in Malawi because of the legacy of British colonialism (Gibbs, 1980: 3; Kerr, 1995: 1). Let us say that ritual drama refers to presentations that are related to specific indigenous performative practices. Richard Schechner (1977) helpfully clarified the terms 'performance', 'theatre', 'script', and 'drama' in his diagram 'the concentric circles: performance' which relates to the broad spectrum of events that occur in audiences and performers alike from the moment 'the first spectator enters the field of performance' to the last second they leave. *Theatre* then is an 'event enacted by a specific group of performers ... usually theatre is the response of performers to the script; the manifestation or representation of the drama and/or script'; *script* is 'the basic code of the event. The script is transmitted person to person'; *drama* is 'a written narrative, text, score, scenario, instruction, plan, or map. The drama can be taken from place to place or time to time independent of the person who carries it' (Schechner, 1977: 44).

For this project, I wanted to create intercultural rehearsal spaces that would allow, as far as possible, for genuine exploration of what a Malawian/British *Romeo and Juliet* could be. I was conscious of problematic power dynamics that had been presumed to exist by those outside of the process, and indeed of the likely issues that would exist and were inherent because of the whole cast and company's cultural, racial, economic, and gendered individual positioning (Walling, 2012). Because of these intersections, it was essential to be aware of the

Western-facing practices of the very act of formal play making, as descended from Ancient Greek drama, and acknowledge their existence and make choices about how the workshops/rehearsal room could work. I decided that I would look to model my directorial practice using the educationalist Paulo Freire as a basis and create a reflexive mode of working (Freire, 1996). By working reflexively I would interrogate my/our practice on an ongoing basis so as to understand more fully the dynamics and development of the process not only for the final artistic outputs, but also for my own and the company's development (Nelson, 2013: 29). This marks the first clear point where applied theatre and commercial theatre converged: my 'self', my 'positioning' was being internally exercised every bit as much as my 'professional' persona, as was that of the company.

Historical, political, and cultural context

The small country of Malawi (formerly Nyasaland), which contains the magnificent Lake Malawi, is nestled between Zambia, Mozambique, and Tanzania in sub-Saharan Africa. It was granted independence from Great Britain in 1964, and in 1966 it became a republic under the leadership of President Hastings Banda ("Malawi: History. The Commonwealth," n.d.). Unfortunately, his presidency became a violent dictatorship that gripped Malawi for decades. Free, multi-party elections were finally held in 1994 and since then the country has remained relatively politically stable ("Malawi: History. The Commonwealth," n.d.). The country remains one of the world's poorest and this, of course, impacts every aspect of life, including culture and cultural development, see Chisiza and Bonsall's *The Donor Dependency Syndrome* for a more detailed analysis (Chisiza and Bonsall, 2016; "Malawi – Worldbank page," n.d.).

It is important to keep in mind that Malawi's story, like all countries, is complex and that a country's culture seems to be the crucible where the political, historical, and societal converge. In order to be able to understand a little of the contemporary performative landscape of Malawi, it is useful to remember that from the 1800s onwards there were (broadly) the populations indigenous to the area now known as Malawi, the European missionaries from the UK, and later the British colonialists. Ritual performance as a record of history and as part of significant life celebrations has long been part of indigenous Malawian culture and remains so, along with dance and song (Gibbs, 1980: 6, 8–17; Gilman, 2004). During colonisation, however, the local culture was deliberately suppressed and Western forms of theatre, such as proscenium arch-style productions, were introduced as entertainment in the expatriate clubs, or as David Kerr terms it, 'theatre of nostalgia exclusively for whites' (Kerr, 1987: 116). However, during the 1930s Gibbs states that early hybrids were being forged in the missions whereby traditional Malawian forms were used along with the European in performances (Gibbs, 1980: 263). The missionaries and the colonialists also brought their own ideas about education and it was through the school system that European ideals were imposed on the local populations. There developed a tripartite relationship in Malawi between education, the political climate, and the development of theatre.

Shakespeare texts were brought to Malawi formally through the colonial education system and were being studied in the country by 1933, though only by a very small number of the indigenous population (Malawi National Archives, 1933; McCracken, 2012: 264). When the country gained independence, it retained the study of a Shakespeare text as part of the English MSCE (equivalent to the UK A-Level, students must pass a minimum of six subjects including English) (Mzumara, 2017). The elevated position that Shakespeare holds within the curriculum, in a country with literacy rates, both historically and currently, lower than the global average, means that any Shakespeare production performed within the country may carry with it what Malawian academic Innocent Ngulube terms a 'colonial hangover'; that is to say that there

are elements of British culture that remain firmly entrenched within contemporary Malawian culture and that these continue to impact Malawi long after independence (Ngulube, 2016: 99; "Statistics," n.d.).

A uniquely Malawian form of performance was developing by the 1950s which Malawian theatre academic Mufunanji Magalasi terms 'Malawian popular commercial drama' (Magalasi, 2008: 161–177). This performance form, undertaken in Chichewa, was born in churches and schools and was a hybrid of traditional Malawian dance, 'episodes of jokes or short dialogue-based acts' and they were all centred on 'strong moral messages' (Magalasi, 2008: 162–163). The censorship that Malawian artists endured during the dictatorship of Banda also impacted the form, the use of state-sanctioned 'proper Chichewa' (as distinct from the language used by the rest of the population) was enforced and so, as Magalasi tells us, Malawian writers began exploring using English for their works (Magalasi, 2008: 163). As such, there developed crucial differences between Malawian dramas written or produced in English (which tended to be thematically serious) and Chichewa drama which tended more to the comedic and came to be rehearsed using improvisation around a written narrative or story outline/situation (Magalasi, 2012: 143, 2008: 172). Kerr describes Chichewa drama as being 'a broadly exaggerated acting style, a storyline borrowed from indigenous popular narrative and adapted to a modern urban environment, a heavy emphasis on comic dialogue and mime' (Kerr, 1987: 124). As I came to understand, the distinction between the comic Chichewa drama and the more elitist serious English drama continues to hold an impact upon contemporary Malawian drama. It is important to keep this in mind because *Romio ndi Julieti* would become a crucible where the serious drama in English text would meet Chichewa drama in form.

Romio ndi Julieti

I learned that although Malawian students must study *Romeo and Juliet*, there were no translations of the play available in any of Malawi's indigenous languages. While English is the language of administration, indigenous languages, especially in rural areas, are the languages of daily life and as such I worked with professional Malawian writers, theatre makers, academics, and students to create a publishable Chichewa translation of *Romeo and Juliet* and to tour an intercultural production of the play in Malawi. Audiences were not charged for tickets to see the final production (much like tickets are sometimes subsidised for commercial productions in the UK for particular groups). However, the mainstream theatrical conventions of the audience arriving, sitting in an allocated place, and watching the production through to the end, all held true. The project was made possible by a small amount of funding from The University of Leeds, Bilimankhwe, and through a crowd-funding campaign.

Workshops

I undertook three trips to Malawi in November 2014 (two weeks), June 2015 (two weeks) and March/April 2016 (three and a half weeks). The first was a fact-finding exercise to see if an intercultural production of Shakespeare might be of interest to Malawian audiences and if so, what form such a production might take. I ascertained, through a variety of interviews with interest groups such as local theatre artists, academics, and school children (post 16), that there would be interest in a full theatre production of *Romeo and Juliet* in Chichewa (Bonsall, 2014). The Malawian Cain Prize nominated writer Stanley Onjezani Kenani translated the full play into Chichewa and I took the first draft of the script to Chancellor College of the University of Malawi where I undertook two weeks of workshops with a group of final year fine arts students.

The final stage was a two-week rehearsal process at Mzuzu University and then a three-venue tour of Malawi. My engaging the actor Misheck Mzumara who in the intervening time took up a lecturing position at Mzuzu University, necessitated the change of venue.

The purpose of the workshops was to use practical exploration and group discussion to explore Kenani's Chichewa translation of *Romeo and Juliet*, now *Romio ndi Julieti*, as preparation for my directing a full production of the work. Forty-six hours of practical workshop and discussion were undertaken. Workshops were timetabled to accommodate the students' university commitments. Therefore, the number of attendees varied daily between whole cast workshops of around ten, and more intimate work with just two or three students.

During the first workshop session, it became clear the students wanted to discuss their ideas about the play, about Shakespeare, and about theatre audiences in Malawi rather than engage with anything practical. A valuable dialogue about their hatred of exams and their struggles to understand the original English text of *Romeo and Juliet* ensued, confirming that a Chichewa translation of the text of *Romeo and Juliet* could have value for students and general audiences in Malawi. From the very first session I endeavoured to employ a dialogical and reflexive method of directing. I wanted to pull away from being a white British director imposing my artistic values upon the rest of the company and risking cultural appropriation; instead the frame was to work *with* the actors to create our own methods of working which would serve the development of the production. They were free to disagree with me, to argue with me if they wished as far as was possible, given that we were all navigating the power structures that are inherent for a new company working through dynamics such as gender, race, status, and age.

I had thought that the workshops would be almost entirely practical, however, it became clear early on that the students wanted to have detailed and meaningful discussions about the play, contemporary Malawian theatre practice, and how the play could be made meaningful to contemporary Malawian audiences. As such, we read through the whole Chichewa translation of the play in order; the significance of this being that the first time the play had been read in Chichewa was profoundly moving to us all.

An example of how the play being translated into Chichewa opened it up to connecting with Malawian culture was our work on the character of the apothecary. In Shakespeare's version of the play, in Act 5 Scene 1 we witness this poor wretch very reluctantly sell Romeo poison in exchange for a great deal of money, albeit against his better judgement. He proclaims 'my poverty, but not my will consents' (Shakespeare, 2012: 317). In the original play there is a clear indication that using the services of such peddlers was socially and morally unacceptable and that, dramatically, Romeo would pay for his folly. In the penultimate workshop of our process we explored that same scene. There was a general consensus that the character of apothecary in Malawi could be a herbalist/street seller locally known as a *sing'anga* – a very poor traditional medicine peddler or witch doctor (Morris, 1996: 161). The group said these were familiar figures in markets in Malawi, and people of all social strata in Malawi use them – Romeo making use of one would be entirely culturally acceptable. Of particular interest was the discovery that women can be *sing'angas*. The group said that women *sing'angas* are common, though this is contradicted in some literature (Morris, 1996: 161). This led to discussions as to whether or not the actress playing Lady Montague could take this role and add a further dimension to the horror of Romeo's tragedy (Bonsall, 2015: 13). This could be a simple but extremely effective manipulation of casting to place the production firmly within Malawi. Chichewa was giving voice to characters that would not have been so readily culturally transferable without the refocusing that translation could offer. This in turn empowered the actors to embed the text, the characters, and the narrative within contemporary Malawian performance forms, something that would have taken an entirely different form had the work been produced in English.

Working together, we created a working methodology, which allowed us to come together and work on large crowd scenes or to split into smaller groups to work on soliloquies, duologues, or individual characterisations. Working like this enabled us to explore most of the play at least once but also to give balance to the exploration, and was successful for the following reasons:

- We were able to get numerous interpretations of the same scene within a small amount of time.
- There was a great deal of opportunity for group reflection. The group members were able to work on their own ideas without my intervention, unless they invited it.
- The group was able to watch and reflect upon the work of other groups and aid in the process of reflection and analysis.
- Within this main framework, a sub-pattern of working method developed. Firstly, the actors would read through the specified section of text, then they would read it while also 'walking' the text, script in hand and building up the detail and ideas. The final stage was to play the scene and improvise the text, free of scripts.

(Bonsall, 2017, 2015: 10–11)

On the final day of the workshops, as this was a reflexive process, we gathered together and discussed the work we had undertaken and its implications. The feedback was overwhelmingly positive and the comments were extremely insightful. G spoke very movingly. She recalled how she had said in our first session that she would like to meet Shakespeare, and she said that because of the work we had done over the last two weeks she felt she no longer needed to do this because she had met him already through the work. This was an extraordinary way of conveying what had happened with her and how the workshop process had affected her. All of the students were very positive and all said that it had vastly improved their understanding of the play, but most importantly, that they felt that the play was relevant to them and to Malawi. Indeed, I was told that they rarely, if ever, wrote or performed using Chichewa but that this project had inspired them to do so in the future. The impact of this work was not only of immense value to the development of Shakespeare production in Malawi, it was also meaningful on a personal, professional, and artistic level for the actors engaged in the work. The work was not only part of a commercial theatre enterprise but it also bore the hallmarks of applied theatre practice. To disentangle the two would be to greatly reduce the value and richness of the work. Writers such as Ngũgĩ wa Thiong'o and, in relation to Malawi specifically, Mufunanji Magalasi discuss the post-colonial impact upon indigenous language and culture in detail.

Rehearsals and production

A year later, rehearsals began for the production of *Romio ndi Julieti*, this time at Mzuzu University with a company formed of student and professional actors. This was a formal rehearsal with the time pressure of a production to deliver by the end, albeit a process heavily informed by the work I had undertaken at Chancellor College. As such, while I had to ensure that all of the scenes were rehearsed and that the production held together as a whole, I retained the methods of working that were developed during the workshops. The production formed no part of their university learning, it was entirely voluntary on their part, though the costs of them taking part were funded. This allowed us to create a system of rehearsal whereby we all rehearsed in the same large space, but groups were able to break away and work on specific scenes, character ideas, and sequences before bringing them back to share with myself and the rest of the group.

This worked well, as had been the case with the workshops, and went some way to counteract the power dynamics of the traditional Western rehearsal room where the single director holds sway.

One clear example from the rehearsals, which showed again how the dialogical/reflexive rehearsal process was both empowering and artistically innovative when used with intercultural practice, was Act 1 Scene 1. Commonly it is vicious and violent, establishing in clear terms the mortal danger that the warring families pose to each other through their ongoing feud. By my strategically working *with* the company I was able to be open to suggestions and this allowed for extremely interesting artistic results:

> MB offered really useful suggestions, firstly about making the Prince a city mayor rather than a chief as this worked better with our theme of business and politics. Then we decided that we would think of Verona as Lilongwe. When we looked at the fight sequences (Hussein Gopole is taking charge of choreographing the dances and the fights) the students were again physically able and quickly came up with convincing slow-motion fight sequences. While I have thought of the fights being extremely serious MB suggested making the first part comic. While I would not normally do this, actually it worked really well in the Malawian context, as it is something the audience would really enjoy and it then contrasts well with the second part, which gets very serious. This is where the real joy of intercultural working comes into play, one is forced to try things totally outside of one's range of experience, and often the results are very positive ... After rehearsals some interesting debates around the translation ensued with observations that the piece jumps from using very ancient Chichewa to 2016 contemporary Chichewa. We discussed how Shakespeare did this also, but the feeling was that it was smoother in English and that it 'jarred' occasionally in Chichewa. What was exciting though was hearing that there was an intention to develop this ideal of translation and to research it and investigate it. This is exactly what I had hoped for.
>
> *(Bonsall, 2016)*

The scene became a kung-fu parody, a form instantly recognisable to Malawian audiences. This rehearsal had shown me that by working in such a way as to give significantly greater agency to the whole company to explore and to some extent lead on developing the aesthetic for the work, I was learning about my identity as a director. I was also learning about the extraordinary flexibility of the plays of Shakespeare. The rather rigid structures of genre in Western dramatic forms became redundant within the crucible of Malawian contemporary performance practice; in Malawi the hysterically comic can be simultaneously horrifically tragic.

The rehearsal process was unlike the earlier workshops in that there was the pressure of time and the expectation of a professional-standard production at the end. There were to be three performances: at the university performance space, Luwinga High School, and at Chingalire Village near Lilongwe.

After the final performance, three of the actors were interviewed. V who played Tybalt was asked his experience of performing Shakespeare, serious drama, in Chichewa. He replied:

> The experience of acting a Chichewa play I think is extraordinary and is something I have never done before, this is my first time. And as a matter of fact I think I would say I feel more liberated to act in Chichewa than English ... because it takes me to the typical everyday experience as a Malawian as, you have just said, it's my language and

most of the time I speak Chichewa and English is only spoken in offices or wherever. So to me it's fantastic.

(Bonsall, 2017: 257)

This was highly relevant because it was an example of how a mainstream theatre project – which had set out to explore if and how a Shakespeare production could be made relevant for a contemporary Malawian audience but within the bounds of working with professional/student theatre practitioners and using the artistic model of Western/British commercial theatre production, had created opportunities for profound and lasting change, an impact akin to those more commonly associated with applied theatre practice. Later in the same interview W, who played Balthazar, described how performing in Chichewa had affected his performance as an actor:

I think I can also say this is my first time to perform in Chichewa and I think it was quite, it was … I mean it gave me that energy. Of course, the way the audience responded to what I was doing to some extent gave me that energy to say, ok, I think I can, I think I can act out some qualities to this character, that is regarding to how the audience were responding. So I think acting in Chichewa was an interesting experience.

(Bonsall, 2017: 258)

W provides us with a unique insight into how performing in a mainstream production, but in Chichewa, has impacted his work as an artist and how he interacts with the audience. This is significant because in Malawi the politics of the language of choice for performance of serious, elitist drama such as Shakespeare has implications: indigenous language-speaking audiences who are often rural or lacking in formal education were all but locked out of accessing serious drama. This, by extension, also meant that actors who in the main work in English did not produce serious drama in the vernacular. Through the participation in this intercultural project, Malawian actors have had the opportunity to engage with audiences through the mode of mainstream serious drama in Chichewa and experience the connections that can be forged between them and audiences who would not usually experience serious drama due to language barriers.

Romio ndi Julieti was conceived as a mainstream production whereby the final production and its aesthetic were deemed an essential part of the work. However, the process that fed into it was also given considerable weight, more so than would be expected of a standard mainstream process. For all of us involved, the work was challenging and at times fraught, as all theatre production is at times, however, the dialogical and reflexive practices embraced within the process ensured that there was always a way to move forward together to achieve our goal of producing a Chichewa language intercultural production of Shakespeare's *Romeo and Juliet*. To this end, the process was deeply transformative for us all. Most of the actors involved had never performed serious drama in the vernacular before and they stressed that they intended to explore this new dramatic possibility in the future. There could be very important implications for the development of Chichewa drama because this project has shown that there are potential audiences for such works. If new writers of contemporary Chichewa drama can be encouraged to hone their craft, the current linguistic hegemony, which positions English as elite over the vernacular, might be challenged.

For my Part I learned that there was considerable scope for comedy in *Romeo and Juliet*, which greatly enriched my understanding of the work; an understanding which could not have

been achieved had not two cultures come together to create this newer, fresher understanding. This has implications for how we in the West view intercultural work. We have much to learn about our own texts and theatrical practices and working on mainstream drama with considerations from applied drama creates an enormously rich artistic learning environment.

This project can neither be strictly bound to the descriptors 'mainstream drama' or 'applied drama', for it is both and neither. To try to force it into either definition reduces an intrinsic aspect of its identity. Examining it through the lens of applied drama does not fully allow for an appreciation of the professional, aesthetic, and dramatic form that the project found, which is highly significant for the contemporary Malawian theatre landscape and for global Shakespeare scholarship. Conversely, divorcing the production from its process dislocates the performers from the very specific performative, linguistic, and political history that created Malawian contemporary performance. This would greatly reduce the significance of the unique connections forged between the performers and the audiences when the work was unfolding live.

Note

1 Since the time of writing, Kate Stafford is no longer artistic director of Bilimankhwe. She was succeded by new co-artistic directors, Amy Bonsall and Brian Desmond, in early 2020.

Bibliography

Ackroyd, J., 2007. Applied theatre: An exclusionary discourse? *Applied Theatre Researcher*, 8, 3-11.
Bonsall, A., ed., 2014. Survey responses: Zomba and Blantyre.
Bonsall, A., 2015. Chancellor College, Zomba, Research Diary.
Bonsall, A., 2016. Mzuzu University, Research Diary.
Bonsall, A., 2017. Exploring Shakespeare for a 21st century Malawian audience. PhD Thesis. University of Leeds.
Chisiza, Z., and Bonsall, A., 2016. The Donor dependency syndrome: The politics of theatre funding structures in Malawi. *Platform: Journal of Theatre and Performing Arts*, 10, 79–89.
Freebody, K., Finneran, M., Balfour, M., and Anderson, M., 2018. What is applied theatre good for? Exploring the notions of success, intent and impact. In: K. Freebody, M. Balfour, M. Finneran, and M. Anderson, eds. *Applied theatre: Understanding change, landscapes: The arts, aesthetics, and education*. Cham: Springer International Publishing, 1–17.
Freire, P., 1996. *Pedagogy of the oppressed*. 2nd Rev ed. London, New York: Penguin.
Gibbs, P.R.A., 1980. Drama and theatre in Malawi. Zomba: unpublished MA Thesis.
Gilman, L., 2004. The traditionalization of women's dancing, hegemony, and politics in Malawi. *Journal of Folklore Research*, 41, 33–60.
Kerr, D., 1987. Unmasking the Spirits: Theatre in Malawi. *Drama Review TDR*, 32(2), 115–125.
Kerr, D., 1995. *African popular theatre: From pre-colonial times to the present day*, Studies in African literature. J. Currey; Heinemann; EAEP; D. Philip; Baobab, London: Portsmouth, N.H: Nairobi: Cape Town: Harare.
Malawi: History | The Commonwealth [WWW Document], n.d. Available from: http://thecommonwealth.org/our-member-countries/malawi/history [Accessed 24 June 2017].
Malawi National Archives, 1933. Advisory Committee on Education in the Colonies - the school certificate examination and the teaching of English in secondary schools in the Dependancies 1933 Folder Number S1/510/30 reference number 8b.
Malawi - Worldbank page [WWW Document], n.d. worldbank.org. Available from: http://www.worldbank.org/en/country/malawi/overview [Accessed 17 November 2018].
Magalasi, M., 2008. Malawian popular commercial stage drama: Origins, challenges and growth. *Journal of Southern African Studies*, 34, 161–177. doi:10.1080/03057070701832957.
Magalasi, M., 2012. *Stage drama in independent Malawi: 1980 to 2002*. Zomba: Chancellor College Publications.
McCracken, J., 2012. *A history of Malawi, 1859–1966*. Woodbridge, Suffolk: James Currey.
Morris, B., 1996. *Chewa medical botany: A study of herbalism in Southern Malawi*. Hamburg: LIT Verlag Münster.
Mzumara, M., 2017. Personal email: Interviewed by Amy Bonsall.

Nelson, R., 2013. *Practice as research in the arts: Principles, protocols, pedagogies, resistances.* London: Palgrave Macmillan UK.

Ngulube, I., 2016. Appropriation of Shakespeare's plays in the postcolonial world: The case of Malawian education. *Postcolonial Interview*, 1, 76–106.

Plastow, J., 2014. Domestication or transformation ? The ideology of theatre for development in Africa. *Applied Theatre Research*, 2(2), 107-118.

Prentki, T., 2006. Drama for change? Prove it! Impact assessment in applied theatre. *Research in Drama Education: The Journal of Applied Theatre and Performance*, 11, 139–155.

Prentki, T., and Preston, S., 2009. *The applied theatre reader.* London & New York: Routledge.

Schechner, R., 1977. *Essays on performance theory, 1970–1976.* 1st ed. New York: Drama Book Specialists.

Shakespeare, W., 2012. *Romeo and Juliet.* New edition. ed, 3. London: Arden Shakespeare.

Statistics [WWW Document], n.d. UNICEF. Available from: https://www.unicef.org/infobycountry/malawi_statistics.html.

Ukeagbu, V., 2004. The problem of defitnitions. *Drama Research*, 3, 45–54.

Walling, M., 2012. The great white director. *Border Crossings Blog.* Available from: http://bordercrossingsblog.blogspot.co.uk/2012_08_01_archive.html.

30
RITUALS (2010) AS A COUNTER NARRATIVE OF HEALING AND RECONCILIATION IN ZIMBABWE

Kelvin Chikonzo and Ruth Makumbirofa

Introduction

One of the topical issues in the aftermath of Zimbabwe's decade of crises was the issue of national healing and reconciliation. This issue became central owing to the bloody run-off of presidential elections in June 2008. The level of political violence and intimidation was so alarming that resources had to be committed towards national healing and restoration. The Government of National Unity (GNU) which came into place after the violent phase created the Organ for National Healing, Reconciliation and Integration (ONHRI). Many Zimbabweans heralded the formation of the Organ as a positive step towards national healing and reconciliation, a step towards Zimbabwe's truth and reconciliation as expressed by Mashingaidze (2012):

> Many Zimbabweans considered the formation, in February 2008, of the Organ for National Healing, Reconciliation and Integration by the inclusive government to be a watershed opportunity for stemming the nation's historically entrenched culture of state sanctioned violence and impunity. Zimbabwe had never before comprehensively attempted to prosecute or compel perpetrators of politically motivated violence to acknowledge their transgressions because the nation's leadership regularly exploited constitutional prerogatives to pardon perpetrators. Political expediency has always outweighed the imperatives of victim sensitive national healing.

There were a number of issues that surrounded the project of national healing. There was a realisation by the citizens of Zimbabwe that the Organ on National Healing, Reconciliation and Integration was not willing to integrate endogenous models of healing and reconciliation, yet these were critical given that much of the political violence took place in rural Zimbabwe (Benyera, 2014; Machakanja, 2010; Machinga, 2012). Secondly, there were certain aspects of African life which could only be restored by endogenous rituals which the Organ could not cater for. Endogenous rituals are systems that are found within traditional settings and are culturally understood and owned by local people as ways of managing conflicts and relationships (Dodo, 2015). There was also an attempt to prioritise retributive justice at the expense of restorative justice which was favoured by communities (Mbire, 2011, Mashingaidze, 2012). One of the great debates that emerged was whether there could be healing without justice and,

consequently, could there be justice without truth, that is 'forgiveness without truth and reconciliation without justice' (Mbire, 2011). Communities felt that the atrocities committed in June 2008 had to be exposed as a first step towards healing and reconciliation. However, certain arms of the state felt that the truth, although ideal, could ignite tension which was probably diffusing with time. The reality on the ground was that the truth implicated various political parties and individuals who were afraid of facing the wrath of the law (Machakanja, 2010).

The state created its grand narrative on national healing which was centred on letting bygones be bygones (Murambadoro, 2014), forgiveness without truth (Mbire, 2011), healing and reconciliation as a state-centred approach (Machakanja, 2010) and reconciliation without retributive and restorative justice. The state created the Organ for national healing which promised to solve the nation's troubled past. However, civic society and communities at large questioned the commitment of state actors and state-centred institutions to the process of national healing and reconciliation. The counter-narrative that these non-state actors weaved centred on the main question: is Zimbabwe ready for an effective reconciliation process?

Rooftop Promotions, an arts trust that produces activist theatre in Zimbabwe, realised the need to use theatre as a platform for informing and engaging the public on issues of national healing and reconciliation. Although the GNU proposed a variety of media reforms, these reforms did not automatically translate to the creation of a media space that was democratic and a media that informed its citizens about the issues of common interest. The debate on healing was also centred in towns while rural communities were by and large excluded in the debate on national healing and reconciliation. It is out of these disparities with regard to media reportage on the complexities of national healing and the need to include marginalised actors in this debate that Rooftop Promotions produced two plays that specifically dealt with the theme of national healing and reconciliation, namely *Heal the Wounds* (2009) and *Rituals* (2010).

It is out of this context that this chapter analyses how *Rituals* offered a counter hegemonic narrative on national healing and reconciliation. It explores how rituals challenged elite- generated narratives on healing which were silent about alternative methods of healing, especially endogenous approaches which had metaphysical dimensions to healing. The chapter also interrogates how *Rituals* takes on the tensions of healing in Zimbabwe, particularly the role played by the Organ for national healing and the state in the healing process. In brief, the chapter analyses how *Rituals* offered versions of truth which were seldom given visibility in mainstream media in Zimbabwe.

Theoretical framework

This study deploys the gaze of postmodernism. One of the greatest tenets of postmodernism is that of counter hegemony and counter narration which dismantles and disrupts grand narratives. Counter narratives challenge the creation and production of meaning, a process which Jean-Francois Lyotard (1999: 419) regards as postmodernism's 'incredulity towards metanarratives.' From a postmodernist perspective, one unpacks a metanarrative or grand narrative as a story that is invented by a power structure in support of its beliefs and value systems. It is a story which attempts to universalise values and ideological desires that are in fact peculiar and specific to one group. In brief, metanarratives are stories that are constructed in order to sustain and maintain the status quo. They play a conservative and preservative function. Postmodernism is a critique of grand narratives. It seeks to unveil the means by which grand narratives serve to mask inequality, exclusion and elitism. It exposes the operation and presence of propaganda and ideological engineering inherent in grand narratives. In the postmodernist sense, there is a need to celebrate multi-vocality, difference and diversity.

To realise the above fundamentals, postmodernism advocates for deconstruction as a method of disrupting one understanding of a narrative. Postmodernists argue that if textual meanings are derived directly from the intentions of the author, such meanings will be confined to the dominant readership. The author's interpretation will be universalised to all readers, a practice which is antithetical to diversity and plurality of interpretation.

Applied to the context of this research, the state is construed as a producer of a narrative or grand narrative of national healing and reconciliation whose thrust is contested by means of performance in *Rituals*. Whereas the state generates and attempts to universalise its narrative on national healing and reconciliation, *Rituals* is a performance text that is incredulous to this narrative as it attempts to dismantle the state's interpretation of Zimbabwe's process of national healing and reconciliation. In this vein, postmodernism guides this chapter to search for tension and opposition in the way in which *Rituals* posits its own version of healing and reconciliation.

Postmodernism is, therefore, useful to this study because it advises the researcher to look at how a counter-narrative unveils the ideological biases of a grand narrative that it critiques. It gives us critical tenets of deconstruction, fragmentation, pluralism, incredulity and oppositional readership that guide the researcher in analysing how *Rituals* critiques the state's version of healing and reconciliation in Zimbabwe.

Background and production data

Rituals (2010) was produced by one of the biggest players in protest theatre in Zimbabwe, Rooftop Promotions Production. Rooftop Promotions operated at a theatre venue called Theatre in the Park, located in Harare, the capital city of Zimbabwe. Prior to the crisis, Rooftop Promotions had produced protest productions such as *Ganyau Express* (2001), *Rags and Garbages* (2002), *Witnesses and Victims* (2003), *Super Patriots and Morons* (2004) and *Two Leaders I know (2008)*. Rooftop Promotions was the first production house to have its play, *Super Patriots and Morons*, banned by the state in 2004 because the play challenged the state leaders' superiority. When the issue of national healing and reconciliation became topical, Rooftop Promotions committed themselves to a citizen's duty of interrogating government policy by producing plays such as *Heal the Wounds* (2009), *Rituals* (2010), *Waiting for Constitution* (2010) and *Indigenous Indigenous* (2012). Amongst these plays, *Rituals* generated controversy and it was so successful that it was performed beyond Zimbabwean borders. *Rituals* was performed in South Africa in 2011 at the Diepsloot Extension Rank, Hillbrow Theatre, The Canopy Theatre Braamfontein, Johannesburg Central Methodist Church and the Grahamstown National Arts Festival (Pazvakavambwa, 2011). In Kenya, *Rituals* was performed at the Nairobi All Africa Dance Festival for Peace in December 2010. The play also toured Zambia in April 2011 where it was performed at the Lusaka Playhouse, University of Zambia and the Quill Club. It was also performed at the Edinburgh Fringe Festival (Guzha, 2019).

Being a theatre project committed to healing and reconciliation, *Rituals'* target audiences were the communities where atrocities of political violence had been committed. *Rituals* toured various parts of rural Zimbabwe which caused a lot of skirmishes with the authorities who did not openly tolerate the idea of the state being portrayed as an obstacle to indigenous processes of healing and reconciliation. The *Rituals* team was detained in Chimanimani in eastern Zimbabwe and at Nyika Growth Point in Masvingo, south-eastern Zimbabwe.

Two Zimbabweans, Daves Guzha and Stephen Chifunyise, scripted and directed the play. The cast of *Rituals* had the following actors: Rutendo Chigudu, Silvanos Mudzvova, Chipo Bizure, Zenzo Nyathi and Mandla Moyo. The play premiered at Theatre in the Park on 15 October 2010. The researchers attended this premiere. Rooftop Promotions recorded the inau-

gural show, which the researchers used, together with notes jotted at the premiere, to make this analysis. *Rituals* protested against the state's monopoly of the process of healing and transformation. The play highlighted how grassroots models of healing and reconciliation clash with the state because they see the state as ineffective in healing communities at family, spiritual and individual level.

The Shona and Ndebele people of Zimbabwe believe that issues of restorative justice do not only exist between the living but also between the living and the departed. Rituals are conducted in order to heal the wounds between the living and the dead. Rituals are therefore traditional ceremonies where communities seek guidance from ancestors (*vadzimu*) to resolve problems that affect families and communities (Mwandayi, 2011; Mhaka, 2014). These ceremonies are presided over by traditional elders, spirit mediums and witch doctors who act as intercessors between the living and the dead. Communities seek guidance and advice through various rituals that are performed depending on the nature of the problem. For example, in a scenario where someone is murdered, justice is realised by seeking peace with the spirit of the deceased. The spirit of the deceased comes back as an avenging spirit (*ngozi*) which causes death and misfortunes in the family of the perpetrator until they pay an agreed sum of money, or present beasts or even a bride as reparation.

There is also another scenario where a person encounters misfortunes in life because they would have mistreated or insulted their parents, thereby angering the ancestors. The perpetrator would have to go through a cleansing ceremony called *kutanda botso*. In this ceremony the perpetrator wears tattered clothes and sacks. S/he goes through communities asking for millet and sorghum which is used to brew beer required for the cleansing ceremony. Rituals are therefore closed ceremonies where participants attend by invitation. They are platforms for truth telling as mediums, and intercessors invite the spirits of the deceased to talk about the circumstances of their death (Mwandayi, 2011). Such truth telling is regarded as dangerous as mediums and intercessors reveal hidden truths when they enter into trance.

These are the rituals that are dramatized and staged in the play *Rituals*. These rituals are community-based platforms for resolving problems whose nature cannot be solved by the organ of the state. These rituals are grassroots platforms earmarked to reconcile and heal communities and individuals. These rituals become a source of tension because they are not controlled by the state and they proffer alternative models to official versions of healing and reconciliation in Zimbabwe.

Endogenous healing and justice as subversive

The Zimbabwean post-election crisis was characterised by a policy vacuum about how the exercise of healing and reconciliation was to be executed (Thompson and Jazdowska, 2012; Mbire, 2011; Bratton, 2011; Makwerere and Mandonga, 2012). These scholars point out that even though the inclusive government created the ONHRI, there was rarely any action from the Organ to address issues of healing and reconciliation. The weaknesses of the Organ provided an opportunity for grassroots models of community healing which, according to Thomson and Jazdowska (2012: 90), 'represented a potential strategy capable of challenging the existing policy vacuum'. The ONHRI, according to Mbire (2011), and Thomson and Jazdowska (2012) was an elite arrangement that did not take cognisance of grassroots approaches to healing and reconciliation. *Rituals* responded to this policy vacuum by advancing an alternative approach to healing and reconciliation, which became a source of conflict with the state. *Rituals* staged/ performed the struggles of different communities to provide an alternative approach to healing and reconciliation in the aftermath of the crisis.

Acknowledging that Zimbabwe had different rural communities that had unique stories to tell with regard to national healing and reconciliation, *Rituals* adopted an episodic plot in the Brechtian sense where in each episode there were different situations, circumstances and players. This diversity enabled the play to stage varying and different contexts of tensions that communities dealt with. The episodic approach enabled various victims and perpetrators to bring into play various perspectives on healing. In addition, state actors, civil society and community leaders also have visibility in this performance, so much so that there is fragmentation and plurality of voices that dismantle the idea of a mono-vocal grand narrative on healing articulated by the state. Most significantly, various Shona dialects have a presence, ranging from the Manyika, Karanga, Korekore and Zezuru dialects.

Benyera (2014:337) observes that:

> In order for these rituals to take place other ceremonies are used to bring the victims and the perpetrators together in the presence of the community, for the first time since the violence took place. This forms the first part of the reconciliation process namely, facing reality. These institutions guarantee not only that offenders face the reality of their wrongful actions, but also that they face their victims in person in the presence of the whole community, so that they realise the magnitude of their crime.

When the play begins, Sarudzai (played by Chipo Bizure) has to participate in a community cleansing ritual called *Kutanda Botso*. *Kutanda Botso* is a ritual where a child who insults or beats his/her parents seeks atonement by publicly confessing the wrongs done in order for the parents to forgive him/her. Sarudzai is a member of parliament who had insulted her parents and her community during the political violence. She has to swallow her pride in order to participate in a ritual where she begs for mercy from villagers, who under normal circumstances, are her subjects. Sarudzai's political advisor, Chipo, is not happy with her participation in the ritual. Chipo informed her that she cannot participate in the ritual without the approval of the Party.

Chipo's reluctance to participate in processes of national healing stem from her belief that engaging in such processes was akin to a form of submission to the moral and intellectual leadership of communities and the grassroots to processes of national healing and reconciliation. The state's problem (as represented by Chipo) was that grassroots leadership proffered a competing platform to its customary hegemony. The people cannot be seen as leading, as having the ability and agency to design, implement, modify at a hegemonic level, processes and discourses of truth and reconciliation. In this vein, whilst it was ideal that Sarudzai participates in a ritual of forgiveness (*Kutanda Botso*), while her political party is reluctant because the ritual gives power to communities and showed that the state was not always capable of leading processes of transformation in society, hence a source of tension. The Nyazema community is projected as possessing the agency to design and implement their own healing exercise.

The issues performed in healing ceremonies are unique and diverse so that the state could not proffer any solution to them. The state model of justice was that of retributive justice which was antithetical to community models of restorative justice. Communities in *Rituals* argued that imprisonment alone did not heal victims especially when the crimes that were committed have metaphysical dimensions over which the state had no control. For example, one of the most contentious issues was that of avenging the spirits of victims that had been killed in the violence of 2008. In Shona culture there is a concept of *Ngozi*. *Ngozi* occurs when the spirit of the dead seeks to revenge its death if it is not compensated. The spirit will kill relatives of the culprit until they pay back. The spirit can be paid back through cattle; at times the culprit's family might have to offer their daughter as a bride as payment for the death. This is the spirit that possesses

John in the play. The spirit of the victim demands that John names all his victims as a first step to reconciliation. This kind of healing and reconciliation can only take place in the presence of traditional healers. In instances of *Ngozi*, the state has no power because the kind of restorative justice that the dead spirit seeks cannot be done within the legal and judicial apparatus of the state. The community intervenes because it has structures for dealing with such cases through ritual processes. That is the reason why John's family consulted the healer. John had gone mad because the spirits wanted his family to acknowledge that John killed people in the violence of June 2008. John was saying out names of people he killed. Their spirits wanted compensation, hence the need to solicit the help of the healer in such issues.

In accordance with fragmentation and pluralism, *Rituals* allowed various ethnic groups the opportunity to articulate their versions, interests and protests with regard to the process of national healing and reconciliation. To this effect, rather than proffering just a critique of the dominant Shona ethnic groups with regard to the way the state handled the question of national healing and reconciliation, *Rituals* also enabled the Ndebele ethnic group a way to convey their concerns on this matter. Indeed, Daves Guzha who ran Rooftop Promotions in Harare, invited actors from Bulawayo to participate in this play. The actors Joyce Mpofu, Zenzo Nyathi and Mandla Moyo, all from the Matabeleland regions of Zimbabwe, enriched the play with Ndebele grassroots approaches to healing and reconciliation that the state was supressing. In Ndebele cosmology, family feuds do not just anger the living, they also disturb the ancestors who demand appeasement and restoration of relations between siblings, as is the case of the children of Dhlamini, Ndaba and Buhle, who belong to different political parties. They both have influential positions in government: Ndaba is a minister while Buhle is a member of parliament. The two did not see eye to eye. Although their parties were designing models of healing and reconciliation, these models were regarded as inappropriate for healing at a family level. Their hatred and rift had to be healed through a family ritual where a beast is slaughtered and presented to ancestors. In both Shona and Ndebele cosmology, a state of disequilibrium in the family also upsets the ancestors. The process of forgiving therefore must be acknowledged by both the living and the dead. A traditional healer presided over the ceremony. However, it was disrupted because a messenger is sent to call for Ndaba and Buhle who have to leave the traditional healing ceremony in order to attend a meeting organised by the Organ for National Healing. Like Sarudzai, Ndaba and Buhle's involvement in a traditional ritual was a sign of admittance that politicians can also make mistakes which, at times, they have no capacity to correct.

Consequently, the ritual space became dangerous and counter hegemonic, in the eyes of the politicians, because the ritual becomes an avenue through which power is diffused from its concentration within elite members of society, especially political elites and civic society. The ritual space had a set of procedures and rules of engagement which, in the moment of the ritual, strip political heavyweights of their power. The ritual context forced the person who wants to go through the ritual to follow the process regardless of class, gender, age or economic position. Despite the fact that Sarudzai was a member of parliament, the *kutanda botso* ritual forced her to forget that she was an MP and forced her to wear tattered clothes and sacks as a way of showing her humbleness to the community that she harmed. An MP was forced to beg for rapoko or sorghum from the houses of villagers, the rural poor, in order to brew beer for the healing ceremony. She had the money to buy all the sorghum and rapoko that is needed but the rules of the ritual dictated that the grain should come from villagers through a process of begging. When villagers gave her grain, they were forced to mock her and tell that she was stupid when she scolded and insulted her parents. She was also forced to roll on the ground as a way of showing humility. The ritual reduced her hubristic arrogance to humility and humbleness. The experiences of Sarudzai, John, Ndaba and Buhle are narratives of healing which rarely get

told in the media, yet they have great presence in the cosmological belief systems of the people of Zimbabwe. It is in giving voice and in revealing the state's attempt to mute these forms of healing that ritual becomes counter hegemonic and incredulous to one version of healing and reconciliation in Zimbabwe.

Victim-sensitive truth and reconciliation versus imprisonment

Another source of tension between the state and alternative endogenous healing models lay in the fact that traditional rituals did not only strip power structures of their usual hegemonic control in society, they allowed victims and perpetrators to settle problems in ways that may not be regarded as desirable by the modern retributive justice system. The scenario in which Rudo and Murambiwa engaged in a process of truth and reconciliation was a case in point. Rudo and Murambiwa revealed how rape was used as an extension of violence during the violence of June 2008. Young people were required to come to all night *pungwes* (vigils) where they were indoctrinated. It is at such a ceremony that Murambiwa, who was a youth cadre, raped Rudo. Their families gather as a way of trying to seek justice and healing for Rudo. Deliberations with regard to how the rape issue could be solved revealed the interplay of not just the state but also of patriarchal power and civic society which all undermined community driven initiatives to healing. It revealed what Dominique le Touze et al. (2005:193) view as 'attempts by dominant forces in society, political and class elites to reinforce their notions of healing'. What then obtained at the gathering is a conflict between Charity (Rudo's sister and NGO worker) who believed that Murambiwa must be punished using state legal instruments. Charity represented the voice of the educated urban middle-class elite who saw justice in imprisonment. The families of the two were of the opinion that imprisoning Murambiwa would not bring justice and peace. They argued that Murambiwa's trial could reveal a lot of happenings during the violent period. They feared that if it happened that Murambiwa was allowed to reveal secrets, those that were afraid of being caught would seek ways of silencing Murambiwa by killing him. The elders felt that there was not enough protection for witnesses of political violence. In the absence of that protection, Murambiwa could get death threats, thereby creating more problems of peace and security. They also stated that even if Murambiwa finally went to jail, his family members would be tormented by relatives of powerful politicians. The play raised an important issue of protection of witnesses if truth and reconciliation is to be realised.

Charity argued with the villagers until Rudo made an important intervention. If she was the one who had been offended, she had the right to speak and air her opinion, as is evident in the following passage:

Charity (to Murambiwa): I will personally see to it that you are locked.
Rudo: But sis Charity, you didn't ask me how I feel.
Charity: What are you supposed to feel towards this criminal?
Rudo: But sis Charity, how about my rights? How about what I feel?

Postmodernism does not create counter narratives that give voice without critiquing the pitfalls of these voices. In this vein, *Rituals* demonstrated that even community-driven processes were marred by paternalistic approaches where some individuals sought to impose their notions of justice on others. Charity thought her method of justice was the best, imposing it on her sister against her will. The play reinforced the essence of individual agency in healing and reconciliation processes: the victim should speak and decide on the kind of justice preferred. Imprisonment did not provide restorative justice as the victim could be having the perpetrator's child. Murambiwa

would not pay Rudo if he went to prison. Charity also made a great mistake of trying to deny the perpetrator vocal space. Charity told Murambiwa to be quiet because he was a criminal. She down-played the fact that asking for forgiveness was part of healing and reconciliation. She did not realise that it was not easy for most people who hold political power to publicly come out into the open and say that they were sorry. She failed to realise that apologising was the first step towards reconciliation. To this effect, *Rituals* also revealed tensions of class and ideology within communities with regard to the process of healing and reconciliation, creating a counter narrative that did not simply empower without interrogating that which it empowered.

Forgiveness without truth

Mashingaidze (2012:20) observes:

> Zimbabwe had never before comprehensively attempted to prosecute or compel perpetrators of politically motivated violence to acknowledge their transgressions, because the national leadership regularly exploited constitutional prerogatives to pardon perpetrators. Political expedience has always outweighed the imperatives of victim-sensitive national healing after all the major political crises of the post-independence years.

Murambadoro (2014) adds that the fear of the truth led to policies of forgiveness without truth such as the 'let bygones be bygones' after the war of independence (1964–1980) and 'moment of madness' after the civil war in Matabeleland (1982–1987). *Rituals* exposed the tension in the handling of the truth. State actors pressured forgiveness without truth and this was contested by both civic society and communities.

The ritual environment was one of the platforms where truth preceded healing and one which produced versions of reality and truth which the state could not censor. The truth that emerged from the rituals usually revealed the involvement of some politicians in the organisation and execution of political violence, intimidation and rape. In traditional rituals, communities wanted those who had participated in the violence to come out in the open, renounce their violence and ask for forgiveness from communities (Mashingaidze, 2012). Other sections of the community wanted perpetrators of violence to come and pay back what they have taken from their victims during the violence (Mbire, 2011). They wanted a system of restorative justice that replenished the victim. Pamela Machakanja (2010:6) observes that:

> There are also strong views that the alleged corruption, violence and political murders of the past ten years as well as the massacres of the early 1980s cannot simply be swept under the carpet under the pretext of preserving national cohesion and unity during the transitional period. Claims are that perpetrators of the worst abuses must be brought to justice, and if individuals are to be forgiven, it must be done publicly as part of a transparent truth, justice and reconciliation process.

The state's fear of the truth was demonstrated in an episode where John (played by Silvanos Mudzvova) had killed opposition supporters in June 2008. The spirits of these people possessed John so that he became insane. Some members of John's family wanted the healer to cleanse the spirits that made John mad. Muchoro (played by Zenzo Nyathi) wanted John to forget what he did and saw because, according to him, forgetting is also healing. But the traditional healer (played by Joyce Moyo) insisted that she could not heal what she did not know. Therefore, John had to announce the names of the people he killed before the ceremony could take place.

Muchoro was afraid that if John spoke, he would expose names of other big politicians who had participated in the violence of June 2008. These politicians, he feared, would harm John's family. One of the relatives was also afraid that John would be imprisoned.

Michael Bratton (2011) points out that the retributive justice model offered by the state emphasises the criminal prosecution of wrongdoers. However, such a model could not address issues of justice between spirits of the people killed in political violence and their murderers. *Rituals* suggested that traditional rituals had to be incorporated into the country's approach to healing. Unlike the courts, such traditional rituals were difficult to monitor in terms of the information that the general public would have access to. This lack of control, in our view, is one of the likely reasons that some sections of the GNU were reluctant to embrace the community-centred approaches to healing and reconciliation. The reason why John's family wanted him to forget is because John would reveal a lot about the violence in terms of its organisation, perpetrators and victims. They were afraid that state actors would unleash more violence on them. The state was willing to have reconciliation that simply erases the memory of violence, torture, murder and rape. They proposed that forgetting is healing because forgetting offers a flimsy escapist route that covers up the violence perpetrated on citizens by political parties. This is why Muchoro insisted that the healer gives John medicine that would make him forget what he saw and heard. The family was opposed to Mavis who wanted his brother John to reveal everything. They wanted healing that did not implicate party cadres in the construction of political violence. It was these kinds of truths that reinforced *Rituals'* function as a counter narrative.

Conclusion

The chapter has revealed how *Rituals* played a counter hegemonic role in the story of Zimbabwe's national healing and reconciliation in a manner that exposed various truths that the state was silent about. The chapter has revealed ways in which *Rituals* contested the state version of reality and the consequences that ensued as a consequence of challenging the moral and intellectual leadership of the state in telling the Zimbabwean story. *Rituals* gave voice to plural voices, fragmented different community perspectives and needs, exposed the role of the state in stifling community driven models of healing, revealed tensions within communities with regard to healing and reconciliation as well as the attempt by some civic actors to control grassroots models of healing and reconciliation. It is through these tensions and contestations that *Rituals* became a counter narrative on national healing and reconciliation in Zimbabwe.

References

Benyera, Everisto, 2014. Exploring Zimbabwe's traditional transitional justice mechanisms. *Journal of Social Sciences*, 41(3), 335–344.

Bratton, Michael, 2011. Violence, partisanship and transitional justice in Zimbabwe. *Journal of Modern African Studies*, 49(3), 353–380.

Dodo, Obediah, 2015. *Endogenous conflict resolution approaches: The Zezuru perspective*. Leicester: IDA Publishers.

Guzha, Daves. 2019. Interview with Author, Harare: Theatre-in-the Park.

Le Touze Dominique, Derrick, Silore, and Anthony, Zwi, 2005. Can there be healing without justice: Lessons from the commission for reception, truth and reconciliation in East Timor. *Interventions*, 3(3), 192–302.

Lyotard, Jean-Francois, 1999. The postmodern condition. *Modernity: Critical Concepts*, 4, 161–177.

Machakanja, Pamela, 2010. *National healing and reconciliation in Zimbabwe: Challenges and opportunities, Zimbabwe monograph*. Wynberg: Institute for Justice and Reconciliation.

Machinga, Mazvita, 2012. Grassroots healing and reconciliation in Zimbabwe: Introducing the RECORE process. *Practical Matters*, 5(Spring), 1–11.

Makwerere, P, and Mandonga, E., 2012. Rethinking the traditional institutions of peace and conflict resolution in post 2000 Zimbabwe. *International Journal of Social Science Tomorrow*, 1(4), 1–8.

Mashingaidze, Terrence M., 2012. Zimbabwe's elusive national healing and reconciliation processes: From independence to the inclusive government 1980 to 2009. *Conflict Trends*. Available from: http://www.conflicttrends.org [Accessed 5 December 13].

Mbire, Moreblessing, 2011. *Seeking reconciliation and national healing in Zimbabwe: Case study of Organ for National Healing, Reconciliation and Integration (ONHRI)*. Masters Dissertation, Hague: International Institute for Social Studies.

Mhaka, Edison, 2014. Rituals and taboos related to death as repositories of traditional African philosophical ideas: Evidence from the Karanga of Zimbabwe. *Academic Research International*, 5(4), 371–385.

Murambadoro, Ruth, 2014. The politics of reconciliation in Zimbabwe: Three times failure—will the fourth time count? *Kujenga Amani*. http://forums.ssrc.org/kujenga-amani/2014/12/17/the-politics-of-reconciliation-in-zimbabwe-three-times-failure-will-the-fourth-time-count/#.WasocMZlDIU [Accessed 2 October 2017].

Mwandayi, Canisius, 2011. *Death and after-life rituals in the eyes of the Shona: Dialogue with Shona customs in the quest for authentic inculturation*, Vol. 6. Bamberg: University of Bamberg Press.

Pazvakavambwa, Regina, 2011. Acclaimed Zimbabwe play 'Rituals' performed in South Africa, Zimbabwe briefing- crisis coalition report, issue 35, http://archive.kubatana.net/docs/demgg/crisis_zimbabwe_briefing_issue_35_110720.pdf [Accessed 1 October 2019].

Thompson, A. and Jazdowska, N. 2012 'Bringing in the Grassroots: Transitional justice in Zimbabwe' in *Conflict, Security and Development*, Vol. 12, No. 1 pp. 75–102.

31
DEAR MR GOVERNMENT

Jessica Lejowa, Bongile Gorata Lecoge-Zulu and Cheraé Halley

Section A

Dear Mr Government, the children have something to say: an exploration of theatre-making in the context of activism and cross-border collaboration

A conversation that took place between 2014 and 2015 between the co-creators about xenophobic violence and mass evictions in South Africa brought into focus the lack of representation of children on media platforms. It brought our attention to situations of unrest internationally, where adult accounts of violence and displacement dominated media coverage and public discourse. This observation led to a desire to create a piece of theatre that could give voice to children whose voices have been the faintest of all throughout episodes of violence and displacement in Southern Africa. In 2016, we began the cross-border collaborative process of creating a theatre piece that focused on how *children* experience and process events of displacement and violent conflict in their lives. At that time, Jessica Lejowa lived in Maseru, Lesotho and worked there as a teacher of drama in a secondary school setting. Bongile Gorata Lecoge-Zulu and Cheraé Halley lived in Johannesburg, South Africa where they taught in secondary and tertiary education settings, respectively. Cheraé brought her experience as a trained theatre maker, applied drama practitioner, and activist, while Jessica brought her experience as a trained theatre maker, director, and choreographer. Bongile came in with her experience as a trained musician, theatre maker, and participant in various cross-disciplinary and collaborative projects. Together, we envisioned a process of research, creation, and performance that would address the topic despite the challenge of living in different countries.

To begin our work, we delineated our approach into three phases that would direct the methodology we employed: the research phase, the creation or devising phase, and the performance phase. Additionally, we identified three core research questions that guided the development of the script from the workshop phase leading up to the creation and scripting phases:

1. What do children consider as a crisis?
2. If children could speak to their government, what would they say?
3. What games do children play?

To facilitate discussion by children, we designed action research workshops that centred on probing the following topics:

a) What is home?
b) Who makes decisions that impact your life?
c) What decisions would you make if you were an adult?
d) How might a perfect world run by children look?
e) What/who is government to you?
f) What would you say to government if you could gain access?

Because the creative team lived in two different countries, we decided to hold our workshops with children in Johannesburg, South Africa and children in Maseru, Lesotho. We met with children who live in the inner city Johannesburg area. The group was made up of South Africans and other nationalities from across Africa. In Lesotho, we met with children living in an orphanage just outside of Maseru, and children who lived in Maseru with family or in care centres. The children in these spaces were unlikely to have any experience of having their opinions at the centre of discourse. All the workshops were facilitated by at least two facilitators at any given time using games, role play, letter writing, drawing, discussions, reflections, and languages, ranging from English to SeSotho, in order to accommodate participant language capacities. Additionally, participants were split into different age groups, depending on their numbers, availability, and size of venue. As participants, they experienced a facilitated platform for dialogue through the creative tools used. Role and role-play became the cornerstones of the workshop process due to its ability to place children in imagined circumstances as a way of furthering their understanding of their world in which they live (Bowell and Heap, 2001).

A world in which the children could make decisions and address their government directly was, in our opinion, the ideal situation in providing answers to our first and second research questions. Borrowing from Dorothy Heathcote's process drama, we felt a need for the children in our workshops to surpass the social roles that they are unable to avoid in real life (O'Neill, 1995). Hence, we enrolled children into two different worlds: one where children had the power to make decisions for themselves, and another where children were in a position to address "Mr Government" and make demands for the betterment of society. This particular exercise resulted in the children physically constructing (out of newspaper, cardboard, and fabric) a village for children, run by children. The children would also construct what they thought would be the office or working space of Mr Government.

As we watched them play and transcend their reality through the imaginary worlds they created, we witnessed the most beautiful games, imagery, dialogue, and ideas of who represents the government for the child-participants in our workshops. One such image that evolved from the workshops was the presence of God, a higher power that needed to hold the government accountable. Another was the sheer disgust in the fictional character of Mr Government himself who "ate like a pig" and "never shared". They imagined Mr Government sitting in an office high above the ground where he could see everyone but not be seen himself. Such imagery provided the perfect base for us to experiment with larger-than-life caricatures when developing the script. An important piece of data that came out of the workshops was the numerous faces of Mr Government. For some children, Mr Government was the president himself, for others Mr Government represented their parents, teachers, or police officers. It became apparent that for the children, the fictional role of Mr Government represented all adults who govern their lives, those who provide for their basic needs and other significant people whose decision making affects their lives. A number of themes emerged from these workshops: the children saw God as a figure that would hold government

accountable but only later, in heaven. We noted a cynicism in this idea in the sense that it meant that children did not believe that a change they desired could occur in their lifetimes. They also brought attention to the limitations of not being given a say in decision making that happened at school and home. In addition, there were real fears of being stolen or trafficked, which were related to the fears of losing home or becoming/remaining poverty stricken.

The second phase of our journey was a theatre-making process that was informed by current affairs workshop content and personal story. Like the research phase, this phase necessitated our travel back and forth between Lesotho and South Africa. Where we could not travel, text messages, phone calls, video calls, and emails maintained the momentum of rehearsal. An example of working from current affairs was a letter that went viral on social media, having been sent out in a South African school to parents of unregistered immigrants threatening to take the children to police stations should the parents not send the child to school with the relevant documents. Out of this came the character of Bucket Head, who arrives at a school to take a child to a police station and then proceeds to terrorise the child about their "papers." The God concept that the children in the workshops offered us became the dialogue in a scene where the two little girls discuss the protocol for entering heaven, and whether Mr Government might be allowed into heaven. Similarly, in almost every workshop, the children expressed their desire to tell Mr Government to get shoes for every child in the world; the character of Daddy was then crafted around representing him through his shoes. Together with our own childhood memories of losing home and family, packing and unpacking—all of which experiences seemed to be mitigated by our mothers—we weaved the stories together until a narrative emerged. We discovered that a story of two little girls who meet at a shelter was the best vehicle to carry the complex and multiple narratives we had engaged with during the workshop process.

The performance style grew out of trying to honour the children we had met, and this became a larger-than-life landscape with characters that were caricatured, and allowed the younger members of the audiences to be delighted by images and colour, movement, and sound. At the same time, these caricatures were quite disturbing for the older audiences, and we discovered that this was something that could be done in our kind of theatre. We were telling the same story at different levels to reach different people in the audience. We chose a non-linear, episodic narrative format; the character stories are disjointed, travelling back and forth without a defined beginning or a conclusive ending. The end is not an end. It does not satisfy our need for narrative closure because the reality is that there are children still in those situations indefinitely.

Aesthetically, the work was built on the symbolic use of costume, props, and paper. The entire stage floor would be covered in butcher paper (the irony of using the paper that wraps parts of dead things was not lost to us), and this paper would transform throughout the play with drawings, tears, scrunching, and origami. The paper became the fictional world, it transformed into mountains and aeroplanes, immigration forms and shoes, a starlit sky, and a transparent bedroom where Mr Landlord's "rent" was paid. A metal bucket transformed into the hollow head of a law enforcement officer and became a pot for cooking stew. A stuffed rabbit became a baby and a vegetable in the stew cooked in the bucket. The stage would seem bare at the start of a performance, with the floor covered in paper and one clothing rail or screen set upstage right to serve as a bedroom, a jail cell, and living room. In front of the "screen" would be a small bench, also covered in paper. The bench transformed into the back of a police car, a school waiting area, a bed, and a mountain. In this way, audiences were given an ever-shifting landscape as the characters travelled and made home where they could and as they were uprooted and forced to leave.

The challenges we encountered fell into two broad categories: the ethical engagement with and portrayal of children, and the creative decisions that disturbed the balance between theatre that entertains and theatre that activates. We debated the efficacy of adult actors portraying child characters, and

the potential for appearing to patronise children rather than performing their characters truthfully. At the end of the process, those characters were informed mostly by children that we have met along our creative journey and in the workshops, as well as children informed by our own childhoods. Therefore, portraying them with respect is something we have always been committed to. It is, however, an ongoing discussion. We also debated at length about the age restriction for the work, feeling strongly that it was not helpful to hide children from the realities of their peers but also wishing to avoid the piece having traumatic effects on young audiences. In the end, we decided on a restriction of ages ten and below, and addressed any potential trauma in post-performance dialogue. While a great deal of the aesthetic quality of the work developed organically, we were also careful to privilege function over form in order to remain true to our original aims. We continue to debate and rethink our approaches to these dilemmas just as the work continues to shift and change, and this seems to be a factor that ensures the longevity of the work and its relevance across varying audience contexts.

Section B

Dear Mr Government,
Please may I have a meeting with you even though i am six years old?
Created by: Cheraé Halley, Bongile Gorate Lecoge-Zulu and Jessica Lejowa
Characters: Girl 1, Mama, Daddy; Girl 2, Mother, Police Officer aka Bucket Head, Brother, Political Leader
Props: Bench, crate, shadow screen covered with butcher paper, sheets of paper (varied sizes), large men's shoes, baby doll, metal bucket, a jar filled with fairy lights, crayons and charcoal, a large cloth—like a sarong—and a child's backpack.

Meeting of the Girls

Girl 1: I saw you and your mother and your baby sister and your baby doll when you came to live here!
Girl 2: You didn't!
Girl 1: I did!
Girl 2: You didn't!
Girl 1: I saw when your mother was bathing you and chasing away the people.
Silence
Girl 1: You shouldn't play here alone. A mean person might steal you and nobody will look for you.
Girl 2: Then why are you playing alone?
Girl 1: I used to come here with my friend and play. But she disappeared. So I don't have anyone to play with anymore.
Girl 2: She disappeared? Where did she go? Was it like the magic? Was there smoke and glitter?
Girl 1: She just disappeared. I don't know where she went. My mother says traffic took her.
Girl 2: To where?
Girl 1: To where traffic goes!
Silence
Girl 2: Can I be your new friend?
Girl 1: Nodding in approval. What's your name?
Girl 2: Whispers in Girl 1's ear. What's your name?
Girl 1: Whispers in Girl 2's ear. Did your daddy give you your name? My daddy gave me my name. And then my mother gave me another. And brother gave me another name. So I have three names.

Girl 2: Well my mama says we are going on a holiday. I think we will find my papa there and I can ask him.
Girl 1: Why didn't he come live here at the shelter with you?
Girl 2: He's doing important things.
Girl 1: Like what?
Girl 2: He's in another country. Far.
Silence

Get Out – Get Out

Girl 2: Can I teach you a new game? It's called "GetOutGetOut".
One, two, buckle my shoe. Three, four …
Girl 1 joins in
> Three, four, lock the door.
> Five, six, pick up little sis,
> Seven, eight, sit and wait.
> Nine, ten, pretend-pretend!

Eviction

Mama: Good. Again.
Girl 2: One, two, buckle my shoe … *continues*
Mama: Faster!
Girl 2: Seven, eight sit and wait.
Nine, ten, pretend-pretend!
Mama: It's not pretend, pretend anymore. It's get out, get out!
Girl 2: Where are we going?
Mama: We're going on a holiday for a few days.
Girl 2: Can I take my things?
Mama: Yes. What do you want to take? Hurry.
Girl 2: I want to take my doll. And and my ballet shoes. And my pyjamas.
Mama: Yes. Hurry. Get out, get out!
They arrive at a bench. Mama tries to make it more comfortable.

Waiting For The Bus

Mama: We are sleeping here tonight.
Girl 2: Why must we sleep here?
Mama: We are waiting for a bus to take us on our holiday. Stay there okay?
Girl 2 draws a bus stop on the screen.
It's an adventure. And guess what?! You don't have to bath for two days!
Girl 2: For two days?
Mama: For two days … Go under.
Girl 2 looks reluctantly at the makeshift shelter.
Mama: Go under! Hold the baby very tight.
Girl 2: Look mama, I found a paper. Can I keep it?
Mama: Yes. You can keep your paper. It's time to sleep now.

Girl 2: Can…
Mama: Shh. Sleep now.

Heaven Is After The Lights With Mama

Girl 2: What's after those lights?
Mama: Heaven.
Girl 2: Can anyone live in heaven?
Mama: Only those who live a good life.
Girl 2: What does that mean?
Mama: Those who do good for others.
Girl 2: Like you.
Mama: Yes, like me, one day.
Girl 2: Not today?
Mama: No, not today. Only one day.
Girl 2: Is it nice up there?
Mama: Oh, very nice.
Girl 2: Better?
Mama: Better!
Girl 2: Better than this?
Mama: Yes.
Girl 2: Do you think Mr Government will live there?
Mama: Where? Heaven?
Girl 2: Yes, after the lights.
Mama: Maybe.
Girl 2: But he isn't doing good for others.
Mama: He doesn't see what we see.
Girl 2: He needs to come visit and see.
Mama: He can't.
Girl 2: We should invite him. Write to him and ask him to come see.
Mama: What will you show him?
Girl 2: Everything. I will show him my mattress, my friends, you. Then I'll show him my ballet shoes and ask him to buy the other children the same shoes.
Mama: Interesting.
Girl 2: What does he look like?
Mama: Who, Mr Government?
Girl 2: Yes. Is his nose big?
Mama: Oh, his nose is very big!
Girl 2: How do you know that his nose is big?
Mama: I've seen him on TV.
Girl 2: Is he as tall as man can be, do you think?
Mama: No, no, he is as short as you can be.
Girl 2: So he is a child like me?
Mama: No, he's a grown up like me.
Girl 2: So, he must enjoy telling us children what to do.
Silence.
Do you think he enjoys cabbage?

Mama: I think he stopped eating cabbage when he became Mr Government.
Girl 2: He doesn't eat cabbage?!
Mama: No.
Girl 2: What does he eat now?
Mama: He eats goat meat and lamb meat and spaghetti and…
Girl 2: Spaghetti?!
Mama: Yes.
Girl 2: How did he get to be Mr Government?
Mama: We, people, everyone, we chose him.
Girl 2: You chose him?
Mama: Yes, but not him, now.
Girl 2: I don't understand.
Mama: "Him," when he still ate cabbage like us.
Silence.
Girl 2: I wish he could come see now.
Mama: Me too.
Girl 2: He must come see now and do good for others so he can go to, after the lights, what is again?
Mama: Heaven.
Girl 2: Yes, heaven. Before he goes to heaven.
Mama: If he ever gets there. Maybe he'll never get there.
Girl 2: Mama…
Mama: Shh. Sleep now. *Hums a lullaby.*

Move Into "Hijacked" Apartment Building

Mama: Get out. Take your things.
Girl 2: But the bus didn't come!
Mama: I know. It will find us.
After a long walk through the city, they arrive at a run-down building. They walk up multiple flights of stairs.
Mama: We're sleeping here tonight.
Girl 2: Why must we stay here?!
Mama: Shh! People are sleeping! It's time to sleep.
Girl 2: Mama … I want to go to the toilet.
Mama: Let's go. Take your things.
Girl 2: Why is the toilet so far? The toilet is so dark mama. My stomach is painful.
Mama: Tomorrow we'll take you to the doctor. Tonight you have to sleep.
Girl 2: There are too many stairs. Do you know the toilet had no water? And no toilet paper? And it smells!
Mama: Quiet! Time to sleep. Hold your sister. Hold her tight. Don't talk to anyone. I'll be back just now.
Girl 2: Where are you going?
Mama: I'm going to talk to Mr Landlord about the rent. I'll be back now. Don't talk to anyone.
Mama puts the kids to bed. Fixes her hair and clothes. Turns her back and stealthily applies some Vaseline. Walks to Mr Landlord to "pay" the rent.

Girl 2: Speaking to another girl. Hello. What's your name? Do you live here? I'm with my mama and my baby sister. We're waiting for a bus so we can go on a holiday.

Mama returns in pain, fixing her clothes. Slips into bed beside the children.

Lollie-Lollie

Girl 1 & Girl 2: Tomatoes and onions are smelly!
Oh no Lollie, We heard Lollie,
From your sister Lollie, You were summoned Lollie,
By the angry Mr, Lollie.
Do you have your papers no, no, no,
Wear your pretty pink dress with a bow, bow, bow,
Go and find more money, go, go, go.
Waiting, waiting,
All the children waiting,
Faces. Faces.
See the hateful faces.
Oh no Lollie, here he comes Lollie,
Vengeant or heaven sent,
Here comes Mr Government!

Repeats as Girl 2 transitions into Police Officer (aka Bucket Head who wears a bucket on their head for the duration of the scene)

The Police Came To School

Girl 1: Why did you have to wear your trousers to school? You see, now Mrs So-and-So has sent us to the office!

Police Officer: Where are your papers?!

Girl 1: Who is this person? His face looks painful. His mouth smells like the Rubbish Mountain.

Police Officer: Where are your papers?!

Girl 1: What papers? Don't take my paper toys!

The Police Officer signals for Girl 1 to come to him.

Police Officer: Where are your papers?!

Girl 1 shrugs, confused. Police Officer shoves her into a police van. The car ride is mimed.

Girl 1: Where are we going? I don't want to go to jail. I told you I will buy you a new pen when my mother gets paid. You didn't have to call the police! Ooh, look at the suburbs! I like the double doubles. What do they do in the top double? How many people live there? Maybe it's many families like at home. People in the suburbs are funny. Their cars don't have roofs. What if it rains? We use plastics to walk in the rain. Maybe they use the cut off roofs to make a garage. Mother says when something is broken we must use it again. Don't waste.

Look at the hospital. It smells. Like home but rotten. There's smoke. When Auntie's leg was rotting they cut it off at the hospital. Maybe they make people drumsticks. Ouch! My head is sooooore. Why does this police like bumps? Potholes. *Laughs.* There are no pots here! Yes! Rubbish Mountain! I'm going there after school with my brother. And my brother promised me that if I help him find more wires for his cars he will let me and my friend go skiing down Rubbish Mountain. Ooooooouuuch! Ishiiii!

Where Are Your Papers?

At the police station. The police officer moves behind the shadow screen and demands documents from Girl 1.

Police Officer: Where are your papers?!

Girl 1 is moving from bench to chair to office to window to cubicle in the process.

Police Officer: *Reappears on stage.* Papers, papers, papers…

Flings paper all across the stage. Repeated with subtext to shuffle child through queues until shift changes.

Girl 1: *Wondering around police station to pass time. She picks up as many papers as she can hoping to find the right one. She stuffs sheets of paper in her backpack and tucks them into her clothing.*

Police Officer: Papers! *Signals for Girl 1 to bring her papers. Police Officer proceeds to throw the document in Girl 1's face and hands her a different document and sends her off to another counter.*

Girl 1: *Walks around, confused as to where to submit the document. She finds a large piece of paper and makes an aeroplane as she counts.* One aeroplane, two aeroplane, three aeroplane, four aeroplane. *Fast.* Five, six, seven … one hundred aeroplane! What time is it? It's late o'clock – my mother should come and fetch me now. She must come now.

Police Officer: *Makes a paper phone for Girl 1 to call her mother.* Papers!

Girl 1: 5789101112. *No answer.* She is not answering, can I call again?

Police Officer: Papers! *Signals that she can call again.*

Girl 1: 5789101112. *No answer.*

Police Officer: *Checks the time. Roams around the police station tidying up the papers to end the shift. Girl one follows and imitates all the actions.*

Opens cell and orders Girl 1 to go in to sleep. Papers!

Girl 1: *Now behind the shadow screen Girl 1 sobs.* Motheeeeeeer! They're putting me in jail! Mother! Mother! You must come and fetch me now. They are putting me in jail … Mamaaa!

Mother and Daddy Talk Papers

Daddy: *Wearing over-sized shoes.* I've collected the forms you asked me to fetch.

Mother: *Cleaning up the paper mess on stage.* They're late.

Daddy: I know, I'm sorry I couldn't get them earlier in the week. I already told you this.

Mother: Which ones did you take?

Daddy: The yellow one, the white one and the list of required documents.

Mother: And the blue one?

Daddy: The blue one?

Mother: For the children!

Daddy: Can't they use the yellow one?

Mother: The yellow ones are for adults!

Daddy: I'll fetch them next week.

Mother: It will be too late! What did they say we need?

Daddy: It's on this paper. We need our passport copy, a letter for proof of work, an affidavit from our landlord, an affidavit from the looting attacks, and that's all. I'll get the forms next week because I need to put some work in at the shop. If I don't get paid there I can't pay the application fee, then we're back here with forms again.

Mother: And for the children?

Daddy: For the children it says nothing.

Mother: It must say something!
Daddy: Maybe it's on the blue form.
Mother: We need to have a meeting with Home Affairs. Or Immigration.
Daddy: They're the same thing.
Mother: No, they're not. Where do we go first?
Daddy: The man who gave us the forms?
Mother: Is that a question?
Daddy: I will speak to him.
Mother: He doesn't care about us. He doesn't need us. We need him.
Daddy: I will ask the man at the shop to take me to him next week when he goes to town.
Mother: But you must ask about the children. You can't forget about them. They are children.
Daddy: I will ask this time.
Mother: I will speak to the ladies at the salon, ask them to write me a letter for work.
Daddy: That's not enough! Being at the salon isn't work.
Mother: How are we supposed to get work without those papers and how are we supposed to get those papers without work?!
Daddy: I will speak to the man that helped me.
Mother: This is all too late. We will get sent back with nothing on our backs this time.
Daddy: It's confusing. The system is confusing.
Mother: Just ask the man who helped you to explain to you again. This time clearly. No mistakes. No confusing. Ask him to repeat it. He must speak slowly. Ask him for patience.
Daddy: You don't know them. They don't care.
Mother: But someone must!
Daddy: Not him.
Mother: Just try. Be brave again. For us. For me. For the children.
Daddy: I'll try next week.

Transition

Girl1 and Girl 2 chant the "Get Out, Get Out" rhyme. The actors create a mountain of rubbish with the papers on stage while singing.

Mama Pays Mr Landord

Mama: Time to sleep. Shh. Hold your baby sister. Don't talk to anyone. I'll be back.
Sequence as before. Stealthy.

Knock-Knock

Girl 1 & Girl 2: Knock-knock?
 Who's that police man, I
 want to send a letter,
 I want to send a letter,
 For you to shoot or kill or burn or save?
Girl 2: Save!
Girl 1 & Girl 2: *Repeat "Knock-Knock".*
Girl 1: Burn!
Girl 2: But I saved you! I don't want to play this game anymore.
Girl 1: Okay, let's draw then.

Dear Mr Government

Heaven Is After The Lights With The Girls

The two girls make use of the glass jar of fairy lights.

Girl 2: Do you know about heaven?
Girl 1: No.
Girl 2: No?! Don't worry, I will tell you.
Girl 1: Thank you.
Girl 2: Heaven is there, there, there, after the lights.
Girl 1: The staaaars!
Girl 2: Yes, those lights are stars. Well done. So heaven is after the stairs.
Girl 1: Stars.
Girl 2: The stars I mean. So people live there you know!
Girl 1: How?
Girl 2: People must do good for others here then they can go there
Girl 1: To heaven?
Girl 2: Yes. In heaven there is a river of milk, and mountains of chocolate. In heaven the tables and chairs are all biscuits and you can eat and drink everything.
Girl 1: Wow! I want to go to heaven.
Girl 2: Yes. And you will because you do good for me here in the shelter.
Girl 1: The Police won't go to heaven.
Girl 2: No, they won't! And Mr Government, he won't go up there also.
Girl 1: He can't!
Girl 2: No, he can't.
Girl 1: Have you ever met him?
Girl 2: Never!
Girl 1: I wonder what he looks like.
Girl 2: My mother says he has a beeeeg nose and he is as short as a child.
Girl 1: And he wears a hat!
Girl 2: No, I don't think so.
Girl 1: He must. All governments wear a hat. A big, brown one like a soldier.
Girl 2: You like to make stories strange.
Silence.
Mr Government does not wear a hat. Okay? I saw on TV, he is like you and me.
Girl 1: If he is like you and me then does he also use the toilet outside?
Girl 2: No, don't be crazy! He has four toilets.
Girl 1: For himself?
Girl 2: Yes. And four toilets for his children.
Girl 1: Does Mr Government have childrens?
Girl 2: Yes.
Girl 1: I wish I was his childrens. I also want four toilets.
Girl 2: Me too.
Girl 1: Maybe Mr Government already lives in heaven.
Girl 2: Don't be crazy!
Girl 1: No, 'strue! He probably has a river with milk.
Girl 2: Milk! I will drink it all day!
Girl 1: I will swim in the milk!
Girl 2: Me too.
Girl 1: Think Mr Government eats all nice things like chicken and rice.

Girl 2: No!
Girl 1: What?! He eats cabbage?!
Girl 2: Don't be crazy, he eats goat's meats and *spaghetti*! Even more special.
Girl 1: Wow!
Girl 2: I wonder if he will allow us to visit him sometime. Then we can also eat meat and spaghetti.
Girl 1: What is spaghetti?
Girl 2: I don't know.
Girl 1: I've never eaten goat's meat. The poor goats.
Girl 2: They kill them special-special for Mr Government you know.
Girl 1: I wish I was Mr Government's childrens.
Girl 2: Maybe we can be his children after the stairs.
Girl 1: You mean stars!
Girl 2: Yes, yes, you're crazy. You hear funny.
Girl 1: I can't wait to be his childrens after the stars. But now I want to tell him I hate him.
Girl 2: What?!
Girl 1: Yes. I hate him. He likes to eat goat's meat and sperrrgeddi and not give us.
Girl 2: Yes.
Girl 1: And he can't use four toilets while our building is sharing one broken toilet that's outside, and it's dirty and it doesn't even have water.
Girl 2: I wish he could come and see us now. He must come see the toilet.
Girl 1: I will punch him in his big, ugly nose!
Girl 2: You can't!
Girl 1: I can! You say he is as short as us so he can't hit me and control me.
Girl 2: You are really crazy now! I will invite him to eat cabbage with us.
Girl 1: Yes, so he can see what we eat every day. And I will tell him that he must put cameras outside the building to catch the criminals who stole our water pipes and set my daddy's shoes on fire.
Girl 2: Yes, but not him now.
Girl 1: I don't understand.
Girl 2: "Him," when he still at cabbage like us.
Silence.
Girl 1: I wish he could come see.
Girl 2: Me too.
Girl 1: He must come see now and do good for others so he can go to, after the lights, what is it again?
Girl 2: Heaven.
Girl 1: Yes, before he goes to heaven.
Girl 2: If he ever gets there. Maybe he'll never get there.
Girl 1: I wonder if my daddy and my brother are after the lights?
Girl 2: What happened to your daddy and your brother?

The Demise of Daddy

The following scene is a retelling of the same event as seen from Mother and Girl 1's eyes.

Girl 1: Mother said: "today we're having meat! It's a special day." I wanted to help her cook but brother said no. He said: "paraffin smells are bad and they will melt your lungs."

Brother said: "Let's go to Rubbish Mountain". Oh wow! Brother never let me go to Rubbish Mountain. He said rubbish was dirty for children and it would give me "titis" and my bones will break. Fun won't break my bones like sticks and stones! And words. We didn't go the normal way. It was faaaaar! Was brother lying to me? He was taking me for an injection! I didn't want! I wanted to go back and help mother with the meat. I love the smell of onion soup. It's fried onion and salt and water. There's Rubbish Mountain.

Mother: I was coming out of the taxi when I saw the police fly by. I remember the lady behind me making a joke about how they like to pretend it's an emergency. Long into my walk past the landfill, an ambulance drove past leaving the township. I said a prayer for the person inside.

Girl 1: Brother said: "Lollipop, find the shiniest wires in the mountain. I will make you a brand new car and you can drive it to the valley and play in the grass."

Mother: As I got to the top of the street, a crowd was formed outside the shop.

Girl 1: I see black smoke. But brother told me to find all the shiny wires.

Mother: I panicked, clutching my packet tighter, I ran towards the shop. It was scary you know, people were angry.

Girl 1: Everybody's running to the smoke. Brother will be angry if I go away. But I can't stay here alone. Rubbish Mountain is dangerous for children. I follow everyone.

Mother: I only pushed through the crowd because I was certain it would involve my son.

Girl 1: The smoke is getting bigger. It smells like mother's cooking. Maybe she is burning our meat. I should have stayed to watch the pots.

Mother: I never expected to see my husband there. On the ground. Set alight. People were just watching. The ambulance just left. The police just arrived. Where were they? Where was my daughter? Where was my son?

Girl 1: We push past the grown-ups. They move away because they think we want to steal money and cigarettes from their pockets.

Mother: I looked around the crowd for the man from the shop. The shop was looted. I couldn't tell them to stop. All these people standing there, watching, I *know* them. I see them every day. I ran into the house. I didn't know what I was looking for. A blanket, a bucket, sand.

Girl 1: It's Daddy's shoes. They are on fire. It smells like meat is melting. Who is cooking daddy?

Mother: I ran outside with a blanket. Everyone was gone. All that was left was a black body, still in flames. Only then the women from the salon came throwing water on him. The police were gone. I think I saw my daughter. But still no sign of my son. I cried. I cried. I am still crying.

Searching for the Body of Daddy

Mother enters with Girl 1 in tow. The words in brackets are mouthed by Mother and said aloud by Girl 1. Each time Mother mouths the words she indicates to Girl 1 to cover her ears.

Mother: Hello, my name is Mother. I'm looking for (my husband). He was brought here two days ago. A (burn victim). Yes, yes, I mean a corpse.

Mother waits.

Mother: That's me! Burn victim! No, no! I paid for that already! Please. Thank you.

Mother waits.

Mother: No, this is not him. I know his wallet. This is not his wallet! He has a picture, a picture of (his daughter).
Mother waits.
Mother: What do you mean moved?! Moved where?
Mother goes to the next counter.
Mother: Hello, I'm looking for my (husband). Thank you. No, not a citizen. Here is his passport number. He had his passport at the time. Here is my passport. His (wife). No, we are not from this … here! Thank you.
Mother waits.
Mother: What do you mean you can't help me? They told me I could find my husband here. I don't understand. How many (burnt bodies) do you have?! I see. *Flips through photos she is given.* Oh my god! I don't know. Don't you have names? They all look the same! No, no ring. No! *Crying.*
Mother is inconsolable. Girl 1 strokes her hair, wipes her tears.

Shadow Dinner

At the table is Mother, Brother, and Girl 1. The following scene is done behind a shadow screen. Only Girl 1 is visible.

Mother: Brother did you find any work today?
Brother: I had other important things to do.
Mother: I need you to find work and help me around the house.
Brother: I invited someone important for dinner. He has important things to say.
Mother: No. I've told you about this. We are not opening our doors to radicals!
Girl 1: What's a radical?
Mother: It's a vegetable, baby. Now finish your food. You know this will only lead to more trouble. You can't take on the establishment when you don't even have papers.
Brother: Would you like me to be like you instead?
Mother: That's enough! You are misbehaving!
Brother: I'm a man now. I have a right to do what's right for my family. And next year I will be sixteen.
Girl 1: You'll be in so much trouble!
Mother & Brother: Cover your ears!
Mother: After everything that has happened, you still want to go making trouble? Do you want us to get kicked out of this place?!
A knock at the door. Enter Political Leader.
Brother: Thank you for coming, my mother has prepared food for you.
Political Leader: I am very grateful. It is becoming very hard to find a good woman these days.
Girl 1: I know you!
Brother: Yes, you would remember him. He's an important person in our community and he wants to help us get organised.
Mother: That's not going to happen in my house. You may sit down and have some food, but that will be all.
Political Leader: This is not your house, madam. You are not allowed to have a house. That is why I am here. To help you see that with action you can one day own a house.
Mother: This is going to start trouble.

Brother: The trouble already began when that burned my fa…
Mother: Cover your ears!
Girl 1: Father!
Mother: Why must you do this? Isn't what happened enough for you? I hear people outside. Do you hear that?
Political Leader: Did you tell on me, boy? Did you? They're coming for me!
Brother: I swear, I didn't! You said I shouldn't! Maybe she did.
Girl 1 objects
Mother: I think we will have to get our belongings and leave. We have to go tonight. We have to leave otherwise they will take us.
Girl 1: Mother! Mother! I'm scared, mother. They're going to burn Brother's shoes!
Mother: Brother, take your sister. Hurry!
Girl 1: Can't we just lock the door?
Mother: No, we have to get out. Get out!
Brother: I'm going with him. I'll find you soon.
Girl 1: No!
Mother: No you horrible man! You will not take my son too!
Girl 1: Don't go! Brother, please don't go!
Brother and Political Leader leave.
Mother: Take your things. Let's go now.
Girl 1: Are we coming back?
Mother: Get out! Get out! Get out!

Transition

Girl 1 and Girl 2 – "Get Out, Get Out" rhyme with choreography.

Mama Pays Mr Landlord

Mama: Time to sleep. Shh. Hold your sister. Don't talk to anyone.
Girl 2: Whispering to another girl. Can we borrow your Vaseline? Mama has run out of hers and she has to go and pay Mr Landlord. Thank you. *Takes tub, puts some of the Vaseline into their own tub.* Mama don't forget to put Vaseline! *Mama leaves to pay Mr Landlord. Girl 2 applies some Vaseline to herself and to the baby very quickly and stealthily.*
Mama: As before. Stealthy and fatigued. Returns but this time fuelled with anger. Get out. Get out!

Bathtime for the First Time

Girl 2: Mama, when are we going back home? I don't like this holiday.
Mama: We will go back soon. But today you have to take a bath.
Girl 2: Where am I going to take a bath?
Mama: We're going to have a bath adventure! We'll play with the bucket, then hunt for water, and take a bath outside!
Girl 2: And the baby? Is she also bathing in the outside?
Mama: Yes, it will be fun. Don't worry if the water looks a little brown. It's clean, it's adventure water.

Girl 2: Where is the soap?

Mama: Use your hands.

Girl 2: But everyone is going to see me!

Mama: They won't see you. We have a blanket, see? You hold that side and I'll hold the other side.

Girl 2: Where is the facecloth?

Mama: Use your hands.

Girl 2: You know, I like it here mama.

Mama: You do?

Girl 2: Yes. There's water. And food. I saw them cooking at the shelter over there. Do you think it's chicken? Can we go and eat there too?

Mama: Yes, we can go eat there after your bath.

She fiercely looks out for people watching her children bathing.

Girl 2: And clothes. Can we go and see the clothes they have there?

Mama: Yes, we can go and see the clothes. You can get some for your doll too.

Girl 2: No. I don't want my doll anymore. She's not my baby. Baby sister is my baby now.

Mock Grown-Up Meeting Talk

Girl 1: I had a meeting with Mr Government's lawyer's gardener today. It was so stressful! He told me that I have to come back tomorrow with a letter that says I have a letter from Mr Government saying I can apply for a meeting with the secretary of the secretary of the division of People's Letters to Mr Government.

Girl 2: Well don't cry, my husband. It's good that you wore the football club T-shirt, it keeps you safe. Mrs So-and-So in the room next door told me that if you wear it every day and walk around, it keeps you safe. She says that Mr Government likes the football club. When you go to the meeting tomorrow, what must you carry?

BOTH: The right food!

Girl 2: Yes, carry some beef.

Girl 1: And beans with no onions.

Girl 2: Carry some beef, like a man.

Girl 1: And white bread, we don't want the Government to think I'm poor!

BOTH: No, poor people must get jobs!

Girl 1: But you know, Mr Government already does so much for us. Let's take a moment to be very…

BOTH: Thankful and grateful and humble and humthank and grateable. Amen.

END

References

Bowell, P and Heap, B. 2001. *Planning Process Drama*. London: David Fulton.

O'Neill, C. 1995. *Drama Worlds. A Framework for Process Drama*. Canada: Pearson Education.

32
APPLIED PERFORMANCE AS A SPACE TO ADDRESS ISSUES AFFECTING GIRLS AND YOUNG WOMEN IN ZIMBABWE
A case study of *Rachel 19*

Cletus Moyo and Nkululeko Sibanda

This chapter seeks to explore how applied performance that infuses aspects of African performance aesthetics and Boalian aspects of participatory theatre, has provided a space to address issues affecting girls and young women in Zimbabwe. The focus is on *Rachel 19*, a theatre project by Victory Siyanqoba Arts performed in Bulawayo, Gweru, Mazowe and other places in Zimbabwe. In Bulawayo in particular, and in Zimbabwe in general, applied performance has grown mainly as part of alternative theatre, seeking to provide a space for dialogue on pressing social, political and economic issues affecting people. Whilst it is generally agreed that applied theatre creates an alternative space for dialogue, *Rachel 19* provides an interesting angle as it is done within the concept of *Laundry Café*, a grassroots centred platform for girls and young women to address issues that affect them in the context of oppressive cultural taboos and boundaries. This chapter therefore explores the strategies and methodologies that have been used by Victory Siyanqoba in order to create an art that is both relevant to the socio-cultural contexts of its creators and audiences/participants, and also an art that can shift consciousness and effect change to the socio-cultural strata. Issues emanating from the *Laundry Café* include HIV and AIDS, domestic violence, sexual and reproductive health and others. The chapter argues that in contemporary contexts that are still riddled with oppressive cultural taboos and boundaries, applied performance has continued to offer a viable alternative to speak to those contexts and to seek to transform them for better. The chapter explores how applied theatre fulfils this role.

Because of its emphasis on social transformation and addressing issues that affect individuals and groups in societies, applied theatre has been seen as strategically positioned to respond to social, economic, political and cultural issues that confront humanity on a daily basis (Boal, 1979; Mda, 1993; Taylor, 2003). Augusto Boal (1979) argues for a kind of theatre that is empowering to the participants so that it prepares them to implement action that liberates them and transforms their communities in real life scenarios. *Rachel 19* is analysed using the *Laundry Café* conceptual framework. The *Laundry Café* is a process that facilitates the bringing together of women to talk about taboo subjects while undertaking their gendered chores. This concept was also devel-

oped by Victory Siyanqoba in an effort to create an effective platform to address issues affecting adolescent girls and young women in contemporary Zimbabwe. Munyaradzi Chatikobo and Katharine Low (2015) engage in a dialogue that examines the role of applied theatre in Southern Africa. They argue that theatre creates a safe space to address sensitive issues like sexual health and creation of democratic spaces that are usually difficult to address in a face-to-face scenario. The project demonstrates the potential that lies in applied theatre to address such issues.

Applied theatre practice in Africa and Zimbabwe

In Africa, applied theatre emerged as a result of the failure by mainstream theatre to capture the political, economic and cultural realities of the majority populace. Applied theatre is considered political because it engages the current socio-politico, economic and cultural landscapes that hinder development and progress (Sibanda, 2017). Karin Barber (1987) posits that to claim that a work or genre represents a certain communal view or consciousness (read as political) one must be able, at least in principle, to show that the audience reads it in the way the artist intends it. This speaks to agreed conventions that define a work of theatre as applied theatre, and are determined by the use of locally understood and appreciated aesthetics.

The presentational and demonstrative style of African performance which is imported into applied theatre performances enables an aesthetic of immediate impact. Barber (1987: 43) posits that this style allows the exploitation of each moment or possibility within the artistic construct for its maximum effect: Its most powerful appeal. Consequently, this style should engage what Barber (1987: 55) terms 'ethnographic categorisation', a process of engaging ways of 'finding meanings of non-verbal communication in community theatre'. This process introduces supplementary readings and analysis of the visual aesthetics and performance styles to arrive at the intended message by the audience. However, this approach liberates it from older indigenous traditional and colonial elite arts and legitimation by institutions and theory.

In this chapter, we examine how Victory Siyanqoba creates and makes use of these layers of communication through *Rachel 19*. Because applied theatre is considered unofficial and a 'theatre beyond boundaries' (Leach, 2008: 162), the trend has been that those in community theatre practice tend to learn informally from experienced practitioners, and usually practice and perform without tertiary and proper theoretical grounding. This exposes community theatre to a variety of experimentation in terms of design practice, writing and performance styles.

In Zimbabwe, theatre in general that address pressing socio-political issues has played a crucial role in providing an alternative space for expression, functioning as an alternative medium (Mpofu and Moyo, 2017). Applied theatre has also not been left out in such an approach. Theatre organisations such as Amakhosi Theatre Productions, Patsime Trust and Victory Siyanqoba, among others, have been at the forefront of using applied theatre to address a plethora of challenges affecting humanity – cultural, social, political and other spheres of human life. Praise Zenenga (2010: 14) argues that '[I]n Zimbabwe, major historical moments – colonization, liberation, and anti-apartheid struggles; the introduction of economic-structural adjustment programs; the fight against HIV/AIDS; and the struggle for land, rights, and democracy – gave birth to theatrical and performance practices'. Applied theatre constitutes part of these practices. Zenenga goes on to explain what he calls 'hit-and-run' theatre, a kind of theatre that has similarities with Augusto Boal's invisible theatre. This theatre is used in Zimbabwe to challenge authorities on issues of poor governance, and it works well in evading detection and arrests in a country like Zimbabwe where one can be arrested for creating theatre that challenges those in authority, especially those occupying political offices. Preben Kaarsholm (1990: 246) also observes that 'where there are areas of conflict in worldview, and tensions between the forces of

dominance, acceptance and revolt, theatre often serves to illuminate self-understanding and to articulate precise needs and aspirations'. Theatre in general, and applied theatre in particular, has been observed to fulfil this role in Zimbabwe.

What is also important is the aspect of how applied theatre can be deployed to effectively accommodate people with their diversities. Kennedy Chinyowa (2011) investigated the use of applied theatre to address issues of HIV and AIDS in Zimbabwe focusing mostly on issues of protection as a prevention strategy. His focus was on a play *Vikela* (protect/prevent) done by Amakhosi Theatre Productions and taken to many rural areas in Zimbabwe. Chinyowa (2011: 67–68) observes that:

> African popular theatre has emerged as an appropriate medium through which gender hierarchies associated with patriarchy can be questioned in the fight against HIV/AIDS pandemic. The freedom created by the 'playful' spirit in popular theatre practise allows even the most sensitive issues to be addressed without consequence … The new frames of reference created within the make-believe world of the theatre simultaneously act as rehearsals for action.

Building on other research done in Zimbabwe and beyond, in this chapter we seek to examine how *Rachel 19*, in the context of the *Laundry Café* concept, provides an alternative space to address issues affecting girls and young women in Zimbabwe.

The Victory Siyanqoba Trust and *Rachel 19*

The Victory Siyanqoba Trust is based in Bulawayo. It was formed in 2008 as a community theatre group specialising in social commentary and protest theatre in pursuit of human rights and freedoms in Zimbabwe. It seeks to create unique artistic artworks and platforms towards positive social transformation in pursuit of human rights and freedoms. Victory Siyanqoba Theatre operates as a branch of the umbrella Victory Siyanqoba Trust (Online, 2019). Under the leadership of Desire Moyo, popularly known as Moyoxide, Victory Siyanqoba has initiated many community projects that seek to promote democracy and respect for human rights. Victory Siyanqoba has also advocated against torture, violence, and HIV and AIDS. Performing arts has been at the centre of Victory Siyanqoba's community projects.

The idea for *Rachel 19* was mooted in January 2018 but Victory Siyanqoba started the actual creative work on the project in February 2018. It has been performed in Gweru (three wards in rural areas), Mazowe (Siza mine), Cyrene High School and multiple sites in Bulawayo. *Rachel 19* was created using data from a baseline survey which was done with different stakeholders – organisations dealing with health issues, counsellors, traditional leaders, health workers, women and girls – to gather information on issues affecting young women and girls (especially teenage girls). The survey was done in six districts across Zimbabwe.

In Bulawayo, Victory Siyanqoba selected girls, young women, boys and young men from different districts and trained them in theatre. Auditions were held to select the performers. A play was then created by the team using material from the survey. When performing in other areas like Gweru and Mazowe, an effort is made to also incorporate people from local communities. At first, the play's duration was 25 minutes, but through incorporating feedback from the audience it was extended to a full-length play of 85 minutes (Moyo, 2018). Moyo also revealed that workshops and rehearsals are done on separate days from the laundry washing sessions by women and girls. The rehearsed play is then performed for an audience – within the *Laundry Café* or sometimes outside it, such as when it's performed at schools and festivals. When the per-

formance is done within a *Laundry Café* setting, the play is performed to the end without any stopping or interruption and then discussion follows. Whilst Boal's (1979) simultaneous dramaturgy spec-actors write the play during the performance by making suggestions, in Victory Siyanqoba's *Laundry* Café, feedback is not incorporated immediately; the team of performers incorporate this feedback later in their rehearsal space. When the next performance takes place it will have incorporated this feedback.

In carrying out research for this chapter, we employed a qualitative approach. We used interviews and observations. We observed the performance of *Rachel 19* through a recorded video shot during Intwasa Arts Festival koBulawayo and we also watched a live performance of the play staged at Stanley Hall, Bulawayo during Ibumba Festival in December 2018. For interviews, we used purposive sampling. In purposive sampling one deliberately picks up participants with the desired qualities. According to Ilker Etikan *et al.* (2016: 2), this allows for the selection of 'the information-rich cases for the most proper utilization of available resources'. We therefore selected Desire Moyo, the Director of Victory Siyanqoba Trust, and Easther Zitha, the Gender Officer at Victory Siyanqoba Trust. Easther is the one who facilitates post-performance discussions.

Conceptual framework: the *Laundry Café*

The *Laundry Café* concept is an idea that was mooted in 2014 for women to come and dialogue among themselves 'away from PowerPoint activism and conferences for the elite' (Moyo, 2018). The concept, a brainchild of Victory Siyanqoba Trust, aims at creating a 100% female space, where men are only invited in their capacities as authorities like councillors to respond to women's issues. Men are also included in the performance of *Rachel 19* and during the post-performance discussions that follow as it has been realised that finding a solution to issues of domestic violence 'needs both sides' (Zitha, 2018). Formatting itself in a similar concept advocated by Augusto Boal (1979) when he writes about forum theatre, simultaneous dramaturgy and applied theatre in general in his book *Theatre of the Oppressed*, the *Laundry Café* seeks the welfare of the oppressed, those at the grassroots who are in need of an avenue and a way to express themselves. The *Laundry Café* concept, consciously or unconsciously building on Augusto Boal's Poetics of the Oppressed, seeks innovative ways of addressing young women and girls' issues in contemporary Zimbabwean concepts. The young woman of the 21st century, surrounded by all the technological advancements of the digital world, still finds herself being cumbered by the burdens of cultural taboos that are limiting and oppressive. The *Laundry Café* responds to these by creating a platform where these issues can be explored, critiqued, challenged and transformed.

During a *Laundry Café* experience, adolescent girls and young women bring their laundry to wash together at a central place such as a borehole. The *Laundry Café* concept borrows heavily from the traditional understanding of the assignment of roles between men and women. In Zimbabwe in particular and, to a larger extent, in Africa in general, laundry duties are seen as women's work. Laundry is done through handwashing which is usually done communally over a shared water source. This water source could be a borehole, dam, river or shared water tap. Women would gather around such water sources to do laundry as they chat with each other – talking about both trivia and serious issues. These traditional gender roles have, however, been challenged as they are seen as patriarchal and burdensome to women. Unsurprisingly, some women's organisations have challenged and criticised the use of the *Laundry Café* concept by Victory Siyanqoba, arguing that it is gender stereotyping women to the duty of washing (Moyo, 2018). In this view, the *Laundry Café* is seen as continuing to cement and perpetuate gender stereotypes that are oppressive to women. However, Victory Siyanqoba uses the *Laundry Café*

concept differently. Victory Siyanqoba uses this space in the margin as a space of resistance, fully recognising that these women's spaces can become a place of social and political talk. This is in line with bell hooks' (1989) observation that spaces in the margin can be spaces of radical resistance from which ideas and works that shift consciousness can emanate.

In Victory Siyanqoba's *Laundry Café* concept, tents with a seating capacity of about 100–150 people are pitched to accommodate the participants. During the *Laundry* Café, problems are personalised and personified. Working within a framework of symbolism and metaphor, the dirt on the clothes is taken to represent problems. Problems affecting women and young girls are brought forward and they are seen as similar to the dirt on the clothes. The water used in washing represents people in the community. The pail that is used for washing represents a platform for dealing with issues. This platform is a community platform. Many African societies believe that an individual's welfare is linked to that of the community (Mbiti, 1970; Menkiti, 1984). Therefore, one should make use of the community to deal with personal problems. The Ndebele people, for example, have many proverbs that attest to this, such as *izandla ziyagezana* (hands wash each other), *injobo enhle ithungelwa ebandla* (group effort is better than individual effort), *okwehlula amadoda kuyabikwa* (a problematic issue should be reported to the community), *umuntu ngumuntu ngabantu* (a person is a person because of other people) and *amasongo akhenceza emabili* (it takes two copper bangles to make a musical sound). The idea of bringing problematic issues to the community platform for discussion resonates with John Mbiti's (1970: 141) articulation of African philosophy: 'I am because we are, and since we are, therefore I am'. The *Laundry Café* therefore incorporates this important component of African societies in its attempt to address women's and girls' issues.

Another important component of the *Laundry Café* is the soap. Without soap, washing is not effective and one may have to repeat the process over and over without any satisfactory results. The soap represents ministries and relevant authorities in the community who need to be roped in when pursuing solutions to problems confronting young women and girls. These include the Ministry of Women Affairs, Gender and Community Development, the Ministry of Youth, Sport, Arts and Recreation, local councillors, traditional leaders and authorities from civil organisations and the church fraternity. Boal (2006: 40) argues that 'the Subjunctive Theatre must be accompanied by the Legislative Theatre so that the knowledge acquired during the theatrical work can be extrapolated into laws and juridical actions'. The *Laundry Café* therefore realises that involvement of the authorities from different structures of society is a necessity for success in addressing women's and girls' issues. In a like manner, the theatre that takes place within this concept makes use of some aspects of legislative theatre. The physical process of washing the clothes symbolises the process of dealing with issues raised. The final hanging of clothes to dry symbolises the embracing of the solutions suggested to the problems.

The *Laundry Café* is not a once off event. It is a process. Young women and adolescent girls would bring their clothes and wash them as they raise and discuss problematic issues affecting them. On some occasions, as a follow-up to the initial process, they would then gather to watch a play that presents the issues raised in previous washing experiences. It is in this context that we find *Rachel 19*. After the play is presented, discussion immediately follows and the cyclic process of discussion–performance–discussion continues to repeat itself. The *Laundry Café* experience creates a metaphoric world, a women-only space where issues can be raised and discussed. Boal (2006: 40) argues that people who find themselves in oppressive circumstances need:

> Conditions in which the oppressed can develop fully their metaphoric world – their thought, their imagination and their capacity to symbolise, to dream, and to create parables and allegories, which allow them to see, from a certain distance, the reality they

want to modify – without diminishing their participation in the social concrete world. We cannot see the real if our noses are glued to it – some aesthetic distance is necessary.

The *Laundry Café* seeks to create this metaphoric world that will allow young women and girls to identify and explore solutions to those issues that affect them. In creating the play, Victory Siyanqoba worked with data from a baseline survey done at the targeted communities and different stakeholders. Looked at from another angle, the communities themselves provide material for the play – they 'wrote' the play. Actresses and actors were drawn from the communities themselves, trained in theatre and given an opportunity to tell stories from their own communities through theatre. The audience continues to participate in the rewriting process through the integration of post-performance discussion where suggestions are made.

Problems personified and gendered approaches to socio-political issues in the community

Kennedy Chinyowa (2014) observes that applied theatre welcomes diverse forms of practice and this diversity must be maintained if social change is to be realistically achieved. He notes that 'accounts of different contexts and participants ensure we keep the field open to varying possibilities of how performance enables people to learn and live through their experiences—good and bad' (Chinyowa, 2014: 2). *Rachel 19* exploits these many possibilities through song, dance, poetry and a storyline that personifies the problems faced by young women in the townships. In this performance, Victory Siyanqoba attempted to capture the Bulawayo township personae through costumes, properties and characterisation. The young ladies wore bum-shorts, t-shirts neatly knotted to the side, striped knee-long stockings and Tommy tennis shoes, while the young men wore red-and-white checked shirts, black long trousers and All Star tennis shoes. The young men's costumes are reminiscent of the *Skhothane* movement largely emerging from South Africa's townships such as Soweto (Inggs, 2017). In the Zimbabwean context, especially in Bulawayo, these costumes are characteristic of the ones worn by young ladies when they attend *vuzu* parties soon after closing or a week before opening schools. *Vuzu* parties, which have *skhothane* exhibitionist characteristics, are music and dance merrymakings hosted by young people at the end or beginning of each school term as a means of welcoming each other back home or seeing each other off to the boarding school. It is important to note that these parties are largely characteristic of the townships in Bulawayo. In using stereotypical costumes in *Rachel 19*, Victory Siyanqoba personifies the problems that they engage in the performance. It allows one watching to relate the situations presented to real characters and scenarios in the townships.

The use of indigenous music and a musical theatre approach as an anchor of engagement with the community and spectators locates *Rachel 19* within the African performance paradigm. While musical theatre is as old a tradition as any other performance paradigm, in Zimbabwe's townships, especially in Bulawayo, it is largely understood from an indigenous African perspective linked to rituals and festivals such as the *Inxwala* ceremony, among others. The *Inxwala* ceremony is a traditional celebration (accompanied by particular rituals) by Ndebele people to mark the official tasting of the first fruits from the fields when crops for that agricultural season are ready for consumption. Although Victory Siyanqoba taps into the use of technological fixtures such as the public address system to boost the sound and improve the aesthetics, the foundational indigenous music which has a disco feel, characterises it as a popular cultural performance. Without treading on the much-complicated race issues with regard to popular culture in an African setting, we argue that in this context any cultural performance that speaks to the

majority poor populace in terms of message and aesthetics, is popular in nature (Sibanda, 2017). The disco-dance aesthetic that characterised much of the content presented attaches a locative dimension to *Rachel 19*; the township. To this end, the problems discussed can be personified as those which affect a specific group of people located within a distinct area.

While there are concerns with the stereotyping effect of the *Laundry Café* in *Rachel 19*, this approach was useful in providing a creative, gendered approach to socio-political issues affecting young women in the townships. The *Laundry Café* model allowed women in the townships to come together at a specific area where they could simultaneously do their chores, such as washing their clothes, watching *Rachel 19* and participating in after-performance discussions. Because it is a particularly gendered approach, the *Laundry Café* enabled Victory Siyanqoba to reach out to its targeted audience through edutainment. Martha Nussbaum (2010: 110) is of the view that 'entertainment is crucial to the ability of the arts to offer perception and hope … it is the way in which performance offers a venue for exploring difficult issues without crippling anxiety'. Within a very patriarchal and culturally sensitive community such as Zimbabwe, engaging in issues such as reproductive health, sex and relationships with adults is usually very difficult, but through *Rachel 19*, deploying a *Laundry Café*, these issues are discussed in an entertainingly light manner. Through the *Laundry Café*, young ladies and men are able to engage openly and creatively with the community of adults and express their challenges, fears and anxieties in the townships of Bulawayo.

Breaking boundaries and taboos through *Rachel 19* and the *Laundry Café*

Through the *Laundry Café*, women are afforded a safe space to challenge cultural beliefs and practices that affect them. Being a woman-only space outside mainstream society, the *Laundry Café* uses this space on the margin for coming up with strategies that challenge the status quo and break boundaries and taboos. hooks (1989) suggests that the marginal space can also be a space of radical openness, a space of possibility where alternatives can be imagined and works that shift consciousness can be created. We argue that the *Laundry Café* creates an alternative space outside mainstream society and in this space women imagine possibilities of freeing themselves from cultural boundaries and taboos. Zitha (2018) said that during the laundry sessions, many women have found alternative ways of approaching the challenges that they face in their marriages and society. The women have used this place as a place of solidarity to empower and arm each other with strategies to confront challenges that face them as women. Zitha also reported that during laundry sessions, women have been found to open up freely and share their problems. The bringing in of a theatrical performance of *Rachel 19* has also enhanced this atmosphere of 'playfulness' that Chinyowa (2011: 67) observes to be present in theatre.

The play *Rachel 19* challenges and breaks boundaries and taboos that oppress young girls and women. Rachel, being supported by her aunt, manages to convince her mother that it is okay for them to have a 'woman to woman' talk about issues of sexual and reproductive health. Rachel's mother, who herself is a victim of oppressive cultural practices as she was married against her will to a man 44 years older than her, comes across as a character who represents the discouraged victims of the system who have come to accept their condition of being oppressed as normal and a thing to be endured and accepted. The character of the aunt, however, comes across as the opposite. She is a well-informed, empowered woman who stands for her rights and refuses to be boxed into oppressive cultural beliefs. Not only that, she empowers and helps others (Rachel, other young girls and Rachel's mother) to break the oppressive and limiting cultural taboos and boundaries.

The *Laundry Café* is presented as a space where women are empowered through information, are supported through solidarity and are encouraged to resist any form of cultural oppression. Boal (1979: xxi–xxii) argues that 'if we do not go beyond our cultural norms, our state of oppression, the limits imposed upon us, even the law itself (which should be transformed) – if we do not trespass in this we can never be free. To free ourselves is to trespass, and to transform'. *Rachel 19* and the *Laundry Café* encourage women to trespass against oppressive cultural boundaries in order to free themselves.

The use of metaphor as a way of dealing with problems

The *Laundry Café* in general and *Rachel 19* in particular are metaphoric. They both create a metaphoric world that creates similarities between the world of the participants and the metaphoric world created. This helps in making participants (in this case, young women and girls) understand their circumstances. Boal (2006: 41) argues that 'art is metaphor. Metaphor, in its broadest meaning, is any translation. It is the transposition of something, which exists within one context, to another context'. He also argues that metaphor allows people to see their problems from a distance so that they can then solve them. It is difficult to see problems when one's nose is glued to them. Art provides that aesthetic distance. The *Laundry Café* itself is a metaphor and it allows women and young girls to understand their problems and deal with them. By using the symbols referred to earlier – dirty clothes being problems, water being people of the community, the pail being the platform to address the problems and the soap being various stakeholders like the women and gender ministry, and washing itself being the act of dealing with problems – a metaphor is created that encourages women to solve their problems. No one wants to go home with dirty clothes after washing and thus no woman would want to go back with an unsolved problem. The metaphor arouses commitment to seeing the problems solved and acceptance of the role other women and society at large can play in changing certain oppressive practices. The play *Rachel 19* employs metaphor to drive its point home. Since the subject of sexual reproductive health has for long been regarded as taboo in a way that can discourage youths from engaging in such discussion, metaphor comes in handy in making the subject accessible for discussion. As a result, young people are empowered to discuss issues that would have been difficult for young people to discuss in normal day to day conversations.

Rachel 19 as a rehearsal for action

Boal (1979) argues that his poetics of the oppressed seek to create a theatre that is a rehearsal for action so that the participants in this theatre can prepare for action in real life when faced with similar circumstances. We argue that *Rachel 19* is a rehearsal for action for adolescent girls and women. Rachel resists the sexual advances of James and stands her ground even when James attempts to rape her. She also confronts her mother and fights for her space, refusing to be caged by oppressive cultural taboos and beliefs. The character of Tracy also stands out. She refuses to be used by Vusi as a sexual object. Both Rachel and Tracy carry condoms in their bags and defend their actions. Through these actions, these girls rehearse what they can do in real life when faced with similar circumstances. The other girls who play supportive roles to Rachel are also rehearsing to stand in solidarity with their fellow sisters in resisting objectification from their male peers. Girls in the play are also seen learning and reciting that they should use their mind to think and abstain from sexual intercourse outside marriage. They also talk about testing for HIV, condomising, avoiding multiple sexual partners and being principled. Boys are also not left out. They advocate for the same things. We therefore argue that as these young people act out

such issues in a fictional theatrical world, they are rehearsing things to do in real life. As Boal (1979: 129–130) argues, 'the fact of having rehearsed a resistance to oppression will prepare him to resist effectively in a future reality, when the occasion presents itself once more'. *Rachel 19* is therefore empowering for adolescent girls, young women and also for their male counterparts.

Conclusion

Rachel 19 as a play and the *Laundry Café* space present a powerful platform for adolescent girls to identify cultural taboos and beliefs that hinder them from fully and freely engaging in dialogue on sexual and reproductive health issues and other issues that affect them such as rape, forced marriages, shortage of water and other basic necessities, and domestic violence. This provides an alternative space to address these issues as mainstream society channels tend to ignore these issues totally or accept them as normal. The play *Rachel 19* is empowering to adolescent girls and young women. It empowers them with vital knowledge that they need to understand their bodies, sexual and reproductive health issues, HIV and AIDS issues, and issues to do with marriage and relationships. The play also affords young girls and women an opportunity to rehearse ways of resisting oppression and being taken advantage of in society so that they can implement such ways in real life. The boys also learn that girls should be seen as persons with rights and not just sexual objects to satisfy their lusts.

References

Barber, K., 1987. Popular arts in Africa. *African Studies Review*, 30(3), 1–78.
Boal, A., 1979. *Theatre of the oppressed*. London: Pluto Press.
Boal, A., 2006. *The aesthetics of the oppressed*. London: Routledge.
Chatikobo, M. and Low, K. 2015. Applied theatre from a Southern African perspective: A dialogue. *Research in Drama Education: The Journal of Applied Theatre and Performance: 20th Anniversary Issue: Looking Back and Looking*, 20(3), 381–390.
Chinyowa, K. C., 2011. Theatre as a laboratory for HIV/AIDS education: The case of Amakhosi's theatre play, Vikela. In: D. Francis, ed. *Acting of HIV: Using drama to create possibilities for change*. Rotterdam: Sense Publishers, 67–79.
Chinyowa, K., 2014. Re-imagining Boal through the theatre of the oppressor. In: H. Barnes and M. Coetzee, eds. *Applied drama/theatre as social intervention in conflict and post-conflict contexts*. Newcastle upon Tyne: Cambridge Scholars Publishing, 2–18.
Etikan, L., *et al.*, 2016. Comparison of convenience sampling and purposive sampling. *American Journal of Theoretical and Applied Statistics*, 5(9), 1–4.
hooks, b., 1989. *Talking back: Thinking feminist, thinking black*. Boston, MA: South End Press.
Inggs, A., 2017. The suit is mine: *Skhothane* and the aesthetic of the African modern. *Critical Arts*, 31(3), 90–105. doi:10.1080/02560046.2017.1383491.
Kaarsholm, P., 1990. Mental or carthasis? Theatre, democracy and cultural struggle from Rhodesia to Zimbabwe. *Journal of Southern African Studies. Special Issue: Performance and Popular Culture*, 16(2), 246–275.
Leach, R., 2008. *Theatre studies: The basics*. London: Routledge.
Mbiti, J., 1970. *African religions and philosophies*. New York: Doubleday and Company.
Mda, Z., 1993. *When people play people: Development communication through theatre*. Johannesburg: Witwatersrand Press.
Menkiti, I., 1984. Person and community in African traditional though. In: R. Wright, ed., *African philosophy, an introduction*. Lanham, MD: University Press of America, 171–81.
Moyo, D., 2018. Personal Interview, 04/11, Bulawayo.
Mpofu, M. & Moyo, C. 2017 Theatre as alternative media in Zimbabwe: Selected case studies from Matabeleland. *Journal of African Media Studies*, 9 (3), 507–520.
Sibanda, N., 2017. *The politics of performance space: An investigation into the practice of scenography in post-independence Zimbabwean theatre*. Doctoral Thesis. Durban: University of KwaZulu-Natal.
Taylor, P., 2003. *Applied theatre: Creating transformative encounters in the community*. Portsmouth, NH: Heinemann.

Zenenga, P., 2010. Hit-and-run theatre: The rise of a new dramatic form in Zimbabwe. *Theatre History Studies*, 30, 14–41.

Zitha, E., 2018. *Not for profit: Why democracy needs the humanities*. Princeton, NJ and Oxford: Princeton University Press.

Zitha, E., 2018. Personal Interview, 01/10, Bulawayo.

33
APPLIED ARTS IN BUSINESS CONTEXTS
Selling out to the oppressor or doing transformational work?

Petro Janse van Vuuren

While South Africa may have moved some distance to achieving greater political equality, systemic economic inequality is still, and perhaps increasingly, rampant. Over the past nine years I have worked in organisational and business settings using applied drama processes and applied improvisation techniques to enable systemic transformation. As a result, I, along with some of my associates, have adapted the language and processes of applied performance to harness the story-shaping effect and ensemble principles of improvised theatre performance for work performance. Did these adaptations lead to a corruption of the inherent ethic of applied drama that aims to give voice to the marginalised and empower the oppressed? In response to this question, focus groups were formed consisting of a combination of applied performance facilitators and organisation development practitioners to workshop and deliberate a set of values that can guide applied performance work in organisations and enable practitioners to communicate their ethical orientation to clients at the outset so as to eliminate misalignment and disappointment. This chapter reports on the findings of the focus groups, outlining seven values, providing illustrative anecdotes from the discussions and analysing the value statements against the ethic of applied drama as understood by scholars who work in community and education contexts. The intention is to begin formulating an ethical code for applied performance work in organisations to bring critical hope and social transformation into spaces where economic inequality still prevails and the dehumanisation of people can be rife.

Introduction: The need for applied performance in the workplace

Late in 2016 at a writing retreat organised by Drama for Life, seven colleagues gathered to discuss the values that underpin the work Drama for Life undertakes in organisations. Drama for Life is an academic, research, and community engagement department based at the University of the Witwatersrand School of Arts. At that time, Drama for Life was working with a consultancy to gather stories and produce a performance, based on workers living with HIV, for a large corporate company. Colleagues experienced an uncomfortable ethical gap, not so much with

the corporate organisation as with the media consultancy that acted as middleman. A colleague thinking back on that project articulated the values gap as follows:

> (For the consultancy) the idea of the stories we captured were commodities rather than identities. The stories we were gathering had only media capital for them, whereas our client and ourselves were going for the essence of the stories… It was about commodity vs. identity. For us a story is connected to a living breathing human being who lives with the legacy of the story and you cannot separate them from the story.
>
> *(Interview November 2018)*

While Drama for Life's applied performance work is mostly in community development, activism and education, we wanted to articulate the ethical gap between work for these spaces and work for business settings because of the experience with the current project. The need was fuelled by an underlying sense that such treatment of people's stories was entrenching, rather than addressing, the legacy of economic inequality still prevalent in South African society.

This chapter is for the applied practitioner interested in addressing and transforming the entrenched inequalities inherited from the marriage between apartheid and capitalism, and who, at the same time, is dependent on the same system to fund and support this work.

When political activist, and later linguistic policy maker, Neville Alexander called for a return 'not merely to the African source of *ubuntu* as a means of undermining the rampant individualism and destructive competition that are inherent in the capitalist system, but more generally to all the springs of a true humanity' (2013, 34), he was referring to a large-scale project of social reform that could find a new dispensation beyond racial capitalism. Such racial capitalism, in his view, is founded upon white economic power and privilege on the one hand, and the systemic exploitation and impoverishment of (cheap) black labour on the other. Yet, such a project seems unattainable in the face of the resilience of such an economic system that, after the abolition of apartheid shifted so that where economic inequality was maintained down racial lines pre-1994, it is now replaced by class lines (Heintz 2007).

In a recent report released by the World Bank, it is found that since the end of apartheid 1994, economic inequality has increased. According to the report,

> poverty has a strong spatial dimension … a demonstration of the enduring legacy of apartheid. Poverty remains concentrated in previously disadvantaged areas, such as the former homelands – areas that were set aside for black South Africans along ethnic lines during apartheid.
>
> *(Sulla and Zikhali 2018: n.p.)*

The report also highlights the income polarisation between a handful of rich, a small middle class, and the large number of people living with high levels of chronic poverty (Sulla and Zikhali 2018).

While Alexander's concept of 'racial capitalism' (1979) might refer to a larger economic system in need of reform, then and now, one might ask what specifically is the responsibility of actual corporate and other business institutions in the face of this need for transformation? For the most part, workplace transformation is understood as something to be achieved through the implementation of policies like the Broad-Based Black Economic Empowerment Act (Act 53 of 2003) (Department of Trade and Industry, 2004) and the Employment Equity Act (Act 55 of 1998) (2019) in order to change the racial, gender, and economic status of the workplace to reflect South African population demographics.

However, the arts, and applied performance in particular, has a more layered understanding of transformation relating to the raising of awareness that can lead to action in participants (Dalrymple, 2006). This awareness and action relate to gaining insight into the power dynamics at play and the hope that these might be influenced and reorganised in some way by what Rancière calls 'a redistribution of the sensible', i.e. a reorganising of what, and who, may be seen, heard, and experienced (Ranciere and Zizek, 2004). In South Africa, applied performance as a genre can be seen as a development from protest theatre that wants to do more than protest against inequality, but also wants to build bridges and bring healing (Nawa and Schneider, 2019; Hauptfleisch, 1997). Yet, in business contexts, where the goal remains mostly focussed on making money for the stakeholders, how is awareness and action that relates to addressing economic inequality addressed?

One might further consider the compounding effect on the inequality in these spaces caused by the already dehumanising character of many workplaces, thanks to the view of the organisation as a machine where each part (human or otherwise) must play its role; each cog and wheel must rotate in its turn. This view becomes compounded in the face of the fourth industrial revolution, where more and more companies are looking for ways to replace their human cogs with robotic ones (Schwab, 2017; Xu, David, and Kim, 2018).

What role can the reorganising and reframing effect of the arts play in these contexts in relation to addressing economic inequality and the compounding effects of dehumanisation? More specifically, what role might applied performance models play, models designed on the principles of Boal's theatre of the oppressed (1993, 2002), and Heathcote (O'Neill, 1995; O'Toole, 1992) and others' concepts of process drama, the first of which aims to empower the oppressed and the latter which is a fundamentally democratic and non-hierarchical process. What place do such processes take up in the world of organisational development and transformation when the very fabric of these organisations is designed for the pure purpose of generating capital, supported by hierarchical leadership strategies that are fundamentally non-democratic, and where productivity and efficiency seem to trump quality of life for workers and transformation?

It is not the intention of this chapter to review the possible ways in which transformation in organisations is currently undertaken, nor to judge their efficacy or not. Rather, it wants to review the perceived values gap between the ethic of applied performance and business contexts – a values gap articulated by Alexander between 'rampant individualism and destructive competition that are inherent in the capitalist system' on one hand, and those reflected by 'the African concept of *ubuntu*' and 'springs of a true humanity' on the other. What is the nature of this values gap and can it be overcome so that applied performance work can be accepted and effective as an agent of reform and re-humanisation in business contexts? It is my argument that, should this values gap be successfully navigated, applied performance practice in organisational settings can bring the reform and critical hope to what can seem like insurmountable systemic resistance.

The chapter tracks a process of values clarification undertaken by three groups of intersecting applied performance practitioners who work for transformation and change in these contexts using their craft to meet both the needs of the paying client and the requirements of transformation. It asks if such work can be successful in the face of the resilience of racial capitalism, and what might be the requirements to ensure a margin of success in the face of the values gap? Success here refers to applied performance being able to re-humanise and transform the South African workplace as measured by specific strategic objectives agreed upon by client and consultant at the outset of any given project.

It is certainly a valid question if one considers that the theatre of the oppressed processes were designed to empower the 'oppressed' and to effectively undermine the power of the oppressor. 'Why then', asked a colleague of mine, 'would a leader of a corporate organisation pay someone

who will undermine his power?' Or, as a student in my class put it: 'Why would you place the tools of the oppressed in the hands of the oppressor' and thereby further entrench their oppression? Of course, these views polarise the workplace into oppressors (leaders) and oppressed (workers). The seasoned applied arts practitioner understands that power relationships are rarely this simple and can shift from moment to moment – a feature of power to be explored through applied performance processes.

Yet, perhaps these remarks are informed by an understandable prejudice in the minds of applied arts practitioners in relation to capitalist institutions. In an analysis of the opportunities available to drama therapists who are seeking to work in business contexts, Hayley Roberts points to the resistance on the part of the arts practitioner. Alluding to a sense that business spaces are inherently cold and unfriendly to the arts, she asks: 'Has the corporate client possibly been our somewhat obvious "blind spot" in considering a diverse client population?' (Roberts and Janse van Vuuren, pending publication). By harbouring this (possibly legitimate) prejudice, applied arts practitioners may be robbing themselves of potential work opportunities. It may also rob the workplaces that make up the South African economic landscape of a transformational tool that might bring the called-for transformation into the heart of its expression: Capitalist business organisations.

This chapter analyses the elements of the ethical gap and articulates the values of the applied arts in such a way that they can make sense in business contexts without either playing into the ethic of racial capitalism or falling prey to it. I look at the explicit articulation of values that a group of applied performance practitioners wish to establish as a potentially important element of the strategy to close the perceived ethical gap between the corporate and the artistic worlds. It is through the exploration of the relationship between these worlds and their related values through applied performance processes that rigid narratives can be nuanced, and hope for their reframing can arise in a way that remains informative and critical about systemic power and its effects.

The ethical gap

There is a fundamental difference in how I approach the work of transformation as applied performance practitioner and how the corporate world generally approaches not only transformation but any project within its midst. For simplicity's sake, I will begin by generalising these differences before attempting to nuance them and explore complexities.

1. Working for *the bottom line*, not for the greater good. Businesses are designed for the purpose of generating profits. Community-based organisations, where applied performance projects usually occur, are designed to serve the greater *good of the community*.
2. The business organisation is usually associated with a *hierarchical* leadership structure that communicates from the top down, while applied performance spaces are *dialogical* and strive for collaboration between mutually-dependent people.
3. In business organisations, value is placed on the *ownership* of process and product. Intellectual property and branding are big, while in applied performance interactions, there is a co-authorship and a *co-creation* that should not be exploited by one or more parties.
4. In business organisations, value is placed on the *individual* and his or her accomplishments, fostering the values of exclusivity and competition. In applied performance spaces, care is taken to focus on the *collective* rather than the individual.
5. Organisations are notoriously *task oriented*, valuing time, efficiency, and efficacy. In *people-oriented* applied drama contexts, time can linger if the facilitator senses the need to stay with

an issue rather than to move on and get through the material. It is more important that people feel safe, heard, and valued than for all the boxes to be ticked.

Of course, these are generalisations and it is important to note that both in organisations that are designed for profit and in spaces where applied performance usually functions (e.g. community development and education), there is a constant tension between the values as delineated above. In many not-for-profit spaces, dehumanisation can be prominent, just as there are many movements in the business space towards re-humanisation, employee engagement, and social and environmental reform. In no space is it always easy to see how to apply the values. However, it is possible to see a marked difference between the expectations of participants and stakeholders in business settings versus those in a community or educational setting. The question then becomes: How does the applied performance practitioner adapt his or her work to suit the business organisation space without compromising his or her values?

Phase 1: Initial identification of values

Sparked by our experience with the media company as outlined in the opening paragraphs above, seven applied performance practitioners from Drama for Life sat down to formulate values that are true to the applied performance work that we want to safeguard against the influence of overtly capitalist values. The session was unstructured and functioned like an open brainstorm on the values of the work we hold dear. I then went away to formulate the five values we identified. The formulation was written out and circulated among us for tweaking and the final values of that round read as follows:

1. *Deep collaboration* — We craft our work in deep collaboration with all stakeholders involved. We do not use the powerful tools of story and embodiment to 'download' information top-down to participants. Rather, we create work that introduces ideas and then facilitate conversations to allow audience members to interrogate and make sense of those ideas for themselves. It is important to us to value the input of all stakeholders equally.
2. *Sustainability of humans as resources* — Sustainability to us means that no process can be a fly-by-night affair. It requires relationship building, negotiation, and development over time. We are deeply interested in the sustainability of the organisations that we support, but also in the human aspects and assets of the community that will inform the organisational culture.
3. *Intersectional symbiosis* — We support and enable leadership styles that seek to negotiate solutions between the organisation and the community, between management levels, between departments, between sections and divisions, between leaders and workers, and between skilled and unskilled labour so that all impacted parties benefit. This means that all parties also have to be willing to adapt and rework solutions based on intersectional input.
4. *Intrinsic value and contribution* — We support the notion that every individual and every social grouping has value and can contribute positively to the workings of an organisation and its health. This means that every person working in an organisation, and also the community outside of the organisation that supports the individuals, has value and can contribute something unique to the organisation that the leaders may not be aware of at the outset. We work to surface and incorporate these in all the work we do.

5.	*Rigorous self-reflexivity*	We hold ourselves and everyone we work with accountable to honour their responsibilities and the agreements they make. We train and support everyone involved in our projects to be self-reflexive and able to see their own perspectives and positioning in relation to those of the other stakeholders so that prejudice, egoism, nepotism, domination, and corruption are never an option.

Phase 2: Interrogating meaning

A second round of deliberation happened early in 2018 when two things happened to further necessitate the need for clearly articulated values. The first was another uncomfortable experience with a client. I had worked with fellow practitioners on a culture change project for a large bank. The consultancy that contracted us understood our values very clearly, but this time it was the corporate client that exuded an air of dehumanisation. They were especially dismissive of the need for clear contracting with the individuals, exemplified by the way they referred to the artists as resources rather than people. I wanted a document that spelled out how we work to help us screen clients in the future.

The second reason for the renewed effort towards formulating a clear values statement, and the reason why I could not simply take on the earlier formulation of five, was that I had taken on new associates. It was important that they take part in the formulation of the values in order to build a sense of ownership. I worked with two focus groups consisting of a mix of business consultants with little arts background, and applied performance practitioners with little business background. We had two sessions to deliberate the values, a two-hour face-to-face workshop and a one-hour live, online workshop for those who could not come to the physical meeting.

In preparation for the sessions I thought that there were two areas that the previous five values did not cover: Systemic awareness and ownership. I decided to add them and see if people would agree that they were needed.

6.	*Systemic awareness*	We support the notion that every issue must be considered in relation to larger systemic influences and conditions. These include social, environmental, political, historical, and strategic factors that may or may not be visible and recognised by stakeholders at the outset. We work to surface and acknowledge the effects of these in all the work we do.
7.	*Intellectual ownership*	We value our intellectual property and yours. It is our livelihood. At the same time, we want you to be able to use what you find on our sites. We therefore ask you to reference our work wherever you use it in written or oral format, when you use it explicitly, or when your own work was adapted from ours.

I brought the values to the sessions, presenting them as seven possible values coming from earlier conversations with practitioners. For the face-to-face session, I printed each value on a separate sheet of paper and placed them in a large circle on the floor. I then asked the participants to read them one by one and finally choose the one that sparked the most curiosity or emotion in them. I asked them what made them choose this value. We made images out of these explanations and discussed them, sharing stories of how they played out in our interactions with clients. In the online session we did something similar: People read through all seven values and picked the ones they wanted to discuss in a more traditional way by just mentioning them. We made individual images of what they meant to us and shared stories of how they played out in

our work. Finally, in both groups, we went back to the wording of the values and tweaked the language where necessary.

What follows is an exploration of the four values that sparked the most interest, stories that illustrate their functioning or lack thereof, and a formulation of two of them in response to the embodied interrogation.

The values conversation

Systemic awareness

In the face-to-face group, there were five of us: me, Les, Chantal, Lollo, and Dave. Les is a thoroughly trained applied performance practitioner with business experience and a new interest in doing change work in business spaces to fund more humanitarian work with street children. Chantal is trained in applied performance and has extensive experience in industrial theatre[1] and production management. Lollo is an experienced coach and business consultant with a new and budding interest in applied performance. Dave joked about himself as being 'the token middle-aged white male'. He is a business consultant with extensive experience in the IT and banking industries, and an insatiable curiosity about applied arts processes, but with little training in it.

Les resonated with the value relating to systemic awareness opening a conversation about race and gender. The image he, Chantal, and Lollo created showed him being the typical boss. 'I chose the systemic awareness thing because I was looking at it from the perspective of the oppressed, but when I created the image, I played the oppressor' (Janse van Vuuren, Les Nkosi et al., 2018). He articulated a conflict that points to the values gap:

> I was feeling, 'I have the privilege, but it is not my fault that I am male and how dare you expect me to adjust to your needs? Why don't you adjust to my level?' But then the conflict came when I was thinking, 'But I am black'. The white person feels the same, oftentimes, in this position. So the conflict is between 'It is not my fault' and my conscience saying, 'No, you don't deserve to oppress. You should understand that we are all equal.'
>
> *(Ibid)*

An awareness arose in the group about how this potential duality of being a victim of the system and perpetrator at the same time might exist in the lives of leaders. We may be able to tap into it, offering the leader a way to make it right, or to wriggle loose from the influence of the system. Chantal said: 'That becomes exhausting; it has no energy to give – this circular movement of victim–perpetrator, the oppressed becoming the oppressor. It eats itself up.' Lollo said: 'I was trying to show that the things you (the leader) don't like might be connected to things that you do like. If you can give it a chance.' We also acknowledged that if we want to work against oppression, we must work against the voice that 'doesn't acknowledge that there is a background, a bigger picture, to a state of being; that does not acknowledge that we should all have equal opportunity' (Les). It was important to us that, should we want to bring transformation to the workplace in the sense of building bridges and bringing critical hope, this systemic awareness can help us quickly overcome oversimplified views of power distribution and polarised perspectives of who is the oppressor and who the oppressed (Janse van Vuuren et al., 2018).

The same value was flagged by the online group consisting of three of us: me; Alison, an experienced management trainer with training in applied performance tools for business spaces; and Christian, an applied improvisation trainer from Austria working in higher education and

freelancing on the side (Janse van Vuuren, Gitelson, and Freisleben, 2018). The online conversation linked the value relating to systemic awareness with the one relating to intrinsic value and will be picked up later. Both conversations validated the inclusion of this value to our list.

Humans as resources

Dave picked this value explaining: 'My concern is that, behind the words is a mindset that does not regard people as people' (Janse van Vuuren et al. 2018). I clarified by asking if he was saying that the wording plays into the dehumanising aspects of the organisational mindset instead of articulating our position in favour of valuing the human. He agreed. Les then explained how this is one of the hardest things for him in his work:

> Do I come and throw myself into it and say, 'Look, I rehumanise'. Or do I try to speak the language of business? And my strategy had always been to do the latter so that they are able to listen to me and then I bring in the rehumanising.
>
> *(Ibid)*

It seemed to him that this was the approach taken in the language of this value statement and he supported it tentatively. I suggested that we build an image to explore what it might look like.

It became a moving image with Dave as the CEO moving around chess pieces on a board, Chantal trying to sell a change process to him, and Les playing the disgruntled and unheard worker or 'human resource'. The consultant came in shaking the CEO's hand and then tried to engage the worker who promptly began to toyi-toyi[2].

Afterwards, Les said he did not trust the consultant, because she was with the leadership, so her attempts to 'rehumanise' after the handshake did not work. Dave explained that he was welcoming Chantal into his game. Les explained that he saw the consultant in that moment teaming up with the CEO,

> and I became more desperate and made more noise … There has to be a bigger level of investment from the practitioner to build trust because I am defaulted to seeing you as being on his side – that man who doesn't even recognise me. Even when I am vocalising.
>
> *(Janse van Vuuren et al., 2018)*

As facilitator I remarked that the value statement does exactly that: It shakes his hand first; and Dave agreed: 'That sums up my concern very nicely' (Ibid).

We all paused, thoughtfully acknowledging the truth of Les's observation that the consultant is automatically seen as on the side of the leader (the oppressor) in the workers' eyes and must find another tack.

Chantal wanted to go again. She tried different things and at one point the CEO and the worker made eye contact. This was the first sign that change was occurring, because up until this point they had engaged with the consultant but not with each other. In the end, CEO and worker were working together and the consultant could step away. When I asked them what it was that the consultant had done differently that had enabled them to look at each other, their answers were as follows:

Chantal (Janse van Vuuren et al., 2018): 'It was very awkward. I was like "well this guy is not going to trust me". So how do I exit out and re-enter cleanly? I needed to come in completely openly. I don't know if that worked?'

Dave (Janse van Vuuren et al., 2018):

> I was overtly expressing my scepticism. The thing that made me give you that one chance was that I was curious … (To facilitator:) I was trying to put her on the chess board as well, but she did not let me. (To consultant:) After you introduced yourself, but were not on my chess board, you turned to Les and (to worker:) it was almost impossible for me at that point not to acknowledge that you were actually human.

Les (Janse van Vuuren et al., 2018): 'Because you were having a conversation with her as a human being and when she looked at me, you saw me too.'

Les recalled a story where this dynamic had played out. He had been asked by a client to use theatre to get 'buy-in' for their change process from the workers. He came in after the leadership had already decided what the process would be and what the message was that the workers needed to buy into.

'I was really good at this getting them to buy in because theatre is awesome and embodiment is awesome. But I felt a little off, because it wasn't really their idea… Is it going to be sustainable?' (Janse van Vuuren et al. 2018).

Les steps into the image between Dave and Chantal treating Dave as CEO again, and Chantal as worker. 'I see the chess board, I go, uh-oh, I see the next move, okay cool, and then [I have a] mandate. (Turning to the worker:) You can fit in there.' Les points to Dave and says: 'and as you can see, he (CEO) is still not looking at her' (Janse van Vuuren et al., 2018).

I asked if this meant we cannot do such work. And Les said, no, it meant we needed to be aware and more strategic. His stint in the shoes of the CEO in the earlier image about systemic awareness came into play as he said:

> And we can't blame them for not being committed … Because the CEO is raised to understand that it is all about the chess board … So the practitioner has to come in and say, 'Look, I acknowledge this because I know your frame of reference, but there is a different perspective to take.' It is a longer process and much more tedious, and painful.
>
> *(Janse van Vuuren et al., 2018)*

He then added:

> My client was an amazing human being who understood the human element, but he was in a territory that was very unfriendly for his way of thinking. So, even though I was caught in a position where I was looking at the chess board, I could trust his intentions and his consciousness
>
> *(Ibid)*

It was clear to us that such a longer, more tedious process could only be undertaken with the right kind of client. That we need to take care to identify and build relationships with such clients is part of being successful in bringing applied performance work to organisations. Furthermore, both the conversations about systemic awareness and humans as resources gave us a clear understanding of the complexities of power relationships in the workplace and a new-found appreciation of applied performance to help us interrogate these and allow us to unlock possibilities of action and reframing that is not possible if we remain locked into oversimplified narratives about oppressor and oppressed. This too opens doors to what we may call critical hope – a hope that acknowledges complexity and yet finds ways to generate fresh narratives.

Based on these conversations, this value was re-articulated as follows:

Sustainability of human relationships:	Sustainability to us means that no process can be a fly-by-night affair. It requires relationship building, negotiation, and development over time. We are deeply interested in the sustainability of the organisations that we support, which includes all the human aspects of the employees and the wider stakeholder community that will inform the organisational culture.

Intellectual ownership

This concept created much debate in both the face-to-face and the online group sessions. There were two sets of conflict that emerged: The conflict between the willingness to co-create and share the work in an improvisational fashion on one hand, and the need for the artistry to be appreciated and used responsibly on the other. Christian related the following example:

> There is an organisation where I do workshops and there are descriptions of these workshops. One day I found the description, in the exact words, but under the name of another trainer … I felt robbed … You must ask me. In most cases I will simply say: 'Of course you may use this. Please acknowledge me'.
> *(Janse van Vuuren, Gitelson, and Freisleben, 2018)*

This conflict is deepened by the experience that the client often requires the consultant to sign a non-disclosure agreement which usually includes much detail about how proprietary information may not be shared. At the same time, there is often little regard for the proprietary information of the consultant. We discussed how this value overlapped with the one about sustainable relationship and how a mutually respectful relationship becomes the key element in the idea of ownership. This idea was further built on by Les who shared an experience where a client gave him a non-disclosure agreement to sign, whereupon he asked the client to reciprocate and do the same. The client was very unhappy about that and it strained the relationship from the start.

These experiences, like my experience with the client that did not contract in time with the artists and called them 'resources', leave us feeling dehumanised ourselves and make it difficult for us to stand on our own value (what our work is worth) and values (the ethical frame that supports that worth). Because we need and want to do the work, we may give in on these contractual details and then be victims of the values that inform the system. It may be through contracting – itself a manifestation of the system – that we are able to protect ourselves, provided we can take a stand during the contracting period.

A further thread of the conversation based on the image Chantal and Les created, focussed not only on how the client recognises the practitioner, but on how responsibly he may be using the work. Building on the idea that theatre is a powerful influencing tool, how can we know the client will use the work dialogically rather than top down, as mentioned in the first value regarding deep collaboration? We concluded again that it is about relationship building with the kinds of people who would honour not just our work but also its underlying ethic, rooted in relationship. We cannot control what others do, but we can choose who to build relationships with. Our values were clearly working as a network of concepts interlinking with each other, and they can help us find the people we want to work with – other practitioners and clients.

In the re-articulation of the value, we wanted to balance our intention to be generous in the sharing and availability of our material, with an understanding of the need for the work to be treated responsibly. We changed the initial description of the value. In this way, we hoped to capture both the requirement of responsible use and of respectful reciprocation. We also decided to be explicit about wanting others also to be able to access it. In this way, we want to work against the need for exclusivity and competition.

It was the improvisational quality of applied performance as an approach that underpinned this discussion. As practitioners of a brand of applied performance called applied improvisation[3], Christian and Alison were insistent that the quality of 'whose line is it anyway?' (ABC Family, 2010), reframed by researchers on reputation and ownership as 'whose idea is it anyway?' (Shaw and Olson, 2015), should permeate the work. At the same time, as artists, some of us were conflicted because it felt like such an attitude may not value our artistry and unique contributions. We acknowledged the power of the images and stories we were sharing to highlight these nuances and complex ambiguities again generating a sense among us of critical hope. In the end, we agreed to lean towards generosity underpinned by mutual respect.

Finally, we had a conversation about our relationship with each other as collaborators. Since we were all independent consultants who worked and collaborated from time to time, we recognised the need to be generous towards each other, both in the sense of allowing one another to use our work and in the sense of generously acknowledging each other when we do. In this way, we hoped to foster the sense of generosity and abundance among each other in contrast to a sense of competing for increasingly smaller pieces of the same pie. We voiced the belief that an attitude of appreciation and collaboration may go a long way towards building the industry, awareness of our work, and its value for the current requirements in the world of work where collaboration, agility, and innovation are sorely needed, and yet are not supported by the mechanistic view of the organisation.

Responsible sharing of intellectual contributions	We value our intellectual property and yours. It is our livelihood. At the same time, we want you to be able to use what you receive through interaction with our work, and integrate it into your own. We also want others to find their way to the materials and use them. We therefore ask you to reference our work wherever you use it in written or oral format, when you use it explicitly, or when your own work was adapted from ours.

Intrinsic value

Both groups identified this one as important, and no less perplexing, than the earlier three. In the image we created, Lollo was drawing intrinsic value from the Earth, through her body, into the universe, while Chantal was very busily presenting various religions and making room for all of them. Dave was part of the image attempting to manage diversity in his space. At one point, Lollo stopped her action and looked questioningly at Chantal. Lollo explained:

> I was questioning why she was focussing on the actions because this (value) is intrinsic. How you bring it out is a different matter. Why are you focussing on the action? It is not really who the person is.
>
> *(Janse van vuuren et al., 2018)*

Dave agreed:

> Yes, you may have phenomenal value, but it might not be what the organisation is interested in … If you look at all the value and contributions of the community, you have to be able to see it in context and see is this something that is actually relevant to us?
>
> *(Ibid)*

In both the face-to-face conversation and the online session, we recognised that acknowledging the intrinsic value of people meant neither the consultant nor the organisation had to actively do all the activities of, for example, all the religions, all the cultures, and even all the sports preferences people hold dear. This is taxing. As Chantal said, 'It is a busy thing practising all these belief systems'. Alison asked, 'The bit that says the community outside the organisation has value and can contribute something unique to the organisation. I was wondering how I bring it into my work?' (Janse van Vuuren, 2016).

It is still the organisation's job to do its core business. Rather, what is needed is an openness that would allow people to contribute freely from their own life experience anything that may serve the organisation. There must be a balance between seeing the organisation as a closed system, dedicated to its core business and its people as open systems, with access to wealth that is intrinsic to who they are and not only linked to what they can do. Again, we acknowledged how the values related to each other, seeing how intrinsic value connected with systemic awareness.

Lollo suggested that such a view would allow people to feel more fulfilled in their work as meaningful contributors rather than cogs in a machine that get rejected if they do not fit in. We talked of how a janitor may have a valuable perspective on a problem that can lead to its solution where the CEO, from his perspective, could not see. In this way, hierarchy must dissolve and people should be valued for whatever they might bring. We agreed that offering this kind of collaborative space is a core benefit of our work that we can offer our clients. Lollo concluded that for organisations who took this view, 'the sky is not even the limit' (Janse van Vuuren et al., 2018).

Conclusion: Counter measures

In view of the original question (How does the applied performance practitioner adapt her work to suit the business organisation space without compromising on her values?), some insights arise from the above analysis of the ethical gap and values clarification process.

1. A systemic awareness on the part of the practitioner is just as important as such an awareness on the part of the client. It allows us to see the ambiguities within the mind of the client and identify with both his/her need to manage his/her chessboard and his/her awareness of the need to acknowledge the human and the possible contributions each person can make. Providing spaces for non-hierarchical collaborative interaction is one of the benefits of our work that can be of great value to clients.
2. There are individuals within business that, if partnered with, can support the work and promote its effectiveness. A set of clear values can help us identify and align with these individuals – whether they are co-practitioners or clients.
3. Practitioners can work among themselves in a way that exemplifies how they want to work with clients. Such collaboration helps us find language for our work and identify its value for work in business. This way we can build the industry and grow the pie.

4. Any endeavour that is nestled within the context of a mutually respectful relationship has a greater chance of sustained success than one that disregards the importance of healthy human engagement in favour of a 'chessboard' perspective of the work place.
5. At the same time, attention must be paid to the contracting phase of any engagement to support the relationship and safeguard the practitioner against the systemic forces that may interrupt his/her work.
6. Practitioners can draw on existing movements and models in the organisational space that seek the same outcome: Transformation. These may provide concepts and language that can aid the practitioner in explaining his/her work. This outcome revealed itself in small moments during the discussion, not as a single prominent moment.

Upon further reflection, as I was writing this chapter, I realised another important principle that was implicit and that I would like to make explicit here. Since our work can only be successful within the context of relationship, rather than in the context of only contract and task (the 'chessboard' perspective), and because shifting perspectives can be 'tedious' and 'painful', it takes longer to sell and execute projects. For this reason, opportunities for doing such work may be few and far between and hardly financially sustainable. All of the practitioners bar one (Dave, who does not actively use applied performance) struggle financially if they try to live off such work only. All of us do many other things too.

There is a lot of industry building still needed, but a growing awareness in the world of the need for organisations to find ways to be more innovative, agile, and able to effectively engage their people. We can serve these needs by offering spaces where the perceived need for serving the bottom line, hierarchy, ownership, individual accomplishment, and a task-oriented effectiveness, can be suspended for a short time. In this liminal space of suspension, it may be possible to shift the values of the interaction towards an awareness of the greater good, the intrinsic value of people independent of their position, a generous sharing of ideas, community, and a people orientation. Furthermore, it is through the use of our processes that perspectives may be critically investigated, complexities understood, and rigid narrative nuanced in a safe environment so that critical hope may arise amidst the resilience of systemic injustices.

Our workshops and processes can create such spaces even if only for the duration of the project. It is our unique value and contribution. There is therefore no need to play into the perceived values of the world of business if we can find a way to sell the need for a temporary suspension of these values. What other field is more equipped to suspend belief and create a space set apart where such new ideas can be experimented with than applied performance? In a South Africa still plagued by the legacy of racial capitalism and polarisation, even in the mind of the practitioner him/herself, such suspension can aid in reimagining and reforming business organisations.

It is therefore not a question of the applied performance practitioner adapting his/her work to fit the world of business, it is a question of clearly differentiating it and expressing this very difference as its most valuable attribute. Of course, the question arises whether such commodification of our values does not play into the capitalist and commercialised value system of the world of work and whether creating only pockets of spaces inside the organisation does not leave us powerless to change the organisation itself? Are our desires to work in business itself a neo-liberalist manifestation of the 'desire to be included among those who are at present feeding at the table of capitalist wealth, opportunity, and privilege'? (Cloete 2014, n.p.) These questions warrant attention and will fuel continued investigations of the possibilities of applied performance work to bring real transformation in the world of business.

Notes

1 Industrial theatre can take one of two forms. 1) A theatre company prepares a performance on a topic relevant to the workplace, e.g. sexual health education, gender equity, or labour law and sells it to various organisations as part of employee wellness, team development, and training. 2) A single organisation employs a theatre company to custom make and perform a piece of theatre with a particular message that leadership wants to communicate to workers.
2 'Toyi-toyi' is a Southern African dance people use in political protest.
3 'Applied improvisation' is the practise of applying and developing the same skills that improvisation actors or musicians use, but in contexts that are not linked to the stage. It has been formulated especially for business contexts and is gaining popularity in the arena of information technology (Applied Improvisation Network, 2016).

References

ABC Family. 2010. 'ABC Family: Whose Line Is It Anyway?' 16 March 2010. https://web.archive.org/web/20100316034938/http://abcfamily.go.com/abcfamily/path/section_Shows+WhoseLineIsItAnyway/page_Detail.
Alexander, Neville. 1979. *One Azania, One Nation: The National Question in South Africa*. London: Zed Book Company.
———. 2013. *Thoughts on the New South Africa*. Auckland Park, South Africa: Jacana Media.
Applied improvisation Network. 2016. 'About Applied Improvisation'. *Applied Improvisation Network*. http://appliedimprovisation.network/about-applied-improvisation/.
Boal, Augusto. 1993. *Theatre of the Oppressed*. Translated by Charles A. McBride. New York: Theatre Communications Group.
———. 2002. *Games for Actors and Non-Actors*, 2nd edition. New York: Routledge.
Cloete, Michael. 2014. 'Neville Alexander: Towards Overcoming the Legacy of Racial Capitalism in Post-Apartheid South Africa'. *Transformation: Critical Perspectives on Southern Africa* 86 (1): 30–47. doi:10.1353/trn.2014.0032.
Dalrymple, Lynn. 2006. 'Has It Made a Difference? Understanding and Measuring the Impact of Applied Theatre with Young People in the South African Context'. *Research in Drama Education: The Journal of Applied Theatre and Performance* 11 (2): 201–18. doi:10.1080/13569780600671070.
Department of Labour, Republic of South Africa. 2019. 'Employment Equity Act 55 of 1998'. *Government Gazette of South Africa* 646 (42380). https://www.greengazette.co.za/documents/national-gazette-42380-of-05-april-2019-vol-646_20190405-GGN-42380.
Department of Trade and Industry, Republic of South Africa. 2004. 'Broad-Based Black Economic Empowerment Act 53 of 2003'. *Government Gazette of South Africa* 463 (25899). https://web.archive.org/web/20101203213807/http://www.http://info.gov.za/view/DownloadFileAction?id=68031.
Hauptfleisch, Temple. 1997. *Theatre and Society in South Africa : Some Reflections in a Fractured Mirror*. J.L. van Schaik. https://scholar.sun.ac.za:443/handle/10019.1/85401.
Heintz, James. 2007. 'Class, Race, and Inequality in South Africa (Review)'. *Transformation: Critical Perspectives on Southern Africa* 64 (1): 152–53. doi:10.1353/trn.2008.0007.
Janse van Vuuren, Petro. 2016. 'Keeping Promises: A Strategic Narrative Embodiment Model for Designing Social Change Interventions | Drama Research'. *Drama Research* 7 (1). http://www.nationaldrama.org.uk/journal/current-issue/articles/keeping-promises-a-strategic-narrative-embodiment-model-for-designing-social-change-interventions/.
Janse van Vuuren, Petro, Alisom Gitelson, and Christian Freisleben. 2018. *Aligning with Associates: What Are the Values That Bind Us? Online Session*. Audio recording. How to Catch a Flying Pig. Zoom video conferencing: Playing Mantis.
Janse van Vuuren, Petro, Les Nkosi, Chantal Natival, Lollo Mafolo, and Dave Evans. 2018. *Aligning with Associates: What Are the Values That Bind Us?* Audio recording. How to Catch a Flying Pig. Johannesburg: Playing Mantis.
Nawa, Lebogang L., and Wolfgang Schneider. (eds.)2019. *Theatre in Transformation: Artistic Processes and Cultural Policy in South Africa*, –. New York: Columbia University Press.
O'Neill, Cecily. 1995. *Drama Worlds: A Framework for Process Drama*. Portsmouth, Hants: Heinemann.
O'Toole, John. 1992. *The Process of Drama: Negotiating Art and Meaning*. London; New York: Routledge.

Ranciere, Jacques, and Slavoj Zizek. 2004. *The Politics Of Aesthetics: The Distribution of the Sensible*. Pbk. Ed edition. London; New York: Continuum Intl Pub Group.
Schwab, Klaus. 2017. *The Fourth Industrial Revolution*. New York: Crown Publishing Group.
Shaw, Alex, and Kristina Olson. 2015. 'Whose Idea Is It Anyway? The Importance of Reputation in Acknowledgement'. *Developmental Science* 18 (3): 502–9. doi:10.1111/desc.12234.
Sulla, Victor, and Precious Zikhali. 2018. 'Overcoming Poverty and Inequality in South Africa : An Assessment of Drivers, Constraints and Opportunities'. 124521. World Bank. http://documents.worldbank.org/curated/en/530481521735906534/Overcoming-Poverty-and-Inequality-in-South-Africa-An-Assessment-of-Drivers-Constraints-and-Opportunities.
Xu, Min, Jeanne M. David, and Suk Hi Kim. 2018. 'The Fourth Industrial Revolution: Opportunities and Challenges'. *International Journal of Financial Research* 9 (2): 90. doi:10.5430/ijfr.v9n2p90.

PART VI

Western Europe

INTRODUCTION TO PART VI

Care for the Open: intercultural challenges and transcultural potential of applied performances in Western Europe

Julius Heinicke

Intercultural challenges are growing across the world and in Western Europe. As a result of refugee movements, migration processes and social upheavals, societies are becoming increasingly diverse; but with tendencies towards partitioning and exclusion. Theatre projects are used with ever-increasing frequency as promising formats to create spaces where cultural diversity and difference can be performed, discussed and lived.

The ambivalent history of Western European performance related to colonial snares and post-dramatic potentials comes to the fore in this section. The facilitators and theatre practitioners work alongside migrants and refugees to negotiate cultural traditions, histories and experiences. Applied performance embodies a tradition of theatre used for democratic change, often linked to Augusto Boal's *Theatre of the Oppressed*, alongside the philosophic traditions of Immanuel Kant, Johann Gottlieb Fichte and Georg Wilhelm Hegel. Yet, one should question the enlightened (*aufgeklärten*) and often so-called democratic concepts that underpin these aesthetics. Hegel's concept of a dialectical system, configures the 'other' as a counterpart to existence. In Hegel`s philosophy, the other is degraded as the servant, often symbolized by members of colonized societies. Susan Buck-Morss has argued that Hegel was trapped in a racist ideology stating: 'It was the brutal thoroughness with which he dismissed all of sub-Saharan Africa, this "land of children," of "barbarity and wildness," from any significance for world history, due to what he deemed were deficiencies of the African "spirit"' (Buck-Morss, 2009: 67–68). In contrast, Hans-Thies Lehmann posits that the concept of aesthetic, especially in Hegel's philosophy, is important for creating a space of freedom in theatre where global concepts and forms of theatre may come together and build something new:

> Classical idealistic aesthetic has the concept of the 'idea' at its disposal: the design of a conceptual whole which allows the detail to concretize (to grow together) as they unfold simultaneously in 'reality' and in 'concept'. Every historical phase of a particular art could thus be regarded by Hegel as a concrete and specific unfolding of the idea of art, every work of art as a special concretization of the objective spirit of an epoch of 'artistic' form.
>
> *(Lehmann, 2006: 20)*

At the end of his lectures on aesthetics, Hegel argues that something new arises:

> And now when the link forged between us generally and in relation to our common aim has been broken, it is my final wish that the higher and indestructible bond of the idea of beauty and truth may link us and keep us firmly united now and for ever.
> *(Hegel, 2018: 265)*

I would argue that at the end of consensus between the idea of a society and art and this 'higher and indestructible bond of the idea of beauty' transcultural theatre begins to create its own performative sphere. As Hegel could not describe this 'new bond' with his own categories and classifications, he points to a far-reaching transformation in Western philosophy. Modern societies are confronted with multiple processes of change – for instance due to migration and other social shifts – with the result that the classical canon cannot describe them at all. However, Hegel argues that the aesthetics and especially the performance arts (drama) have the potential to deal with these new circumstances in creating transcultural spaces. Nevertheless, this European transcultural tradition has a neo-colonial sensibility, as this new bond is constructed through Western concepts of 'otherness' within a dichotomous structure.

Recently, applied performance artists in Western Europe have engaged with these challenges of cultural diversity, seeking artistic techniques for transcultural communication. The challenge seems to be to pursue an attitude, which strives not to generate dichotomous differences between 'we' and the 'other,' but instead to emphasize that diversity is the symptom of a plural society. In this regard, the philosopher and sociologist Achille Mbembe presents a philosophical vision that he describes as 'care for the Open,' which develops interesting assumptions to respond to current transcultural challenges. Care for the open overcomes dichotomous structures in our societies, as the concept promotes processes of 'unkinning' (*désapparentement*), as discussed by Mbembe:

> This question of universal community is therefore, by definition, posed in terms of how we inhabit the Open, how we care for the Open – which is completely different from an approach that would aim first to enclose, to stay within the enclosure of what we call our own kin. This form of *unkinning* is the opposite of difference.
> *(2017: 183)*

Mbembe's understanding of 'unkinning' can also come across as the opposite of assimilation and points the way forward for a kind of artistic and cultural creation that pays tribute to the diversity of traditions and techniques, rather than forcing them into a construct and constraining them. In allowing artistic and personal traditions of different cultural backgrounds to meet one another at eye level, these works show in their artistic expression 'care for the open.' This idea of a performative aesthetic of *désapparentement* denies a European concept of performance that is often criticized within applied performance, but also denies the idea of a homogeneous society, that is mirrored in the arts. Here, Hegel's inkling of the new bond of the end of European idealism in art becomes obvious. One can argue that Mbembe finds a way of pronouncing the new bond that Hegel was not able to. Applied performance techniques may construct an ideal setting to explore the construct of *désapparentement*.

For this reason, I used applied performance techniques for a workshop entitled Creating Transcultural Spaces that I led at the beginning of the conference Action Art[1], hosted by the Zurich Academy for the Arts. I attempted to develop spaces for an aesthetics of *désapparentement* with the workshop participants. The goal was to deliberately create at the beginning of the

conference a space for experiencing cultural diversity, since guests from Hong Kong, Indonesia and Ghana were taking part. I asked some of them to present a short gestural sequence with a specific meaning in their culture, without, however, revealing this meaning. Participants were supposed to practise these short performances and reflect on what significance they ascribed to these gestures. Afterwards, they were asked to develop their own, personal gestures, in which they expressed specific feelings like joy, fear, closeness or isolation. They were to present these to one another in groups of two. The requirement was that the reciprocal presentation and combination of gestures first took place nonverbally, followed by the presentation to one another of the respective personal meanings attached to them. Thus, the workshop sharpened their observational capacities with respect to one another and created a space in which one could first observe others and their modes of expression, then to imitate them and then to combine them with one's own gestures. However, in order to guarantee openness, this process also included phases of mutual reflection. The workshop was the first step in an attempt to create spaces in which diversity could be experienced, and in which tensions and differences between different cultural gestures would not be negated, but rather consciously permitted as part of the diversity of human expression in an 'aesthetics of *désapparentement.*' This kind of aesthetic experience promotes a feeling of being 'unkinned' with other cultural traditions. Moreover, it combines this experience of 'otherness' with oneself. Whereas the dialectic system of 'otherness' leads one to believe that I know everything about me and feel that I am one with me, this aesthetic illustrates that some parts of me also evoke a feeling of otherness and that other cultural traditions and techniques find a way to collaborate with this feeling. The different traditions and techniques take on new meanings and are part of a permanent process of changing. However, this turns out to be the basic theme of recent Western Europe performance practices. Even smaller towns and villages have growing numbers of inhabitants from different backgrounds and with alternative lifestyles. The vision of a society that cares about openness viewing the Other not as a dichotomy but as one that shares diversity with itself and others is reflected in the manifold experiences of the opposing poles. For this reason, and from a policy standpoint, the concept is appropriate for understanding diversity as an opportunity for community-building rather than as a mutual danger.

Facilitators and organization teams can reflect and promote care for the Open. As Hegel's concept of aesthetics suggests, performance provides an ideal setting to create spaces to experience this openness. The goals of applied performance projects can be combined with this attempt at creating a room for experience and reflection to encompass the cultural and social diversity European societies are increasingly faced with. Mbembe's principle of 'care for the Open' can also provide valuable suggestions for the planning, organization, management and evaluation of applied performance projects. One essential problem lies in the fact that the claim to universality of Western thought is hardly questioned. Political demands of European-Occidental provenance, like democracy and the rule of law, are unthinkingly taken up into the agenda of cultural politics and turned into promises for the future. Thus, the political and sociopolitical institutions decide not only about the financing, but also about the nature and course of performance projects. The support, execution and evaluation of applied performance projects in transcultural contexts should thus take care that diversity is not destroyed, but rather guaranteed.

Applied performance with refugees

The chapter entitled 'The right artistic solution is just the beginning' regarding a three-year project Hodja from Denmark – Theatre for Asylum Children by Lene Thiesen analyzes the com-

plexity of migration theatre projects and underlines the need for scholars and practitioners to develop strategies to meet these challenges in a sustainable way. Sofie de Smet, Lucia De Haene, Cécile Rousseau and Christel Stalpaert focus on 'Exploring dramaturgy in participatory refugee theatre as a dialogical art practice: dialogical tensions in a temporary relational playground' related to the context of refugees and participation. They focus their analysis on the theatre project *Tijdelijk* (translated as *Temporary*) that was produced in Brussels to explore varied creative processes and dialogical practices of coping with symptoms of trauma during the rehearsal and performance processes. Similar to the example of applied performance in Denmark, the chapter describes methods to develop dramaturgical strategies through applied performance.

Rikke Gürgens Gjærum not only focuses in 'Core of Nordic Applied Theatre: Challenges in a Sub-Arctic Area' on projects with refugees. Based on nowadays projects the article also discusses techniques of applied performance that both bridges the gap between local aesthetics, social significance and involves people from marginal positions. Gjærum presents a deep scientific analysis on which various ways Nordic applied performances deal with issues of cultural and social change in northern Europe. The article empathically shows how important applied performance is for a diverse society, but also, how challenging these processes are for the actors.

Between art and real life: political strategies of applied performance

Rolf Bossart critiques Milo Rau's productions *Empire* (2016), *Hate Radio* (2011) and *The Congo Tribunal* (2015) concerning the potential of performance to transform cultural, social and political conditions. In this way, enabling a space to provoke social and political discussions about current debates that are otherwise avoided or distorted within the current polity. Similarly, the chapter 'Artistic creation and participation in Portugal and Brazil: the urgencies of today' by Hugo Cruz focuses on political questions raised through theatre. This reflection situates community arts practices in the diverse and vast spectrum of contemporary artistic creation, namely the ones based on participatory processes. In this panorama, the cases of the Pele and of the Mexe – The International Art and Community Festival in Portugal, and of the collective Bonobando in Brazil are analyzed. Based on a literature review in this field, and on these concrete experiences, some common aspects are highlighted in the processes and in the consequences emerging in part from the development of these practices. More specifically, possible consequences for community arts practices are explored through individual, collective, community, institutional and political levels; also considering their limitations. Therefore, these festivals can be discussed as institutional spheres, where the dialogue between different aesthetics and ethics is possible.

The fairy tale written and reflected by Maria Kwiatek also focuses on nowadays challenges for young people and the Youth in Western Europe. The tale was written in the context of a theatre project in a juvenile education centre in Warsaw. With the help of Theatre of the Oppressed the project team created during the performance workshop spaces for participation and real action, where the boys and young men at the juvenile education centre were confronted with practices and reflections on self-reliance, watchfulness and responsibility. Kwiateks's article underlines, how important applied performance practices are for young people, who are not always among the winners of globalisation and its processes of cultural change.

The chapter of Giulia Innocenti Malini '*Legami in spazi aperti* (Open spaces bonds)' reflects on a theatre project involving convicts and their families in Brescia, northern Italy. Similar to the project in Warsaw the workshops in northern Italy facilitate the development of strategies to

cope with parental and familial problems, the reconciliation with the indirect victims of crime and the implementation of an educational approach. In addition – and this points the way forwards – she argues and shows that this project also creates an aesthetical space, a theatrical feast, mobilising artists, performative laboratories, associations, co-ops, public administration, citizens and inhabitants to involve the local community in acting together artistic and convivial performative practices. Applied performance is used here not only to support marginalized people, moreover to create sphere where the diversity and variety of the society is celebrated.

Conclusion

In all of the case studies related to applied performance in Western Europe, there is the illumination of critical spheres for reflection between artistic, political and aesthetic levels. Although several of the examples identify the use of applied performance in relation to migration, the theorization of these practices in relation to post-colonial theory and current neocolonial debates does not adequately contextualize the practices within the wider social, cultural and political frameworks from which the forms and practices emerge. In terms of addressing this issue, facilitators could potentially theorize relational aesthetics and the aesthetics of care through a kind of 'care for the Open,' offered by Achille Mbembe. Applied performance practices could more overtly identify inherent colonial structures that are embodied within the forms to create spheres of the Open. As Hegel's concept of aesthetics suggests, performance can provide an ideal method to create spaces for the Open.

The practitioners in the field of applied performance should be more overtly aware of aesthetic capabilities to experience and to reflect the cultural and social diversity of Western European societies (and beyond). Mbembe's principle of 'care for the Open' can provide valuable guidance for the planning, organization, management and evaluation of applied performance projects. One essential problem within applied performance in Western Europe lies in the universality of Western thought within the techniques and structures of performance making itself. Political demands of European-Occidental provenance, like democracy and the rule of law, are unthinkingly taken up into the agenda of cultural politics and turned into promises for the future. Thus, the political and sociopolitical institutions decide not only about the financing, but also about the nature and course of performance projects. The support, execution and evaluation of applied performance projects within a transcultural context should take care that diversity is not destroyed, but rather guaranteed.

Note

1 The conference, which took place on 4 and 5 May 2016, was conceived of by the project Foa Flux, under the direction of Dominique Lämmli and Annemarie Bucher. It was carried out in cooperation with the following master programmes of the Zurich Academy of the Arts: "Transdisciplinary Studies," "Fine Arts," and the program "Connecting Spaces Hong Kong–Zurich."

References

Buck-Morss, S., 2009. *Hegel, Haiti, and universal history*. Pittsburgh: University of Pittsburg.
Hegel, G.W.F., 2018. Aesthetics, translated by Paul A. Kottman, Hegel and Shakespeare on the pastness of art. *In:* P. Kottman, ed. *The Art of Hegel's aesthetics*. Paderborn: Morphomata.
Lehmann, H.-T., 2006. *Post-dramatic theatre*. Abingdon/ New York: Routledge.
Mbembe, Achille, 2017. *Critique of black reason*. Durham: Duke University Press.

34
REALISTIC ART AND THE CREATION OF ARTISTIC TRUTH

Rolf Bossart

In this chapter, I discuss the artistic means Milo Rau uses to interpret the world and I examine how his oeuvre opens possibilities for the transformation of cultural, social, and political conditions. I do this with reference to three major productions, namely *Empire* (The International Institute of Political Muder 2016), *Hate Radio* (Berliner Festspiele-Theatertreffen 2011), and *The Congo Tribunal* (The International Institute for Political Murder 2015).

Milo Rau's work follows an antithetical structure, which points to an existential tension of the human condition per se. In his pieces, the audience simultaneously experiences attraction and repulsion that is deeply linked to this existential tension of being human. His work translates the existential into the general, without the dissolution of the individual into the general and without making the general unimportant in the face of the individual. Rather, it examines how the existential and the general constitute each other mutually. And yet they do not converge, but remain in antagonism to each other.

Thus, Rau links the academic question of the justification of representation in theater to the practical reality of the tension between representation and immediacy. With reference to his children's play *Five Easy Pieces*, he once framed this tension between representation and immediacy as follows: 'Working with ten-year-olds as a director, you have to seduce or urge them to do on stage what you want. The criticism of these theater techniques becomes simultaneously a criticism of reality again' (Rau 2017: 106).

It is not enough to make the tensions of human ambiguities the starting point of the artistic endeavor. The point is to resist any attempts at their harmonization and the destructive fantasies in the course of the material debate. Out of theater, the representation of tension succeeds because it is not important for him to show something concrete, but to show everything in its concrete form or incarnate into the bodies marked by history and fate. Specific talents – a manic and egalitarian interest in almost everything, a photographic memory, and dialectic – give him an unmistakable sense of what can stand for the broken whole and what disintegrates into its individual parts. 'In doing so, he does not think either his audience or himself are on the safe side, but always puts all points of view up for discussion', as it says in the jury's statement on the Peter Weiss Prize of the city of Bochum 2017.

Right is mixed with wrong, hate with fun, ideologies dwell in affects, beauty appears in banality. In Rau's work, the complex and dialectical arrangement of material and thoughts is always tied together by one familiar, simple thing; for example a famous TV picture, the main-

stream pop music of his youth, the adversary format of the trial, the five acts of the tragedy, a simple children's melody, the crucifixion scene. With this 'almost bursting enrichment and ultimately humble simplicity of the fugal structure' (Rau 2017: 14), the The International Institute for Political Murder (IIPM) aesthetic is popular and elitist in a positive sense, which is why criticism sometimes disagrees as to whether it is all too simple or too complex, too trashy or too intellectual.

Rau trusts iconic images, symbols, institutions because he recognizes in them the condensation of the spiritual, social, and emotional substance of a society, which must be read analytically as an expression of violence and repression as well as affirmatively as attempts at mediation and reconciliation. After all, it is the always open possibility of mediating opposites that constitutes the depth of Rau's theater: that the view into hell and into heaven, as in the late medieval representations of the Last Judgement, is always open. Or, to say it in Rau's terms: in order for *Cynical Humanism* to become *a Repeated Catastrophism*, a *Global Realism* and a precise framework of expectations for the future are needed.

The reenactment (*Hate Radio*), the tribunal (*The Congo Tribunal*), the allegorical narrative (*Empire/The Europe Trilogy*); all these framings direct the theoretical penetration of the material, the design of the stages, the guidance of the actors, the expectation of the audience. Although they demand submission to their rules, they can also lead the individual who enters the stage extended by the frame out of the direct identification of himself. For an ecstatic moment it – and with it the audience – can step out of what it has become and re-enter and continue with a different relationship to its actions. Milo Rau's stage does not transform bodies into ideas, but it shows the corporeality of ideas. It does not transform fate into freedom, but 'fate into narrative' (Rau and Brossart 2017). The repetition is not a category of coercion that calls for ecstatic liberation, but rather a variation that wrestles new perspectives from the given. The ecstasy, on the other hand, does not call for intoxication, tearing out and unfolding, as happens again and again in self-destructive forms of religion, politics, and art, but enables movement as a symbolic act of entering and leaving. The repetition enables ecstasy, the ecstasy frames the repetition anew.

I will now explore the work of Milo Rau through the case studies of *Empire* (2016), *Hate Radio* (2011), and *The Congo Tribunal* (2015). These examples are also meant to indicate the great diversity and differences in his artistic work.

Memory and condensation: *Hate Radio* (2011)

At the origin of *The Last Days of the Ceausescus*, Milo Rau's first big reenactment, stands the iconic picture of the Romanian dictator couple in the improvised courtroom. For *Hate Radio*, he chose the opposite approach. The piece deals with the 1994 genocide in Rwanda committed by the Hutus against the Tutsis. Images with piles of corpses form the collective memory of this historical incident. But Rau decided to approach the subject from another angle, devoid of images. This allowed him to develop a completely different visual language of the genocide. In search of a place devoid of images, he came across the radio studio of Radio Télévision Libre des Mille Collines (RTLM). It was a postmodern, young radio with popular local presenters – and a white Belgian host – who broadcasted reportages, joked around with his guests, and played cool music. All young people knew this radio station at the time, including the later victims of the genocide. At a certain point in time, the radio studio started to incite genocide; in the beginning only subtly, later more and more openly. Between quiz shows and hit parade songs, the hosts aired racist speeches and called for the persecution and extermination of Tutsi neighbors.

The show was produced in a radio studio, of which we have no pictures. Rau's stage designer made a detailed reconstruction of the studio, based on the information of two former radio

hosts; the then very popular Valérie Bémériki and the Belgian Georges Ruggiu. For his research, Rau visited both in prison. In conversation with Valérie Bémériki, she compared herself with the apostle Paul and his transformation from Saul to the purified apostle. The conversations showed how the narrative chosen by the witness relates to his situation. In their first conversation, Bémereiki was very welcoming, probably as a strategy to achieve amnesty and/or a reduction of punishment. Later, her request for retrial was rejected. In the second interview, she was completely different. Hence, there are better and worse moments for interviews. It turned out that in the case of the genocide of Rwanda, 20 years later was the right time. Thus, every event has a favorable time to be dealt with. In Germany, for example, it was impossible to talk to witnesses and survivors about the World War II atrocities in a productive way until the 1960s. Changing political constellations and time shape the collective memory, and suddenly certain things can be voiced that were silenced before.

With the exception of the white Belgian radio host, all actors casted for the show were Tutsi. The fact that the victims should speak this good-humored hate discourse was very important. That the actors on stage called for the destruction of their own ethnic group could only have an impact if they did it honestly, that means, if their laughter was real. They really had to do this transgression, this perversion. Of course, this turned out to be incredibly difficult, especially since the piece was also played in Rwanda itself. Even more difficult was the decision to change or Europeanize certain things; on the one hand, because Rau worked with actors living in exile in Europe, and on the other hand to avoid the exoticism that always threatens a European audience with material from Africa. For example, they played songs from Nirvana in the studio, although everyone knew that this had hardly been the case in the real RTLM. When the crew went to Kigali, Rwanda they were worried that they would all be torn apart as historical liars in anticipation of a purely documentary piece. In Rwanda they played, among other places, at the central genocide memorial in the capital. But surprisingly, the people – survivors of the genocide, representatives of victim associations, etc. – came afterwards and thanked Rau and said, 'That's exactly what happened', even though the songs weren't right, although they were based on the dubious testimonies of the perpetrators, although they were greatly shortened. Apparently, with his selective approach and the dramatic intensification, Rau struck a chord in the collective memory.

Documentary theater is committed to the truth of the details. Thereby it often loses sight of the overall picture. Milo Rau, deliberately detached himself from the source materials and created a condensed, artificial situation. But precisely through this approach the work of art can express a historical feeling in its entirety. For by approaching the audience in a slightly alienated way, the situation known to all does not generate identification, but reflection on why the artificially alienated appears more real than reality. The reenactment, as Rau understands it, is an attempt to show an overall picture close to the historical facts, but in a deliberate deviation from historicity, so that one can at best say: not everything has happened in this way, but it is nevertheless true, because it can show something new in an already known matter.

Fate and unity: *Empire* (2016)

While the first two parts of the *Europe Trilogy: The Civil Wars* draw inspiration from Chekhov and *The Dark Ages* from Shakespeare, *Empire* works with the subject matter of the tragedy *Medea*. It reveals the *Europe Trilogy*'s mythological basis. In contrast to historical narratives, myths reveal the 'dramatic unity of humanity', which is the common leitmotiv of all three plays. In Homer there is no doubt that Trojans and Achaeans suffer a common fate in the collapse of Mycenaean civilization. In Euripides's *The Trojan Women* too, the Athenian catastrophe in the Peloponnesian

War, brought on by hubris following the victory over the Persians, is understood as a mythic recurrence of the Achaean catastrophe after the defeat of Troy. This same clarity about the intertwined fate of east and west can be seen in the Platonic myth of Athens and Atlantis, etc. The world of the historical, scientific narrative, on the other hand, is an open field – a multiplicity of peoples and civilisations driven by fear and greed, by interests and instincts, a power struggle between man and man, ruler and subject, tribe and clan, nation and nation. A world of this kind perpetually threatens to break up into individual and national centers of power, which rise and fall without any apparent reason, without any sense of the 'dramatic unity of humanity'. *The Europe Trilogy* attempts to give this outmoded sense of the unity of humankind a current form on the stage: the actors tell their own family histories – which have been recounted in conversations and rehearsals and been put into writing by Milo Rau in the context of civil war, exile, the experience of power, and powerlessness, family conflicts, etc. – as if the text had come over them, as if it did not belong to them alone, as if the point was not to tell one's own story but to give an example, and not to have a personal story but a fate. A personal experience often directly becomes a historical one, and the personally spoken account a quotation of the classical, and vice versa. The individual conception of the trilogy, however, leaves no doubt that the fates being negotiated are not exchangeable, but are only these specific ones. The narratives of the actors in *The Civil Wars*, *The Dark Ages*, and *Empire* are not an open field. They do not revolve around contingencies and possibilities, free decisions, and opportunities seized or missed. Milo Rau releases them from the basic ideological narrative of the liberal meritocracy, the order of which has a place neither for failure nor for suffering. Thus these narratives also do not set an 'abstract', collective history against a 'concrete' individual, one that is truer according to a postmodern reading. Rather, one's own story proves in its banal as well as its special moments to be a real and therefore controversial and problematic embodiment of European history as world history. The incredibly focused, almost meditative atmosphere in which this takes place leads – certainly after a viewing of all three plays – to a perhaps astonished, but surely astonishing '*Ecce Europa!*' The trilogy's obvious relation to classical tragedy does not arise from the theory of catharsis through compassion, which Aristotle did not develop until after the decline of the tragedy, but from what must have been the actual effect on the contemporary ancient audience: the shuddering at one's own fate in light of the fate of the hero. The accent lies on the gentle shock which triggers the insight that what we see on the stage may not completely result from a series of individual actions or political acts, but may rather be co-determined by humanity's common fate which, consequently, strategies of individual autonomy or collective autarchy are insufficient to overcome. The philosophically relevant point is that the persons on the stage present their own stories with a consciousness of themselves as part of the universal story. The tragic moment in this causes one to shudder at one's personal inability to escape the collective fate. Yet it also places one in a larger context and ensures that the freedom of the self to have to create purpose and meaning on its own – a freedom that in this depressive age has become a heavy burden — loses its arbitrary and solipsistic character.

What is also tragic, in the broadest sense, is the circumstance that the individual stories do not paint a picture of an innocent diversity, but that each for itself instead takes on the assertion of a conflicted, impossible unity (Europe or humanity?) as a task for the future, but above all as a bearing and enduring of the guilt of the ancestors. The heroic moment of the drama lies in this free act of humility, which is the necessary basis for any constructive notion of unity. The actors of the Europe trilogy offer an impressive counter-image to the nihilistic-narcissistic terrorists of our times for it is this guilty and painful past – one's own and that of society – which the suicide-murderer must destroy. In his narcissistic mania, he is unable to bear or endure anything, shudder at anything, or grieve. And so, what manifests itself in this contradiction is ultimately nothing

less than the tragic, fundamental question of humanity, which the modern age, for all its effort to prevent and suppress suffering, has never been able to fully solve. Under what conditions can the suffering we experience make our soul wise or fill it with hate? The at once beguiling and oppressive magic of the Europe trilogy comes from the fact that its audience is ready to grapple with this question.

Truth and justice: *The Congo Tribunal* (2015/2017 film)

The following question was at the origin of *The Congo Tribunal* project: what exactly keeps this eternal civil war going, which has cost the lives of 5–10 million people, according to the various estimates? The research confirmed the suspicion that the main reasons are the Congo's mineral resources that are vital for the world economy. Mining companies, warlords, politicians, and many other actors have benefited from this unstable situation for years. After the fall of the long-standing dictatorship of Mobutu, Congo introduced a new Code Minier on the initiative of the World Bank in the late 1990s. Mining rights were sold to only a few companies. Above all, Canadian, German, and Swiss companies were the lucky ones that were granted large concessions and could permanently put pressure on a weak government to enforce poorer working conditions and expulsions for new developments. In such a heated and often lawless situation, massacres repeatedly occur that do not entail any clarification. In total, there are 1000 cases of mass expulsion, mass rape, or mass murder for which there is no Court of Appeal – since international economic law exists on paper but is not institutionalized.

During the preparatory research for *The Congo Tribunal*, Milo Rau's team became witness to a massacre of children and women – the Mutarule massacre near the provincial capital of Bukavu, where the tribunal was later to take place. He decided to select this and two other cases and tried to bring them to a tribunal of national and international judges. In addition to the massacre of Mutarule, the tribunal also heard a case involving the Canadian gold company Banro, including illegal expulsions by the company. The third case dealt with the Bisie coltan mine, in which the fatal relationship between war economy and international intervention was the issue.

Rau asked lawyers and judges from the Congo and the International Court of Justice in The Hague to outline the legal basis for the tribunal: an international business law composed of national law and local land law, the Congolese constitution and international human rights law, a utopian legal institution at eye level with the global economy. The tribunal took place in two hearings, each divided into three sessions: three days of negotiations were held in Bukavu, the center of the civil war region in eastern Congo, and another three days in Berlin. Since human rights activists, displaced farmers, and former rebels appeared in Bukavu and put their lives in real danger with their statements, a complex witness protection program was developed in cooperation with the UN, including a complete body veil, vocoder, and safe houses. Since there was an indirect complicity of the UN troops in the case of the massacre of Mutarule, because they had withdrawn from the village of Mutarule the night before the massacre for inexplicable reasons, a few days before the start of the tribunal the New York UN headquarters demanded that this case not be dealt with. Rau refused. As a response, the UN withdrew witness protection from the tribunal. As a consequence it had to be organized with the help of the local, totally corrupt police – a very questionable but inevitable process, typical of the dubious way in which all these projects take place.

This example and many others, documented in the book *The Congo Tribunal*, show that every step of the way, they came across a variety of interdependencies and guilt relationships, knots that seemed almost impossible to dissolve. Rau worked in Bukavu with the government, the opposition leader, paramilitaries, corporate representatives, small miners, rebels, and farmers.

Everyone took part in the tribunal and almost everyone somehow regarded himself or herself as a victim. Simultaneously, depending on the perspective, they were also accomplices. The testimonies of the witnesses were extremely open, and as a result, two experts were abducted and both the Interior Minister and the Mine Minister of the South Kivu Regional Government were dismissed (a province about the size of Germany).

This brings us to the most frequently asked question in connection with *The Congo Tribunal*: why did these people participate in the tribunal at all; a tribunal without any legal consequences? And why was the media and audience interest in Central Africa and worldwide so overwhelming? Why did people trust a theater tribunal and participate in it, even if they put their lives in danger? The answer is simple: there is no other possibility to speak the truth. The German newspaper *Die Zeit* wrote in its critique of the piece: 'Where politics fails, only art helps'. With *The Congo Tribunal*, Rau has done something that was not only felt to be urgently necessary by the actors, but that is not possible in reality because it does not yet exist in any form. Together with local and international lawyers, Rau has created a utopian legal space. *The Congo Tribunal* brought together domestic law, human rights, and international commercial law. This 'chamber mixte' opened a space for negotiating the local effects of economic crimes on a global level; with real judges, jury members from all over the world, dozens of witnesses, 1,000 spectators, in the center of the civil war area, accompanied by international reporters. The victims called this 'fictional institution' because there was no other. And through her invocation she became real, she realized herself.

This is the teaching of art: anything is possible if you only want to. Or as Milo Rau repeatedly emphasizes: 'Realism, as I understand it, does not mean that something real is depicted. Realism means that the depiction itself becomes real – even if what is depicted is in the future, i.e. comes, as it were, from the space of collective hopes'. The idea of *The Congo Tribunal* was to use a symbolic action to show an institution at work that doesn't exist, but that should exist. It was a propaganda action on a global scale, almost the positive counter-image of the show trials that Rau was tracking down in the 'Moscow Trials'. If we have a globalized world economy that has concrete effects on local populations, we also need a global legal system that can offer law at the local level. Think global, act local – as the multinationals have been doing for decades. And this is what Rau means when he repeatedly uses the term 'global realism' in relation to *The Congo Tribunal*: a realism at eye level with the world economy that not only describes realities, not only postpones collective assessments, but ultimately creates new realities.

Looking back, it is interesting that Rau was always told that it was impossible to ever make such a tribunal: 'Who pays for it, who protects it? You're all in mortal danger'. Ultimately, however, these voices have spurred Rau on to prove that it is possible and that there is a legal basis for imposing economic debt, which is always 'complex' and 'diffuse', on actors and sanctioning them. The world economy is describable, it is sanctionable – that is the doctrine of global realism and its political continuation. The exchange with Jean-Louis Gilissen, the President of the Congo Tribunal's Court of Justice, was very important in this context. He has already worked closely with Rau at *Hate Radio*. As a founding member of the International Court of Human Rights, Gilissen once faced the same problems. Everyone had advised them against this at the time, talking about the political, legal, and financial impossibility of such a project. People said, 'Jean-Louis, you are crazy. There is no government behind you, there are no laws, you need a billion euros'. Ten years later, they had the laws, the buildings, the money and brought the Rwandan genocides to justice. At first everything is a crazy idea. First everything is art, propaganda, hope. Because the factual, as terrible as it is, was humanly possible – so too is the alternative always possible. And so, thanks to the steadfastness of people like Gilissen, international law is spoken today in The Hague. And, thanks to the steadfastness of the Chief Investigator

and Attorney General, Maître Sylvestre Bisimwa, who is also Chairman of the Congolese Bar Association, the Congo Tribunal is already being continued today.

Social imagination, as realized in *The Congo Tribunal* means appropriating existing discourses, formatting them, radicalising them, closely guiding them, and putting them in a space where suddenly their meaning becomes completely open once again. And in order to make Rau's artistic approach with reference to the concept of realism even clearer, I would like to conclude with the following quotation: 'Realistic art has a transformative power. It is able to turn an unconscious action into a conscious one, hence it has the capacity to bring it under scrutiny of morality and politics. The realist must make unacceptable suggestions; images that force us to see what we do not want to see or that are just too beautiful to bear. For me, this is the only way to create realistic art: It aims for the transformation of the world and of history, despite the entire, frustrating ambiguity of every position' (Rau 2018: 183).

References

Rau, M., 2018. *Globaler realismus: Global realism*. Berlin: Verbrecher Verlag.

Rau, M. and Bossart, R., 2017. *Wiederholung und Ekstase. Ästhetisch-politische Grundbegriffe des International Institute of Political Murder*. Zürich: Diaphanes Verlag.

Rau, R., 2016. *The European trilogy. The civil wars, the dark ages, empire*. Berlin: Verbrecher Verlag.

Rau, R., 2017. *Das Kongo tribunal*. Berlin: Verbrecher Verlag.

35
ARTISTIC CREATION AND PARTICIPATION IN PORTUGAL AND BRAZIL
The urgencies of today*

Hugo Cruz[1]
*Translation: Adriana Miranda da Cunha
and Matthew Wilhelm-Solomon*

Introduction

In the context of a fragmented, frightened world seemingly anaesthetized from its wounds, concrete ideas and actions that strengthen the construction of other ways of life seem to emerge. Contrary to the claims of large economic groups, the mainstream mass media, and the effective marketing machinery that fuel various interests, the world is not facing a one-way road. On the one hand, the multiple crises (social, ecological, political, cultural, economic, demographic, etc.) have been diminishing the space of individual and collective freedom through rigid responses, but, on the other, curiously encouraging the multiplication of alternative experimentations of self-organization and social relation. Partially, this movement of building other possibilities has its impetus in the disbelief in conventional political configurations, namely those related to representative democracy, and it poses questions about the private and public sectors central to our lives. These aspects may justify a decline in participation in conventional political activities (Putnam, 2001; Borba, 2012). However, the current concern about this decline, among those who argue for the existence of a participatory crisis, is rebuffed when, at the same time, there seems to be an expansion of new political configurations. In this regard, we can highlight the movement of occupations happening since 2011: the "Arab Spring" – North African countries; *Occupy Wall Street* – E.U.A.; *Indignados* – Spain; *Geração à Rasca* – Portugal[2]; and the occupation of schools by *Secundaristas*[3] – Brazil (Harvey, Teles & Sader, 2012; Negri & Hardt, 2014). These movements, despite the specificities related to different contexts, manifest a series of recurrent elements (e.g. lack of single leaders, movements based on horizontal relations, strategic use of new technologies and social networks and holding open assemblies) that seem to indicate a possible new wave of participation. Thus, we may be faced with another reading of reality that reveals citizens not participating less, but in a distinct and less institutionalized and hierarchi-

* The first version of this text was written in 2018.

cal form, offering a more creative alternative (Menezes et al., 2012). We will be dealing with counter-narratives that do not operate within the context of the idea of "power over", feeding in the dominant narratives, but rather with alternative narratives based on the idea of "power for" (Prentki, 2009).

Criticism, in particular through actions based on participatory democracy, has gradually become sedimented in the face of unbalanced relations between public and private sectors, and particularly the public sphere because of its overly institutional character, closed to the proposals that emerge from citizens. Given these criticisms, one of the urgencies of Western societies seems to be precisely to find a constructive dialogue between representative and participatory democracy, the public and private. Thus emerges a fertile ground for discussion on new ways of doing and building the "common" in today's societies. In this context, it is important to take into account renewed ideas about the "common", placing them in a space that goes beyond the private and the public, in their more institutional sense, and which seems to want to propose another logic of functionality and social organization, based on a destituent principle[4] (Negri & Hardt, 2014; Dardot & Laval, 2017). The intense emergence of these conceptions seems to be crucial to today's democracies, with obvious impacts on contemporary artistic creation. In this context, which spaces does artistic creation occupy as one of the dimensions that transverses human existence? What forms has artistic creation found to dialogue with the fissures of this world?

It is precisely in this unstable climate, and therefore also open to evolution, that artistic creation has been disseminating – and disseminating itself with – increasingly participatory processes. Facing the risks that the position of artistic creation has globally announced, it has increasingly been based on a participatory logic, in different configurations, and in some cases taking on a community dimension. The interest in participatory artistic practices is not new, having had, in previous moments of history, a determinant action. However today, the way these practices can contribute to a reinterpretation of the world can be the differentiating element in the specifics of the present moment.

Community arts practices

In the wide range of possibilities in the field of participatory artistic practices, we can consider the interaction with a work by the public, or the research of stories by a group of professionals into communities, and even the involvement of these communities in all the phases of a creative process. These different approaches fulfil objectives and processes, and have different consequences regarding the different actors and levels of participation. This reflection focuses on the artistic community practices, based on the experience of some theatrical groups in Brazil and Portugal. Here, these practices are focused specifically on the performing arts, namely the theatre, for their connection to the concepts of justice and politics inherent in Ancient Greece and the more recent currents of collective creation (e.g. devising theatre, theatre of the oppressed, among others). Independently of the legitimacy of the different configurations of participatory artistic practices, the communitarian ones define themselves as having their own field that integrates action and thought based on participation in a process of collective artistic creation triggered by the cultures, identities, stories, traditions, and emotional necessities of the people and collectives which are approached artistically, and configure a dramaturgy (Cruz, 2015; 2019). In this trajectory, the work seeks to develop a critical perspective about the past, a point of view relative to the present, and a projection into the future. In this process, at the same time artistic and collective, in spite of the differences of logic in a more traditional view, consideration should be given to the involvement of participants in all phases, as well as to the aesthetic elements and

community life, questioning who determines them and how they are determined. A potentially transformative aspect that crosses these processes is the space of tension between political and artistic, rejecting an attempt at accommodation in this relation. In this sense, Bishop states that "art and the social are not to be reconciled or collapsed, but held in continuous tension" (2011, p.6). This connection is inevitable and exists even before art attempts to deny this relation (Rancière, 2005), ending the recurrent discussion between the concepts of "art for art" and "art with social function". The maintenance of this tension between these two dimensions is crucial, enhancing the participatory, heterogeneous, decentred aspects, and the reinterpretation of channels for social change and network collaborations that are designed as strategies of resistance and must be analysed as the art of today. In this regard, it is no accident that cultural innovation is valued today as the invention of sensations and relationships. It is enough to consider it as one of the keys to economic growth of the last 20 years. This is a fundamental point when one approaches these practices that can very easily serve a false consensus, or the maintenance of social and artistic statutes and a kind of "aesthetic messianism".

These practices assume different terminologies, closely related to their hybridity, referring essentially to similar epistemological and methodological approaches, albeit with idiosyncrasies related to diverse social, cultural, and historical contexts. However, these different designations manifest, in a denser analysis, common elements as will be discussed later. According to Van Erven (2001), they can be found almost all over the world and involve artists and non-artists, in the sense of non-professionals in the field, meaning, they do not make their survival dependent on this action. Organizational strategies, concerns, and methodological elements are generally shared and are realized in an alternative space of creation in which those involved come together for the purpose of creating artistic objects, in most cases unstable and open. Regarding the same logic, for Prentki and Preston, in the field of applied theatre, another possible designation, is considered:

> A wide range of theatrical practices and creative processes that take participants and audiences beyond conventional and mainstream theatre into the world of a theatre that responds to ordinary people, their stories, their locations and priorities. The work happens almost always in informal spaces, in non-theatrical places, in a variety of geographic and social environments: schools, street, prisons, community centres, housing complexes, or any other place that may be specific or relevant to the interests of the community.
>
> *(2009, p.9)*

In this field, the contribution of Augusto Boal is unavoidable. The Theatre of the Oppressed is considered, integrated to a broader movement of popular theatre, a method that synthesizes exercises, games, and theatrical techniques with the objective of the physical and intellectual de-mechanisation; the "test" of alternatives for solving situations of everyday life. It focuses on the stimulation, discussion, and problematization of situations of oppression in a reflexive logic regarding the power relations that characterise human interactions (Boal, 1977). Supported by Boal's idea that everyone can be an artist, Matarasso defines these practices as those involving professional artists and non-professional artists, emphasizing the relevance of "a theoretical and aesthetic structure that guides who is involved; the duration in time, based on the principle middle and end; and the presentation of the creation" (2017, p.2). Applying the concept of performance to the community logic, Cohen-Cruz opts for the designation of "community-based performance" considering it:

> A response to a collectively significant subject or circumstance. It is a collaboration between an artist or a group of artists and a community in which the community is

the main source of the text, possibly also of the actors, and definitely of much of the public. Therefore, the centre of community-based performance is not the individual artist, but the community constituted through a primary local-based shared identity.

(2005, p.2)

A fundamental movement to be invoked, through a connection to this field, is artivism, defined as a form of participation that differs from the idea of violent action traditionally associated with activism. Artivism intersects with territories of social protest and the political dimension of art with the purpose of highlighting politically-significant social situations (Raposo, 2015). This movement arises from the growing connection between contemporary art and politics, debating the limitations of the system in the face of political criticism.

These approaches, among others, highlight several common points that seem to be equally present in the cases of the groups that inspire this reflection. Artistic community practices are generally developed in communities where groups are established, or with which they maintain relations, and are based on the participation of those involved in the various phases of the creative process. This method of work is positioned on principles of collective creation, involving non-professionals in the creation of horizontal relationships with professionals. The identification and research of the themes emerge from the daily life of the participants and the communities, considering the various layers they cover, and taking into account procedural aspects inherent in collective creation: joint decision making, a balance between collective and individual achievements, and a sense of belonging and solidarity. These practices seem to be settled within a continuous and systematized relationship with the territory, highlighting social, historical, economic, cultural, and political characteristics.

In general, studies in this area divide these practices into two broad lines: orientation towards the process, defining participation as the goal; or orientation towards the outcome by looking at participation as a means. In the paradigm followed in this reflection, the main dimensions are based on the studies and my professional and research experience that call for an orientation towards the process, considering the result (in this case the shows) as one of the phases of this process. First of all, there are diverse forms of participation that look towards a transition from passivity to proactivity, considering all the participants as necessary and contributing something particular to the process. These practices are not compatible with the concealment of rules and objectives, determined exclusively by professionals. This posture contributes, essentially, to perpetuating socially-established power relations. On the contrary, the transparency and discussion of all the conditions from the outset is fundamental to the process. Another aspect, closely related to the previous one, is the orientation of the processes towards the result (the show), or in the other extreme for the development of the process. This guidance also takes into account individual and/or collective achievements of the professionals and/or non-professionals, as well as of the institutions involved. The definition of the theme, how it is handled, which themes are identified, and how all the research around these is constructed is equally crucial and recurrent. One of the most referenced aspects is the professional to non-professional relationship. It is essential to take into account what kind of relationship this is, what roles are assumed and by whom, the basis of the logic of creation and the collective organization. The spaces where this type of practice takes place also play an important role. For instance, where the rehearsals and the presentations take place, and what meanings are associated with them, raise pressing issues of public–private and centre–periphery relationships. The spatial dimension is also linked to access. In addition to the economic issues that are decisive, there are also the symbolic ones of access and identification, or lack of identification, with certain spaces that interfere in the relationship established by those involved and the communities in general.

Community arts practices in Portugal and Brazil

The choice of the experiences analysed in this reflection is related to several factors. In the first place, the contexts of Portugal and Brazil arise in an organic sequence that is related to my professional experience, training, and research (Bezelga, Cruz & Aguiar, 2016; Cruz, Bezelga, & Menezes, 2020). The proximity between the two realities in the field of community arts practices has several explanations which go beyond the object of this text, but, for example, include the influence of the actions of Augusto Boal during exile in Portugal, at the time after the Portuguese revolution in 1974. The choice of groups is related to the presence of common aspects in both experiences, despite the different contexts, from an ethical, aesthetic, and methodological viewpoint. However, it is important to note that this is not a comparison between cases, but rather the identification of some recurrences in cases of this nature.

The case of Pele

This reflection engages the Portuguese experience starting from the work developed by Pele[5] in the city of Porto since 2007. This approach specifically focuses on the Map project that brought together five theatre groups over seven years, based on the continuous actions of this collective. The members of these groups[6], in the context of regular participation, established through a mode of working developed by Pele called Forum, concluded that after each group had developed various processes and presentations, it was time to create a joint show centred on the issues of the city. This project began in 2013, exploring a specific situation experienced in Portugal. At that moment, the country had just made a request for a bail-out from the IMF[7] and the European Union, following what happened with Ireland and Greece with all its consequent implications. The Portuguese government implemented a series of austerity measures unprecedented in the country which had very significant impacts on the life of the population. The participants of Map took into account their characteristics – the majority were unemployed, beneficiaries of social grants (RSI)[8], residents of social housing complexes, or retired people who felt in their daily lives the cutting of social rights. This reality crossed the whole process, fuelled the research, the form that the show took, as well as the performance of those involved[9]. This scenario also encompassed the beginning of the accelerating gentrification process in Porto, following an increase in tourism motivated by different factors. All these elements contributed decisively to the project being created as a space to raise the concerns and urgencies of the different stakeholders. Themes were addressed synthetically including the isolation of the elderly, the economic difficulties of families, environmental problems, difficulties in accessing public transport in the peripheral areas from which participants came, the rising unemployment rate, the exponential increase in house rent, a demolition of part of a social housing complex, among others (Cruz & Serafino, 2016). For each of these situations, it was proposed, throughout the process, to think of possible solutions for the resolution of these issues; concrete possibilities so that the narratives were not crystallized into a general disillusionment with the representative political system. Taking into account that the Map involved more than 150 people coming from the musical groups that joined the project in a final phase, the work methodology followed several stages (Figure 35.1).

At first, the groups worked individually, joining only after visits to each of the spaces of the city they inhabited. This phase was instrumental in deconstructing preconceived ideas that the communities had of each other. In the second step, with all the groups together, it was possible to deepen the research and the discussion on the identified themes. To synthesize this work, a drama group was formed by representatives of each collective who later passed the informa-

Figure 35.1 The Map show presented at Casa da Música in Porto, Portugal. (Photo: Patrícia Poção.)

tion to the other members. At the same time, technical workshops (movement and voice) and seminars on different subjects (city and citizenship) were developed, drawing back to a historical perspective, anchored in Ancient Greece, thus reaching the next step – the design of the show. A contemporary approach to Ancient Greece was proposed based on the trilogy of justice, theatre, and citizenship. The groups functioned as the "tribes" who gathered in the *ágoral* (forum) to discuss the city. These "tribes" were attracted by a contest whose prize was the best of all times, even without knowing what it was, symbolizing the maximum will possible to win at any cost. In the space of the *ágora*, the "tribes" were confronted with the fraud that this contest represented and were summoned to a discussion about the city, without the presence of the usually powerful ones. In the end, what emerged was the possibility for citizens to assume their own destinies as well as those of their communities:

> But you changed inside. You are the cities, each one is a city. By joining many inner-cities many dream-cities, the city that belongs to all changes its colours and pathways.
> *(Guimarães, 2015)*

In this process, some aspects should be highlighted. The encounter between different groups and people with heterogeneous characteristics regarding age, socioeconomic level, religion, and background. This diversity in confrontation, discussion, and construction is one of the potentialities of this type of practice and, in general, necessary for the functioning of democracies. The place that the word occupied in this project was also very relevant, taking into account the bad relation with this dimension, mainly in the written register, of the majority of those involved. The connection with a playwright, who collaboratively composed the final text in a continuous dialogue with what the corporeality and orality proposed, was fundamental. Another aspect to

be highlighted was the occupation of places symbolically associated with a culturally legitimized circuit (the National Theatre of São João, the National Theatre of Maria II, and the Casa da Música) as well as the presence of politicians exercising public functions that allowed the writing up of the discussion and the opportunity of this being heard by other interlocutors.

Furthermore, the work based on the choir, supported by a strong musical component, was important. The chorus initially allowed the comfort of being integrated into a collective body at the moment of action and of the engagement with the text. To do so, the choreographic scheme, the costumes, and the scenography, which reinforced the consolidation of the text using memory associations, were relevant. In a second moment, after the sedimented words, it was possible to ease the work of choir, that is, each one assumed its singularity in the collective choral movement. They replaced the costumes with the participants' everyday clothing and the diminished scenic elements, approaching more a proposal for the *performance*. Finally, the feeling of being capable, of overcoming, and appreciating is one of the most present aspects of this project:

> MAP gives voice to the common citizen to be able to say what you feel on your skin. It is citizenship.
>
> *(E.S. – participant in the project)*

> We do not have all the solutions, we are not illusionists. But if we are able to get people to think, it has already been worth it.
>
> *(J.B. – participant in the project)*

The case of Mexe: The International Art and Community Festival

There were several consequences of the creation of Map, and it is important here to emphasize a difference in its configuration, the area of cultural programmes in the case of Mexe - The International Arts and Community Festival[10]. Based on the methodology of the Map project, and understanding the cultural programme also as a creative process, participatory procedures were developed in the conception and implementation of this project taking into account the skills developed and the adaptation to the reality of a cultural programme. It reinforced the idea that a cultural programme is designed as a drama, using the same elements and inviting artistic proposals which are coherent with one another (Figure 35.2).

Presently, based on this continuous work, this encounter is organized as one of the inescapable references in Europe to community arts practices, globally following a community scheme. Generally, the members of the various groups associated with Pele participate with the team of professionals in the various fields of the Mexe: programming, production, design, communication, reception of groups, etc. This experience, which has been consolidated and reflects the ways the encounter is configured and presented, having focused mainly on public spaces and guaranteeing access to different audiences, is today a sustainable element of these and a permanent mode of questioning the city.

The case of Bonobando

This reflection also engages the community arts practices developed in Brazil through the case of the collective Bonobando[11] from Rio de Janeiro. It is important to identify the work of this group in the first half of 2018, a time of particular social and political instability. During this period, military intervention in Rio de Janeiro was ordered, Marielle Franco (a Brazilian politi-

Figure 35.2 Duck March #Porto by Caterina Moroni and pregnant women at Mexe 2019 edition, Portugal. (Photo: Patrícia Poção.)

cian, feminist, and human rights activist) was murdered, and Lula da Silva (former president of Brazil) was arrested. These are some of the events that marked a context of particular difficulty and with obvious consequences in the field of community arts practices. The ways in which the daily life of its members and those of other similar groups was affected determines the configuration and intensity of the obstacles and potentialities that emerge in this type of work. Taking into account that those involved in Bonobando are black youth from different peripheries of the city, critical conditions including declining employment, greater distances to get a job and financial incapacity, to pay, for example, for public transportation, have affected the group. In addition to these aspects, state support for this type of project has been intensively reduced, producing an element of instability.

The analysis of this collective is based on the *Monumoments*[12] project, developed in a public space called Tiradentes Square, in the city centre, which proposed a dialogue questioning the statues that refer to central historical moments of Brazil. The actions of the bodies of the black youth in a confrontation with a colonial past offers an alternative approach to the present, one that questions the country's structural social differences, and is one of the distinctive points of this work. In this case, public space is particularly important because of the memories associated with this square, some invisible (e.g. where the *pelourinho*[13] of the city was located) and other visible ones, because they are inscribed in the statues (e.g. the equestrian statue of Dom Pedro I, questioned about the representations of indigenous people). In this square, through this show, elements of the group, a heterogeneous public, institutions represented by the statues, and the police that attend the intervention are confronted. The possibility of challenging dominant narratives and actions with the repositioning of bodies and words in a public space, and consequently rehearsing the reformulation of crystallized power relations, is a powerful production of

alternative narratives. Public spaces as privileged arenas for the exercise of citizenship may have the potential to change, in a poetic way, everyday relationships, and may produce perceptions that transformation is feasible and that reality is not predetermined.

Bonobando assumes, through its actions, a configuration that can fit the characteristics of the artivismo, although this is not how they present themselves. They work horizontally, including all the members in decision-making and implementation. An example of this is how they get involved in organizing a street action before the performance, or how they complement one another in a public intervention at the university. It is also worth mentioning the fact that the collective moves around the city in a transversal and symbolic way, transiting in spaces of power, until recently far from their daily lives (e.g. presentations in theatres, conferences, and lectures at universities and cultural and social spaces). The strong involvement of the members of the group in political actions is also an aspect to be highlighted. In this regard, one must take into account that their political activities were developed, in most cases, before the group was formed, such as active participation in the black consciousness movement. However, these political actions seem to maintain and reinforce themselves with the depth of artistic practices. This tension between the political and artistic is present in the group and the ways they make and present theatre:

> You can engage in politics without theatre, but not the other way around ... So, I think you have to make the relationship to stay in dialogue, stay active ... Theatre is a political tool, a tool to merge stories, to not let stories die, to not erase them as well. I think theatre is very much within politics, a politics of resistance.
>
> *(L.L. – Bonobando member)*

Finally, it is important to mention that the actions of this collective, and specifically the ways in which they are organized, seem to promote development and consolidate personal, group, and community networks.

Conclusions

Reviewing the literature and studies in this field, organized in a synthetic way, and the analysis of the experiences discussed here, allows us to point out some conclusions for this chapter. Based on the procedural dimensions identified here (professional with non-professional relationships, spaces and access, themes, process orientations, and levels of participation) we can think of possible consequences at different levels: individual, group, community, institutional, and political. It should be emphasized that the work inherent in community arts practices traverses these levels, trying to approach them in a dialogical mode based on the diverse potentiality of the actors, realities, and languages.

From the individual point of view, the development of personal capacities related to assertiveness, group work, critical thinking, and decision-making were present. Self-image and its appreciation, through the opportunity to have space for self-affirmation, through body and voice work, seems to be crucial for those involved in these practices. Regarding the group dimension, the process shown here, based on principles of horizontality and creativity, where the contribution of each is both singular and complementary, seems to be fundamental for active participation and possible elaboration in the sense of experimenting with these capacities in other life contexts. This work results, for example, from collective dramaturgy in which rules, opinions, and experiences are valued in the same way. Other examples, including improvisation, listening, and choir work, seem to allow for greater capacity to consider the perspective of the other and the collective decision. These two levels are deeply linked to the community dimen-

sion and are reflected in the way in which the power relations established in the communities can be questioned in processes of creation. The opportunity of communities working together poetically, rehearsing multiple alternative realities, and the emergence of new protagonists in the narratives and actions of these communities should be highlighted (Figure 35.3).

The institutional relationship is crucial in this work, as the issues identified and the ways in which the processes are developed contrast with the more rigid procedures of institutions. However, this relationship should not be denied; rather, it must be understood as part of these practices and something that cannot be misinterpreted but absorbed and transformed. The work in public spaces can be an example of a possible way for dialogue with outside institutions and their traditional limits, looking at other forms of relation. In fact, the difficulty that institutions demonstrate in dealing with complex realities is one of the weaknesses of today's democracies. The experience of creative spaces can then privilege the transposition between the real and the imagined because the process happens in daily spaces, the same ones where change is desired. The relationship with the institutional is also decisive in financial terms and, in a broader way, to the sustainability of the groups.

It is fundamental to structure the different consequences of these practices so that they may (or may not) contribute to broader ways of questioning public policies directly related to them. Taking into account the various aspects identified above, the next step may be to look at these practices not only as a strategy of social inclusion, but in a community setting. That is, not focusing these projects exclusively on the most disadvantaged populations, but thinking of them in a transversal way, approaching a territory with the diversity of people who inhabit it, and provoking a constructive dialogue between different aesthetics and ethics. In this way, the contribution can be in the direction of a broader discussion on the basis that different experiments can develop approaches to alternative modes of social organization.

Figure 35.3 António Bukhar and Faizal Ddamba performance with participants of the workshop at Mexe 2019 edition, Portugal. (Photo: Patrícia Poção.)

These practices can still be regarded as a "pretext" and not as a sort of "magic solution" to social and political problems that often have a structural character. Attributing the changes that occurred exclusively in these practices, without taking into account the other contexts of life, is fallacious and can feed into manipulative approaches. Synthetically, the potential of these practices can be read as one more contribution, complementary to others, that, in an integrated way, can leverage change. However, these projects, while fostering a relationship between the "I", the "others", and the "realities", as experiences suggest, do not solve the more complex problems of today's democracies. Thus, we return to the beginning of this reflection seeking to clarify what the role of artistic creation in the world could be. In this sense, it is crucial to look at the positive and negative aspects of these practices, not leaving aside the opportunities to celebrate and connect with the "other" and the communities, against a background that crosses the traditional and contemporary, the real and poetic.

Notes

1 Director, Cultural Programmer, Artistic Director of Mexe – The International Art and Community Festival and *Mira Artes Performativas* – Porto, Portugal. Co-founder of PELE and Nomad, Art and Pubic Space. Invited professor at several national and international universities. Doctorate fellowship of the Science and Technology Foundation (Ref. PD / BD / 128117/2016) at the Center for Research and Educational Intervention (FPCEUP). Researcher at the Center for History of Art and Artistic Research, University of Évora. He frequently publishes in the area of "artistic creation and public space", "artistic creation and participation", and "community artistic practices". We highlight the coordination of the book *Art and Community* edited by the Calouste Gulbenkian Foundation (hugoalvescruz@gmail.com).
2 Translator's note: *Geração à Rasca* literally translates as the "Generation of Scratches", though commonly translated in English as the "Struggling Generation", referring to those who participated in the anti-austerity protests in Portugal in 2011.
3 Translator's note: *secundaristas* are the so-called students from secondary schools or high schools.
4 Translator's note: Hardt and Negri (2014) characterize the "destituent process" in contrast to a constituent one as "a kind of exodus from the existing political structures".
5 The Pele is an artistic structure that from its origin sees artistic practice as a privileged space of dialogue and collective creation. It focused its work processes on the principle of inviting individuals and communities to the centre of creation, fostering individual and collective "empowerment" processes, and striking a balance between ethics, aesthetics, and effectiveness. Its objectives are to promote artistic projects that allow human development, integration and the affirmation of citizenship; designing and producing projects with distinct languages in specific communities and contexts of social exclusion; to foster artistic creation, experimentation and innovation in the context of different communities; to combat cultural centralization, promoting art, not only in the form of shows, but also as a process of creation within the most excluded contexts, such as social housing complexes and prisons (Retrieved from www.apele.org)
6 The five groups involved in the Map project were: age group (a theatre group of the oppressed constituted by youth); the Auroras group (a theatre group of oppressed women) based in Lagarteiro (a social housing complex in the eastern periphery of the city characterized by a large number of residents with single-parent female families); a community theatre group Em Comum based in Lordelo do Ouro (a social housing complex in the western part of the city of Porto very affected by the closure in recent years of several factories in the area); a community theatre group in Vitória (Porto's historic centre, characterized by elderly, isolated, and low-skilled residents); and the Porto deaf theatre group.
7 The International Monetary Fund.
8 Translator's note: the Rendimento Social de Inserção (RSI – Social Integration Income) in Portugal provides both cash grants to low-income individuals for basic needs along with support for social and professional integration (see - https://www.economias.pt/rendimento-social-de-insercao/).
9 The Map process, a show with artistic direction by Hugo Cruz, is documented in the movie *Citizens of The Whole Body* (*Cidadãos de corpo inteiro*) by the director Patrícia Poção, available and subtitled in English and Spanish. This project also has a written record by Ana Luísa Castelo and a dramatic text by Regina Guimarães published in the book *Map: The Game of Cartography (Drawing in Words)*. To access these materials, contact the author of this text via email.

10 Mexe – the International Art and Community Festival has been recognised throughout its four editions (2011, 2013, 2015 and 2017) as one of the spaces, national and international, essential for the crossing and deepening of the community arts practices. In previous editions, Mexe included more than 1,500 participants from 22 countries and more than 20,000 spectators in 130 actions that occupied 30 distinct spaces of the city of the Porto. (Retrieved from www.mexe.org.pt)
11 Bonobando (Bando de Artistas Autônomos) was created in 2014 from the experiences lived in the Artistic Residence of Laje Theatre in Penha. Its elements come from various parts of Rio de Janeiro and take as a central action the connection of the city and the occupation of spaces. Its objectives are to contribute to the dynamic territorialization, decentralization, and democratization of resources and access to arts and culture, celebrating and showing the contribution that the daily practices of youth from the outskirts of Rio can give to the creation of another possible theatre. (Retrieved from https://www.sympla.com.br/bonobando)
12 In the synopsis, one can read, "What if our monuments spoke? What if our monuments could be reinvented? What if our story was told by ourselves? What would they say, what would they be, and what would she say? Monumoments is an action that subverts the monuments of Tiradentes Square, creating a counter-monument action" (retrieved from https://www.facebook.com/pg/coletivobonobando/posts/?ref=page_internal).
13 Translator's note: *pelourinho* were spaces for public punishment of criminals or the commerce of slaves.

References

Bezelga, Isabel, Cruz, Hugo, & Aguiar, Ramon. Research in Theater and Community practices: perspectives from Portugal and Brazil. [La investigación en prácticas de Teatro y Comunidad: perspectivas desde Portugal y Brasil.] *Investigación Teatral-Revista de Artes Escénicas y Performatividad*, v. 6, n. 9, pp. 8–26, 2016.
Bishop, Claire. Participation and spectacle: Where are we now? Lecture for creative Time's living as form. 2011. Disponível em: <http://dieklaumichshow.doragarcia.org/pdfs/Bishop.pdf>. Acesso em: 21, nov., 2018.
Boal, Augusto. *Técnicas Latino Americanas de teatro popular*. Coimbra: Teatro Centelha, 1977.
Borba, Julian. Participação política: Uma revisão dos modelos de classificação. *Sociedade e Estado*, v. 27, n. 2, pp. 263–288, maio/ago. 2012.
Cohen-Cruz, Jan. *Local acts: Community-based performance in the United States*. London: Rutgers University Press, 2005.
Cruz, Hugo (Coord.). *Arte e comunidade* [Art and Communnity]. Lisboa: Fundação Calouste Gulbenkian, 2015.
Cruz, Hugo (Coord.) Art and Hope. Lisboa: Calouste Gulbenkian Foundation, 2019. https://gulbenkian.pt/en/publication/arte-comunidade-percursos-da-iniciativa-partis/
Cruz, Hugo & Serafino, Irene. Theatrical creation in Portugal in the context of community artistic practices. [A criação teatral em Portugal no contexto das práticas artísticas comunitárias.] *Revista SubTexto*, v. 8, n.12, pp. 170–189, 2016.
Cruz, Hugo, Bezelga, Isabel & Menezes, Isabel. For a Typology of Participation in Community Artistic Practices: the experience of three theater groups in Brazil and Portugal. *Revista Brasileira de Estudos da Presença, 10*(2), pp. 1–30, 2020. https://www.scielo.br/pdf/rbep/v10n2/en_2237-2660-rbep-10-02-e89422.pdf
Dardot, Pierre & Laval, Christian. *Comum: ensaio sobre a revolução no século XXI*. São Paulo: Boitempo, 2017.
Erven, Eugene van. *Community theatre: Global perspectives*. London: Routledge, 2001.
Guimarães, Regina. Mapa_o jogo da cartografia. In: Cruz, Hugo (Coord.). *Map_the game of cartography: drawing in words*. [Mapa_o jogo da cartografia: desenho em palavras]. Porto: PELE, 2015.
Harvey, David, Teles, Edson & Sader, Emir. *Ocuppy: Movimentos de protesto que tomaram as ruas*. São Paulo: Boitempo Editorial, 2012.
Matarasso, François. A restless art: participatory art in a changing world. A Restkess Art: how participation won, and why it matter. 2017. Disponível em: <http://arestlessart.com>. Acesso em: 10, mar., 2018.
Menezes, Isabel, Jesus, Maria Fernandes, Ribeiro, Norberto, & Malafaia, Carla. Agência e participação cívica e política de jovens. In: Menezes, Isabel, Malafaia, Carla, & Ribeiro, Noberto (Orgs). *Agência e participação cívica e política: Jovens e imigrantes na construção da democracia*. Porto: LivPsic, 2012, pp. 9–26.
Negri, Antonio & Hardt, Michael. *Declaração: Isto não é um manifesto*. São Paulo: n-1 Edições, 2014.
Prentki, Tim. Contranarrativa – Ser ou não ser: Esta não é a questão. In: Nogueira, Maria Pompeo (Org.). *Teatro na comunidade: Interacções, dilemas e possibilidades*. Florianópolis: Udesc, 2009, pp. 13–36.
Prentki, Tim, & Preston, Sheila (Eds.). *The applied theatre reader*. London and New York: Routledge, 2009.
Putnam, Robert. *Bowling alone: Collapse and revival of American community*. New York: Touchstone Books, 2001.
Rancière, Jacques. *Estética e política: A partilha do sensível*. Porto: Dafne Editora, 2005.
Raposo, Paulo. "Artivismo": Articulando dissidências, criando insurgências. *Cadernos de Arte e Antropologia*, v. 4, n. 2, pp. 3–12, 2015.

36
CORE OF NORDIC APPLIED THEATRE
Challenges in a subarctic area

Rikke Gürgens Gjærum

Nordic applied theatre takes place outside the traditional theatre institutions and focuses on social, political or educational aspects where the aesthetic form, thematic content and the locally situated context of the theatre medium are the central focal points. The issues faced by Nordic countries are thus reflected in such theatre practices. This may include the much-talked-about age wave and challenges with dementia, theatre projects related to the refugee crisis, Sami affiliation and identity in the subarctic regions, or normality and social exclusion in disability theatre.[1] The organizing and financing of applied theatre varies between the Nordic countries due to different national, cultural and social policy guidelines and different educational opportunities (Gjærum, Ineland & Sauer, 2010). The Drama Boreale organization, however, ensures knowledge transfer across the Nordic countries by organizing seminars and conferences.[2]

As an umbrella term, applied theatre does not primarily represent "performance art" as an art innovation, but bridges the gap between locally-situated aesthetic practices, the social and epistemological significance that such practices are able to achieve (Gjærum & Rasmussen, 2012). Applied theatre often involves people from marginal positions (from a given location within a cultural framework) as co-researchers in the aesthetic creation process. One may understand Nordic applied theatre in the light of the inclusive arts because democracy and equality have a strong position in Nordic countries.

This chapter describes and analyzes Nordic applied theatre as an art of didactically, socially and ethically involved theatre. A selection of field examples where the vulnerability is staged will be analyzed in a place-philosophical perspective where we enter four different rooms: The activity room, the objectively-given room, the sensed room and spatiality. All rooms are set in the framework of the Nordic welfare model.

What is the Nordic context?

The Nordic region is a historical-geographical common denominator comprising Denmark, Norway, Sweden, Finland, Iceland, the Faroe Islands, Greenland and Åland. These countries have common linguistic, cultural and historical features. The Nordic countries have, over the years, developed a collaborative platform to solve complex challenges in society.[3] Collaboration is linked by the Nordic Council of Ministers through ten thematic initiatives: Language compre-

hension,[4] democratic competence,[5] research,[6] early and inclusive efforts in education systems[7] (Hadnagy, 2016), lifelong learning,[8] entrepreneurship and innovation,[9] digital competence[10] (Bocconi, Chioccariello & Earp, 2018), sustainable development,[11] mobility[12] and recognition of qualifications.[13] These ten initiatives all relate to what the Nordic countries refer to as the social democratic "welfare state". That is, a state that guarantees all citizens of the community the right to free education and assistance should they experience health problems, social distress or loss of income. This way of organizing a society also has consequences for applied theatre (Heggstad, Rasmussen & Gjærum, 2017; Gjærum, Ineland & Sauer, 2010), for the so-called "Nordic welfare model" refers to more than the welfare state. "The model is about a distinctive interaction between public policy, the market, family and organizational life … [thus] a social affiliation and cohesion system, a political system and a cultural system" (Hvinden, 2009: 2).

Marginality

Nordic applied theatre is concerned with destigmatizing the marginal by breaking down the boundary between majority society and marginal groups. The Nordic field is concerned with normalizing the general human experience of "feeling socially excluded" and counteracting status differences (Torrissen et al., 2017; Aurne, 2017; Lilletvedt & Myklebust, 2017; Heggstad & Heggstad, 2017; Ineland, 2007; Sauer, 2004). A marginal voice is a voice we can all have. It is a contextual voice that may feel strong yet is hardly heard in public. The involuntary social exclusion can be recognizable in any human life. Per Fugelli, Professor of Social Medicine, claims that man is an innate malconstruction (Fugelli, 2015). He considers all people, on a profound level, as equals, regardless of diagnosis, health and function, and he reminded us that we all have a predisposition, a defect, a rust spot on the soul or a scratch in the paint. Today's Western society is characterized by an ever-increasing focus on appearance, success and streamlining. We also see an increase in the Nordic population in terms of lifestyle diseases, anxiety and depression (Sund, Rangul & Krogstad, 2019), as well as greater income disparities and the development of relative poverty (Omholdt, 2016). In this context, applied theatre is emerging as a potent arena for inclusion and interaction (Storsve, Rasmussen & Gjærum, 2019).

We can all be the one who does not fit in, the one who appears abnormal in the gaze of the community (Aurne & Gürgens, 2015). Different contextual sentences will thus produce a myriad of marginal voices, of marginality and marginal groupings of different kinds. Counteracting marginalization is a pervasive theme in Nordic applied theatre practices, because marginalization involves an undesirable situation in a social democratic welfare state, i.e. a degradation of you as a human being or exclusion from a social context: "He is regarded as an *outsider*" (Becker, 1963: 1).

Conceptual clarification in a Nordic context

In the Nordic languages, the term *drama* applies in relation to fiction, role and fable, and is used both about drama-pedagogical procedural work and about the manuscript itself for a theatrical performance.[14] The term *theatre*, on the other hand, can mean two things in the Nordic languages. Either the institution itself that presents performances/events or:

> a live performance or event that takes place in real time and in the same room as living people involved both on the side of actor and the spectator. The audience plays a more or less interactive role in the performance and in the stage energy, something which implies a response loop from the audience to the stage and back.
>
> *(Gran & Gjærum, 2019: 12)*

The art of making things possible is called *facilitation*. The term comes from the Latin "facilis" that means "to ease". A facilitator thus makes it possible for team members to exchange ideas and find solutions, thus achieving something they would not have accomplished equally well on their own (Solem & Hermundsgård, 2015). According to John Heron, facilitation can be divided into six dimensions: Planning, meaning, confronting, feeling, structuring and valuing (Heron, 1999). The facilitation of applied theatre is about creating and maintaining a safe space for equal dialogue between the actors, promoting creativity and ownership towards common goals, and also to facilitate productive and impartial meetings (Ellinggard, 2015).

The term "applied theatre" in the Nordic countries is used for projects in which one plays for, about and/or with actors who reside outside the mainstream art institutions, such as nursing homes, schools, disability care, psychiatric care, prisons, kindergartens, refugee centres, libraries, local cultural centres or in inclusive art practices. Here, the importance of facilitator competence, target group analysis and ethical considerations is strongly emphasized (Enoksen, 2017). Applied theatre as a concept did not gain a foothold in the Nordic countries until Helen Nicholson's (2005), Phillip Taylor's (2003) and James Thomson's (2003) textbooks appeared on the curriculum in drama/theatre studies.

In 2019, we saw a theatre landscape in great change in the Nordic region, a process which will have consequences for applied theatre practices in the future. We are in the midst of a technological revolution, and cultural area by cultural area is subject to the conditions of digitalization (Gran & Gjærum, 2019). The Nordic theatre field has consisted of three rather different sub-fields: institutional theatres, private theatres and free groups. Today, however, we see ever closer interaction, exchange and overlapping networks between the fields, although they are financed differently and are based on different historical traditions, organisational structure and organisational culture. Among other things, we see a tendency for well-functioning close teams of artists to enter the institutions with new methodology during project periods. The fields no longer have waterproof bulkheads. In our time, cross-aesthetic forms, alternative playing styles and a greater degree of audience involvement are developed (Berg, 2018). We also see how documentary theatre (Aurne, 2017), reminiscence theatre and citizen theatre are becoming more common. The working methodology we recognize from traditional applied theatre practice is further institutionalized and aestheticized (Gran & Gjærum 2019). An increasing number of productions at both the major institutional theatres and in the free groups stage performances with "ordinary people" on stage. A good example is the Danish theatre company Fix&Foxy's productions such as *Pretty Woman* and *A Doll's House in Ordinary Homes*.[15] We also increasingly see representatives from so-called "marginalized groups" performing together with professional actors in productions, such as those by Martens & Goksøyr, Kjersti Horn or at Reykjavik Þjóðleikhúsið. The audience is facilitated in our time to a greater degree of participation. Children and young people are invited into productions, and "backstage-stage" discussions, reflection groups or café dialogues are organized to bring fiction and reality together.[16]

In light of art didactics

Applied theatre as an art of didactic practice deals with, or involves, marginality in various forms. Nordic applied theatre may be viewed in light of the concept of relational and "performative art didactics": "The contemporary ambiguous, multi-faceted, relational, performative and context-oriented art didacticism that paves the way to a dynamic and situated topos for dissemination" (Aurne et al., 2013: 14). This didactic approach is characteristic of applied theatre projects and is used in facilitating a mediation situation understood as a didactic meeting between three

instances: performance/ presentation/event; the observer as co-creative actor; and facilitator/ educator/artist (Aurne, 2013).

In the communication situation, the applied theatre facilitator enters what one may choose to call *the activity room* (Pahuus, 2015). This space underlines the fact that everyone involved in the art didactic context is always an actor; active co-creators of the events that occur in the meeting between them – events that may be experienced as aesthetic experiences (Dewey, 1934). In this sense, we understand the art didactics of applied theatre as a form of relational aesthetics (Bourriaud, 2007). The activity space is closely linked to life itself: "The most basic form of the activity room is the room of the living – a space that can assume the different forms … determined by the human body and by human needs" (Pahuus, 2015: 123).

As an applied theatre facilitator, one exercises professional judgement in art didactic assessments in the face of people with different life experiences. Discretion is contextually contingent and linked to human intuitive sensation, cultural norms, values and silent knowledge. Art didactic processes in applied theatre may be perceived in light of Aristotle's (2013) concept of phronesis.[17] Then the processes can be understood as sensory, relational and intuitive. They are thus culturally and contextually conditioned. In a Nordic theatre context, we can see that the Nordic welfare model plays a role, though in different ways. We find dividing lines between the Nordic countries. Therefore, let us dive into a comparative study of Norwegian and Swedish Disability Theatre to illustrate the contextual differences.

Applied theatre and disability

In Norway, the national cultural policy governs applied theatre for people with disabilities,[18] while in Sweden it is the health and social policy. The consequence thereof is that in Sweden, funding is earmarked for this purpose, giving day care centres, etc. the task of initiating such projects as part of the comprehensive care that the welfare state offers (Gjærum, Inland & Sauer, 2010). An example is the Ållateatern theatre (for people with intellectual disabilities) in Sundsvall, which for years has staged classics such as *Romeo and Juliet* and *Carmen*.[19] This group is respected in Sweden and has gradually gained national and international attention (Sauer, 2004). The Disability Theatre hires professional theatre instructors and is considered by the public as both art and therapy (Ineland, 2007; Solvang, 2010). Cultural logic values the actors' otherness from a purely artistic point of view, while therapeutic logic categorizes actors primarily as clients in the welfare state. This Swedish applied theatre project is funded by the welfare state of Sweden because it contributes to education, mastery, identity development and affiliation (Ineland, 2007; Sauer, 2004).

In Norway, however, such funds are not earmarked for Disability Theatre and it is therefore up to voluntary enthusiasts or theatre institutions to fund and organize such projects (Gürgens, 2004; Gjærum et al., 2010). Nevertheless, so-called cultural democracy (Gjærum, 2017) is the goal of Norwegian cultural policy today and has been since 1973. With the new parliamentary White Papers in 1973–1974, we got a cultural concept that embraces both art, leisure, sports and outdoor activities. The view of art that underlies the idea of cultural democracy and the expanded concept of culture is open and wide. But no matter the parliamentary White Paper buzz words such as diversity, inclusion, cultural democracy and freedom of speech, the reality of Norwegian cultural life today is characterized by stronger elitism and categorization (Gjærum, 2008). The latest parliamentary Cultural White Paper, Meld. St. 8 (2018–2019) *The Power of Culture: Cultural policy for the future*, says nothing about specific investments in art for and with people with disabilities. However, the Cultural White Paper states that "the Ministry of Culture assumes a broad understanding of the diversity concept that comprises several dimensions", but the way the concept of diversity is operationalized

in the Cultural White Paper still does not appear to include people with disabilities (Meld. St. 8 (2018–2019)). In the White Paper, diversity and multiculturalism are only associated with immigrants, indigenous peoples and so-called "national minorities: ... Jews, Kvens/Norwegian Finns, Roma (Gypsies), Romani people/Norwegian and Swedish Travellers and Forest Finns are accepted as national minorities in Norway" (p.76). The priorities in the Norwegian Cultural White Paper do not include people with disabilities in general or with intellectual disabilities in particular,[20] despite the fact that these citizens are and always have been part of the natural diversity in Norway (Gjærum et al., 2019; Gürgens, 2004; Gjærum 2008). We see that in a Norwegian context, national and ethnic minorities are given cultural and economic priority, which will have consequences for applied theatre projects such as Dissimilis[21] (Henningsen, Berkaak & Skålnes, 2010; Gjærum, 2008). The Nordic welfare model thus has two completely different effects in Sweden and in Norway in terms of organizing and financing different forms of applied theatre.

Location-specific rooms

The art didactics of applied theatre practice enable several forms of *objectively-given spaces* where projects can be carried out. Let us consider two examples, one from a hospital and one from a prison. We can think of applied theatre brought into the hospital as an objectively-given space – that is, into the hospital-clown's sensational-empathetic universe.[22] In this setting, the art didactics create meetings between people in the body of the hospital, understood as the hospital's architectural building mass, but also the patient's body, a body that holds a marginal voice that is under medical treatment. Art didactics thus become – through the hospital clowns – the meeting point between the sick and the healthy in man: "Everyone who is born holds dual citizenship, in the kingdom of the well and in the kingdom of the sick" (Sontag, 1991: 3). All people can get sick. However, it is important to point out that the sick person also has a healthy half that needs nourishment and comfort in order to give strength to heal the sick side (Gjærum & Kinn, 2016). The hospital – the "sick-house" (in Norwegian) as an objectively-given space – has inherent drama in the site-specific dramaturgy and scenography (Brodzinski, 2010). Thus, the health institution is not "the empty space" (Brook, 1995: 11). It is a landscape filled with social meaning; with fear, power, expectation and hope (Foucault, 1972: 166). Human warmth, sensation and dialogue extend the scenic framework for the objectively-given space when the hospital clown shows us what applied theatre can be in a hospital.

We also find applied theatre projects in Nordic prisons.[23] Today, several different free groups operate by playing for or with the prisoners, such as the Vardeteateret in Norway. In Nordic countries, the use of theatre in prisons increased with the help of, among others, the Swedish pioneer Jan Jönson. He staged *Waiting for Godot*, first at the Kumlaanstalten in Sweden and later in the USA. Through Beckett's drama he explored, together with inmates as actors, the waiting situation and existence as a lifetime prisoner, in the early 1990s.

Other applied theatre projects bring the stories of prisons into the community outside the prison walls. An example is the project 'The Quadruple Room', created by Karoline Enoksen (2017), which toured secondary schools under the auspices of "The Cultural Schoolbag" (*Den Kulturelle Skolesekken*).[24] The theatre performance is based on interviews from Norwegian women's prisons.[25] Four young actors communicate the women's stories and stage in a documentary manner difficult life choices, coping with everyday life and a situation beyond their own control. The students who experience the performance are reminded of the challenges of making choices that prove to be fateful, they get a sense of what it means to be in marginalization processes, and are reminded of the systemic differences between female and male inmates in Norway.

Spatiality

To sense means to perceive, feel, observe and experience. Sensation is about sensory recognition (Gadamer, 2012). However, the term "to sense" is often used when referring to experiences we cannot quite put into words or point to as clear, distinct signs. We sense when we feel that something is happening, as if the body internalizes the world and lets the sensation mature until we have analyzed the experience, placed it and become able to put it into words.

The activity room is the place where one as an active being participates in interaction with others in joint exploration, often with a desire to move on in a purposeful action that provides recognition or mastery. Then the needs of the body and the possibilities of man are the only limitation in the space of living where we are going, directed towards something (Pahuus, 2015). *The sensed room*, on the other hand, is the place where one can tacitly be inside oneself and where the experience is subjective, bodily and emotional. One does not depend on others in the processing of the experience in one's interior. According to Pahuus (2015), the sensed room is closely related to "dance" or "hike" in the outdoors. Here, the distance is not the goal itself; one can move crosswise, one can dance backwards and in circles, the essence becomes "dimensions such as width and depth – and a shift between the open versus the closed" (Pahuus, 2015: 127).

The last room we can reach through applied theatre projects as observed from a place-philosophical perspective is *spatiality*. Spacious means far-reaching, solid, rugged, powerful, bulky and comprehensive. The concept thus exceeds the boundaries of a *closed room*. Thus, spatiality is opening, welcoming and transboundary. When people reach spatiality, it provides tranquillity. For spatiality, claims Pahuus (2015: 133), is about returning home. Man always longs for "home", for belonging and thus for human existence in the place (Norberg-Schulz, 1978). The home represents the safe roots we require to be able to face challenges with confidence in our own lives. Only when we can give room to others, create dialogue rooms between the known and the unknown, will we as human beings reach the *spatiality* of life. What, then, does "spatiality" entail for applied theatre projects, for the facilitator, the artist and the audience? Let us consider the example "Blodklubb", which can be understood as both performance art and an applied theatre project, in the meeting between culture and genetics. The title of the project comes from the dish *Gumbá* (a kind of blood sausage), which is the feast food often served on the Sámi National Day.[26] The quartet behind the project has Sámi/Finnish/Norwegian backgrounds and they problematize on stage how we romanticize family background, tradition and culture in Nordic countries, while genetics as an explanatory model is very problematic in a political and social context. They draw the audience into polls and practical exercises, analyze real genetic tests, and the artists claim to conduct what they call "charlatanism". Together, they explore how it: "feels paradoxical to be Sámi, having to relate to an identity and a mindset of belonging that is ultimately a genetically conditioned collective".[27] This concept of regular club meetings puts spatiality to the test when people, as a non-Sámi northern Norwegian audience, are challenged on whether blood is thicker than water, and some types of blood are better suited than others to own ancestral songs and the narrative of living in the circumpolar north.

Challenges ahead

Nordic applied theatre is characterized by the art fields merging, the theatre industries working in more and more interdisciplinary ways and that theatre – as an epistemological forge – is coming more into focus in society. This is due to the need for new reflection rooms in the face of a more complex society with increased social and ecological challenges. An example

of a field in expansion is the nursing home sector due to an increasingly older population, growth in the dementia diagnosis spectrum and a demographic shift in society. Thus, in the Nordic countries (like in many other places in the world),[28] there is a growing need to find alternative aesthetic community work for citizens with dementia. We see the emergence of three different forms of applied art projects for this target group. The first are the *therapeutic* projects in which art is used as a form of activation with clear instrumental medical or social goals such as reducing drug use against anxiety in dementia (Mysja, 2005). The second form is *entertainment value*[29] projects that hire professional musicians and actors, or possibly other older amateur artists, to contribute to meaningful and life quality-enhancing moments for patients with dementia (Heggstad et al., 2018; Rønning, 2017). The third and final form of applied projects in nursing homes is related to *procedural "co-creativity"* work which aims for evenly balanced dramaturgy, actors as equal partners and relational cross-aesthetical art meetings between patients, relatives and improvisational artists in music, visual arts and theatre (Zeilig, West & van der Byl, 2018; Ursin & Lotherington, 2018).

Nordic applied theatre has clear similarities to applied theatre in other parts of the world (Prendergast & Saxton, 2016). Some features of the Nordic countries, though, can be viewed in light of national, regional and local power structures and location-specific challenges. The basic motives in applied theatre are the same in the Nordic countries: degrees of *participation* by the artist, the facilitator, the actor and the audience; different *aesthetic* genres, styles, methodologies. There are a wealth of *ethical* dilemmas with regard to thematic issues that may be processed by the participating actors and a need for *evaluation*, feedback, impact measurement or post-reflection on complex projects with often delicate topics.

Notes

1. Arnesen & Gjærum, 2017; Heggstad, Rasmussen & Gjærum, 2017; Rasmusse & Gjærum, 2010; Gjærum, 2013a, 2013b, 2015, , 2017.
2. http://www.openensemble.se/?p=1230
3. https://www.norden.org/no/information/10-innsatsomrader
4. http://www.sprogpiloter.org/
5. https://nordicsafecities.org/
6. https://www.nordforsk.org/no/programmer-og-prosjekter/programmer/education-for-tomorrow-1/education-for-tomorrow
7. https://www.norden.org/no/node/7630
8. https://www.nordplusonline.org/
9. https://www.nordicinnovation.org/
10. https://www.itd.cnr.it/doc/CompuThinkNordic.pdf
11. https://www.norden.org/no/node/7767
12. https://www.nordplusonline.org/
13. https://norric.org/
14. The way a drama is realized on stage through the ages is explored in theatre studies. Literary researchers focus on the dramatic text that is the point of departure for the performance (https://snl.no/drama).
15. https://fixfoxy.com/en/
16. Examples include the Goksøyr and Marten productions at the Norwegian Theatre (https://www.detnorsketeatret.no/framsyningar/dottera/) or Rommen Scene in the Groruddalen suburbs (https://www.rommenscene.no/).
17. Aristotle writes in *Nicomachean Ethics* about phronesis as the ability to act in a wise way, to imagine differently, to see what makes sense to know, to make the right decisions in specific contexts, to justify choices which presume moral virtue.
18. After 1991, with the dismantling of the major central institutions, people with intellectual disabilities should move to their home municipalities, in line with the normalization ideology. From now on they will be treated as ordinary citizens.
19. https://www.svt.se/nyheter/lokalt/vasternorrland/mittnyttjournalister-bakom-alla-dokumentar

20 https://www.dagsavisen.no/debatt/kulturmeldingen-er-ikke-relevant-og-representativ-for-alle-1.1491977?fbclid=IwAR0vwX-rZzqULI2k7JDsq1iL6SCLjuczdL87JtxSkbL8zdXZhOigCxDWN5w
21 The Dissimilis National Competence Centre is experiencing financial cuts from the Norwegian state despite the fact that the private foundation offers arts and culture experiences and high-quality customized education. Measures that the state is obliged to offer to its citizens, which is enshrined in both the Norwegian Culture Act (2007) and in human rights.
22 In Norway there are 16 hospitals employing hospital clowns (https://www.syhushusklovnene.no/her-er-vi/).
23 https://underskog.no/sted/6351_vardeteateret and https://www.dagbladet.no/kultur/kreativ-kriminalomsorg/60169661
24 https://www.denkulturelleskolesekken.no/english-information/
25 https://dks.osloskolen.no/firemannsrommet/
26 https://www.ferskescener.no/forestilling/blodklubben/
27 https://www.ferskescener.no/forestilling/blodklubben/
28 https://www.economist.com/the-economist-explains/2018/08/16/why-universities-for-the-elderly-are-booming-in-china
29 https://www.nrk.no/vestfold/xl/det-er-aldri-for-seint-a-debutere-1.13337170

References

Aristoteles. (2013). *Den nikomakiske etikk*. Oslo: Vidarforlaget.
Arnesen, J., & Gjærum, R. (2017). #KunstInnsatsen: Estetiske erfaringer og skjønnsvurderinger på asylmottak. *InFormation - Nordic Journal of Art and Research*, 6(1), 1–16.
Aurne, V. (2017). Vår frues folk. In K. Heggstad, B.K. Rasmussen, & R. Gjærum (Eds.), *Drama, teater og demokrati. Antologi II - I kultur og samfunn*. Bergen: Fagbokforlaget.
Aurne, V., Bjerkestrand, K.B, & Songe-Møller, A. (2013). Emancipatory theatre and performative didactics. *InFormation - Nordic Journal of Art and Research*, 2(2), 179–198.
Becker, H.S. (1963). *Outsiders*. New York, NY: The free press.
Berg, I.T. (2018). Participation to the people! Locating the popular in Rimini Protokoll's home Visit Europe. *Nordic Theatre Studies*, 29(2), 162–183.
Bocconi, S., Chioccariello, A., & Earp, J. (2018). *The Nordic approach to introducing Computational Thinking and programming in compulsory education*. doi:10.17471/54007.
Bourriaud, N. (2007). *Relasjonell estetikk*. Oslo: Pax forlag.
Brodzinski, E. (2010). *Theatre in health and care*. London: Palgrave.
Brook, P. (1995). *The empty space: A book about the theatre: Deadly, holy, rough, immediate*. New York, NY: Tutchstone.
Dewey, J. (1934). *Art as experience*. New York, NY: Perigee Books.
Ellinggard, S. (2015). Etnoteatrets dialoger. *Nordic Journal of Art and Research*, 4(2). doi:10.7577/information.v4i2.1538.
Enoksen, Karoline (2017). *Marginale røster i kunstnerens varetekt. Et etnoteaterarbeid Med innsatte i Norske kvinnefengsler*. Oslo: OsloMet.
Foucault, M. (1972). *The Archaeology of knowledge & the Discourse of language*. New York, NY: Tavistock Publications Limited.
Fugelli, P. (2015). Jeg er forelsket i det vanlige mennesket. Derfor er jeg imot prestasjonskulturen. *Aftenposten*. Retrieved from https://www.aftenposten.no/meninger/kronikk/i/vrq4/jeg-er-forelsket-i-det-vanlige-mennesket-derfor-er-jeg-imot-prestasjonskulturen-per-fugelli.
Gadamer, H.G. (2012). *Sannhet og metode*. Oslo: Pax forlag.
Gjærum, R.G. (2008). Inkludering og mangfold i det flerkulturelle Norge estetisk eller etnisk mangfold i kunsten. *Spesialpedagogikk*, 73(8), 14–19. ISSN 0332-8457.
Gjærum, R.G. (2013a). Art, age & health: A research journey about developing reminiscence theatre in an age-exchange project. *InFormation - Nordic Journal of Art and Research*, 2, 244–266.
Gjærum, R.G. (2013b). Recalling memories through reminiscence theatre. *InFormation - Nordic Journal of Art and Research*, 2(2), 214–243.
Gjærum, R.G. (2015). Mulighetsrommet i kunstdidaktikken: Betraktninger av til-stede-værelse. *InFormation - Nordic Journal of Art and Research*, 4(2), 1–15.
Gjærum, R.G. (2017). The performance of cultural democracy in the light of care regimes. *Applied Theatre Research*, 5(3), 213–224. ISSN 2049-3010.

Gjærum, R.G., & Aurne, V. (2015). Kunstdidaktikkens møte Med marginale røster. *InFormation - Nordic Journal of Art and Research*. 4(2), 1–17.
Gjærum, R.G., Eckhoff, M., Utsi, M., & Edvardsen, N. (2019, 13 May). Kulturmeldingen er ikke relevant og representativ - For alle. *Dagsavisen*.
Gjærum, R.G., Ineland, J., & Sauer, L. (2010). The story about theater organizations, the public's approval, and the actors' identity formation in Nordic disability theater. *Journal of Social Work in Disability & Rehabilitation*, 9(4), 254-273.
Gjærum, R.G., & Kinn, H. (2016). Humanistisk og estetisk omsorg: Om medborgerskap, kulturell identitet og ukrenkelig menneskeverd. *InFormation - Nordic Journal of Art and Research*, 5(2), 1–13.
Gjærum, R.G., & Rasmussen, B.K. (2010). The achievements of disability art: A study of inclusive theatre, inclusive research and extraordinary actors. *Youth Theatre Journal*, 24(2), 99–110. doi:10.1080/0892909 2.2010.518909.
Gjærum, R.G., & Rasmussen, B. (2012). *Forestilling, framføring, forskning: Metodologi I anvendt teaterforskning*. Torndheim: Tapir forlag.
Gran, A.B., & Gjærum, R.G. (2019). *Teaterbransjer: Delbransjer, organisering og finansiering*. Oslo: Universitetsforlaget.
Gürgens, R. (2004). *En usedvanlig estetikk: Studie av betydningen av egenproduserte teatererfaringer for det usedvanlige mennesket*. Trondheim: NTNU trykk.
Hadnagy, J. (2016). *School - A basis for successful inclusion: Newly arrived children and young people in the Nordic countries*. Stockholm: Nordic Welfare Centre.
Heggstad, K., Erikson, S., & Heggstad, K. (2018). *Jenta på loftet: En forestilling for mennesker som har levd lenge og noen ganger strever Med å huske*. Hordaland: Arna Helseheim.
Heggsatd, K., & Heggstad, K. (2017). Til stede – Om demens, reminisesn og langsomme dramaprosesser. In K. Heggstad, B.K. Rasmussen, & R. Gjærum (Eds.), *Drama, teater og demokrati. Antologi II - I kultur og samfunn*. Bergen: Fagbokforlaget.
Heggstad, K., Rasmussen, B.K., & Gjærum, R. (Eds.). (2017). *Drama, teater og demokrati. Antologi II - I kultur og samfunn*. Bergen: Fagbokforlaget.
Henningsen, E., Berkaak, O.A., & Skålnes, S. (2010). *Mangfoldsåret: Muligheter og motsigelser i politikken for et flerkulturelt kulturliv* (NIBR-rapport). Oslo: Norsk institutt for by- og regionforskning.
Heron, J. (1999). *The complete facilitator's handbook*. London: Kogan Page.
Hvinden, B. (2009). Den nordiske velferdsmodellen: Likhet, trygghet – Og marginalisering? *Sosologi i dag*, 39(1/2009), 11–36.
Ineland, J. (2007). *Mellan konst och terapi: Om teater för personer med utvecklingsstörning*. Umeå: Umeå universitet.
Lilletvedt, A.B.U., & Myklebust, S.T. (2017). Stemmer fra innvandrerkvinner. In K. Heggstad, B.K. Rasmussen, & R. Gjærum (Eds.), *Drama, teater og demokrati. Antologi II - I kultur og samfunn*. Bergen: Fagbokforlaget.
Meld. St. 8. (2018–19). *Kulturens Kraft: Kulturpolitikk for Framtida*. Retrieved from https://www.regjeringen. no/no/dokumenter/meld.-st.-8-20182019/id2620206/.
Mysja, A. (2005). Bruk av musikk som terapeutisk hjelpemiddel i sykehjem. *Tidsskrift for Norsk Legeforening*, no 11/ 2005.
Nicholson, H. (2005). *Applied drama – The gift of theatre*. London: Pallgrave Mcmillan.
Norberg-Schulz, C. (1978). *Mellom jord og himmel: En bok og steder og hus*. Oslo: Pax Forlag.
Omholdt, E.L. (2016). *Økonomi og levekår for ulike lavinntektsgrupper*. Oslo: Statistisk sentralbyrå.
Pahuus, M. (2015). Det levende rom, med sideblikk på syepleie. In T.A. Kjær, & K. Martinsen (Eds.), *Utenfor tellekantene: Essays om Rom og rommelighet*. Bergen: Fagbokforlaget.
Prendergast, M., & Saxton, J. (2016). *Applied theatre, International Case Studies and Challenges for Practice*. Bristol: Intellect Book.
Rønning, H. (2017). *Det er aldri for sent å debutere*. Oslo: NRK-nett. Retrieved from https://www.nrk.no/ vestfold/xl/det-er-aldri-for-seint-a-debutere-1.13337170.
Sauer, L. (2004). *Teater och utvecklingsstörning: En studie av Ållateatern*. Umeå: Umeå universitet.
Solem, A., & Hermundsgård, M. (2015). *Fasilitering*. Oslo: Gyldendal forlag.
Solvang, P. (2010). *Diagnose: Kulturelt perspektiv*. Trondheim: NAKUs kompetansebank.
Sontag, S. (1991). *Illness as metaphor and AIDS and its metaphors*. Harmondsworth: Penguin.
Storsve, K., Gjærum, R.G., & Rasmussen, B.K. (2019). Demokratisk samhandling: Drama- og teaterpedagogiske læringsformer som demokratisk praksis og tilpasset opplæring i skolen. (data) (fulltekst). *DRAMA: Nordisk dramapedagogisk tidsskrift*, 1, 60–70. ISSN 0332-5296.
Sund, E., Rangul, V., & Krogstad, S. (2019). *Folkehelsepolitisk rapport Med helsestatistikk fra HUNT inkludert tall fra HUNT4*. Levanger: HUNT forskningssenter.

Taylor, P. (2003). *Applied theatre: Creating transformative encounters in the community*. Portsmoth: Heineman.
Thomsson, J. (2003). *Applied theatre: Bewilderment and beyond*. New York, NY: Peter Lang.
Torrissen, W., Berg, E., Krogset, Olsen, T., & Scheele, H. (2017). Den blå timen: act2 Forumteater, demokrati og helse. In K. Heggstad, B.K. Rasmussen, & R. Gjærum (Eds.), *Drama, teater og demokrati. Antologi II - I kultur og samfunn*. Bergen: Fagbokforlaget.
Ursin, G., & Lotherington, A.T. (2018). Citizenship as distributed achievements: Shaping new conditions for an everyday life with dementia. Retrieved from https://munin.uit.no/handle/10037/12510.
Zeilig, H., West, J., & van der Byl Williams, M. (2018). Co-creativity: Possibilities for using the arts with people with a dementia. *Quality in Ageing and Older Adults, 19*(2), 135–145. doi:10.1108/QAOA-02-2018-0008.

Internet Sources

Retrieved from https://www.dagbladet.no/kultur/kreativ-kriminalomsorg/60169661
Retrieved from https://www.economist.com/the-economist-explains/2018/08/16/why-universities-for-the-elderly-are-booming-in-china
Retrieved from https://www.ferskescener.no/forestilling/blodklubben/
Retrieved from https://www.ferskescener.no/forestilling/blodklubben/
Retrieved from https://fixfoxy.com/en/
Retrieved from https://dks.osloskolen.no/firemannsrommet/
Retrieved from http://www.openensemble.se/?p=1230
Retrieved from https://www.norden.org/no/information/10-innsatsomrader
Retrieved from https://nordicsafecities.org/
Retrieved from https://www.nordforsk.org/no/programmer-og-prosjekter/programmer/education-for-tomorrow-1/education-for-tomorrow.
Retrieved from https://www.norden.org/no/node/7630
Retrieved from https://www.nordplusonline.org/
Retrieved from https://www.nordicinnovation.org/
Retrieved from https://www.itd.cnr.it/doc/CompuThinkNordic.pdf
Retrieved from https://www.norden.org/no/node/7767
Retrieved from https://www.nordplusonline.org/
Retrieved from https://norric.org/
Retrieved from https://snl.no/drama
Retrieved from https://www.rommenscene.no/
Retrieved from https://www.svt.se/nyheter/lokalt/vasternorrland/mittnyttjournalister-bakom-alla-dokumentar
Retrieved from http://www.sprogpiloter.org/
Retrieved from https://www.sykehusklovnene.no/her-er-vi/
Retrieved from https://www.detnorsketeatret.no/framsyningar/dottera/
Retrieved from https://underskog.no/sted/6351_vardeteateret
Retrieved from https://www.nrk.no/vestfold/xl/det-er-aldri-for-seint-a-debutere-1.13337170

37
YOUTH TRANSFORMATION IN SEARCH OF FREEDOM

Maria Kwiatek

In place of an introduction: a fairy tale about growing up to be responsible

A long, long time ago, in a modest pit-house surrounded by fields and forests, there lived a married couple with two children. The family lived in poverty. The parents strived to provide a decent standard of living for their children, but they could hardly get by. One day, the Mother fell very ill, and because she could not afford to rest, she soon died from being overworked. As a result, the family's life became even harder. The Father had no time to take proper care of his sons and struggled to provide for their basic needs.

One day, the three of them sat at the table: the Father, the Younger Son, and the Older Son. The Father said:

- "Since your mother has been gone, we don't have enough bread."

And the sons answered in chorus:

- "Yes, we miss our Mother."
- "I know," replied the Father. "From now on, you have to be self-reliant."

Self-*reliant* – what does it mean? Neither of them knew.

They knew what it meant to be *valiant*. Secretly, they believed that they were valiant descendants of a royal family – the Older Brother brought such news home one day. He announced that from that day on, they would live like kings. He was hardly ever home, and when he did return, he was changed beyond recognition – he became unpredictable and uncontrollable. He either shouted and gave orders to the Younger Brother, as though he was his subject, or got drunk on the best alcohols and offered them to the Younger Brother as a representative of the same royal blood. It was hard for the young boy to settle into this new role, but he trusted his brother and did as he was told. The Older Brother took him on night-time escapades and showed him this better world where all that counts is money, power, and authority. The young one grew to like it and each trip with the Older Brother was like a treasure hunt expedition of two valiant knights. Impressed by the Older Brother, the Younger Brother wanted to be just like him. Unfortunately, he always fell short of the Older Brother's expectations – he was never brave enough, funny

enough, fast enough, agile enough, cunning enough, aggressive enough, devious enough, or ruthless enough.

During one of their escapades, when they were walking through a forest, the Older Brother put the Younger Brother to the test to check whether he had all the above virtues, and in a moment of the Younger Brother's inattention, he disappeared from view. The Younger Brother started to look for the way home, but they had come a long way by that time and he had not followed their route.

- "I am not watchful enough," he observed (quite rightly), but that day, he still had no idea what it meant to be *watchful*.
- "I need to *watch* out," he said to himself.

And indeed, from that moment on, he was watchful not to trust anyone and not to be deceived by any tricks. "A man is a wolf to another man," as his Older Brother used to say. He remembered those words well – after all, his Older Brother was the one who taught him the best lesson.

Since then, the Younger Brother lived in the forest. He built himself a modest pit-house out of clay, which he covered with precious stones found during his many expeditions to show that "a valiant descendant of kings lives here." He also made himself a suit of armour out of bark, putting it together layer after layer, meticulously and methodically. The armour protected him firmly from suffering. In the forest, he learnt how to fight for food and how to outsmart other animals, deceiving them before they deceived him. In the forest, he learnt to be cunning, agile, and ruthless. This did not escape the attention of a pack of wolves inhabiting the area, which kept a sharp eye on him since he appeared in their territory.

"Are you brave enough, funny enough, fast enough, agile enough, cunning enough, aggressive enough, devious enough, and ruthless enough to join us?" the oldest Wolf asked.

"I am," he replied.

"You will prove that if you join our pack."

He agreed without hesitation, as "it's not a wolf's trait to hesitate." And from that moment on, he went hunting with them. Now he was a true explorer of new lands. Together with the pack, he went deeper and deeper into the forest and conquered new territories. Now the forest belonged to him. He was not just a descendant of kings, he was the king of the wilderness. Wherever he appeared with the pack, everybody trembled with fear, while he feared nothing, for the wolf brothers were his brothers. He knew they had his back and would never abandon him.

And yet, there came moments when he did not want to do what the wolves told him.

He did not want to be aggressive, devious, and ruthless.

There came moments when he missed his family.

He missed his Older Brother, although he had abandoned him in the forest.

He missed his Father, although he had abandoned him after his Mother's death.

And he missed his Mother, although she abandoned him forever when she died.

One day, he decided to look for the way back home. His wolf brothers barred his way:

"You are our Younger Brother. You are either with us or against us. Choose."

And he did. He chose to stay with them.

At the same time, in a modest pit-house surrounded by fields and forests, the Father was standing at the window waiting for his sons to return home. When the Older Son came back without the Younger Son, the Father notified the forest police and the search began.

Each day, the forest police combed the forest in search of the Younger Son,
inch after inch.

Each day, the Father waited for his Younger Son at the window, overcome by emotion,
tear after tear.

Finally, they found him, in a forest clearing, among grass and fern, caught in a snare left there by poachers. There was no one there to help him. He was lying there alone, whimpering like a defenceless animal:

"Run away, there are wolves here! A whole pack of wolves!"
"You must be delirious, boy, there isn't a living soul here," replied the police. "But for all your thefts and robberies, you will answer in person."

His bark armour broke into pieces,
layer after layer.

"You have to take responsibility for your actions, son. I believe that this experience has taught you a lot. I hope you will be responsible from now on."

What is means to be *responsible* – this the Younger Son did not know yet.

But he did know how he wanted to *respond* to his Father:

"It was not my fault. I am innocent."

It was not until years later that the Younger Son learnt to take responsibility for himself and his actions. It was not until years later that he understood what it meant to be self-reliant, watchful, and responsible. Only then did he understand what it meant to truly be free.

"Please, forgive me, my dear Father."

Yet how that happened is a whole different story.

Responsibility for words

As I am writing this fairy tale, my eyes fill up with tears, because this is how I imagine the life of this young boy, and many others similar to him, who were told to grow up too fast, who had to be *self-reliant, watchful, and responsible* before anyone explained to them what these words even mean. The tale is my creative reinterpretation of certain pieces of various life stories of a group of young boys aged 16–18 who – through their own or maybe just fate's fault – ended up in a juvenile education centre. Admittedly, in my fairy tale, one central character comes to the forefront, but he represents a broader community. I included certain facts from his life in the plot; others were changed or made up. Such a model of creating stories is in line with the methodology of my work, based on drama and the Theatre of the Oppressed. A story is created as a result of sharing life stories within a group, either directly or through

improvisation and theatre exercises. The fragments presented by the participants merge, interweave, evolve. Slowly, an individual account loses its author and becomes the common story – which belongs to the entire group. Everyone can find a piece of themselves there, while at the same time remaining anonymous. I would like the participants of my workshops to stay anonymous, which does not deprive them of their role of co-creators and the central figures of this chapter. I wish to thank them for their trust and for sharing an important part of their lives on stage.

I met the boys from the Orionine Fathers' Juvenile Education Centre in Warsaw in April 2017, when Paulina Chodnicka invited me to hold theatre workshops at the Polish Theatre in Warsaw. The project, ultimately awarded first place in the Warsaw Cultural Education Award competition, was organised in a comprehensive manner: the young participants had the chance to visit the back rooms of the theatre (various studios and storage rooms go backstage), learn about actors' work from the inside (by participating in rehearsals and in a meeting with a theatre director), and enter into a role themselves and play on an actual stage (through theatre workshops concluded with a performance). Together with Grzegorz Milczarczyk and Jubilo Theatre Group, we accompanied them on this journey and were responsible for the latter part. Preparing for this work, we decided that we were not going to conduct a preliminary interview with the boys' tutors, as we wanted to get to know them based on how they introduce themselves to us. We therefore started the first class by opening a box that contained a number of all sorts of random items. The task of the group was to take a look at these items and select the one which makes them think of a story – either their own or one they have heard somewhere, a true or a made-up story. Everyone had the chance to speak out and everyone could remain silent and listen to others. This simple exercise revealed a lot of information about the group and allowed us, as instructors, to become part of it. We were not just passive observers, but could participate in the discussion on the same terms. It quickly became clear to us that some of the stories are known to the entire group, when one of the items made all of the boys laugh and they all cast a meaningful glance towards one friend. We did not have to wait long until that friend told us the anecdote of which he was the hero. However, before that happened, the boys specified the rules of the game themselves. "Will what we say stay in this room?" one of them asked. I was really happy to hear this question and turned to the rest of the group, asking them whether they agreed. All of them nodded. I took this chance to introduce one of the most important rules in theatre work based on the participants' stories. Each of us said: "Everything that happens in class shall stay between us" and since then, we knew that it was going to be our place, a place where one can feel safe.

Even though they had the opportunity to choose what they would say, whether it was going to be a true or a made-up story, whoever decided to speak, talked about his own life. What is more, all of the stories were stories about the authors themselves, not anecdotes they have heard somewhere. It was then that I understood that they wanted to talk to us, that they needed to be heard. It was a good starting point for further work, where during short improvisations they shared whatever they wanted to share. Ultimately, it was up to them to decide which of their stories were to be shared beyond the workshop room and included in the performance. They started with small provocations, stories with sexual, obscene or offensive overtones. They put us, instructors, to a test of sorts, to see how far we would let them go on stage. We accepted everything, but only as long as they could justify it. The stage quickly teaches us responsibility for our words. It is one thing to tell a funny anecdote, but it is a whole different thing to play in it in person. They understood that we gave them complete freedom of expression, but also full responsibility for what they say on stage.

Watchful of each other

"It Won't End with the Premiere" – this is the title that the participants of the 2017 performance at the Forum Theatre suggested, thus obliging us to organise another edition of the workshop. Words were not wasted. The project was continued in 2018, courtesy of the Polish Theatre in Warsaw. The shape of the group changed, which is typical of this type of juvenile facilities. Some of the boys returned home, some were transferred to other places. This year, younger boys were the majority in the group. More mistrustful, they treated us with reserve, at the same time fighting for their position in the group, eager to appear to be funny and fearless. They tried to impress us with their nonchalance, while, in reality, they needed time to reveal their true colours from behind the mask of a tough guy or prankster. They also tested us: will they gain more by outsmarting us or by playing straight? I remember the breakthrough when, during yet another seemingly unproductive workshop, dominated by noise and chaos, we decided with Grzegorz to stop these self-propelled resistance dynamics. We sat with the boys on the wooden floor of the stage and told them honestly that we were there in a slightly different role than the teachers and tutors they had met before. We did not want to teach them anything, we simply wanted to spend some time with them, to share our passion for theatre, and learn about what excites them. But in order for that to happen, we had to be honest with each other, because theatre is about truth. Suddenly, the hard surface of the stage became like a sofa, and we lounged comfortably and talked for about an hour. It was then that we found out that they felt as if they were in prison. It was then that they told us fragments of their life stories, why they ended up in the facility and what they are "doing time" for. We understood then that most of them joined the criminal world in order to prove something to themselves and others, but above all, to command authority and respect in their peer group. Just like in the pack of wolves in my fairy tale, they were left out in the cold by their older friends, as bait for the police... The friendship turned out to have been fake and the youngest ones had to suffer the consequences.

I am innocent

The stage is in semi-darkness, the light only illuminates the actors' faces. An interrogation is taking place on stage:

"Do you plead guilty?"
"No."
"Who can confirm your innocence?"
"Everybody knows I'm innocent."
"But someone did see you at the scene."
"That's not true."
"Do you plead guilty?"
"No."

The performance is set in a prison, but the actors are not the boys from the so-called juvie. The young boys on stage are of similar age to them, but they come from a completely different background – from decent, loving homes where parents care about their upbringing and education. They are students of one of the best high schools in Warsaw, whom I met in more or less the same period of 2018. I would like to thank Iwona Borowska for the invitation. Iwona is a teacher of great sensitivity, mindful of her students' needs. She is the only teacher I know

to have stopped giving marks to her students. Instead, she gives them descriptive feedback and holds motivational talks with them. She was the one to put forward a proposal to the head teacher to organise project-based theatre workshops. Projects are something that makes this high school stand out; something that goes beyond the core curriculum of the Polish system of education. The projects are voluntary, yet mandatory classes, which means that a student may choose from a whole range of projects (related to art, nature, civic society, etc.) and take part in one matching their personal interests, but everyone is obliged to complete the selected project. The project involving theatre workshops at the Forum Theatre, concluded with a performance, enjoyed considerable popularity among the students. Together with Iwona, we ran the classes throughout the entire school year.

"What would you like to talk about?" and "What matters to you?" – these were the main questions we asked the workshop participants and our drama and theatre explorations were aimed, even if not directly, at answering them. In order to recognise the young people's needs, during our first meeting, we asked everyone to make up a story in which the central character would be a person who really wants to achieve something in life, but there is something or someone hindering their path to reach their goals. The stories, written and collected anonymously, were published with the participants' consent only in the second semester of the school year, at the stage of preparations for the performance:

> There is a certain pattern that good news, eagerly awaited, is usually accompanied by a dark side. This was the case when I found out I was accepted to school – and not just any school, the best one, a school all the ballet lovers and fanatics from all over the world dream about. I already knew that my parents would only give me a disgusted look.
>
> The entire basement full of paints and easels was hers. Her parents treated her talent with reluctance, considering it worthless. Behind her family's back, Sonia sent a few of her works to the Academy of Fine Arts in New York.
>
> Quiet and shy at first, the thought bringing back all the wonderful memories related to little school theatres developed and settled comfortably in the "dream future" drawer. Yet solving the problem of choosing the field of study did not make life easier at all. For how do you tell your business-obsessed parents that your plans differ slightly from following in the footsteps of your lawyer sister and turn more towards the uncertain, unstable, difficult, and not necessarily well-paid job of an actor.
>
> "This is wonderful, Melka, you have to go. It's your chance," he said and hugged me.
>
> "They will kick us out of the house, we're not the children they've dreamed of," I whispered.
>
> "We are not, Mela, and never will be, but we can be happy, and that's more important," he replied.
>
> And finally, right before the moment of this important choice, we went and took part in theatre workshops. I met people there who seemed "different" to me, they spoke differently, thought differently, they only just seemed to look like other people. I thought they were extraordinary. I can safely say that these few days spent there changed me completely. I looked at the world from a different perspective, a perspective of a free person, not enslaved by the contemporary system.

The above are just some of the excerpts from the stories used as an inspiration for the performance at the Forum Theatre. The first scene of the play is the interrogation scene. We can quickly realise that the story is set in a prison and the characters' stories are flashbacks from their

life in freedom. Apparent freedom, in fact, as each of them was stuck in their own internal prison of self-censorship, expectations, and obligations. Why do they have to prove their innocence? To fight for freedom?

Although the groups I mention in this chapter come from two different worlds, they paradoxically have surprisingly much in common. In spite of the fact that the two groups have never met, they worked in a separate space and time, this piercing sense of imprisonment connected them metaphorically in theatre space.

While the high school students were stuck in the prisons of overprotective homes, the boys from the juvenile facility felt as though they were prisoners of the institution to which they were sent from their homes. They construed the rules imposed by the educational and rehabilitation system as punishment. Meanwhile, it was a framework they never had the chance to experience at their unpredictable homes. They perceived the world as evil and dangerous, where all that matters is deviousness and deceit, and saw adults as biased judges wanting to prove their guilt. Our Forum Theatre workshops were aimed at understanding the perspective of the oppressor and the victim. We devoted a lot of time to building relations based on honest conversation, deeply convinced that only truth and honesty can give them a sense of freedom. In one of the improvisations, we tested a few versions of the same discussion. A boy had misbehaved and was having a disciplinary conversation with his father. Grzegorz entered into the role of the father and the task of one of the boys was to conduct the conversation. Each of the workshop participants was asked to enter into the role of the son for a while and suggest a different conversation scenario. All the boys entering the stage behaved in a similar way, they started by confronting the father. It seemed significant to us that none of them was able to admit that he had made a mistake. They kept equivocating, lying, and making excuses. The more cunning the plan they came up with, the better the pretext; and the bigger the lie, the louder the applause and laughter that they received from their friends observing the scene. This is very typical of this group. Throughout the years, they have developed escape strategies and their own survival methods. What mattered in their world was only the categories of "guilty vs. innocent," "winner vs. loser". The category of meeting or conversation did not exist; in fact, there was only a battle of arguments. We tried to break it, move beyond this pattern. In this specific case, we suggested they try something different now and told them to try to admit their guilt. And once again, one by one they entered into the role of the son and tried to direct the conversation towards owning up to what they had done. It was very difficult for them. They kept coming up to the stage until they themselves (as actors and spectators) decided that the suggested way was realistic and justified. This justification meant convincing the audience that there was so-called "truth of the stage" behind the actor's behaviour. To force yourself to say "sorry," just to play to the crowd, was not enough. And so we waited until the audience believed the actor. It happened only after Paweł entered into the role. He surprised everyone. He was the only one to not just apologise, but actually take responsibility for what he had done wrong. He said he knew he was going to be punished for it; that he would be sent to the facility, but he added that it just had to be this way and that maybe he would learn something along the way. He ended by asking his father to visit him from time to time. Several classes later, Paweł sung us a song he had written for his father. This is the first stanza:

> At the start of this letter, dad, I'd like to say I'm sorry.
> Now I know it wasn't worth it, so you don't have to worry.
> All the problems of my youth and all the hardcore stuff,
> I was so overwhelmed, started to have enough.
> So I drank, I did drugs, and I smoked Mary Jane,

Got in trouble with the law, almost drove me insane.
And in all of this mess I forgot about you, dad.
You were standing at the window, while I partied like mad.
And I cannot turn back time, hear the ticking of the clock.
I'm so far away from home, thinking how we're gonna talk
When I come back to you and you'll hold me like no other.
Please, forgive me, my dear father.

After that, we no longer had any doubts as to which scenes would be included in the performance, even though the participants were the ones deciding about the final form of the script until the last moment.

The incredible power of failure (learning through experience)

"The answer to many simple questions might take one or two forms – either that of information or else that of direct experience; the former answer belongs to the category of academic education, the latter to drama" – these words are the opening lines of one of the most important books about drama, and one of only a handful on the subject to have been translated into Polish, written by one of the precursors of this method in the UK, Brian Way. Even though the book comes from the 1960s and was first published in Poland in 1990, admittedly, not much has changed in our education system since that time. In spite of yet another education reform, it still focuses primarily on the educational function in the didactic and educational process. Just like research knowledge needs to be documented with numerical results, school knowledge needs to be proven by proper marks. And although the repertoire of extracurricular activities keeps growing, most of them are still result-oriented. Instead of activity clubs, we therefore have "targeted activity" clubs, i.e. clubs serving the achievement of a specific target, e.g. winning a knowledge contest or any other type of competition. As a result of such perception of development, increased pressure on the part of the school or the family appears. Acting in good faith, we unconsciously harm our children by burdening them with our expectations of success understood in terms of progress, without listening to their needs and dreams. Meanwhile, dreams are the driving force of our life, and in adolescence, they gain particular significance and power. Dreams blocked by the system of obligations appear in night-time dreams and fantasies, and they can also find an outlet in theatre. In theatre which does not hold casting calls, verify the acting talent or expect learning progress. In theatre which provides space to be oneself, to make attempts and mistakes, to ask questions and search for answers by experiencing the moment.

Growing up under the mask of an actor's role

Paweł, a 17-year-old from a small town in the Mazovia region, did not stand out from the crowd in any way. Even though he was one of the oldest participants, he was not among the so-called leaders. Quite the opposite. As I found out later, his friends did not like him, because, I quote,

> the moment he appeared at the facility, he started to tell all kinds of incredible stories, he was a show-off trying to impress everyone with all the stories about himself and his family, with all kinds of dangerous situations for which he was sent to the facility, etc., yet it quickly turned out that it was all a lie.

He also confabulated in his conversations with the tutors. Soon nobody trusted him anymore, neither the adults, nor his peers. He lost his position in the group for good when he told a tutor about something that was going on between his friends. That moment, he discredited himself completely. Meanwhile, he did all that, because he desperately needed attention and someone's interest. His mother had died, he kept arguing with his father, and his older brother had a very bad influence on him, and so the only type of attention he knew how to draw was the negative type.

And suddenly, we see him on stage, at the Polish Theatre in Warsaw, as the main character, delivering his monologue to his father, or actually singing it *a cappella* to the rhythm of hip-hop music. He gets a standing ovation.

Is this an indicator of progress? I believe not. This is not his greatest achievement. It is the proverbial "cherry on the cake," and at the same time one of many cherries growing on this tree. I will use Brian Way's metaphor again, as he compares development to a growing tree. From one day to the next, we will not see any change. Yet if we watch the tree for a longer time, then the change becomes visible to the naked eye. Growth depends on meeting a number of conditions: the amount of sunlight, water, type of soil, nurturing, etc. If even one of these factors is disturbed, growth will also be hindered (Way, 1990). I will go a step further in this analogy. Development may be perceived in terms of growth and moving upwards, but we might also consider the number of tree forks and branches, not only those visible in the crown of the tree, but also, or maybe even primarily those hidden underground, in the roots, determining the tree's actual strength.

Our hero's true progress occurred in the course of the workshops, in a completely unplanned and spontaneous way, initially invisible to us as instructors. As I stressed at the beginning of the chapter, we did not know anything about our participants, as we decided it would be better this way. We had no idea that Paweł had a brother or that he had lost his mother or that he does not get on well with his father. I found out about all this only after the performance, during an interview with his tutor. All of the scenes presented by the boys during classes were spontaneous and intuitive in nature. The initiative was always theirs. Additionally, they often swapped roles, changed the course of events, and gave them new meanings. During one of the classes, we had an improvisation with three of the boys taking part. They sat at the table and for three minutes, they only talked about how poor they were and that there was no bread in the house. I asked a question about what this bread meant to them and asked them to repeat the scene. And then, in place of the conversation about bread, they started talking about their mothers, about death, about what or who they missed. Paweł did not take part in this improvisation. He was a spectator just like the rest of the boys.

This example shows how with each story, we got to know our young actors better. With each change of the actor, the story gained additional owners. It was all intentional, as it created conditions for the boys to express themselves without exposing themselves. In drama, we say that we "play," that we put on the "mask of the role." The word "play" has two meanings. On the one hand, it refers to engaging in an activity for enjoyment, and on the other, to entering into the role of someone else. Both these meanings are extremely important for the process of change. Winnicott points to children's natural need for play in their development process, which apart from bringing them joy, provides space for expressing emotions, learning to overcome their fears, broadening their experience and social relationships, and personality integration. The entire current of non-directive play therapy of children is based on the use of toys and play as a natural medium to express themselves. Through play, the child can play out the problems of their daily life and relieve tension. What is more, non-directive therapy is based on the assumption that every person has the potential to change towards growth, maturity, and fulfilment and to overcome obstacles along this development path (Axline, 1971).

Augusto Boal adds one more important semantic aspect of the word "play" to the above discussion. The title of his book alone (*Games for Actors and Non-Actors*) points to the differentiation between playing in a performance and participating in playing a game that is taking action. This approach is crucial to the methodology of the Theatre of the Oppressed he created, continuing the philosophy of the Pedagogy of the Oppressed (Freire, 1996). Just like the word according to Freire and play according to Winnicott, in Boal's view, theatre is a natural tool of interpersonal communication and provides space for experiments and getting to know oneself and others. It may also be a tool of change, both individual and social. Everyone has the potential to act if they dare to take a risk, start playing the game, and try something new.

We can take a look at the story of our main character from this perspective. We may read it in two ways: as a spectator/listener; or as an actor/participant.

My fairy tale about the Younger Son gives us the opportunity to do the former. It is a metaphor of our hero's growth. We can listen to it and try to understand it in the context of the most important terms included there; these are self-reliance, watchfulness, and responsibility as manifestations of growing to maturity. In the latter case, we can create a space for participation and taking real action. Drama and the Theatre of the Oppressed give us this opportunity. During short improvised scenes, everyone feeling that this story is close to their heart has the chance to enter into the role of the main character and face his dilemmas. We went a step further and, based on this story, we created a performance, providing space for participation to a broader audience. For, as Augusto Boal proposed in the Theatre of the Oppressed, everyone is a "spect-actor," not just a spectator. The two words differ only in one letter, which further emphasises the power of this difference. Everyone who came to the premiere of "It Won't End with the Premiere" knows that the title is not without significance. Each proposed action expands the repertoire of methods of dealing with real life in the future. Paweł, our main character, made use of them. In the course of the workshops, he talked to his father about his return home, which was to happen soon after the performance. As far as we know, Paweł is home today and the story actually ended in a similar way to the way it did in the script of our play, the focal point of which was the song written by Paweł, which ends as follows:

> Now I come to appreciate everything that I have lost,
> And I'm so sorry, dad, I know I've hurt you the most.
> Now I come to appreciate every moment that we had,
> And I promise that I won't let you down again, dad.
> Now I'll reach for my dreams, I have chosen my path,
> I don't want to stand still, I just want to change my life.

References

Axline V. M., 1971. *Play therapy*. New York: Ballantine Books.
Boal, A., 2008. *Theatre of the oppressed*. London: Pluto Press.
Boal, A., 2014. *Gry dla aktorów i nieaktorów* [Games for actors and non-actors]. Warsaw: Drama Way Fundacja Edukacji i Kultury i Wydawnictwo Cyklady.
Freire, P., 1996. *Pedagogy of the oppressed*. London: Penguin Books.
Way, B., 1990. *Drama w wychowaniu dzieci i młodzieży* [Development through Drama]. Warsaw: WSIP.

38
LEGAMI IN SPAZI APERTI (BONDS IN OPEN SPACES)

Giulia Innocenti Malini

Legami in spazi aperti (Bonds in Open Spaces) is a social theatre project started in 2009 in the Verziano prison in Brescia, Northern Italy. A conspicuous number of people (of differing ages, sexes, education, capacities and professions) is involved in this experience of theatrical and festive performativity, aimed at the care and maintenance of social bonds which, according to convivialist views (*Manifeste convivialiste*, 2013), can feed the human disposition for being together (Illich, 1973; Fistetti, 2010, 2017; Chanial and Fistetti, 2011). Thanks to its developments through the years, *Legami in spazi aperti* has become an innovative rehabilitational and performative case that stands out in the rich scenario of theatrical activities in Italian prisons.

A short account of prison theatre in Italy

During the first decade of the 2000s, the prison population grew progressively under the effect of the introduction of new legislation imposing stricter sanctions against immigration, drug consumption and recidivism.[1] In 2010 the prison population reached 68,000, versus a statutory capacity of 44,568, so that on average 153 people were incarcerated into every 100 places.

(Pagano, 2017: 39)

Despite some early intervention to address the emergency, the situation grew critical (ISSP, 2012), so that the European Court for Human Rights in 2013 sentenced the Italian State for the inhuman and degrading conditions in which people were forced to live in prison (Ministero della Giustizia, 2013). These conditions contravened the principle of humanisation of the sentence expressed by article 27 of the Italian Constitution, namely that "punishments may not be inhuman and shall aim at re-educating the convicted" (Constitution of the Italian Republic, n.d.: 10). The same proposition is reinforced by the rules of prison management issued in 1975, and their subsequent updates,[2] directed towards re-educational interventions and alternatives to detention, introducing actual rehabilitation paths, leading the people who have served their sentences to be reinstated into a civil society asked to play an active and engaged role in the process. The prison system remains, however, to this day, rather ambivalent about the value and recognition of rehabilitation activities, as proven by the allocation of prison funds: according

to data from the Direction of Accounting of the Department of Prison Administration (DAP), "the biggest outlay is for the personnel of the Prison Police, while the total expenditure for the prison population amounted in 2015 to only 7.8% of the total budget, of which only 2.5% spent for rehabilitation activities" (Pagano, 2017: 46).

Changes are being introduced in the organisation of the departments and institutes in order to rectify this imbalanced situation, whereby rehabilitation and security are integrated in a process of responsibilisation and normalisation centred on the people in prison and their path of progressive reintegration into society (Castellano, 2015). One of the main issues still open and critical from this respect concerns the negative impact of incarceration on social relationships (ISSP, 2015), particularly on the bond between adults serving sentences and their children, as detention turns out to be a form of punishment not only for offenders but equally for their entire immediate family, a fact that severely affects the growing up development of their children (Talini, 2015: 9–10). Because of their parents' crimes, these children become veritable collateral victims of a prison system (Murray and Farrington, 2008: 133–135) that does not always shun archaic revenge mechanisms (Bartoli, 2016). This is the backdrop to the Italian prison theatre experience.

> At the beginning of the '80s, prison theatre, which had already made an appearance in some prisons with amateur experiences, started acquiring new meaning, methods and objectives, which were to be clarified and consolidated in the following years. The focus shifted from shows to theatrical practice, to incarcerated people's workshop and creative activities and their therapeutic and pedagogical function, which impacts on human relationships and self-care. The theatre also became an important means to open prisons to society, both through opening to the public the prison performances and through taking groups of incarcerated people to perform outside theatres.
> *(Ministero della Giustizia, 2016)*

From the middle of the 1990s, these activities spread to the point that a survey by the DAP in 2015 found that more than half of the prisons[3] were hosting theatrical activities with rehabilitation objectives, 33% of which had been active for more than a decade (Langer, 2017: 59). The variety of experiences is wide: the types of work range from therapeutic and educational theatre to professional theatre, both classic and of research, covering a rich assortment of performative solutions. They involve different professional figures, from artists, to educators, therapists and volunteers. They also have and achieve different aims and objectives, some more inclined to professional artistic production, others to rehabilitation treatment, others, still, engaged in holding together virtuously the two aspects (Mancini, 2008: 25–94; Pozzi and Minoia, 2009; Valenti, 2012; Langer, 2017).

It is worth underlining two more things here. On the one hand, the artistic value of some of these experiences renders prison theatre one of the most interesting fields of contemporary performative research (De Marinis, 2011: 171–178; Porcheddu, 2016). On the other hand, a comprehensive evaluation of the treatment impact of prison theatre activities has yet to be carried out (Bodo, 2015). The one exception to this is a study currently underway in the Milano-Opera prison. Its early results point in the direction of confirming the social value and the positive impact of theatrical practices on their four stakeholders: the currently incarcerated people, formerly incarcerated people, the prison system and the civil society (Giordano *et al.*, 2017).

To conclude, it is interesting to mention that during the last decade the activities of prison theatre are becoming more and more institutionalised. At regional level, regional coordination

units[4] have been set up, supporting local experiences through the network of prisons, public administration, non-profit sector and theatre facilitators. At national level, in January 2011 a *Coordinamento Nazionale Teatro in Carcere* (National Coordination of Prison Theatre) was established with the aim to monitor the experiences, to promote synergies and national and international comparisons, and to organise training paths (Coordinamento Nazionale Teatro in Carcere, 2011). Additionally, since 2014, the National Day of Prison Theatre is celebrated on 27 March, in conjunction with World Theatre Day.[5]

Diary notes[6]

In 2001, the degree in Sciences and Technologies of the Arts and Performing Arts (STARS) of the Università Cattolica of Brescia started the first ever university course in social theatre. This was an outstanding result, as "social theatre" had begun to be spoken of only as recently as 1998 (Bernardi, 1998), indicating those theatrical and performative activities (Turner, 1982; Schechner, 1984, 1988, 2018; Dalla Palma, 2001) which had already been taking place for some time in many different environments, such as hospitals, prisons, schools (from nurseries to universities), firms, territorial services for the disabled, social services for the elderly, canteens and shelters for people in serious conditions of poverty and homelessness and centres for immigrants and refugees. All these activities were using different approaches and practices in their fields, required different trainings and had different objectives (Dragone, 2000; Bernardi, Cuminetti and Dalla Palma, 2000; Conte *et al.*, 2003; Bernardi, 2004, 2015, 2017; Valenti, 2004; Rossi Ghiglione and Pagliarino, 2007; Pontremoli, 2015).

Beginning of the project

As I was in charge of the course, I started by making contact with key people in the area. In 2008, I met Francesca Paola Lucrezi, director of the Verziano prison in Brescia, in view of establishing cooperation between our two institutions in order to put to the test in her prison the prison theatre methodology used as a rehabilitation path and as support of the interactions between prison and local territory. The project lent itself to act as field experience for the university students. The third actor in this venture was the cultural association of social theatre *I Briganti*, recently founded in Brescia by graduates in theatrical studies, represented by Barbara Pizzetti and Carla Coletti.

Verziano is a small prison in the outskirts of Brescia. The correctional institution is run as an open prison and holds on average 100 people of both sexes serving sentences (versus a regulatory capacity of 71), with 73 prison police officers and two educators.[7] There is an educational unit, formed by the director, the head of the police officers, and the educators. It is housed in a small complex, which renders its relationship with the local community absolutely crucial for the reinstatement of the incarcerated people, especially those who are serving alternative forms of sentence.[8]

From the point of view of its pre-existent theatre activities, Verziano regularly hosts a few local companies throughout the year and between 2003 and 2006 set up some performances involving incarcerated people as actors, with the help of theatre professionals (Innocenti Malini, 2011: 70–72).

In 2009, we started a pilot theatrical workshop named *Legami in spazi aperti* with a limited number of meetings, for two, small, single sex groups of people serving sentences and university students. The purpose of the experiment was to assess and monitor the fit between our theatrical action and the educational aims of the university on the one hand, and the rehabilitation scope

of the prison on the other. Following the positive outcome of the experimental phase, from the year 2010 the workshop activities became an integral part of the rehabilitation plan of the prison, with a first important innovation: the participation of the people in prison to the theatrical workshop as a single mixed-sex group, which constitutes a rare occurrence in the Italian prison system. As the outcome on the University front was academically sound, a convention was established between the University and the prison, which is still in place, setting up the workshop *Legami in spazi aperti* as an applied research field and as an internship opportunity for the students.

That year, the workshop put up a performance called *Coffee-theatre… appearances are deceiving!* in the prison chapel, which is regularly made available for theatre activities, staged in a coffee shop with little set tables. The actors sat among the spectators and played out some scenes that had been prepared during the workshop. The choice to forego the stage and mix with the public was proposed by one of the participants and immediately accepted by the entire group and shared by the educational unit: "As we are always separated and secluded from everyone and everything, kept at a distance, I do not want this to be replicated in the theatre as well". An ex-post (Gabrielli, 2015) scenic dramaturgy was devised by the participants (Rossi Ghiglione, 2013), based on comic and wrong-footing effects, centred on complex human relationships such as friendship and love.

Crisis and development

In the third year, 2011–2012, more than 40 people in the prison filled in the application ("*domandina*" in Italian) for the theatre workshop, representing one-third of the prison population. "I have come only to kill time, and break the routine… but they told me that at some point something happens and you start coming because you like it", emerged as one of the attitudes driving them. The cooperation with the educational unit, the prison director and the prison police officers was going well. Despite some difficulties and minor conflicts with an institution, like the prison, constantly under pressure and in state of emergency, we managed to carry on the project and fine-tune it as we went along, thanks to everyone taking their responsibilities on and lending their peculiar competencies. On the academic side, things were going equally well, and I was invited to share my experience in the form of a contribution for the online magazine of the Università Cattolica, *Comunicazioni Sociali* (Innocenti Malini, 2011).

In this very positive climate, we were struck by the unexpected news that the University Social Theatre course, together with the entire curriculum of theatrical studies, was cancelled due to the insufficient number of participants, according to a new minimum requirement set by the Italian Ministry of Education, University and Research (MIUR) for university courses. Pizzetti, Coletti and I decided unanimously to carry on the project on a voluntary basis, supported by the educational unit, the prison director and the *Centro di Cultura e Iniziativa Teatrale* (CIT) of the Università Cattolica of Milan.[9] We attempted to raise funds for our project but to no avail, and this failure revealed to us how little known and understood was, outside the prison, the value of our rehabilitation activities. This was so true that someone went as far as telling us that it was actually immoral to fund a theatre project for the benefit of prison people as they should be serving their sentences instead! We understood therefore that our project had not impacted in any way on the local social narrations of the prison and of its inhabitants. It had also failed to inform adequately the outside community of the rehabilitation value of the prison theatrical activities. This must have been because we concentrated too much on the educational internal synergies and on the team building activities of the workshop group, and this was not enough. We realised that no substantial change could happen if the outside community was not

mobilised and involved, as it is the wider community that feeds the social bonds, and attributes sense and rules to them.

In agreement with the educational unit, we decided to follow two strictly integrated procedures. On the one side, we kept working hard with the workshop group in order to make the social theatre practice as effective as possible for the evolution of its participants. On the other hand, it had become clear that we needed to rethink the whole experience in a wider context, the context of the prison and local communities, and of the local policies of social reintegration of people serving sentences into society.

The social theatre workshop of Verziano: elements of a theatrical process intended to work on the development of the different subjects involved (individuals, groups and communities)

With reference to the need we perceived to outline the peculiar workings of social theatre in more detail, as the years went by, the fundamental elements of the workshop process have been emerging with increasing clarity.

The weekly two-hour meetings always begin with an informal chat in small groups, to allow people to catch up on the news. This informal relationship time may last up to half an hour, before training can start after everybody has arrived and is settled. People are prompted to form a circle and start moving their bodies and using their voices in an unusual, theatrical manner. There is often an initial element of embarrassment in the fact of seeing and being seen, as in a prison, where they are always under scrutiny, people find it difficult to have and sustain an open gaze. Only after a few sessions and the fine-tuning of the training method to the particular set of participants, the giggling and interruptions die down. Some participants need the occasional break to smoke a cigarette, and a few drop out.

After training, there are games, repeated several times during the year as they improve their perception, listening, attention, memory, imagination, responsibility and sense of belonging to a group. These are all qualities that are dimmed during long detentions. Play is a long forgotten experience for most adults, particularly in prison. Quite often, some of them do not understand the rules of the game, and this may appear as a metaphor of their lives. Repetition helps, as fun and engagement increase with time. This makes it easy to move from playing games to theatrical improvisation, exploiting the dimension of imagination (what-if) and the dimension of practice (fall, turn around, run away, trust, dare, communicate) of the ludic stimulus. Imagination plays a major role, even too big on occasions, as it has been pent up for too long (Meldolesi, 1994). What is needed is an opportunity to express it in forms and symbols that can be communicated and shared. Theatre lends itself very well. It is a simple theatricality, which emerges progressively in the same way as it does in the process of human development: mimesis, expressivity, play and theatre (Piaget, 1972; Dalla Palma, 1985; Vygotskij, 1987). Participants are divided into actors and spectators and each sub-group shows its own improvisations. In the beginning, we find it difficult to perform both roles, to play and to watch, even if it is pleasant. As time goes on and theatrical and personal skills grow, namely the abilities to express oneself and to listen and watch, the scenes become more and more interesting. They are predominantly comic scenes.

After a few months of working in this manner, we start debating within the group what to select out of all the materials produced and how to find a dramaturgical focus for the final performance. The social theatre facilitators ensure that everyone has a right to express themselves in words, actions and creations. Once the main theme is chosen, everything centres on it: training, games and scenes. Dramaturgies are developed, with characters, changes of scene and of time. Quite often the dramaturgy refers to real life, offering the opportunity to share, evalu-

ate and compare life experiences. "We tell real stories, because we ARE. Why do you have to make up the plot of a movie when we've been through it all ourselves? We are authors of real stories, love stories. It is at the same time simpler and more beautiful" says one of the members of the Verziano community group. Someone starts writing down the dialogues, and sketching the scenes. Work is carried out during the week in the cells and in the corridors of the sections to give a form to the scenes transforming them into text, pictures and music. As the weeks go by, the participants start bringing into the workshop handwritten notes, pages torn from books, CDs, all crammed into their pockets together with their cigarettes and sweets.

What follows is the analysis of the texts they have written, based on their improvisations, and this is always a critical step. Their memory seems to be lost. Their attention shifts. The language can sound alien, as it is often not their native tongue. The script feels inadequate. The groups have to find ways to tolerate the frictions arising when someone lets the others down, or forgets their words, or is negligent in learning their lines. One of the participants compares the texts to cells and says that they "have had enough of cells". On the other hand, some others find the text reassuring, as a foothold. What is clear to everyone is that in all instances the scenes need to remain open forms, despite a certain level of repetition, polishing and adjusting, in order for them to be alive.

In the final stages of the workshop, a wider dramaturgical frame has to be invented. Quite often the choice falls on a place or a setting, for example a train compartment, a building block with its parking lot, a coffee bar opening onto a piazza. In this final phase, every author and actor, as well as every sub-group, is required to take up a collective attitude and responsibility for the whole work, performance or feast, leaving behind any self-centred behaviour and focusing on co-creativity. "Within the group one can really change, without being told off or forced to think, because if the group is a good group, its rules are good rules, and becoming part of it, one is transformed" is the fitting conclusion of one of the social theatre facilitators (Coletti, 29 November 2018).

The release from prison: the feast as performative mediator

From the point of view of rethinking the experience against the wider backdrop of the community, and of local policies, it is important for the workshop participants to be able to go beyond themselves and bring change into their lives, and for the workshop group to write a new social narration of detention and prison. It is also essential that the community, for its part, take an active role in the re-educational process of the people in prison, who must be perceived as subjects and resource of the community itself. But how can this be achieved? According to the participants, it is of paramount importance to find an open and inclusive theatrical form. They do not want to be kept on a stage and separated from the rest, nor do they want to be seen as "strange animals". "We have nothing to prove to anybody" is how one of the 2012 participants puts it. The educational unit agrees that it will be necessary to take the structure of ordinary theatricality and of the prison apart, in order to open the workshop up to the wider possibilities of artistic and social performance. The opportunity arises quite unexpectedly as in 2012 Pope Benedict XVI dedicated the *Seventh World Meeting of Families* to *family, work and celebration*. These themes stand out immediately as being close to what we have been working on in the workshop and more in general to the guidelines of the prison. So the idea of a theatrical feast on the occasion of the international event held in Milan in early June 2012 is conceived. It is to be organised in a public space having a clear mark of community inclusion, outside the prison. As we had already experienced refusals when we were looking for funds earlier in the project, we decide to rely on proximity relationships, exploiting supporting professional networks on a personal basis. The festive event is set up with a system of engagement according to the complex

circle model, that is based on every subject pluralising and sharing resources, especially those pertaining to close relationships (Schininà, 2004: 37–39).

The community theatrical feast called *Legami in spazi aperti*,[10] premiered in 2012, has reached its sixth edition in 2019. It is a yearly gratuitous event built on the cooperation of a wide, free and supportive network of local artists, social and cultural bodies and voluntary organisations,[11] with the aim of celebrating intercultural and intergenerational bonds through the medium of artistic and performative practices and of their processes of collective co-creation. It lasts a whole day. In the morning, the beautiful cloister of the St. John's Parish in the Carmine area in central Brescia is the setting for workshops of several disciplines, such as open dance, rap, beat box, percussions, theatre, clowning and sculpture. Lunch is taken together, sharing dishes prepared by the participants. Later in the afternoon, a collective performance is composed and realised putting together the results of the different workshops on "bonds" in a unified dramaturgy.

"The feast in June is a time for us to be all together, and more, to make sense of our being together. It is something that binds us and holds us all together" is how one of the mothers who attends the workshop with her children puts it. "It is a breath of fresh air: one cannot understand if one is not there".

To be there for someone else: the rediscovery of parenthood as a process of reconciliation

The theme of family bonds, which permeated the first edition of the feast in 2012, is chosen again by the participants to the Verziano workshop in 2013, closing an ideal virtuous circle between inside and outside of the prison. Training, games and improvisations deal with the joys and sorrows of human relationships and become the occasion to express the sense of belonging to one's family, and in particular the attachment to one's children, and the pain of being separated from them during detention. The resulting theatrical performance is ironically about families, expressing the imaginaries and the experiences of the actors-authors.

The analysis of the theatrical results of the workshop, carried out by the educational unit, reveals that it worked as creative re-elaboration of the prison people' past experiences, facilitating an inter- and intra-subjective reflexion, being an occasion for emotional experiments, and a chance to plan new developments for their future, taking advantage of the what-if dimension. From the point of view of family relationships, these processes seem to give real opportunities for reconciliation. Taking upon themselves the responsibility for the collateral damage caused by their mistakes to their dependants, and attempting to re-establish and rebuild their parental roles, people who have committed a crime can take the first step of a more complex and far reaching mechanism of reconciliation, as this becomes a turning point in their rehabilitation process (Reggio, 2010).

Consequently, we decide to pursue this line of work and for the following edition (2013–2014) we plan a theatrical workshop involving parents who are in prison, both male and female, and their young and teenage children. This is an innovative, experimental and unique experience in Italy for the time, which immediately appears to be extremely intense for all of us who are involved. Through the mediation of theatrical play, the detained parents rediscover with their children many behaviours and emotions that have been muffled by their detention. They play, sing and improvise with their children and with everybody else, they share treats. One of the mothers tells us,

> My son waits for every Tuesday and tells everybody that he goes to "make theatre" with his dad. It is so different from regular visiting times, when he has to sit at the desk. During the workshop, he wants to do things with his dad, to have a shared project. This

is very important for a child, and it touches me deeply to watch him being carried piggyback by his father, and playing at leisure.

The educators observe how the relationships and bonds among the participants are reinforced, with a positive effect on the quality of life inside the prison. More specifically, for example, prison officers are requested to look after the children as they arrive to the prison, to take them through the corridors and even sometimes to play along with the white lie that Verziano is not a prison and that their parents are not truly incarcerated. The children make new friends and look forward to meeting again the following Tuesday; sometimes the mothers meet during the week to have coffee and let the children play together. Since 2016, as it happens, the workshop includes the partners of people in prison as well as their children, making the workshop a veritable theatrical community workshop within the prison culminating each year with the *Legami in spazi aperti* feast.

A local network to promote its community

Thanks to the feast, to the support of the educational team of the prison, and to proximity relationships, today the activities of the *Legami in spazi aperti* project interact with a high number of non-profit and voluntary organisations. It has become part of the local networks in charge of planning alternative measures of detention and of devising better processes of social reintegration for the people in prison (Folghereiter, 2007: 462–465). In the same spirit of community thought and action, *Legami in spazi aperti* fostered the birth and development of *ExtraOrdinario, Esperienze di ascolto della città* (Listening experiences of the city)[12] project funded by the Municipality of Brescia together with the *CTB Centro Teatrale Bresciano*, in cooperation with eight local social theatre companies. *ExtraOrdinario* is a collective that manages a rich programme of events, including workshops, performances, feasts, seminars, festivals and meetings with private social entities and non-profit organisations, to promote multilevel actions of social theatre and performance aimed at an inclusive development of the local community (Magatti and Giaccardi, 2014).

Performing the social[13]

At the time of writing, no quantitative analysis can yet confirm the impact of *Legami in spazi aperti*, so there is no evidence that performative practices finalised to develop and strengthen the bonds – existing inside the prison, with the families and with the local environment – bring down repeat offending, which stands at approximately 70% in Italy (Pagano, 2017: 49), nor that they increase community inclusion. From a qualitative standpoint, however, the direct participation to the activities and the feedback received from the different groups of participants allow us to start drawing some initial conclusions.

One of the social theatre facilitators summarises it as follows:

> The most important thing we do is to give a different point of view to people who often come from long histories of repeating mistakes… We give them a chance to get involved in new ways, to try out authentic relationships.
>
> *(Coletti, 29 November 2018)*

This is a process that gradually moved from the workshop inside the prison to the outside, and thanks to which the individual and collective subjects have used the magnitudes of performance

for development (Schechner, 1999). Theatrical experience has been reinvented to satisfy the needs, expectations and desires of its subjects, a process that was set in motion when the aspiration not to be kept "always separated and secluded from everyone and everything, [not to be] kept at a distance" was expressed and shared, and the theatre was elected as the place where this should not be replicated. The closed and traditional theatrical model, its frontal structure, rigid roles, supremacy of the text and cultural production mechanisms have all been rejected.

Thanks to these choices, a post-dramatic (Lehmann, 2006) and plural performativity (Schechner, 2018: 54–55) was born in which authorship, actorality and spectatorality are played in direct and diffused manner, so that the boundary between artistic and social performativity becomes blurred, transforming the reality of everyday life (Fisher-Lichte, 2008: 11–23). These practices have been sustained by the pre-existent proximity relationships, but in turn they have contributed to strengthening them and created new bonds (Giardiello, 2016: 22–34). We do not know yet how long these new bonds will hold true, but they certainly appear to be effective in facilitating access to alternative forms of detention and to criminal mediation (Favero, 2009: 8–9) and in supporting the families. Furthermore, the events, as they were organised in wide and multi-sector programmes and characterised by an active participation to intercultural and intergenerational processes, originated counter-cultural narrations and experiences of co-creation on shared issues (such as work, family, hope and crisis) during which new imaginaries were created and shared.

In conclusion, through the years *Legami in spazi aperti* has given the opportunity to different subjects to suspend their ordinary lives – at a personal and community level alike – in order to take part communally in performative arts and practices according to the methodology of social theatre. The resulting dramaturgies have given new collective meaning to relationships, space, time and imaginaries on the occasion of ritual events of the calendar. The performing experience has become the field for exploration, invention and re-elaboration of a better way of life, where the primary anthropological dynamics of giving-receiving-reciprocating (Mauss, 2002) offered real opportunities to lay down arms and discover ways to become part, or associates, of an inclusive and open community (Fistetti, 2017: 10–13). It is an anti-structural (Turner, 1982: 44–47) and dialectic process, sometimes unconscious, intermittent and still in progress. It is, however, certainly already contributing, in our opinion, to making the living conditions in the Verziano prison, as well as the lives of the families involved and of the people of the local community, more human.

Notes

1 The author is referring to Laws nos. 189/2002, 251/2005 and 49/2006.
2 The Italian prison system is ruled by Law n. 354 of 26 July 1975, "Provisions on Penitentiary organisation and on The Implementation of Private and Restrictive Measures on Freedom", unanimously considered one of the most advanced and civilised of the international prison law system. Available from: http://presidenza.governo.it/USRI/ufficio_studi/normativa/L.%2026%20luglio%201975,%20 n.%20354.pdf [Accessed 7 January 2019]. The system was later updated and further developed by Law n. 663/1986 and the "Regulations Containing Provisions on the Penitentiary Act and on the Measures Entailing Restrictions on and Deprivation of Personal Liberty" of 30 June 2000. Available from: http://www.normattiva.it/uri-res/N2Ls?urn:nir:stato:legge:1986;663 the former and from www.giustizia.it/giustizia/it/mg_2_3_8.wp the latter [Accessed 7 January 2019, both].
3 The number of penal facilities/institutions as of 31 December 2015 was 195. Available from: www.prison-insider.com/countryprofile/prisonsinitaly [Accessed 7 January 2019]. "Italian prisons are mostly classified as Casa Circondariale (CC) or Casa di Reclusione (CR). CC prisons host pre-trial, remand and short sentence people, while CR prisons hold sentenced people… There are five women-only prisons… People who have completed prison terms but remain under secure supervision are held in

either a Casa di Lavoro (CL) or Colonia Penale (CP). Juveniles and young adults are held across 16 juvenile detention centres (IPMs)… Four prisons for the criminally insane (OPGs) house as many as 164 detainees with severe mental issues". Available from: https://www.prison-insider.com/countryprofile/prisonsinitaly?s=le-systeme-penitentiaire#le-systeme-penitentiaire [Accessed 7 January 2019].
4 See for example: "Teatro in carcere", *Regione Toscana*. Available from: http://www.regione.toscana.it/-/teatro-in-carcere [Accessed 7 January 2019]. *Coordinamento teatro Carcere Emilia Romagna*. Available from: http://www.teatrocarcere-emiliaromagna.it/ [Accessed 7 January 2019]. *Coordinamento teatro carcere Lazio*. Available from: https://teatroecarcere.wordpress.com/il-coordinamento-teatro-e-carcere-del-lazio/ [Accessed 7 January 2019].
5 Available from: https://www.giustizia.it/giustizia/it/mg_2_3_0_6.page [Accessed 7 January 2019].
6 What follows is based upon work notes by the workshop facilitators (Innocenti Malini, Pizzetti and Coletti), reports from the educational unit, previous written material on the experience, video documents (including *Fragili legami*) shot by Angelo Urgo and Luca Walter Mariani, information collected from participants, an interview with Coletti and one with the wife of one incarcerated person, who has been attending the workshop for a year with their two children aged 4 and 9. Where not otherwise indicated, the citations are taken *verbatim* from conversations with people in the prison.
7 The most recent data available dates from 7 August 2020. Available from: https://www.giustizia.it/giustizia/it/dettaglio_scheda.page?s=MII172610 [Accessed 25 August 2020].
8 Available from http://www.antigone.it/osservatorio_detenzione/lombardia/193-casa-di-reclusione-di-brescia-verziano [Accessed 7 January 2019].
9 See https://centridiricerca.unicatt.it/cit.
10 See https://www.facebook.com/pages/category/Community/Legami-in-spazi-aperti-269704386801157/.
11 The last edition was organised by bodies as diverse as a prison, a cultural association, a juvenile institution, a parish, a university and two social cooperatives: Casa di Reclusione di Verziano, Associazione Culturale Teatrale I Briganti, Casa di Accoglienza per adolescenti I tre Volti, Parrocchia S. Giovanni Evangelista, Università Cattolica del Sacro Cuore, Cooperativa Sociale GenerazioniFa, Cooperativa di Bessimo.
12 Available from: http://www.centroteatralebresciano.it/eventi/extraordinario-esperienze-di-ascolto-del-la-citta [Accessed 7 January 2019].
13 *Performing the social (Performare il sociale. Formazione, cura e inclusione sociale attraverso il teatro)*, is a national research project currently underway involving the Italian universities of Turin, Rome, Pavia, Genoa and Cattolica of Milan, funded by the MIUR (Italian Ministry of Education, University and Research) which has chosen *Legami in spazi aperti* as one of the field experiences to monitor.

References

Bartoli, R., 2016. Il diritto penale tra vendetta e riparazione. *Rivista italiana di diritto e procedura penale*, 59(1), 96–108.
Bernardi, C., 1998. Il teatro sociale. *In:* C. Bernardi and B. Cuminetti, eds. *L'ora di teatro*. Milano: EuresisEdizioni, 157–171.
Bernardi, C., 2004. *Il teatro sociale. L'arte tra disagio e cura*. Roma: Carocci.
Bernardi, C., 2015. *Eros. Sull'antropologia della rappresentazione*. Milano: Educatt.
Bernardi, C., 2017. La piccola rivoluzione del teatro sociale. *Ateatro #BP2016, 160*. Available from: http://www.ateatro.it/webzine/2017/03/21/la-piccola-rivoluzione-del-teatro-sociale/ [Accessed 7 January 2019].
Bernardi, C., Cuminetti, B. and Dalla Palma S., eds., 2000. *I fuoriscena. Esperienze e riflessioni sulla drammaturgia nel sociale*. Milano: EuresisEdizioni.
Bodo, C., 2015. Come valutare l'impatto della cultura in carcere: l'esperienza anglosassone. *Economia della Cultura*, 25(1), 133–140.
Castellano, L., 2015. Il carcere dei diritti. *il Mulino*, 64(6), 1093–1099.
Chanial F. and Fistetti F., 2011. *Homo donator. Come nasce il legame sociale*. Genova: il melangolo.
Coletti, Carla. Social Theatre Facilitator of *I Briganti* Cultural association (video interview 29th November 2018).
Constitution of the Italian Republic (n.d.) Rome: Parliamentary Information, Archives and Publications Office of the Senate Service for Official Reports and Communication. Available from: http://www.senato.it [Accessed 7 January 2019].

Conte, I., et al., eds., 2003. *Teatro e disagio. Primo censimento nazionale di gruppi e compagnie che svolgono attività con soggetti svantaggiati/disagiati*. Cartoceto (PU), [s.n.].

Coordinamento nazionale teatro e carcere, 2011. *Atto costitutivo comitato "Coordinamento nazionale teatro in carcere"*. Available from: http://www.teatrocarcere.it/tcwp/wp-content/uploads/2013/05/statuto_documento_condiviso.pdf [Accessed 7 January 2019].

Dalla Palma, S., 1985. Gioco e teatro nell'orizzonte simbolico. *Comunicazioni sociali*, 7(2–3), 37–64.

Dalla Palma, S., 2001. *La scena dei mutamenti*. Milano: Vita e Pensiero.

De Marinis, M., 2011. *Il teatro dell'altro: interculturalismo e transculturalismo nella scena contemporanea*. Firenze: La casa Usher.

Dragone, M., 2000. Esperienze di teatro sociale in Italia. In: C. Bernardi, B. Cuminetti and S. Dalla Palma, eds. *I fuoriscena. Esperienze e riflessioni sulla drammaturgia nel sociale*. Milano: EuresisEdizioni, 61–123.

Favero, O., ed., 2009. *Spezzare la catena del male. Esiste un modo per riparare quello strappo profondo prodotto da chi ha commesso un reato?* Venezia: Ristretti Orizzonti.

Fischer-Lichte, E., 2008. *The transformative power of performance. A new aesthetic*. London and New York: Routledge.

Fistetti, F., 2010. *La svolta culturale dell'occidente. Dall'etica del riconoscimento al paradigma del dono*. Perugia: Morlacchi.

Fistetti, F., 2017. *Convivialità. Una filosofia per il XXI secolo*. Genova: il melangolo.

Folgheraiter, F., 2007. *La logica sociale dell'aiuto*. Trento: Erickson.

Gabrielli, R., 2015. *Scrivere per il teatro*. Roma: Carocci Editore.

Giardiello, M., 2016. Riconsiderare la coesione sociale e l'integrazione civica nella prospettiva della generatività sociale. *Scienze e Ricerche*, 37, 22–34.

Giordano, F., Perrini, F., Langer, D., Pagano, L. and Siciliano G., eds., 2017. *L'impatto del teatro in carcere. Misurazione e cambiamento nel sistema penitenziario*. Milano: Egea.

Illich, I., 1973. *La convivialité*. Paris: Seuil.

Innocenti Malini, G., 2011. Niente è come sembra! Sviluppi contemporanei del teatro in carcere: l'esperienza di Brescia. *Comunicazioni Sociali – Csonline*, 4, 64–75.

ISSP – Istituto Superiore di Studi Penitenziari, 2012. Gli spazi della pena. Tutela dei diritti umani e istituti penitenziari. Monograph of *Quaderni di ISSP*. Ministero di Giustizia, 10. Available from: https://www.giustizia.it/resources/cms/documents/Quaderni_ISSP_n_10.pdf [Accessed 7 January 2019].

ISSP – Istituto Superiore di Studi Penitenziari, 2015. La dimensione dell'affettività in carcere. Uno studio su sessualità, genitorialità e possibilità di procreazione nel sistema penitenziario. Monograph of *Quaderni di ISSP*. Ministero di Giustizia, 13. Available from: https://www.giustizia.it/resources/cms/documents/quaderno_issp_13.pdf [Accessed 7 January 2019].

Langer, D., 2017. Le attività trattamentali negli istituti penitenziari: il ruolo delle attività teatrali. In: F. Giordano, F. Perrini, D. Langer, L. Pagano and G. Siciliano, eds. *L'impatto del teatro in carcere. Misurazione e cambiamento nel sistema penitenziario*. Milano: Egea, 53–76.

Lehmann, H.T., 2006. *Postdramatic theatre*. London and New York: Routledge.

Magatti, M. and Giaccardi, C., 2014. *Generativi di tutto il mondo unitevi! Manifesto per la società dei liberi*. Milano: Feltrinelli.

Mancini, A., ed., 2008. *A scene chiuse: esperienze e immagini del teatro in carcere*. Corazzano (Pisa): Titivillus.

Manifeste convivialiste. Déclaration d'interdépendance. 2013. Lormont: Le Bord de L'Eau.

Mariani, L.W. and Urgo, A., 2017. *Fragili legami: Laboratorio di teatro sociale a cura di Giulia Innocenti Malini, Carla Coletti, Barbara Pizzetti, con Bano Ferrari*. [Video, available from: https://www.youtube.com/watch?v=rsyxpPLz94g].

Mauss, M., 2002. *Saggio sul dono. Forma e motivo dello scambio nelle società arcaiche*. Torino: Einaudi. First edition (1923–1924) Essai sur le don. Forme et raison de l'échange dans les sociétés primitives. *Année Sociologique*, seconde série.

Meldolesi, C., 1994. Immaginazione contro emarginazione. L'esperienza italiana del teatro in carcere. *Teatro e storia*, 9(16), 41–68.

Ministero della Giustizia, 2013. *Sentenza della Corte Europea dei Diritti dell'Uomo dell'8 gennaio 2013 – Ricorsi nn. 43517/09, 46882/09, 55400/09, 57875/09, 61535/09, 35315/10 e 37818/10 - Torreggiani e altri c. Italia*. Available from: https://www.giustizia.it/giustizia/it/mg_1_20_1.wp?facetNode_1=1_2(2013)&facetNode_2=0_8_1_85&previsiousPage=mg_1_20&contentId=SDU810042 [Accessed 7 January 2019].

Ministero della Giustizia, 2016. *Teatro in carcere*. Available from: https://www.giustizia.it/giustizia/it/mg_2_3_0_6.page [Accessed 7 January 2019].

Murray, J. and Farrington, D.P., 2008. The effects of parental imprisonment on children. *In:* M. Tonry and D.P. Farrington, eds. *Crime and Justice: A review of Researches*. Chicago: University Press of Chicago, 133–206. Available from: https://pdfs.semanticscholar.org/715e/0c5bbfc1d62c118da32480d7250a44e06475.pdf [Accessed 7 January 2019].

Pagano, L., 2017. Il sistema penitenziario: governance e dinamiche di cambiamento. In: F. Giordano, F. Perrini, D. Langer, L. Pagano and G. Siciliano, eds. *L'impatto del teatro in carcere. Misurazione e cambiamento nel sistema penitenziario*. Milano: Egea, 39–52.

Piaget, J., 1972. *La formazione del simbolo*. Firenze: La Nuova Italia. First edition (1946) *La formation du symbole chez l'enfant*. Neuchâtel–Paris: Delachaux et Niestlé.

Pontremoli, A., 2015. *Elementi di teatro educativo, sociale e di comunità*. Novara: UTET.

Porcheddu, A., 2016. Il teatro sociale è la nuova ricerca? *Gli stati generali*. Available from: http://www.glistatigenerali.com/teatro/il-teatro-sociale-e-la-nuova-ricerca/ [Accessed 7 January 2019].

Pozzi, E. and Minoia, V., 2009. *Recito, dunque sogno. Teatro e carcere 2009*. Urbino: Nuove Edizioni Catarsi.

Reggio, F., 2010. *Giustizia dialogica. Luci e ombre della Restorative Justice*. Milano: FrancoAngeli.

Rossi Ghiglione, A. and Pagliarino, A., 2007. *Fare teatro sociale. Esercizi e progetti*. Roma: Dino Audino.

Rossi Ghiglione, A., 2013. *Teatro sociale e di comunità. Drammaturgia e messa in scena con i gruppi*. Roma: Dino Audino.

Schechner, R., 1984. *La teoria della performance. 1970–1983*. Roma: Bulzoni.

Schechner, R., 1988. *Performance theory. Revised and expanded edition*. New York and London: Routledge.

Schechner, R., 1999. *Magnitudini della performance*. Roma: Bulzoni.

Schechner, R., 2018. *Introduzione ai Performance Studies*. Bologna: Cue Press. First edition (2017) *Performance studies: An introduction*. New York and London: Routledge.

Schininà, G., 2004. "Far away, so close" psychosocial and theatre activities with serbian refugees. *Drama Review*, 48(3), 32–49.

Talini, S., 2015. Affettività e sessualità in carcere. *Quaderni di ISSP*. Ministero di Giustizia, 13. 9–30. Available from: https://www.giustizia.it/resources/cms/documents/quaderno_issp_13.pdf [Accessed 7 January 2019].

Turner, V., 1982. *From ritual to theatre. The human seriousness of play*. New York: Performing Arts Journal Publications.

Valenti, C., 2004. Teatro e disagio. *Economia della cultura*, 14(4), 547–556.

Valenti, C., 2012. L'età adulta del teatro in carcere. Appunti per il futuro. *Report 2012, Osservatorio dello Spettacolo*. Bologna: Assessorato Cultura e Sport, Regione Emilia Romagna, 6–17.

Vygotskij, L.S., 1987. *Il processo cognitivo*. Torino: Bollati Boringhieri, 135–152. First edition (1978) *Mind in Society. The Development of Higher Psychological Process* edited by M. Cole, S. Scribner, V. John-Steiner and E. Souberman. Cambridge and London: Harvard University Press.

39
EXPLORING DRAMATURGY IN PARTICIPATORY REFUGEE THEATRE AS A DIALOGICAL ART PRACTICE

Dialogical tensions in a temporary relational playground

Sofie de Smet, Lucia De Haene, Cécile Rousseau, and Christel Stalpaert

In participatory refugee theatre, refugees are actively involved in creating and performing a theatre play (Jeffers, 2012). This means participation is central in each step of the creation process, including inventive acts of organic, unformalized, unsolicited acts of participation (Bala, 2017, 2018). Here, interventions with refugee participants have greatly emphasized the construction of refugees' personal narratives as their core theatre practice. The predominant goal is to give refugee participants the opportunity to voice their autobiographical stories, verbally or symbolically, while at the same time sharing these stories with a wider audience. The expression of refugees' personal narratives is primarily understood as a vehicle of benefit and for agency, a mobilization of marginalized voices in society, and as a means to create individual empowerment. At the same time, research on participatory refugee theatre has recently examined how this type of theatre intervention may entail both emancipatory actions as well as simultaneous risk of a reiteration of disempowerment when coming up against the limits of participation (de Smet, De Haene, Rousseau, and Stalpaert, 2018). Indeed, theatre scholars have pointed to the potential limitations of giving voice in the process of theatre participation. Participatory theatre interventions may run the risk of reiterating refugees' victimhood and powerlessness within the encounter with host-society audiences, which are embedded within a wider socio-political context. Shifting away from an emphasis of benefit on refugees' disclosing personal stories in applied theatre, scholars have increasingly raised awareness on the potential risks for refugee participants, adjacent to lines of agency, reiterating the loss of power and agency in applied theatre while documenting the socio-political dynamics at play in the process of giving voice, both between refugee participants and audiences within the broader macro-context of a public encounter (Dennis, 2013; de Smet, De Haene, Rousseau, and Stalpaert, 2018; Erel, Reynolds, and Kaptani, 2017; Jeffers, 2008, 2013). Scholars have increasingly explored the potential of the variety of meaning in artistic expression and aesthetic representation of testimonies of collective violence

and forced displacement (Cox, 2008; Tinius, 2016; Trezise and Wake, 2009). In doing so, they have been calling for a dynamic and critical exploration of the aesthetic representation of testimonies of collective violence and forced displacement in applied theatre practices with refugee participates in host societies beyond the representation of their personal narratives (Balfour and Woodrow, 2013). Furthermore, theatre scholars have argued for the importance to broaden the theoretical reflection on aesthetic language and representation in participatory theatre practices beyond the modes of representation and transmission in the performative encounter with an audience. Scrutinizing the aesthetic dimensions of a participatory theatre process should entail all relational actions, inside and outside the rehearsal space, off and on stage (Warstat, Heinicke, Kulu, Möbius, and Siouzouli, 2015) while understanding the power dynamics of participation as a relational "embodied practice" (Harpin and Nicholson, 2017: 3).

In this chapter, we aim to further this debate on the dynamics of participation in participatory refugee theatre by shedding light on the creative process of the participatory theatre project *Tijdelijk* (translated as *Temporary*). As part of the interdisciplinary research project in the field of theatre studies and transcultural psychology on the role of trauma narratives in participatory refugee theatre, we initiated the theatre project *Temporary* in partnership with theatre director Mokhallad Rasem, a Brussels-based community centre, and nine Syrian refugees, in Autumn 2017. In *Temporary*, the nine participants and the director collaborated towards a public performance work throughout weakly rehearsals that took place at the heart of the Belgian capital. In this chapter, we aim to listen to the voices of its director and the nine participants by means of several formal research interviews and informal conversations. Using the written traces of those conversations that took place inside and outside the rehearsal space, we reflect on dynamics of participation by zooming in on how the director's dramaturgical approach in *Temporary* aspired to a kind of "dialogical art practice" (Cools, 2015) in relationship with the audience and with the participants. A dialogical art practice has been articulated in theoretical reflections on art practices and dramaturgy on different levels, including dialogues both outside and inside the creation process. First, this dialogical art practice, inspired by the work on dialogism of linguists Mikhail Bakhtin and Valentin Volosinov, evolves through processes of exchange and conversation and "shifts its focus from the productive to the receptive side of the creative cycle" (Cools, 2015: 120) as the artist strives towards an active dialogue with the audience with the aim of producing a productive polyphonic conversation, without persuading other pre-existing ideas, in order for new thoughts to emerge.

Thus, all real and integral understanding is actively responsive, and constitutes nothing more than the initial preparatory stage of a response (in whatever form it may be actualized). And the speaker himself is oriented precisely toward such an actively responsive understanding. He does not expect passive understanding that, so to speak, only duplicates his or her own idea in someone else's mind (Bakhtin, 1986: 69). Second, such a dialogical practice is also formulated as taking place within the creation process, between director and participant, and between participant and participant, who all take part in a continuous conversation in the process of creating. In that way, approaching dramaturgy as a dialogical practice between directors and participants ties in with the recent reconceptualization of dramaturgy as, beyond a mere practice from action to performance, a mode of working and action that entails a "social and political kind of work *in practice*" (Georgelou, Protopapa, and Theodoridou, 2017: 20). It is important to acknowledge that the sound of these dialogical practices, both inside and outside the creation process, is not without dissonances of moments of disagreements, misperceptions, conflict, and violence. In *Temporary*, we observed various tensions within dialogical practices both in and outside the creation process, between participants, between participant and audience, between director and participant, and between director and audience. We zoom in on particular tensions that may have evolved between two dialogical practices in and outside the creation process in relation to

the role of director in *Temporary*. Intriguingly, we took note that the pursued dialogue between director and audience seemed to have implications for the dialogue, the dynamics of participation and interaction between the director and the individual participants. We scrutinize this tension in *Temporary* with the use of concrete examples and interview fragments, and reflect on the role of other potential, active but silent dialogues that may have impacted both dialogical art practices, namely inner dialogue and interaction with personal life history of collective violence and forced displacement. Before proceeding with our reflections on the different dialogical art practices at play in this particular participatory refugee theatre project, we first outline the development of the creation process of *Temporary*, followed by an in-depth description of the performance.

A temporary common playground

The participatory theatre project *Temporary* took place in 2017 in the framework of an interdisciplinary research project that explores trauma coping processes for refugees in theatre practices in Western countries of resettlement, and was initiated in collaboration with a Brussels-based community centre and a professional theatre director, Mokhallad Rasem. Nine Syrian refugees with different ethnic and religious backgrounds, aged between 18 and 26, participated in the theatre project. They had all fled pre-displacement stressors of war and organized violence in Syria, had lived in Belgium for a duration of between one year and five years, and were granted permanent resident status. Although only a small minority of Syrian refugees worldwide is resettled within European borders, the Syrian community constitutes the largest country of origin for recognition of refugee status in Belgium in 2016 and 2017 (CGRA, 2016, 2017). Indeed, during the past decade, the wars, armed conflicts, and individual persecutions have continued to force people across the world to flee their countries and leave their families and communities behind in search of a safe haven and to live in exile. After arriving in a host society, refugees face the challenge of coping with these experiences of collective violence and persecution. However, they often also face accumulative experiences of structural violence in the form of discrimination and social exclusion, as well as direct social hostility, as a result of a growing socio-political climate of polarization and xenophobia (De Cleen, Zienkowski, Smets, Dekie, and Vandevoordt, 2017; do Mar Castro Varela and Mecheril, 2016; Jackson, 2005; Rousseau, 2018; (Figure 39.1).

Throughout the entire project, the lead author of this contribution conducted participant observation during the rehearsals and public performances, as well as three in-depth semi-structured interviews with each participant. One year after the start of the project, the same author conducted an interview with Rasem to reflect further on the entire research collaboration and the theatre project.

Rasem studied theatre at the Bagdad Conservatory and Bagdad University in Iraq, where he created his first performances. A European tour with his performance *Sorry, Sir, I didn't Mean It* in 2005 suddenly inaugurated radical change in Rasem's life course. Against the backdrop of an increasingly protracted conflict and organized violence in his home country Iraq, he applied for asylum in Belgium at the end of the tour. After a long waiting period in an asylum centre in a small village in Belgium, Rasem picked up the thread of making theatre with Belgian theatre organizations, often in international collaborations, such as the Antwerp city theatre Het Toneelhuis, where he has been a permanent artist in residence since 2013. He toured internationally with several of his award-winning performances, for example, *Waiting* (2014) and *Body Revolution* (2015). After staging a range of classical European repertoire, Rasem developed a more documentary approach in his theatre performances and theatre making processes while focussing extensively on improvisation with actors in the creative process and incorporating

Figure 39.1 A temporary common playground. (Photo: Steff Nellis.)

documentary material, which includes photography and video-material, in his performative work.

Rasem often distances himself from the classical theatre scene and rehearsal space by immersing himself and his audiences in unconventional spaces to create and perform his theatre work. For example, for the performance *Zielzoekers* (translated as *Soul Seekers*), he engaged with the inhabitants of an asylum centre at the Belgian-French border for several months and created a visual performative collage of their testimonies. In *Delivery Theatre*, the audience could place an online order of one of several performances described on a menu, which would then be delivered to them at home by Rasem himself, who would drive around the city on his delivery moped. A cardboard theatre maquette at the back of Rasem's mopeds forms the backdrop of a performance in miniature on a theatre stage in ruins. In his most recent theatre production, *Dagboek van Een Leeg Bed* (translated as *Diary of an Empty Bed*), Rasem engages for the first time in his artistic career with personal diary excerpts written during the last 20 years travelling in time from his life in Iraq to the one in Belgium. In this intimate performance, he reconnects with his memories and mother tongue, Arabic. Through word association he creates a world violence, depicted with poetry.

The creative process: towards the new world

The theatre project *Temporary* consisted of eleven weekly collective theatre workshops of four hours in the community centre in Brussels. The creative process developed around the overall narrative structure of a collective imaginative transgression of an old world into a new and envisioned one as the main structuring device. This was delineated by Rasem at the start of the project. The old world symbolized the past, the new world the present, and the envisioned world

the future. In this way, the overall collective narrative suggested a temporal continuity from the past to the present and the future. This narrative served as the overall structure of the theatre process, which was composed of four different types of creative activities: creative movement and expression exercises, video-recorded interviews, the development and discussion of participants' creative writing material, and role-playing games and improvizational exercises.

Creating collective tableaux vivants

The transgression of the old to the new world was reflected in a steadily increasing collection of words selected by the director, as they appeared and reappeared in the course of the rehearsals. At the end of the creative process, the following 25 words were selected.

Freedom
Fear
Happy
Flight
Memory
Embrace
Dead
Love
Farewell
History
Border
Time
Lost
Gain
Loss
Animals
Birth
Life
Sleep
Shock
Scream
Sorrow
Revolution
Danger
Selfie

Here, participants were invited to express these words physically and non-verbally while reflecting on their meaning and associations. During the exercise, participants could verbally elaborate on their bodily expression within the group. Furthermore, as a group, they were encouraged to develop a collective *tableau vivant*, interweaving all group members' bodily expressions into a unifying realm for each word. In this exercise, which combined the possibility for mere nonverbal as well as verbal means of expression, participants could witness each other's bodily expressions of significant words associated with the past, present, and future. Steadily, the growing chain of words was translated into a series of *tableaux vivants*, during which the participants very slowly transformed one word or one *tableau* into the other, from one emotion or memory to the other, from the past to the future.

Reflecting on video interviews

Second, the director asked each participant to reflect verbally on the meaning of some of the collected words in individually videotaped interviews. The responses of the participants varied from long silences and single words to long monologues including personal life trajectories and more general statements and opinions about the meaning of these words. During the subsequent rehearsals, the director showed a montage of the videotaped interviews, in which the chain of words was represented by verbal accounts of the participants. While watching these edited videos, participants could see themselves and each other while reflecting on potential differences and opposing opinions on the meaning of words such as "freedom", "flight", "fear", "happiness", "memory", "love", and "history".

Creating and sharing personal material

Thirdly, throughout the rehearsal process, the director encouraged participants to write or bring texts, stories, poems, or other creative material inspired by the creative process. This creative input, which established a connection between the rehearsals and the personal work and daily life of the participants, took place on a continuous basis throughout the rehearsal process. Some participants brought written texts, others brought drawings or songs. Seven participants decided to write texts themselves, which resulted in six prose texts and five poems. All creative writing material was brought into the rehearsal space and presented by the writers to the entire group and the director. Afterwards, all texts were translated into Dutch and were, in the following rehearsals, recited simultaneously in Arabic and Dutch. For example: one participant's poem, entitled "Achilles", referred to heroes, gods, and goddesses of the Greek mythology and other Western cultural symbols.

> Mother, you are greater than Thetis, mother of Achilles
> who made for him an impenetrable shield
> to protect his strong body.
> You made shields to protect my soul
> from love, passion, madness, and the acceptance of the other.
> Mother, you are greater than Thetis
> and therefore
> I will be stronger than Achilles.
>
> *(excerpt of "Achilles")*

Another participant wrote a prosaic dialogue between several fictive Syrian asylum seekers in a Belgian asylum centre. In the course of this dialogue, he integrated his own voice while referring to the exercise of the collection of words in the rehearsal process.

Osama interrupts Mohammed, and asks me: "And you, what are you writing about?"
I say: "I participate in a theatre play with some refugees, but the organization and the audience are Belgian. I'm writing a text on some of the words that are central in the play."
Osama: "Oh, which words?"
I: "Love."
Ilyas replies: "Love is when the smuggler likes you so much that he puts you on the sea when the waves are not that high."

(excerpt of "Those who are recently defeated")

Envisioning a new world

Finally, through role-playing games and improvization exercises, the participants were encouraged to enact the transformation of an old world into a new one, both on a personal level and as a group. For example, during one improvization exercise, participants were asked to enact a gathering for a last supper before leaving to the new world. During another exercise, they were asked to pose as a king or a ruler of the new world. The participants could verbally generate ideas and values on how they as a king would imagine a new world. During a follow-up exercise, every participant could improvise a particular action he or she would use to exercise power upon the others if he or she were to be king. Whoever takes the king's crown becomes the king. The participants compelled each other to sing, to dance, or laugh, but also to obey and abuse power. This exercise was aimed towards personal reflection on subtle forms of violence present in daily interactions, exercised by every individual against the backdrop of a polarizing social climate.

Temporary

As the premiere approached, the collection of created expressive verbal, choreographic, auditory and visual material, and theatrical scenes were arranged into a continuum of scenes in which all the participants were continuously present. The result was the public performance *Temporary*, of which every theatrical scene and every text was developed by the participants during the creative process. The performance was staged during three consecutive evenings in a community centre in Brussels, followed by three performances in the state theatre in Antwerp during the following week. In this respect, it is important to note that the participants were able to shape and reshape the very form of their participation on stage within the public performance at all times, and were allowed to decide whether they wanted to perform or not up until one week before the premiere would take place. In the end, all participants decided to take part in the public performance. The audience consististed both of members of the host society and members of the (Syrian) diaspora community.

As the audience enters the performance space in *Temporary*, the performers' presence fills the stage, each of them carrying a collection of shredded pieces of white fabric. Once the light fades, excerpts of the participants' written texts and poems, which were recorded in Arabic and Dutch, are played, directing the audience's attention to a multiplicity of parallel multi-linguistic auditory and visual signs. While listening to the self-written poetry, the audience members witness the performers picking up their clothes and gathering behind a beautifully laid table decorated with white fabric and a wide variety of fruits. Simultaneously, fragments of individual interviews mixed with images of moving clouds can be seen, projected on a spacious white canvas at the back of the stage. As the words disappear and the background music becomes louder, the performers move very slowly towards each other in front of the table before they start an endless collective journey towards the audience. They are supported by projected images of a pathway through the forest. Once they have arrived in the spotlights, in front of a king's crown lying on the floor, the audience notices that the performers' faces have been painted in vivid colours. Suddenly, one performer slowly unfolds one shredded piece of fabric and presents it to the audience. It reads "welcome". This is the start of a chain of words. On shredded pieces of white fabric, the performers present big, hand-written words in different languages including Arabic, Dutch, French, and English. The large volume of cut fabric functions as meaning-shifting performative objects within the performance, varying from pieces of luggage to meaning-denotations explicitly shown word for word to the audience members. The music fades and an endless silence fills

the performance space. The performers continue to silently present words, one after the other, with footsteps and coughs as the only auditory signs. A series of *tableaux vivants*, during which the performers slowly move from one *tableau* into the other, from one emotion to the other extreme and back, breaks the silence for the first time. The performers start to faintly whisper certain Arabic words. A sudden interruption of the chain of silent words occurs when one of the performers secretly picks up the crown. From this moment onwards, the audience witnesses a chain of absurdly and hilariously dominant Arabic-speaking rulers, kings, and queens, as the performers alternately seize power by deceivingly taking away the crown until one of the performers refuses to become the group's successor. This critical juncture confronts the performers and the audience with the increasing absurdity of power abuse. Fragments of texts written on large pieces of shredded white fabric convey a harsh reality: "Love is when the smuggler likes you so much that he puts you on the sea when the waves are not that high". The scene results in a final rejection of the crown followed by a joint return to the table. Sequences of poetry are replayed, converging into the voice of Lebanese singer Fairuz, supported by dissonant chords, while the performers are preparing for another departure towards another new unknown world.

Dialogical practices inside and outside the creation process

"The outwardly, actualized utterance is an island rising from the boundless sea of inner speech; the dimensions and forms of this island are determined by the particular situations of the utterance and its audience" (Volosinov, 1973: 96).

Throughout the dialogical practice that the director aimed to generate with the audience members in *Temporary,* he adhered to a particular format in the representation and expression or, in Bakhtinian terms, "utterance" of the participants' experiences of loss and suffering within that dialogue. As a director, Rasem emphasizes the importance to adhere to a specific kind of theatrical representation, one that shelters the audience in favour of personal interpretation. In this way, he gives audience members the freedom to witness refugees' experiences of loss and suffering according to each person's particular character and history. The creation of beauty – or aestheticization – through the exploration of experiences of collective violence and forced displacement enables movements of interpretation for each individual audience member. For Rasem, this is the affective force of sharing experiences of war and displacement in art, which might reinforce an actively responsive understanding from the audience members. An aesthetic language could protect those who express and those who bear witness in the process of expressing experiences of atrocity and social suffering, as well as the connection between them.

> In *Temporary* we have a kind of representation of what has happened, without texts, but with the use of the body and the use of images. When you see the *tableaux vivants* of the performance, they seem portraits of people who experienced terrible events. But how do you present that to an audience while still creating space for the audience to interpret? That is a very important question for me. As an audience member watching the performance, you are looking at a beautiful painting. However, if you explored the beauty of the painting more deeply, you would perhaps discover a painful colour. You would discover certain horrifying thoughts in that same painting. The performance is like a very beautiful flower. But as an audience member, you might wonder, what are the roots of this flower? As a director I started working with the roots, but I will not present the roots. I present something that can communicate with the audience. I will present a flower. But I find it very important that the audience can go back and forth from the flower to the roots, as a continuous back and forth analysis. Perhaps, it is an

analysis that the audience member cannot make at the very moment of watching. But if one wants to explore, one will discover.

(de Smet, personal communication, November 14, 2018)

Besides what he calls throughout an active dialogue with the audience members, Rasem aims to move beyond stigmatized notions of refugees in his frame of representation. In his perspective, the purpose of participants' expressions is to dismiss stereotypical notions of the refugee in order to develop an interaction based on a shared humanity. Rasem eschews the dominant testimonial culture, which is mainly focused on refugees' singular stories of loss and suffering. As such, Rasem's words fit into a wider debate in participatory refugee theatre in Western countries of resettlement that questions the focus on the telling of personal stories in theatre encounters (Balfour and Woodrow, 2013; Cox, 2012; Jeffers, 2008; Wake, 2013), while examining dimensions of agency in refugees' refashioning and remoulding of aesthetic and theatrical language throughout participation (Cox, 2008; Tinius, 2016).

> The people on stage do not want to be presented as a cliché, they want to be presented as human beings, people like you and me, and not as solely framed by their situation, as refugees. How can we stage them as beautiful people as well? That was a recurring question for me. I always look at the human being when I create something. At the same time, I am looking for a way to present this authenticity to the audience by exploring a certain form. For me, that form always entails that we see who we are, as human beings, as me, as you. That is always the starting point. Be on stage, you, not a different character. There are other things we talk about and the audience should not assume they can only talk about loss; they can also talk about other things. They can dance, play, jump, and laugh. That is exactly what I wanted to achieve in this performance. I did not want them to get on stage with lots of grief. Thousands of people have these stories, all the people that came here, they have these stories, but what do you want to express with these stories? Do you want to say: "This is what happened to me", or "This is my story", or "People who fled their country can only tell stories".
>
> *(de Smet, personal communication, November 14, 2018)*

At the same time, Rasem delineates how in the creation process he aimed to create a dialogue between him and the participants.

> During the first meeting, I could read certain questions in the eyes of the performers: "What will we do? How are we going to play? Which texts are we going to perform? Which role will I play?" They were waiting to receive something from me and I waited to receive something from them. They were expecting a classical theatre text. During the process, people got to know each other. Their background, their mentality, their rhythm, their imagination, their power, everything revolved around them. Everything. And I watched and observed. I left everything open. I could have made a script today and given it to them, but it is not about the script that has to be performed. It is about them, a unique meeting place that becomes a common playground to understand each other and tell stories to one another.
>
> *(de Smet, personal communication, November 14, 2018)*

Through an active engagement during the rehearsals, the director stimulated the participants to shape their own aesthetic language, focusing on embodied and poetic practices. In this way, Rasem explained that each individual participant took active part in creating the *flower*, presented to the audience in *Temporary*.

> In *Temporary*, the people are the roots of the performance. They create meaning at each very moment. They form the rhythm and paint the colour of the flower. For me, the entire group forms the roots of the performance.

Here, it seemed that the dialogical practice within the creation process took place against the backdrop of a future dialogical practice in the public performances. The audience member as a future witness and conversation partner continuously entered the rehearsal space as a silent listener that impacted the dialogue between director and participants. The focus on creating beauty or a *flower* as a structuring container to represent experiences of loss and violence in a dialogical practice with the audience might have mitigated the dramaturgical listening in interaction with the participants. The format of representation aimed at by the director may at times have limited the space to remain present to practise a continuous open dialogue within the creation process on the theatrical representation of experiences of collective violence and forced displacement. In what follows, we outline by means of concrete examples how the dialogical practice in the creation process became an area of tension where both dialogical practices met. The director's dramaturgical format of representation, through its malleable creative structure, seemed to bore the vital potential to protect and support participants, while at the same time running the risk of silencing them throughout that dialogue.

It should be noted that the sense of beauty and its indirect gaze by symbolization provided some participants with vital ways for protecting themselves against emotional deregulation and distress, and to alleviate pain through expressing personal stories of loss and suffering. Furthermore, symbolic pathways of expression may enable the exploration of a mode of expression for ensuring cultural continuity and transcultural transmission in the process of giving expression to experiences of loss and trauma in relation to their own as the host society community (de Smet, Stalpaert, Rousseau, and De Haene, 2019). However, we observed how the exclusion of the representation of the harsh reality of Syria through an aestheticized language may have in some ways silenced the urge of some participants to explicitly disclose stories of suffering and loss. Indeed, being confronted with a growing climate of xenophobia and polarization in Western countries, including the resettlement country, several participants attributed an important political role to remembering histories of collective violence in the presence of the audience as witnesses. This remembering could contribute to the remobilization of empathy for the human suffering that Syrian refugees faced, and bring about change in the dominant representation of Syrian refugees. Besides the role of recalling experiences of collective violence as a vehicle for adjusting the dominant de-humanizing representation of refugees in society, participants emphasized the meaning of recollection as a political act to challenge the dominant unilateral narrative of the Syrian conflict in the resettlement country and the international community. Indeed, some participants expressed how the public performance could create the opportunity to disclose those stories of Syrian history of oppression and repressive dictatorship that have been silenced in the media, while at the same time addressing the prevalent media images and official master-narratives that focus on the recent upspring of ISIS and Islamic terrorism. Furthermore, voicing these personal accounts of oppression and war in the presence of the audience members as representatives of the host society, provided some participants with a certain hope for a change in the current situation in Syria, as it offered means for denouncing

the complicity of the international community and re-humanizing the representation of the conflict.

Furthermore, in the dialogical practice with the audience, the notion of refugee was explicitly avoided by focusing on a shared humanity. One participant indicated, however, how he particularly wished to counter the dominant attitude within the Syrian refugee community to "act" as if there is no pain and dismiss their identities as refugees. Therefore, he aimed to reinforce a sense of pride and human dignity for the word "refugee" and advocate for vulnerability within the Syrian community by disclosing stories of daily hardship and mundane stressors within the life in exile for Syrian refugees. Paradoxically, refugees' vulnerability forms a rationale behind legal legitimation, while at the same time causing suspect in its absence in the host country (Kirmayer, 2013). In *Temporary*, the very legitimacy of refugees' vulnerability in dialogue with the audience became a source of tension between participant and director. Within this particular tension it becomes apparent how director and participant might have had different pursued addressees in mind in their dialogical practice with the audience members. Indeed, throughout the creative process, some participants envisioned the silent listener as one belonging to their own Arabic community and refugee community, rather than the host society. This tension calls for a critical reflection on the complexity of staging vulnerability and the "re-enactments of victimhood" in refugee theatre (Jeffers, 2008: 217) while integrating the voices of refugees themselves within this debate. Overall, however, the question remains whether *Temporary* may have reinstalled the focus on Syrians' resilience in the host society and the Syrian community, by creating a public platform showing successfully integrated Syrians on a public stage in Belgium.

Finally, the container of beauty that was important in the dialogue with the audience, for some participants seemed to resonate with the language used by the Syrian (political) elite. An aesthetic language might not be understandable for all present audience members, including the refugee community. In this way, conforming to the format of theatrical representation of loss and suffering in *Temporary* for some participants seemed to induce feelings of ambivalence and disloyalty towards the cause of the Syrian revolution and the Syrian people. For the participants, the pursued format of representation therefore may have constituted a certain continuation of the oppression of the weakest in the society by a political and intellectual elite. For example, one participant explained that he disliked the stretched series of *tableaux vivants* in the performance as he feared of losing track of the connection with the man in the street. He indicated the importance of him speaking a language that continues to address his people, the men and women in the street, as revolution in the past and the future will always arise from the street.

In sum, it seemed that in *Temporary*, an open dialogical practice between director and participants was not entirely compatible with a responsive understanding in interaction with the audience through the aspired format of representation of loss and suffering. In *Temporary*, the aesthetic language or *flower* that formed the structural base for an active dialogue with the audience seemed to have been perceived as a vehicle of power dynamics within the relationship between director and participant and the group's "microphysics" of power (Dona, 2007). The very experience of the director's control in determining the creative format was by some participants experienced as intrusive, and resonated with experiences of oppression and authoritarian rule in the home country. By contrast, another participant explicitly delineated the importance of the director to take up such a hierarchical position with the purpose to safeguard the unity and equality within the group. He underlined that his experiences with other participants, who attempted to acquire a sense of control throughout the creative project, reminded him of previous experiences of corruption and sectarian discrimination in Syria. The director's ambivalent role and position of power thus demonstrated the fine and fragile line in securing unity and the exercise of power, while directing a theatre project with people whose life histories are marked

by experiences of organized violence and discrimination. Indeed, applied theatre scholars have increasingly encouraged theatre makers to acknowledge hierarchical pitfalls and power dynamics when dealing with aesthetic languages, as well as to deconstruct power tendencies in the creation process, funding models, and evaluation of applied theatre projects (Enria, 2015; Hamel, 2013; Heinicke, 2017). However, it could be noted that this tension, in which power dynamics became more present, might have been affected by another inner dialogue: a continuous dialogue that the director has with his own personal history of organized violence and forced displacement. Here, we would like to denote how the aesthetic language of representation in *Temporary* seems to resonate with the director's life as an artist.

> Not every production is about the war, but the power, the energy, the atmosphere, the images of war stay with you – they inhabit your body, your mind and your thoughts. How can I turn all that into art, how can I portray all those elements like a painting, like a dance? How can I portray those terrible things? That's how I started making theatre.
>
> *(Toneelhuis, 2019)*

Beyond being a mere format of representation in the dialogical interaction with the audience, the creation of beauty and an aesthetic language might mirror how the director personally interacts with his personal life story of loss and forced displacement. The language of art and beauty became an important vehicle for support in director's life, and a pathway to express experiences of the war – perhaps it was also a way to reinstall a sense of continuity in a ruptured artistic life.

Conclusion

In this chapter, we elaborated on the different dialogical practices at play in the participatory theatre project *Temporary*. By zooming in on the role of the director within this theatre project, we examined how the pursued dialogue with the audience implicated a tension with the dialogical practice inside the creation process, and in the interaction between the director and the participants. We pointed to the concern of considering the director's personal engagement with a history of forced migration.

However, it is important to highlight that such a tension equally unfolded within the dialogical practices between the participants themselves. In that way, the internal group dialogue has been equally affected by the participants' continuous inner dialogues with their personal histories of organized violence in a fragmented and polarized Syrian community shattered by trauma. A dialogical practice amidst the plurality of potentially discontinuous inner voices within the rehearsal space as a dramaturgical practice "that is already a politicized activity" (Georgelou et al., 2017: 21) did not elude the macro socio-political dynamics at play in the protracted current Syrian conflict, the Arab world, and the Western host society. Furthermore, it was coloured by the participants' personal histories of traumatic experiences of atrocity and man-made violence. In this respect, it seemed that the development of dialogical practices within the creation process, between the director and the participants, and among the participants, were not without a vital risk in reiterating acts of violation resulting in a further polarization and breaches of trust between participants in line with macro-political dynamics. However, we observed that the rehearsal space may have provided a relative safe space, where the participants could carefully and collectively explore and hold this tension and dissensus between them. Here, they could negotiate as "diplomatic bodies" (Protopapa, 2013; Stalpaert, 2015a) via a symbolical communicative manner through the use of the body, cultural symbols, music, and prose while work-

ing towards a collective performance. In this respect, it is arguable that the tension within the participant–director dialogue may have become more discernible due to the director's position of power within the creation process, but also because of the protective strength of distancing mechanisms at play in the symbolic way participants could dialogue in the creative workshops that the director facilitated. As Cools (2017) describes in his work as a dramaturge in conversation with choreographers, a practice of correspondence (written letters) or ekphrasis (a work of art in response to another work of art) throughout a dialogical practice could initiate a distance in time and hence "a delay in the dialogue" in favour of freedom of interpretation, use, and reaction at the side of the addressee (Cools, 2017: 106). For example, in *Temporary*, several participants wrote poetry and prose that were at times written in reply to the other group members' texts. Reciting these texts to each other in the workshops, with a distance to the adversarial content and a distance in time in reply, may have created moments of transcending the tension within their dialogical practice.

Further, in addition to the dialogical practices described above, there remains another dialogical practice, one that evolves around the role of the involved researcher, who initiated formal and informal research conversations in and outside the rehearsal space with both the individual participants and the director. The resemblance with the role of a dramaturge in artistic practices is striking here. Indeed, the role of a dramaturge has been described as a witness and moderator in a dialogical practice with the participants and the director: "A good moderator keeps his own voice and opinion out of the discussion. But you do support and reinforce the voice in the discussion that you feel is most relevant in contributing to a solution in which everyone can eventually recognize themselves" (Cools, 2015: 122). The similarity between researchers and dramaturges in the observation of creation processes in Belgium and other European countries has recently been proposed in the field of theatre studies, more specifically with the notion of a "researcher-as-dramaturge" or "dramaturge–researcher" (Karreman, 2017; Lievens, Persyn, de Smet, and van Baarle, 2018; Stalpaert, 2017). In *Temporary*, we became the witness of tensions that arose between different dialogues inside and outside the creation process. This essay as a written trace of those tensions intends to be a continuation of such a dialogical practice as a dramaturge–researcher, as witness and as moderator. After all, engaging in a dialogical practice as a dramaturge entails "to participate in the affective (mine)field he or she must by necessity tread on, daily, inside the studio and outside, alone and along with everyone else" (Lepecki, 2010: 71). Indeed, throughout the prevailing focus on the social and political strength of productive and responsive polyphonic dialogues as dramaturgical practices, we tend to forget how easily these encounters may turn into an emotional, social, and political minefield with a cacophony of voices that may harm, confuse, and violate. And holding those may also hold the promise of restoration in the aftermath of violence.

Acknowledgements

This work was supported by the Special Research Fund (BOF), Ghent University, Belgium.

References

Bakhtin, M., 1986. *Speech genres and other late essays*. Austin, TX: University of Texas Press.
Bala, S., 2017. The art of unsolicited participation. In: T. Fischer and E. Katsouraki, eds. *Performing antagonism: Theatre, performance & radical democracy*. London: Palgrave Macmillan, 273–287.
Bala, S., 2018. *The gestures of participatory art*. Manchester: Manchester University Press.
Balfour, M. and Woodrow, N., 2013. On stitches. In: M. Balfour, ed. *Refugee performance: Practical encounters*. Bristol: Intellect Ltd., 14–34.

cgra, 2016. *Asylum statistics 2016*. Available from: https://www.cgra.be/sites/default/files/asylumstat_2016_en.pdf.

cgra. 2017. *Asylum statistics December 2017*. Available from: https://www.cgra.be/sites/default/files/asylumstat_december_2017_en.pdf.

Cools, G., 2015. *In-between dance cultures: On the migratory artistic identity of Sidi Larbi Cherkaoui and Akram Khan*. Amsterdam: Valiz.

Cools, G., 2017. Correspondence and ekphrasis. *In:* K. Georgelou, E. Protopapa and D. Theodoridou, eds. *The practice of dramaturgy: Working on actions in performance*. Amsterdam: Valiz, 100–107.

Cox, E., 2008. The intersubjective witness: Trauma testimony in Towfiq Al-Qady's Nothing But Nothing: One Refugee's Story. *Research in Drama Education: The Journal of Applied Theatre and Performance Research*, 13(2), 193–198. doi:10.1080/13569780802054851.

Cox, E., 2012. Victimhood, hope and the refugee narrative: Affective dialectics in magnet theatre's every year, every day, i am walking. *Theatre Research International*, 37(2), 118–133. doi:10.1017/s030788331200003x.

De Cleen, B., Zienkowski, J., Smets, K., Dekie, A. and Vandevoordt, R., 2017. Constructing the 'Refugee Crisis' in Flanders. Continuities and adaptations of discourses on asylum and migration. *In:* M. Barlai, B. Fähnrich, C. Griessler and M. Rhomberg, eds. *The migrant crisis: European perspectives and national discourses*. Berlin: LIT Verlag, 59–78.

Dennis, R., 2013. Inclusive democracy: A consideration of playback theatre with refugee and asylum seekers in Australia. *In:* M. Balfour, ed. *Refugee performance: Practical encounters*. Bristol: Intellect Ltd, 281–296.

de Smet, S., De Haene, L., Rousseau, C. and Stalpaert, C., 2018. 'Behind every stone awaits an Alexander': Unravelling the limits of participation within micro and macro dramaturgy of participatory refugee theatre. *Ride – The Journal of Applied Theatre and Performance*, 23(2), 242–258. doi:10.1080/13569783.2018.1438181.

de Smet, S., Rousseau, C., Stalpaert, and De Haene, L., 2019. A qualitative analysis of coping with trauma and exile in applied theatre with Syrian refugees: The role of within-group interactions. *The Arts in Psychotherapy*, 66, 1–12. doi:10.1016/j.aip.2019.101587.

do Mar Castro Varela, M. and Mecheril, P., 2016. *Die Dämonisierung der Anderen: Rassismuskritik der Gegenwart*. Bielefeld: transcript Verlag.

Dona, G., 2007. The microphysics of participation in refugee research. *Journal of Refugee Studies*, 20(2), 210–229.

Enria, L., 2015. Co-producing knowledge through participatory theatre: Reflections on ethnography, empathy and power. *Qualitative Research*, 13(3), 319–329.

Erel, U., Reynolds, T. and Kaptani, E., 2017. Participatory theatre for transformative social research. *Qualitative Research*, 17(3), 302–312.

Georgelou, K., Protopapa, E. and Theodoridou, D., 2017. *The practice of dramaturgy: Working on actions in performance*. Amsterdam: Valiz.

Hamel, S., 2013. When theatre of the oppressed becomes theatre of the oppressor. *Ride - The Journal of Applied Theatre and Performance*, 18(4), 403–416. doi:10.1080/13569783.2013.836918.

Harpin, A. and Nicholson, H., 2017. *Performance and participation: Practices, audiences, politics*. London: Palgrave Macmillan.

Heinicke, J., 2017. Koloniale Fallstricke erkennen und meiden. Perspektiven für interkulturelle Theaterarbeit von der Finanzierung über Ästetik bis zur Evaluation. *In:* M. Warstat, F. Evers, K. Flade, F. Lempa and L. Seuberling, eds. *Applied theatre: Rahmen und positionen*. Berlin: Theater der Zeit, 111–136.

Jackson, R., 2005. *Writing the war on terror: Language, politics and counter-terrorism*. New York: Manchester University Press.

Jeffers, A., 2008. Dirty truth: Personal narrative, victimhood and participatory theatre work with people seeking asylum. *Research in Drama Education: The Journal of Applied Theatre and Performance Research*, 13(2), 217–221.

Jeffers, A., 2012. *Refugees, theatre and crisis: Performing global identities*. New York: Palgrave Macmillan.

Jeffers, A., 2013. Hospitable stages and civil listening: Being an audience for participatory refugee theatre. *In:* M. Balfour, ed. *Refugee performance: Practical encounters*. Bristol: Intellect Ltd.

Karreman, L., 2017. *The motion capture imaginary: Digital renderings of dance knowledge*. Unpublished dissertation. Ghent: Ghent University.

Kirmayer, L. J., 2013. Foreword. *In:* K. Block, E. Riggs and N. Haslam, eds. *Values and vulnerabilities: The ethics of research with refugees and asylum seekers*. Toowong: Australian Academic Press, v–ix.

Lepecki, A., 2010. Dramaturging. A quasi-objective gaze on anti-memory (1992–98). *In:* J. Peeters, ed. *Are we here yet?* Dijon: Les presses du réel.

Lievens, B., Persyn, L., de Smet, S. and van Baarle, K., 2018. Gesprek: de onderzoeker als dramaturg. *Documenta (Tijdschrift voor Theater)*, 38(1), 110–155.
Protopapa, E., 2013. *Diplomatic bodies. Redirecting, sidetracking, deflecting, bypassing.* Paper presented at the choreography & corporeality working group of the FIRT/IFTR world congress, re-routing performance, Barcelona.
Rousseau, C., 2018. Addressing mental health needs of refugees. *Canadian Journal of Psychiatry*, 63(5), 287–289.
Stalpaert, C., 2015. The performer as philosopher and diplomat of dissensus. A thinking and drinking tea with Benjamin Verdonck in Bara/ke (2000). *Performance Philosophy*, 1, 226–238.
Stalpaert, C., 2017. Dramaturgy in the curriculum: On fluctuating func, dramaturgy as research, and the macro-dramaturgy of the social. *Documenta*, 35(1), 130–158.
Tinius, J., 2016. Rehearsing detachment: Refugee theatre and dialectical fiction. *Cadernos de Arte e Antropologia*, 5(1), 21–38.
Toneelhuis, 2019. Bio Mokhallad Rasem Available from: https://docs.google.com/document/d/1zmfqrfUtA0TImIr-sPTSeAqY18p4JwfRflfWRBsYcKc/edit.
Tr, B. and Wake, C., 2009. On the ethics of non-disclosure: A roundtable with urban theatre projects and collaborators. *Performance Paradigm*, 5(2).
Volosinov, V.N., 1973. *Marxism and the philosophy of language*. New York: Seminar Press.
Wake, C., 2013. Between repetition and oblivion: Performance, testimony, and ontology in the refugee determination process. *Text and Performance Quarterly*, 33(4), 326–343.
Warstat, M., Heinicke J., Kalu, J. K., Möbius, J. and Siouzoul, N., 2015. *Theater als Intervention: Politiken ästhetischer Praxis*. Berlin: Theater der Zeit.

40
THE RIGHT ARTISTIC SOLUTION IS JUST THE BEGINNING

Lene Thiesen

Background

Hodja from Denmark[1] *– Theatre for Asylum Children* was a three-year project (2016–2019) presenting a specifically curated programme of Danish theatre productions and creative workshops to children and young people living (temporarily) in asylum centres throughout the country. The initiative was a response from the artist community to an acute humanitarian situation when hundreds of thousands of refugees[2] from Syria, Afghanistan, Iran, and Eritrea arrived in Europe seeking shelter. Extensive media coverage of thousands of refugees walking along the Danish motorways with their children on their way to Sweden divided politicians and citizens alike on how to react to this situation, and many small communities hosting these temporary centres were directly challenged by the sudden and complex presence of a relatively large number of refugees. Over 21,000 refugees applied for asylum in Denmark (5,7 mil. pop.) in 2015. In comparison, Sweden (9,8 mil. pop.) received 163,000 refugees and Germany (82,2 mil. pop.) received 1,1 mil. refugees.

The response of the children's theatre community was directly motivated by a concern for the future life of children who were starting a new life in these asylum centres in a totally unknown country. The immediate context is that Denmark has both a high level of public funding in the arts and a critically acclaimed children's theatre sector. So, a natural and immediate reaction was to propose that children's theatre companies should perform in the asylum centres. On one level, decades of experience of presenting work in many different social and cultural contexts in many countries had led to an astute understanding of performances giving strong and positive emotional experiences. However, the overall *premise* on a strategic level was also rooted in the proposition that strong artistic encounters can widen individuals' views of the world and can even empower them to act.

The main purpose of the project was to trigger a sense of "being seen and being part of" – to bring moments of relief, joy, and self-forgetfulness in the current situation. Secondly, the approach also aimed to give the children a window to the future with a glimpse of the country and the culture that they would meet and where they probably would spend their next years (97% of the Syrian refugees who arrived between 2014 and 2017 were granted a temporary residency permit).

The political and cultural context

In August 2016, when *Hodja* was launched, 77 asylum centres were functioning; often in temporary buildings. These centres housed approximately 17,000 adults and 5,000 minors. In November 2016, new restrictive asylum policies, including border control, were already being implemented in Denmark and Sweden to stem the flow of refugees.

What kind of country did the refugees arrive to? Denmark is a Scandinavian country that has been identified for its monoculture. The transformation from a homogenous cultural identity concept to an acceptance of a diversity of voices (8.5% of the Danish population originate from descendants of immigrants from non-Western countries) (2019) is occurring only gradually with regard to the production and dissemination of art and culture. Cultural diversity was first put on the agenda in the late 1990s, only to be swept off the table again when a right wing-liberal government, supported by an immigrant-hostile party, came to power in 2001. For a short period, during a centre-left wing government from 2011–2015, there was a will to implement a new diversity strategy, but good intentions were not converted into concrete policies. The common agenda throughout this period was based on "integration" in the sense of "assimilation" (Skot-Hansen 2017). Today, there is still no national portfolio regarding diversity policy in the cultural field and no specific state funding for diversity-related projects. One has left it to local municipalities and private foundations to find their own way.

The Danish theatre for young audiences and the "expressive literacy"

Danish children's theatre is no exception to this. It has no explicit diversity policy and the topic as such is not high on the agenda. The sector has nevertheless succeeded to convert many of the classical diversity parameters (e.g. access for all as related to geographic decentralization, gender, age, socio-economic status) as it reaches out to children where they are: in kindergarten, schools, libraries, etc. A total of 50% of all performances for young audiences in Denmark are outreach based. Where 25% of the Danish population is made up of people under the age of 18, 33% of Danish theatre audiences are in fact made up of people under 18 years of age, illustrating the success of this policy.

Danish theatre for young audiences is also characterized by rather intimate performances for small audiences, seldom made up of more than 80 spectators. The sector is a major supplier of new, relevant and meaningful Danish drama as most productions are created from scratch – it embraces all performance genres, and traditionally there are no taboos when it comes to topics, and they stage children's perspectives of their own life experiences. Children are considered "beings" not "becomings" (Juncker 2006).

Beth Juncker, a former professor at the University of Copenhagen and specialist in children's culture, has summarized the development of the Danish children's theatre: "Since the 1980s we have gradually professionalized the various artistic fields and developed modes of expression, so we are clear on what we can deliver. The reason why Danish Children's Theatre is in demand throughout the world, is because we no longer put pedagogical performances on stage, but rather performances which connect with children's curiosity, their ability to philosophize over life, death and their own existence – because that is what they do. These artistic experiences have independent cultural and social meanings, competencies and values which contribute to make a difference in the lives of the youngest generations." Beth Juncker has labelled these experiences "expressive literacy" (Juncker 2017).

Most Danish theatre companies who took part in the *Hodja* project did not specifically consider "ethnicity/race" as a key parameter. They were convinced that the long tradition of taking children "seriously" by creating performances at "eye-level" could accommodate the asylum children.

But something is slowly changing: the artistic experience must continue to stand alone, but there is a growing awareness of the need to qualify this experience with a pre- and a post-performance context. Not only to enhance the experience, but also to make space for children not accustomed to this art form by giving them a language to understand what they have experienced. Matthew Reason, from the University of York, UK (Reason 2013), and his research into young audiences has been one of the sources of inspiration for the *Hodja* project.

Methodology

There was no model or format for the *Hodja* project, no outer framework to refer to, no monitoring methodology and only limited knowledge of the key audience.

Looking back, it is now clear that the project was conceived on four levels: as an individual artistic immersive experience and "exchange" (performance and workshop); as a social intervention in a well-defined socio-political space and situation (visit to the asylum centre), as a mobilization of civil society to an extraordinary situation (the theatre community), and as a symbolic action (model in the public media). In reality, the foundation of the project was based on the artistic and production capacities and human resources of the theatre companies' approach to engage with young audiences, including their vast experiences with performing internationally. In order to develop a basis common framework and pedagogic approach to the workshops, which were added to the project, we invited experienced representatives from the Red Cross Asylum Department to participate in a seminar with drama pedagogues and project management. The seminar resulted in a guideline paper about values ("recognition" was a key word), outline of actions (e.g. how to relate to the performances), and orientation (to deal with the future and future possibilities, not with the past).

Other methodologic tools included:

- to engage with consultants of Red Cross Asylum Section, who managed 30% of the asylum centres, and to draw on their experiences
- to respect the "arm's-length-principle", thus leaving the final selection of productions to independent, professional dramaturges
- to engage in a dialogue with the host-persons of the asylum centres/schools prior to the *Hodja* visit to maximize the understanding of the context and framework
- to introduce the *Hodja* character as a commonly recognizable figure for both asylum and Danish children. Later in the process, we had to give up this *Hojda* character, as it required ongoing adaptation of the dramaturgy in order to be relevant for all age groups
- to collect data and personal notes after each visit and statements from the host person, teachers, and children from the audience.

In order to secure ongoing reflection regarding the opportunities and threats embedded in the project as well as the evaluation, we initiated a collaboration with The Inclusion Center[3] to provide and supplement both educational process support and formal evaluations. The Inclusion Center's desire to conduct follow-up research had to be dropped for financial reasons.

The first steps: the pilot project (November 2016–February 2017)

With financial support from a number of small private foundations, the project team secured a base for the project at the office of ASSITEJ Denmark[4] and Teatercentrum, a competence centre for the distribution and dissemination of theatre for young audiences. We also employed a project manager. To test our format, we set up a four-month pilot project. In September 2016, we received €100,000 from the private Wilhelm Hansen Foundation to launch the pilot project. We chose to work with a small number of asylum centres and theatre companies and set up a partnership with *Aktør* – a network of drama pedagogues – as only a few theatres offered workshops. We opted to work with centres in two regions, which were already politically aligned to our strategy.

The directors of asylum centres advocated for a common social and cultural platform where children from the asylum centres and from the local neighbourhoods could meet on equal footing to facilitate an understanding of the daily life of Danish children as well as their values and social codes. Therefore, we decided to involve children from local schools in the project where this was a realistic option, although it made the logistics more complicated, e.g. the need to coordinate four schedules (the companies', the Aktør-pedagogues', the asylum centres', and the schools'), the need for larger venues and for more workshops in order to limit the number of participants to 35. In fact, this resulted in more performances took place in schools than in the asylum centres. This decision therefore impacted both the overall strategy, the context, as well as the pedagogical structure of the workshops.

The pilot project was implemented with 7 productions, performed 11 times for 620 spectators, and 14 workshops for 365 participants from 8 asylum centres and 5 schools.

Evaluation of the pilot project

The Inclusion Center conducted an external evaluation of the pilot project, based on a two-day visit to Farsø School and Asylum Centre Ranum in Jutland. The interviewed children were 6–8 and 14–16 years old, respectively.

The following five methods were used: 1) interviews with children, teachers, pedagogues, drama pedagogues, actors, and project manager; 2) questionnaires for Aktør-pedagogues; 3) written contribution from teachers; 4) observation of activities: the performances and workhops; and 5) an analysis of children's drawings created in the workshop.

Project objectives were measured in relation to four themes: 1) meaning for children; 2) meaning for pedagogues and teachers; 3) potential for the pupils' future life; and 4) teachers' and pedagogues' assessments of the potential and effects of the project.

Following is the general assessment of the quality and potential of the *Hodja* project: "A pilot project with clear potential for strengthening the reception and integration of refugee and migrant children who are in special circumstances. We have found strong qualities with regard to creating positive free space for refugee children, positive meetings between refugee children and Danish children, and a fine potential for further development of a solid and supportive concept ... performances and play-workshops are a positive and meaningful format for the sensitive creation of a common space between all children ... There is, however, as expected in a pilot project, a need to clarify the basic assumptions and the applied methods. This is especially true of links between an artistic, play-therapeutic and an everyday educational-didactic effort. Stronger cooperation between project staff, educators and teachers will be desirable."

The full *Hodja* project (March 2017–August 2019)

The pilot project was invaluable and impacted several levels: strategy, the pedagogic structure and method, communications, and also the budget.

This resulted in several specific revisions to strengthen the basic narrative of the visit via a clearer framework. Firstly, including more structured pre-information for the host (school or asylum centre) about the objectives and the programme. Secondly, guidelines as to how to secure more benefit from the teachers' professionalism and their knowledge about the children, especially traumatized children. Thirdly, improving the role of the workshops by linking them to the individual theatre productions via collaborative involvement between the actors and the drama pedagogues in each situation. Fourthly to consider working with four to five productions already known by the drama pedagogues. Finally, to focus on methods to stimulate more collaborative interaction between the asylum children and the school children before, during, and after the workshop.

Partnerships

After the evaluation of the pilot project, the *Hodja* project was extended nationwide. An open invitation was sent to all 77 asylum centres in the country: 64 centres for adults (including families) and 13 centres for unaccompanied minors (12–17 year olds); 80% expressed interest in participating. The 120 Danish performing arts companies for young audiences, which are officially accredited by The Ministry of Culture[5], were also contacted, and 60 were interested in participating. The cooperation with *Aktør* – the theatre pedagogical network – was strengthened. The project thus engaged with multiple partners and stakeholders. The main partners, ASSITEJ and Teatercentrum, supported the project with their know-how, but in fact all stakeholders (the theatre companies, Aktør-pedagogues, the asylum centres, and the schools) could benefit from the project. Engaged, motivated partners and a networked project organization sounds ideal, but the amount of communication required to keep the project moving forward was unexpected and demanded constant attention. The complexity combined with the need to have an effective production and delivery management required a co-ordinating role which only the *Hojda* project could take on, and this was a challenge to the small organization.

Financing and key figures

The final cost of the two-year project amounted to €280,000, of which private foundations covered 76% and the Danish Arts Foundation 24%. For Denmark, this is a remarkably high percentage of private funding. There was no other income as all activities were offered for free. Compared with other theatre touring projects in Denmark, management costs were high. This reflects the time required to kick-start the project, time-consuming logistics, and also the complexity of the project and the necessity to involve external know-how, e.g. The Inclusion Center. All artists and theatre pedagogues, as well as the project management, were paid standard tariffs.

The cost per activity unit (performance or workshop) was €3.733. There was surprisingly hardly any in-kind financing and no funding from the highly regulated "refugee system". See key figures[6].

After the pilot project, the situation became financially insecure, and the organization also suffered from a change of project manager in May 2017. In all, including the pilot project, 22 productions were performed 51 times for approximately 2,900 children/young people, and 24 workshops were organized with 740 participants.

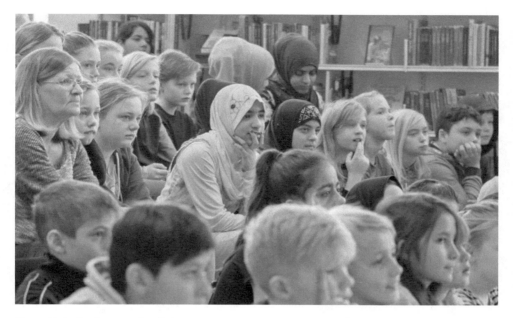

Figure 40.1 Performance by Thalias Tjenere, Hanstholm School. (Photo: Søren Kløft.)

Performances

The four independent specialists in dramaturgy selected 24 different productions for three different age groups, ranging from 3–17 years old. The selection criteria were artistic, thematic, and logistic. However, due to timing-logistics, not all of these productions could actually be presented. Most genres were represented – from poetic mime theatre, humorous musical performances, interactive plays, and comic clown street theatre for all ages to dance theatre about everyday life, contemporary breakdance, poetic object theatre about human rights, and for youngsters, stories about a returning soldier and about homosexuality. This list illustrates that the themes were intentionally varied.

Half of the theatre companies had some previous experience of performing for refugee children. According to responses in an internal survey, almost all companies adjusted their performance to the audience, but basically they did not approach the task as very different from performing in Danish schools. Surprisingly very few said they would have done something different if they had to repeat the process. One reason for this is the Danish children's theatre's belief in the "expressive literacy" approach to audiences. Another very good reason is that the performances were, with few exceptions, a success with the asylum children. Most performances proved that they could bridge cultural differences and create an inviting, safe, and community-oriented atmosphere. Refugee children were hardly more homogeneous than the Danish children, but as an audience they tended to be amazingly focused. It was, however, seldom that a real dialogue between the performers and the children took place which could open up for a discussion and involve the teachers/pedagogues. There were many obstacles, e.g. the time schedule of the school. But when the actors deliberately shared the space with the children, both before and after the performance, it made an immense difference and often involved the teachers/pedagogues.

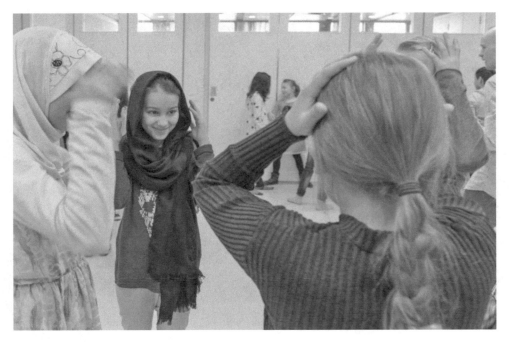

Figure 40.2 Workshop, Hanstholm School. (Photo: Søren Kløft.)

Workshops

After most performances, the audience was split into groups of a maximum of 35 children. The *Aktør* facilitators attempted to create a collective experience, despite working with different age groups. The basis was creating a shared space where refugee children coming from different centres and local school children could meet in a meaningful way. Most workshops were simple and play-based, with names-based exercises, impulse exercises, and mirror exercises, concluding with a session where the children drew their dreams and then performed them.

The focus was always on the future, not on the past. Most importantly was that workshops took place in an inviting atmosphere and that the children had fun. The refugee children were generally open-minded and receptive, and they threw themselves into this playful situation.

There were traumatized children, in particular among the unaccompanied minors group. Teachers were present to take special care of them, as *Aktør* pedagogues did not possess therapeutic training.

Due to The Danish Arts Council's policy to exclusively support *artistic* activity, very limited finances for the workshops were available from January 2018. Consequentially, the new strategy that followed after The Inclusion Center's evaluation of the pilot project could only be implemented in part. Right from the start, the asylum centres advocated for longer-term workshops for unaccompanied minors, and we managed to secure specific funding to offer two long-term workshops. The first was conducted by three dancers from a contemporary multi-ethnic breakdance company who gave daily workshops over a ten-day period for three asylum classes, and this resulted in a successful public performance. A review of this project highlighted how much the children became more focused, disciplined, and resilient, and how glad the children were throughout the process. One of the boys was allowed to take up professional classes.

The second workshop was planned as a follow-up of a highly successful workshop with 12 minors. In the meantime, the asylum centre was closed down, and the refugee minors moved to

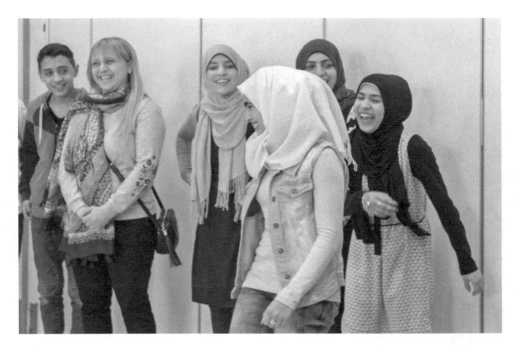

Figure 40.3 Workshop, Hanstholm School. (Photo: Søren Kløft.)

other centres. We partnered with another nearby centre for minors, and an actor–educator from the local regional theatre who introduced contemporary drama and music exercises to them. The workshops resulted in a theatre installation, but it was a difficult process. Most of the young boys were newly-arrived migrants, with little pre-knowledge of the format, and this created a disabling filter, despite great support from the staff. The lack of a common language was also suddenly crucial as the process required a certain level of dialogue, and locating interpreters of three different languages in a remote island proved impossible.

Upon reflection, these experiences underline the necessity to design a clear format which builds on an immediately accessible and commonly accepted format and language (dance, music, visual, etc.), and it points to the necessity to ensure that there is a common point of departure for the group members and that group dynamics should be supported at the outset to ensure trust and to stimulate interest, openness, and engagement. Thirdly, it became clear that there is a remarkable shortage of theatre pedagogues in Denmark who have experience in communicating with non-Western youths.

Two case studies of applied performance

Two cases of performances will illustrate some of the key issues already mentioned. The two are chosen because of their differences in location, venue, target age group and genre. First setting: *Body Parts* (35') by Uppercut Dance Theatre, for 4–8 year old children, followed by a workshop. A fun, wordless performance with two dancers (a break dancer and a contemporary dancer) presented in November 2018 in Brovst, a small village in Northern Denmark which hosted an asylum centre. The venue was a gym in a school with integrated classes for asylum children.

The participants: 50 children aged 6–9 years, from two asylum classes and from a Danish third class, and their teachers. The children transform gym mats into theatre seats. The performance

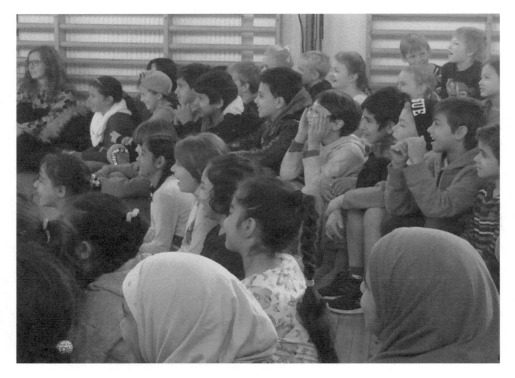

Figure 40.4 *Body Parts*, Uppercut Dance Theatre, Brovst School. (Photo: Lene Thiesen.)

is about two siblings who cannot sleep. There is banter, pillow fights, and scenes in the dark of the night. All senses are on high alert, empathy and adventure are two sides of the same story.

The mats are removed to make space for a musical workshop, run by the two dancers. The focus is on play, movement, and togetherness. The workshop had the undivided attention of all the asylum children, and their joy was contagious. Some of the older Danish children walk away, thinking that things were becoming a bit too silly, but they soon came back. The children throw themselves into the movements. It is striking how quickly the asylum children decode the Danish children if there are games they are unfamiliar with. It is evident there is good interaction between all the children.

The company had planned to have two workshop groups, which would have provided better opportunities for a conscious mix of the asylum and ordinary classes, but the teachers opted for one group, due to time limits. The teachers did not take part in the workshop.

Was this applied performance? Maybe not, the performance and workshop did not directly negotiate the different perceptions and identities of the children, and they did not have an intention to generate change. However, it did provide a safe and inviting environment where all children could engage both cognitively and affectively. It offered the asylum children a unique opportunity to experience a theatre production, it offered them 35 minutes' worth of self-forgetfulness, reflected in the mimic and reactions – from surrendering laughter to deep concern – and it also gave them an opportunity to act and play physically, to participate with the local children, and to be what they are: normal children in an abnormal situation. They entered the gym as two groups, but left as one.

Second setting: *Fucking Åmål* (65') by the theatre company Hils din mor, for 12–18 year olds, with a talk before and after the performance. A raw verbal and wildly theatrical adaptation of Swedish Lukas Moodysson's cult film about living in a small town and not being like the others, about the first love between two young girls, about finding oneself and having the courage to stand by who you are. It was presented in August 2019 at Sjælsmark Exit Center (30 km north of Copenhagen), which operates, since 2016, as a "reserve" refugee camp run by the Prison Service for families denied asylum and who cannot or will not leave the country. The venue is a small sports hall right outside the fence. The participants were Sjælsmark's Maxi Club: 7 young boys and 4 girls aged between 14 and 16 years, plus 4 Red Cross pedagogues. The company manager introduced the performance and explained why the theatre is a genuine medium for bringing topics along you rather not talk about. He also talked about Åmål, a small Swedish village where nothing happens and where teenagers erase boredom with parties and alcohol. The set is a street with two house windows – all in pink.

The language is raw and direct, the actions are often straight out and barrier breaking. The spectators are lying on gym mats or sitting on gym equipment. Some of the scenes are so provoking that the young boys hold their hands over each other eyes as they send each other glances of embarrassment. But the story about how the introvert Agnes succeeds to get the attention of Elin, the most popular girl in the class, makes a huge impact – with the girls and the boys. Little by little, they stop checking their mobile phones; they are challenged and provoked, they cannot take any more. But they all stay and are completely absorbed at the end.

After the performance follows a one-hour long discussion between the three actors, the director, and the spectators about "the film", as they called it, having never experienced outreach theatre before. They tell that they have met homosexuals, but do not know much. An Iranian girl relates what happened to a friend of hers in Iran, when she had a relationship with another woman. One of the boys expressed interest in being an actor and he has a private conversation with one of the actresses. The young people are open, they discuss, they ask. *Fucking Åmål* was an event that generated change of awareness and attitude. They left the hall energized and invited the actors to play ball at sunset.

Three weeks later, the pedagogues mention that they still talk about *Fucking Åmål* in the Maxi Club, and that they want more information. Since then, the pedagogues have organized an afternoon with Sex and Society (The Danish Planning Family Association).

Monitoring

The *Hodja* project engaged with 25 different asylum centres. Although the staff was often new, untried, and had many other priorities, they usually tried hard to meet the demands of a *Hodja* visit. But there were also some surprises: the space offered was often too small and could not accommodate the workshops; there was an imbalance with overflowing audiences; people often passed through the room, etc. But, all can be forgiven when the passers-by actually stayed. Cool teenage boys dressed in leather strolled by, ready to impress, but were impressed themselves by the poetic mime theatre and the quiet, focused atmosphere – and stayed to the end.

With or without the Danish schoolchildren?

What was most important: social relations with Danish children or quiet and focused moments where the refugee children could talk about what they had experienced with the opportunity to answer any questions they might have? The theatre pedagogues generally considered that

the refugee workshops *with* Danish children worked best for younger children, but, for minors (12–17 years), the value of the workshops was greater *without* local peers. It can be potentially intimidating for a minor to talk about her/his dreams, surrounded by privileged and unexperienced Danish teenagers. The decisions were taken locally for each programme, often in a dialogue between the local host and visiting pedagogues.

Language was rarely an issue. In all asylum centres, one speaks Danish from day one. Since most refugee children are in kindergarten or in school immediately on arrival with Danish pedagogues and teachers, they learn Danish surprisingly quickly, and furthermore, none of the performances were text-based. Especially the performances for families, which were visual with very few words.

However, it was not all about theatre. It was not only a question about theatre and asylum children meeting their local peers. It was just as much about testing oneself amidst new realities and about visiting the school that might be theirs in the future. It was also about Danish children seeing living conditions in the asylum centres, and about meetings that could lead to new play dates and new team mates on the football pitch.

It was also about the Danish kindergarten that twice travelled 50 km in order to share a performance and a burger in an asylum centre. Sometimes real barters occurred, such as a Danish fifth grade class that prepared lunch boxes for everyone, and refugee children who prepared a Syrian folk dance which led to a common chain dance. And it was about a breakthrough for teachers who saw unaccompanied minors – boys, usually locked up in their own shell and with their mobile life lines to home always at hand – suddenly open up, using their bodies, interacting with each other, and having fun.

When *Hodja* was "overtaken" by reality

Hodja continued to raise complex questions in an ever-changing reality. The discrepancy between the long-term planning horizon of the theatre companies and the short-term horizon of the asylum centres complicated the logistics from the outset. This imbalance became more alarming with the sudden drop in the number of asylum seekers from January 2016 (6,200 new asylum seekers in 2016 compared to 21,300 in 2015) not only weakened the basis of the project, but also influenced the stakeholders.

The flow of people in the asylum centres was erratic and this resulted in closures of centres and firing of staff, and the "here and now" management became even more erratic. Performances could be cancelled with only a few days' notice. The decreasing number of refugees was a new reality that demanded an added phase, focusing on "reception classes" in the schools. But lack of resources to secure competent management became, at the same time, an acute problem. Finally, in January 2018 when an application to a major foundation (which had shown interest in the project) failed, we decided to wind down the project and hand over the responsibility for implementing the few performances that took place in the last year of the project to Teatercentrum and ASSITEJ.

Conclusion

This project was dedicated to the refugee children arriving in Denmark between 2015 and 2018. The project was automatically subject to negotiating between an insecure long-term planning and a "here and now" crisis planning reality with only few artistic tool kits available, and this required building receptive and responsive frameworks.

There were many structural challenges. Once we realized and accepted that timeframes and timing were the key factors to project management, and that the ability to act and address any extraordinary situations were the lifeblood of the project the learning curve became steep. In this concrete situation *and* with the influx of some 8,000 children and unaccompanied minors in the asylum centres from 2015–2016, there was no scope for long-term planning, but a logistical requirement for theatres to work with a flexible format and adapt to many situations in order to find solutions to new challenges.

It is recommended to secure clearly formulated goals and objectives which can be both operationalized and measured by clear indicators. This is vital for planning, but also for the evaluation perspective. The challenge of insecure funding had to be addressed and we can conclude that it is also necessary to have clearly defined objectives related to different levels of funding and phases of funding to avoid an all-or-nothing scenario. The challenge of the discrepancy between the long-term planning horizon of the theatre companies and the short- term horizon of the asylum centres was basically insoluble, but it might have been more productive to work with fewer theatre companies which had already shown interest in working in socially challenged and non-institutional situations (in fact there are very few in Denmark). With fewer companies, it would also be possible to involve them as partners rather than stakeholders who simply delivered performances. An "expanded brief" for partners would be an ideal scenario.

To counterbalance the "here and now" planning and the consequences of sudden closures of a number of asylum centres, a closer collaboration with, for example, the Danish Red Cross Asylum Department, would possibly have given an overview to be able to plan with greater certainty, and this might have made it possible to concentrate the programme in selected centres over a longer period.

At present, Red Cross administrates almost half of the remaining 14 centres. With a more committed partnership, we might have avoided contacting all 77 centres at the project outset, which generated simply too many uncertain options.

It is also advisable, pending distances, to conduct on-the-ground research (by the project manager or theatre company) and to pay visits to the key host-persons at the institutions as early as possible in the planning process. The aim of these visits is to discuss practicalities and logistics, but also to agree on the teachers' role in the workshop and discuss how the project can profit from the teachers' professional knowledge of the children, especially the more vulnerable. The new project manager since July 2017 acted as a "co- host" during all *Hodja* visits, which resulted in smoother logistics.

We can conclude that theatre for young audiences can certainly play a role in socially and culturally charged and challenged situations where individuals are placed in insecure life-changing situations. Theatre, after all, deals with many kinds of narratives. The companies are mobile, they work "on the ground" and in the "every day", and they work with the most vulnerable people – child refugees. The *Hodja* project proved, however, that it may be relevant to question the "product-driven" theatre as opposed to artistic-creative processes, which can link to the needs and situations within society, and which in the *Hodja* situation could have contributed to making the performance and the workshop a more holistic and immersive experience with a higher level of interaction.

Indeed, this perspective is one which might fit well into a more general trend in the (performing) arts of creating temporal "microtopias" (Bourriaud 1998) which can offer alternative realities and counterweights to "reality" as it is perceived. The potential of the project was only partly realized, but the knowledge and the know-how accumulated was highly relevant and will benefit future projects.

In September 2019, with only few children left in the 14 active Danish asylum centres, there is much public attention on the living conditions of the children in the Sjælsmark Exit Center (for refugees refused asylum). A number of private cultural initiatives support these children, e.g. a private music school offers regular and free teaching, and the last four performances of the *Hodja*-project took place in Sjælsmark. This was a resounding success due to an intense programme within a short period, an exemplary collaboration with the Red Cross pedagogues who helped to select performances, and due to an extremely attentive and focused audience. Despite structural challenges, the *Hodja* project proved that performing arts can intervene in situations of crises, can bridge cultural differences, and can create situations where it is possible to create an inclusive environment – in contrast both to the concrete conditions in the asylum centres and in the "real" world. The genuine experience of the individual child was without a doubt at the core of the project and this was kept intact in most events, to the credit of the theatre companies and the theatre pedagogues involved.

Notes

1. The name of "Hodja" is inspired by Nasreddin Hodja – a well-known trickster figure in folktales in Afghanistan and Iran, and equally popular among Danish children thanks to Danish writer Ole Lund Kierkegaard's modern Hodja-figure.
2. A person becomes a *refugee* when a state or an international agency has acknowledged that this person is fleeing due to persecution or other threats – this acknowledgement is also known as asylum. An *asylum seeker* is a person who asks for protection as a refugee but whose case is in the process of consideration. The Danish asylum centres housed both.
3. Center for Rummelighed (http://rummelighed.org/).
4. International Organization of Theatre for Children and Young People (www.assitej-international.com).
5. Danish Arts Foundation's market regulated scheme for theatres for young audiences supports the sale of performances. The scheme has been an important contribution to the success of the Danish children's theatre.
6. Key figures: The breakdown in costs of the total budget of €280,000 were: 44% activities; 40% planning, management and communication; 10% office expenses incl. rent; 3 % travel and accommodation; 3% evaluation and documentation. OBS Denmark has one of the world's highest cost of living index.

References

Bourriaud, Nicolas. 1998. *Relational Aestetics /L'Estétique Relationelle*. Les Presses du Réel, Paris.
Juncker, Beth. 2006. *Thesis: Om processen. Det æstetiskes betydning i børns kultur* (About the Process. The Importance of the Aestetics in Children's Culture). Tiderne Skifter, Copenhagen.
Juncker, Beth. 2017. *Expressive Literacy*. Keynote Speech at ITYARN (International Theatre for Young Audiences Research Network) Conference at 19th ASSITEJ World Congress and International Festival for Children and Young People, Cape Town.
Reason, Matthew. 2013. The Longer Experience: Theatre for Young Audiences and Enhancing Engagement. In: *The Audience Experience*, Eds. J. Radbourne, H. Glow and K. Johanson. Bristol: Intellect.
Skot-Hansen, Dorte. 2017. Is Something Rotten in the State of Denmark? – Nationalisme, national identitet og kulturpolitik. In: *Vem får vara med? Perspektiv på inkludering och integration i kulturlivet i de nordiska länderne (incl. a summary and abstracts in English)*, Eds. Sverker Härd and Kulturanalys Norden, Nordic Council of Ministers, Copenhagen.

Further reading

Schramm, M., Moslund, S.P., Petersen, A.R., Mirjam, G., Post, H.C., Vitting-Seerup, S. and Wiegand, F. 2019. *Reframing Migration, Diversity and the Arts: The Postmigrant Condition*. Routledge, New York.

INDEX

2042 AD 105–7

Aboriginal 11, 56–64, 66–74
activism 4, 79, 82, 91, 129, 186–192; activist 91, 100, 187, 188, 192, 228, 315–318, 342, 374
Adichie, C. N. 190
affect 15–16, 20, 246, 248–250; affective 11, 17, 29, 152, 198, 247, 248–250; affectively 438
Ahmed, S. 72
Alcázar, J. 5, 221–223, 226–234
Aleksandra Zec 134
Alexander, N. 342–343
Alrutz, M. 10
Antigone 13, 32, 135
Ardern, J. 46
Aristotle 386
Arrivals Legacy Project 4
Art for Social Change: Play against Violence 120–122
artivism 3, 228; art actions 261–269, 360, 374
asylum 81, 96, 417, 420, 430–442
Atkinson, J. 71–72
Auckland Prison 12, 32–42
Ávila, A.C. 6, 223, 235–244

Back, L.: *The Art of Listening* 2, 70–73
Badiou, A. 262
Bakhtin, M. 416
Balfour, M. 2, 17, 19–31, 295, 416, 423
Barber, K. 332
Baumann, Z. 201, 229
Beckett, S.: *All That Fall* 69; *Waiting for Godot* 387
Beljanski-Risić, L. 5, 80, 116–129
Belliveau, G. 79, 141–148
Benjamin, W. 136
Benza, R. 5, 217–225
Bhabha, H.: *Third Space* 63
Bitef Polyphony 127–128

Boal, A. 167, 191, 222, 261, 331–339, 343, 373, 375; *Games for Actors and Non-Actors* 112, 402; spectactor 167
Bobiwash, R 150–151
body 219–224, 225–243, 263–269, 281, 365, 378, 387, 388, 426, 452; as a weapon 237; as art 5, 226–233; bodily 419; body's wisdom 206–207; decolonization of the 254
Body Parts 437–438
Bolton, G. 178
Bonobando 377–379
Bonsall, A. 6, 290, 291, 294–304
Borwick, D. 91
Bossart, R. 3, 362, 364–370
Bottom(s up) 102
boundary crossing 11
Bourriaud, N. 453; *Relational Aesthetics* 163, 386
Brecht, B. 97, 108, 174, 261, 274
Breed, A. 1–6
Brisbane Women's Correctional Centre 65–74
Brook, P. 189, 201, 387
Bruguera, T.: *El Peso de la Culpa* 232–233
Buck-Morss, S. 359
Bustamente, N.: *America the Beauty* 229–230
Butler, J. 211

Cabral, A. 289
CADA (Collective of Art Actions) 5, 262, 264–269
Cahill, H. 2, 9–18
care 1, 65, 85, 163–164; aesthetics of 163; economies of 15–16, 43–55
Care for the Open 359–363
Carpio, P. 5, 217–225, 254–260
Carter, J. 4, 80, 149–157
Castro, F.G. 5, 219, 223, 261–270
catharsis 63, 97, 144, 167, 168, 191

Index

CEDEUM (Centre for Drama in Education and Arts) 116–129
certification 258
Chichewa 291, 294–303
Chikonzo, K. 6, 291, 292, 305–314
children's theatre *see* theatre for children
Chinyowa, K. 290, 333, 336, 337
Christchurch terror attack 13–16
CIP San Joaquin 245–253
Clark, L. 232
clowning 1, 17, 80, 247, 409, 435; clowning and health 387; relational clowns 2, 17, 19–31; therapeutic clowns 158–164
Cohen-Cruz, J. 89, 373–374
colonial 44, 72, 73, 150, 213, 217–223, 240, 296, 332, 359, 378; colonisation 4, 12–13, 60, 64, 201, 205, 297, 332; colonising 291; colonised 72; coloniser 72; decolonial 34, 39, 40, 205; decolonising 1, 4, 39, 44, 51, 64, 201, 204–206, 291; legacy 32, 39, 40, 68; neo-colonial 3, 289, 360
Communal Living Culture 5, 222–224, 254–259
community passport 257–258
conductor 166–172
conflict transformation *see* peacebuilding
Conquergood, D. 181
Contact! Unload 141–148
Cook, C. 79, 141–148
Cools, G. 416, 427
correctional facility *see* prison
counter-hegemonic 195, 273, 306, 311, 313
counter-narrative 6, 305–313, 372
Cox, S. 79, 141–148
Croatian Centre for Drama Education 110–113
cross-cultural 11, 56–68, 123, 201
Cruz, H. 3, 362, 371–382

dadirri 71, 72, 74
Dance of Souls 281–284
Danchev, A. 80
Daughters of the Floating Brothel 67–74
de la Fuente, A. 263, 267, 268
Dear Mr Government the children have something to say 6, 291, 292, 315–330
decolonial *see* colonial
dementia 2, 17, 19–31, 45, 90, 383, 389
demythologizing *see* myth
Derrida, J. 262, 265
Dewey, J. 65, 386
DICE (Drama Improves Lisbon Key Competencies in Education) 5, 122–123
Diéguez, I. 221
disability 84, 158, 386–387; physical
Dobson, W. 173–179
documentary theatre 11, 366, 385
Donnelly, H. 4, 158–165
Drama for Life 289–290, 341–342, 345

drama in education 108–115, 119, 176, 289
dramaturgy 379, 389, 406, 407, 409, 411, 415–429; dramaturgical 407, 408
drug addiction 102–104
Đulić, S. 5, 80, 93–100
Dunn, J. 2, 17, 19–31

Eduham 213–214
Ehrenberg, V. 175
Eisner, E. 85
elders 1, 10, 45
Elliott, M. 6, 245–253
embodied forms 5; embodied archives 206
empathy 71, 166, 169, 178, 189–191, 227; empathising 106
epic theatre 6
ethics 1, 6, 32, 72, 141–146, 362; ethical 4, 10, 18, 44, 73, 129, 141–147, 180, 184, 214, 241, 253, 317, 341, 375, 389; ethical gap 344; ethic of care 15, 37–38, 49; ethics of engagement 12–13; ethics of inclusion 10–11; ethics of memory; ethics of representation 9–18; ethics of response 184
ethnography 1, 19, 125; auto–ethnography 1

facilitation 43, 195, 198, 199, 385; facilitator 74, 105, 119, 202, 205, 257, 316, 348, 349, 385, 386, 389, 405, 407, 410, 436
FARC 236, 240
feminism 46; feminist 44, 126, 163, 181, 217, 226–233, 269, 378
Fine, M. 12
First Nations 64, 71, 80
fool 160, foolishness 164
forum theatre 12, 33, 87, 99, 102, 109, 112, 124, 169, 398, 399
Foucault, M. 262, 387
Fox, H. 4, 166–172
Freire, P. 246, 248, 249, 252, 253, 261, 297; *Pedagogy of the Oppressed* 402
Fucking Åmål 439

Gærum, R.G. 4, 383–391
Galindo, R.J. 5; *Lo Voy a Gritar al Viento, Perra* 229
Gallagher, K. 11
gatekeepers 80, 173–178
Geese Theatre Company 66
Generation 91-95 132
Georgeson, R. 202–209
Gorata-Zulu, B. 6, 289, 291, 315–330
Gray, J. 4, 158–165
Gross, I. 267
Gruić, I. 111–113
Grupo de Teatro Catalinas Sur 272–274
gylphing 149–156

De Haene, L. 3, 362, 415–429

Index

Halley, C. 6, 289, 291, 315–330
Hamilton 4, 210–214
Hazou, R. 12, 32–42
Heathcote, D.; Mantle of the Expert 105, 109, 178, 316, 343
Hegel, G.W. 359–361, 363
Heinicke, J. 2, 359–363, 416, 426
Hermant, H. 202–209
Herrera, B. 210–211
Hill, A. 15
Hincapié, M.T. 5; *Una Cosa es Una Cosa* 231
HIV/AIDS 51, 52, 223, 278–279, 289–290, 292, 331–338, 341
Hodja from Denmark–Theatre for Asylum Children 430–442
Holloway, J. 251
homecomings 194–199
Homeland War 130–138
homeless, homelessness 405
hooks, b. 181, 334, 337
Horvat, N. 87, 101–107
hot-seating 100
Huizinga, J. 247–248
human rights 6, 10, 65, 86, 100, 136, 174, 211, 212, 220, 262, 290, 333, 369, 378; children's rights 6, 246; European Court for Human Rights 403; violations 130, 219, 292; workers' rights 226
hybrid 298; hybridity 373; hybridized 211, 212; hybridizing 210

image theatre 66
incarceration *see* prison
Inclusion Center 432–433
indigenous 1, 2, 11, 12, 36, 39, 64–74, 149–156, 166, 174, 201, 206, 208, 212, 217–224, 228, 235, 240, 292, 296–298, 302, 332, 336, 378
intergenerational 68, 201, 409, 411
International Court of Human Rights 368–369
International Institute for Political Murder 365
invisible theatre 101, 261, 332

James, J. 65–66, 74
Jeffers, A. 423, 425
Jelić, A. 127
Jerke, L. 173–179
Johnston, K. 245
Junker, B. 431

Kandil, Y. 180–185
Kelly, H. 36
Kenani, S. O. 294, 295, 298, 299
Kerr, D. 296–298
Krušić, V. 80, 108–115
Kuppers, P. 89–90
Kwiatek, M. 393–402

Laundry Café 6, 292, 331–339

Lea, G.W. 79, 141–148
Leavy, P. 1
Legami in spazi aperti 403–414
Legislative Theatre 335
Lehmann, H-T. 359, 411
Lejowa, J. 6, 289, 291, 315–330
Lenin, V. 175
LGBTQ 90, 211; LGBTQI+ 49
Lie 103–104
liminal space 36, 201, 261–269
Living Together 119–120
lost generation 131, 132
Lukić, D. 4, 79–91, 108–115, 130–132
Lyotard, J-F. 306

MacLeod, C. 4, 80, 194–200
Majid, A. 186–193
Makumbirofa, R. 6, 291, 292, 305–14
Malini, G.I. 403–14
Mantle of the Expert *see* Heathcote, D.
Māori: community 1; culture 57; heritage 66; knowledge 34; *manaaki* 34, 38, 39; *manaakitanga* 43–55; prison population 13, 32; protocols 33, 34, 45, 52; *pōwhiri* 36; *Puāwai* Festival 43, 48, 51–53; students 57; *tangihanga* 34, 39; *Te Reo* 44–47; *tikanga* 43–47, 52; *tohunga* 34, 35–36, 39; *Whaikōrero* 35–36, 39; worldviews 39
MAP 375–77
marginal 46, 337, 384, 387; marginalisation 64, 74, 185, 226, 384, 387; marginalised 10, 12, 80, 85, 91, 117, 136, 181, 204; marginality 181, 384, 385
Marx, K. 173–178
Mashingaidze, T.M. 305, 312
Matišić, M. 132, 135
Mayer, M.: *El Tendedero* 228–229
Mbembe, A. 360, 361, 363
Mbiti, J. 335
Medina, C. 237–238
memory 1, 29, 59, 79–81, 149–156, 183; 201–207, 219–224, 266, 271, 280, 365–366, 378, 407, 408, 418, 419, 420; ancestral 61, 80, 203–204; collective 274; counter 81; emotional 241; historical 281
Mexe 377
migrants *see* refugees
migration 3, 80, 182–184, 194–199, 201
Milczarczyk, G. 396–399
Millones, L. 217
Minh-ha, T. 197
Minujín, M. 232
monocultural 83, 89; monoculturalism 92
Moogahlin 58
Mostar Youth Theatre 93–100
Mouffe, C. 211, 252, 262–264
Moyo, C. 6, 289, 292, 331–340
Moyo, D. 333–334

Mujeres por la Vida 262, 264–269
Mullen, M. 16, 43–55
multiculturalism 387
multidisciplinary 23, 83
multimedia 119
myth 97, 124, 131; mythological 98; mythologies 80, 202; mythologization 133; demythologizing 130–131

neoliberal 46, 65, 84, 212, 252, 289, 290, 291; neoliberalism 43, 289, 293
New York Times 211
Nichols, J. 79, 141–148
Nicholson, H. 183, 385, 416
No me olvides 5
Nogales, I. 222, 223, 254–260
Nussbaum, M. 337

O'Connor, P. 2, 9–18
O'Rourke, H. et al. 20–25
other 63, 208, 361; othering 10; otherness 82–92, 129, 181–182, 360, 361

Pahuus, M. 386, 388
Pākehā 35, 48, 49, 57
Pammenter, D. 175
participation 20, 67, 82, 84, 101, 116, 117, 118, 169, 238, 281, 371–381, 386, 402, 410, 415–429; participatory 45, 104, 112, 116–129, 180, 195
Pasifika 47, 57
Pax Bosniensis 93, 96, 97
peace 235–43; peacebuilding 5
Pele 375–377
penitentiary *see* prison
physical theatre 33, 133, 158, 159
play 56, 58, 95, 116, 118, 120, 122, 127, 245–253, 401, 407, 409, 423; playful 436; *Playful Engagement* 17, 19–31; playfulness 2, 22, 129, 315; playing 94, 127, 410; relational playground 415–429
Playback Theatre 4, 80; conductor 166–171
pluriversity 258
Points of Culture 222, 256, 259
Polish Theatre, Warsaw 396, 397, 401
polyphony: *Bitef* 117–129; polyphonic 116–129, 416
post-colonial 79, 289, 291, 300, 363
post-communist 82–92
post-conflict 82–92
post-democracy 212
post-dramatic 359, 411
Prentki, T. 1–6, 83, 87, 88, 175, 180, 181, 185, 251, 294, 295, 372, 373
Preston, S. 87, 88, 151, 175, 295, 373
prison 12, 65–76, 101, 248, 278, 312, 366, 385, 387, 397, 399, 451; juvenile justice 245; prison theatre 12–13, 403–414
process drama 66, 87

protocols of engagement 182–184
psychodrama 87, 93, 166–168
psychotherapy 240
Puppet Antigone 32–42
puppets 13; Bunraku 33, 37–38; theatre 87, 273

quality moments of life 19–31
Quarmyne, L. 202–209

Rachel 19 291, 292, 331–339
radio drama 12, 65–76
Rancière, J. 136, 210, 343, 372
Rasem, M. 3, 416–424
Rau, M. 3, 362, 364–370; *Empire* 364–368; *Hate Radio* 4, 362, 364–366, 369; *The Congo Tribunal* 364–370
reconciliation 11, 63–64, 72, 80, 151, 225, 240–243, 305–313, 365, 409–410
refugees 15, 109, 183–185, 194, 199, 219, 359–362, 383, 385, 405, 415–442
relational encounters 17; relational space 197
research-based theatre 79, 141–148
resistance 14, 80, 181, 188, 205, 219, 220, 223, 227, 243, 246, 248–250, 280, 289, 291–293, 343, 373, 397
re-traumatization *see* trauma
Rice, T. 70
Richard, N. 264–265
Ricoeur, P. 80
rights *see* human rights
ritual 13, 58, 161, 166–171, 217, 227–233, 282, 294, 295, 297, 305, 308–313
Rituals 6, 291, 292, 305–313
Roberts, D. 4, 80, 201–209
Robles, R.M.: *Navajas* 229
Roma 123–125, 387
Romio ndi Julieti 6, 291, 294–303
Roof Top Promotions 292, 306–307, 310
Rothberg, M.: *Multidirectional Memory* 202
Rousseau, C. 3, 362, 415–429
Routes and Roots 152–156
Rubio, M. 218, 220–223

Sadeghi-Yekta, K. 4, 79–81
Salverson, J. 182–185
Sámi 383, 388
Schechner, R. 296, 405, 411
Scher, E. 6, 220, 223, 271–277
Seeds of Peace 190–191
Selva, R.M. 220, 221, 223, 278–286
SENAME 245–253
Setchell, J. 4, 158–165
Shange, N. 201
Sibanda, N. 6, 289, 292, 331–340
simultaneous dramaturgy 6
Škozorište 116–119; *Hamlet* workshop 118–119
Škuflić-Horvat, I. 87, 101–107

de Smet, S. 3, 362, 415–429
Smith, D. 202–209
Smith, L.T. 39, 44, 73
social justice 4, 10, 88, 173–178, 186–192, 223, 236
social theatre 405–411
Sölter, A.G. 5, 219, 223, 261–270
Sosa, A. 5; *Tejido Amarillo, Azul y Rojo al Infinito* 230
Stalpaert, C. 3, 362, 415–429
Stolen Generations 58, 59, 62, 68
Sutherland, A. 289–293
Sviben, M. 101–107
syncretization 217

Taurima Vibes 16–17, 43–55
Taylor, P. 385
Te Rongopai Tukiwaho, B. 16, 43–55
Teatro Trono 223, 254–259
Temporary 3, 416–427; *The Fall* 134
The Masks 98–100
theatre for children 87, 119, 442
theatre in education 91, 97–99, 101–107, 108–115, 294, 404
Theatre of the Oppressed 112, 166, 222, 261, 334, 343, 359, 372, 373, 395, 402
therapy 93, 109, 142, 386, 401; dance 86; drama 66; theatre 17, 87, 91; therapeutic 72, 145, 158, 266, 294, 386, 389, 404
Thiesen, L. 4, 442
third space 63–64
This Fella, My Memory 56–64
Thompson, J. 20, 48, 49, 53, 84, 163, 174, 182, 189, 196, 248–250, 385
Tierra de Esperanza 246–253
Tinius, J. 416, 423
Tirena Theatre 80, 87, 101–107
Tkaronto/Toronto 149–156, 158
Toro, J. 5, 261, 262, 264–269
Torres Strait Islander 58, 67–74
transcultural 359–363
transformation 393–402

trauma 13–15, 61, 68, 80, 130, 136, 142–146, 162, 168, 169, 182, 206, 237, 292, 318, 416, 426; of colonisation 72; playwriting 134; traumatic 166, 318, 426; traumatized 436
Tree that Tells Stories or the Mining Illusion 280–281
Trilogy on Croatian Fascism 133–134
Trouillot, M-R. 204–205
Turn on Your Computer, Turn on Your Brain 104–105
Turner, V. 171, 405, 411

Ukeagbu, V. 295
Ungunmerr, M-R. 71, 72

Velasco, E. 186–193
verbatim theatre 1
veterans 79, 131, 132, 135, 142–146
Victory Siyanqoba Arts *see Laundry Café*
Volosinov, V.N. 416, 422
Vukovar 134–135
van Vuuren, P.J. 6, 289, 341–356

Way, B. 400–401
Wilkinson, L. 11, 56–64
Winston, J. 249
witness 4, 95, 97, 136, 151, 167, 169, 182, 202–209, 311, 366, 369, 419, 421, 424, 427; witnessing 4, 9, 57, 80, 81, 142–146, 188, 202–204, 316
Wolfgram, M. 79, 81
Wong, J. 202–209
Woodland, S. 2, 12, 65–76
World Bank 297, 342
Worthen, H. 4, 210–214

youth: arts 46; theatre 5, 95, 108
Yuin 60–61

Zafón, C.R. 79
Zagreb Youth Theatre 85, 86, 90–91, 108–113, 134, 135
Zenenga, P. 332
Židek, N. 5, 80, 130–138